AMERICA'S
COLLECTION

Virginia B. Hart

with

Bri Brophy

Laaren Brown

Elliot Bostwick Davis

Alice Cooney Frelinghuysen

Allan Greenberg

Mark Alan Hewitt

The Honorable John F. Kerry

Alexandra Alevizatos Kirtley

Elizabeth Mankin Kornhauser

David M. Rubenstein

Stacy Schiff

Carolyn Vaughan

Deborah Dependahl Waters

PRINCIPAL PHOTOGRAPHY BY

Durston Saylor

Bruce M. White

AMERICA'S COLLECTION

The ART & ARCHITECTURE of the DIPLOMATIC RECEPTION ROOMS at the U.S. DEPARTMENT of STATE

Rizzoli Electa

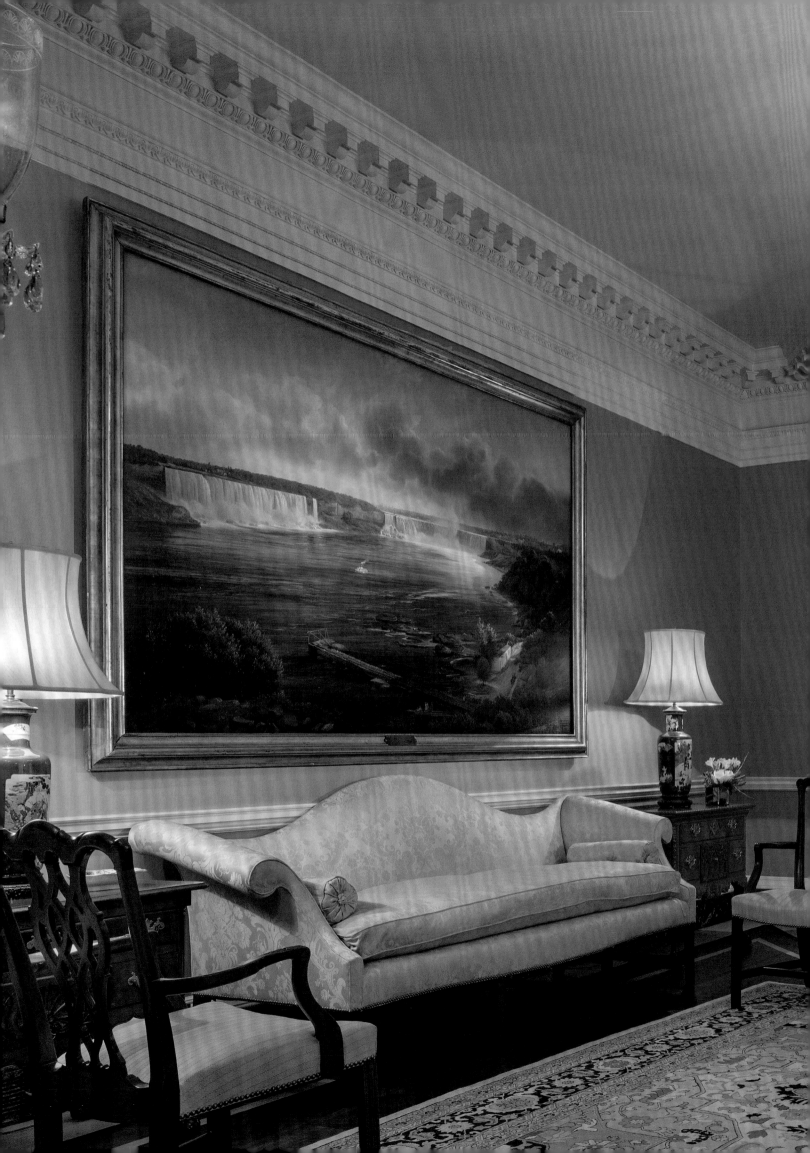

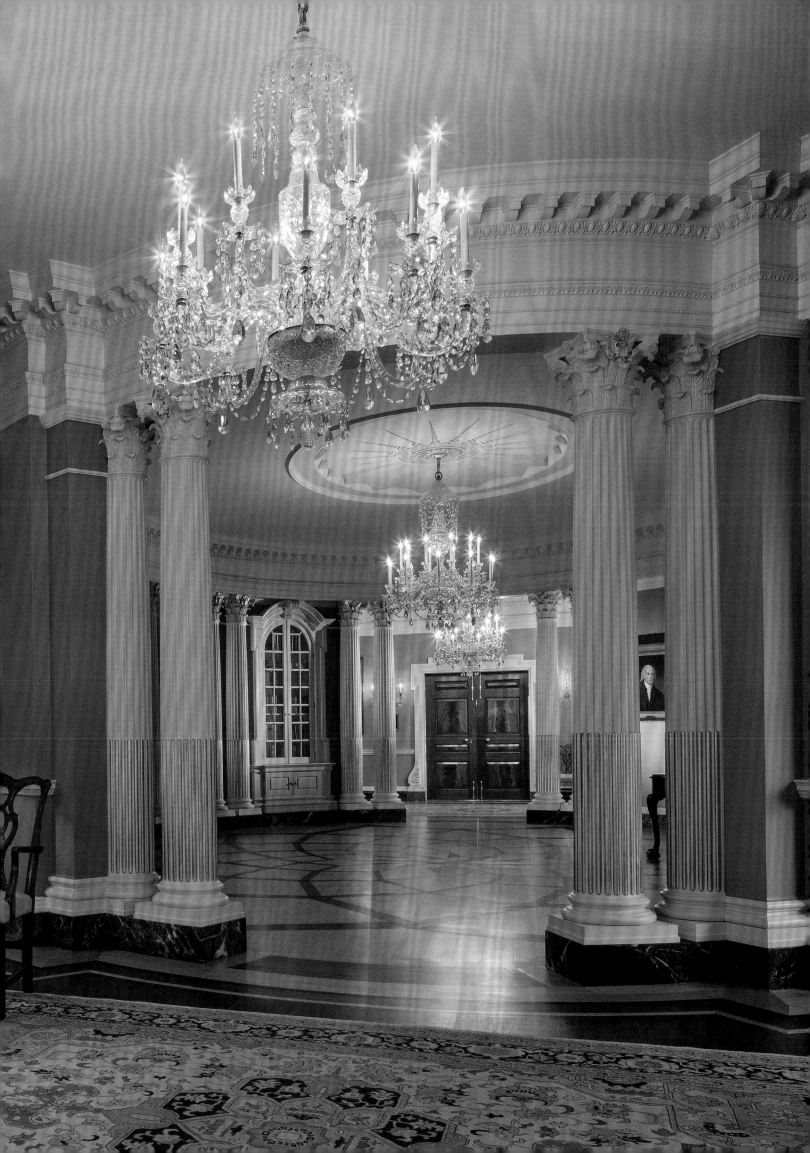

CONTENTS

RIGHT The Gallery

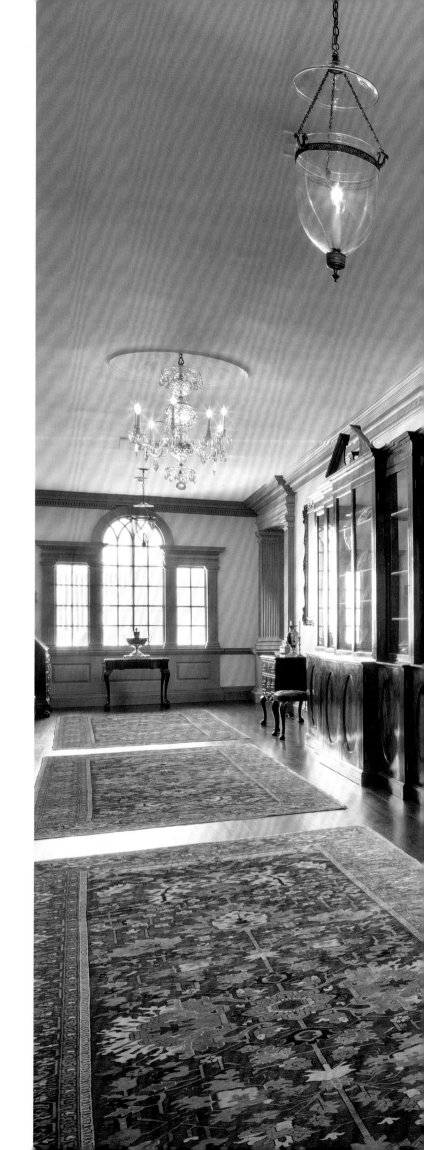

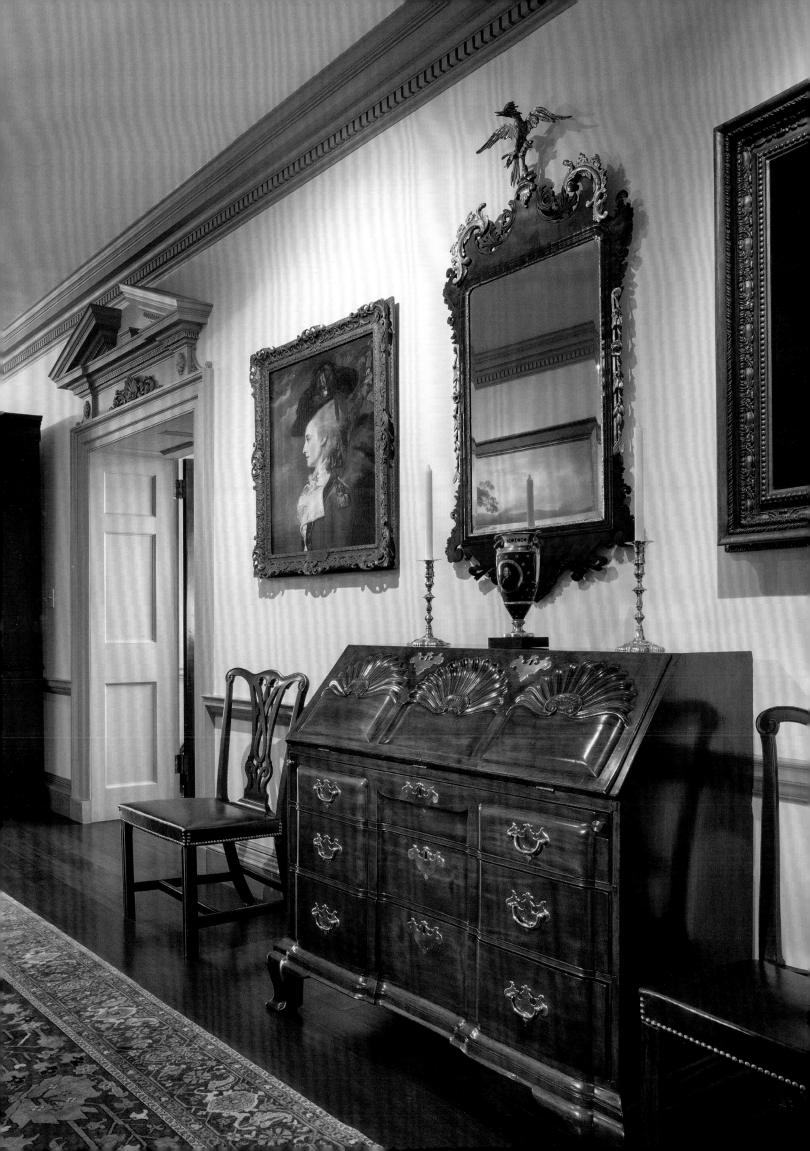

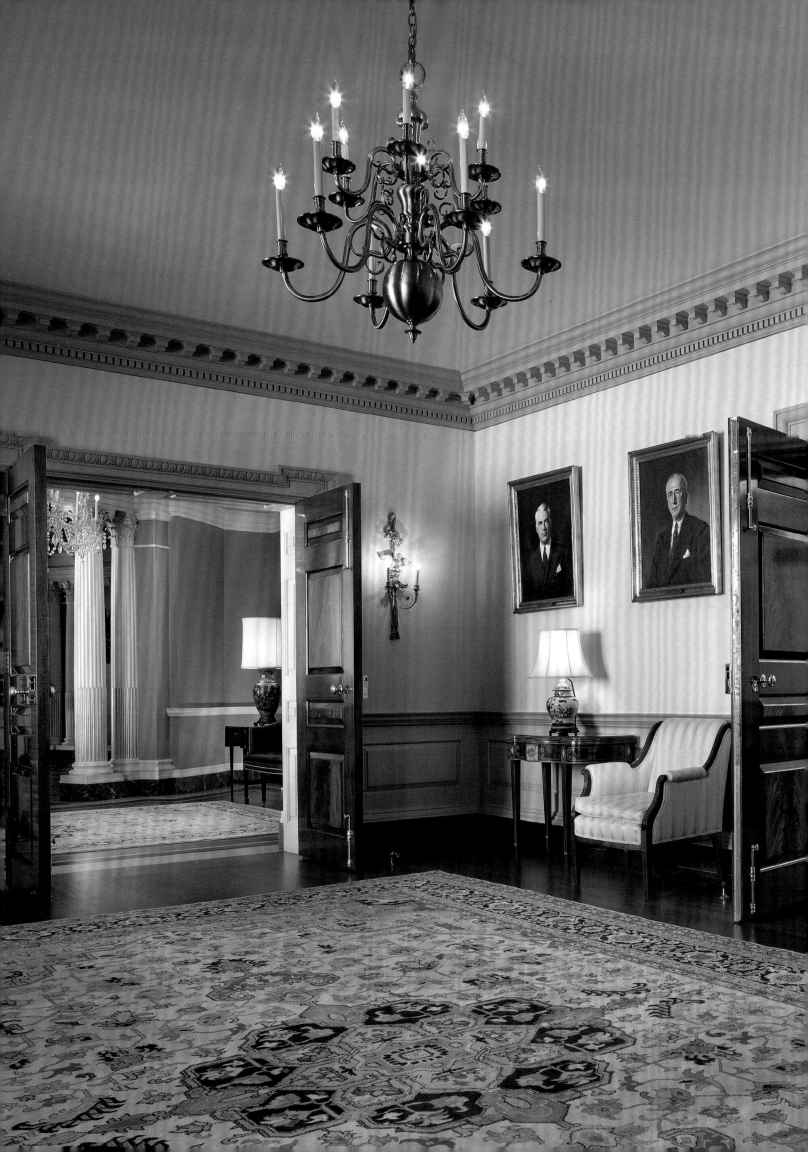

FOREWORD

The Honorable John F. Kerry

YEARS AGO, WHEN I READ about the early American experiment in democracy and nationhood, I was struck by the story of Washington and Pierre Charles L'Enfant laying out the new capital city of Washington, D.C., with the aim of leaving foreign visitors, adversaries, and competitors intimidated by the young city's grandeur. They planned marble steps from the water's edge leading to a sweeping, grand, unspoiled Mall and wide boulevards leading to the White House and farther up the grand avenue to the Capitol. That is one side of statecraft. Another is more subtle, and in the case of the State Department, even hidden. It is the grand gesture that says to a visitor to our shores: you are *welcome* here. It is inclusivity through cultural diplomacy. It is both a skill and an art, and it has a special home—on the seventh and eighth floors of the Harry S. Truman Building at the United States Department of State, the seat of American diplomacy. This book is the story of the gifts that reside there, their place in American diplomacy, and the often unheralded contributions of the incredibly gifted people who carefully bring it to life each and every day to advance our values, protect our interests, and share our culture with the world.

Approaching the massive, understated, and, some might even say, ever so slightly aesthetically unappealing Truman Building, a visitor in our nation's capital would have no outside indications of the treasures that can be found inside, in "diplomacy's penthouse." The building is unassuming by design, a humble, unadorned place where the dedicated diplomatic corps of our nation work every day with great care, skill, and dedication. But, to welcome our counterparts from around the world, our diplomats have the biggest home field advantage you could ever hope for: just one mahogany elevator ride away, our special guests can experience something akin to the moment in *The Wizard of Oz* when the picture changes from black and white to color. It happens thanks to the special patronage of the beloved sixtieth secretary of state, George Shultz, and his wife, Charlotte, who invested so much time into beautifying these magnificent spaces; to the donations of many others; and to years of curation and dedication by the incredible team behind the Diplomatic Reception Rooms. And now, through this volume, readers can experience that moment from the comfort of their own homes, schools, and libraries.

I am confident you will be in awe of the spectacular pieces from the forty-two rooms on display within these pages, as I continue to be—inspired by the names and legacies etched in our national memory. Take them in one by one: portraits

OPPOSITE
West Reception Hall of the Treaty Room Suite

11

done from life of Benjamin Franklin, our nation's first and certainly most colorful diplomat; the architect's table on which our first secretary of state, Thomas Jefferson, drafted the blueprints of a democracy; the important silver made for President John Adams by his fellow Massachusettsan Paul Revere. It is one thing to hear about these objects. It is quite another entirely to study their fine details and stunning artisanship. If you look closely, you can see the marks on the silverware from care and use, perhaps by guests at events hosted by John Quincy Adams or James Monroe. On the back of the delicate spoons, you can admire Revere's carefully stamped last name in plain block letters. These are reminders that, just like us, our Founders and earliest diplomats were not statues or icons, but real people navigating

an uncertain world and difficult choices with imperfect information and their own imperfections too. They did not know whether their fledgling nation and the experiment of American democracy would succeed, but they were willing to "get caught trying"—to strive and sacrifice in the attempt to give it life. Because they succeeded, we can all continue that work today.

Through this collection, you will also see defining moments for America depicted—from Revere's engraving of the Boston Massacre, a moment of fear and tragedy for the colonists, to paintings of Franklin hard at work, trying desperately to convince the world that our young nation was here to stay. In the abolitionist medallions given to early opponents of

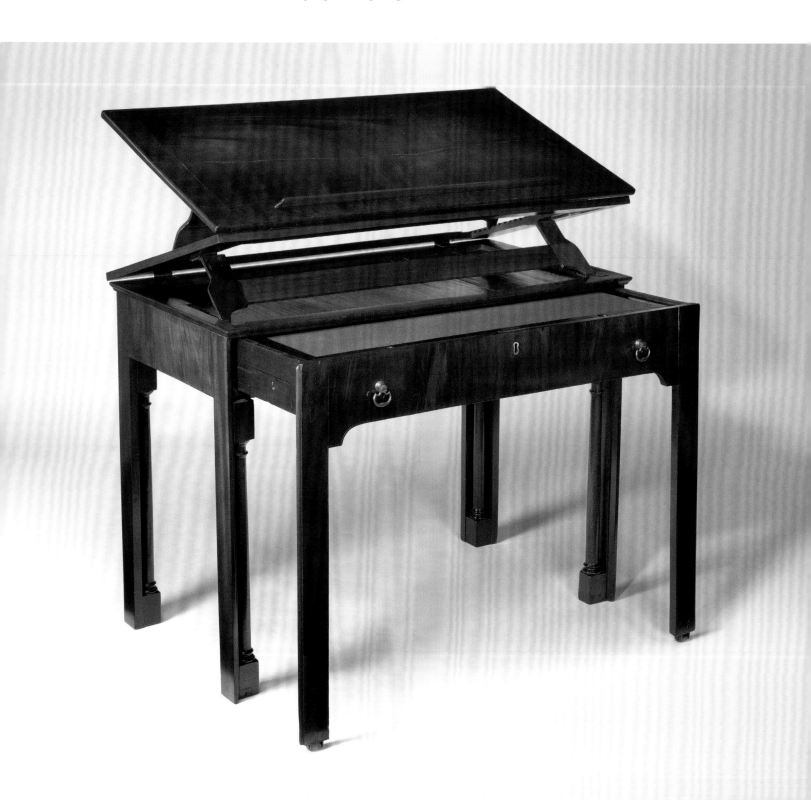

slavery, you will see for yourself a promise that justice could one day prevail for all—and a recognition that a great nation does not hide from its own mistakes but holds them up to scrutiny, believing that there is something redemptive in the acknowledgment that nationhood is a journey and that America is an idea still being perfected.

It is fitting to house this collection in a building named for President Truman. It was Truman, as the world recovered from World War II, who ordered that on our national emblem—originally created as a result of efforts by committees, the first of which included Benjamin Franklin—the eagle would from then on face away from the arrows of war gripped in one claw and toward the olive branches in the other. It was a symbolic gesture that, as you can see in this collection, reflects the attitude of our earliest diplomats: even as they drew allies to our side to win wars, they struggled just as mightily for peace.

What our first diplomats knew, and what is still true today, is that our strength ultimately lies in inviting people to see and, on their own terms, embrace the values that inspired us— and are reflected in this collection: protecting children from hunger and disease, ensuring that people can live their lives free from fear and want, finding friends in a dangerous world, and making old enemies into new allies. Our early leaders took risks, were creative and courageous in their mission— and as they did their work, they were surrounded by furniture and other beautiful pieces created by those who made up the society they were representing, including women artists and artisans of color, showcasing what is possible when all people are allowed to contribute their full talents and skills. Their persistence left the world vastly different and far better than they found it.

When I was secretary of state, we held dinners and meetings with visitors from every corner of the globe in the Diplomatic Reception Rooms. Often, to the dismay of my staff who were hoping to keep my schedule running on time, I would encourage foreign leaders and other guests to take their time to absorb this magnificent collection.

This collection celebrates all people who aspire to be free and to shape their own futures. That is the work that the State Department continues today, to keep the promise for the next generation and for all the world, in quiet corners of the globe, in loud public squares, and everywhere in between. As we navigate a world of unparalleled technology, of unprecedented growth in the number of young people, of new evidence of old tensions, this collection reminds us that some things must never change. Drawing on our history, the United States can and must continue to join with other nations to pool our resources, our talents, our thinking, and to bring stability to places where there is none, to fix what is broken, and to protect what must be safe.

"There is no substitute for seeing the actual building blocks of our democracy up close," as a visitor from Texas said to me. She had taught college history for decades and seen these images in scores of textbooks, but never before had she seen the originals with her own two eyes. What a gift that is—for all of us. And now, that gift is yours—a reminder that America is exceptional not because we say we are, but because America does exceptional things.

Often, after events had concluded in these Rooms, I would find myself in front of the portrait of Benjamin Franklin in the room that bears his name. I would consider that fateful evening of debate at the Constitutional Convention in 1787 after which he wearily walked down the steps of what is now known as Constitution Hall in Philadelphia, late at night and alone. A woman waiting outside is reported to have shouted a question at him: "Tell us, Dr. Franklin, what do we have, a monarchy or a republic?" And he is reported to have looked at her and answered: "A republic, if you can keep it." *"If you can keep it."*

I hope this volume gives you a newfound appreciation for the diplomats, the artists, and all others who did and who still do that work—and continue to "keep it" today.

ARCHITECT'S TABLE, ca. 1785

Unidentified maker

England

Mahogany, white oak, spruce, cherry

33¼ x 42¾ x 23⅜ in. (84.5 x 108.6 x 60 cm)

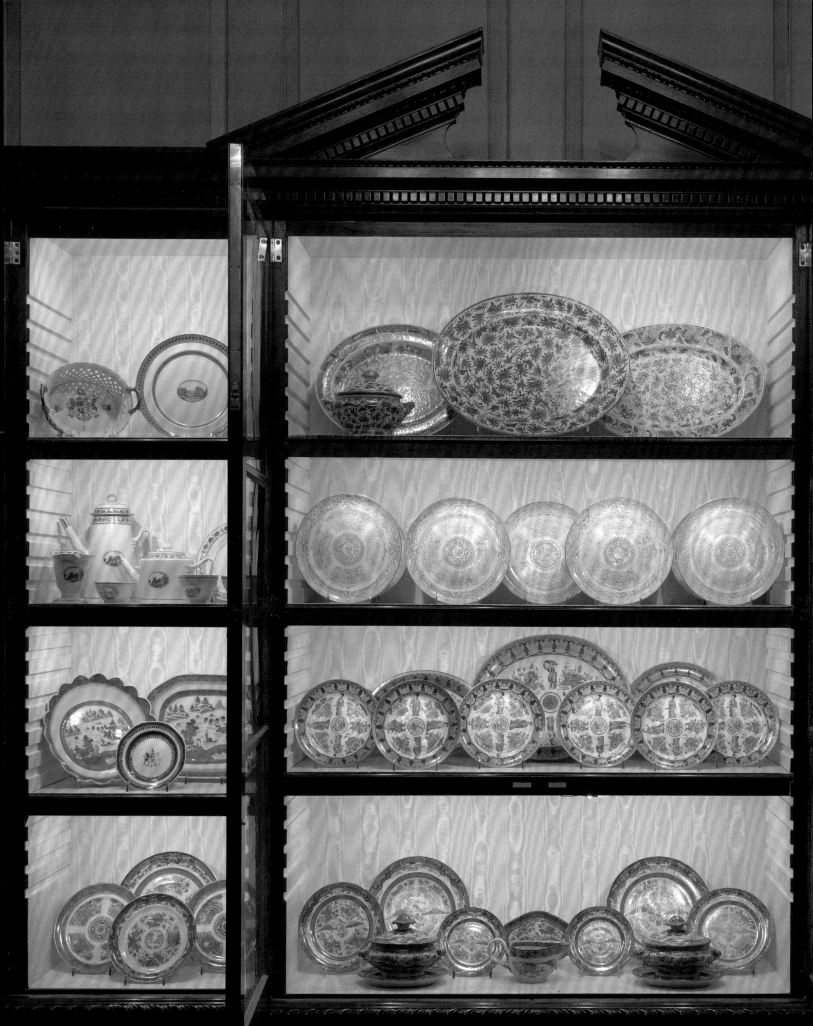

THE ART
OF WELCOMING
THE WORLD

Virginia B. Hart

*These rooms represent everything that is good about our country.
They represent all of the trials and tribulations we have gone through
from that famous day when they wrote and signed the Declaration
of Independence until today, while we're still living that creed.*

—THE HONORABLE COLIN POWELL, 65TH SECRETARY OF STATE

THE DIPLOMATIC RECEPTION ROOMS and their collection tell America's story. Oil paintings by Gilbert Stuart and John Singleton Copley, silver by Paul Revere, chairs attributed to Duncan Phyfe, all from the era of America's founding and early years, celebrate the new nation and the development of new artistic styles. These and the more than five thousand other fine and decorative arts objects that furnish these State Rooms reflect the optimism and the ideology of the Founders. They evoke the thinking and spirit of George Washington, John Adams, Thomas Jefferson, and Benjamin Franklin—Americans whose likenesses are portrayed in oils in these rooms and who themselves are associated with the objects displayed here. These images and objects have been brought together and preserved to ensure that the legacy of the Founders' ideals would live on and inspire future generations.

Diplomatic guests, American leaders, and members of the public are received in spaces that reflect the energy of the young republic and share its story. They can look up to see *The American Commissioners*, a copy of an unfinished painting by Benjamin West that depicts the American diplomats who drafted the treaty ending the Revolutionary War. Then they can look down to see the very desk on which the final treaty was signed, securing the new nation's independence and sovereignty. These national treasures, which are a reflection of our nation and the American people, celebrate our history, cultural heritage, and commitment to diplomacy. They form a vital, tangible link between the past and today's endeavors to represent the American character through diplomacy.

It is the signing of the Treaty of Paris 240 years ago, in 1783, that has occasioned this book. The first publication of the Diplomatic Reception Rooms collection in twenty years, it reveals an unprecedented look at the exceptional architecture and superlative collection that was the brainchild of the first curator, Clem Conger.

OPPOSITE
Entrance Hall

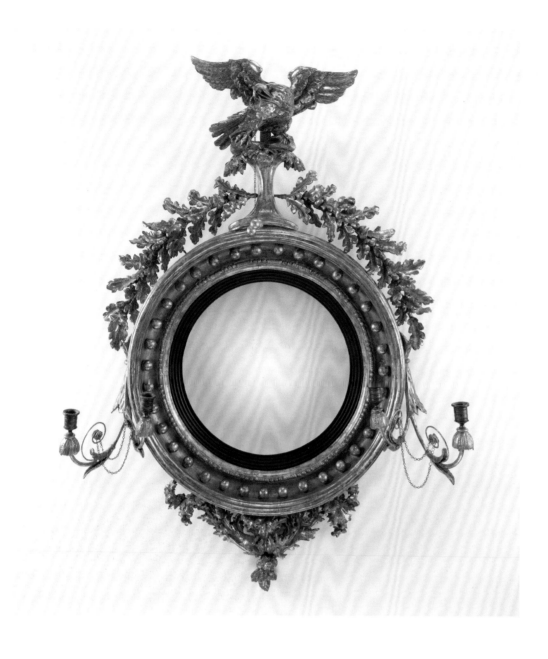

CONVEX MIRROR, ca. 1800–1820
Unidentified maker
Probably England
Eastern white pine, sylvestris pine,
spruce, basswood or lime, gilt
51⅝ x 36¾ in. (131.1 x 93.3 cm)

LIBRARY BOOKCASE, ca. 1794–1800
Attributed to John Seymour
(American, born England, 1738–1818)
and Thomas Seymour
(American, born England, 1771–1848)
Boston, Massachusetts
Mahogany, mahogany veneer, cherry, birch, eastern white pine
89³⁄₁₆ x 96½ x 20⁷⁄₁₆ in. (226.5 x 245.1 x 51.9 cm)

Beginning in 1961, he began converting modern and sterile spaces on the top floor of the U.S. Department of State's Harry S. Truman Building into forty-two breathtaking period rooms that drew inspiration from eighteenth-century American and British interiors. He also began collecting outstanding cabinetwork, silver, paintings, sculpture, porcelains, and works on paper that would make these spaces both welcoming and significant. He aimed to build a collection that would represent our nation's greatest strength—its people. And, since no tax dollars could be allocated to the project, he did it entirely through donations. Having served four years in the army, Conger reflected, "I should have known better than to volunteer."

Fortunately for us, he did. The collection he assembled is both among the finest in the nation and a gift from the American people. It is also in service to the nation, for it

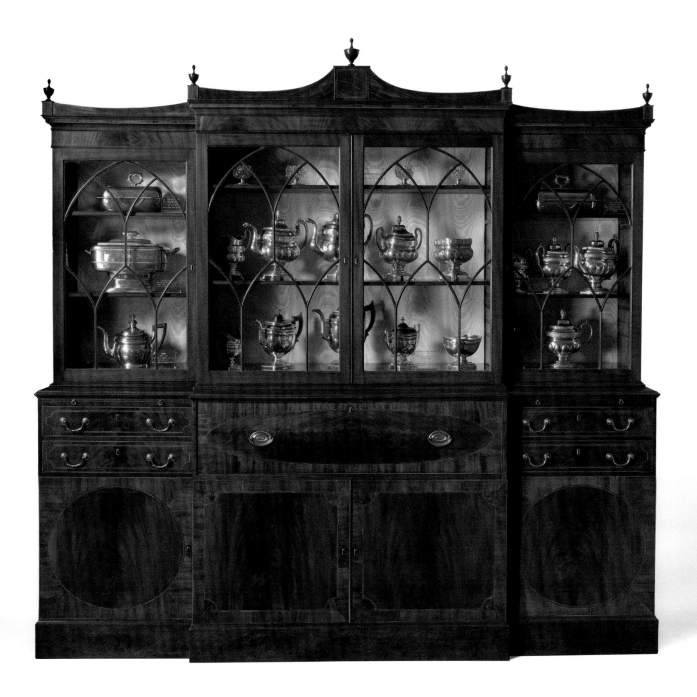

is used every day for receptions, meetings, and events that bring leaders together from all over the world to form friendships, build trade relations, settle problems, and secure peace. The Diplomatic Reception Rooms and their collection are both admired and inhabited, awe-inspiring and comfortable, exquisite and engaging.

The collection has grown since Conger's time, and its mission has grown as well. In May 2022, when I became the collection's fifth curator, we began *America's Collection*, an adventure to retell the American story at the heart of this national museum. With an expanded view of what makes us uniquely American, we explored the collection holdings once again. Respecting diversity and inclusivity, we looked for the stories behind the painters and the portraits to find people struggling to choose sides during the Revolution. In the cabinetmakers, we rediscovered artisans as immigrants

who brought their craft traditions to America. We came to understand the collection—America's collection—as giving expression to a nation that is still in the process of becoming and of living up to the founding generation's ideals. It is our hope that visitors to the Rooms and readers of this book will find that seeing historical objects placed in context can encourage conversation and expand the dialogue about our shared values.

The heart of the book is an exploration of the Rooms' architectural and artistic marvels. We are honored that Allan Greenberg, one of the four notable architects who transformed the Rooms, returns after thirty years to guide us. Along with the architect and architectural historian Mark Alan Hewitt, he discusses the democratic ideals inherent in the architecture of these rooms and reminds us that a style fitting for the fledgling country still speaks to us today.

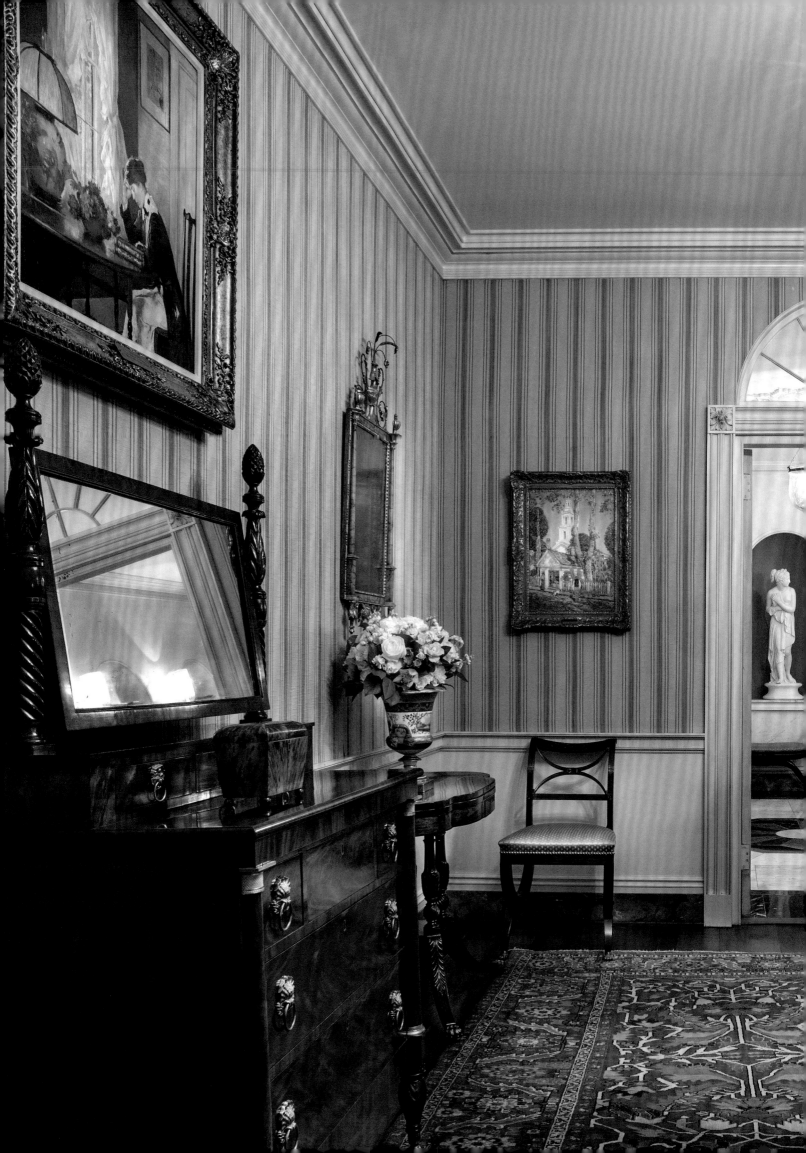

We are incredibly fortunate to have distinguished art historians participate in this publication. Each one has selected highlights from the collection and written about them compellingly to elucidate their place in the country's history and their message to visitors today. For their invaluable contributions, we thank Elliot Bostwick Davis, Fellow, Harvard Advanced Leadership Initiative; Alice Cooney Frelinghuysen, Anthony W. and Lulu C. Wang Curator of American Decorative Arts, The Metropolitan Museum of Art; Alexandra Alevizatos Kirtley, Montgomery-Garvan Curator of American Decorative Arts, Philadelphia Museum of Art; Elizabeth Mankin Kornhauser, Alice Pratt Brown Curator of American Paintings and Sculpture, The Metropolitan Museum of Art; and Deborah Dependahl Waters, independent curator and part-time assistant professor, History of Design and Curatorial Studies, Parsons School of Design. Meanwhile, writer Laaren Brown introduces the individual works of art with perception and wit.

In rediscovering our past, we also introduce new voices and perspectives on the Diplomatic Reception Rooms, and we appreciate their insights and acumen. From his memories of working in these spaces, the Honorable John F. Kerry, 68th Secretary of State, recalls their importance for representing American values to people around the world. The history of American diplomacy began with Benjamin Franklin, minister to France during the American Revolution, as Stacy Schiff explains, and traditions he established continue to influence modern diplomacy. David M. Rubenstein speaks to the significance of the Rooms for our understanding of American history. In recounting the history of this collection, Carolyn Vaughan explores its roots in the optimism of the 1960s and an enthusiasm for preserving the past, while my colleague Bri Brophy explores values expressed through artisan traditions.

The success of *America's Collection* reflects the involvement of other extraordinary people whose support and encouragement have made this project a reality. First and foremost, we recognize the exceptional vision of the Honorable John Bass, acting deputy secretary of state for management and resources, and his dedication to excellence in the arts, which has influenced this work in important and countless ways. We are grateful to Alaina B. Teplitz, assistant secretary of the bureau of administration, whose belief in this project gave us confidence to do great things. We also thank Lauren O'Doherty, office of the under secretary for management; we consider ourselves lucky to have her with us every step of the way. We extend our special thanks to Elliot Chiu and Erin M. Kriynovich, legal advisers, at the State Department for their expertise in making this publication a truly special and worthwhile project. This book would not be complete without recognizing extraordinary people, like Marsha Laufer, John D. Evans, Steven Wozencraft, and Robert Kogod Goldman; a special thanks to each of them. For steering the book from inspiration to publication, we are grateful to Margaret Rennolds Chace, associate publisher at Rizzoli Electa; Janice Yablonski-Hickey, president of Museum Revenue Partners and our consultant and friend; and Carolyn Vaughan and Ellen Cohen, talented and able editors. Sarah Gifford brought our collection to life in this beautifully designed work, and Durston Saylor and Bruce M. White captured the beauty and timelessness of American art and architecture in their superb photography. I especially thank our dedicated core curatorial team, a small but mighty group of colleagues who work every day to protect and preserve these rooms for future generations: Bri Brophy, Jessica Brooks, and Cherlissa Sellman.

Our special thanks also go to Carlyle Eubank, chair of the Fine Arts Committee, as well as to his board members, without whose leadership, support, and friendship this publication would not have been possible. In addition, I would like to thank the Honorable Jane Sloat, chair of the Fund for the Endowment of the Diplomatic Reception Rooms, our foundation, which contributes to special projects that keep these rooms and their collection alive, and Shannon Burkhart for her support of our shared initiatives.

Although many donors contributed to the building of this national collection, we wish to thank the Honorable Rex Tillerson, 69th Secretary of State, and Mrs. Renda Tillerson for their generous financial support that has allowed us to modernize these important spaces where diplomacy happens every day. Through this outstanding support, the Benjamin Franklin State Dining Room is more beautiful today than ever before. We also recognize the generous support of the Honorable Hillary Rodham Clinton, 67th Secretary of State, who, along with the Honorable Capricia Penavic Marshall, raised the twenty-million-dollar endowment that preserves these State Rooms for future generations and makes possible important projects, like *America's Collection*. In celebrating this national museum collection, we honor all of those who have generously given of their time and resources. We dedicate *America's Collection* to you.

OPPOSITE Dolley Madison Powder Room

BENJAMIN FRANKLIN & THE BIRTH OF AMERICAN DIPLOMACY

Stacy Schiff

THE FATHER OF THE AMERICAN foreign service was not born a diplomat. By his own admission, he was combative and callous, overbearing and insolent. He wrestled with his pride. Were ever he to tame it, he suspected he would crow about his victory. He kept score. He broke hearts. Family relations defied him. He rubbed his brother's face in his success. He ran away from home. He went on to miss both of his children's weddings—and his wife's funeral. He was also a quick study, an expert negotiator, a man of omnivorous curiosity, and a master psychologist. Additionally, he was the only American of his time with any substantial experience of the world beyond her shores.

Which meant that in 1776, when thirteen colonies looked to a foreign power that might underwrite their nascent revolution, they turned to Benjamin Franklin, champion fundraiser, the sole American to have published in Europe, and the Founder who best understood, as Talleyrand had it, that "speech was given to man to disguise his thoughts." At the same time, the Continental Congress turned to France, Great Britain's traditional rival and a country that had contemplated American revolt longer than had most Americans. Months after signing the Declaration, seventy-year-old Franklin set sail on a mission original in the annals of diplomacy: he was to appeal to a monarchy for help in establishing a republic.

Few in the New World could have risen to either Paris's diplomatic or conversational agenda. Even fewer could have done so with the requisite wit, in a language that approximated French. The obvious man for the job on one side of the ocean, Franklin was the ideal man on the other. Already he was the world-famous tamer of lightning. In sense and sensibility, he seemed a joint production of Voltaire and Rousseau. The most celebrated American in the world, he touched down in France like a meteor. His face bloomed on playing cards and ashtrays, mugs and wallpaper. He joked that it was nearly as familiar as the moon. Conspicuous though he was, he could not, however, be welcomed by the French court, as eager publicly to preserve relations with Great Britain as it was covertly to undermine its ancient adversary.

BENJAMIN FRANKLIN, 1778
Attributed to Jean Antoine Houdon
(French, 1741–1828)
Terracotta on marble base
19¼ x 12¾ x 8½ in. (48.9 x 32.4 x 21.6 cm)

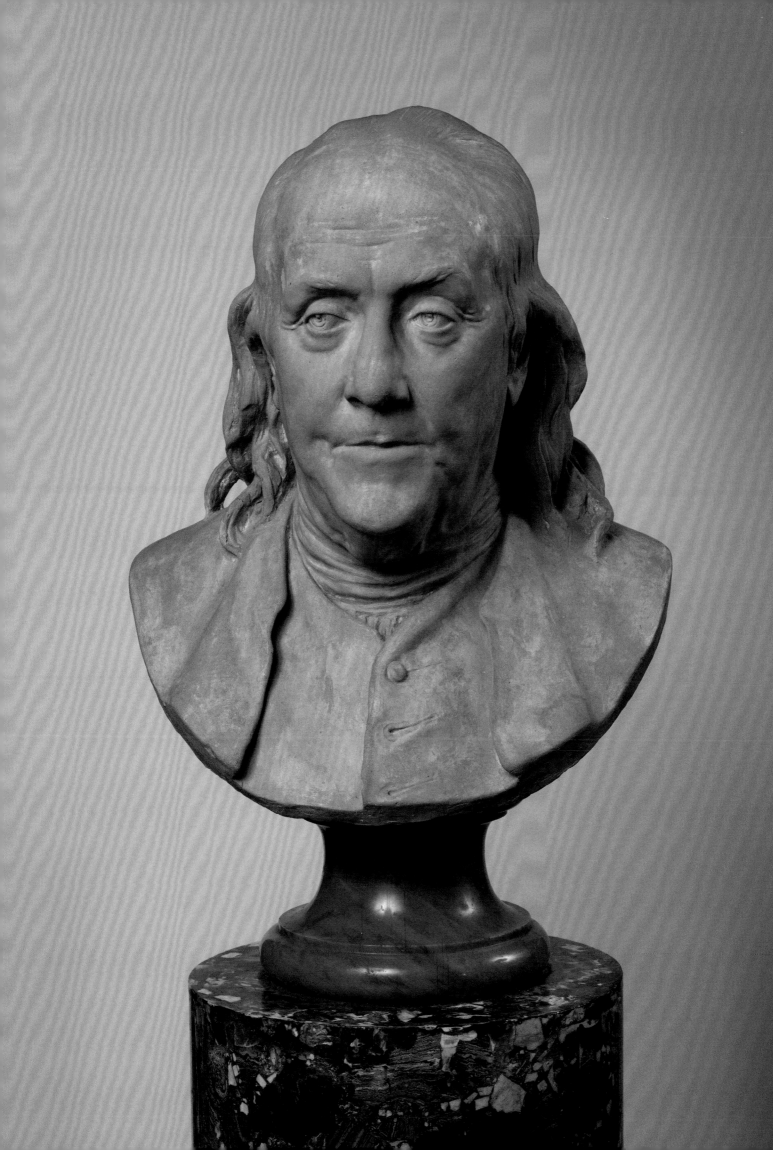

For nearly a year, Franklin played a tense waiting game. He inserted himself into French society. He peddled misinformation. He shrugged off General Washington's defeats. He kept his distance from the French foreign minister, the comte de Vergennes, obliged—when British envoys yelped about secret arms shipments to America—to profess himself shocked, *shocked* to learn of gambling in his casino.

With victory at Saratoga in 1777, the American cause suddenly seemed a viable one. French and British emissaries fell all over themselves trying to secure Franklin's favor, the British intent on reconciliation and peace, the French on an alliance and war. The French won out: a treaty of alliance was signed promptly, so promptly that France proceeded without the consent of her ally, Spain. The king's ministers afterward marveled at their own behavior. They had thrown over their closest ally for a new and unproved one, on which none of them had set eyes. They had entered into a treaty, in defiance of a power with whom they were not at war, to create a republic. It had been a vexed decision, sighed the king's closest advisor, but Franklin had negotiated masterfully. Few troubled themselves with long-range implications. There was little confidence that the colonies would survive their own revolution and a general inability to so much as locate them on a map. It was equally possible that they bordered Turkey or were part of India. No one was quite sure what language was spoken there.

For the next years, Franklin's job consisted of sustaining an alliance that was ill-advised and, in the end, ruinously expensive for Versailles. He was splendidly suited to the task: honest, but not too honest, which qualifies in France as a failure of imagination. If in the Philadelphia of his youth Franklin had recognized the value of seeming to work

hard, he soon mastered the essential French art of accomplishing much while appearing to accomplish little. Few were aware of the drudgery he faced daily and to which he often devoted himself in the middle of the night. At no time did he appear to bend under the burden, just as he never offended his hosts, as did his colleagues, by arriving punctually. He had landed in a world where tardiness practically constituted an art form.

A formal alliance in place, Franklin could finally appear in his official capacity at Versailles. On March 20, 1778, at the doorway of Louis XVI's private rooms, he heard himself announced for the first time as the representative of "the United Provinces of North America." It was an emotional moment; a fellow ambassador noticed tears glinting in Franklin's eyes. Solemnly, he thanked Louis XVI. The young king replied that he hoped the alliance would prove beneficial to both countries. "Your Majesty can count on the gratitude of Congress, and on her commitment to the engagements into which she enters," answered Franklin. It was a debt he felt profoundly, though the Franco-American alliance was to play itself out with all the grace of a three-legged race. The countries did not make for natural partners. As the Marquis de Lafayette sighed, "I cannot deny that the Americans are somewhat difficult to handle, especially for a Frenchman." His compatriots observed that the Americans were American when it came to dealing with the British, British when it came to dealing with the French.

In his rooms on the outskirts of Paris, Franklin faced hurdles of his own. The paperwork, the solicitations, the invitations, the callers piled up. A dazzling array of benevolent souls could supply folding tables, shoes, beer, and playing cards to America at attractive prices—or promised to transform ordinary salt into saltpeter. Every aspiring French officer came Franklin's way, as did volumes of unsolicited advice. He came to dread the sound of carriage wheels in the courtyard. The mail arrived in torrents. Around him formed a circle of French spies, surrounded by a circle of British spies. Stumbling over one another, they pilfered locked drawers and dove into closets. Their dispatches arrived like clockwork in Versailles and London. The sole address Franklin could not seem to reach was Congress, from whom he might go six months without a word, and which—with his missives rerouted—legitimately wondered if it still maintained an envoy at the Court of Versailles.

Then there were the colleagues. Today we look back at the team that represented the infant America as the greatest collection of diplomatic firepower in our history. At the time, those envoys appeared distinctly human, most of all to each

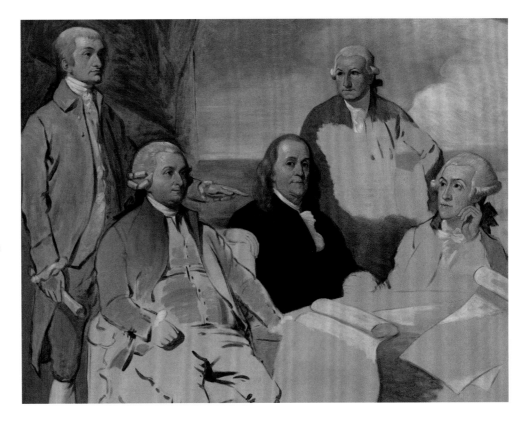

other. John Adams, who as of 1778 intermittently joined Franklin in Paris, found him not only callous and contentious but peremptory, disorganized, and maddeningly vague. He choked on Franklin's celebrity. He found him hopeless with paperwork. (He had a point.) Adams refused to recognize American indebtedness to France, where Franklin subscribed to the great aphorist who held that "there is no excess in the world so commendable as excessive gratitude." Distaste curdled to contempt; when Adams returned to Paris in the fall of 1782, he had nearly to be wrestled into his coat to call on his colleague. Of Franklin he sputtered: "If I were in Congress, and this gentleman and the marble Mercury in the garden of Versailles were in nomination for an embassy, I would not hesitate to give my vote for the statue, upon the principle that it would do no harm." For his part, Franklin dismissed Adams as "always an honest man, often a wise one, but sometimes and in some things absolutely out of his senses." Thomas Jefferson was meant to travel to Paris in 1783, when after Yorktown—a battle won in large part thanks to French troops, French ships, and French munitions—it came time to negotiate a peace. Jefferson sailed only much later but anticipated immediate fireworks. How, he wondered, would Adams comport himself? "He hates Franklin, he hates John Jay, he hates the French, he hates the English. To whom will he adhere?"

Franklin handled the first peace proposals alone, stabbing about in the dark with various British envoys. In mid-1782,

John Jay joined him. Jay shared neither Franklin's finesse, his nerves of steel, nor his gratitude to a country that had bankrolled a revolution. Congress had instructed its emissaries to negotiate a peace in tandem with their ally. Jay insisted on circumventing that instruction, as would Adams, on his October return. Franklin had no choice but to accede to his colleagues' wishes. Tucking away their differences, the three proceeded without consulting Versailles. None was a professional diplomat. None had any grounding in what we today call geopolitics. Neophytes, they were left to contend with the most adroit players in Europe. Each negotiator, moreover, had his hobbyhorses. Franklin was adamantly opposed to Loyalist reparations. He dearly hoped to wrest Canada from Great Britain.

The primary issues for a treaty were independence, boundaries, and fishing rights. John Jay ultimately drew up a draft agreement, finalized without Vergennes's knowledge. It acknowledged the unconditional independence of the United States and affirmed all the points Franklin had made early on, establishing boundaries and entrusting Loyalist compensation to individual states. We have some idea of how Franklin comported himself at the negotiating table from a journal he kept of the initial talks. "Great affairs sometimes take their rise from small circumstances," he had noted after the initial peace overture came his way, through a chance encounter from a vacationing friend. He took poorly to threats. He knew that debts made people,

and countries, uncomfortable. He layered in the historical analogies. He missed no nuance. He brushed off the flattery, admitting he would have sopped it up when younger.

The American envoys signed a preliminary treaty in November 1782. Crisp-thinking Jay seems throughout to have been the prime mover, but it fell to Franklin to ride to Versailles to explain to a furious comte de Vergennes why—in direct contravention of their instructions—the Americans had proceeded to make peace without consulting their ally. Vergennes reminded Franklin of his obligations to the king. Franklin knew well what propriety dictated. He had neglected it. Franklin availed himself of American naïveté, an odd refuge for a wily, worldly seventy-six-year-old, but the only one available. Indeed they had blundered. He was sorry. Nothing in the treaty undermined French interests, however. No king had ever been so loved, even by his own subjects, than was Louis XVI by the people of America. And surely Vergennes did not care to offer the British the satisfaction of believing they had divided the allies? It would be a shame if their glorious project—Franklin made it sound as if American independence had been the brainchild of Louis XVI—were ruined by a single American indiscretion. Indeed they had acted foolishly and neglected a point of propriety. But what could Vergennes expect? Franklin essentially asked. They were but babes in the woods. He managed to leave Versailles not only on affectionate terms but with a massive new loan, at a time when the French treasury struggled to pay its own bills, exhausted by its American war.

Final peace talks limped along over the better part of a year. David Hartley, a member of Parliament, an inventor, and a longtime friend of Franklin's, was finally dispatched in 1783 to urge along the balky negotiation. He evidently traveled from London with a handsome mahogany rolltop desk. Hartley brought the discussions to a close, arranging for final documents—they were virtually indistinguishable from the preliminary agreement—to be signed at his Left Bank apartment. He preferred that the ceremony take place far from the scrutiny of the French court; the commissioners obliged him. Sometime after nine o'clock on the morning of September 3, 1783, John Adams, Benjamin Franklin, and John Jay assembled around Hartley's desk, in his quarters on the rue Jacob, and set their names, in alphabetical order, to the Treaty of Paris. In its first article, His Majesty King George III recognized the thirteen colonies to be "free, sovereign, and independent states." He relinquished all claim to them. In red wax, each man affixed his seal to the short document that ended a long war. The envoys rode out later that day to Versailles to witness the signing of treaties between Great

Britain and France and between Great Britain and Spain. The business was finished by 3:00 p.m. The importance of the moment was not lost: Adams hailed the negotiations that created the United States as "one of the most important political events that ever happened on this globe." America was again friends with Great Britain, as Franklin put it days later, "and with all mankind."

It was not a turn of events he had expected to live to see. Nor did he expect a syllable of thanks for his contribution, on which count he proved correct. (All three commissioners were reprimanded for having ignored their instructions. Jay came in for a particular drubbing. He justified the decision with an aplomb worthy of a future chief justice of the Supreme Court.) Even Vergennes had to admit that New World innocence had somehow trumped Old World guile. The triumph in Paris was equivalent to and as improbable as Washington's against the redcoats in the field. Weeks afterward, Franklin wrote to Congress with a few reminders: America should remain on guard against Great Britain. It counted still on the former colonies splintering among themselves and returning to the fold. The young republic could not be too careful to preserve and nurture its new relationships abroad. America would be well advised to discharge all obligations punctually and to comport herself wisely, "since we know not how soon we may have a fresh occasion for friends, for credit, and for reputation." He had arranged for the American state constitutions to be translated and distributed, in duplicate, to every member of the ambassadorial corps. The documents had occasioned tremendous surprise; their recipients "could not have expected so much political knowledge and sagacity had existed in our wilderness." He hoped the pages would encourage immigration and—in dispelling clouds of misapprehension—establish cordial foreign relations all around.

Franklin sailed home in July 1785. One hundred and forty-one years later, Hartley's trim desk followed him. In 1963, it made its way finally to Washington, D.C. No one who had sat before it in 1783 could have imagined that it would take its unassuming place amid forty-two Diplomatic Reception Rooms at a massive Department of State, in the beating heart of a power soon to rival both France and Great Britain. It stands as a modest reminder of a time when a foreign service had to be invented from whole cloth; when America was still very much in the neighborhood of India or Turkey; when she could write down a gaffe to her crippling inexperience; when no colony had yet successfully liberated itself from its mother country; and when nothing seemed so improbable as a republic that might endure.

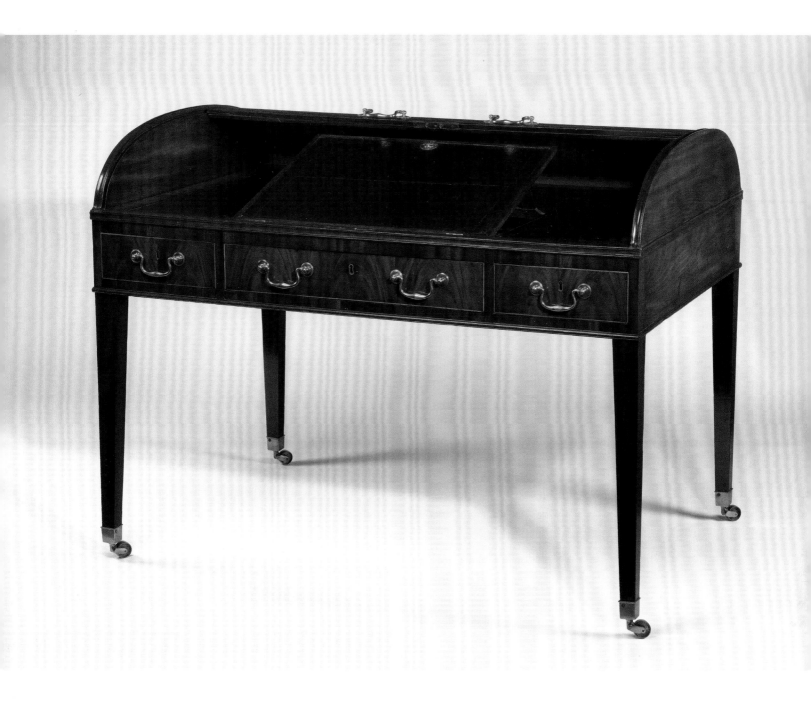

WRITING TABLE
FROM THE SIGNING OF THE
TREATY OF PARIS, ca. 1780
England
Mahogany, spruce, white oak
37⅞ x 50 x 33⅞ in.
(96.2 x 127 x 86 cm)

ONE OF THE jewels in the State Department collection, this desk is an extraordinary piece of American history. At this desk, on September 3, 1783, the American commissioners, Benjamin Franklin, John Jay, and John Adams, signed the treaty that established American independence.

Made in England by British cabinetmakers, the desk belonged to the British commissioner, David Hartley. Hartley was sent to Paris in 1783. His mission: wrap up the negotiations and get a signed treaty. He brought his desk with him.

Traveling with personal furniture was not unusual. Hartley's desk had a tambour cover, an innovation that was fashionable in England at the time. Its locking mechanism, along with an embossed leather work surface and casters, made the desk practical as well as stylish.

At Hartley's apartment at the Hôtel de York, the American commissioners signed a document entitled "The Definitive Treaty of Peace Between His Britannic Majesty and the United States of America," but known forever after as the Treaty of Paris. The war was over.

Mission accomplished, Hartley returned to London with his desk. Over the years, the desk went through several owners before traveling to the United States to be sold at auction and donated much later to the State Department.

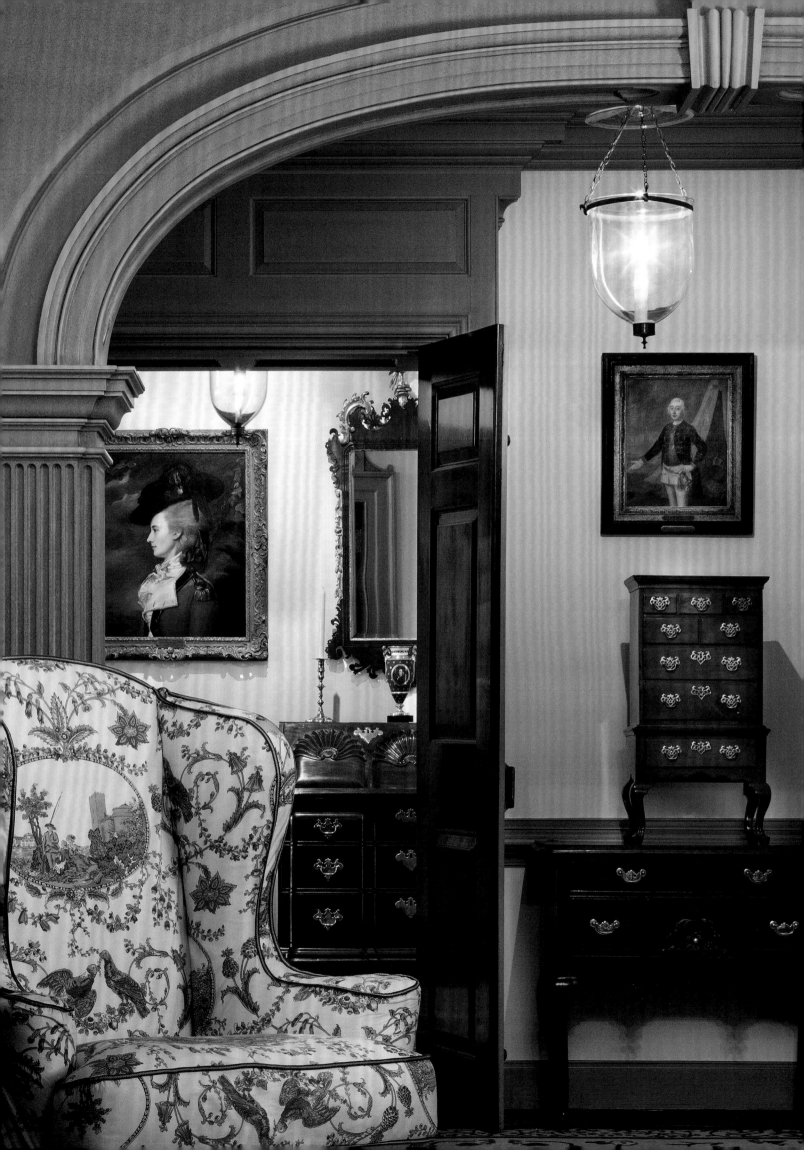

THE
AMERICANA
PROJECT

Carolyn Vaughan

THE 1960S ARE OFTEN REMEMBERED as a time of turmoil and tragedy: the struggle for civil rights, the Vietnam War, student protests, the assassinations of JFK, RFK, and MLK. But the decade began with a spirit of optimism, of looking forward to a boundless future, of the promise of progress.

It was the dawning of the space age and the jet era, the arrival of the laser, the bikini, and, perhaps most influential, color television. In 1960, nearly half the U.S. population was less than eighteen years old;[1] the Silent Generation was quickly superseded by a particularly noisy one, as the stodgy fifties gave way to the swinging sixties.

In the nation's capital, Eero Saarinen's sleek Terminal Building at Dulles International Airport, the first airport designed specifically for jet planes, was under construction, as was the ultramodern performing arts venue that would be named the John F. Kennedy Center for the Performing Arts. A charismatic new president, the youngest ever elected, moved into the White House with his elegant and enchanting wife and two small children, whisking away the staid atmosphere of their predecessors. The inaugural poet, Robert Frost, predicted "a golden age of poetry and power."[2]

In the midst of this fascination with the future, though, Americans also discovered a passion for the past. During the postwar economic boom, with its focus on urban renewal and automobile culture, outmoded buildings had been razed, shabby neighborhoods demolished, and historic districts replaced with high-rises and highways. Even before the unforgivable destruction of New York's McKim, Mead & White–designed Pennsylvania Station, some people began to question this disregard for the nation's cultural heritage in the name of progress. As advocates sought to put the brakes on these well-intentioned but shortsighted programs, the historic preservation movement gained momentum, and in 1966, Congress finally passed the National Historic Preservation Act, a federal policy to safeguard historic and cultural sites.

It did not take an act of Congress, though, to set some preservation plans in motion. Two of the most significant restoration and reconstruction projects of the era were initiated in 1961 through the sheer will of two persistent and patriotic individuals.

When the future First Lady Jacqueline Kennedy toured the White House with Mamie Eisenhower, her predecessor, she was disheartened by the decor and the furnishings,

OPPOSITE
Martha Washington Ladies' Lounge

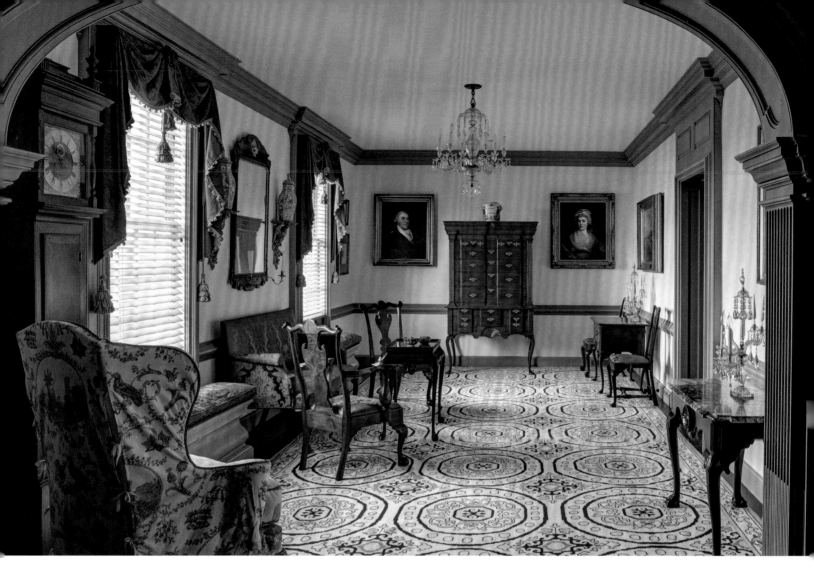

later bemoaning the "seasick green" and "ghastly pink"[3] and the rooms that looked as if they had been "furnished by discount stores."[4] She determined then and there to make the President's House look less like a hotel for traveling salesmen and more like "a grand house,"[5] where visitors would learn about and be inspired by the history of the country.

A few weeks later and a few blocks away, Clement Conger, the U.S. Department of State's deputy chief of protocol, was preparing for a dinner honoring Queen Frederika of Greece at the Diplomatic Reception Rooms of the newly opened Harry S. Truman Building, a bland behemoth with lackluster interiors in a "late 1950s motel" style to match. He guided Mary Caroline Herter, the wife of Secretary of State Christian Herter, through room after nondescript room with all the ambience of an airport waiting area, until they finally arrived in the ladies' lounge (now the Martha Washington Ladies' Lounge). Mrs. Herter, appalled at the sight of what Conger later said looked like a "gangster's moll's quarters on a Twentieth-Century Fox lot," said she had "never been so mortified in her life"[6] at the thought of hosting royalty— or anyone—in such an uninspiring environment. Conger resolved—and indeed volunteered—to organize a public campaign to furnish the Rooms to make an appropriate setting for diplomatic occasions, never dreaming he would spend the next thirty years on what came to be called the Americana Project.

It was Conger himself who had proposed, when the Truman Building was under construction, that space be allocated for diplomatic entertaining, as he knew well that no appropriate

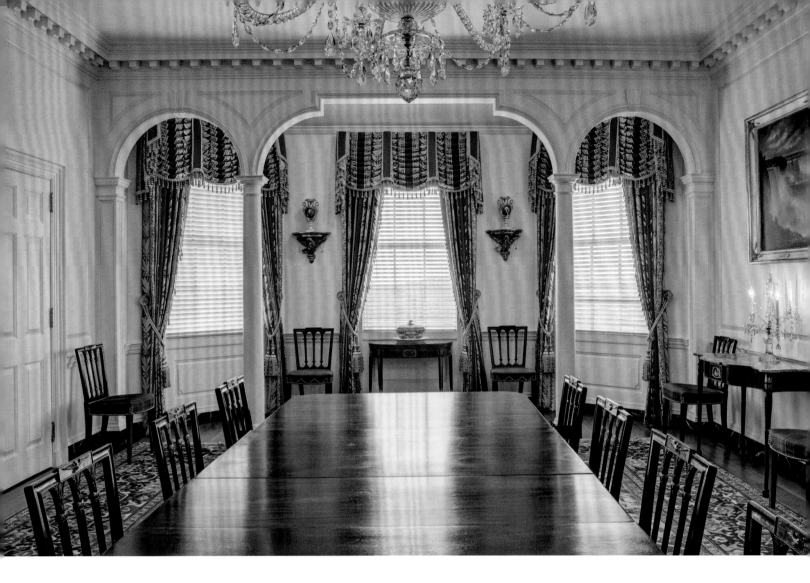

area existed for receiving foreign dignitaries or conducting diplomatic negotiations. The White House was reserved for the president. The vice president, secretary of state, and other cabinet members had to entertain in hotels or private clubs—neither congenial nor inexpensive.

This was nothing new. In the early days of the republic, American public officials, unlike their foreign counterparts, had no palaces or stately homes for diplomatic dinners and balls. Nor did they have government funding. Furthermore, they were uneasy about adopting the trappings of aristocracy, believing them to be at odds with the egalitarian principles of democracy. Thomas Jefferson was particularly disdainful of formality, offending a British minister by receiving him in a costume "indicative of utter slovenliness and indifference to appearances, and in a state of neglect actually studied."[7] Receptions were private affairs, often hosted by the secretaries in their own homes and on their own dime. Foreign diplomats looked down their noses at this lack of pomp and circumstance and assumed their hosts were uncultivated and uncouth.

As the nation grew in stature and showed signs of becoming a world power, it became clear that social responsibilities were

OPPOSITE, TOP TO BOTTOM Martha Washington Ladies' Lounge today and before renovation

ABOVE, TOP TO BOTTOM James Madison State Dining Room today and before renovation

a vital part of a diplomat's job and that a suitable setting for receiving and conferring with visitors was required. But it was not until 1961 that the State Department acquired a dedicated home for entertaining.

The Truman Building sprawls across two city blocks and contains well over a million square feet of space. It was constructed of reinforced concrete, steel beams, and glass curtain walls, and, as the eminent and eloquent architectural critic Paul Goldberger described it, was "utterly banal, institutional, and graceless, suggesting the dreariness of bureaucracy more than the dignity of diplomacy."[8] The two top floors, dedicated to the Diplomatic Reception Rooms, an area of more than twenty-eight thousand square feet, featured wall-to-wall carpeting, acoustical tile ceilings, and recessed lighting. It was this space that Conger had undertaken to refine.

There was one problem: there were no federal funds for a venture of this kind. He was going to have to raise a small fortune in private donations.

Jackie Kennedy was in a similar situation. The fifty thousand dollars allotted by Congress for redecoration of the White House by a new administration was immediately used on refurbishing the First Family's private rooms—understandably, since the Kennedys had two small children newly plunged into public life—leaving no budget for the public areas. When she described the White House furniture as discount department store, the First Lady was not far wrong. Under the Truman administration, extensive structural repairs had to be made to the White House, leaving no funds for furnishings, so reproductions were provided by the department store B. Altman.

In February 1961, the White House announced Jackie's plan to acquire the highest-quality, historically accurate furnishings to restore to the White House a sense of its history and the people who had inhabited it. She established a Fine Arts Committee, headed by Henry Francis du Pont, founder of the Winterthur Museum in Delaware and a noted authority on American antiques, to advise her, to help locate potential works of art, and, of course, to procure funds for acquisitions. Within months, she was receiving donations from around the country, including objects associated with presidents and other historical figures. By the time she gave her nationally televised tour a year later, many of the public rooms had been transformed.

It was not just the interior of the White House that Jackie revitalized. She made it a showcase for American culture, inviting writers, painters, and musicians to events and presenting performances by the American Ballet Theatre, the American Festival Shakespeare Theater, and the Metropolitan Opera Studio, as well as regular concerts for young people of student orchestras from around the country. She understood that the arts are an important part of the American character and that they could be a source of national pride. With her purposeful programs, she showed the world that American culture had arrived on the international stage, and no longer would the United States be seen as a backwater.

Conger also wanted to show America's best face to the rest of the world. By providing an elegant area favorable to the business of diplomacy and decor that reflected the country's history and heritage, he would create a place where foreign visitors would be honored to be received. In an atmosphere of sophistication and distinction, they would confer amid prized heirlooms instead of around an uninspired and uninspiring conference table. One month after the First Lady's announcement, his own Fine Arts Committee of top-notch advisers held its first meeting, and he began his quest to replace the motel-style furnishings with works that represented the finest in American artistry. While the White House restoration focused on the nineteenth century, Conger's Americana Project concentrated on the colonial and federal styles. The development of the two collections neatly complemented each other, with no competition for acquisitions.[9]

He began by asking notable antiques dealers from New York and Philadelphia to lend furnishings, showing what the Rooms could look like and priming the pump for donations. He accepted loans from collectors of fine Americana in the hope that they would eventually become gifts. He canvassed the country in search of people to donate works of art or the funds to acquire them. He sought not only paintings and sculpture, furniture and porcelain, but also documents that could attest to the growth of the nation. By all accounts, Conger was quite persuasive. He believed three things encourage people to contribute their belongings to the nation: "tax deduction, patriotism, and family pride."[10] S. Dillon Ripley, secretary of the Smithsonian Institution from 1964 to 1984, dubbed him "the Grand Acquisitor," and a 1984 *Washington Post* article suggested that he had "perhaps raised more money from more people for the U.S. government than any one person outside of the Internal Revenue Service."[11] In truth, Americans were eager to participate.

Contributions came from deep-pocketed collectors and enthusiastic amateurs. An immigrant couple gave portraits of George and Martha Washington by Rembrandt Peale in gratitude for what America had done for them. Descendants of John Quincy Adams donated portraits of that president and his wife. Others provided funds for works of art that filled gaps in the collection. A ten-year-old boy gave fifteen dollars.

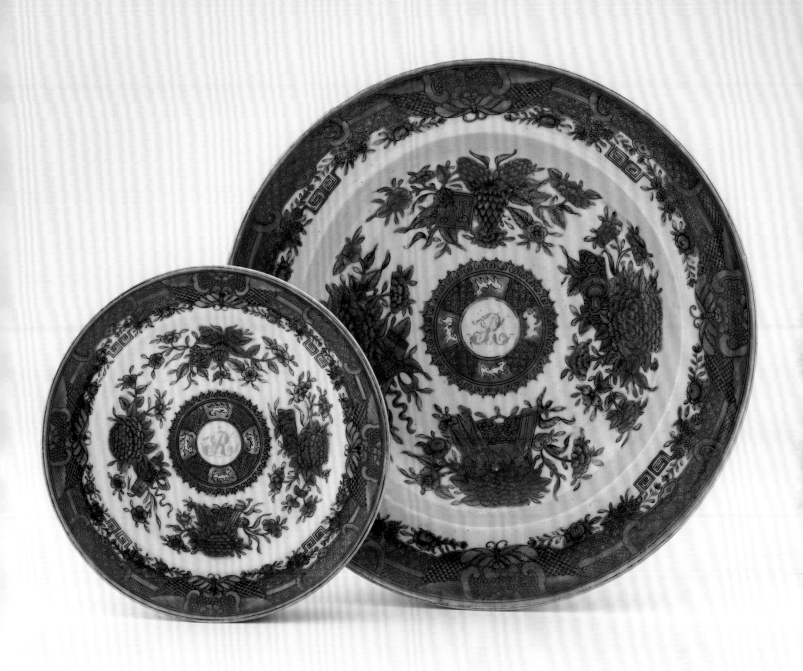

PLATES FROM A DINNER SERVICE
MADE FOR BENJAMIN LEEDOM, ca. 1810–20
Made in Jingdezhen, decorated in Guangzhou
China
Hard-paste porcelain
Various sizes

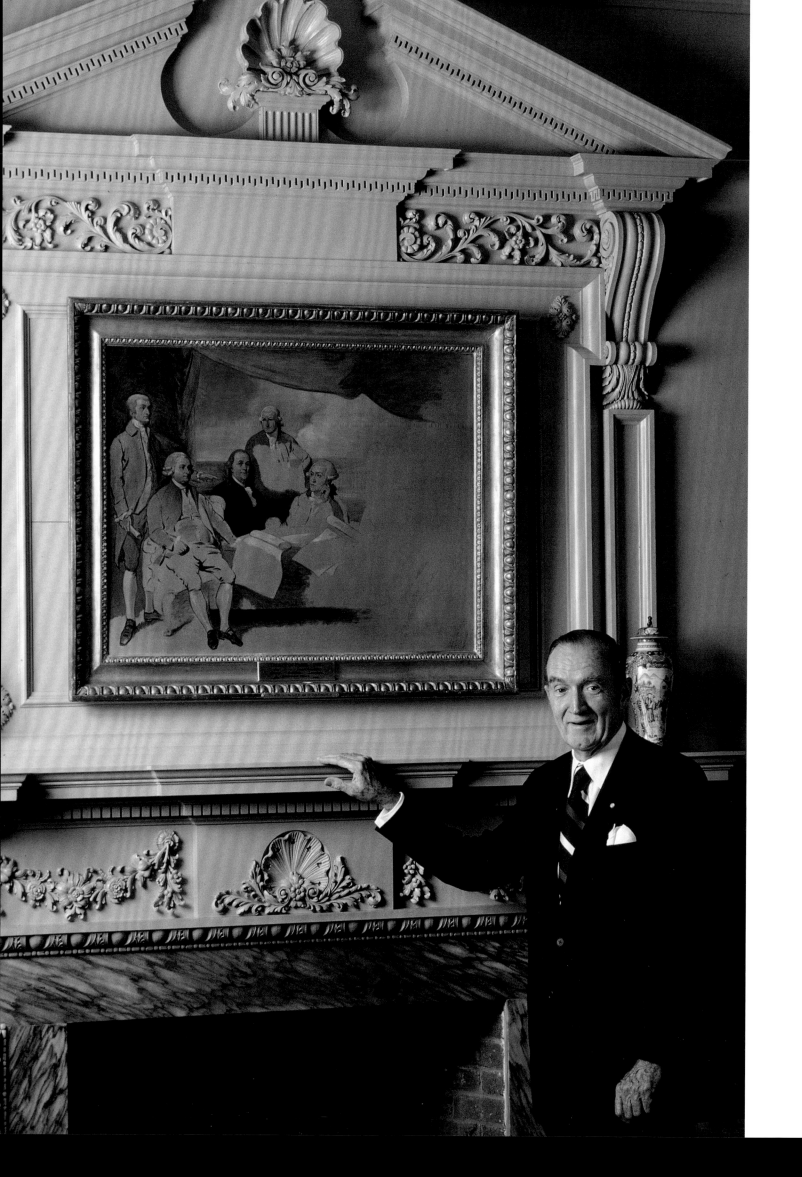

Another donor waited every year until December 31 to confirm his gift so he could make the most of his tax deductions, requiring the faithful Conger to forgo New Year's Eve celebrations while he waited for the donor's call.

But even as the collection of fine American works of art grew, the objects were still displayed against a lackluster background. Unlike the historic White House, the Truman Building had only a series of characterless offices. The outstanding works of art that Conger acquired deserved a more attractive and appropriate environment. In 1961, Conger was introduced to the architect Edward Vason Jones, and together the two men hatched the ambitious plan to transform the generic rooms into architectural marvels, reflective of the era and ideals of the nation's founding and inspired by the great houses of the same periods as the collection: Monticello, Philadelphia's Powel House, Kedleston Hall in England. By 1965, Conger had raised enough money to begin, and in 1969 the first of the reconstructed rooms, the Gallery, was complete. Over the years, and one by one, under the guidance of the esteemed architects Jones, Walter M. Macomber, John Blatteau, and Allan Greenberg, the magnificent period settings were unveiled.

A succession of secretaries of state willingly participated in the project and gratefully benefited from its results. It was Dean Rusk who proposed that the rooms be named for secretaries of state who had gone on to become president.[12] Rusk also displayed on his desk Jean Antoine Houdon's bust of Benjamin Franklin (see p. 21), then on loan to the Rooms, to encourage a donation to purchase it. George Shultz was secretary when the seventh-floor suite including his office was remodeled. A former executive at Bechtel, the giant construction company, he had in-depth knowledge of building on a large scale as well as a deep reverence for the cabinetmakers, carvers, plasterers, painters, and carpenters whose skill and dedication were essential to the project. As Allan Greenberg recalls, Shultz never interrupted their work as he inspected the progress at the job site, and he hosted a gala party for the artisans and their families at the completion of the construction.[13] Henry Kissinger served before the transformation of the secretary of state's office, when it still resembled "the boardroom of a medium-sized bank," so he gratefully escorted visitors through the upstairs Diplomatic Reception Rooms to show them a "more artistic and historic side of America."[14] Madeleine Albright said the Rooms gave her guests "a glimpse of the rich traditions of our republic's youth. They depict liberty's birth and America's rise from wilderness to greatness."[15] Colin Powell admired the Rooms so much that he was even known to give impromptu tours to schoolchildren.[16]

Refinements to the architecture are ongoing, and the collection continues to grow. Today, the forty-two rooms house more than five thousand works of art and represent one of the finest collections of American art in the world. But this is not a typical museum collection. These exquisite settings filled with invaluable works of art are also public spaces. This is a museum where people sit on the Chippendale chairs. Every year, the Rooms accommodate all kinds of official State Department functions—international summits, bilateral negotiations, formal dinners and lunches, receptions, conferences and meetings, and swearings-in of American ambassadors and other Foreign Service personnel. They also host members of the press, school groups, and public tours, where everyday people come to experience the world of the Founders.

Clem Conger envisioned an assemblage of rooms whose design and contents would be impressive but not intimidating, that would show the best of American art and architecture and still be comfortable and conducive to conversation. The Rooms that he and his successors have created are a testament to the taste and talent of the American artists, architects, and artisans—including those in the late twentieth century—who devised them. They show that America's early citizens espoused the ideas of the Enlightenment, including admiration for nature, regard for science, appreciation of beauty, and respect for reason, and that the Founders recognized that symmetry and proportion in art and architecture represent balance and reason in government.

The Rooms are a reminder to foreign dignitaries and American citizens alike that the people who conceived this country were men and women of sophistication, invention, and culture.

And optimism. The optimism of people forming a new nation, dedicated to life, liberty, and the pursuit of happiness. The optimism of the 1960s, when people emerging from difficult decades found the enthusiasm for new endeavors, on earth and beyond. And the optimism of Clem Conger, who knew what he could accomplish by shaking a few hands and pulling a few strings, with persuasiveness and perseverance, determination and dedication, and above all, with a belief that the American people deserved a home for diplomacy that would reflect, as Jackie Kennedy's husband said, "an America which commands respect throughout the world not only for its strength but for its civilization as well."[17]

OPPOSITE Founding curator Clement Conger

AMERICA'S COLLECTION

Bri Brophy

THE DIPLOMATIC RECEPTION ROOMS belong to us all.

When the idea for the State Rooms first sparked in Clem Conger's mind in 1961, there was little representation of American art and culture in the country's diplomatic customs. In the modern rooms designated for the conduct of diplomatic business and events, Conger saw soulless and unconsidered spaces, devoid of character or attempts at hospitality.

As deputy chief of protocol, his experiences in foreign affairs and ceremonials had shown him that our international counterparts came to the proverbial table with their best. By comparison, our nation was like a bold youth, who despite all best intentions was decidedly less formal, and apparently unbothered by the possible repercussions of our image. Conger, though, understood that the success of diplomacy so often hinges on a nuanced dance; on tact, deference, and the methodical signaling of mutual respect and goodwill. Diplomacy, he knew, is as much an art as a science, and he made it his life's work to construct an environment that would elevate our nation's literacy in this regard—not just for the benefit of our international guests but for the enrichment of Americans as well.

When world leaders come together, the event is often accompanied by a cultural tour to open hearts and minds, and when diplomats are hosted abroad, it is not uncommon for their hosts to take them to World Heritage sites. From the Palace of Versailles to the Pyramids of Giza, the Taj Mahal to Machu Picchu, Borobudur Temple to Vatican City, the exercise of immersing oneself in sacred places and spaces is one of untold value. These monuments are so ingrained in the peoples and histories from which they arose that their poignance conveys across centuries and even millennia. Each is a shining demonstration of human potential: feats of art, engineering, and virtue so remarkable that they at once humanize and sanctify their makers.

When our diplomats are shown other nations' cultural artifacts and buildings that evidence great histories—long, storied ones, full of victories and accomplishments—the suggestion might be that with age comes greatness, that storied pasts give us the wisdom and credibility that can be achieved only with the passage of time and through world experience. What, one might ask, does our younger nation have to compare? Regardless of whether this question was actually or directly verbalized, Conger was wise enough to sense that it was being asked of the United

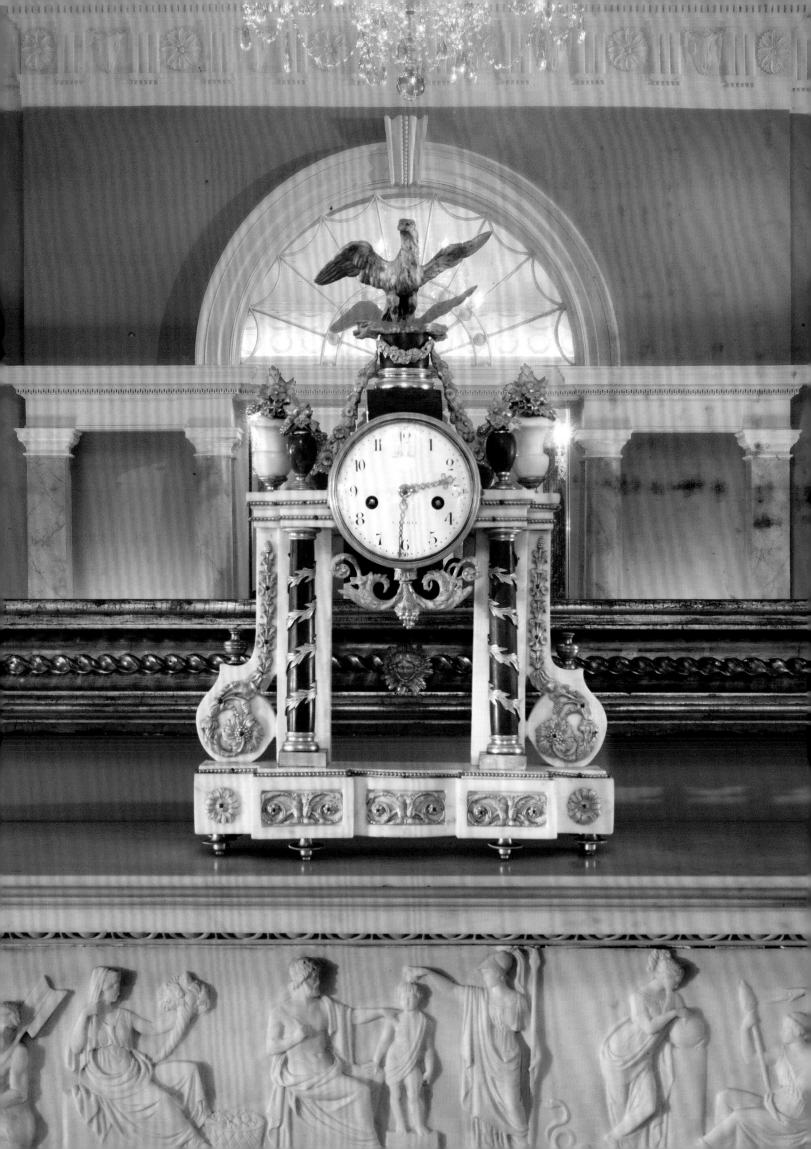

States, and also to recognize that it could no longer go unanswered. The Diplomatic Reception Rooms that he created over the second half of the twentieth century through his Americana Project were intended to serve as our declaration that while we may be a young nation, we are an extraordinary one. We, too, have a story.

There are countless ways to be American, and our inherent diversity has become our defining national characteristic. But where we intersect—and indeed, one of the great advantages of our country's youth—is the clarity with which we can still see our nation's founding moment, and the proximity we feel to this impetus and spirit. Our nationhood was a conscious choice, a moment in history when British subjects in the colonies were emboldened to unite in their principles and together accomplished something extraordinary. Few other countries can point to the very parchments upon which their intent to form a nation was declared, their system of government organized, and their fundamental rights defined. Ours is a uniquely tangible history, forged in revolution and conceived through the written word along with a distinct and concurrent material culture. We can still, quite literally, touch it.

The visual language of the early United States was established as swiftly and intentionally as our independence. The very words used to describe our founding are steeped in the building arts and skilled trade (the *architects* of our nation, the *framers* of the Constitution), alluding to the uniquely American phenomenon wherein our case for nationhood resulted in a government seen as inextricable from the written word, visual arts, and architecture. Our sovereignty was not passively created or inherited; rather, we were drafted, designed, and constructed through the very process of attaining our own agency. The Diplomatic Reception Rooms and their collection are perhaps the best illustration of this relationship in existence, and they abound with the symbols that were used throughout our young nation to cite, validate, and reinforce our fledgling democracy. These are not merely relics from history but conscious applications of classicism intended to reincarnate the deeply held beliefs expressed by our Founders—ideas of order, reason, and balance; of the divinity of logic; and of the value of the individual—and to ensure that those principles continue to be upheld by our leaders today.

Entering these period-style rooms, one feels awash in a chorus of voices emanating from the thousands of works of art filling them. A closer look reveals that an ink-stained

RIGHT Founding curator Clement Conger working in the Benjamin Franklin State Dining Room before renovation

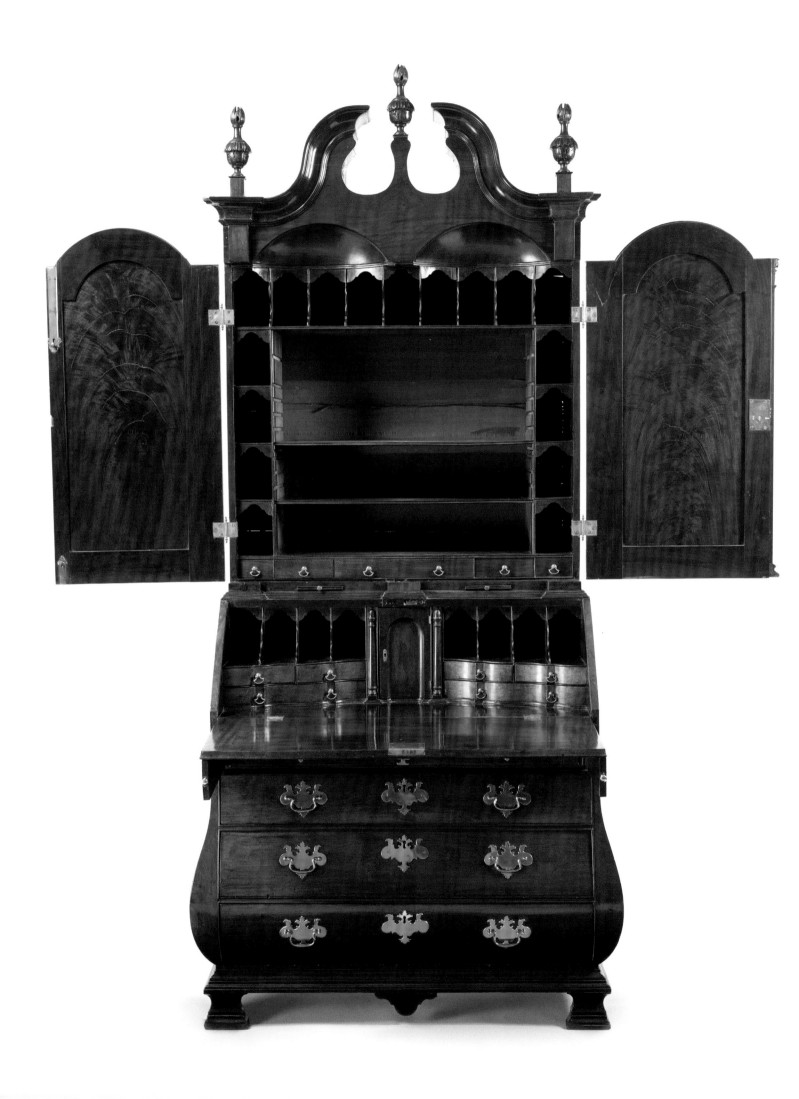

traveling desk was the implement of Thomas Jefferson, that chairs lining the halls descended from the family of Francis Scott Key, that artfully engraved silver in the cabinets was smithed by the hands of Paul Revere, and that the delicate Chinese export porcelain on display was from the personal collection of George Washington.

Breadth and quality of provenance have always been a hallmark of these State Rooms, resulting in a built environment that feels at once familiar and astonishingly momentous. These historic voices are amplified, though, by works that illustrate how the Revolution touched and forever changed the lives of all Americans. A striking desk and bookcase found in the Entrance Hall, for example, was made by Benjamin Frothingham, when he was about twenty years old, in 1753. It is the earliest documented work by this important maker from Charlestown, Massachusetts, as well as the earliest documented piece of bombé furniture in America. Though an important decorative work in its own right, it is impossible to separate it from the life that would follow for its young maker. Herein lies the story of the journey from apprentice to master; of the ways that artisans in America adapted British design; of trade, resources, importation, and taxation; and of the impact of revolution on this one cabinetmaker, who lost his shop and livelihood to the torches of British soldiers, took up arms, rose to the rank of major, befriended George Washington, and returned to his craft after the war, transformed by what he and his fellow Americans had achieved. In these works, we see our transition from colonists to revolutionaries and, eventually, to independent citizens and first-time statesmen. We see our before and our after; we see our sacrifices, the fruits of our resolve and unity . . . and our improbable yet glorious outcome.

The eighteenth-century scope of the Diplomatic Reception Rooms collection established by Clem Conger was initially intended to complement the nineteenth-century collection found at the White House, with the idea that by seeing both of these institutions on an official visit to the United States, a foreign dignitary would be exposed to the full diapason of American fine and decorative arts. With a narrowed focus on the period widely considered to be the height of American cabinetmaking, the works acquired from the period of 1740 to 1840 exemplify a uniquely American character: a confluence of the ingenuity of our artists and artisans, the evidence of the European aesthetic influence, the marked shift in our visual expression brought about by the establishment of our independence, and the impact of the diversity that is at the heart of who we are as a nation. Within this scope, we see some of our greatest achievements—both artistic and diplomatic—as well as reminders of the challenges and fallibilities that have revealed themselves in our path toward becoming the best version of the nation we envisioned. As we have entered the twenty-first century, we now seek to tell the story of the broader America and to ensure that all Americans feel represented by this collection today.

The Diplomatic Reception Rooms began with a realization by one person that there was a need to be filled, met by an innate sense of responsibility to fill it. Clem Conger's keen connoisseurship coincided with an era of interest in Colonial Revivalism as well as an opportune market, creating the conditions that allowed him to build something irreplicable and priceless. What is *most* remarkable about his Americana Project, however, is that it was accomplished entirely through gifts from philanthropic individuals who were moved by what Conger sought to create. His tenacious communication of the need for these rooms inspired countless individuals to contribute toward his vision. Among the donors to the Rooms are individuals who have dedicated their lives to the military or to the U.S. Foreign Service and immigrants who have personally realized the American Dream and felt compelled to give back to the country that made their success possible. Each object in these rooms was given as a patriotic gesture, and likewise is the collection sustained. Acquisitions, annual conservation, renovations, and the sharing of the collection are all activities made possible entirely through gifts offered by American citizens to ensure that this collection remains the pride of our nation.

This exercise in patriotic custodianship has paid us back in untold ways. The collection and the Rooms that the American people built together work on behalf of every citizen, speaking volumes about who we are in a way that no single diplomat could communicate in words. They paint an intimate portrait of us as a people and in effect serve as our nation's cultural ambassadors to the world.

Most importantly, the Rooms serve as points of entry to historical common ground and create opportunities to identify shared axes of understanding that are the key to successful diplomacy. They immerse visitors in the story of a people who strove to construct a nation based on the idea that there do indeed exist "self-evident truths" and "unalienable rights."

DESK AND BOOKCASE, 1753

Benjamin Frothingham (American, 1734–1809)

Charlestown, Massachusetts

Mahogany, white pine, eastern red cedar, Spanish cedar

98¼ x 44½ x 24¾ in. (249.6 x 113 x 62.9 cm)

See cat. 83

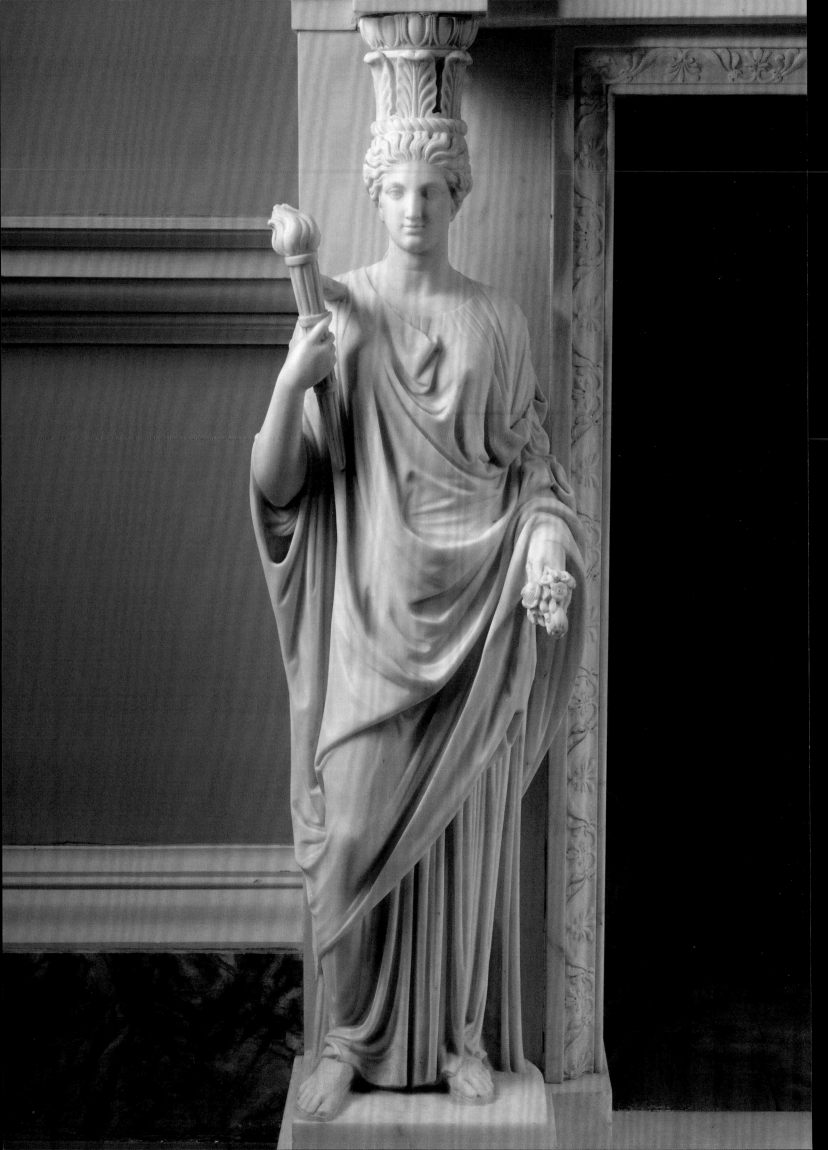

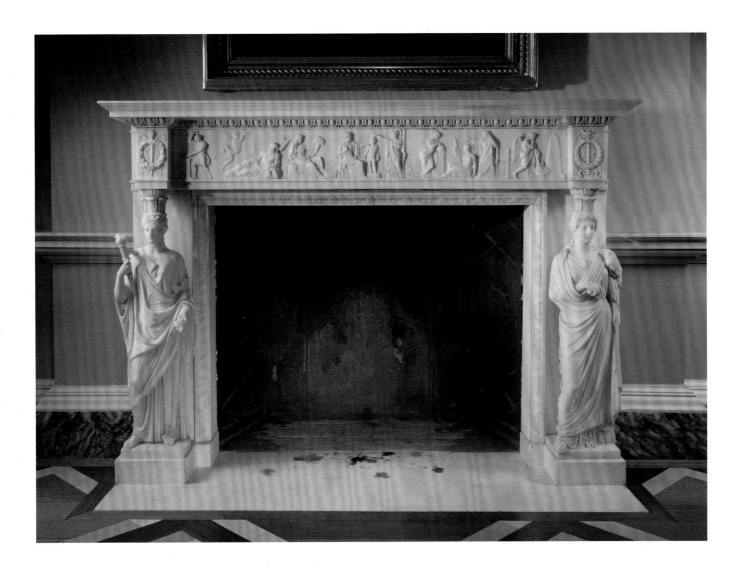

This core belief is written into our national identity and asserted here today as the touchstone for all conversations and negotiations. Whether guests are brought to this place in friendship and ceremony or in conflict, these rooms signal our intent to honor them. The classicism expressed in this setting imbues the work that happens here with this guiding light held sacrosanct since our country's inception: *that people are of value*. This tenet was the justification for our Revolution and is the ideal we must continue to strive for. By being enveloped in this history and by looking it in the eye each day, our leaders are reminded of the role that they play in writing our story and of what is at stake. If the Founders' vision for America is our compass, these rooms are our constant reminder today of true north.

The Diplomatic Reception Rooms are a demonstration that Americans understand a crucial element of nationhood: that a culture that values art is indicative of a culture that values people, and that a civilization *without* art is a civilization without a record of its humanity. In this collection, one can see, and time will further reveal, that these objects from our founding era are our legend and lore; these documents, our carefully constructed logic; these paintings, our Renaissance; these busts and pillars, our hieroglyphs. The Diplomatic Reception Rooms are our monument to democracy, and to the people and ideas at the heart of our founding. By assembling them we have created a testament to our merit and upheld Conger's goal of establishing a place for the United States within the artistic canon. Beyond this, though (and perhaps unforeseeable at the time by even Conger himself), we have also formed through this collection a shared voice—one that captures and communicates our spirit in a way that only the language of visual arts can. This, then, truly is America's Collection: of and by the people, and our gift to the world.

FIREPLACE MANTEL, ca. 1810
Unidentified maker
Italy
Carrara marble
51 x 69½ x 10¼ in. (129.5 x 176.5 x 26 cm)

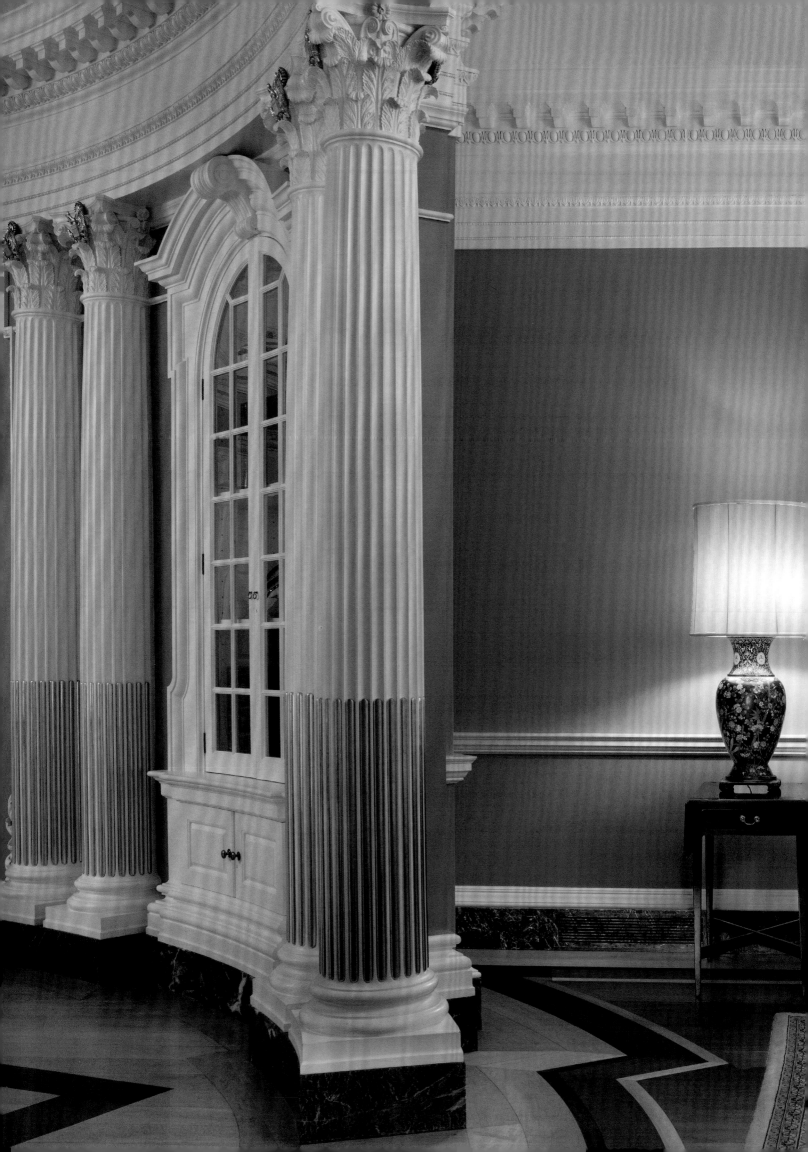

The
ARCHITECTURE
of the
DIPLOMATIC
RECEPTION
ROOMS

Allan Greenberg
& Mark Alan Hewitt

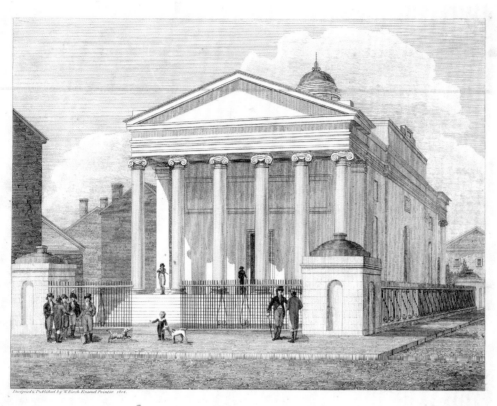

BANK OF PENNSYLVANIA, *South Second Street* PHILADELPHIA.

THE
CLASSICAL TRADITION
IN THE
UNITED STATES

LONG BEFORE THE FOUNDERS sat down to write a constitution for our young republic, immigrants brought the enduring forms of classical architecture to American shores. They could hardly do otherwise, as King George II of Britain mandated such building types and city plans for British colonial settlements. Philadelphia and Boston contain the most prominent classical edifices from the colonial period, but many other examples remain.

Classicism arises from a two-thousand-year-old corpus of art, architecture, landscape, and city design that has persisted, virtually uninterrupted, until the present day. It is the most widespread and durable language of design ever invented, as John Summerson informed us in the last century:

> A classical building is one whose decorative elements derive directly or indirectly from the architectural vocabulary of the ancient world—the "classical

world" as it is often called: these elements are easily recognizable, as for example columns of five standard varieties, applied in standard ways; standard ways of treating door and window openings and gable ends and standard runs of mouldings applicable to all these things.[18]

Edward Vason Jones, Walter M. Macomber, John Blatteau, and Allan Greenberg were steeped in this knowledge, and their inspiration guided the creation of the extraordinary rooms in this book.

The first classical buildings in the colonies were churches, fortifications, government buildings, and houses. Few elaborate examples exist today in places like Massachusetts and Florida, as most were destroyed in wars and city expansions around Boston and St. Augustine. In the second half of the eighteenth century, prosperous towns like Philadelphia, Newport, Charleston, and Annapolis could boast sophisticated, British-influenced buildings. But it was Pierre Charles L'Enfant who provided a truly classical city plan for Washington, D.C. (1791–92), that inspired architects and urban designers throughout the new nation. He was influenced by, among others, André Le Nôtre's seventeenth-century plans for Versailles, which gave him knowledge of French gardens that George Washington recognized as important for the design of the new capital.[19]

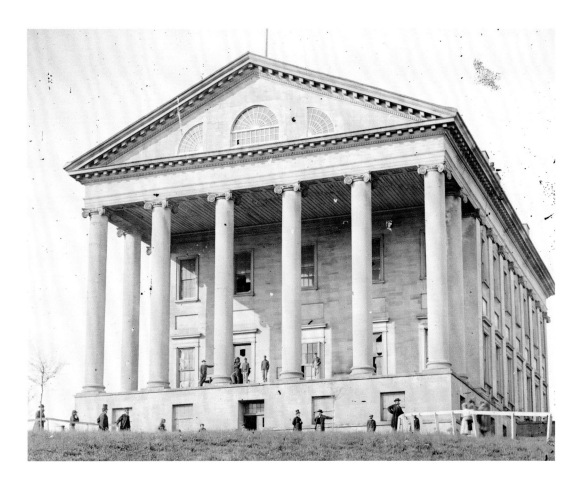

The first true monumental buildings constructed during the early republic were designed by architects with a predilection for pure, abstract classical forms influenced by the Greek Revival in Europe, as William Pierson pointed out during the 1970s.[20] Thomas Jefferson, Charles Bulfinch, and Benjamin Henry Latrobe had far more specific aims in mind than just pulling a few ideas from European architects. Each in his own way created a powerful archetype for the kind of classical buildings that would henceforth guide every designer from Thomas Ustick Walter to Robert A. M. Stern.

Since he lacked formal training, Jefferson enlisted the French architect Charles-Louis Clérisseau in realizing his vision for a statehouse in the new Commonwealth of Virginia (above). Built from 1785 to 1788, the capitol building was inspired by a Roman temple, the Maison Carrée in Nîmes, France. The most significant example of a true American type was Bulfinch's Massachusetts State House (1795–98), with its golden dome presiding over Boston Common. The body of the building conforms generally to the material and ornamental vocabulary of Beacon Hill houses such as Bulfinch's second Harrison Gray Otis House. But the billowing dome is a truly astounding design, probably inspired by the dome of the Colonial Capitol in Annapolis. Shortly thereafter, residents of Philadelphia constructed the impressive, virtually indestructible, classical Bank of Pennsylvania (1798–1802), taking a

chance on a young architect who had recently left England for Virginia: Benjamin Henry Latrobe. Latrobe's magnificent and original hybrid of a Greek temple merged with Roman baths created an enduring model for banks and other institutional buildings (opposite page).

During the mid-nineteenth century, American architects created many Greek Revival and Gothic Revival masterpieces,

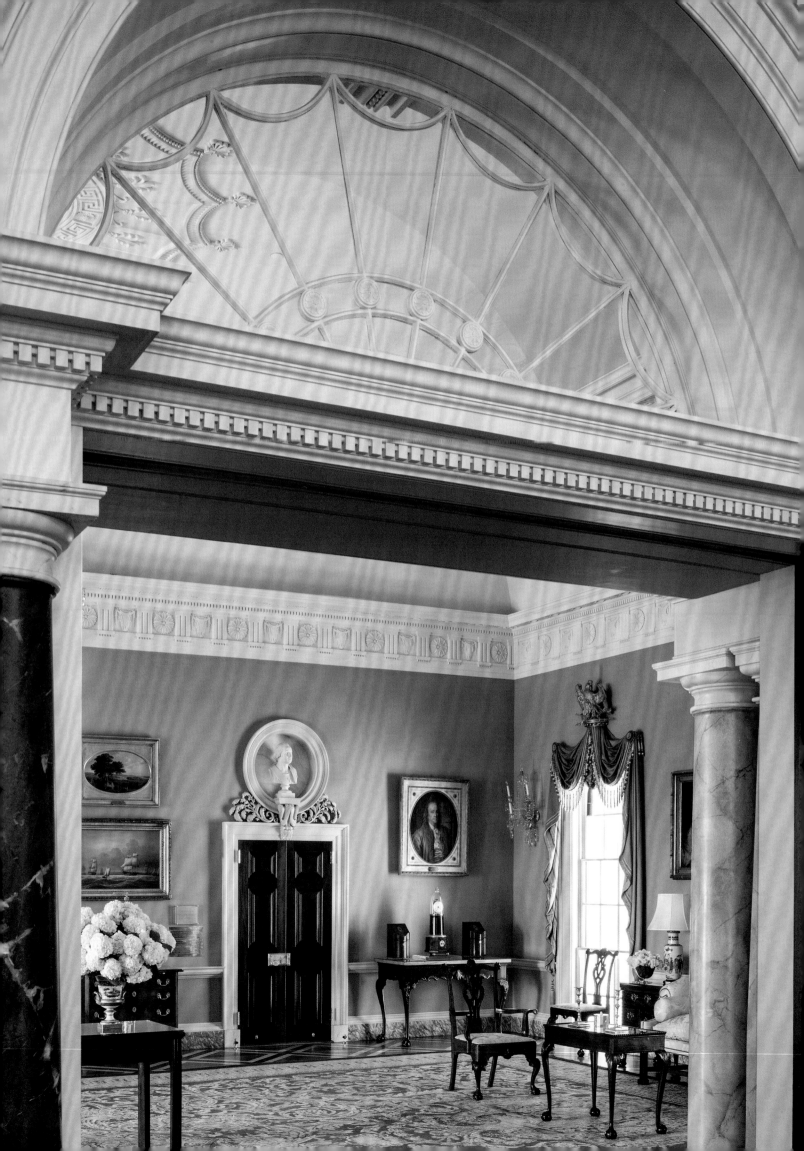

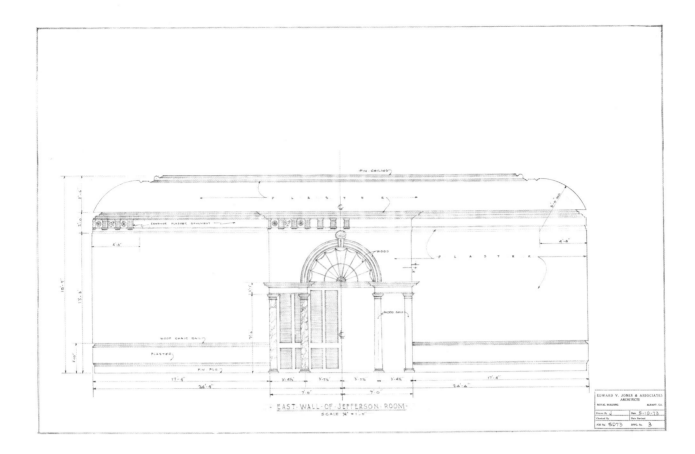

· EAST · WALL · OF · JEFFERSON · ROOM ·
SCALE ¼" = 1'-0"

but few were built in Washington, D.C. Statehouses, such as William Strickland's striking example in Tennessee, continued to follow classical precedents. With the interruption of the Civil War and Reconstruction, America awaited a classical renaissance to erect its most impressive and enduring monumental edifices.

During what is today called the American Renaissance, leaders in the arts used classical precedents in an extraordinary creative outpouring, a true national movement that led to twentieth-century leadership in many aspects of culture.[21] In the nation's capital, architects transformed a city languishing in the doldrums of Victorian eclecticism into a magnificent pillar of classical architecture and urbanism.

Working within the armature of the 1901 plan by the Senate Park Commission, established by Congress, architects filled in the spaces envisioned by L'Enfant with some of the finest monumental buildings ever conceived:[22] the Lincoln Memorial, National Gallery of Art, House and Senate Office Buildings, Library of Congress, Union Station, Jefferson Memorial, Temple of the Scottish Rite, National Portrait Gallery, and Federal Triangle, to name a few. The Mall was finally planted and embellished as intended, and numerous city parks were designed by a group of talented landscape architects who established professional standards for the new century. Moreover, cities throughout the nation took Washington as an example

of how to design their public spaces and government centers—Rhode Island and Minnesota erected capitol buildings on a par with anything built in America before or since.

Thus, when Clement Conger approached Edward Vason Jones in the early 1960s to help improve a group of rooms in the new Department of State headquarters near the Mall, he had two centuries of outstanding precedents to build upon. Not only did the two men initiate a program that lasted for twenty years, but they also gave the nation unique spaces for foreign dignitaries who would visit the seventh and eighth floors to meet with American diplomats and other leaders.

The completed Diplomatic Reception Rooms and Offices of the Secretary of State not only contain a superb collection of American fine and decorative arts but also represent a rebirth of classical design principles. Visionary architects such as Jones, Macomber, Blatteau, and Greenberg provided inspiration to a new generation of classical designers working today. Without their courageous efforts, the nation would not be building classical courthouses, university buildings, and other institutional edifices based on the rich, centuries-old tradition that inspired our forebears—American classicism will live on because of them. —MAH

OPPOSITE Thomas Jefferson State Reception Room
ABOVE East Wall of Jefferson Room. Edward Vason Jones & Associates (Architects), Albany, Georgia, May 10, 1973

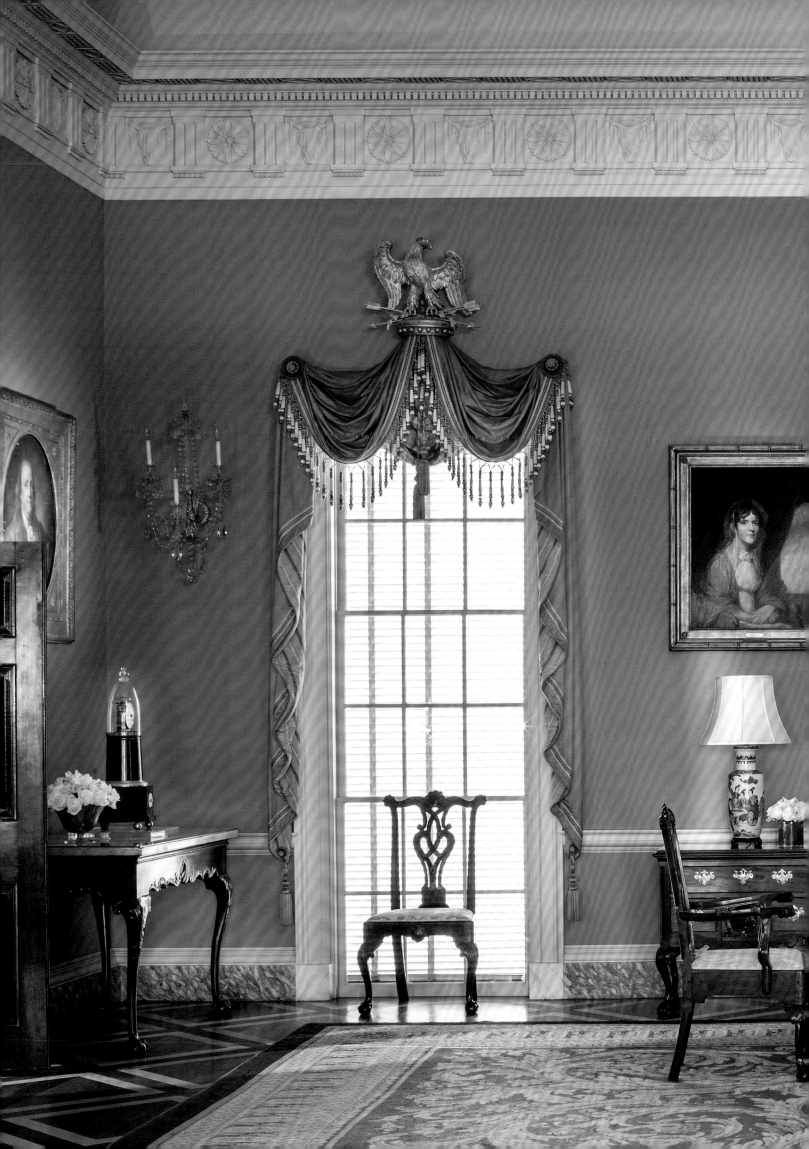

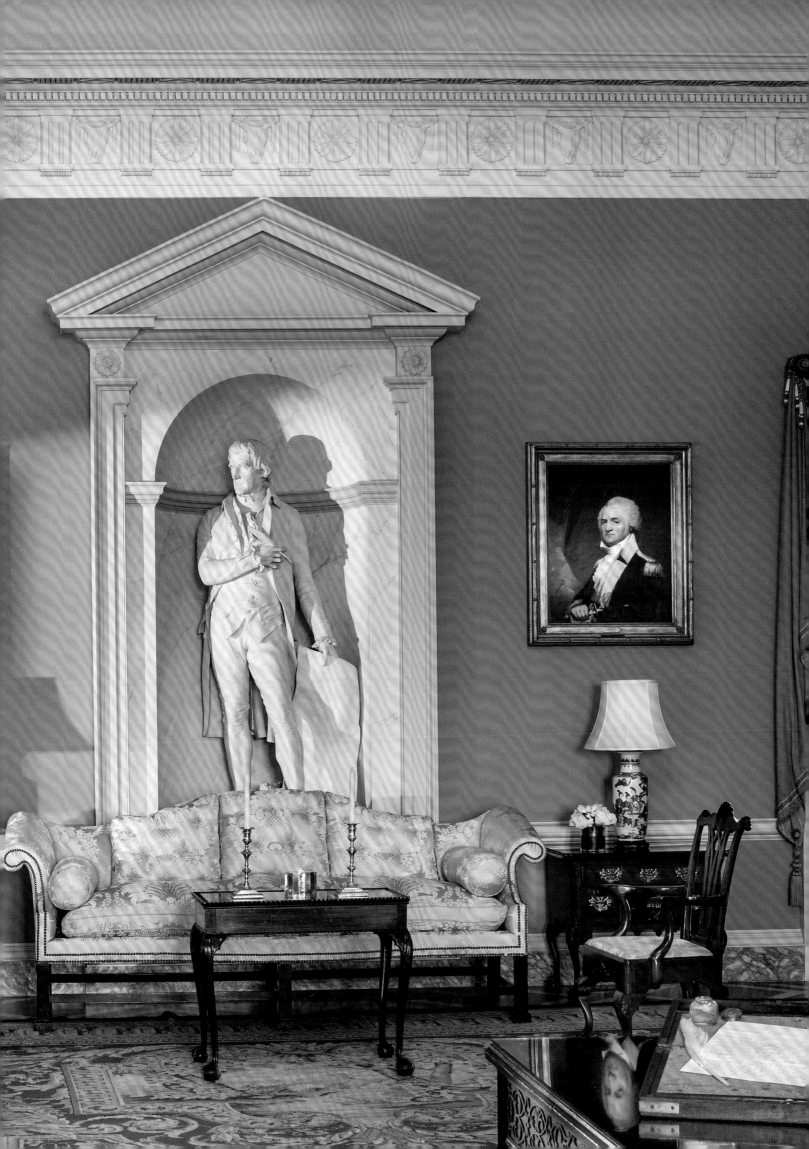

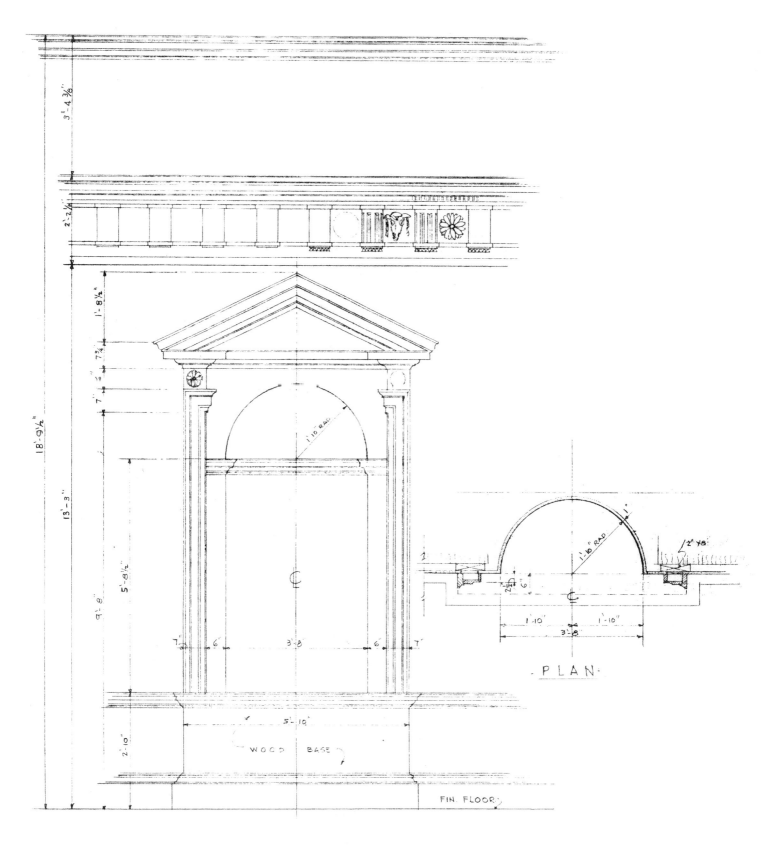

ELEVATION·OF·PLASTER·NICHE

SCALE 1" =1'-0"

·PLAN·

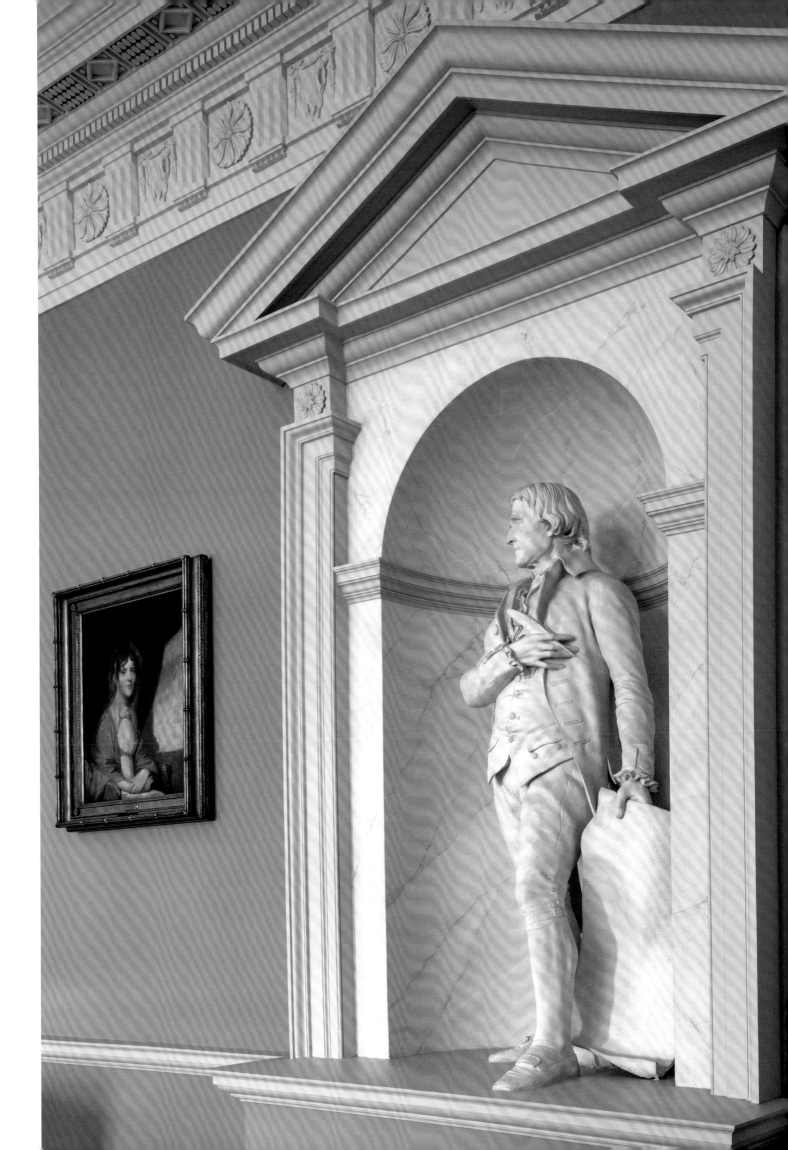

ABOVE Thomas Jefferson State Reception Room before renovation, 1961

OPPOSITE Bust of George Washington from the Thomas Jefferson State Reception Room

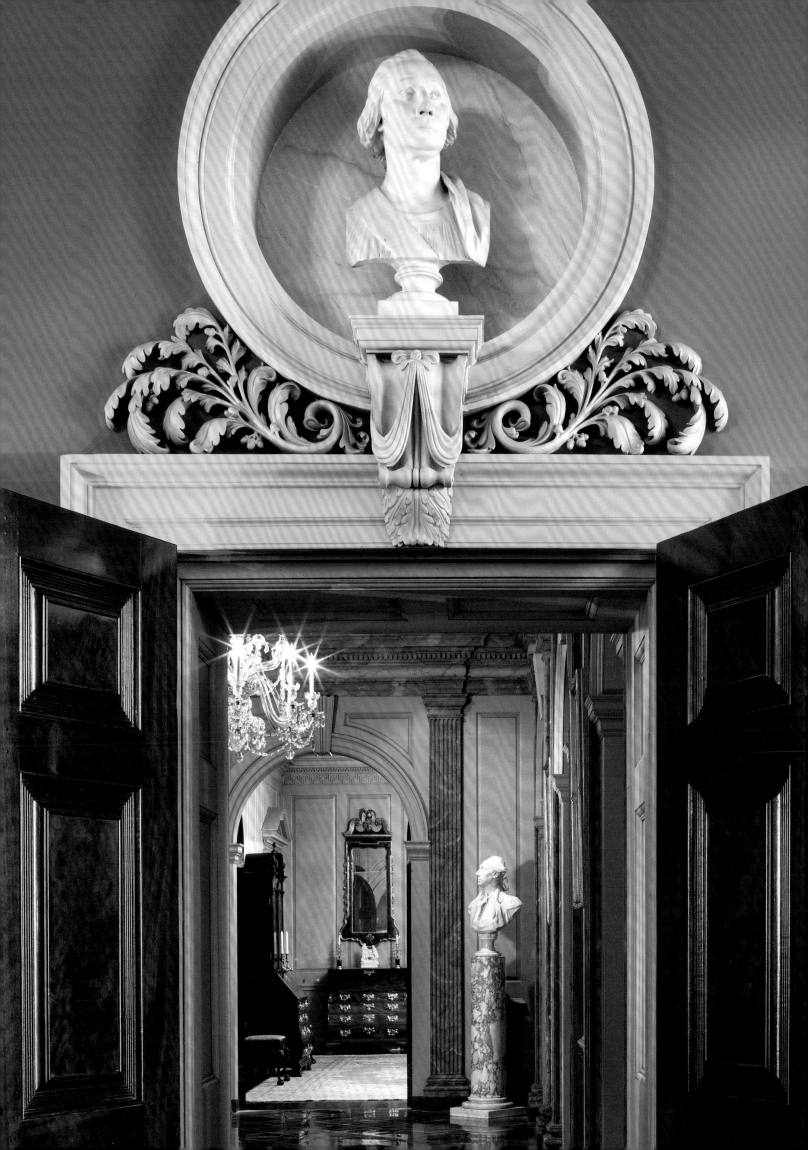

EDWARD VASON JONES

LIKE MOST GREAT ARCHITECTS, Edward Vason Jones (1909–1980) was self-taught. Seminal in his development was his time stationed in Savannah, Georgia, while serving in the navy during World War II. The city's great buildings initiated Jones's consuming and lifelong passion for colonial, federal, and Greek Revival architecture and decorative arts. He used every free moment to make measured drawings and to photograph Savannah's buildings. Eventually his eye became so sharp and his understanding so profound that he managed to think of design problems in the same manner as the original architects and artisans. It is precisely this quality of being able to enter into the mind and almost become the hand of an early American architect that makes Jones's work so special.

Jones's challenge in redesigning the Diplomatic Reception Rooms was a far cry from any of his restoration projects or new buildings. The new State Department building, completed in 1960, is uncompromisingly modern, as were the reception rooms on its eighth floor.

Jones's brief from Clement Conger, curator of the collection, was to create a suite whose architecture and furnishings would embody the unique architectural and cultural heritage of the United States. The suite comprises the elevator hall (renamed the Edward Vason Jones Memorial Hall), Entrance Hall, Gallery, John Quincy Adams State Drawing Room, and Thomas Jefferson State Reception Room, which form a continuous series of connected spaces, and the Martha Washington Ladies' Lounge and Dolley Madison Powder Room, which open off the Gallery. From the elevator hall, one proceeds through the Entrance Hall and Gallery to the Adams State Drawing Room, the largest room in Jones's suite. Beyond it is the Jefferson State Reception Room, which may be used as either a drawing or dining room for sixty to eighty people. One door from the Jefferson State Reception Room leads to the elevator hall, while another opens into the Benjamin Franklin State Dining Room, the James Monroe State Reception Room, and the James Madison State Dining Room, all of which were redesigned by other architects after Jones's untimely death in 1980.

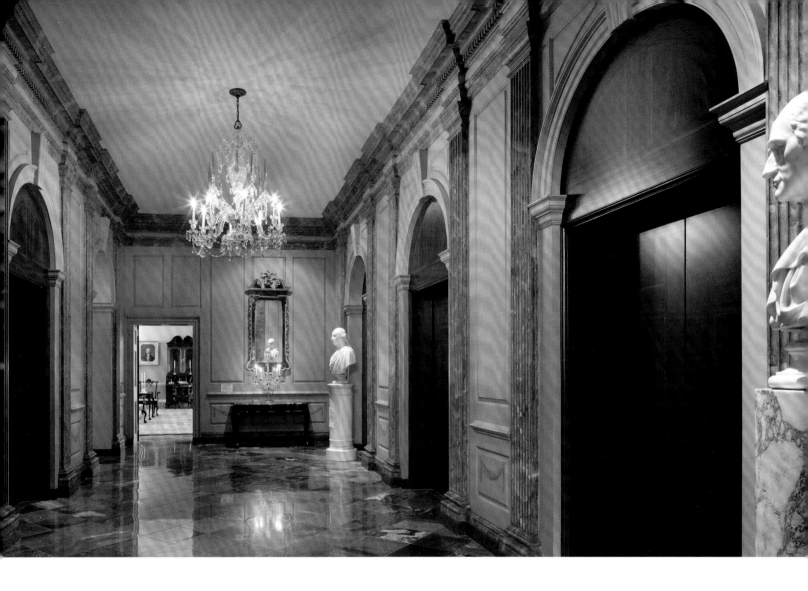

The State Department's growing collection of eighteenth- and nineteenth-century furniture, porcelain, and silver set the architectural character of the suite, while the style of and furnishings for each room were chosen after discussions between Jones and Conger. The initial vision was Conger's, and he raised the money to realize the dream. In Jones he found an inspired architect with knowledge, experience, and, most essential, access to the finest artisans. In addition to his encyclopedic knowledge of the architecture of the eighteenth and nineteenth centuries, Jones was an authority on the decorative arts of the period and, together with the art historian Berry B. Tracy, was a leading figure in the revival of interest in federal and empire decorative arts.

The practical problems in the Diplomatic Reception Rooms were enormous. A major encumbrance was the structure itself, including the air-conditioning, which had to remain in place. Furthermore, all rooms not under construction had to

be available for State Department receptions. Jones considered the Thomas Jefferson State Reception Room, completed in 1974, to be his masterpiece. Of it he wrote:

> I tried to do something I thought Jefferson might have done, appreciated, given his approval to. . . . I just did the room . . . using all of the original design books in my library. I think I have nearly every book Jefferson had in his library. This was the way all the early architects got their design inspiration.[23]

While the architecture of the room appropriately reflects some of the character of Jefferson's magnificent house, Monticello, it is also clear that this is a Jones design. For example, the floor pattern is a diagonal grid of dark mahogany squares within which are smaller mahogany squares, each surrounded by a frame of lighter yellow maple. The source of the pattern is the parlor floor of Monticello, although Jefferson's design is simpler: dark cherry squares set in a grid of lighter-colored beech. Jones's more elaborate composition is appropriate to the large scale of the Jefferson Room.

The magic of the transformation grows out of Jones's ability to retain a sense of his source while subtly altering it to suit a

EDWARD VASON JONES
MEMORIAL HALL

Through his tireless genius this
distinguished architect transformed
seven modern reception rooms into
authentic 18th century style American
interiors. 1965-1980

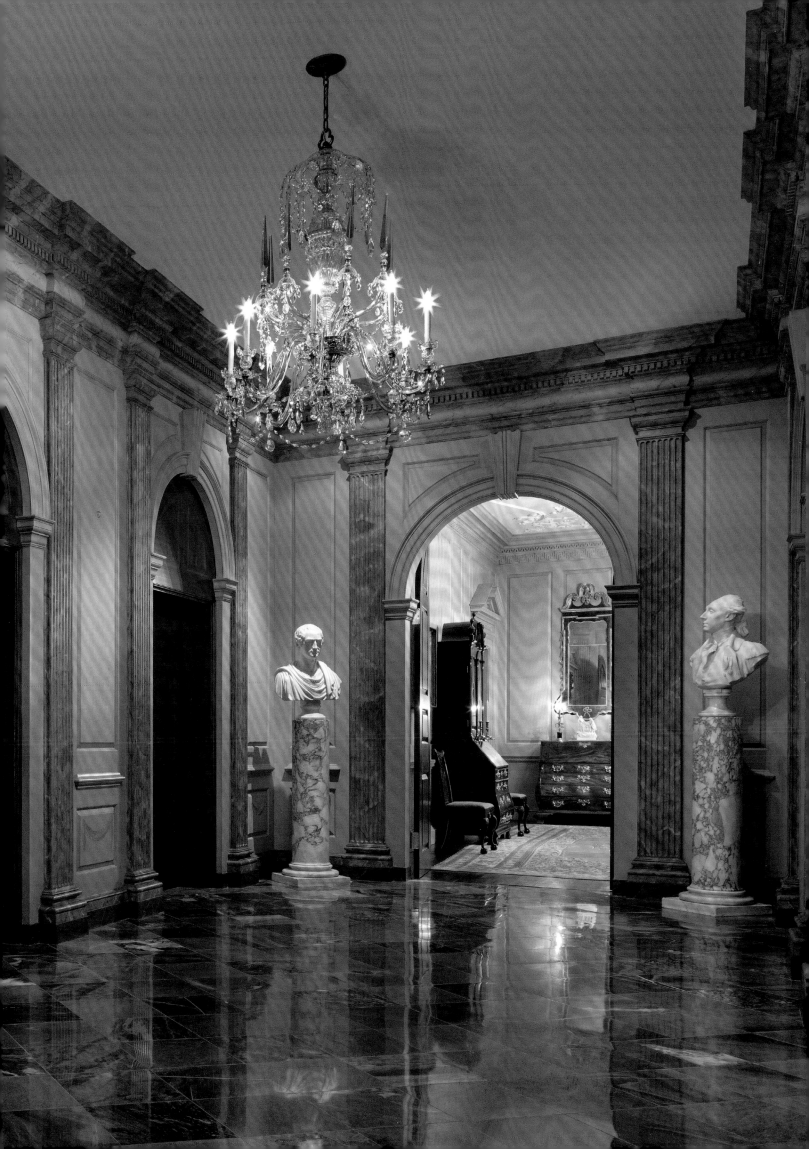

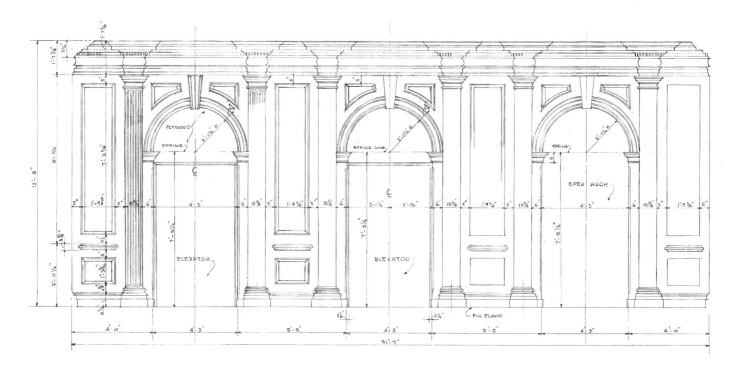

different purpose. The same transformation is evident in the entablature of the Jefferson Room. The source is the Doric entablature in the dining room at Monticello, with its alternating metopes of ox skulls and rosettes in the frieze. Jones provided a band of dentils above the frieze, which added shadow and highlights to compensate for the larger dimensions of this room. However, the proportion of the whole entablature to the wall below is a ratio of one to six and a

ABOVE North wall of elevator lobby. Edward Vason Jones & Associates (Architects), Albany, Georgia, September 6, 1978
BELOW Edward Vason Jones Memorial Hall before renovation
OPPOSITE Edward Vason Jones Memorial Hall

half, similar to the ratio of the corresponding elements in Jefferson's dining room. The profile of Jones's cornice, baseboard, and chair rail has its equivalent at Monticello, as do the tall, triple-sash windows and the pedimented door leading to the terrace. Jones's masterstroke is the design of the two paneled wooden doors leading to the Adams State Drawing Room and the elevator hall. They are domestic in scale—seven feet high—and play a critical role in establishing the human scale of this large room.

Set in a console above the architrave of each door is a circular niche nested in a composition of plaster oak leaves and acorns. The niches contain busts of Washington and John Paul Jones. Jefferson used oval portholes in his bedroom (to ventilate a mezzanine-level closet) and round windows in the dome room at Monticello, and busts, on consoles, of heroes of the American Revolution—including John Paul Jones and Washington—decorate the tearoom in his home. Jones combined these two elements into a brilliant composition that articulates the scale of the room. From a purely architectural viewpoint, ignoring symbolism and sentiment, this sense of human scale is so Jeffersonian that we can palpably feel the presence of the man in this room. The noble cove of the tray ceiling was probably inspired by the ceiling of the Masonic Lodge room (1790) in the Masonic Temple Theatre in New Bern, North Carolina, and the ballroom at Mount Vernon (1776–78). The plaster medallion, which combines Greek Revival and Adamesque elements, completes Jones's design.

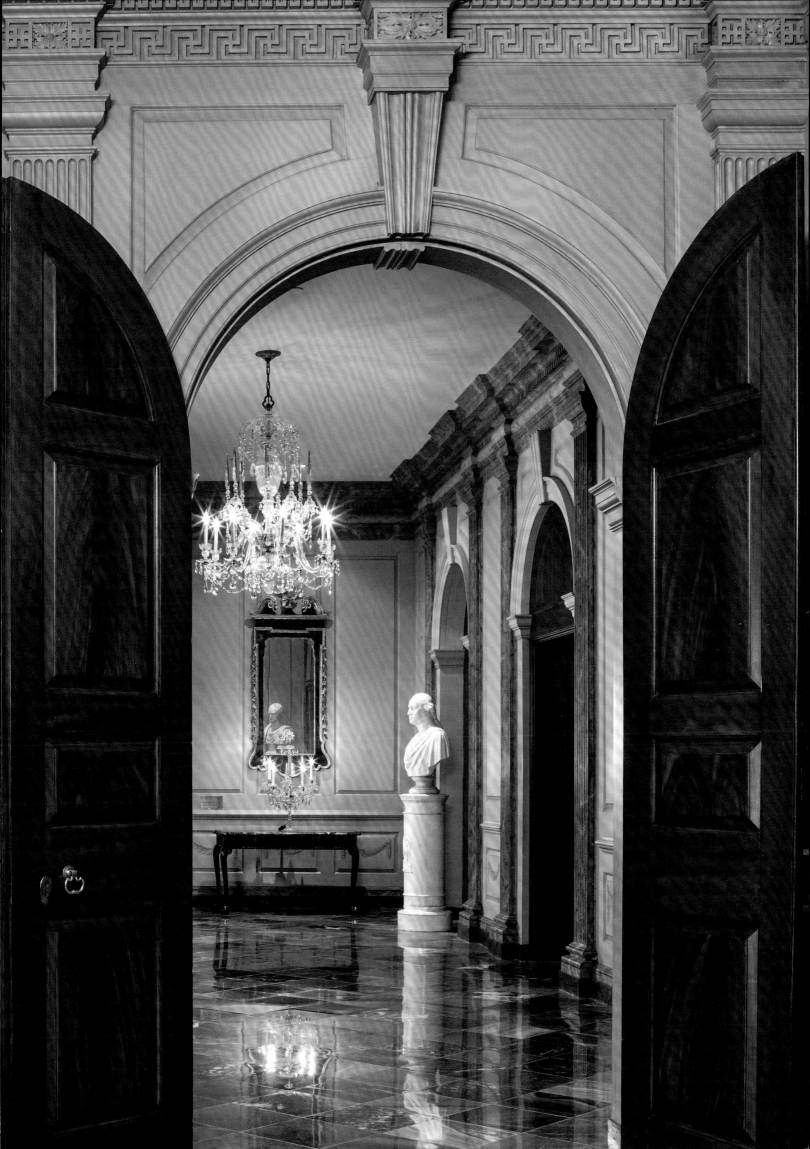

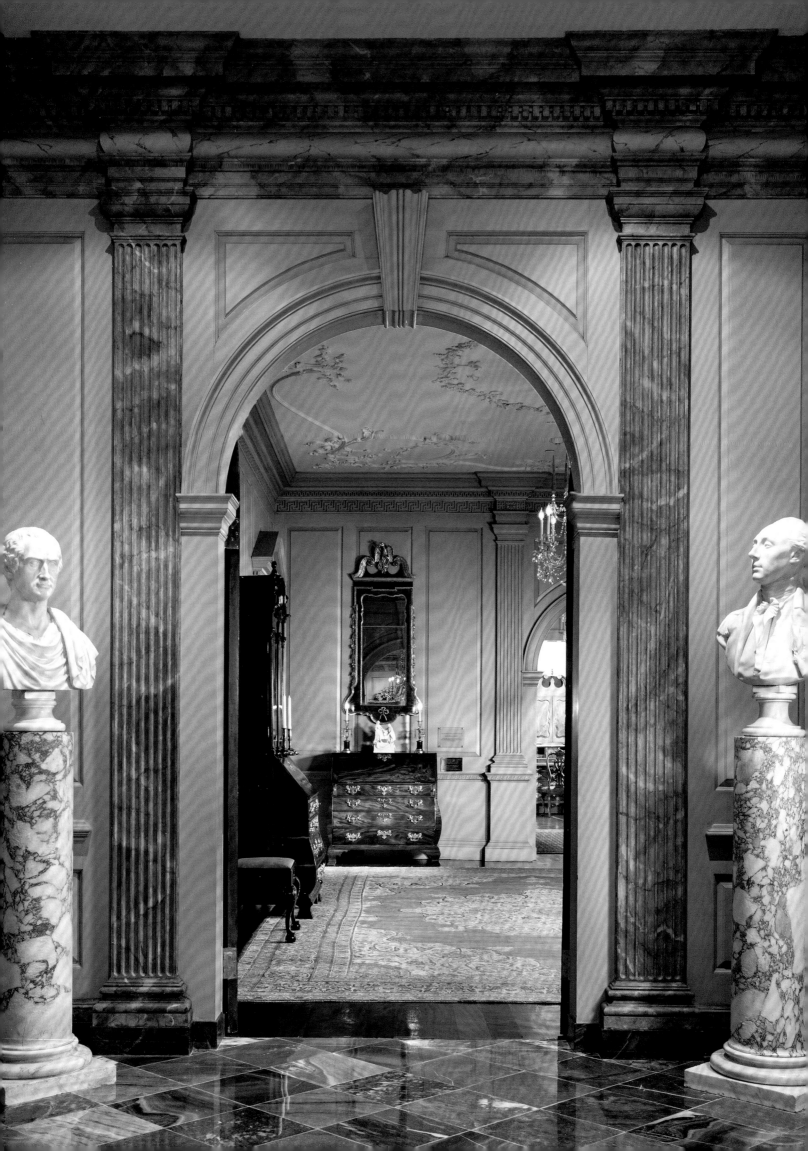

Surprisingly, Jones's most brilliant room in the State Department is the elevator hall of 1979, which, together with the Entrance Hall, was his last completed project. Although the hall was inspired by the small mid-eighteenth-century painted and paneled room from Marmion in King George County, Virginia, now in the Metropolitan Museum of Art, it is very different. It has a monumental, Roman grandeur, with tall groups of marbleized pilasters framing the arched architraves around the elevator doors. Framing an arch with pilasters is a Roman device, which is most appropriate given the importance of ancient Rome to our architecture. The wall paneling is treated as a monochrome surface filling the spaces between the pilasters. The floor is an expanse of King of Prussia marble. Jones said that this beautiful, rare material was as "American as apple pie." It was used for mantel facings and for floors in some of our finest houses up to 1860, when the quarry was exhausted. Conger found a cache of this stone buried on a Pennsylvania farm. The elevator hall was dedicated to Jones's memory in 1981, and it is now known as the Edward Vason Jones Memorial Hall.

Like the elevator hall, the Entrance Hall was completed in 1979 and is windowless, but such is Jones's skill that one is not aware of any sense of oppressiveness. Similar raised paneling above the wainscot occurs in many Virginia houses. The beautiful entablature incorporates a Greek fret design in the frieze and dentil course, which is echoed in the chair rail. To make the elaborate rococo ceiling, Jones used molds of the ceiling decoration of the front upstairs parlor of the Powel House (1765) in Philadelphia, installed in the Philadelphia Museum of Art, and added elements taken from the Andrew Low House (1840s) in Savannah, Georgia. The musical instruments, garlands, ribbons, small masks, and flowers all strike an appropriately festive note. The room has the feeling of a drawing room in a great James River, Virginia, mansion without actually recalling a particular prototype, although both the entablature and the split pediments above the doors have affinities with Shirley Plantation (renovated ca. 1770) in Charles City, Virginia.

The Gallery was the first of the State Department rooms that Jones rebuilt, in 1969. The Passageway, between the Entrance Hall and the Gallery, was inspired by the hall in Woodford (1756–72) in Philadelphia and has a Doric entablature atop square, attached columns set on pedestals beginning at the height of the chair rail. These are repeated as pilasters in the center of the Gallery. The main feature of the Gallery is the two doors with pediments set directly on the architraves. A Greek fret design similar to those in the Entrance Hall forms a dentil

band in the pediments. Decorating the frieze is a superb composition of shells and flowers brilliantly created by the master wood-carver Herbert Millard in the three-dimensional manner of Grinling Gibbons.

The John Quincy Adams State Drawing Room was Jones's second project, started after the Gallery and completed in 1972. Forced to deal with an extremely low, ten-foot ceiling, he devised a characteristically brilliant solution. On the long south wall, Jones built a boldly scaled door topped by an arched fanlight and flanked by Ionic pilasters. On the north wall, he placed a projecting central fireplace, also framed by square pilasters. This establishes a strong central axis, which effectively stops the eye in the middle of the room so that one tends to measure floor-to-ceiling height against only half the length of the room. The pilasters are repeated in the corners of the room to reinforce this sense of scale. On either side of the south door, the wall is subdivided by three windows. So strong is their insistent vertical rhythm that movement of the eye along the wall is discouraged, and one is forced to measure floor-to-ceiling height against each of these vertical elements in turn rather than the full or even half-length of the room. The fireplace opposite the door has a powerful overmantel, and the wall on either side of it is divided into two parts by a tall, arched, pedimented display cabinet with wooden doors. The vertical emphasis here is stronger, but less insistent, than on the window wall. The simple rhythm of the tall, recessed paneling reinforces the verticality of the major elements and provides a simple background against which the windows and display cabinets stand out.

The mantel and overmantel, inspired by the Powel House mantel in Philadelphia, is Herbert Millard's masterpiece in Washington. The play of shadow and highlights across the elaborate, deeply undercut carved surfaces is the spectacular feature of the room. The overmantel cartouche, egg and dart molding, and bold consoles are the focal point of the composition. The Ionic capitals on the flanking pilasters are beautifully carved with grapes and leaves hanging from the spiral volutes, echoing the festive theme more forcefully developed on the ceiling of the Entrance Hall.

The Martha Washington Ladies' Lounge and the Dolley Madison Powder Room were incomplete when Jones died. The completion of these rooms was faithfully undertaken by his team of artisans.

Jones's drapery designs for the Diplomatic Reception Rooms are inspired. In the Jefferson State Reception Room, the

OPPOSITE Edward Vason Jones Memorial Hall
FOLLOWING Entrance Hall

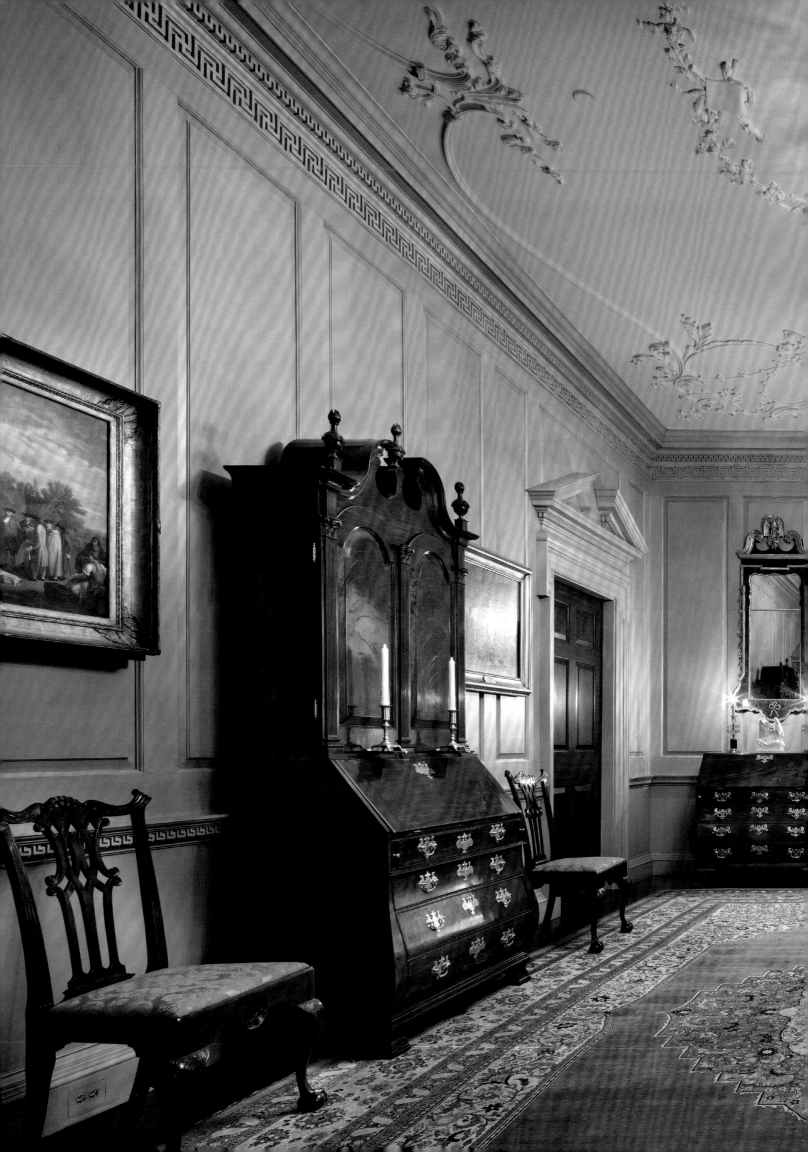

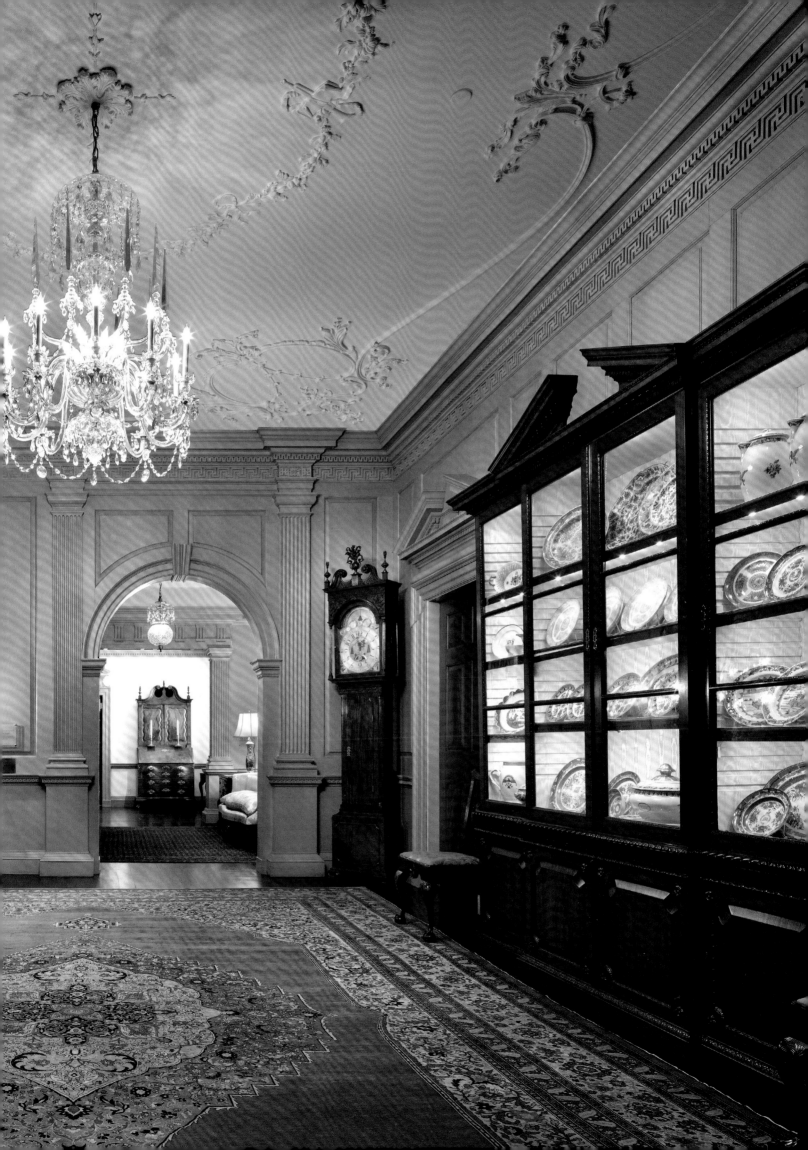

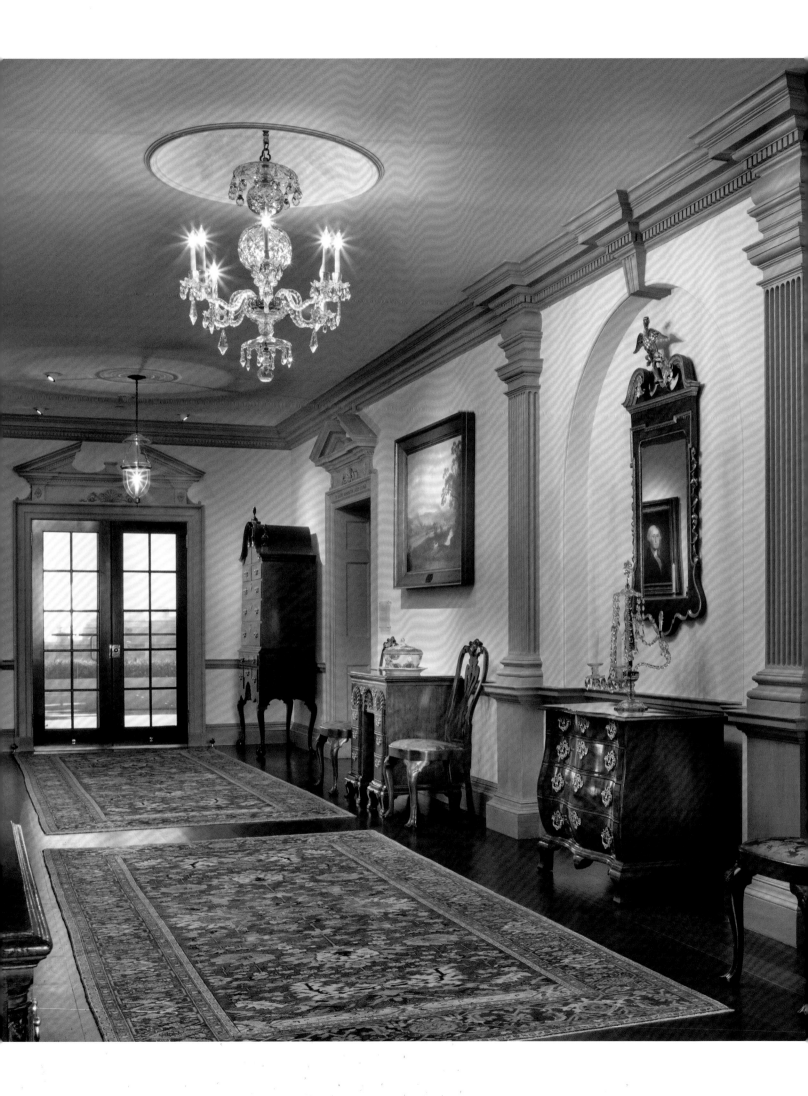

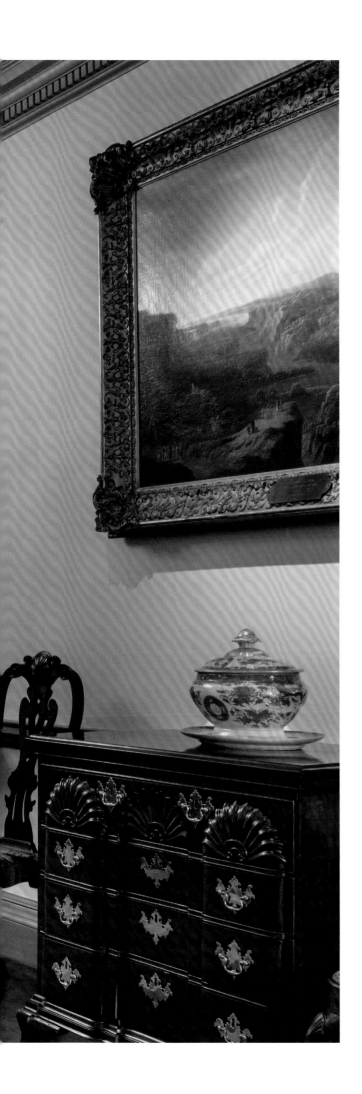

draped swags are crowned with carved and gilded eagles. The exquisite rosettes in the corners and the bold tasseled fringes and striped yellow lining are equal to the finest French designs of the eighteenth century. In the Adams State Drawing Room, the yellow brocade drapery is more modest in scale but just as magnificent. The fringes are a confetti of multicolored pom-poms, and the rose-colored lining provides just the necessary touch of bravura. Jones's extraordinary drapery at the White House as well as in the Diplomatic Reception Rooms warrants study in its own right, for in this sphere of interior design Jones has no peer.

It has been a rare privilege for me to sit at the feet of this great master and to learn from the example of his work. I regret not having known him and wish that he could have lived long enough to see the rising tide of interest in traditional American architecture.[24] —AG

LEFT The Gallery
ABOVE The Gallery before renovation
FOLLOWING John Quincy Adams State Drawing Room

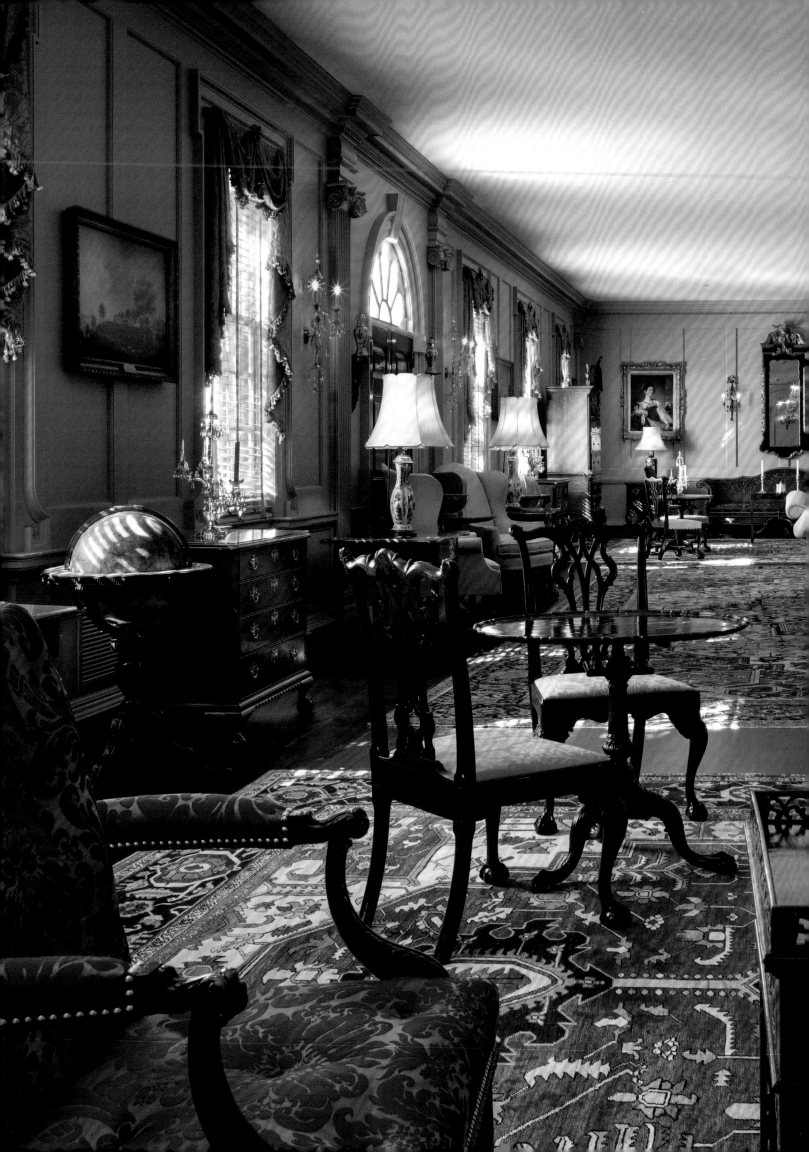

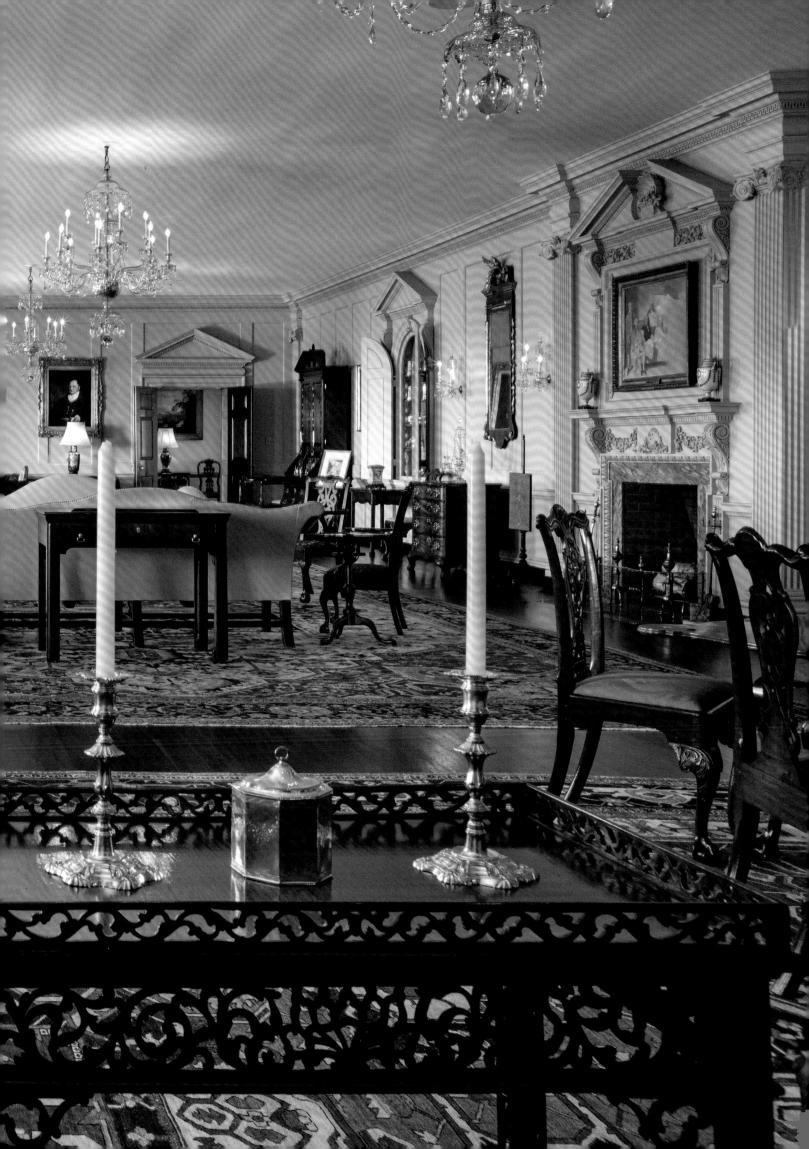

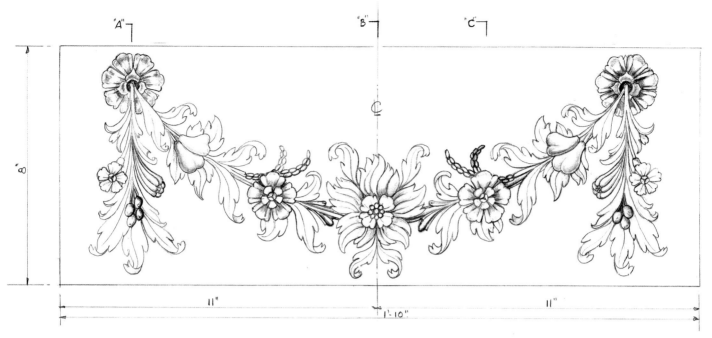

"A" "B" "C"

8"

11" 1'-10" 11"

· FULL·SIZE·CARVED·FLORAL·SWAG·FOR·DRAWING·ROOM·

(BASSWOOD MATERIAL (BASS WOOD) 1³/₁₆" THICK)

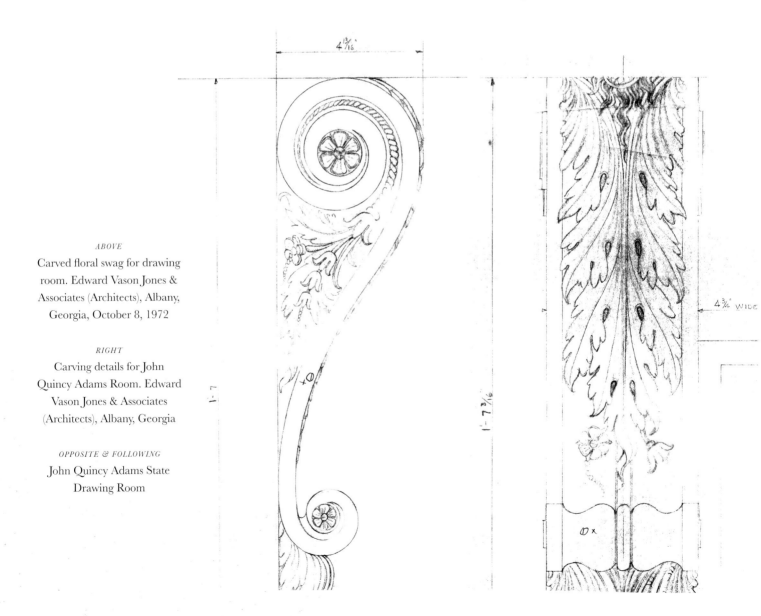

ABOVE
Carved floral swag for drawing
room. Edward Vason Jones &
Associates (Architects), Albany,
Georgia, October 8, 1972

RIGHT
Carving details for John
Quincy Adams Room. Edward
Vason Jones & Associates
(Architects), Albany, Georgia

OPPOSITE & FOLLOWING
John Quincy Adams State
Drawing Room

4¹³/₁₆"

1'-7"

1'-7³/₁₆"

4¾" WIDE

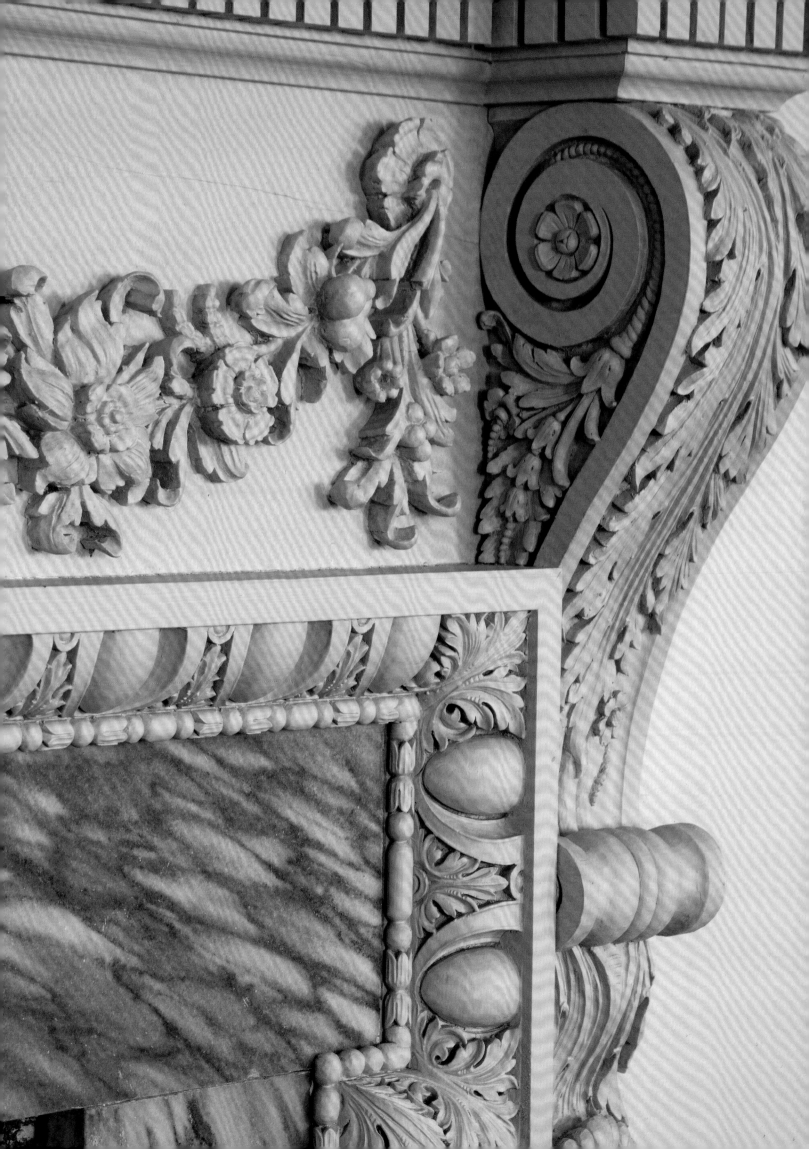

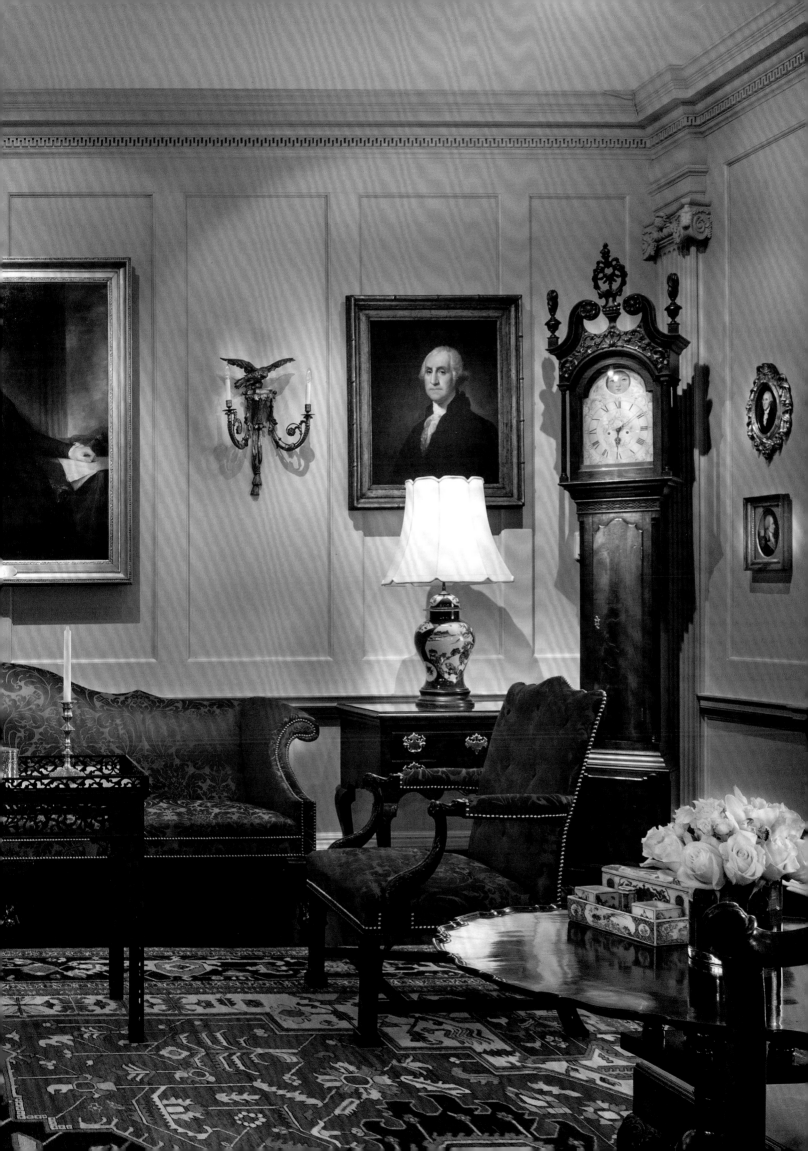

ELEVATION OF ELLIPTICAL ARCH
SCALE 1" = 1'-0"

· ELEVATION · TOWARDS · ARCH ·
SCALE 3/4" = 1'-0"

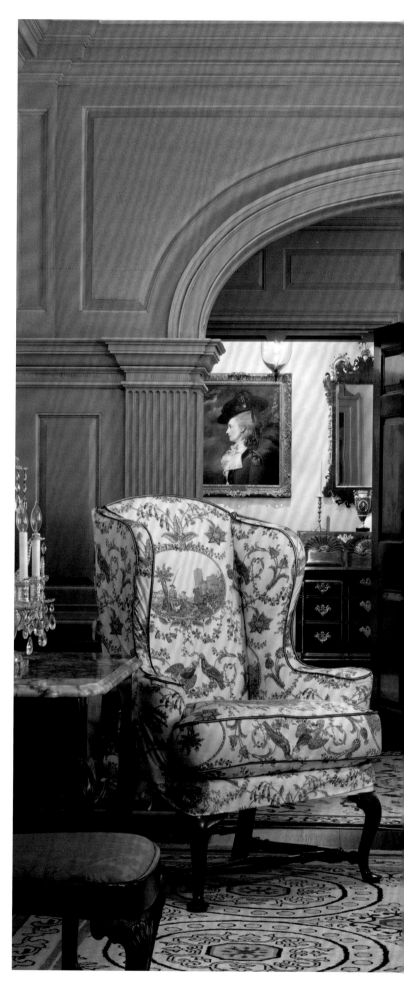

ABOVE TOP

Elevation of elliptical arch for the Martha
Washington Ladies' Lounge. Edward Vason Jones &
Associates (Architects), Albany, Georgia

ABOVE BOTTOM

Elevation towards arch for the Dolley
Madison Powder Room. Edward Vason Jones &
Associates (Architects), Albany, Georgia

RIGHT

Martha Washington Ladies' Lounge

FOLLOWING

Dolley Madison Powder Room

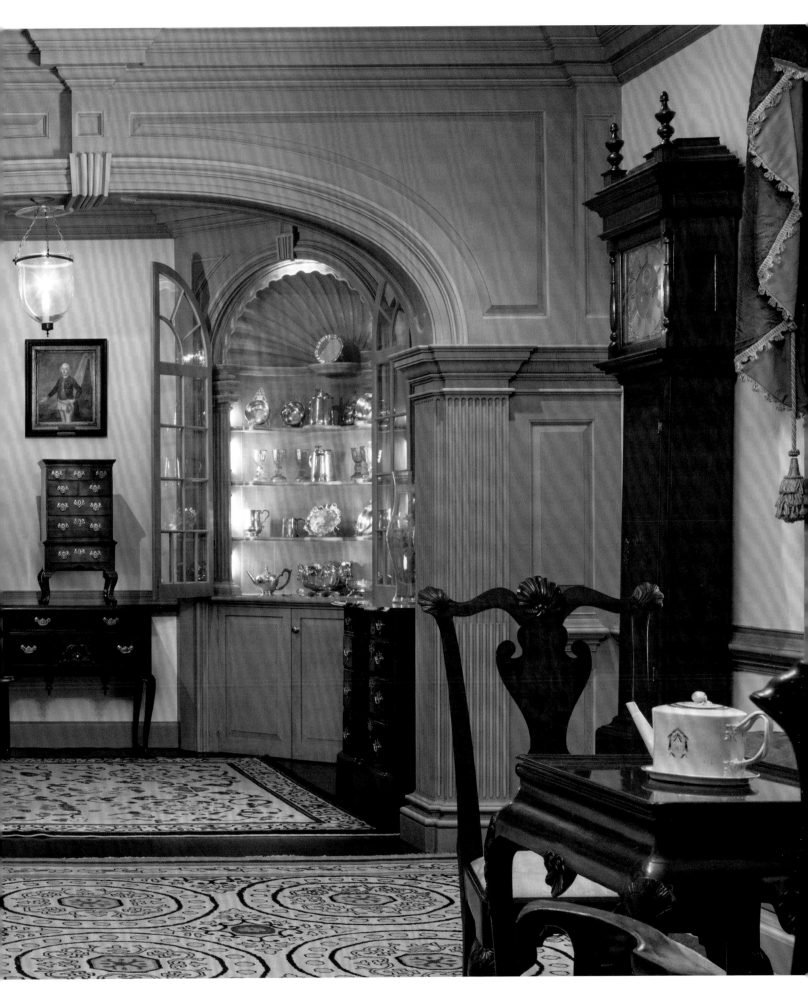

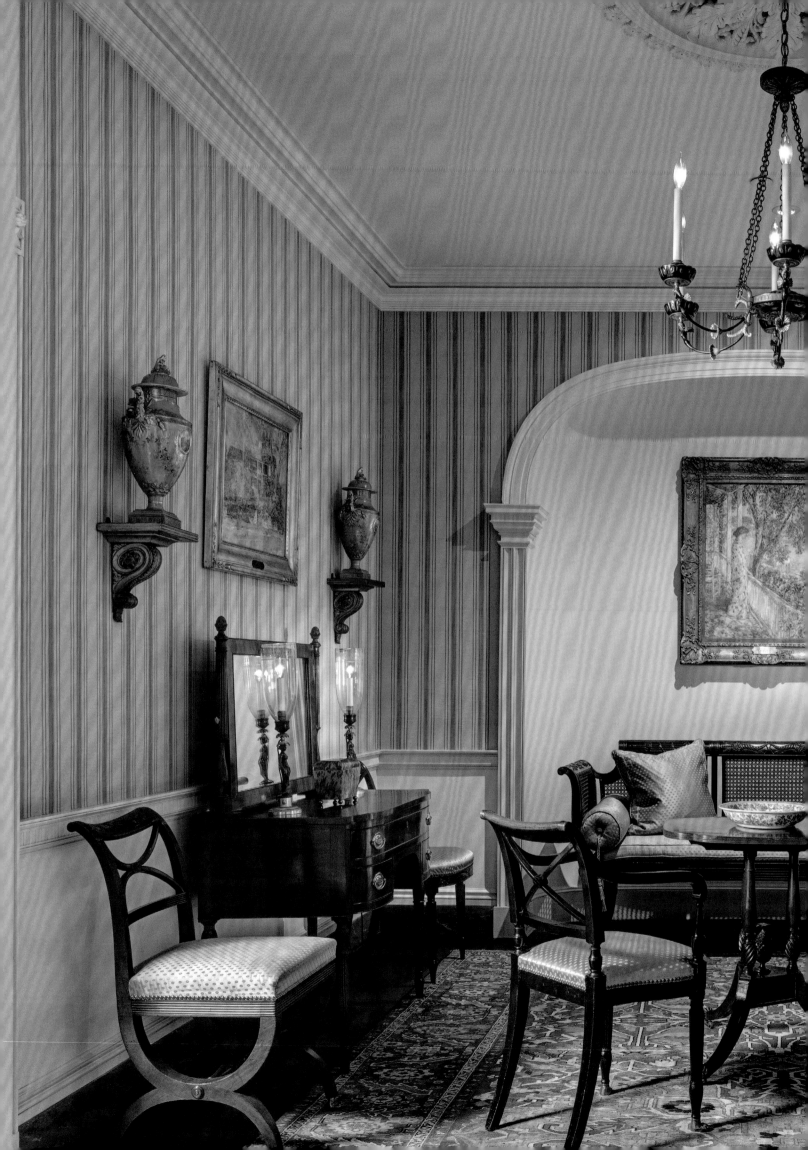

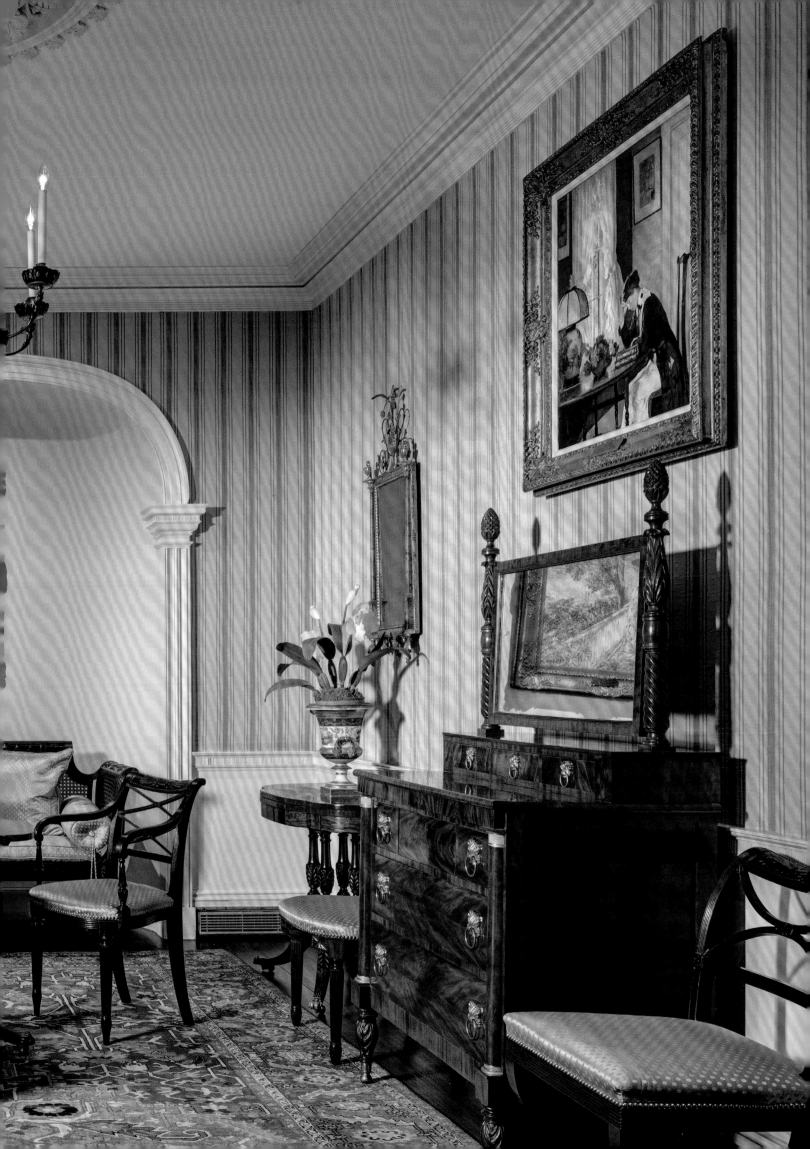

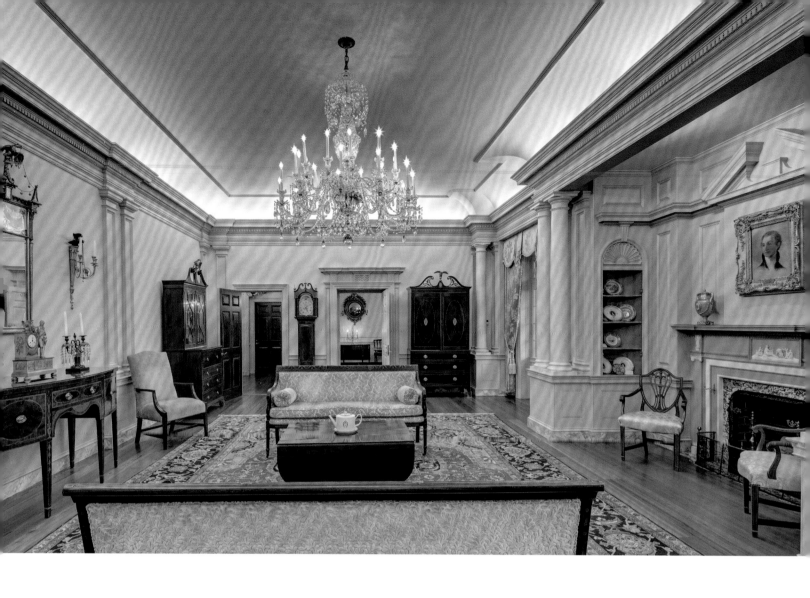

WALTER M. MACOMBER
& JOHN BLATTEAU

FOLLOWING EDWARD Vason Jones's death in 1980, Clement Conger turned to Walter M. Macomber (1894–1987) to design the remaining rooms in the eighth-floor suite that Jones had begun. In 1982 and 1983, the two laid out nine smaller rooms in various colonial idioms that might readily be associated with their namesake secretaries of state.

Macomber had been for many years the architect of Mount Vernon, the expansive estate of George Washington, run by the Mount Vernon Ladies' Association since the mid-nineteenth century. His knowledge of restoration as well as eighteenth-century American architecture made him a perfect choice. He was born in Revere, Massachusetts, and learned to design as an apprentice to his father—an architect, cabinetmaker, and builder. As a volunteer in the French Ambulance Corps in 1916, he was awarded a French medal for his service during World War I.

Macomber was fortunate to be hired by Perry, Shaw and Hepburn, the firm that John D. Rockefeller Jr. chose to serve as restoration architects at Colonial Williamsburg during the 1920s and 1930s. A kind of "Manhattan Project" of the historic preservation movement, this massive effort transformed the town into a showplace of colonial life, eventually becoming one of the nation's most popular tourist destinations. Macomber was given responsibility for two of the most complex projects: the Sir Christopher Wren Building at the College of William and Mary and the Capitol. The latter had to be reconstructed from scant evidence in an engraving from Oxford, a major challenge for any architect. Leaving that job in 1934, he went to Washington, opened his own firm, and worked not only at Mount Vernon but also on many other restorations in the city and in Virginia.

The centerpieces of Macomber's designs for the Rooms at the State Department were the James Monroe State Reception Room and the James Madison State Dining Room, both subtle essays in styles associated with the two men. Each presented challenges, as Macomber had to work around two structural steel columns, projecting out onto the terrace, and another bay projection nearby, to shape these rooms. In

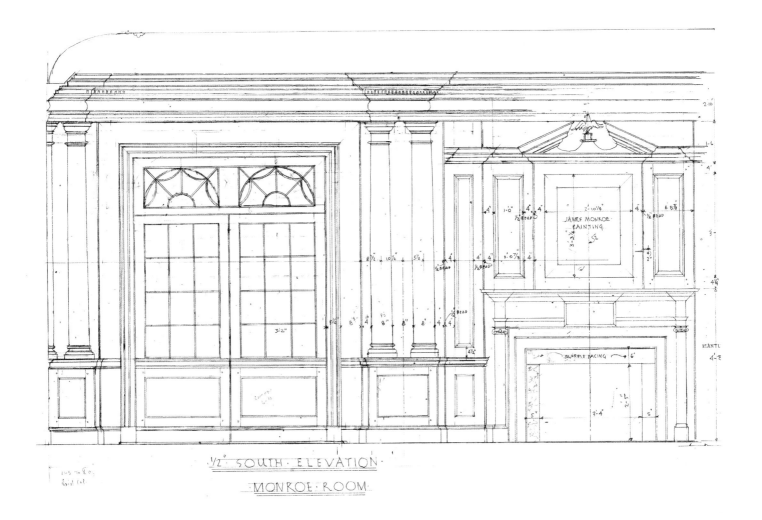

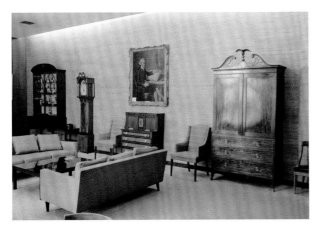

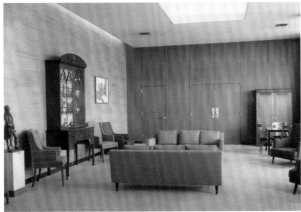

the Monroe State Reception Room, he designed an alcove flanked by elegant Doric columns on pedestals. He used a similar Doric order, though more slender in proportion, in the adjoining Madison State Dining Room; he also designed two alcoves with subtle flat arches to frame large furniture arrangements there, since he needed some natural light and additional room for the large dining table.

Macomber chose to use more complex, and intricate, moldings in the cornice, door surrounds, and elegant mantelpiece in the Monroe State Reception Room. The antique mantel, painted a striking Wedgwood blue, has delicate Ionic pilasters and a group of three ivory reliefs inspired by the eighteenth-century Scottish architect Robert Adam. Flanking it are two arched niches that feature important Chinese export porcelain. Though the key of the room is a subtle blue-gray, brighter blue upholstery and curtains add richness to the ensemble. Everywhere are objects with American eagle

OPPOSITE & FOLLOWING James Monroe State Reception Room
ABOVE South elevation and details of the north elevation for the James Monroe State Reception Room by Walter M. Macomber (Architect), ca. 1981
LEFT James Monroe State Reception Room before renovation

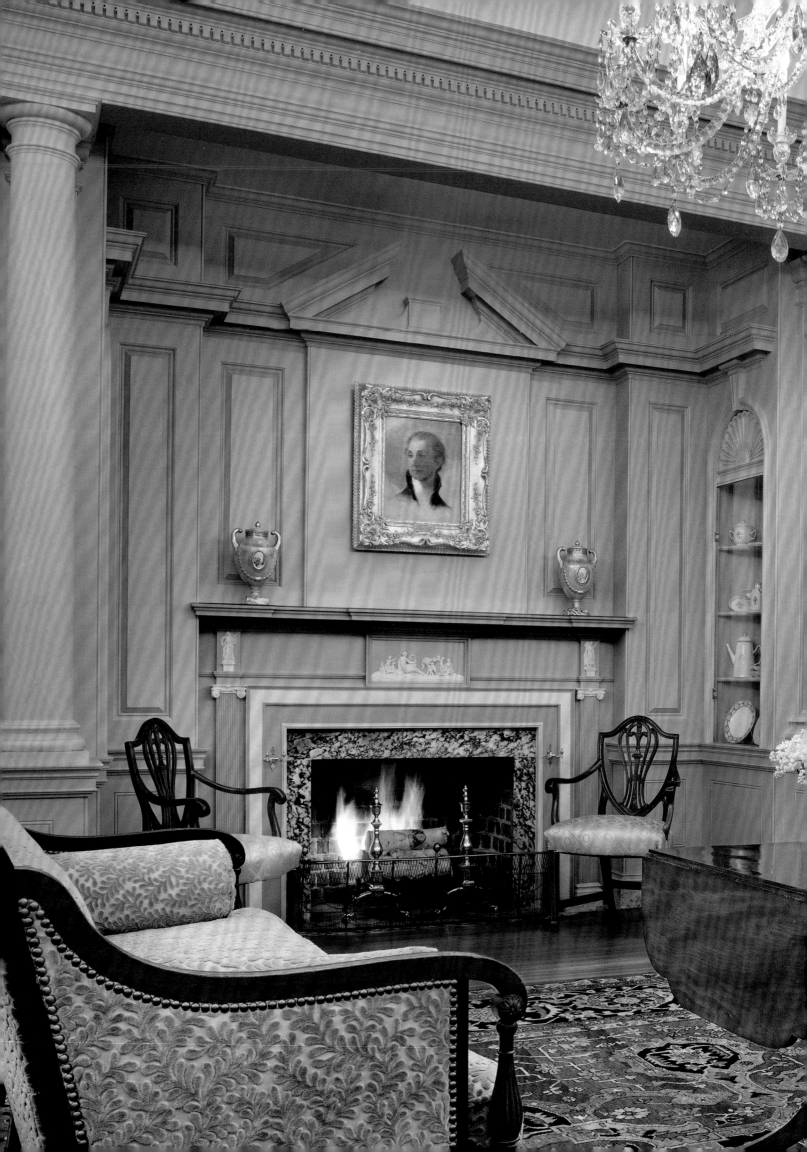

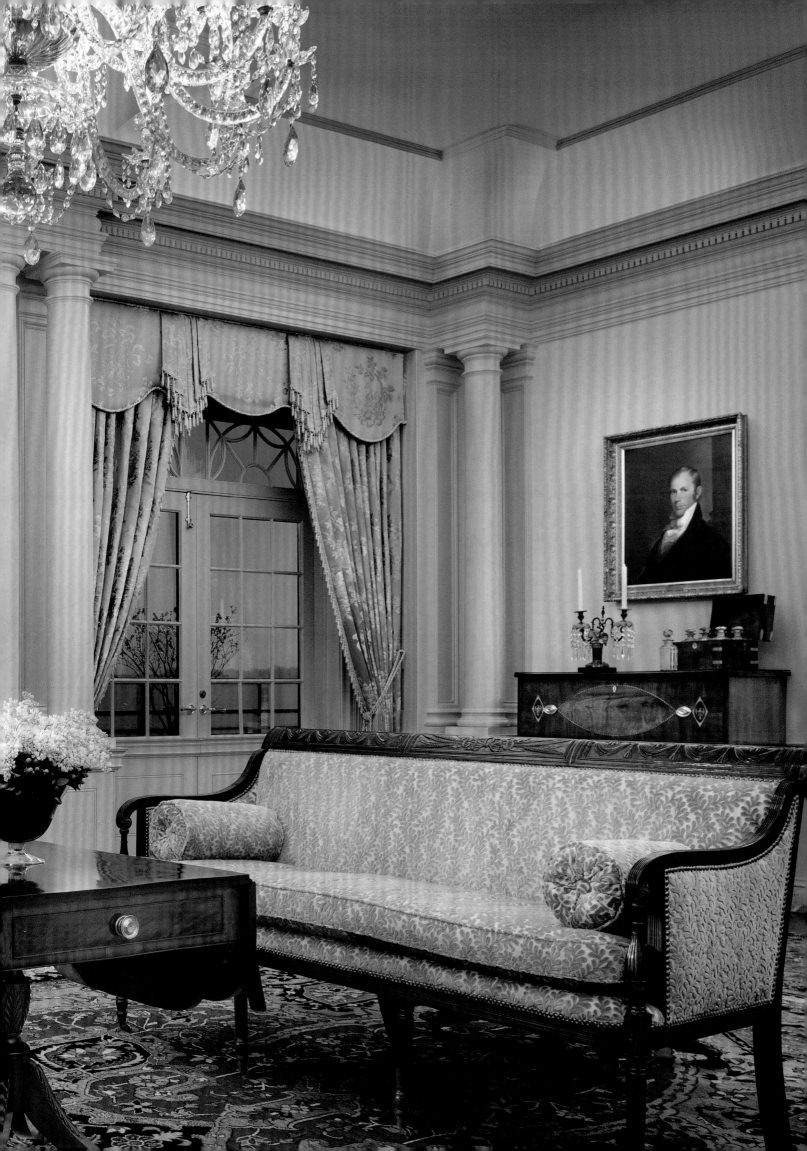

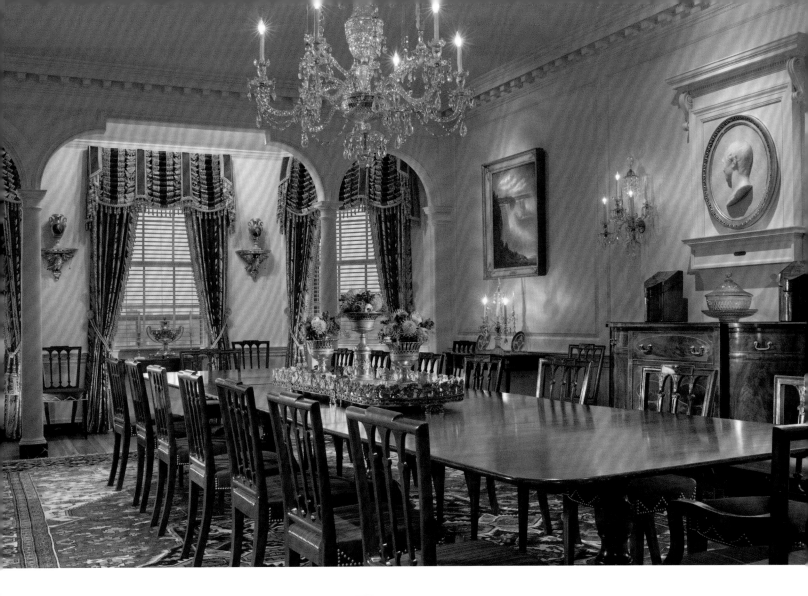

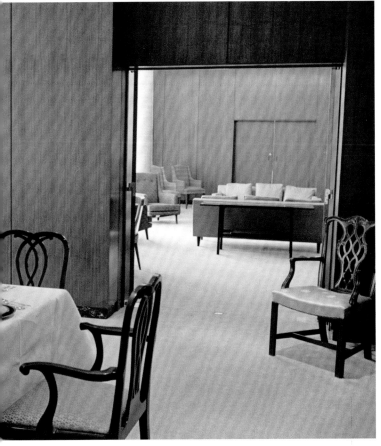

motifs, a favorite of Monroe. Particularly striking is a pair of candelabra sconces flanking a pier glass on the wall opposite the fireplace, each surmounted with an eagle. The pediments over the two main doors are also marked by delicate moldings and carved enrichments: fluting, leaf pateras, and a lattice pattern in the center panel.

The Madison State Dining Room has a more subtle classical flavor marked mainly by the slender columns flanking the arched alcove at the terrace end of the room. The buff-and-yellow-ocher color scheme provides a more colonial tone to the paneling that dominates the room. A sturdy modillion cornice ties the room together beautifully, and the room is well lit to feature several fine pieces of furniture from the late eighteenth century.

Another large room designed by Macomber was the Martin Van Buren Dining Room, with its stained paneling and more modern low ceiling. Used for less formal dining, it serves its purpose well. The adjacent sitting room is also elegant, with its three large panoramic panels of French wallpaper, *Les Paysages de Télémaque dans l'Île de Calypso*. A bold Doric order in the Passageway allows access to three other dining areas, framed by arched openings.

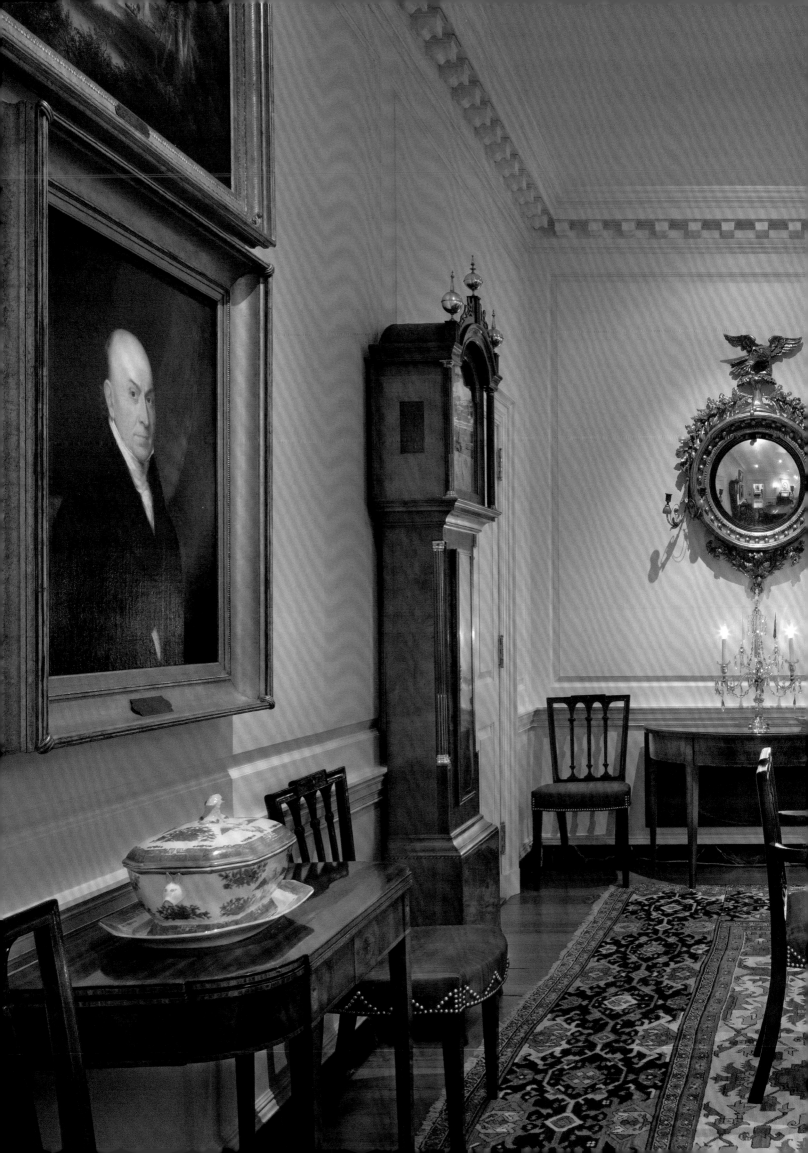

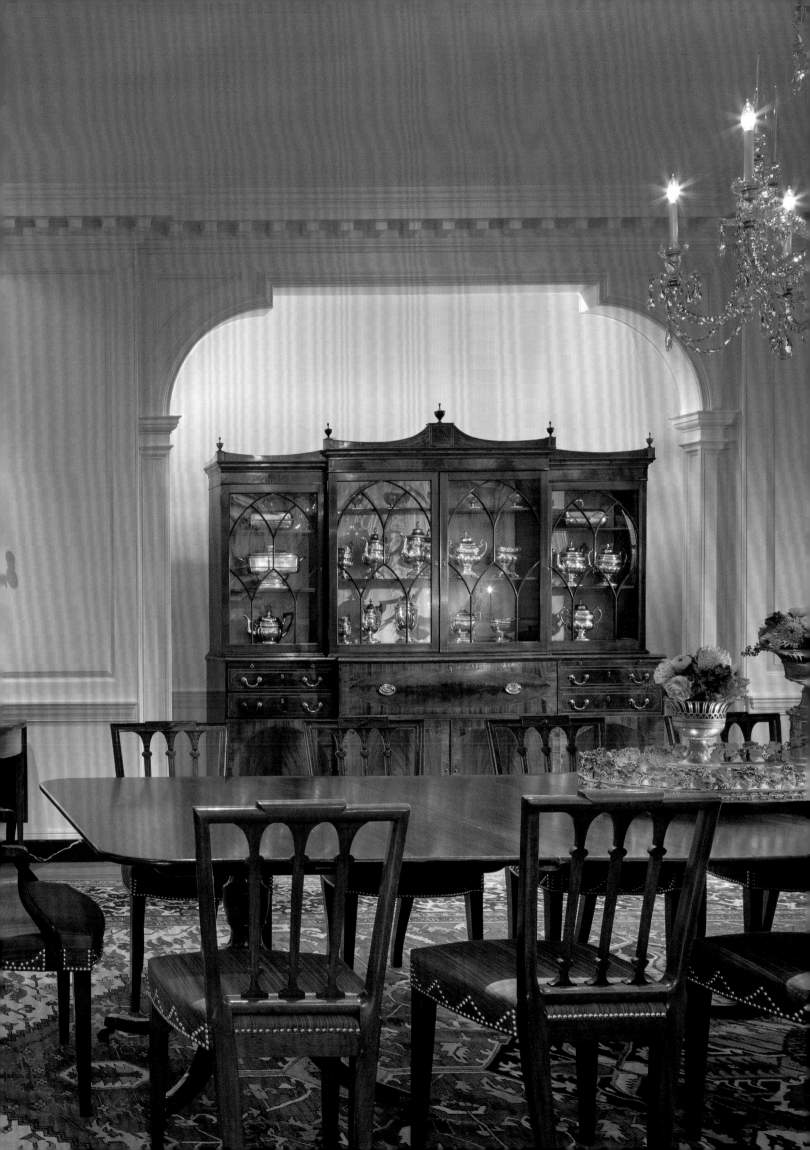

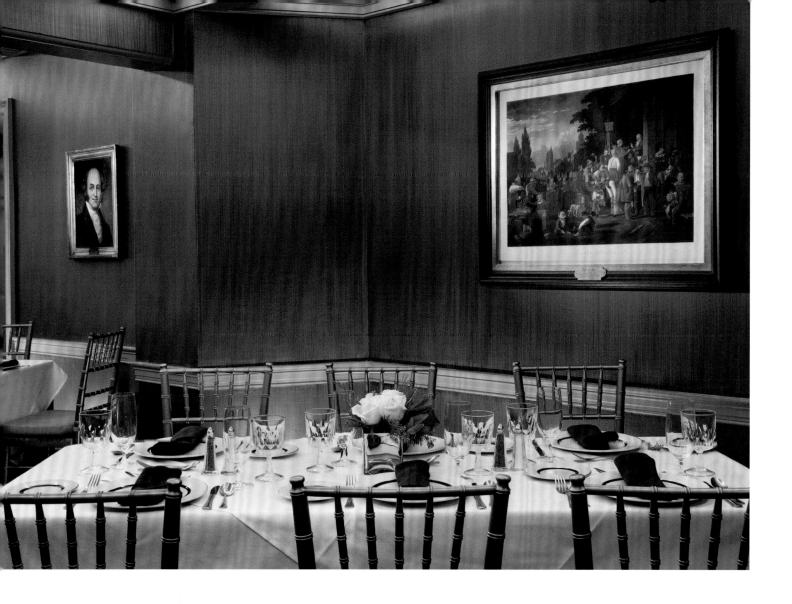

The Robert Livingston Dining Room has light stained paneling and a fine set of sconces to frame the large dining table. The Henry Clay State Dining Room was the last in this suite to be designed by Macomber, filling out the construction that occurred in the early 1980s. Its rich blue palette accentuates a group of wallpaper panels also from *Les Paysages de Télémaque*. It is accessed by a clever staircase enclosed by a triple-arched Doric order screen. Macomber designed special Chinese Chippendale railings and other details for the room, including a meander in the cornice. Macomber also designed the Walter Thurston Gentlemen's Lounge, named for a U.S. diplomat to nations in Central and South America, to be a quiet, reflective space, with its serene color scheme. Macomber's slightly more academic interpretation of the interior styles used in this suite of rooms sets them off from Jones's earlier designs, but the two architects who followed him would strike out in bold new directions, reflecting the confidence of the Reagan era in Washington.

ABOVE Daniel Webster Dining Room
OPPOSITE & FOLLOWING LEFT Martin Van Buren Dining and Sitting Rooms
FOLLOWING RIGHT James Buchanan Dining Room

Following a short break, Conger began to plan the seventh-floor rooms used by the secretary of state and the large Benjamin Franklin State Dining Room. He chose to hold an open architectural competition for the latter, something that had not occurred in Washington in some years, and definitely not for a room interior. Conger knew that this room would be the largest and, in some ways, most prominent in the suite, and he wanted the best ideas from around the world.

During the 1980s, a group of English and American architects studied the classical orders with a seriousness not seen since before World War I, inspired by Henry Hope Reed's bold condemnations of modernist city planning and celebration of monumental buildings such as the New York Public Library, Carrère & Hastings's 1898–1911 masterpiece. Reed and John Barrington Bayley founded the nonprofit organization Classical America to teach the principles associated with the American Renaissance to all who might be interested in the long tradition that began in Greece and Rome. Not only were they prospering with new commissions during the 1980s, but Quinlan Terry, Demetri Porphyrios, Robert Adam,[25] and John Simpson were making similar headway

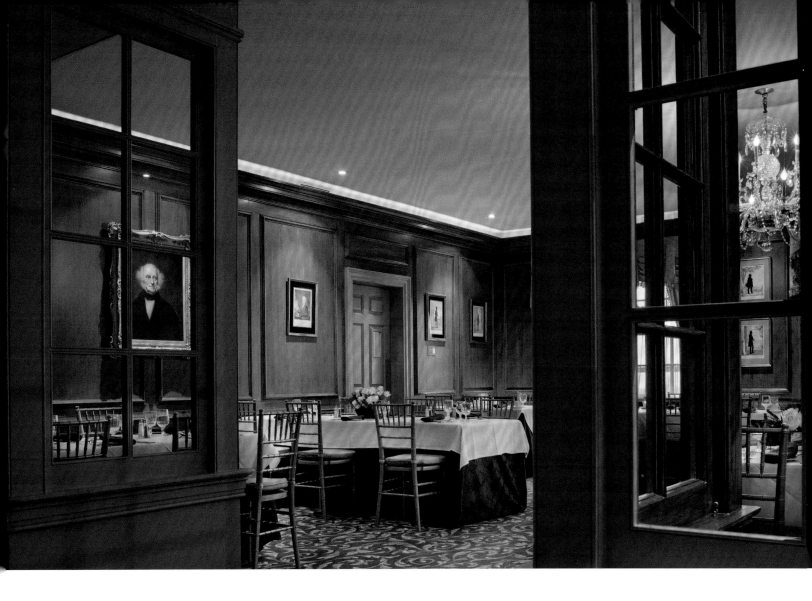

in Britain with their essays in traditional and classical archi-
tecture. There was a true reawakening spurring the study of
these timeless sources of art and design.

John Blatteau (b. 1943) was a product of the excellent
architecture program developed by Paul Philippe Cret at
the University of Pennsylvania in the early years of the
twentieth century. When Blatteau received his bachelor
of architecture degree in 1966, the program was under
the strong hand of George Holmes Perkins, a Harvard-
trained planner who had instituted a modernist pedagogy
to replace Cret's Beaux Arts one. Blatteau and his fellow
students were initially drawn to the new architecture but
quickly turned against it once they began practicing during
the 1970s. Fellow students Stanley Taraila and John Sutton
were learning from Beaux Arts planning principles as they
devised schemes for Old City, Philadelphia, and many were
looking to Robert Venturi and Denise Scott Brown for their
critiques of the modernist movement.

Thus, when Blatteau heard about the 1983 competition, he
jumped at the chance to compete with other young classi-
cists for the commission. Working for Blatteau was Stephen

Bonitatibus, a talented young designer with a brilliant hand
in watercolor rendering, who had received his master's
in architecture from Penn in 1978. The two men labored
for weeks on a set of spectacular drawings of their design,
inspired by the hall at Kedleston Hall (1759–65), an English
Palladian house in Derbyshire designed by Robert Adam.
With these magnificent drawings, and a superb design, they
won the competition.

John Blatteau made the simplest possible case for reviving
classical idioms in contemporary design: *beauty*. Though
even the word acquired negative associations after the
advent of modernist art in the 1920s, philosophers such as
Roger Scruton hastened to remind us that when cultivating
taste for anything worthwhile, beauty is the ultimate crite-
rion for quality. It can be understood by anyone, not just
connoisseurs of art and antiques. As Blatteau emphasized
in an interview, classical architecture represented "dignity,
security, stability, and permanence."[26]

The rouge scagliola columns, gilt cornices, and cove ceiling
with the Great Seal of the United States that Blatteau
designed for the Franklin State Dining Room are indeed

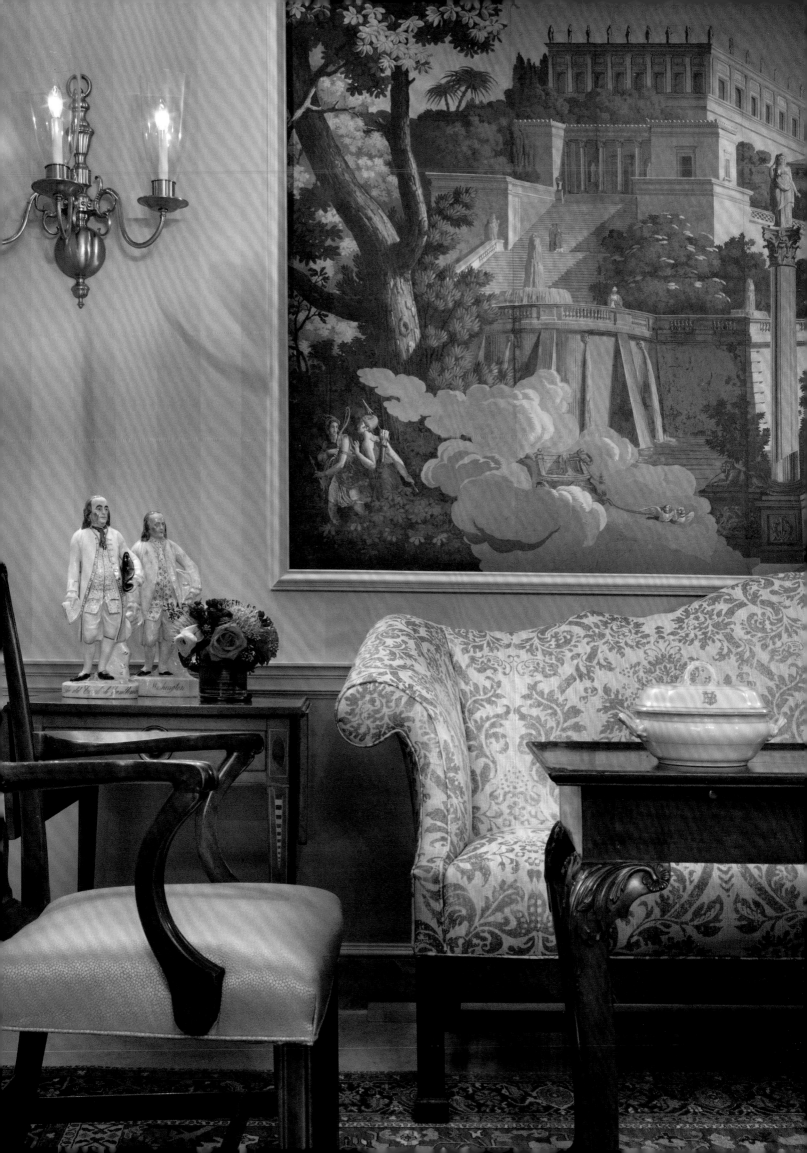

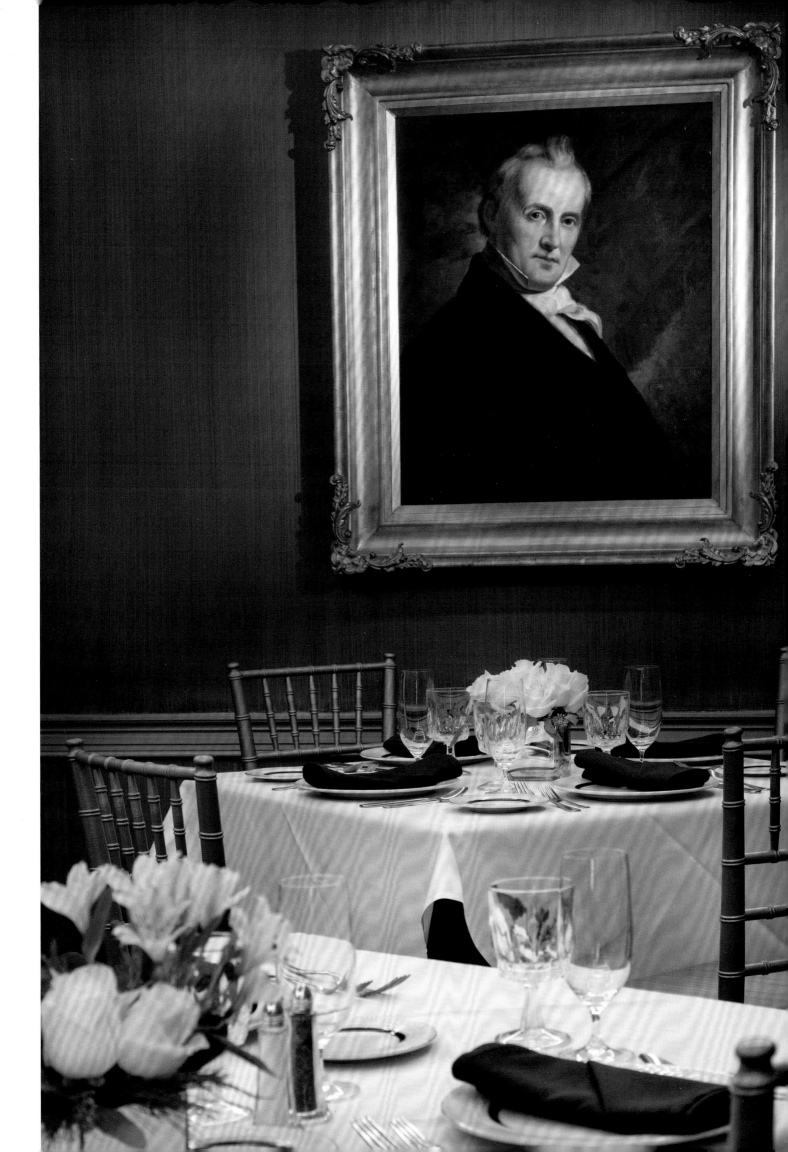

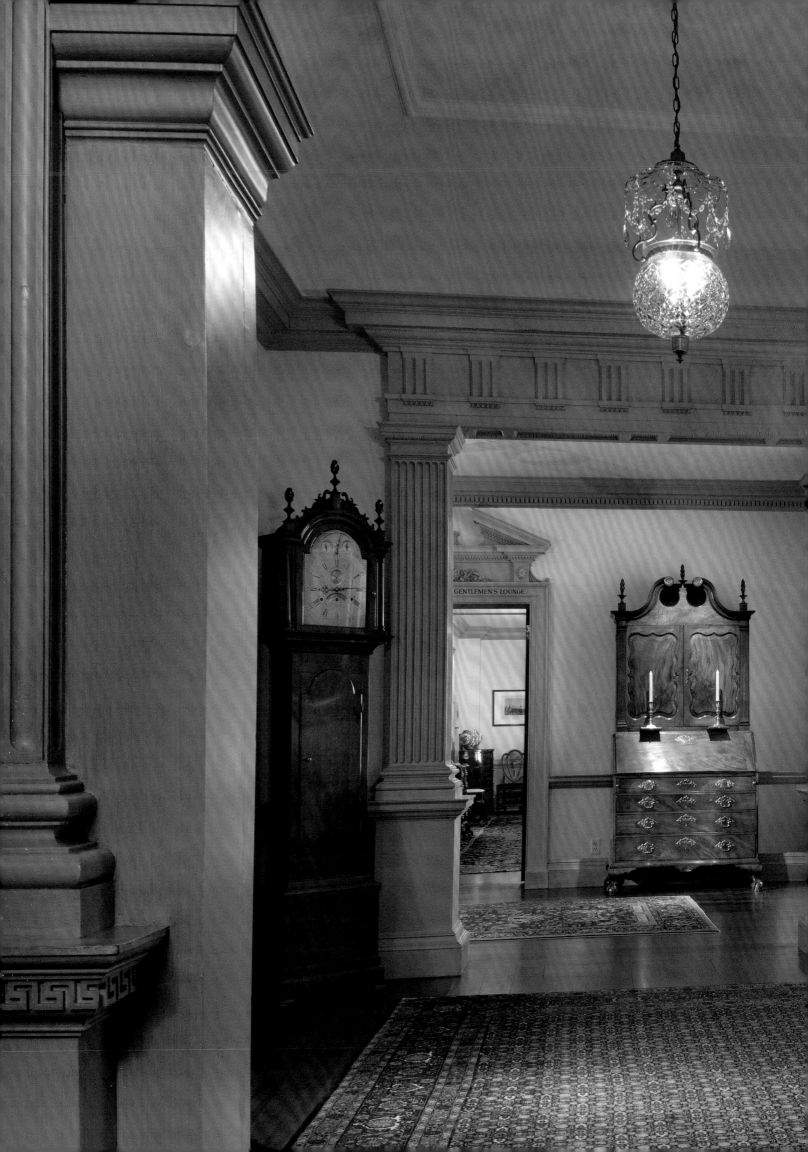

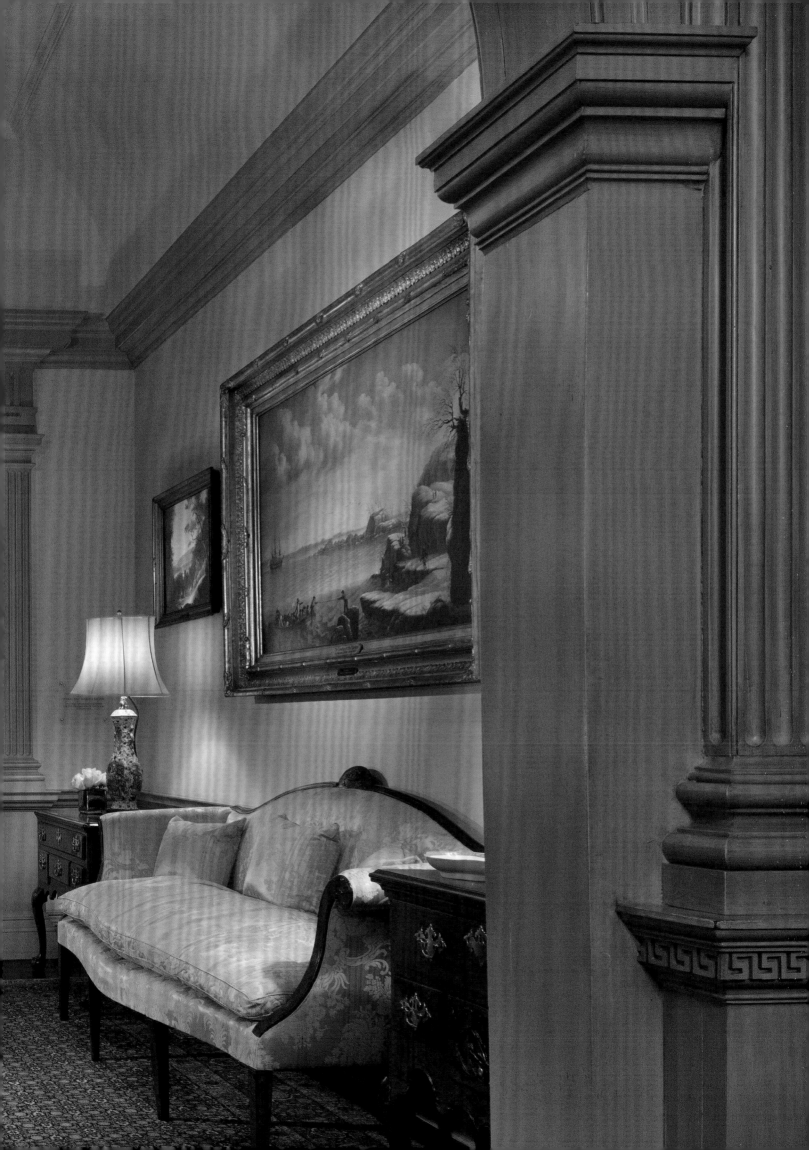

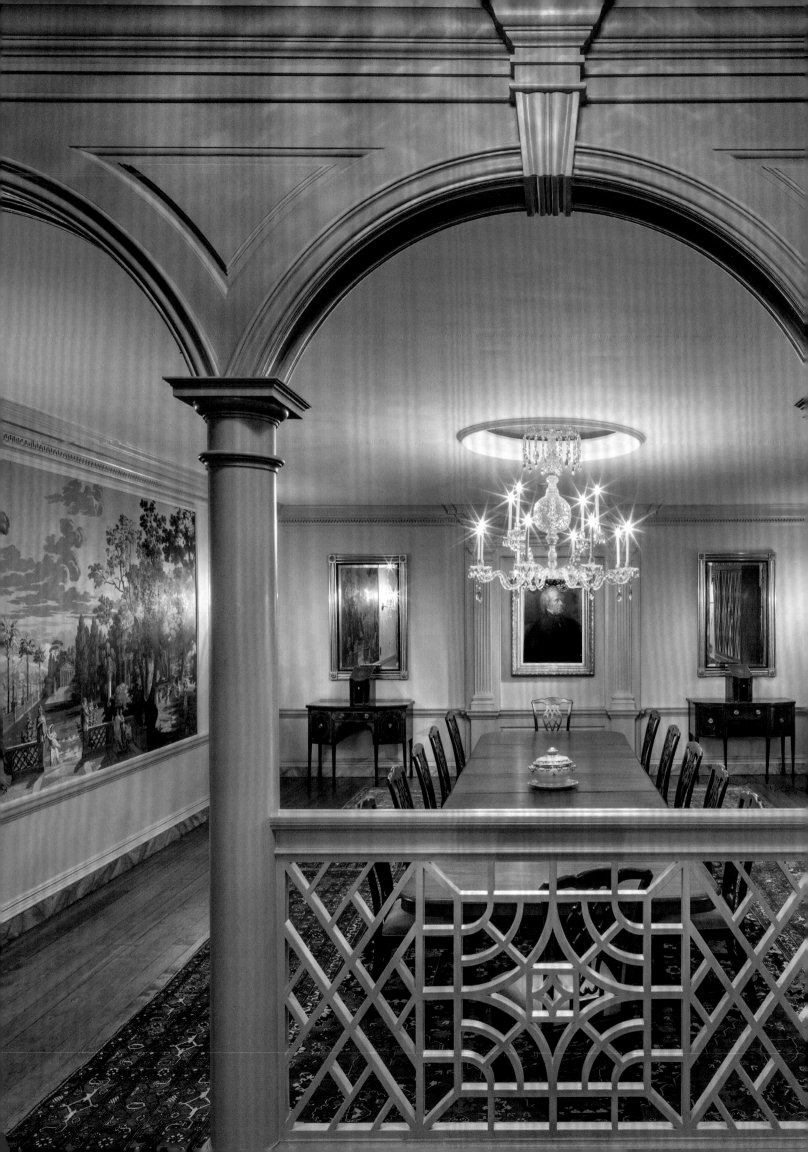

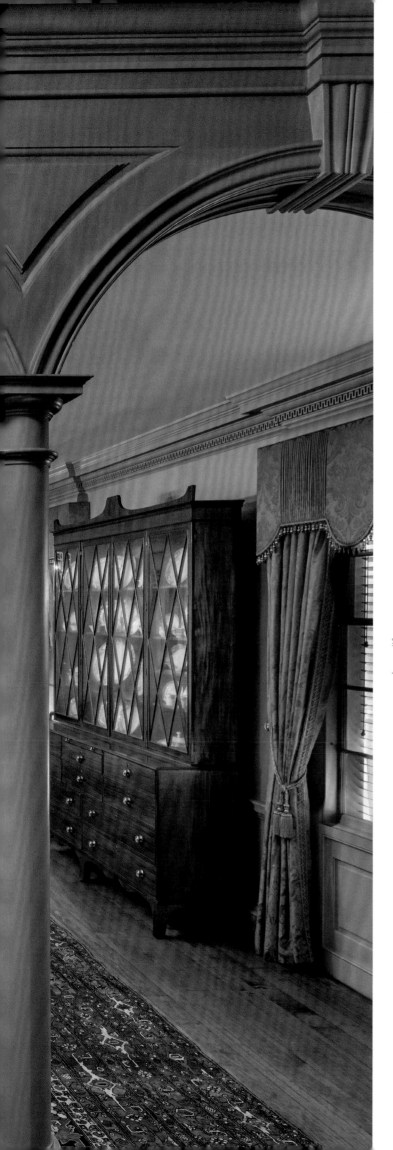

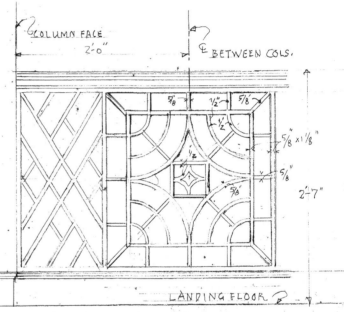

PREVIOUS
The Passageway

LEFT & FOLLOWING
Henry Clay State Dining Room

ABOVE TOP
Details for Henry Clay State
Dining Room. Walter M. Macomber
(Architect), May 28, 1982

ABOVE BOTTOM
Elevation of landing rail, Henry
Clay State Dining Room.
Walter M. Macomber (Architect),
December 4, 1981

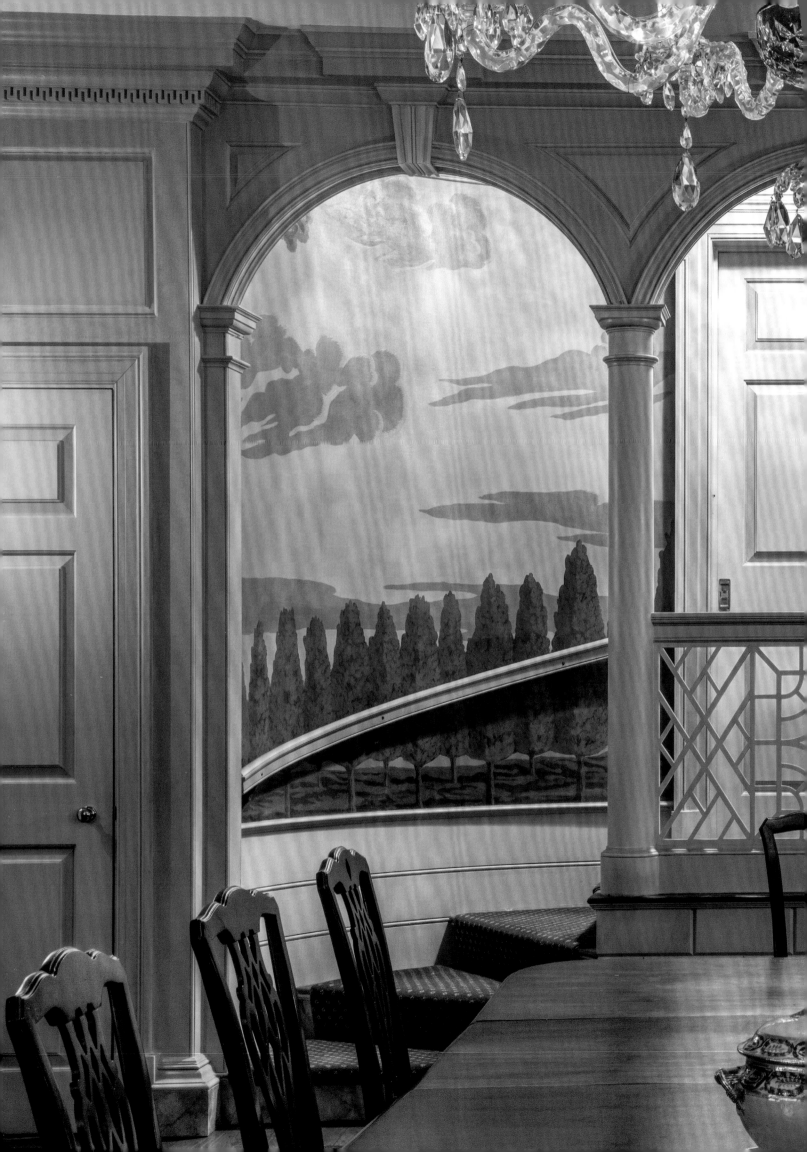

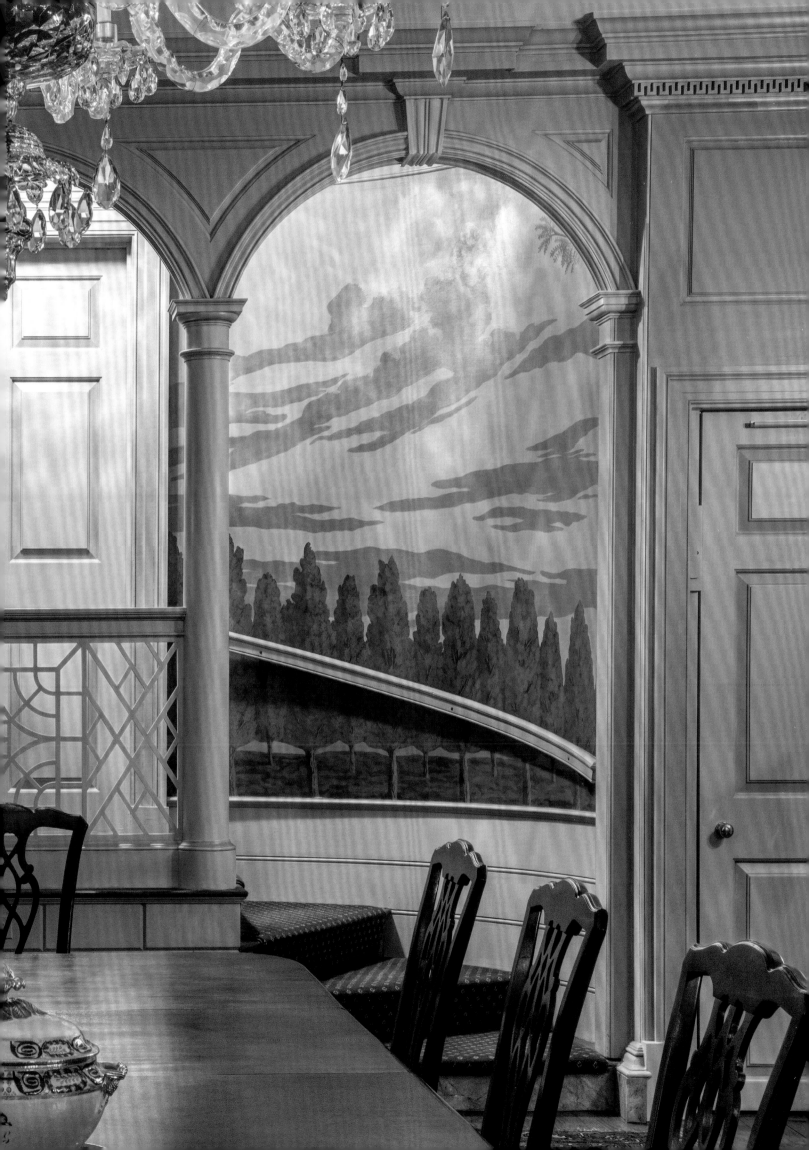

as beautiful as anything in Washington. His knowledge of English, French, and Italian precedents provided the basis for an original design that maintained the monumental scale of the room while also dividing the column bays to reduce the "flat" proportions of the overall space, something that visitors hated about the original room interiors. Using paired columns in alternating rhythms also provided variety to the design. In order to turn the corner, he let the double columns terminate on the long side of the room without adding a third column to the short side—a solution that emphasized the length of the space, which needed to seat 375 comfortably for formal dinners.

Another innovation in the room was the design of the huge carpet, which contains symbols of each of the fifty states as well as a large medallion at the center to reflect the ceiling above. Learning from Robert Adam and his brother James (1730–1794), the architects integrated each large element in the room with others to form a unified composition—the small paired Doric columns in the fireplace mantel are similar to the largest ones ringing the room, as well as the intermediate-sized

pairs flanking each doorway in a serliana motif. They reinforce the red-and-gold key of the color scheme as well.

The most striking aspect of the room is the massive cove cornice, which integrates the upper and lower zones brilliantly. The gilded octagonal coffers in the curving upper zone create an elegant transition to the Corinthian order cornice below, itself beautifully articulated in buff enamel and 23-karat gold leaf. The cost and effort required to gild the entire room were extraordinary, as related by William Adair, the master artisan in charge of the project:

> The ceiling required over 90,000 hand-beaten leaves of gold—roughly 45 ounces of the material, with each leaf 3¼ inches square—and the hands of 30 skilled artisans to apply it. About $20,000 gold bullion was donated by Mr. Samuel Etris on behalf of the Gold and Silver Institute. Sam told us it was obtained from the Engelhard mines in the Black Hills of South Dakota, and he was happy to contribute to such a worthwhile endeavor as American diplomacy.[27]

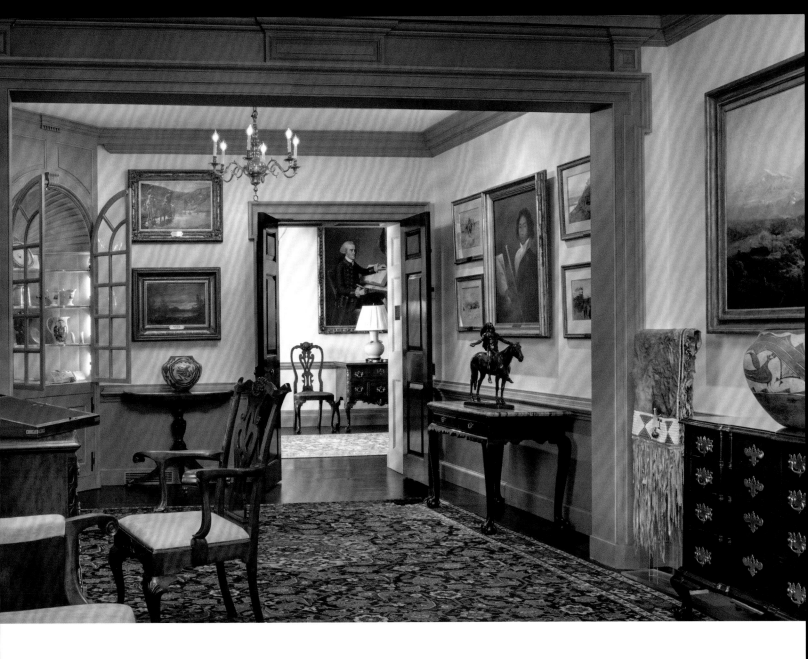

Three teams of ten artisans worked for three months to complete the project. Like Michelangelo on his scaffolding, the men experienced not only fatigue but numbness in their hands after holding them above their heads for even fifteen minutes. Special brushes were required to minimize the time between grabbing each gold sheet and attaching it to the surfaces. The gilders worked directly with sculptors casting the column capitals and medallions, allowing them to meet the compressed schedule.

Clem Conger and his team of antiquarians and administrative staff were key to all the efforts, not only in the Franklin State Dining Room but in every project. The final set of rooms they would redesign were those of the secretary of state on the seventh floor of the building at Foggy Bottom. For these, they turned to Allan Greenberg, a South African–born architect who became a passionate American patriot. —MAH

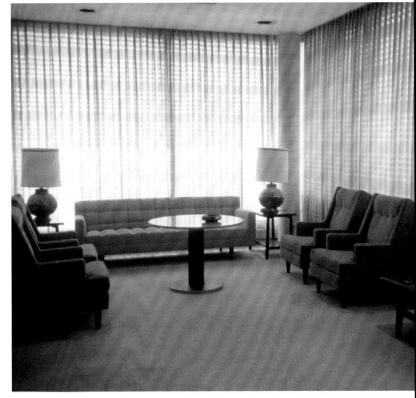

OPPOSITE & ABOVE Walter Thurston Gentlemen's Lounge
RIGHT Walter Thurston Gentlemen's Lounge before renovation

ABOVE TOP & BOTTOM Benjamin Franklin State Dining Room before renovation, 1961, and during renovation in the early 1980s

OPPOSITE Benjamin Franklin State Dining Room

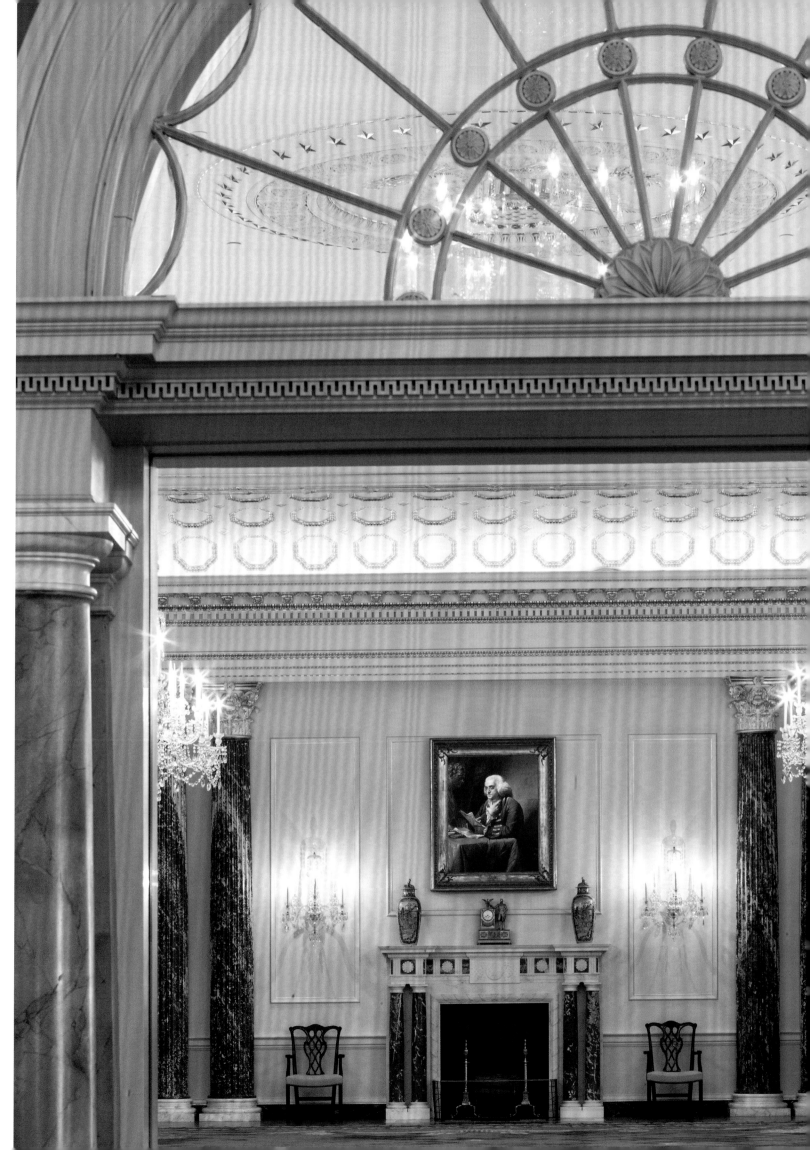

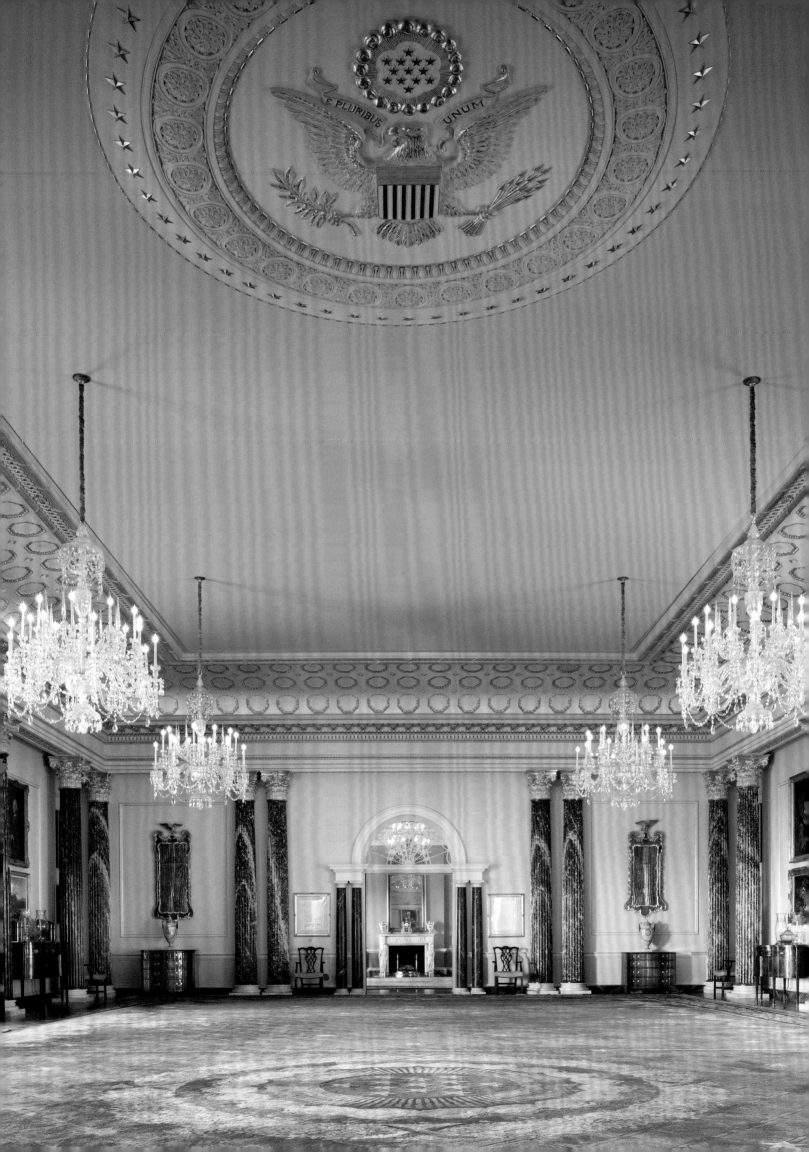

THE
GREAT SEAL
OF THE
UNITED STATES

THE FINAL DESIGN FOR the Great Seal of the United States was made by Charles Thomson, secretary of the Confederation Congress, and presented to Congress on June 20, 1782, with the first seal and die cut later that year. The wartime Continental Congress originally requested its creation by a committee consisting of Benjamin Franklin, John Adams, and Thomas Jefferson as an extension of their task of drafting America's first foreign policy document, the Declaration of Independence.

The seal's design was a six-year process under the direction of three committees. Congress ultimately handed the committees' various designs to Thomson, who took elements from each, with some revisions by the heraldist William Barton. The resulting image is a symbolic celebration of the new nation. Central to it is the image of a bald eagle, whose talons hold arrows, symbolizing war, and an olive branch, symbolizing peace. In its beak is a banner with the motto *E pluribus unum*, meaning "Out of many, one."

Official custody of the Great Seal was assigned to the secretary of state in 1789, a tradition upheld by each secretary since Thomas Jefferson. It is used today to seal documents signed by the president and secretary of state, and it can be affixed only by an officer of the U.S. Department of State. The physical seal includes the die and counter die, press, and mahogany cabinet—all locked within a glass enclosure at the State Department. Its imagery, however, is widespread and familiar. A monumental gilt plaster rendition of the Great Seal on the ceiling presides over the Benjamin Franklin State Dining Room, imbuing the work that happens in the Diplomatic Reception Rooms with the authority and ceremony of our nation's highest symbol. —BB

OPPOSITE Benjamin Franklin State Dining Room
ABOVE The Great Seal (detail)

Great Seal Capital

Inspired by the beautiful corinthian order of the Pantheon in Rome, so admired by Jefferson, the capital for the Franklin State Dining Room has been designed to incorporate the Great Seal of the United States as its centerpiece. It follows precedent, both ancient and modern, in using symbols to enhance architectural order. The Horns (zodiac) of the Temple of Mars, Rome, eagle in the order at the Portico of Octavian, and, nearer home, Benjamin Latrobe's beautiful American Corn and Tobacco Leaf capitals at the Capitol are all examples of this approach.

Benjamin Franklin State Dining Room.

① *Allan Greenberg, Architect.*
New Haven, Connecticut.
September 23, 1983.

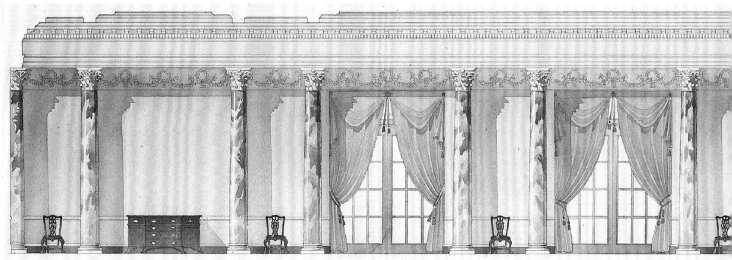

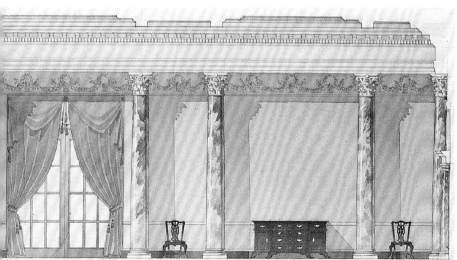

OPPOSITE ABOVE

Proposed design for a Great Seal capitol
for the Benjamin Franklin State Dining Room.
Allan Greenberg (Architect), New Haven,
Connecticut, September 13, 1983

ABOVE RIGHT

Entablature study for the Benjamin
Franklin State Dining Room. John Blatteau
Associates, Philadelphia, Pennsylvania

LEFT

Terrace elevation for the Benjamin
Franklin State Dining Room. John Blatteau
Associates, Philadelphia, Pennsylvania

FOLLOWING

Benjamin Franklin State Dining Room

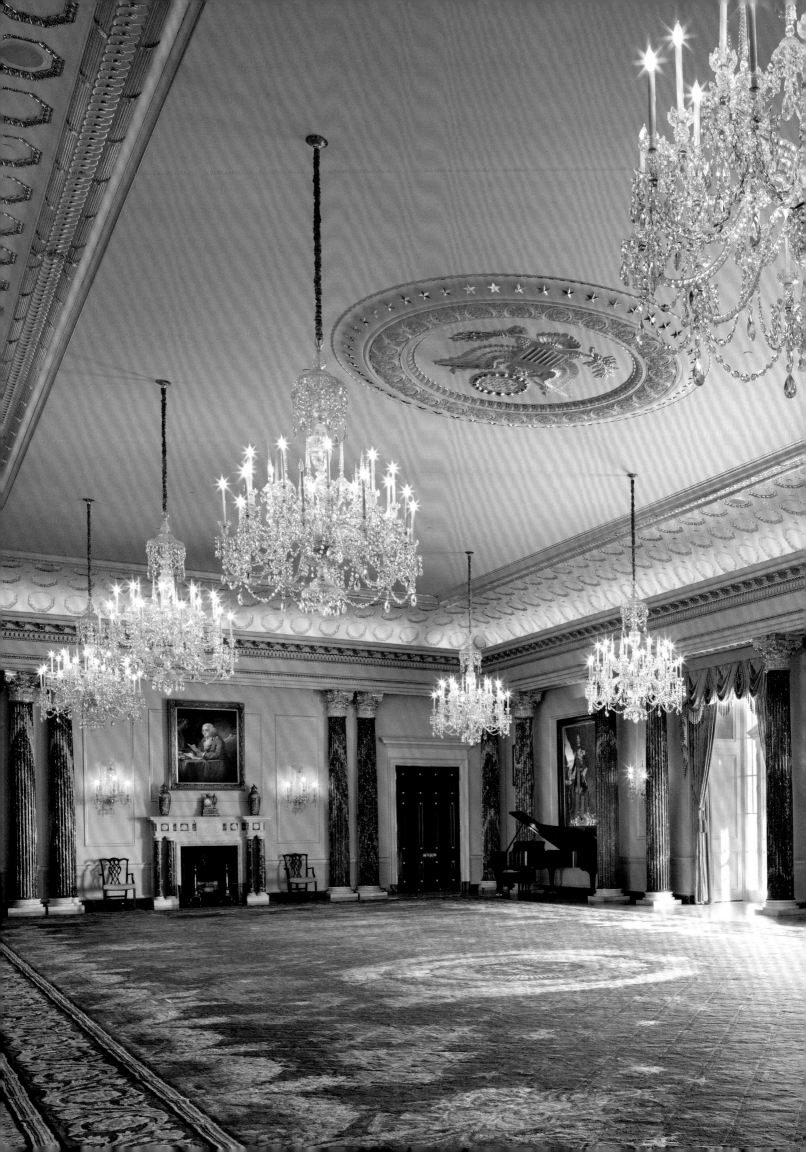

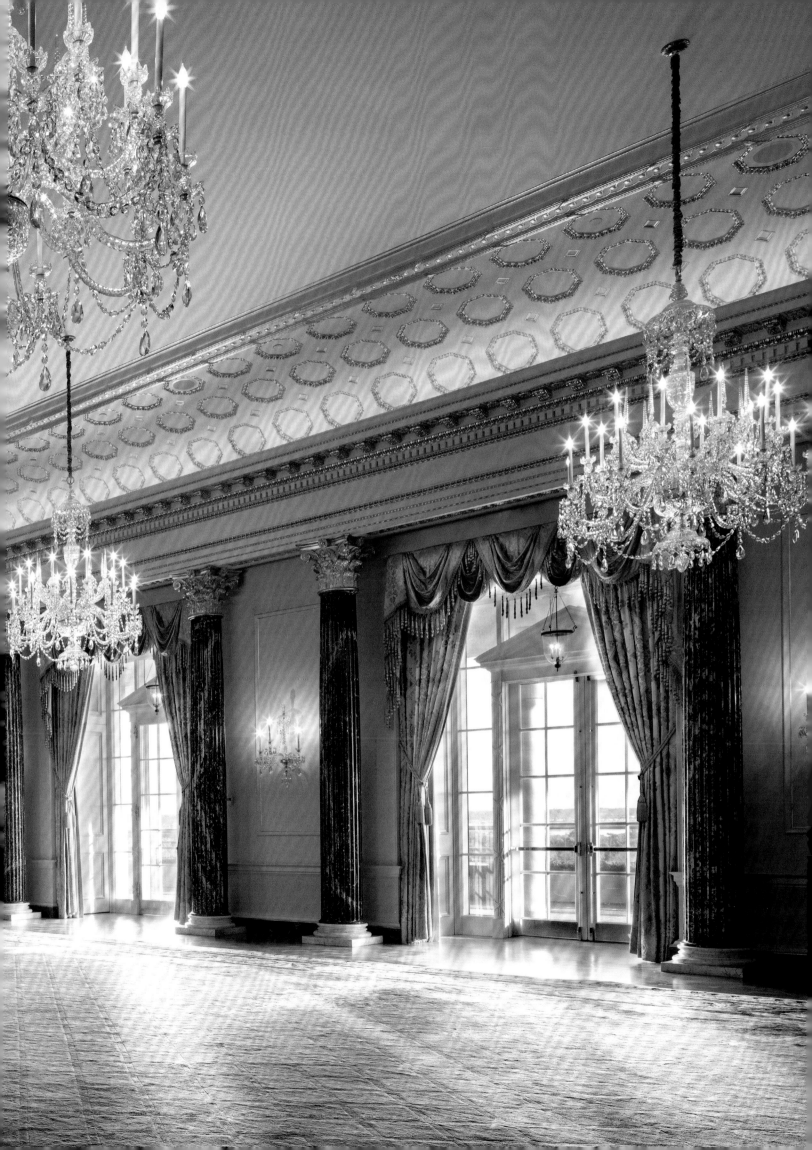

ALLAN
GREENBERG

ALLAN GREENBERG'S SUITE of rooms on the seventh floor are masterpieces of interior architecture, some of the finest ever built in America. But Greenberg (b. 1938) was not the renowned architect in the early 1980s that he is today. He had taught at several universities, including Yale and the University of Pennsylvania, but his New Haven practice was running low on work when he received a call from Conger to come to Washington, where he would meet directly with Secretary of State George Shultz. The two men immediately struck up a friendship and worked closely together on the design of the secretary's office and other important rooms in the new suite.

Greenberg's journey from his boyhood home in South Africa to the highest levels of American civic architecture in Washington was a circuitous one. After completing his architecture training at the University of Witwatersrand in Johannesburg in 1958, he worked briefly for an architect. His eventual goal was to get a job with Le Corbusier in Paris, but when he visited the famous architect in May 1958, he was told he wouldn't be paid; he promptly left for London, where he shared an apartment with the Australian guitarist John Williams, then a student at the Royal College of Music. In June 1961, Greenberg was in Denmark, where he secured a position with Jørn Utzon, the winner of the Sydney Opera House Competition. During his year there, he met his future wife, Elizabeth. They had a daughter and decided to go to Helsinki, where he hoped to win a job with Alvar Aalto. Rejected there, he went to work for Viljo Revell instead, from January 1962 to January 1963. He was to spend several years in Scandinavia, finishing his tour in Sweden with Erik and Tore Ahlsén in July 1964.[28]

After curing his wanderlust, Greenberg, now the father of a girl and a boy, applied to the master of architecture program at Yale under the renowned Paul Rudolph. Arriving in 1964 with other foreign students, including Norman Foster and Richard Rogers, he prospered at Yale and received an offer to teach at the school upon graduation. His superb knowledge of architectural history, achieved while studying at Witwatersrand, made him an ideal choice as a lecturer in 1968. He had meanwhile befriended another South African

LEFT West Elevator Hall of the Treaty Room Suite

architect, Denise Scott Brown, and her husband, Robert Venturi. Greenberg, like the two young professors, had begun to question the hegemony of orthodox modern architecture, and they looked to historical, and classical, sources for inspiration. He was moved, as he watched them teach their pioneering studio classes on Las Vegas and Levittown, to find historical sources as inspiration for his own work. Greenberg left Yale in 1973 and spent three years teaching at the University of Pennsylvania.

While at Penn, Greenberg met John Blatteau, who was beginning his own practice in classical architecture, and the two advised students who wished to work in traditional idioms. They also corresponded with Pierce Rice and John Barrington Bayley, older classicists who could teach the two younger men from their own experiences. Greenberg and Blatteau were quick studies and hired their most talented students just as commissions were coming their way. Greenberg was fortunate to have the Brandt family as a client for a large Mount Vernon–style house in Greenwich, Connecticut.

Thus, when he began to work with Clem Conger on the rooms for the secretary of state, Allan Greenberg was fully in touch with artisans and restoration specialists who could help him realize his vision. For the elaborate millwork, he chose Don Lockard of Eisenhardt Mills in Easton, Pennsylvania, a company with Amish staff members. With few windows, he did not need the decorating services used by Jones and Macomber, but he called on special carvers to execute delicate elements in the millwork. He recalled his first meetings with the secretary of state, who had been an executive at a major construction company, before beginning his designs:

> George Shultz has a very strong presence. You feel it even before he enters the room. After the introductions by Clem Conger, his first words to me were: "Allan, we are both builders. We know the importance of schedules, budgets, and management of construction projects. My plan is to hand the rooms over to the contractor at the end of the first week of December, to allow Mr. Conger time to move the furniture and art." I replied: "Mr. Secretary, I have already discussed this project with our contractor, subcontractors, and artisans like

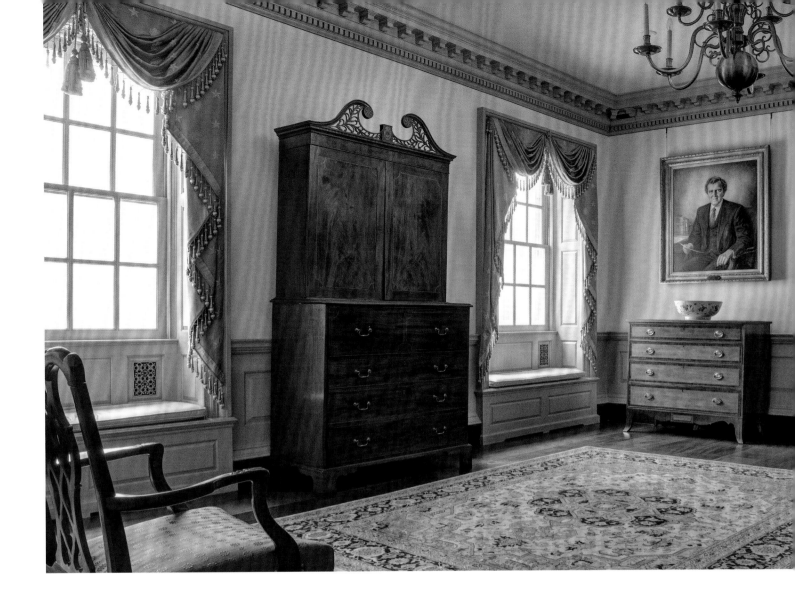

carvers, plasterers, etc. Your timetable is acceptable to us." George then said, "I want the rooms to be a place Thomas Jefferson could walk into and feel at home, while also noticing the architecture had developed in ways he may not have anticipated: the use of machines and computers, and the absence of the slight but beautiful irregularities which result from hand production."[29]

Instead of referring to direct sources among Georgian and federal houses in the colonies, Greenberg turned to Edward Vason Jones, Edwin Lutyens, and Andrea Palladio for inspiration—an eclectic group, to be sure. But he was also ready to express the rich fecundity of decorative details in working with carved motifs and moldings. His Doric, Ionic, and Corinthian order ensembles would be typically robust, bold, and truly original, traits that had already distinguished the work in Connecticut. Greenberg's work is more like that of Michelangelo and Lutyens than that of Jefferson, Latrobe, or Bulfinch in America.

He began as Jones did with the elevator halls, in this case flanking the Treaty Room suite, which would be the preludes to other spaces on the seventh floor. Always sensitive to establishing a color palette at the beginning of a project, he elected to use a dark red for the walls, accented by brass in the elevator doors. He used a shallow vault with deep coffers to emphasize the directionality of the rooms, leading the eye laterally once one got off the elevators.

These rooms would also contrast markedly with those of the secretary of state but would introduce a theme that would be closely followed in the large Treaty Room suite: white columns and pilasters set against colorful walls and floors. The black marble floor is accented with white marble squares. Prominent fluted Doric columns hold up a shallow entablature supporting the vault, which gets light from several sources including glass pendants. One has clearly entered a space unlike the delicate colonial and federal ones above.

Greenberg's homage to Edward Vason Jones is also clear as one walks into the anterooms and other spaces associated

OPPOSITE East Foyer of the Treaty Room Suite
ABOVE West Foyer of the Treaty Room Suite

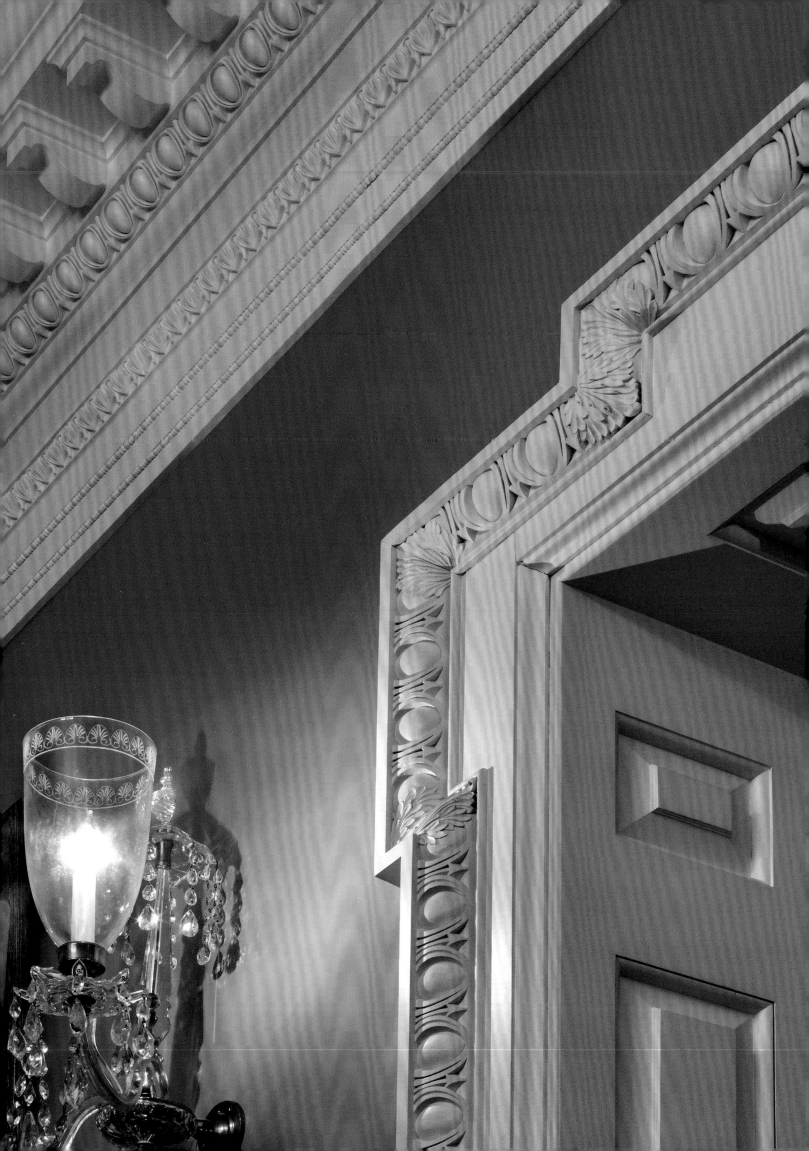

with the secretary of state. The overall key uses stone colors as Jones did, and many of the cornices contain subtle references to rooms on the floor above. The George C. Marshall Reception Room uses slender fluted pilasters and a heavy denticulated frieze and cornice, an echo of Jones's in the John Quincy Adams State Drawing Room. Like his mentor, Greenberg was not afraid to extend the depth of a frieze or add complex undercut moldings for dramatic effect. Though the Marshall Room is not as large as the Adams, Greenberg retained the intense, deeply carved panels and accent moldings, reminding visitors of the eighth-floor spaces. This subtle suggestion of a past memory, even a direct quotation, is a hallmark of Greenberg's work—always steeped in history. The John Jay Reception Room, with its portrait of the former jurist, is an identical bookend to the Marshall Room, but with red upholstery instead of blue. Another room with a Jones connection is the long, top-lit Deputy Secretary of State's Conference Room. It uses faux marble pilasters, flat cornices, and high relief paneling in an echo of the colors of the Edward Vason Jones Memorial Hall on the floor above.

The secretary of state's conference and office suite is the centerpiece of the seventh floor and the glorious culmination of Clem Conger's decades-long effort to bring American antiques and decorative arts together at the State Department. In a series of relatively small rooms, Greenberg achieved elegance and strength that come only with absolute mastery of the classical language of architecture. He met his charge from Secretary Shultz to create rooms that Jefferson would admire, while also pushing forward with a modern interpretation of eighteenth-century themes. The architect also framed furniture, lighting, paintings, and even computer monitors in a coherent, logical scheme. Nothing is out of place.

The rooms are in enfilade, or alignment, each door framed by the next, in the French manner. Thus, the doorways become the critical element in the suite as a whole. Greenberg's designs for each maintain a theme, as each frame is surrounded by a rope molding or spiral that finishes in a swirl around a particular Washington-area flower. Some are grand and have an upper pediment, while others are flat and topped by two "ears" at the corners. Greenberg's historical acumen gave him the ability to work with both architectural and furniture embellishments taken from English and French precedents. The carving is worthy of Thomas Chippendale.

OPPOSITE East Foyer of the Treaty Room Suite, detail of egg-and-dart and acanthus-leaf moldings
RIGHT Treaty Room Suite before renovation, 1961

THE
DIPLOMATIC
RECEPTION ROOMS
LOGO

THE ELLIPTICALLY SHAPED Treaty Room is the physical center of the Diplomatic Reception Rooms and the formal entrance to the principal offices of the seventh floor. The elaborate pattern of the floor—inlaid in stained maple, ebony, and mahogany—is a striking statement by the room's architect, Allan Greenberg, that was inspired by the artist and architect Michelangelo Buonarroti's designs for the Piazza del Campidoglio, the civic plaza on top of the Capitoline Hill in Rome.

In 1536, Pope Paul III commissioned Michelangelo to transform the dilapidated square into a monumental urban center that would reflect the glory of Rome. As part of his plan, Michelangelo devised a design for the pavement of the piazza that consisted of a colossal radiating and unifying axis. Set atop the high Capitoline Hill, exposed to the stars, and at the threshold of civic government, it would create the sense that one was standing at the top of the earth, hence the name of its central, twelve-pointed star: the Caput Mundi (Latin for "head of the world"). It is this pattern that Greenberg adapted for the floor of the Treaty Room, saying it symbolized the harmony of nations from the four corners of the earth.

That star is also the basis of the Diplomatic Reception Rooms logo. The precise mathematical beauty of this mark is associated with the Renaissance humanism that

contributed to the Enlightenment movement and the American Revolution. Mirroring the symbolic intent of Michelangelo's original design, the star's application in the Diplomatic Reception Rooms imbues the work that happens here with the classical ideals at the heart of the quest for American independence. —BB

CAPITOLII·SCIOGRAPHIA·EX·IPSO·EXEMPLARI·MICHAELIS·ANGELI·BONAROTI·A·STEPHANO·DVPERAC·PARISIENSI·ACCVRATE·DELINEATA
ET·IN·LVCEM·AEDITA·ROMAE·ANNO·SALVTIS·ꟾꟾꟾDLXIX

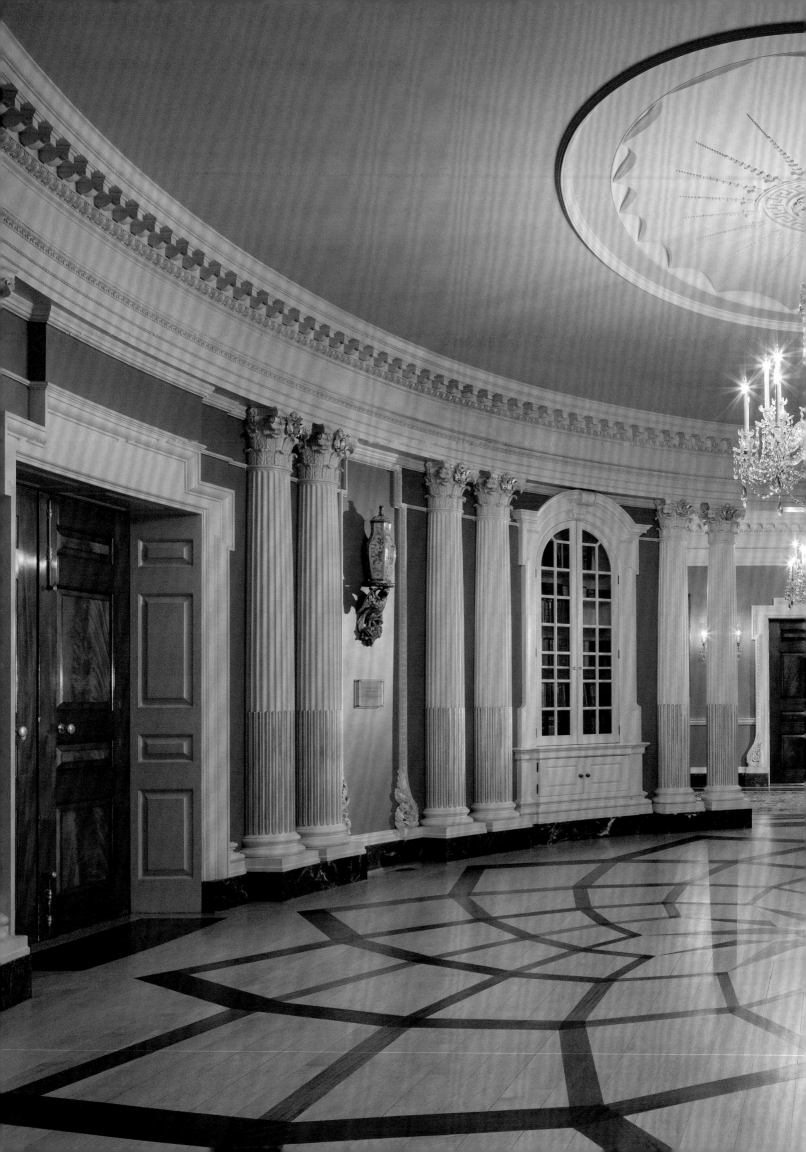

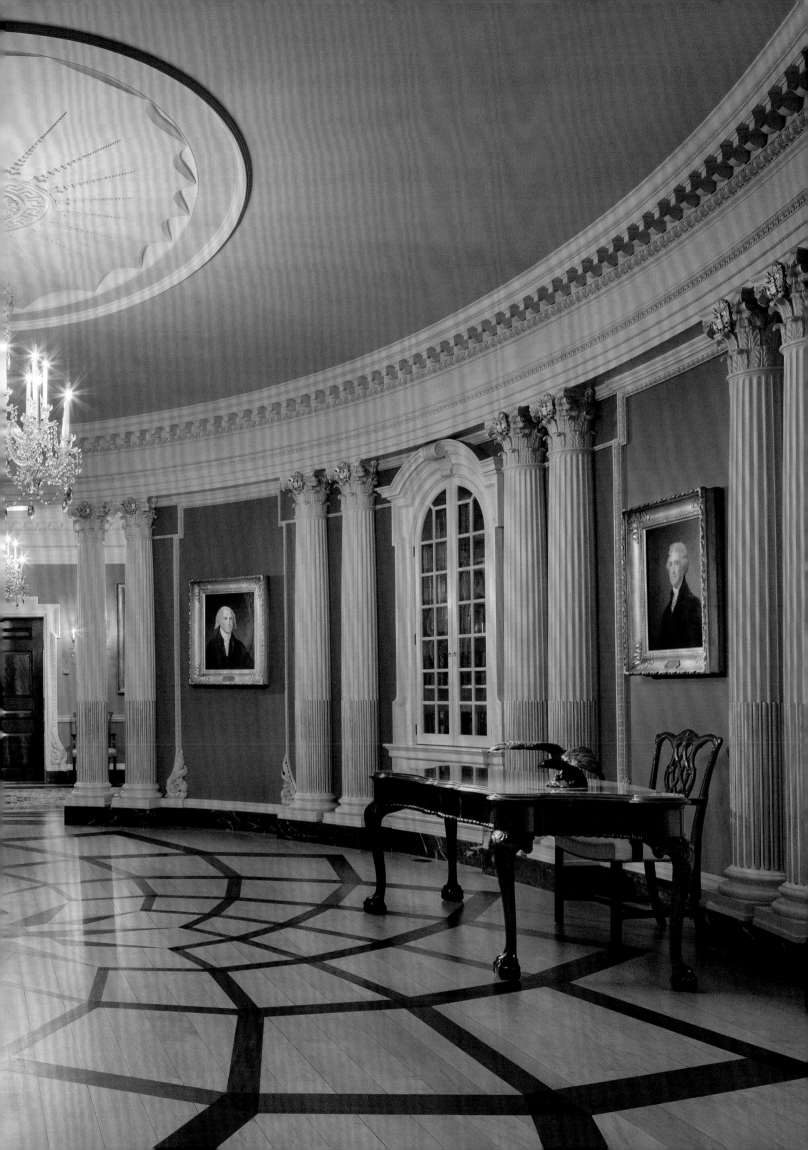

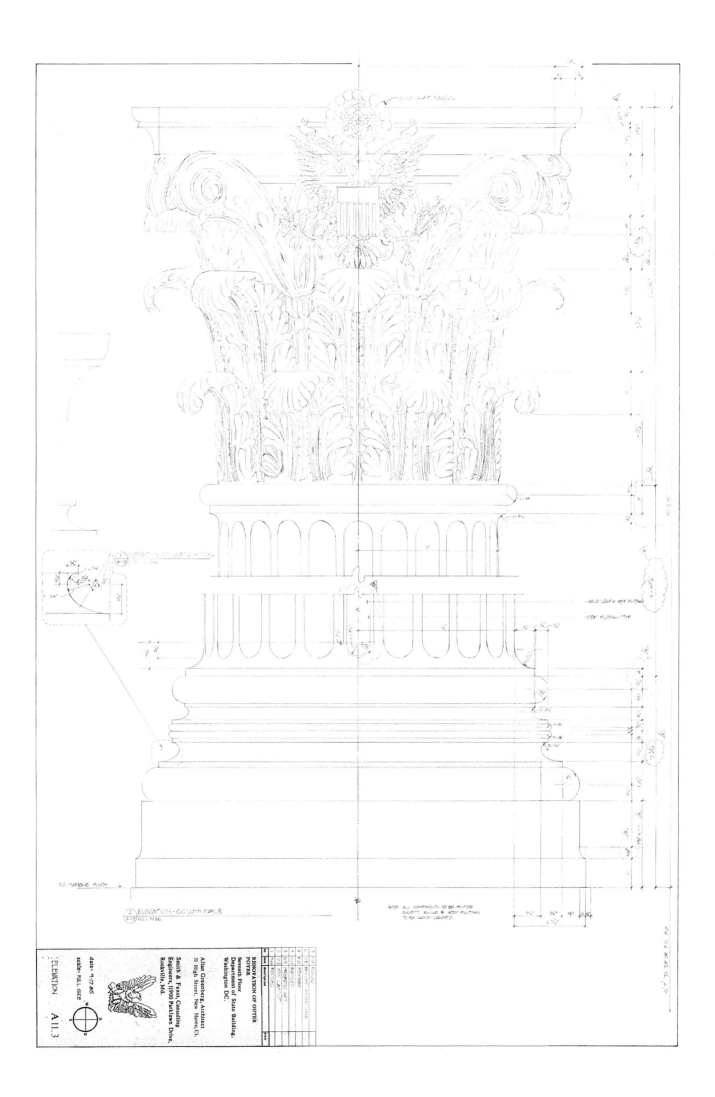

GOLD LEAF'D EAGLE

GOLD LEAF'D STOP FLUTING

STOP FLUTING - TYP

NOTE: ALL COMPONENTS TO BE PAINTED
EXCEPT EAGLE & STOP FLUTING
TO BE GOLD LEAFED.

TO. MARBLE PLINTH

ELEVATION · COLUMN BASE
FULL SIZE

RENOVATION OF OUTER
FOYER
Seventh Floor
Department of State Building,
Washington D.C.

Allan Greenberg, Architect
31 High Street, New Haven, Ct.

Smith & Faass, Consulting
Engineers, 11900 Parklawn Drive,
Rockville, Md.

date: 9/17/85
scale: FULL SIZE

ELEVATION

A11.3

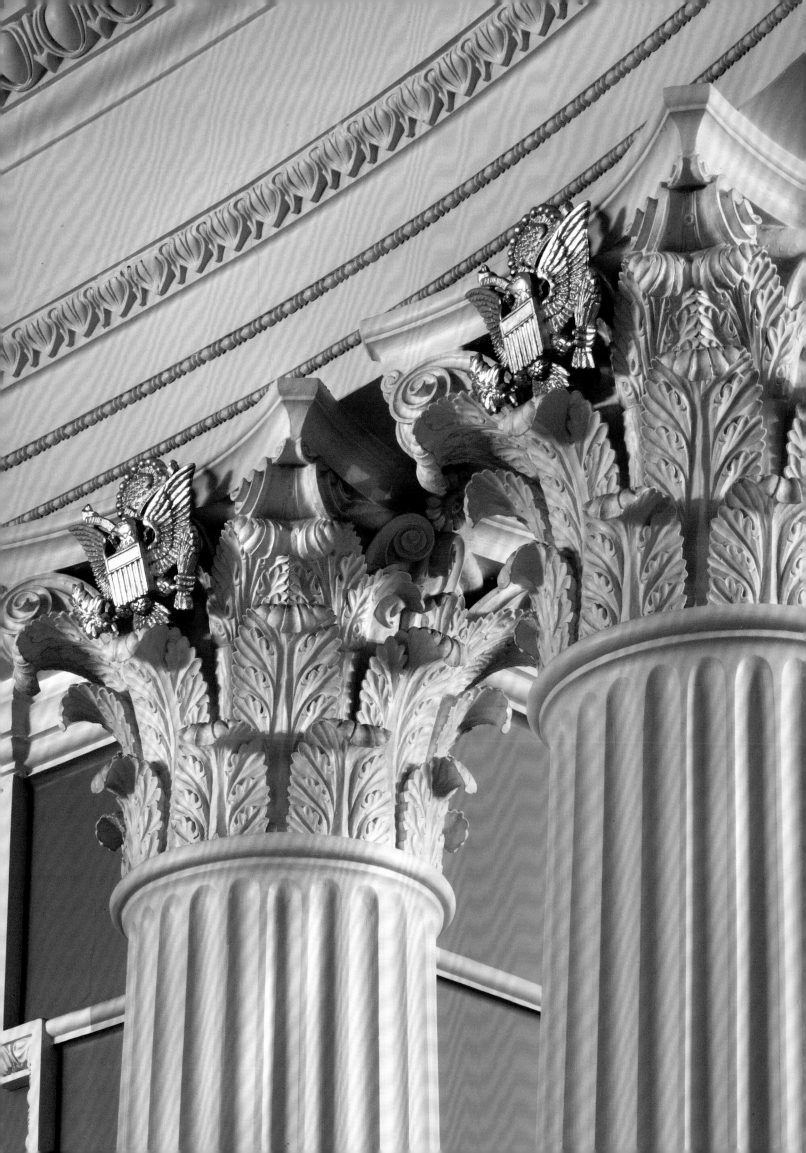

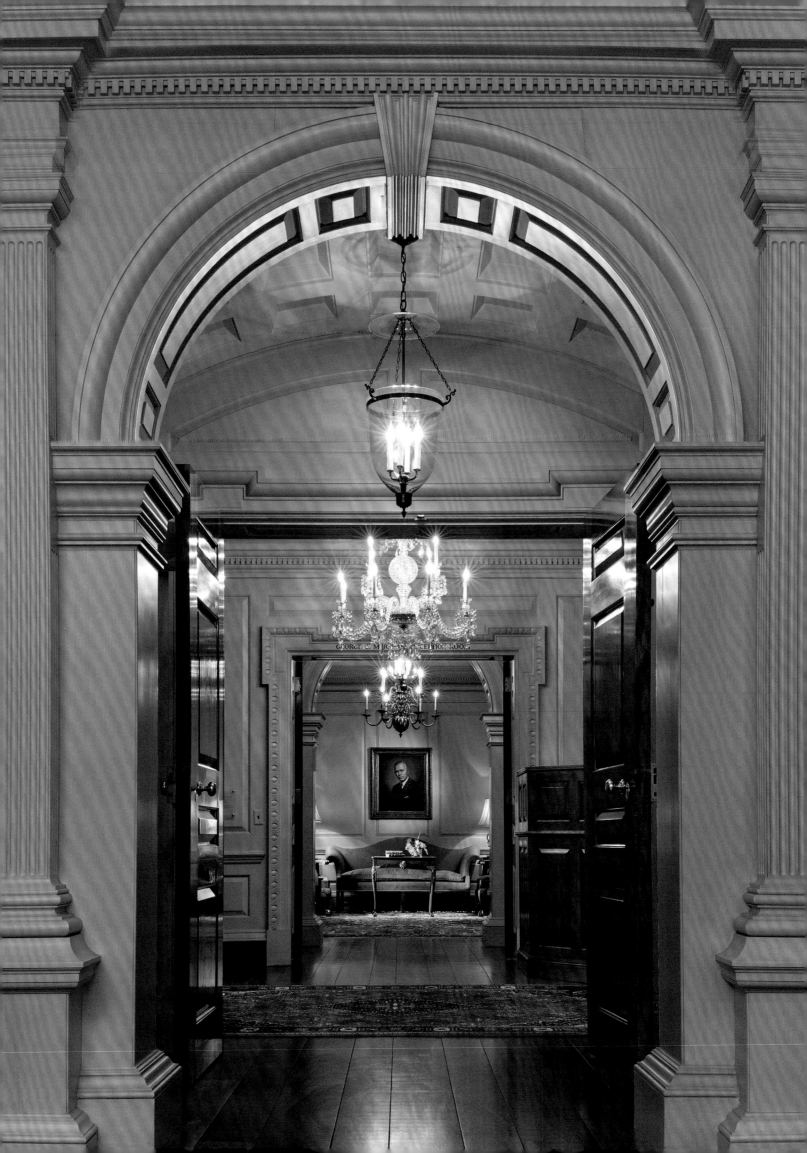

PREVIOUS LEFT
Elevation, column capitol, and
base for the Treaty Room.
Allan Greenberg (Architect),
New Haven, Connecticut,
September 17, 1985

PREVIOUS RIGHT
Corinthian capital in the
Treaty Room with Great Seal
of the United States

OPPOSITE & BOTTOM
George C. Marshall
Reception Room

TOP
George C. Marshall Reception
Room before renovation

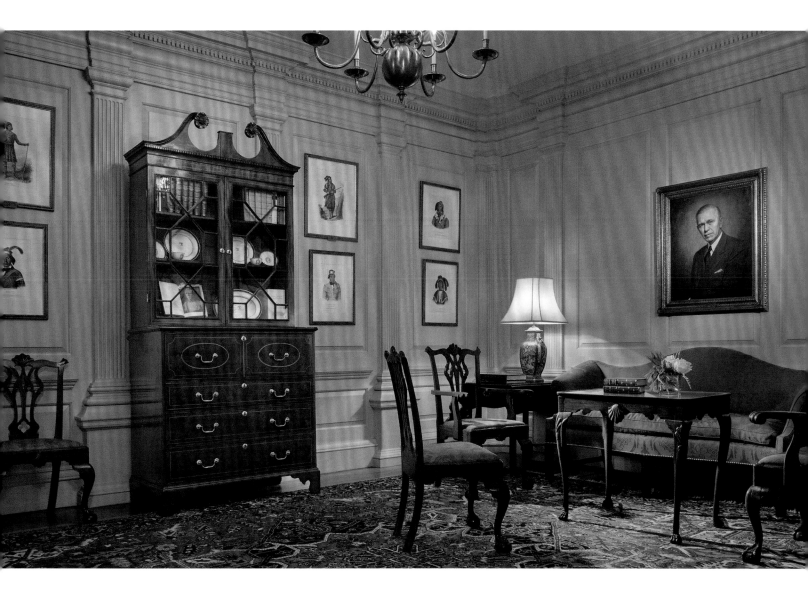

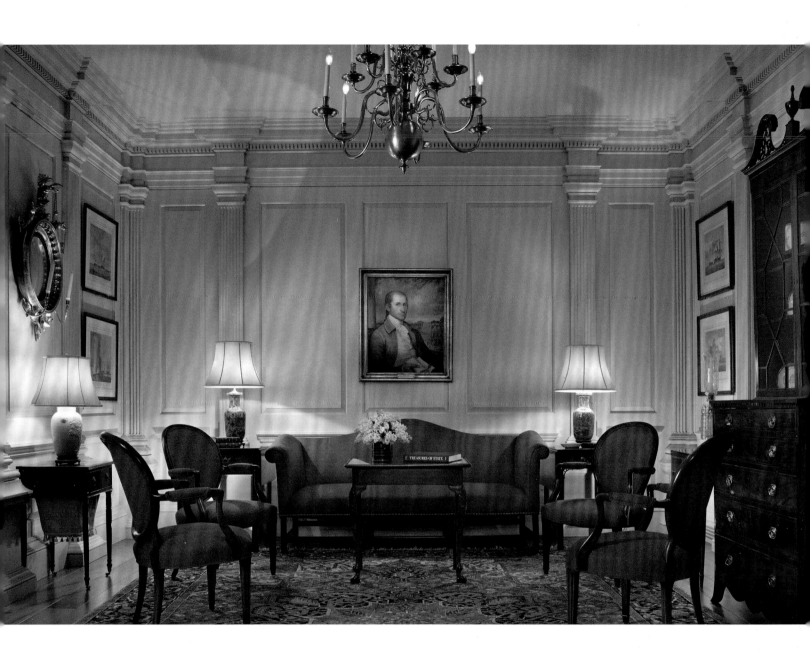

Passing through two small rooms and an arched hallway, one enters the Office of the Secretary of State, a virtually perfect evocation of an eighteenth-century drawing room or large parlor. The focus is immediately on the fireplace, framed by double Corinthian pilasters pushing forward into the room. The chimneypiece is a brilliant variation on one illustrated by James Gibbs in his *Rules for Drawing the Several Parts of Architecture*, which inspired many in the colonies.[30] A spectacularly veined inner surround of King of Prussia marble draws the eye toward the firebox and continues below in the base around the room.

ABOVE John Jay Reception Room
LEFT Office of the Secretary of State before renovation
OPPOSITE Corridor of the Secretaries
FOLLOWING Office of the Secretary of State

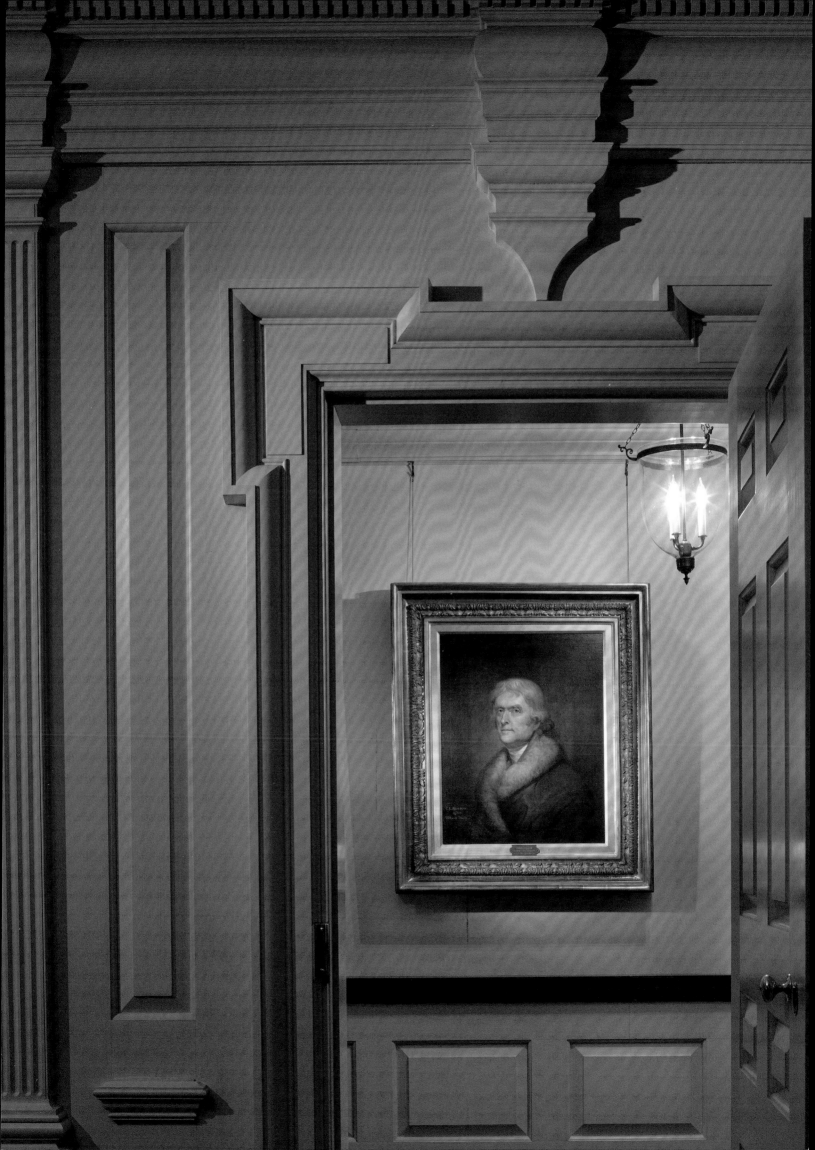

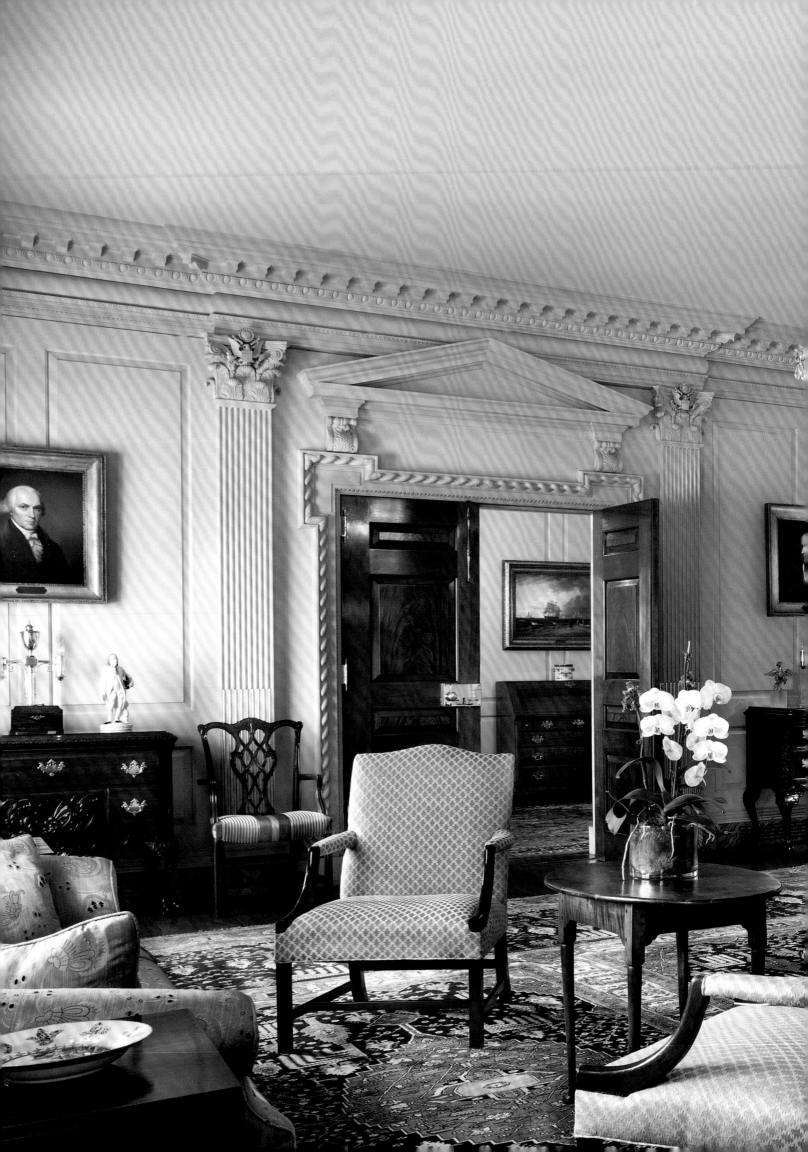

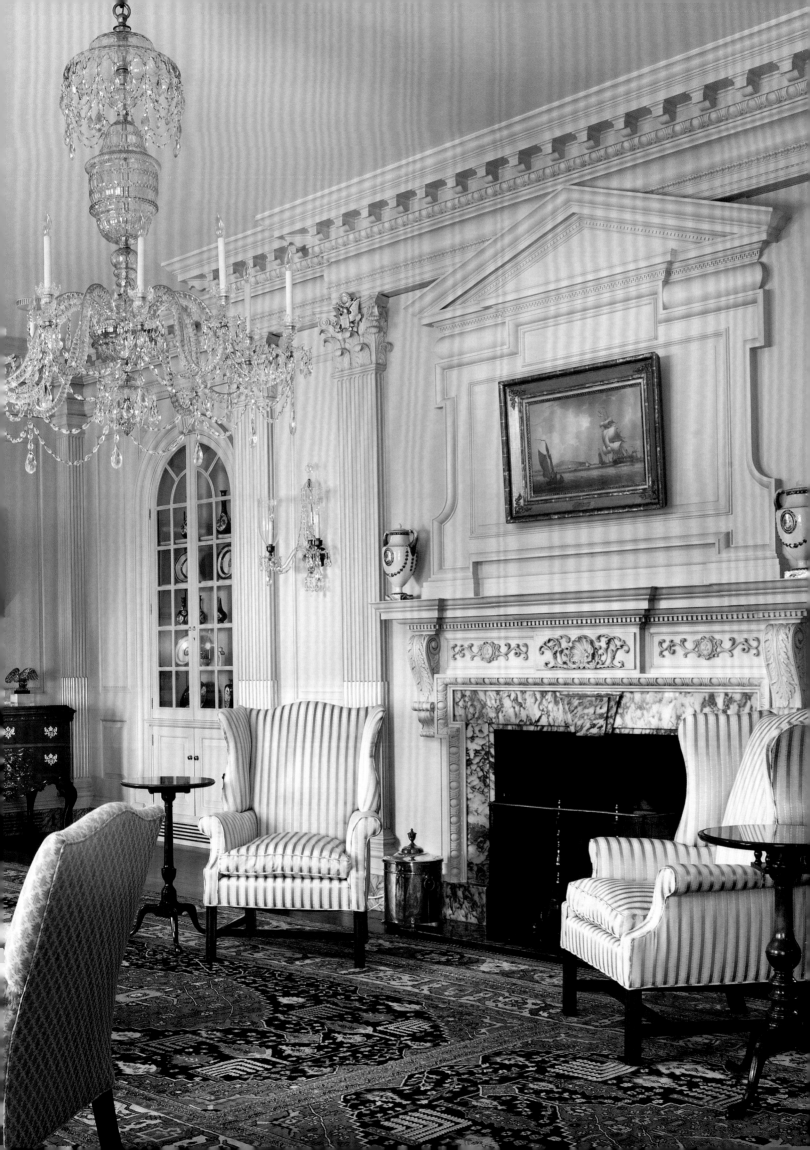

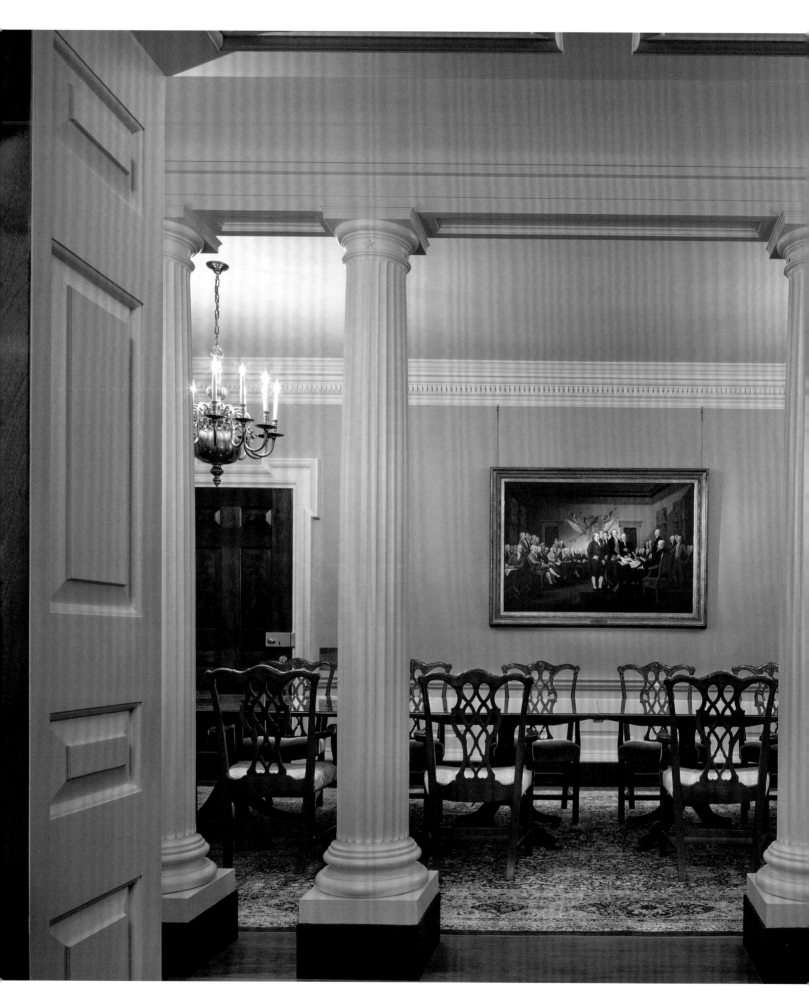

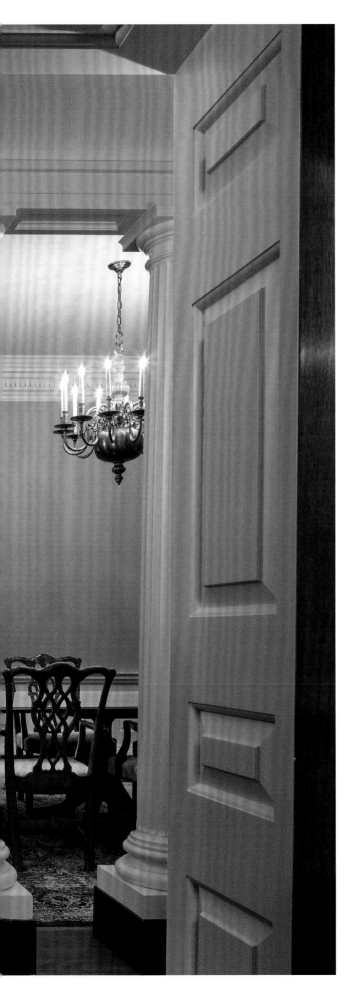

The architecture of the room has a deliberate Palladian flavor, owing mainly to the pulvinated frieze at the center of its constantly changing cornice—each bay either projects from or is recessed in a play of light and shadow. The fireplace pediment centers the composition, but it is merely one element in a chamber opera of brilliant set pieces. The main doorway features a pediment similar to that over the fireplace, supported by squeezed consoles in a kind of mannerist touch. Here Greenberg tipped his hat to his favorite English architect, Edwin Lutyens, who consistently pulled and distorted moldings to achieve anthropomorphic qualities. Greenberg, too, brought his compositions to life with his inventive, almost playful, variations on decorative themes.

The architect almost went too far in using full Corinthian pilasters around the room, each with its Great Seal gleaming and lower portions also gilded. Yet the constant movement of Palladian modillions establishes an upper datum, as Greenberg turned the corners with slight cornice projections—something unheard-of in Palladio's time, or Jefferson's. The subtle colors and astounding artisanship of everything from stonework to paint finishes are a testament to everyone involved in the project. As Greenberg was working with Shultz, he found a man with taste and learning equal to his own, and this room is a fitting testament to their friendship and mutual respect. The smaller inner office faced in cherry paneling has the same gravitas, but in a more intimate vein.

The architecture of the Office of the Deputy Secretary of State draws on elements of fine colonial and federal period homes in the thriving port cities of Annapolis and Philadelphia. The room is entered through mahogany doorways framed by crossetted corners and ornamental ropework that envelops hand-carved roses. King of Prussia marble from the now-depleted quarries in Pennsylvania was recut to make the fireplace facings and hearth. The fireplace is decorated with acanthus leaves, echoing the consoles over the door head. This elaborate shell-and-vine carving has also been added to the three panels below the mantel shelf.

The massive Treaty Room and its antechambers are equally masterly for several reasons. First, Greenberg was faced with an oval space with asymmetrical entrances in the original rooms. Second, he had to redirect visitors from the axis of the elevator lobby to that of the secretary of state's suite, while also allowing access to the ceremonial Treaty Room. Finally, his deft use of a continuous cornice in the two differently

LEFT Secretary of State's Conference Room

shaped rooms called for uncommon technical brilliance from the architect and his staff.

That cornice provides scale and continuity to the suite, as the eye follows it both into and out of the oval main room. The curved shape is preserved on one wall of each rectangular anteroom, seeming to burst into it with a flourish. Using a deeply projecting modillion corona, contrasted with a high, flat fascia below, allowed the architects to deal with differing conditions around doors and built-in cabinets. One of Greenberg's trademarks is his penchant for bringing projections in and out of the walls to vary the rhythms of the vertical bays in a room. Though the antechambers are on the long axis of the room, there is a deeply set door opposite a bay with a portrait of Thomas Jefferson on the short axis, framing a desk for signing documents.

Though the fluted Corinthian columns here reflect the theme established in the secretary of state's suite, the capitals are more abstract, inspired by John Russell Pope's at the National Gallery of Art. The lower portions of each column are filled by gilded concave strips, another clever touch that adds distinction. At the center of each capital are three-dimensional casts of the Great Seal of the United States, also fully gilded. The striking color combination of teal blue, brilliant white, and gold is truly majestic, and like nothing else in Washington. The elaborate wood floor inspired by Michelangelo's paving at the Campidoglio (on Capitoline Hill) finishes the ensemble with a flourish.

No American museum, historic house, or decorative arts collection contains a suite of rooms like this one. Because they retained Allan Greenberg at the beginning of his career, but also in full command of his creative powers, State Department officials found the perfect architect to continue the challenge begun by Jones, Macomber, and Blatteau of taking a prosaic group of office rooms and turning them into paragons of classical interior design. Seeing the before-and-after photographs, one can scarcely believe the transformation was possible. But that sense of achieving the unthinkable is at the heart of the American spirit. —MAH

RIGHT East Reception Hall of the Treaty Room Suite
FOLLOWING West Reception Hall of the Treaty Room Suite

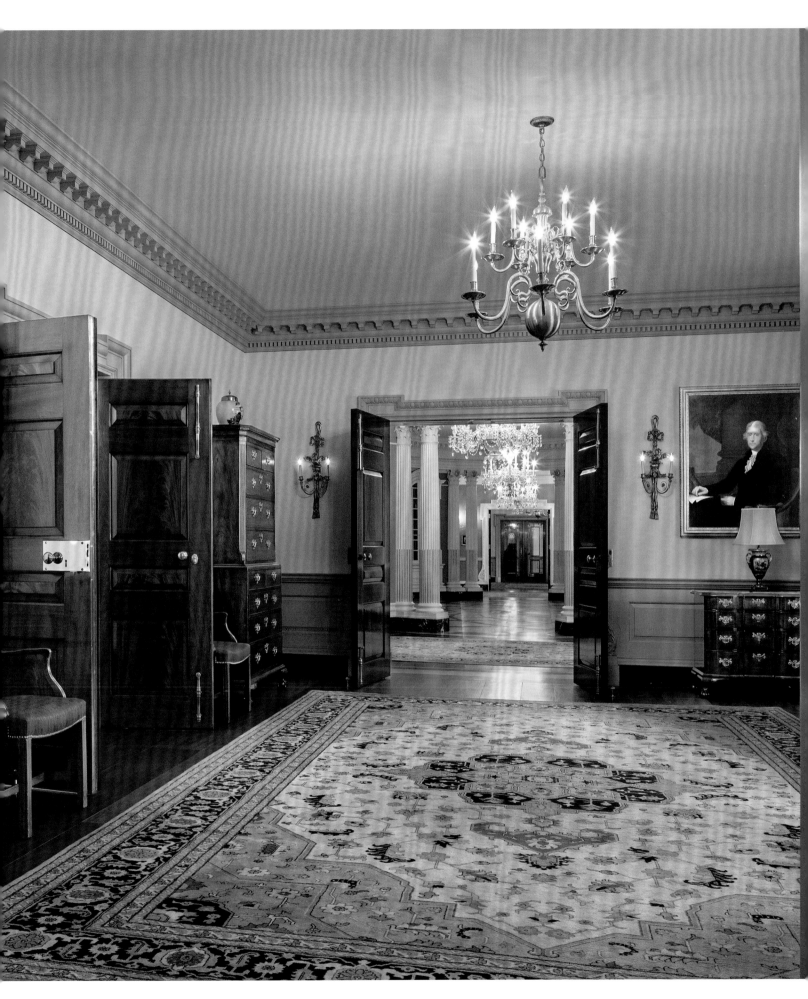

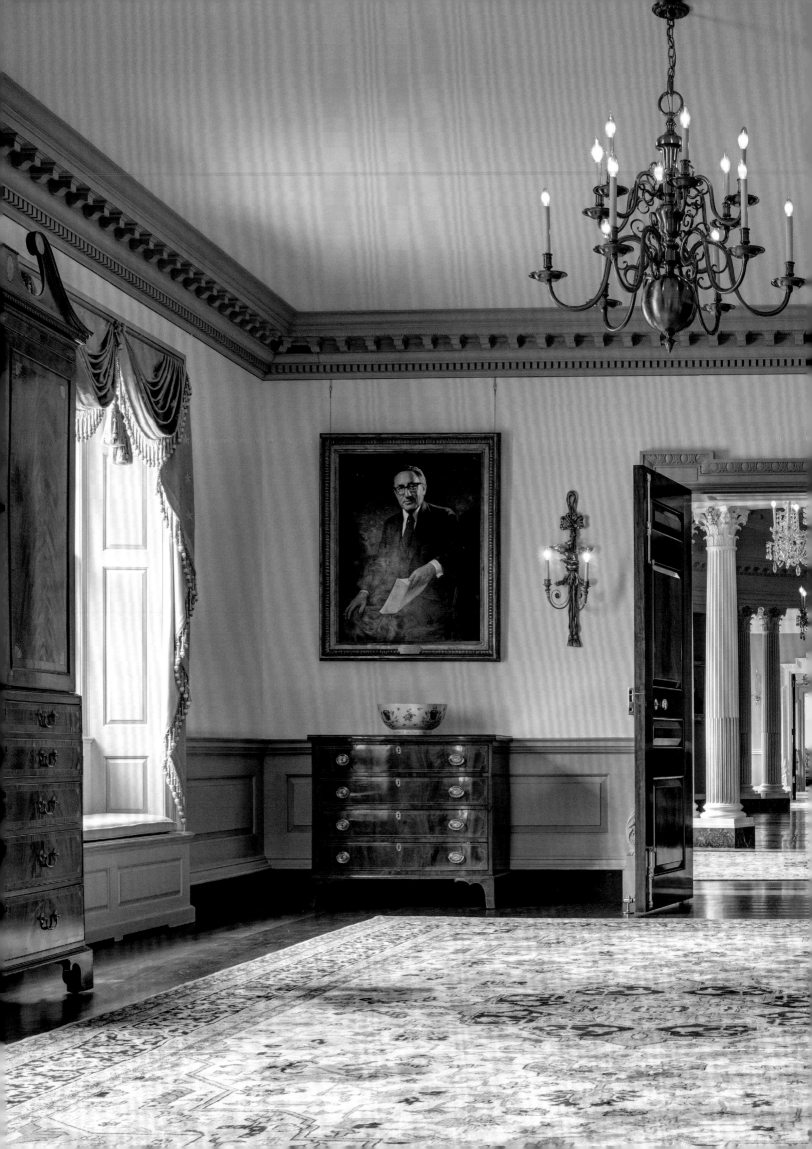

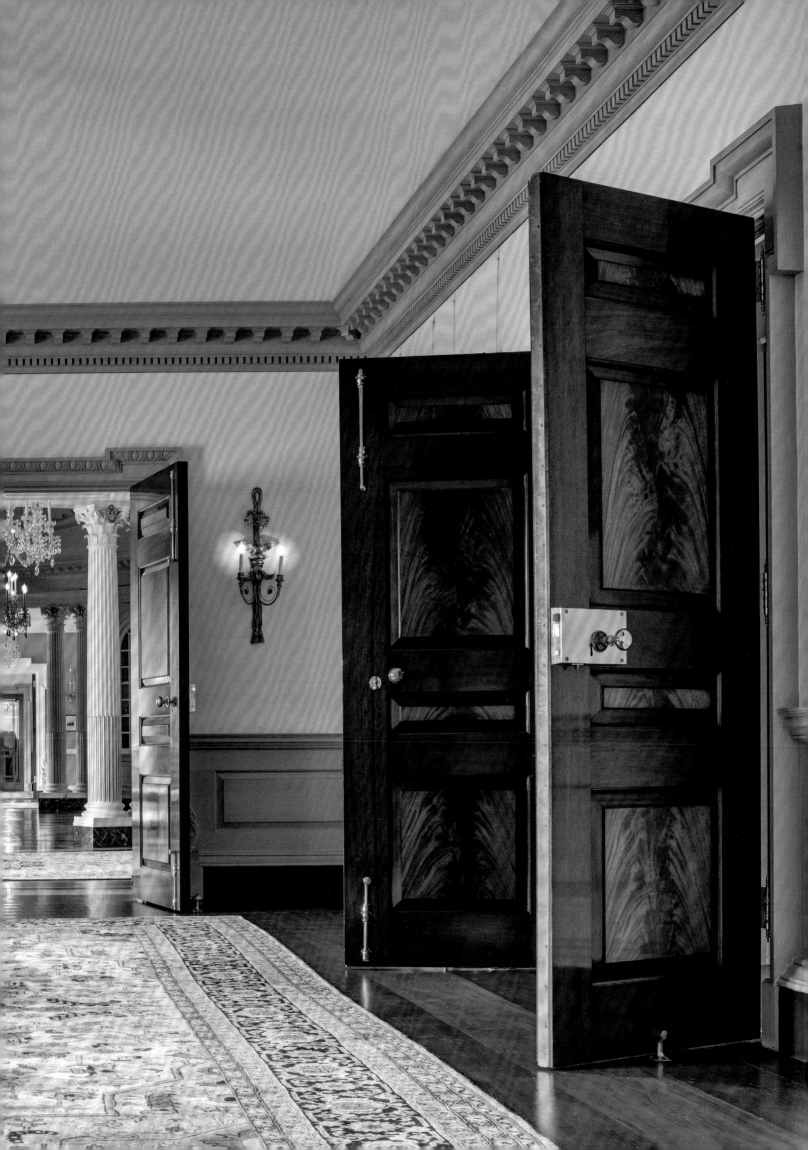

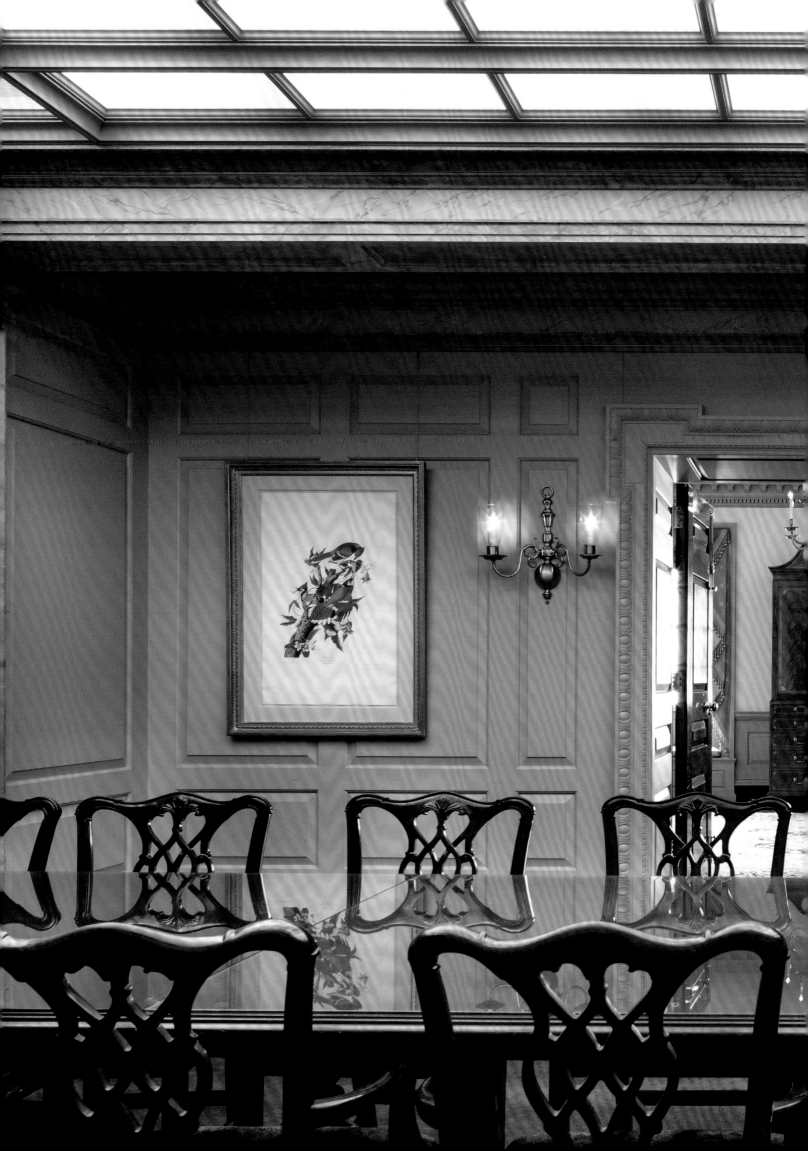

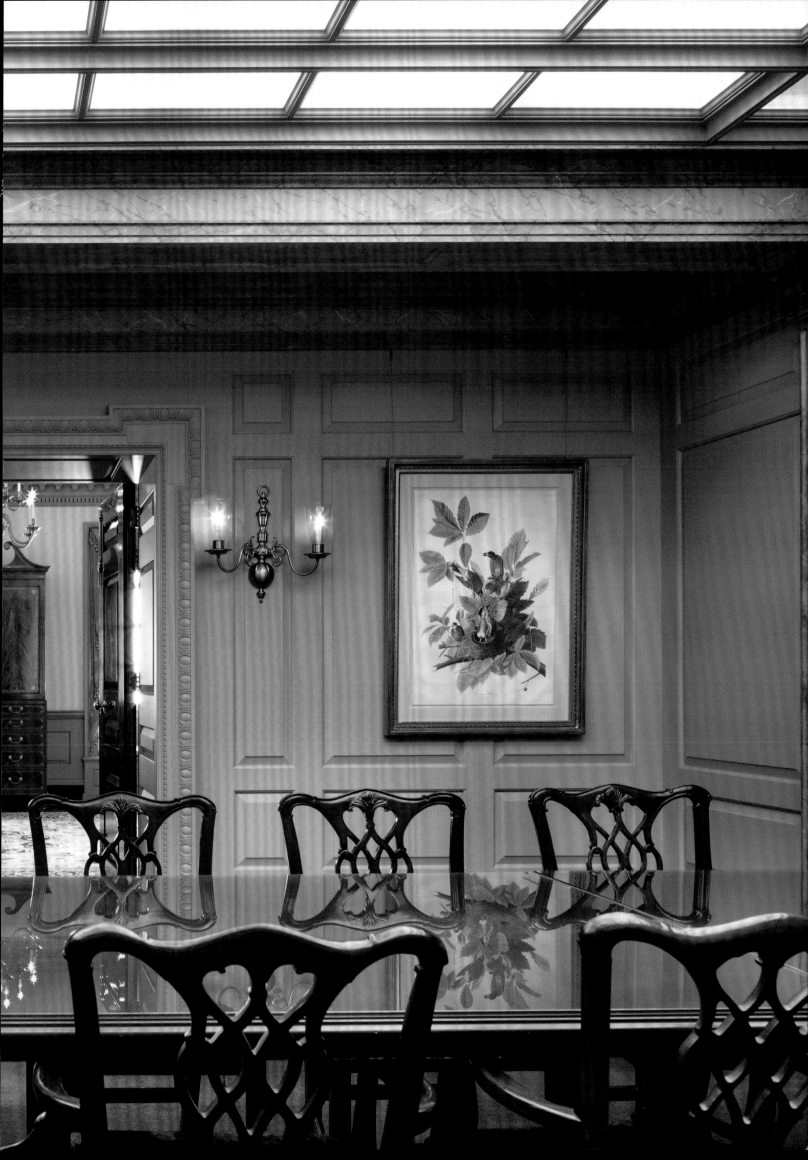

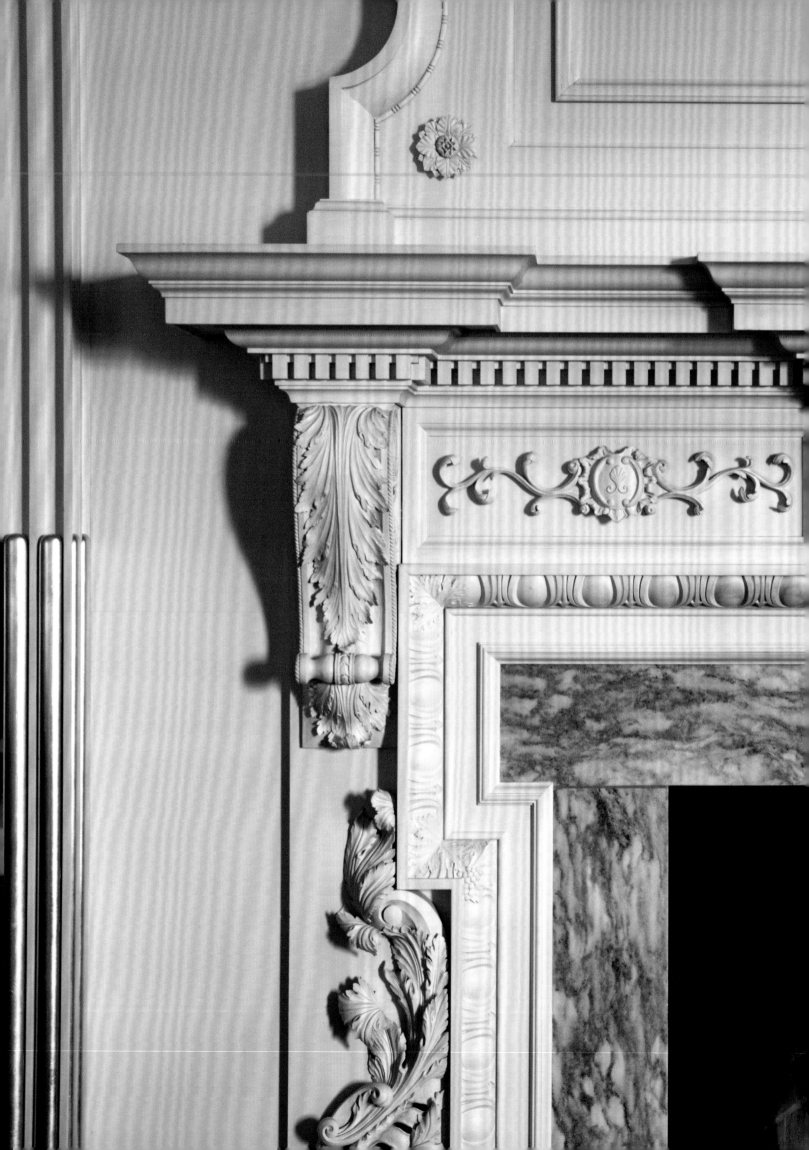

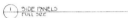

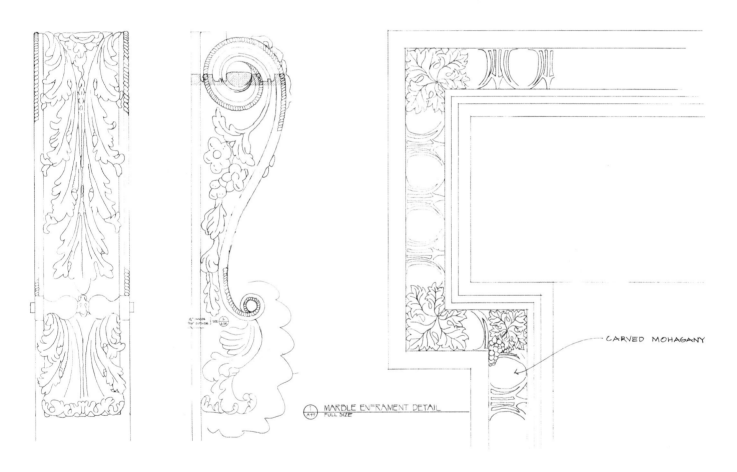

CARVED MOHAGANY

PREVIOUS
Deputy Secretary of State's Conference Room

OPPOSITE & FOLLOWING
Deputy Secretary of State's Office

ABOVE TOP
Details of mantel for the Offices of
the Secretary of State. Allan Greenberg (Architect),
New Haven, Connecticut, August 21, 1984

ABOVE LEFT
Detail of marble fireplace for the Offices of
the Secretary of State. Allan Greenberg (Architect),
New Haven, Connecticut, July 31, 1984

ABOVE RIGHT
Details of fireplace console for the Offices of
the Secretary of State. Allan Greenberg (Architect),
New Haven, Connecticut, June 20, 1984

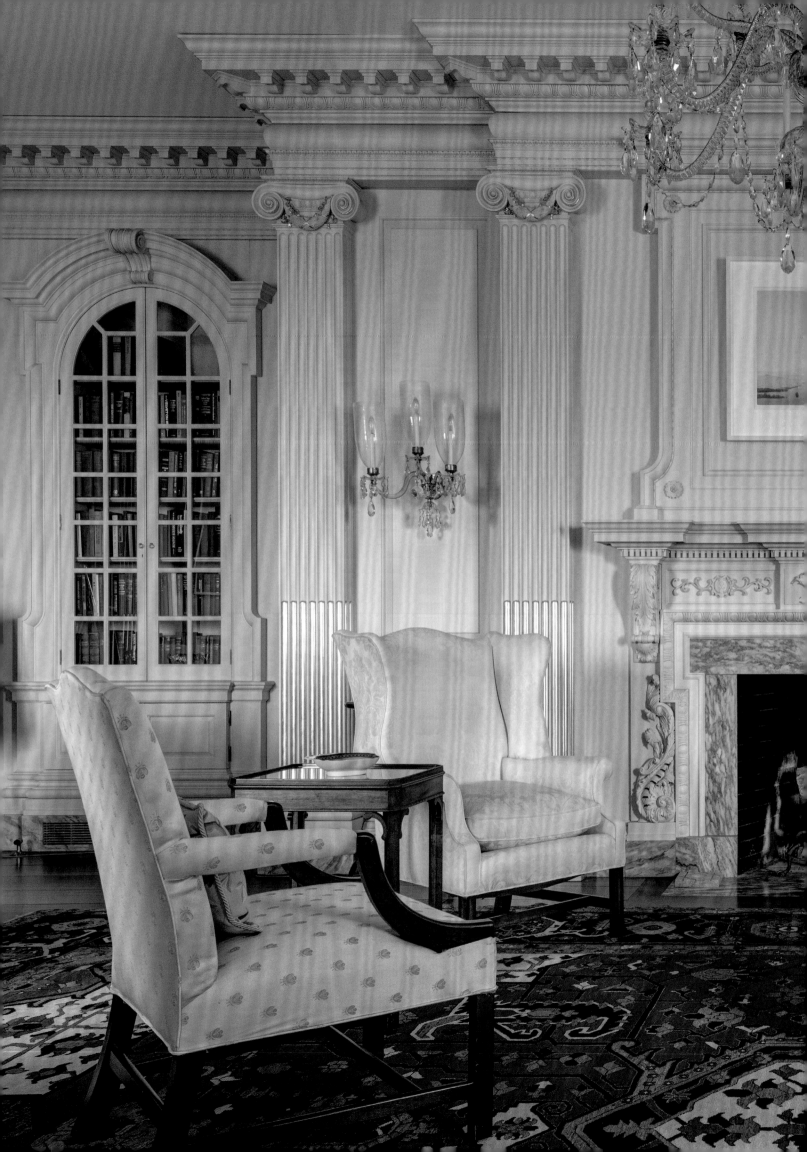

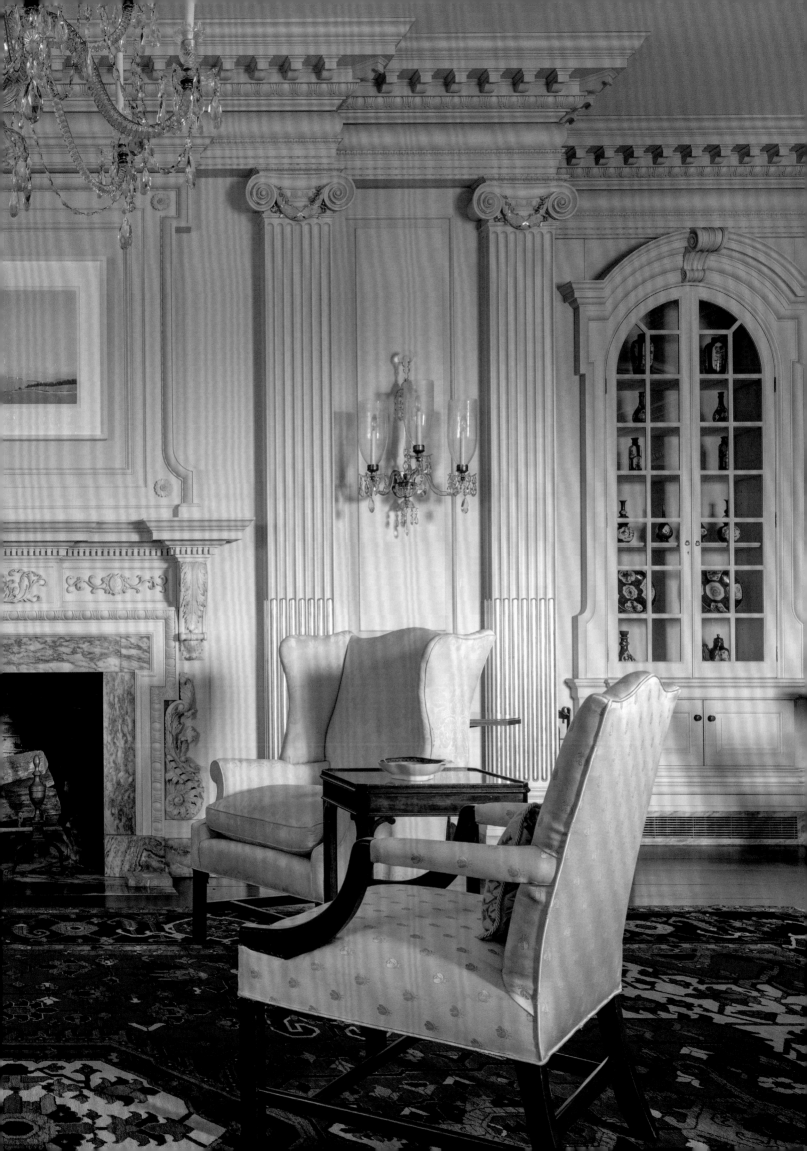

THE
HARRY S. TRUMAN
BUILDING

THE BUILDING THAT NOW contains the Diplomatic Reception Rooms was designed by the noted Chicago firm of Graham, Anderson, Probst and White in 1957 and dedicated in early 1961. It is actually a massive extension to the Department of War Building, commissioned by President Franklin Delano Roosevelt and constructed from 1939 to 1941. Both buildings are clad in a bright, shot-finished Indiana limestone, the predominant material for many federal buildings in Washington, D.C. There are granite accents at the base of the building and a long colonnaded glass entry on the main facade. On completion, it was the second-largest federal office building in the United States, surpassed only by the massive Pentagon (1941–42), which houses the Department of Defense. Both War and State are listed on the National Register of Historic Places (2017).

The two attached buildings are located in what is called the northwest quadrant, one of the last areas of the original L'Enfant plan for Washington to be filled in with government structures. The National Capital Parks and Planning Commission initiated the classical building programs under John Russell Pope during the 1920s. The ten-building Federal Triangle was begun at that time but left unfinished until the late twentieth century. The Northwest Rectangle, which contains the buildings bounded by Constitution Avenue, Seventeenth Street, New York Avenue, E Street, and Twenty-Third Street, was completed by 1961.

The buildings are part of a larger neighborhood known today as Foggy Bottom. To the west of the buildings is Potomac Hill, containing a State Department Annex, and beyond that is the Kennedy Center for the Performing Arts. The area is to the north of the Arlington Memorial Bridge, giving it views to the southwest of the Potomac River and Arlington National Cemetery. The Secretaries of State Terrace of the Diplomatic Reception Rooms faces the river.

Though the vaguely classical Department of War Building was one of the last vestiges of a distinguished campaign for giving United States federal architecture the stamp of authority, the State Department was built too late for such coordinated, and potentially off-putting, classical pomp. By the 1950s, the government was committed to modernism, and when it sought architects, it was inclined to go where that style was flourishing—in Chicago. Ludwig Mies van der Rohe was ensconced at the Illinois Institute of Technology,

and the Second Chicago School was in full flower. Daniel Burnham and John Wellborn Root had started the firm in the 1870s; it eventually evolved into Graham Anderson, which by the end of World War II was a huge multi-office corporation with hundreds of architects and no particular house style. In concert with the Detroit engineering firm of Harley, Ellington & Day, the Chicago team completed the designs for the $46.7 million building by February 1957 and construction began shortly thereafter.

It was so large that five courtyards were included in order to get natural light into all the office wings (two adjoining the War building). There were six elevator banks accessing both the outer wings and the central eight-story main building. Like the space program that was just getting underway, construction was a high-tech, logistical tour de force requiring the services of the best structural and mechanical engineers and contractors. Like the earlier War Department, the State Department relied on huge banks of fluorescent lighting to illuminate offices, conference rooms, cafeterias, service areas, and an auditorium. In many respects, the interiors were so vast that one architectural firm could not design an appropriate scheme for all areas of the building. So interior design firms took over the tasks, barely finishing in time for the opening. A few ground-floor rooms were decked out in marble and metal accents, but by and large the building failed to impress officials used to the lavish palaces that served European diplomats.

While the building today is dwarfed by surrounding high-rise structures, in its time it was a behemoth that dominated its site. Never loved by diplomats or admired by foreigners as are many buildings along the Mall, the stark modernist structure was almost immediately seen as being in need of better landscaping, art, and decoration. Though murals were included in the Department of War Building, as well as sculpture for both the interior and exterior, no funds were allotted for State following completion. One fountain and a sculpture in the south courtyard were finally installed, executed by Marshall Maynard Fredericks (1908–1998). The space is often the setting for television shows wanting the monumental, bureaucratic look of "official" Washington. The marble-clad lobby is impressively festooned with flags of the many nations with embassies in the city. —MAH

OPPOSITE Secretaries of State Terrace

LEFT (DETAIL, SEE ALSO P. 68)
Louisa Catherine Johnson Adams, 1816
Charles Robert Leslie
(British, 1794–1859)
Oil on canvas
36½ x 29 in. (92.7 x 73.7 cm)

139

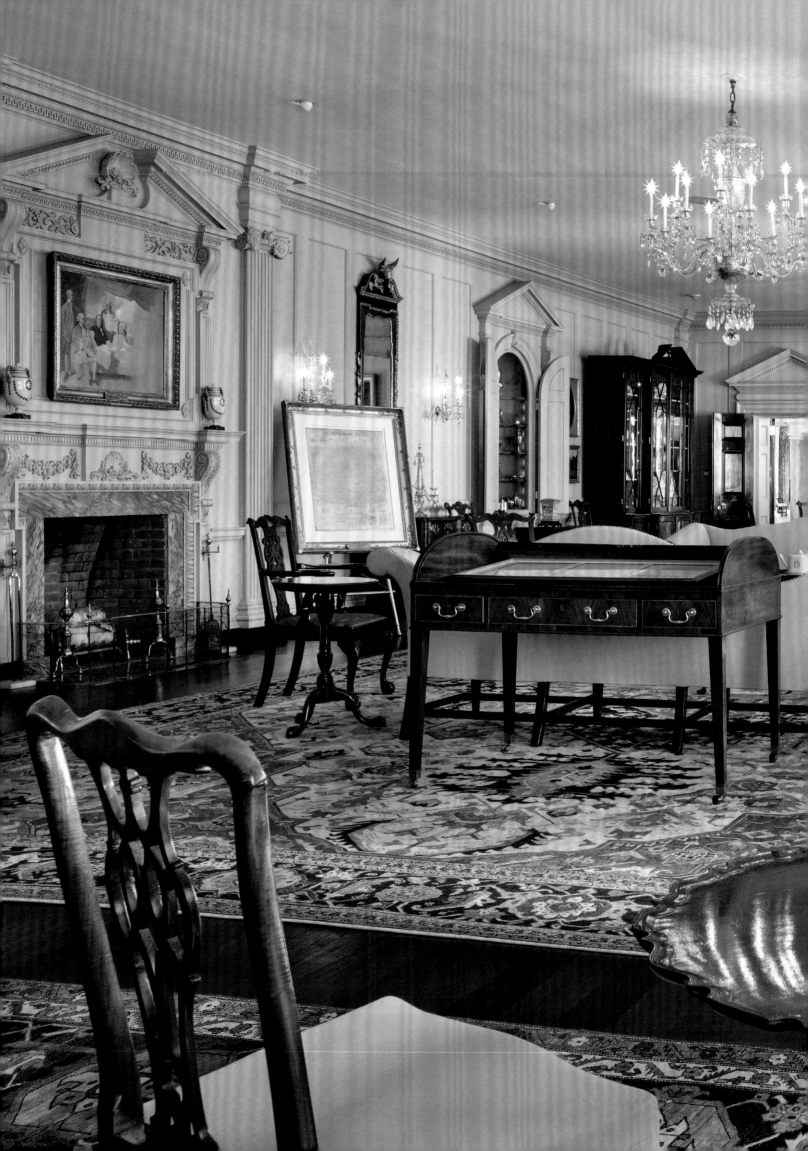

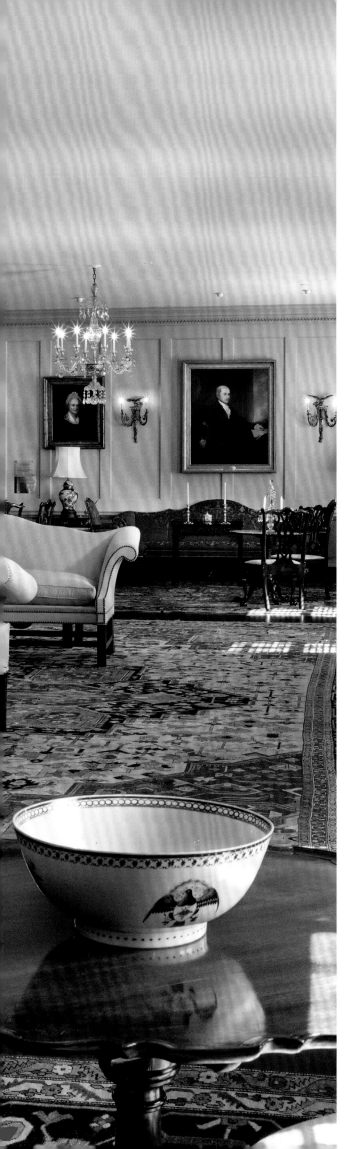

HIGHLIGHTS
of the
COLLECTION

PAINTINGS &
SCULPTURE

THE AMERICAN SCHOOL
AND BEYOND

Elizabeth Mankin Kornhauser

THE AMERICAN EXPERIENCE—from its colonial beginnings to the modern era—was captured by American artists in their paintings and sculpture. The portraits, history paintings, sculpture, landscapes, and genre paintings of American life in the collection of the Diplomatic Reception Rooms celebrate the advancement of the arts in America.

Fundamental artistic training was not available to aspiring artists in the American colonies. The long struggle for independence from Britain further hindered the emerging careers of painters and sculptors as American commerce was disrupted. When the Revolutionary War began, many artists chose to go abroad in pursuit of artistic instruction and patronage. While several never returned, remaining in London, most came back, some to fight in the war, and later to establish professional careers in the new nation.

The American artist Matthew Pratt (1734–1805) left Philadelphia, sailing to London in 1764 accompanied by his cousin Elizabeth Shewell, who was engaged to marry his fellow Philadelphia artist Benjamin West (1738–1820). As the first American artist to study in Italy, West embraced the neoclassical movement then developing in Europe. He quickly established himself as a rising star in the London art world and soon became the court painter to King George III, remaining in London for the rest of his life.

He welcomed into his London studio three generations of American artists traveling abroad in search of artistic instruction, including Charles Willson Peale (1741–1827), John Trumbull (1756–1843), Gilbert Stuart (1755–1828), and Thomas Sully (1783–1872)—all represented in the Diplomatic Reception Rooms. Pratt's most famous work, *The American School* (p. 144), depicts that studio, with West seen at left teaching several young art students in the essential skill of draftsmanship,

capturing the emergence of American painting.[31] Most of West's students returned to America, where painting took hold in the colonies and later flourished in the post-Revolutionary era.

From about 1760 to 1820, most American artists were restricted to the compositional possibilities of portraiture. Based in Boston, John Singleton Copley (1738–1815) became the colonies' leading portrait painter in the years leading up to the Revolution, catering to his patrons' desire to appear as British subjects. In order for his career to thrive, he painted Loyalists and Patriots alike. For his portrait of *Mrs. John Winthrop* (above right), a Patriot and a woman of letters, Copley depicted his subject's face and clothing as well as her surroundings with great care and skill, with the rare nectarine in her hand reflected in the mahogany tabletop. As a Patriot, she expressed her strong Whig politics, writing to her friend Mercy Otis Warren on August 17, 1775, "But my heart bleeds for the people of Boston, my blood boils with resentment at the Treatment that they have met with Gage. Can anything equal his Barbarity."[32] But as the war approached, with the encouragement of Benjamin West, Copley left in 1774 for London, where he rose to prominence, remaining for the rest of his life. His London portraits, such as *Frances Tucker Montresor* (cat. 1), a Bermuda heiress, depart from the intense realism and directness of his American works. She is shown in the latest British style, wearing a riding habit adapted from military uniform, in profile in a cool neoclassical pose.[33]

In London, West and his colleague and rival Copley successfully engaged in the highest compositional art form— grand-scale history painting—derived from antique and old master sources. They gained added fame in London's art world by establishing a new genre known as contemporary history painting. In their touchstone works, including West's *The Death of General Wolfe*, 1770 (National Gallery of Canada, Ottawa) and Copley's *Watson and the Shark*, 1778 (National Gallery of Art, Washington, D.C.), instead of depicting biblical, mythological, and literary heroes, they rather portray real people from contemporary life. West's unfinished *American Commissioners of the Preliminary Peace Negotiations with Great Britain*, begun in 1783 (Winterthur Museum), was intended to be the first in a series on the American Revolution, commemorating the commission that negotiated the preliminary treaty between America and Britain, signed in Paris on November 30, 1782 (see cat. 2).[34]

Charles Willson Peale, who studied in London with West between 1767 and 1769, returned to Philadelphia and fought in the Revolutionary War. In addition to his career as an artist, he was also an inventor, scientist, and founder of the nation's first museum, improving the civic and artistic life of the young republic. As a friend of the country's great leaders, he painted many portraits of George Washington, Benjamin Franklin, and Thomas Jefferson (see cat. 3), among others. He formed a family dynasty of artists, with eight of his ten children, along with his brother and nephews and nieces, becoming professional artists in the early national period.[35]

The Connecticut-born, English-trained John Trumbull became the leading chronicler of the United States' newly won freedom in the years after the Revolution. In March 1785, he wrote to his father, Jonathan Trumbull Sr., that "the great object of my wishes . . . is to take up the History of Our

Country, and paint the principal Events particularly of the late War." Influenced by the work of West and Copley, he finished his first history painting, *The Death of General Warren at the Battle of Bunker's Hill* (Yale University Art Gallery) in March 1786. He began the composition of *The Declaration of Independence* (Yale University Art Gallery; see also pp. 310–11) during a visit to Thomas Jefferson in Paris that July. After returning to the United States in the fall of 1789, he traveled along the East Coast for the next four years, painting life portraits of the faces of the figures he would incorporate into his series of history paintings depicting events and leaders of the American Revolution.[36]

In the early years of the American republic, Gilbert Stuart became the leading portrait painter in the United States after a twenty-year career in England and Ireland. He returned to paint the nation's first president, George Washington, using

OPPOSITE LEFT
The American School, 1765
Matthew Pratt (American, 1734–1805)
Oil on canvas
36 x 50¼ in. (91.4 x 127.6 cm)
The Metropolitan Museum of Art,
Gift of Samuel P. Avery, 1897 97.29.3

OPPOSITE RIGHT
Mrs. John Winthrop, 1773
John Singleton Copley (American, 1738–1815)
Oil on canvas
35½ x 28¾ in. (90.2 x 73 cm)
The Metropolitan Museum of Art,
Morris K. Jesup Fund, 1931 31.109

BELOW
Walter Thurston Gentlemen's Lounge

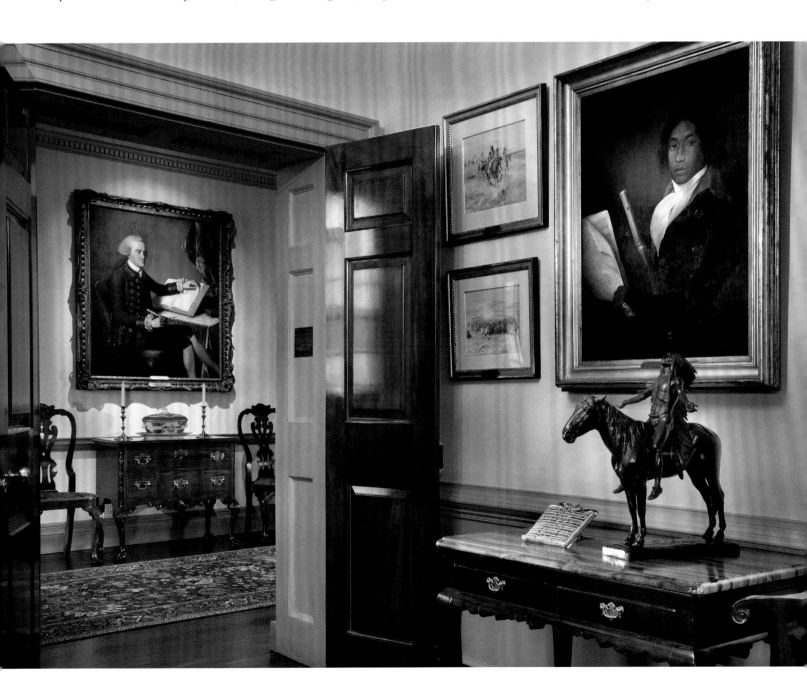

three distinct portrait types painted from life: the so-called Lansdowne full-length portrait; the Vaughan portrait, a more close-up version focusing on the right side of Washington's face; and the most popular, the Athenaeum portrait showing more of the left side of his face. When he first sat for Stuart, Washington was sixty-three years old and toward the end of his second term of office. Stuart famously engaged his subject in conversation and managed to reveal the president's character and inner qualities. His Washington portraits were an instant success, and he painted many replicas of them in the years to come (cat. 4).[37] Among Stuart's many portraits of important women of the period is *Mary McIntosh Williams Sargent* (cat. 5). She was married to Winthrop Sargent, who served in the Revolutionary War under George Washington and later became governor of the Mississippi Territory. Mary was very close to her sister-in-law Judith Sargent Murray, a prominent advocate for women's equality and author of a seminal essay, "On the Equality of the Sexes" (1790).[38]

Although figures of African Americans appeared in eighteenth-century history paintings by American artists, including such notable examples as Copley's *Watson and the Shark* and Samuel Jennings's (active 1789–1834) *Liberty Displaying the Arts and Sciences, or The Genius of America Encouraging the Emancipation of Blacks*, 1792 (Library Company of Philadelphia), portraits of African Americans were rare. Joshua Johnson (ca. 1765–after 1825), the earliest known professional African American painter, was the son of a white man and an enslaved woman of color. Johnson secured his freedom in 1782, becoming part of the large free Black population in Baltimore, where he painted portraits of the city's leading residents, including African American subjects.[39] A rare portrait of a Black musician, *A Flutist* (cat. 6), is an intriguing example of a highly accomplished work by an as yet unidentified American or European painter.[40]

The tradition of miniature painting—making small watercolor portraits on ivory—emerged in America in the mid- to late eighteenth century. Based on European models, American portrait miniatures are related to ancient and medieval devotional paintings and illuminated manuscripts. Originally made to be worn or carried, each is inextricably tied to its function as memento, love token, or reliquary. At the height of their popularity in America, from about 1760 to 1840, these highly personal portraits were often commissioned as a way to hold on to absent loved ones and were made by leading oil portrait painters as well as miniature specialists, many of whom were women.[41] Some were painted during travels abroad. For example, at the request of his mother, Abigail Adams, John Quincy Adams had

the British miniature painter John Parker (b. 1745) paint a miniature portrait of him while at The Hague, *John Quincy Adams* (cat. 7). Adams was soon sent from The Hague to London, where he met twenty-year-old Louisa Catherine Johnson at the home of her father, Joshua Johnson (1744–1802), who served as the American consul in London. They were engaged by the spring of 1776. Abigail Adams then asked for a miniature of her son's fiancée to accompany that of her son. Samuel Shelley (1756–1808) created an intimate youthful portrayal of his subject in *Louisa Catherine Johnson Adams* (cat. 8).

The visual commemoration of national heroes following the Revolution included marble sculptures of such leaders as George Washington, the Marquis de Lafayette, and James Madison. But in the absence of professional sculptors in America, these portraits were done by European artists, including Jean Antoine Houdon (1741–1828; cat. 9) and Giuseppe Ceracchi (1751–1802; see cat. 13). It wasn't until the nineteenth century that American sculptors began to work in marble, often setting up studios in Rome, as well as in bronze (see cat. 40), when the United States had proper foundries for casting works of art.

Landscape art took hold in the new nation in the early decades of the nineteenth century. British-trained artists including William Guy Wall (1792–after 1864), John Hill (1812–1879), and Joshua Shaw (1776–1860; see cat. 20) immigrated to the United States, introducing British landscape traditions of the sublime and the picturesque in their watercolors and print portfolios. The British émigré artist Thomas Cole (1801–1848), who spent his childhood in industrial England, set a new direction for landscape art in the United States by painting the country's wilderness scenery and, in such works as *The Oxbow*, 1836 (opposite), embedded the moral message to preserve the wilderness.[42] Cole originated the Hudson River School, the nation's first artistic school, with artists largely based in New York City. Together with like-minded poets and writers, they forged an "American" landscape vision that focused on the exploration of American scenery as a resource for spiritual renewal and as an expression of cultural and national identity, seen in such works as Ferdinand Richardt's (1819–1895) sublime views of Niagara Falls (cat. 21). While Native Americans were frequently represented in these landscapes (see cat. 24), artists rarely portrayed the catastrophic suffering of Indigenous communities, including land dispossession, cultural imperialism, and loss of life. Leading artists including Frederic Edwin Church (1826–1900), Asher Brown Durand (1796–1886), and, later, John Frederick Kensett (1816–1872; see cat. 22) and Sanford Robinson Gifford

(1823–1880) explored American scenery and grappled with the upheaval of the country during the Civil War era and the legacy of slavery. Born free in upstate New York, the African American artist Robert S. Duncanson (1821–1872; cat. 27), influenced by Thomas Cole, established a successful career as a landscape artist. He first worked in Cincinnati, Ohio, where he came to the attention of abolitionist leaders, who later sponsored his study in Europe. Self-exiled in Montreal during the Civil War, he also helped launch a Canadian landscape movement.[43] Additionally, landscape painters including Albert Bierstadt (1830–1902), Thomas Hill (1829–1908), and Thomas Moran (1837–1926) (see cats. 28, 29) celebrated the rapid white settlement of the western territories, and later, the railroads that brought settlers west. Their Edenic views of the West became influential in the establishment of the national parks movement by century's end.

ABOVE
View from Mount Holyoke, Northampton, Massachusetts,
After a Thunderstorm—The Oxbow, 1836
Thomas Cole
(American, born England, 1801–1848)
Oil on canvas
51½ x 76 in. (130.8 x 193 cm)
The Metropolitan Museum of Art,
Gift of Mrs. Russell Sage, 1908 08.228

1

FRANCES TUCKER MONTRESOR,
ca. 1778

John Singleton Copley
(American, 1738–1815)
Oil on canvas, in a period gilt frame
30⅜ x 25⅛ in. (77.2 x 63.8 cm) overall

STYLISH FRANCES TUCKER Montresor appears in the latest fashion of 1778: a women's riding habit designed to mimic military uniforms. War was in the air, and even ladies were attending military reviews and wearing regimental colors.

Frances, born in New York, was the wife of John, an officer in the British army. He served as General William Howe's aide-de-camp in 1778, but he was dismissed by Howe's successor; he and his family returned to England.

There John Singleton Copley was chosen to paint Frances's portrait, since he had completed a portrait of John Montresor several years earlier, in America. Copley, working to establish his career in England, responded by creating this striking image with sure design and bold color. The pose is derived from antique coins and cameos, and it showcases Frances's elegant profile and imposing mien.

THE AMERICAN COMMISSIONERS OF THE PRELIMINARY PEACE NEGOTIATIONS WITH GREAT BRITAIN, after 1820

American School, after Benjamin West
(American, 1738–1820)

Oil on canvas, in a period frame
28¹⁄₁₆ x 36⅛ in. (71.3 x 91.8 cm) overall

WITH PORTRAITS OF John Jay, John Adams, Benjamin Franklin, Henry Laurens, and William Temple Franklin (left to right), *The American Commissioners* was intended to commemorate the signing of the preliminary articles of peace between the United States and Great Britain on November 30, 1782. The final accord was not signed till September 3, 1783.

The five men depicted were present at the 1782 meeting, but only three of them—Jay, Adams, and Benjamin Franklin—attended the 1783 meeting and signed the accord.

Benjamin West planned to create "a set of pictures containing the great events which have affected the revolution of America,"[44] with *The American Commissioners* as the first in a series. (This painting is an early copy of the unfinished original, now at the Winterthur Museum.) However, gathering the men involved proved

an insurmountable problem. Adams, Jay, and Laurens posed for West in person. Benjamin Franklin was in Paris and unable to travel, but he sent a portrait for copying. His grandson, William Temple Franklin, was the last of the Americans to pose.

The two British commissioners who were supposed to occupy the right-hand side of the painting were Richard Oswald, a Scottish merchant, and Caleb Whitefoord, Oswald's secretary. Whitefoord was available—in fact, he was the messenger who brought Benjamin Franklin's portrait to West. But Oswald was reportedly "an ugly-looking man, blind in one eye." And he had passed away in 1784, "without leaving any picture of him extant."[45] Thwarted, West abandoned the painting and the historical series he had planned.

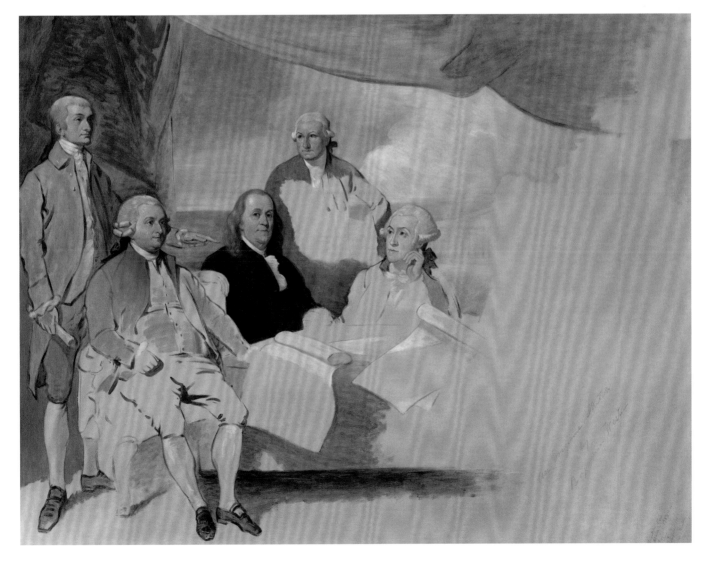

THOMAS JEFFERSON, 1791
Attributed to Charles Willson Peale
(American, 1741–1827)
Oil on canvas
33½ x 28¾ in. (85.1 x 73 cm)

THOMAS JEFFERSON and Charles Willson Peale were close friends; the two men shared a love of natural history, invention, and science. "I have a great desire to exert my abilities in this portrait,"[46] Peale wrote as he prepared to paint Jefferson, then the new nation's first secretary of state. Many heads of state visited Peale's studio, both to sit for portraits at his request and to explore his "Repository for Natural Curiosities," part of the museum the artist had established in rooms adjoining his studio.

In 1791, as he painted Jefferson's portrait, Peale was planning to invite prominent citizens to become "visitors," or trustees, of his museum. His chosen group met in February 1792 and elected Thomas Jefferson as their president. Because of Jefferson's association with the museum, many of the specimens sent back from the "wild and perilous expedition"[47] of Lewis and Clark were exhibited there, including a Mandan buffalo robe, a live prairie dog, and two large, live magpies. An experienced taxidermist, Peale preserved some of the specimens, including two heads of bighorn sheep. One was displayed at the museum and one in the entrance hall of Jefferson's home, Monticello.

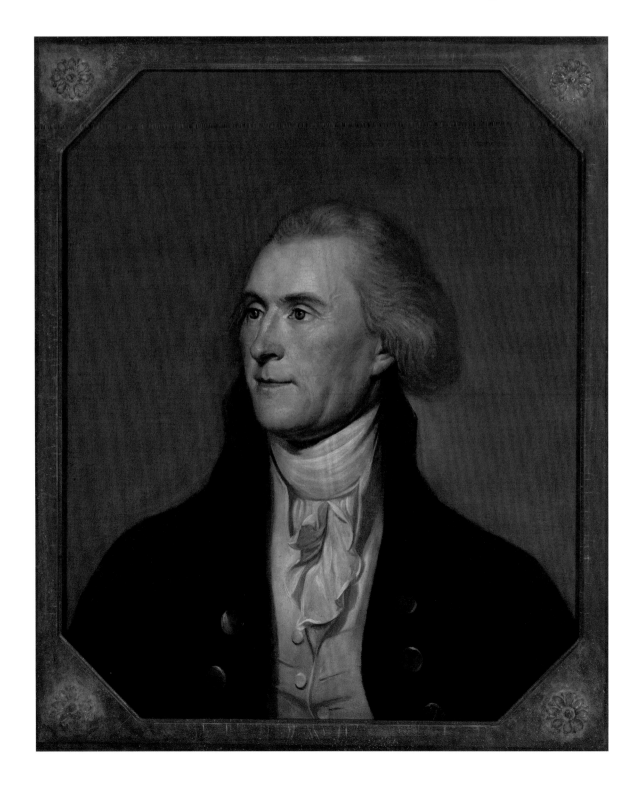

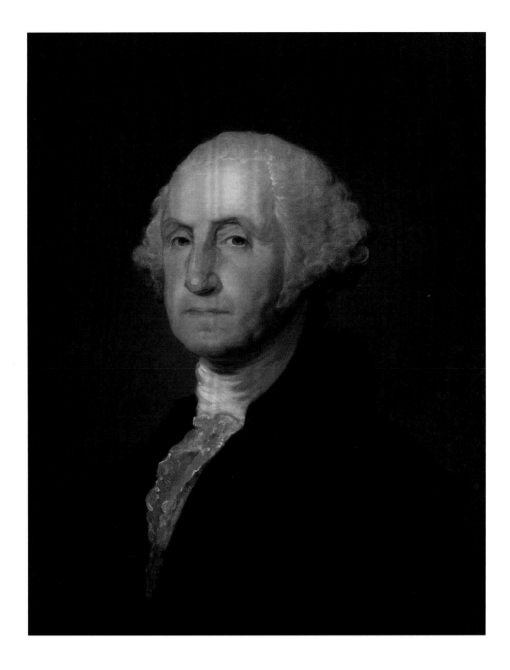

GEORGE WASHINGTON, ca. 1803–5
Gilbert Stuart (American, 1755–1828)
Oil on canvas
30 x 25 in. (76.2 x 63.5 cm)

AFTER GILBERT STUART, a great artist but a spendthrift, was released from debtors' prison in Dublin, he determined to return to America and paint George Washington. "I expect to make a fortune by Washington," he told a friend.[48]

He approached Washington in late 1794 with a letter of introduction from John Jay, and the president sat for his first portrait by Stuart in 1795, his second in 1796. Stuart kept the second painting, today known as the Athenaeum portrait, for the rest of his life, despite promising it to Martha Washington. (Today it is owned jointly by the National Portrait Gallery, Washington, D.C., and the Museum of Fine Arts, Boston.)

The Athenaeum portrait served as the model for about seventy similar paintings over the next thirty years, providing a steady source of income for an artist who struggled to live within his means. Still, Stuart's portraits of Washington were never identical. He invariably made changes in mood, color, clothing, and other subtleties that made each painting distinctive.

This version of Washington shows us a forth-right leader with a clear gaze and a strong profile. Over his shoulder, Stuart shows us the dark silhouette of the president's hair bag, a haberdashery item that was common in the late 1700s. One witness who saw Washington address the Continental Congress in Philadelphia described his look: "His hair [was] profusely powdered, fully dressed, so as to project at the sides, and gathered behind in a silk bag, ornamented with a large rose of black riband."[49]

5

MARY McINTOSH WILLIAMS
SARGENT, ca. 1799–1805
Gilbert Stuart (American, 1755–1828)
Oil on canvas
33½ x 27 in. (85.1 x 68.6 cm)

GILBERT STUART painted both Mary Sargent and her second husband, Winthrop Sargent. Winthrop, the first governor of the Mississippi Territory, valued the paintings highly.

In his will, he wrote, "The Portraits of myself and Wife by Stewart & amongst the best paintings of that most excellent Artist I wish ever to remain with my Name & Family & that my Wife at her Death provide to such purpose by ordering them in safe keeping, till my Sons or either of them shall be of Lawful age and Discretion . . . the elderest should have a Preference if they both be equally worthy."[50] (Despite his wishes, Mary Sargent left her portrait to her son by her first marriage, and

the portrait of her husband went to their younger son.)

Stuart, eternally strapped for money, painted many members of the American elite, including numerous women. Critics concurred that portraits of men were his strength, as his pictures of women were sometimes, as one of them put it, "too strongly individualized perhaps for female portraiture."[51] Stuart's remarkable ability to reveal the spirit of his subject was not appreciated in portraits of women at the time; many critics felt that portraits of women should be concerned with their beauty and costume, not their distinctive personalities.

A FLUTIST, ca. 1785–1810
American School, unidentified artist
Oil on canvas
35 x 28 in. (88.9 x 71.1 cm)

THIS PAINTING, SURELY one of the most intriguing in the collection, offers few answers to its many questions. The mysterious flute player, with his Continental-style jacket and dashing ascot, is dignified. His flute and his music reflect his fine taste. His natural hair, rather than a powdered wig, gives his appearance a modern look. But who is he? When was he painted? Who painted him?

The flute gives us some clues. Between 1770 and the end of the century, flutes gained three extra keyed holes. This instrument has only the D-sharp keyed hole, hinting that it was created before 1800.

The music also helps to date the painting. It is inscribed "Six Duets by W. Shield." William Shield was an English violinist and composer. His opus 1 and 2, from 1777 and about 1780, respectively, each consisted of six duets for two violins. Violin and flute compositions were considered interchangeable at the time, so the music must be one of these—leaving 1777 as the earliest date for this painting.

The flutist's jacket, with its big buttons and red collar, could be English, from about 1785 to 1800, or it might be French and slightly later. His hairstyle, without wig, powder, or pigtail, suggests a date after 1795. But these dates assume he is European. In North America or the West Indies, fashions changed more slowly.

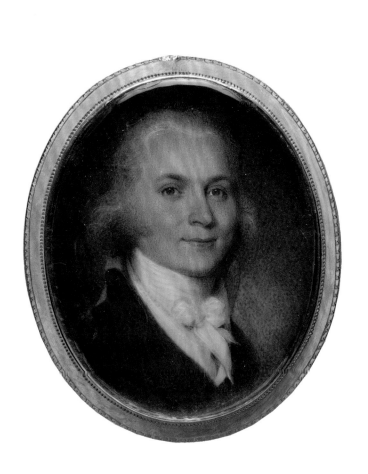

7

JOHN QUINCY ADAMS, 1795
John Parker (British, b. 1745)
Watercolor on ivory, in gilded case
2⅛ x 1¹³/₁₆ in. (5.4 x 4.6 cm)

8

LOUISA CATHERINE JOHNSON ADAMS, ca. 1796
Samuel Shelley (British, 1756–1808)
Watercolor on ivory, in gilded copper case with burnished bezel
1⅞ x 1½ in. (4.8 x 3.8 cm)

THIS PORTRAIT OF John Quincy Adams was a gift for Adams's mother, the redoubtable Abigail Adams. Painted in The Hague, the miniature captures the animation and intensity of the brilliant young man destined to become the sixth president of the United States. Later in life, as a nine-term member of the House of Representatives, Adams would become "Old Man Eloquent," fiercely standing up against the most controversial issue of his life—slavery.

In the House, Adams was purposely contentious. He baited House members to censure him for his conduct, then used his time for defense to espouse his views on slavery. Once he spoke for two weeks on the topic, then threatened to go on for another week unless the House tabled the censure resolution against him. The resolution was tabled. One rival called Adams "the acutest, the astutest, the archest enemy of southern slavery that ever existed."[52]

But in this portrait, painted for a loving mother, Adams was still a young, idealistic man—the man who wrote, "Always vote for principle, though you may vote alone, and you may cherish the sweetest reflection that your vote is never lost."[53]

THIS MINIATURE SHOWS Louisa Adams about the time of her marriage to John Quincy Adams. Born in London and raised in Nantes, France, she was stunned by her in-laws' boisterous household in Quincy, Massachusetts. "Had I stepped into Noah's Ark, I do not think I could have been more utterly astonished," she wrote.[54]

In 1809, John Quincy Adams was appointed minister to Russia. Louisa Adams was a favorite of the czar, but she struggled with harsh winters and poor health. The family's time in Russia ended abruptly in 1814, when Adams was called to Ghent, Belgium, to help negotiate the peace treaty after the War of 1812. To follow him, Louisa Adams settled their affairs in St. Petersburg and set off on a harrowing six-week journey across war-torn Europe in winter.

Napoleon, newly escaped from exile on Elba, had reached France and was on his way to Paris and to seizing control of the country. Louisa Adams was traveling with her young son in a Russian carriage, and French soldiers threatened her, believing her to be the enemy. But Louisa Adams reportedly had her servants whisper that she was Napoleon's sister, traveling incognito; when she stepped out of the carriage, she cried, "Vive Napoléon!" and rallied the troops in her perfect French. They allowed her to pass. When Abigail Adams learned about their journey, she was impressed with her daughter-in-law's courage and quick thinking.

MARQUIS DE LAFAYETTE, ca. 1786
Attributed to Jean Antoine Houdon (French, 1741–1828)
Marble
H. 30½ in. (77.5 cm)

IN 1775, THE Marquis de Lafayette attended a dinner with the Duke of Gloucester, the younger brother of George III. Throughout the evening, the duke complained about the American colonists who had dared to revolt against British rule. The colonists had even organized an army!

"My heart was enlisted," Lafayette later wrote.[55] In 1777, at just nineteen years old, he sailed in secret to America to offer his services to George Washington. Lafayette was to become a hero of the American Revolution, and a close confidant of Washington.

To create his portrait busts, the sculptor Jean Antoine Houdon started by modeling his sitter in clay, then creating a plaster mold. With the mold, Houdon made busts in plaster, terracotta, marble, or bronze, as his customers ordered. For the Marquis de Lafayette, Houdon made a life mask in Paris in 1785 to serve as his mold. America's favorite fighting Frenchman is seen here at the height of his youth and vigor, just twenty-eight years old, dedicated to the cause of liberty.

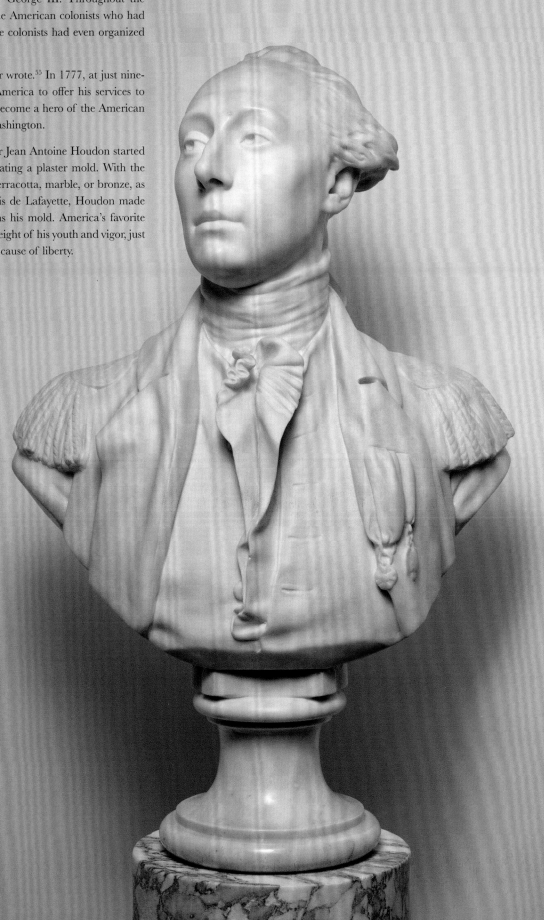

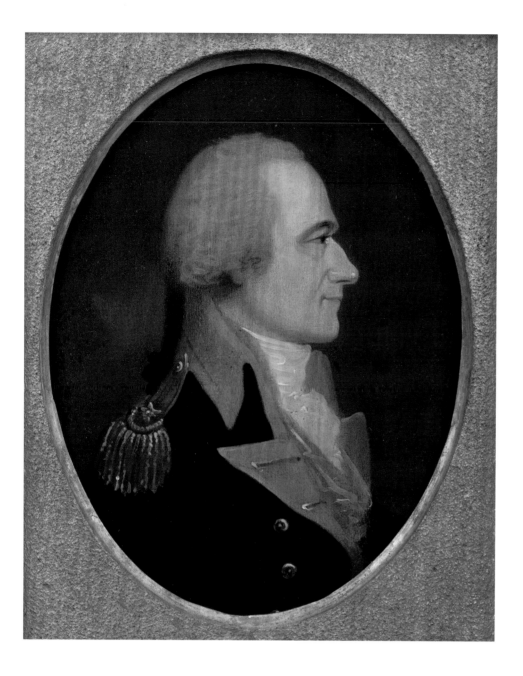

10

ALEXANDER HAMILTON,
ca. 1794–1806
William J. Weaver
(American, born England, 1759–1817)
Oil on oval panel
8½ x 7 in. (21.6 x 17.8 cm)

AFTER ALEXANDER HAMILTON's senseless death in a duel with Aaron Burr in 1804, his controversial personal history was swept aside in an outpouring of public mourning. In this portrait of the nation's first secretary of the treasury, probably created around the time of Hamilton's death, the artist William Weaver paid tribute to his years in the military, as George Washington's aide-de-camp and then as a field commander at Yorktown. Following Giuseppe Ceracchi's marble bust of Hamilton as his model, Weaver captured a strong likeness.

Before emigrating from England in 1794, Weaver had worked for Joseph Booth, an artist who published extensively and bombastically about his secret method for reproducing oil paintings by "a mechanical and chymical process, without any touch or finishing by the hand."[56] Eight copies of Weaver's portrait of Hamilton survive today; this is one of three that were painted entirely by hand by William Weaver, without any kind of mechanical intervention.

The others probably date to about 1805 and 1806, when public demand for tributes to Hamilton surged. Weaver's "Polygraphic Art" was first announced in a *New-York Evening Post* ad in January 1805, and in December 1806, he was inviting patrons to his South Carolina studio, where "the friends of the late General Alexander Hamilton" would be convinced that he could produce "as good if not better LIKENESSES than have ever appeared in this country."[57]

THOMAS JEFFERSON, 1821
Thomas Sully
(American, born England, 1783–1872)
Oil on canvas
29 x 18 in. (73.7 x 45.7 cm)

THOMAS SULLY MAY be best remembered today for capturing likenesses of Americans. He painted more than 2,600 artworks in his long career, including hundreds of portraits. His secret? "Flattery—nothing so sure of success as flattering your portraits."[58]

In March 1821, Sully traveled to Thomas Jefferson's home at Monticello to paint the Founder. The resulting likeness did more than flatter its subject, who was turning seventy-eight in April. "There was a dignity, a repose, I will go further, and say a loveliness, about this painting," wrote James Fenimore Cooper, "that I never have seen in any other portrait."[59] Jefferson is depicted standing at the Capitol on the steps to the House of Representatives (the house of the people) and is dressed in the style that was popular during his presidency more than a decade earlier, with an old-fashioned coat and knee breeches rather than the pantaloons popular in the early 1820s.

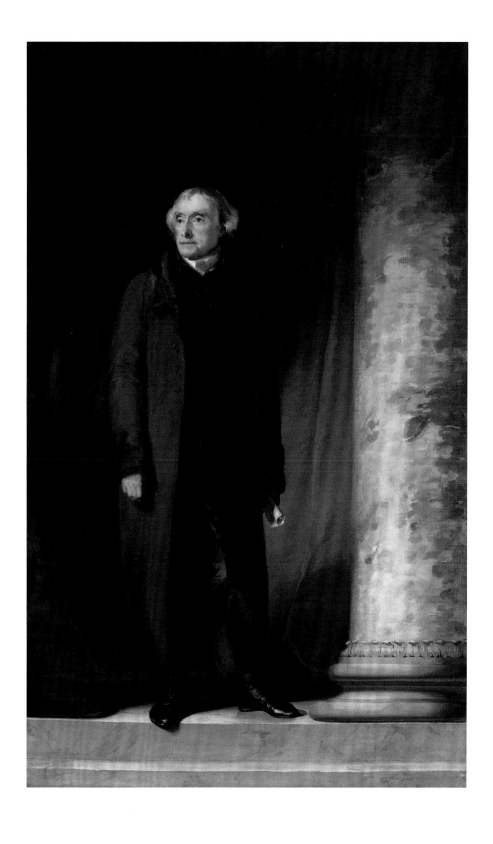

JAMES MONROE, 1829
Thomas Sully
(American, born England, 1783–1872)
Oil on canvas mounted on board,
in the original gilt frame
19 x 15 in. (48.3 x 38.1 cm) overall

IN THIS PORTRAIT, James Monroe, the fifth and last of the Founders to serve as president, is shown as a debonair éminence grise. As a young man, he was a protégé of Thomas Jefferson and an officer in the Revolutionary War, serving under George Washington at the battle of Trenton.

When Thomas Sully painted this portrait of Monroe, the former president was seventy-one years old, hugely popular in his home state of Virginia and throughout the country—and deeply in debt. Monroe had looked younger than his age for most of his life, but in 1828 he was seriously injured in a fall from his horse, and the years caught up with him.

Sully was known for his flattering portraits, but in this one he subtracted more years than was usual even for him. Possibly intending to show Monroe as he appeared during his first presidential term, he emphasizes Monroe's suavity and thoughtfulness rather than his age or infirmity.

<table>
<tr><td align="center">13</td><td align="center">14</td></tr>
</table>

JAMES MADISON, 1794	*JAMES MADISON*, 1826
Giuseppe Ceracchi	Charles Bird King (American, 1785–1862),
(Italian, 1751–1802)	after miniature by Joseph Wood (American, 1778–1830)
Alabaster mounted on marble	Oil on panel
28 x 24 in. (71.1 x 61 cm)	24 x 19½ in. (61 x 49.5 cm)

WHEN THE WELL-KNOWN artist Giuseppe Ceracchi visited America in 1791, he modeled thirty-six terracotta busts of famous Americans— George Washington, Thomas Jefferson, Alexander Hamilton, and James Madison among them. But Congress failed to appropriate funding for the artist's ambitious proposed monument to Liberty, and the sculptor went home to Italy.

At his studio in Florence, he began converting his original terracotta works to alabaster and marble. The terracotta portraits were cast in plaster by studio workers, and then the stone version of each was made by skilled assistants who specialized in carving. For this alabaster portrait of James Madison, Ceracchi probably intended a traditional full bust. But there was a blemish in the alabaster block he had chosen. He wrote to Thomas Jefferson about it in 1794, saying, "I tried to do it in marbre as rapresented with the bust I modeled but the block torned with spots . . . and didn't permit me to perform my proposition."[60]

With his Roman-style hairdo and realistic expression, Madison looks natural in his alabaster bas-relief portrait. The artist originally intended to give the bust to Jefferson, but instead, in 1794, he presented it to Madison's new bride, Dolley.

BORN IN NEWPORT, Rhode Island, Charles Bird King moved west with his parents as a child. (Bird was his mother's family name.) But in 1789, his father was killed by Native Americans in Ohio. His mother took her son back to Newport. As a teenager, he traveled to New York to study art, then to London to learn from Benjamin West at the Royal Academy.

When he returned to America in 1812, he worked as a portrait painter; by 1818, he had settled in Washington, D.C., where he painted John Quincy Adams, James Monroe, Henry Clay, Daniel Webster—and, of course, James Madison. (Later he was commissioned by the government to paint portraits of Native American delegates who visited the city, and he completed more than a hundred over the next twenty years. These paintings remain the work for which he is best known, although many were destroyed in the Smithsonian Institution fire of 1865.)

This 1826 portrait of James Madison has an inscription on the back indicating that King copied it "from Wood." Joseph Wood, another portrait artist, usually worked in miniature or cabinet size. His painting of James Madison measures nine by seven inches, and in it Madison is seated half-length. King copied only James Madison's head, and he apparently generalized the former president's facial features—only the distinctively quirked right eyebrow is true to the actual face of the Founder.

15

LEONIDAS WETMORE, ca. 1839–40

George Caleb Bingham
(American, 1811–1879)

Oil on canvas

60 x 48 in. (152.4 x 121.9 cm)

GEORGE CALEB BINGHAM moved to Franklin, Missouri, as a child. His family had lost their farm in Virginia, and Franklin, at the beginning of the Santa Fe Trail, was said to have land that was "bountiful, fertile, and cheap."[61] For the rest of his life, Bingham would be associated with Missouri, both as an artist and as a politician.

His subject here, Leonidas Wetmore, was the son of the founder of the *Missouri Saturday News*. After joining the army as a second lieutenant in the Sixth Infantry, he served in the Mexican-American War and was made a captain in recognition of his heroism in the battle of Molino del Rey in 1847.

In Bingham's portrait of him, Wetmore wears traditional Native American clothing, tanned leather with thread embroidery. He has a hunter's caped frock coat, leggings, and moccasins. The black sash across his chest is the strap for a beaded woolen bandolier bag.

This full-length portrait, with the subject posed against a river backdrop, anticipates Bingham's later genre paintings of life along the Missouri and Mississippi Rivers.

EARLY VIEW OF THE CAPITOL,
n.d.
Attributed to Victor de Grailly
(French, 1804–1889), after
William Henry Bartlett (British, 1809–1854)
Oil on canvas
23½ x 29 in. (59.7 x 73.7 cm)

VICTOR DE GRAILLY, A FRENCH painter, never set foot on American soil. Instead, like other European artists, he followed the works of William Henry Bartlett and based his "American" paintings on Bartlett's engravings.

Bartlett traveled extensively in America, starting in 1836. Over the next three years, his pictures of the northeastern states were published in London as *American Scenery; or Land, Lake, and River Illustrations of Transatlantic Nature*, in thirty monthly installments. A map in *American Scenery* suggests that from 1837 to 1838, Bartlett arrived in New York City, then traveled to the White Mountains of New Hampshire, west to Niagara Falls, and then south to Washington, D.C.

Bartlett's engravings were presented as travel books, designed to appeal to the armchair tourists of the day. Other artists, including Victor de Grailly, used the engravings as inspiration and source material. Bartlett's view of the Capitol is very similar to this painting; even the approaching visitors are almost identical.

*A GLIMPSE OF THE CAPITOL
AT WASHINGTON*, ca. 1844
William Douglas MacLeod
(American, 1811–1892)
Oil on canvas
21¾ x 29½ in. (55.2 x 74.9 cm)

PIERRE CHARLES L'ENFANT, hired in 1791 to plan the fledgling nation's new capital city of Washington, sited the U.S. Capitol in a location he called "a pedestal waiting for a monument."[62]

But everything about the construction of the Capitol was fraught. The work was slow and arduous. Funding was inadequate. Architects came and went. Sandstone had to be ferried in from quarries in Virginia. Workers required special incentives to travel to the wilds of Capitol Hill.

But when the Capitol was done, with its tall, gleaming dome, it was by far the dominant building on the skyline. Charles Dickens, visiting in 1842, called Washington "the City of Magnificent Intentions . . . Spacious avenues, that begin in nothing, and lead nowhere; streets, mile-long, that only want houses, roads and inhabitants."[63] The artist William Douglas MacLeod, born in Alexandria, served as the curator of the Corcoran Gallery of Art from 1874 to 1888. He was a young man when he painted this glimpse of the Capitol in a bucolic landscape; he lived to see Washington completely transformed into a major city, filled with the houses, roads, and inhabitants that Dickens had looked for.

VIEW OF BOSTON HARBOR, 1852

Fitz Henry (Hugh) Lane

(American, 1804–1865)

Oil on canvas

22½ x 34¾ in. (57.2 x 88.3 cm)

FITZ HENRY LANE PAINTED Boston Harbor from the late 1840s to the late 1850s, when it was at the peak of its maritime supremacy. Soon New York Harbor would take over more business, the Civil War would limit trade, and the whaling industry would fade away, but in Lane's day, traders from Europe, China, and the East Indies called on Boston as a matter of course, along with passenger ships, clippers, and whalers. The city was home to a burgeoning skyline and a bustling waterfront.

Lane's specialty was capturing the harbor in the quiet, still hours of early morning and evening, with delicately layered colors that conveyed silence and light. *Boston Harbor* is unusual in that the scene is alive with movement. Dark clouds gather in the distance, and the turbulent water and full sails show that a storm is brewing.

To sketch the skyline beyond the ships, Lane probably stood on the western side of Governor's Island. The State House is clearly visible, but the steeple of the First Baptist Church would not be added until 1853.

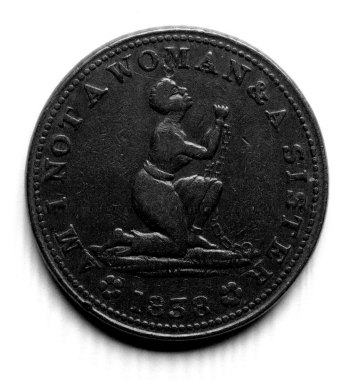

19 *FRONT AND BACK*

ANTI-SLAVERY TOKEN
("AM I NOT A WOMAN
& A SISTER"), 1838
Gibbs Gardner & Co.
(American, active 1830s)
Copper
Diam. 1 in. (2.5 cm)

THIS ANTI-SLAVERY MEDAL, the same size as a penny and sold for the same price, was designed to further the cause of abolition in a subversive way—by being passed from hand to hand as pocket change. A November 1837 advertisement for the medals read: "The friends of liberty have it in their power now to put a medal into the hands of every person in the country, without cost, containing a sentiment of immense value. It is a tract that will not be destroyed."[64]

Commissioned by the American Anti-Slavery Society, the tokens mostly circulated in New York, where the society had its headquarters at 143 Nassau Street. (Harriet Tubman was

a frequent visitor; she stopped by to pick up train and boat tickets for the people she had helped escape from slavery.) The society also distributed a coin with a male figure and the words "Am I Not a Man and a Brother." The male token was imported from Britain and did not circulate as widely as the American female version.

When the "Am I Not a Woman and a Sister" cents came to the attention of the director of the United States Mint, he moved swiftly to suppress their circulation. By December 1837, the newspaper ads stopped appearing, and eventually the coins disappeared.

20

*VIEW ON THE
KISKEMINITAS*, 1838

Joshua Shaw

(American, born England, 1776–1860)

Oil on canvas

34¾ x 48 in. (88.3 x 121.9 cm)

FROM 1819 TO 1821, Joshua Shaw published *Picturesque Views of American Scenery*, one of the first American publications to boast color plates. In his text, Shaw wrote that every inch of Europe had been explored by artists, "while America only, of all the countries of civilized man, is unsung and undescribed. . . . [And yet here is] every variety of the beautiful and the sublime . . . unsurpassed by any of the boasted scenery of other countries."[65]

View on the Kiskeminitas shows Shaw at his peak. The light-filled center clearing, the bucolic cattle, the clouds and shadow, and the lush foliage add to the pastoral landscape. In the distance, though, smoke rises from industrial buildings beyond the river.

The Kiskiminetas River (the current spelling) is a tributary of the Allegheny, and this painting shows not the iron-ore blast furnaces that might be expected near Pittsburgh, but the area's bustling salt-manufacturing facilities. An 1826 Pittsburgh city directory explained: "On the Conemaugh and Kiskeminitas rivers, about 40 miles from Pittsburgh, there are twenty-five salt manufactories in operation. . . . These establishments give employment to at least 400 persons, and support, including managers, coopers, blacksmiths, colliers, boilers, &C."[66]

21

VIEW OF NIAGARA FALLS AND TERRAPIN TOWER FROM THE AMERICAN SIDE, ca. 1857–60
Ferdinand Richardt (Danish, 1819–1895)
Oil on canvas
36 x 29¼ in. (91.4 x 74.3 cm)

IN THE NINETEENTH CENTURY, landscape artists flocked to Niagara Falls to try their hands at capturing its beauty and power. Although many artists show the falls as a lonely natural wonder, surrounded by miles of unspoiled forest, the railroad brought many, many tourists to the site—by 1850, an estimated eighty thousand sightseers per year.

Ferdinand Richardt, a Danish artist, famously created dozens of stunning paintings of the falls. During his first visit to America, from 1855 to 1859, he produced thirty-two canvases and exhibited them together in his "Great Niagara Gallery." (This painting has not been identified as part of the exhibit.) Later, in 1873, when he immigrated to the United States, he stopped at Niagara Falls for another visit before settling in California.

Terrapin Tower was built on Terrapin Point, a group of rocks on the edge of the falls; they looked like giant turtles to some viewers. In 1827, the owners of the land on the American side of the falls, including Terrapin Point, built a three-hundred-foot wooden bridge from Goat Island to the very edge of the falls, creating a spectacular vantage point. In 1833, they added Terrapin Tower, an observation deck. The tower attracted many visitors (and much criticism because it distracted from the falls' natural beauty), but it was destroyed by 1873. In this painting, the tower—and about forty tiny figures, some mere squiggles of paint—spotlights the vast scale of the falls.

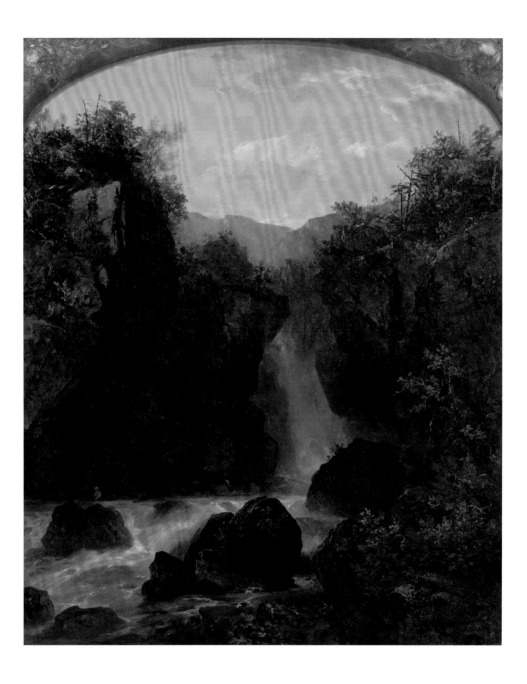

WATERFALL, 1853
John Frederick Kensett
(American, 1816–1872)
Oil on canvas, in the original frame
35 x 29¼ in.
(88.9 x 74.3 cm) overall

JOHN FREDERICK KENSETT was the son of an engraver, and he did engraving work for banknotes before turning to landscape painting. His finely detailed landscapes were influenced by Thomas Cole (1801–1848) and John Constable (1776–1837), and later by Asher Brown Durand (1796–1886). Friends with almost every other American painter of note during his lifetime, he was known for his busy social life and his fondness for cigars and whiskey.

Kensett was based in New York City, and unlike artists who traveled long distances to seek out new inspiration, he returned again and again to paint beauty spots that were easy to reach from the city. "I long to get amid the scenery of my own country for it abounds with the picturesque, the grand, and the beautiful—to revel among the striking scenes which a bountiful hand has spread over its wide-extended and almost boundless territory," Kensett wrote.[67]

The exact site of this waterfall has not been identified, but wherever it was, it probably looked very similar to this painting. Kensett's work is noted for its realism, and he crafted completely recognizable paintings of Lake George in New York, Bash Bish Falls in Massachusetts, and the coast off Rhode Island and Massachusetts.

23

VIEW OF OTSEGO LAKE
NEAR COOPERSTOWN,
NEW YORK, 19th century
Jacob Caleb Ward (American, 1809–1891)
Oil on canvas
22½ x 29½ in. (57.2 x 74.9 cm)

ALMOST TWO HUNDRED YEARS after Jacob Caleb Ward captured it in this painting, Otsego Lake in New York State remains clear and sparkling today. Located in the foothills of the Catskill Mountains, the lake is the source of the Susquehanna River and the largest freshwater contributor to the Chesapeake Bay.

The name "Otsego" comes from the Iroquois word for "place of the rock." Council Rock, a large rock at the southern tip of the lake, near the mouth of the river, served as a meeting place for the Native American nations of the Haudenosaunee, or Iroquois, Confederacy.

James Fenimore Cooper gave Otsego the nickname Glimmerglass in his Leatherstocking Tales, and it plays a major role in *The Deerslayer*. "They reached the lake just as the sun was setting. Here all was unchanged; the river still rushed through its bower of trees; the little rock was wasting away by the slow action of the waves in the course of centuries; the mountains stood in their native dress, dark, rich, and mysterious; while the sheet glistened in its solitude, a beautiful gem of the forest."[68]

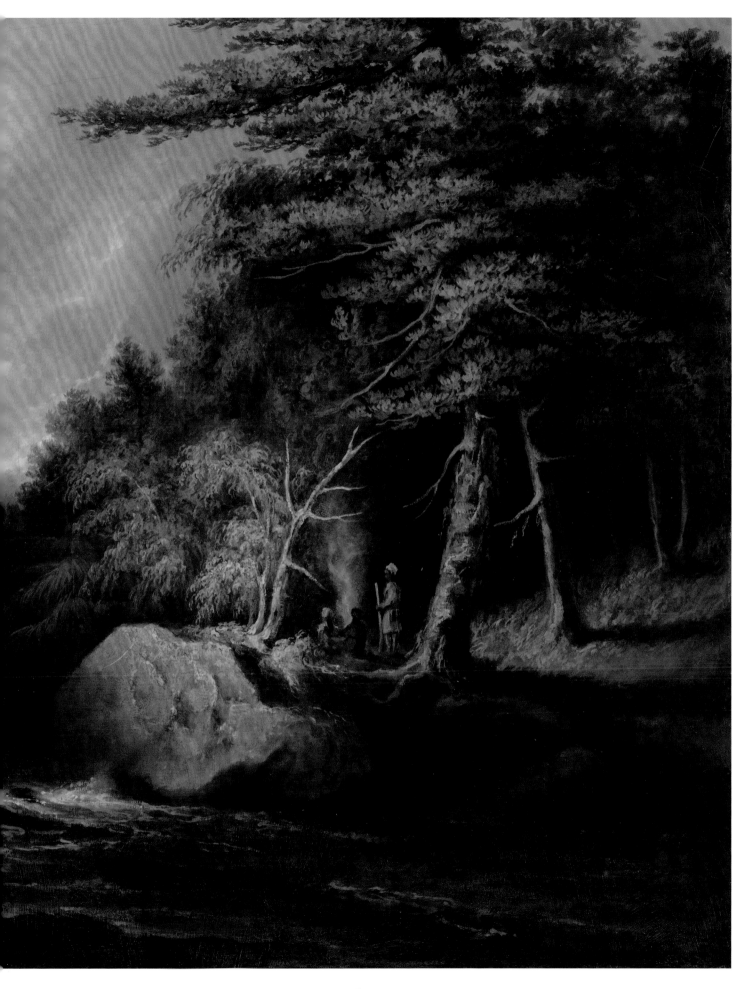

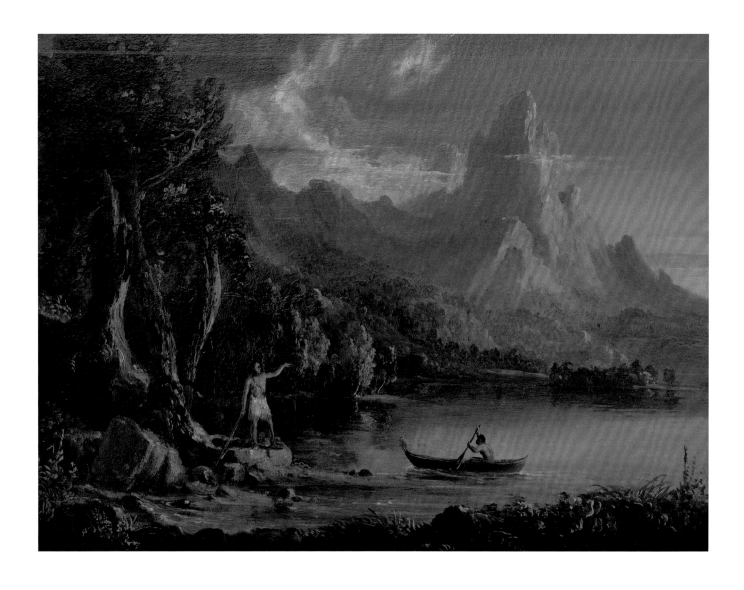

*INDIANS IN A MOUNTAIN
LANDSCAPE*, n.d.

Thomas Cole

(American, born England, 1801–1848)

Oil on walnut panel, in the original frame

17¾ x 21½ in. (45.1 x 54.6 cm) overall

"THE MOST DISTINCTIVE, AND perhaps the most impressive, characteristic of American scenery is its wildness," wrote Thomas Cole. "It is a subject that to every American ought to be of surpassing interest . . . it is his own land; its beauty, its magnificence, its sublimity—all are his."[69]

Born in England during the Industrial Revolution, Cole moved to Ohio with his family as a teenager, then, as an adult, to Catskill, New York. His career as a landscape artist flourished when his work drew the attention of John Trumbull, Asher Brown Durand, and other artists and patrons. He went on to produce dozens of paintings of the Adirondack and Catskill Mountains, and he is best known for initiating the Hudson River School.

Later in his career, he worked to create a "higher style of landscape," one that encompassed narrative. Some of these paintings had a biblical component; others were allegorical. A few were literary—he created several landscapes illustrating the climactic scene in James Fenimore Cooper's *Last of the Mohicans*. Like those paintings, *Indians in a Mountain Landscape* places Native people in a scene of stunning natural beauty, but relegates them to the nation's past.

25

*A TWO-TIERED STILL
LIFE WITH FRUIT (NATURE'S
BOUNTY)*, after 1852
Severin Roesen
(American, born Prussia, 1815–after 1872)
Oil on canvas, mounted on Masonite
29¼ x 44¼ in. (74.3 x 112.4 cm) overall

THIS STILL LIFE, with its voluptuous fruit and twining vines, is very representative of Severin Roesen's oeuvre. (Note that he twirled the grapevine into his signature at lower left.) Born in Prussia, Roesen worked as a porcelain painter and artist in Cologne. As a young man, he immigrated to New York, where he exhibited a few paintings. In 1857, he moved to Pennsylvania: Philadelphia at first and then the smaller towns of Harrisburg, Huntingdon, and finally Williamsport.

There, the Williamsport newspaper later reported, Roesen's studio was "much frequented by his friends, who would sit all day with this genial, well read and generous companion, smoking his pipes and drinking his beer," and "he was seldom without this beverage."[70]

In the 1860s and 1870s, Williamsport was a wealthy lumber town, and Roesen found buyers in the large German American community. He painted variations on his favorite compositions over and over, often using the same flowers or fruits or even whole arrangements of a bouquet or overflowing bowl. Even the bird's nest makes frequent reappearances, always with three eggs—like many of the other elements, a symbol of renewal and rebirth that would have resonated with his clients after the Civil War.

BARTER FOR A BRIDE
(*FAMILY GROUP*), ca. 1854–60
John Mix Stanley
(American, 1814–1872)
Oil on canvas
40 x 63 in. (101.6 x 160 cm)

IN JANUARY 1865, a fire caused massive damage to the Smithsonian Institution's main building, the Castle. Among the treasures lost that day were dozens of paintings by John Mix Stanley, all part of his planned Indian Gallery.

An artist and an adventurer, Stanley had made the paintings over eleven years traveling the American West, creating a record of the people and the landscapes he saw. Of 150 paintings housed at the Castle, only seven were saved. Stanley was to spend the rest of his life struggling to re-create the works that had been destroyed.

Barter for a Bride captures a courtship ritual among the Blackfoot Indians in what is now Montana. (The waterfalls in the distance are the Great Falls of the Missouri.) The prospective groom, on horseback, brings gifts for the chief and his daughter; the gifts, rather than being carried by hand, are transported on two travois—sleds for carrying loads, pulled behind horses. The prospective bride reclines on the grass, considering her suitor.

27

VALLEY OF LAKE PEPIN,
MINNESOTA, 1864
Robert S. Duncanson
(American, 1821–1872)
Oil on canvas
29½ x 46 in. (74.9 x 116.8 cm)

ROBERT DUNCANSON WAS THE FIRST African American painter to become renowned at home and abroad. In 1850, Duncanson was commissioned by Nicholas Longworth, a Cincinnati patron of the arts, to create a series of eight murals for his home. Longworth, impressed by Duncanson's work, called him "one of our most promising painters,"[71] and sponsored him on a grand tour of Europe in 1853. When he returned home, Duncanson continued to paint landscapes, as well as portraits of local notables.

As the Civil War began, life in Cincinnati became increasingly dangerous for free Blacks. To escape the dangers, Duncanson traveled north, through the upper United States and eventually into Canada. During that time, he created romantic landscapes of sites in the Midwest, including this painting of Lake Pepin, one of the most beautiful lakes in the United States.

After Canada, Duncanson traveled to Europe, where he was treated like a celebrity. He met earls, duchesses, and even the king of Sweden, who purchased a Duncanson painting. Queen Victoria bought one, too. When the war ended, Duncanson returned to Cincinnati and opened his own art gallery, filling it with paintings of the Scottish Highlands he had admired on his travels.

VALLEY OF
THE YOSEMITE, 1868
Thomas Hill
(American, born England, 1829–1908)
Oil on canvas
42 x 39 in. (106.7 x 99.1 cm)

BORN IN 1829, THOMAS HILL originally came from Birmingham, England; his family immigrated to the United States when he was a teenager. In 1861, after painting the White Mountains of New Hampshire and becoming familiar with the work of the Hudson River School painters, he moved to California and set up a studio in San Francisco. He made his first trip to Yosemite in 1865. He spent the next few years traveling between California, Boston, and France; in Paris, he studied the techniques of the Barbizon School, with its emphasis on naturalistic landscape painting.

Each of his moves included his wife, Charlotte Hawkes, and their nine children. In 1873, the family moved back to San Francisco, where Hill became part of the emerging California art scene. After one sketching tour of Yosemite in 1879, for example, he returned to his studio with thirty oil sketches; several were turned into full paintings.

Today his studio, located near the Mariposa Grove of Giant Sequoias, serves as the Wawona Visitor Center at Hill's Studio. The visitor center hosts a permanent exhibition of Thomas Hill's work, re-creating a Victorian art gallery with paintings hung from floor to ceiling.

29

THE CLIFFS OF
GREEN RIVER, WYOMING, 1900
Thomas Moran
(American, born England, 1837–1926)
Oil on canvas
20¼ x 30¼ in. (51.4 x 76.8 cm)

IN 1871, THOMAS MORAN was hired to illustrate a magazine article about a remarkable area called Yellowstone, in Wyoming Territory. With spewing geysers, towering waterfalls, fierce grizzly bears, and boiling mud, Yellowstone sounded incredibly exotic to the young artist, and so he took the train from his home in Philadelphia all the way to Utah. Then he continued north, traveling by horse and coach to join the United States Geological Survey near Virginia City, Montana; from there they would enter Yellowstone.

But on his way to Yellowstone, Moran stopped off in Green River, Wyoming, and spotted the towering cliffs that lined the river valley.

This vision proved life-changing for him. He sketched the cliffs right away, drawing a picture he labeled "First Sketch Made in the West." He was to sketch the cliffs again and again on subsequent trips. From his sketches, he created more than thirty paintings of the cliffs over the next forty years.

Moran did go on to join the geological survey, and to paint watercolors that helped persuade Congress to designate Yellowstone as America's first national park. But throughout his long career, he returned to Green River repeatedly.

AMERICAN EAGLE
WALL PLAQUE,
ca. mid-19th or mid-20th century
George Stapf (American, 1862–1958) or
John Bellamy (American, 1836–1914)
Pine, painted and gilded
23 x 40½ x 5⅞ in. (58.4 x 102.9 x 14.9 cm)

"HE IS A BIRD OF BAD moral character," wrote Benjamin Franklin.[72] Despite Franklin's misgivings, Americans embraced eagles as a national symbol starting from the earliest days of the United States. Wood-carvers like George Stapf and John Bellamy often featured the birds alongside the Stars and Stripes.

Although little is known of George Stapf, Bellamy specialized in eagles, producing them in large quantities in his hometown of Kittery, Maine, and throughout New England. Bellamy eagles, like those by Stapf, adorned homes, town halls, and sailing ships. The distinctive

style featured deeply incised eye sockets, broad hooked beaks, and well-defined wings to give his birds the illusion of lift and flight.

This noble example supports a fluttering flag with thirty-five applied gilt stars. Its eye is a faceted glass bead, and its scalloped beak reveals a scarlet tongue. The carver worked in sections, which were painted before being assembled into the imposing whole. Other examples by Bellamy feature carved mottoes, ranging from "Don't Give Up the Ship" to "Merry Christmas" to "Live and Let Live."

31

WINTER FARMSTEAD, 1856

George Henry Durrie
(American, 1820–1863)
Oil on canvas
22 x 30 in. (55.9 x 76.2 cm)

EARLY IN HIS CAREER, George Henry Durrie was a portrait painter. But as photography became increasingly available (and increasingly popular for portraits), he turned to landscapes. By 1845, newspapers near his hometown of New Haven, Connecticut, were carrying ads for Durrie's "snow pictures." He specialized in winter scenes of idyllic rural settings.

As with many New England artists and writers, Durrie did not dislike winter; he saw it as a time of rest and self-reliance. "Today the weather has been beautiful and the sleighs have been constantly on the move, making the scene very animated," he wrote in his diary.[73]

Durrie's art appealed to patrons who sought a connection to their own childhoods and to a simpler way of life. Starting in the early 1860s, the lithographers Currier and Ives capitalized on the public's sense of nostalgia by creating affordable prints of ten of Durrie's paintings. The lithographs went on to become some of the most beloved and oft-reprinted items in the company's catalogue, remaining popular until well into the twentieth century.

THOMAS STRONG'S FARM,
SETAUKET, 1864
William Sidney Mount
(American, 1807–1868)
Oil on paper mounted on panel
10⅞ x 17¼ in. (27.6 x 43.8 cm) overall

WILLIAM SIDNEY MOUNT is considered America's first professional genre painter. His landscapes, most sketched outdoors near his home in Stony Brook, Long Island, are less well known. He disliked working outdoors—he was bothered by insects and unpredictable weather—so he commissioned his own portable sketching house in 1861. The unit, designed by Mount himself, had plate glass windows, a skylight, ventilation, a stove, and wheels.

"No time is lost on account of the hot or cold air. This vehicle with glass windows can be drawn by hand, or behind a wagon if the painter should not wish to keep a horse," Mount wrote.[74]

Strong's Neck in Setauket, the location of Thomas Strong's farm, is less than four miles from Stony Brook, so Mount may have sketched the site from the comfort of his portable studio. Although a native of the region, the artist probably did not know that Thomas Strong's farm was used as a spy stronghold during the American Revolution. Historians believe that Anna Strong, the mother of Thomas, was part of the Culper Spy Ring, which supplied George Washington with military intelligence during the Revolution. Anna Strong's job was to coordinate communication among the spies by hanging specific garments on her clothesline—coded messages that were easily visible from Long Island Sound and surrounding areas.

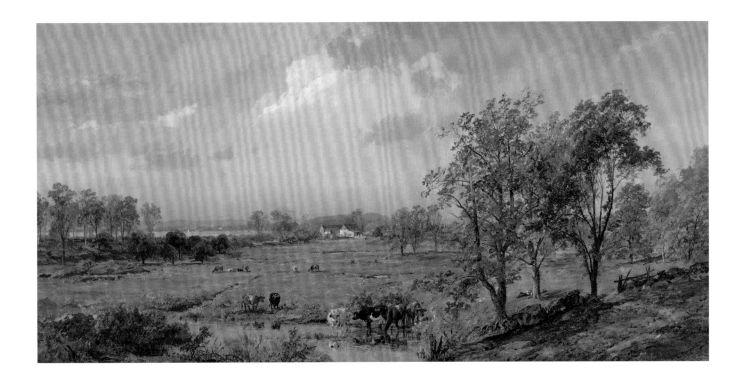

33

FARM ON THE HUDSON, 1879

Jasper Francis Cropsey

(American, 1823–1900)

Oil on canvas, mounted on Masonite

17½ x 35½ in. (44.5 x 90.2 cm) overall

TRAINED AS AN ARCHITECT, Jasper Cropsey studied art in Europe, then returned home to travel through New York, Vermont, and New Hampshire. In 1856, he moved to London. There, and for the rest of his career, his specialty was paintings set in the fall—he was often called the Painter of Autumn.

To capture the vivid colors of fall foliage in the northeastern United States, he made full use of new, brighter, chemical-based paints first manufactured in the mid-1800s. When she saw one of Cropsey's autumnal landscapes, Queen Victoria is said to have suspected that he had exaggerated the brightness of the leaves. So Cropsey had real fall leaves sent from America to show her, and to display alongside his paintings for other disbelievers.

Cropsey went back to New York in 1863 and continued to paint autumn landscapes for several decades. In 1878, returning to his architectural training, he designed the ornate wrought iron passenger stations for the El along Sixth Avenue in Manhattan; the owners of the elevated rail line hired Cropsey in hopes that his distinguished artistic credentials and his elegant stations would distract people living along its path from the noise and grime of the trains.

34

THE SPIRIT OF '76
(YANKEE DOODLE), 1875
Archibald M. Willard
(American, 1836–1918)
Oil on canvas
24 x 18 in. (61 x 45.7 cm) overall

FOR THE CENTENNIAL Exhibition of 1876 in Philadelphia, the business partners Archibald Willard and James F. Ryder (1826–1904) planned something special. Their usual stock-in-trade was humorous drawings created by Willard, the artist, which were then turned into chromolithographs promoted by Ryder, the entrepreneur.

Yankee Doodle was originally going to be just another funny picture, but Willard changed his mind. Instead, he created a work of art that was destined to become one of America's best-known patriotic images.

The finished painting, ten feet tall and eight feet wide, made an impression on every visitor who saw it at the Centennial Exhibition—and

conveniently enough, every visitor could take home a full-color photomechanical reproduction of the painting for two dollars. (The cost of making each print was seventeen cents, allowing for a truly all-American profit margin.)

This smaller painting is the original, used as the model for the chromolithograph; it was painted by Willard as an exact guide for the printers so that the reproductions could be made up in advance and ready to sell when the large painting was exhibited.

In 1879, with the big Centennial painting touring the country and the reproductions already common in households across America, Willard renamed the image *The Spirit of '76*.

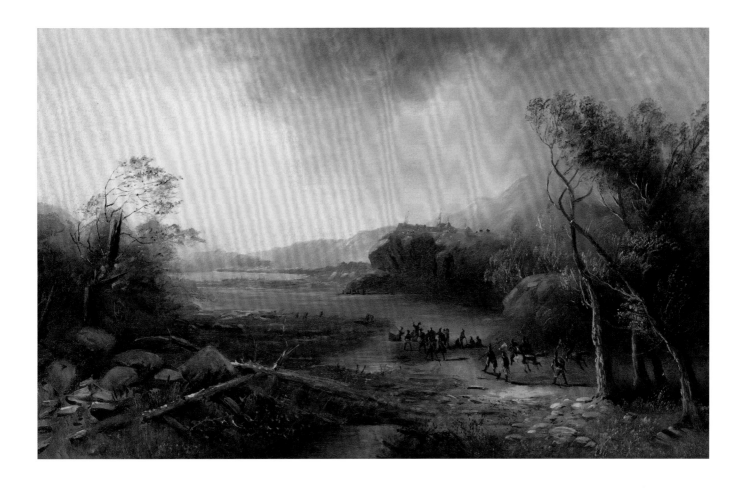

MANDAN VILLAGE ON UPPER MISSOURI, n.d.
Andrew Melrose
(American, born Scotland, 1836–1901)
Oil on canvas
30 x 50 in. (76.2 x 127 cm)

ANDREW MELROSE EMIGRATED from Scotland to America in 1856. In 1867, he was commissioned by the Chicago and North Western Railway to commemorate the extension of the railroad line to Council Bluffs, Iowa.

By the 1870s, Melrose was painting large landscapes in a style similar to that of Frederic Edwin Church. Like Hudson River School paintings, Melrose's landscapes are often panoramic in scope, with tiny human figures revealing the majestic scale of mountains, lakes, and other scenery.

The Mandan Indians, who lived in large settlements on the Upper Missouri River in what is now North Dakota, were known for their business prowess, farming, and hospitality. In October 1804, the Lewis and Clark Expedition began a long winter stay near the five villages of the Mandan and Hidatsa tribes. Today, visitors can see three of the villages at the Knife River Indian Villages National Historic Site.

INDIAN PUEBLO, n.d.
Joseph Henry Sharp (American, 1859–1953)
Oil on composition board
16 x 14 in. (40.6 x 35.6 cm)

A CHILDHOOD ACCIDENT led to the loss of Joseph Sharp's hearing, and an early exit from conventional schooling. But he discovered his talent for art while he was still a teenager, and he made his first trip to the American West in 1883, when he was twenty-four years old. He always traveled with a notebook, which served as both a sketchbook and a communication tool.

On that first trip, he visited pueblos like this one in New Mexico; made stops in Santa Fe, Albuquerque, and Tucson; and then took a boat trip up the West Coast. Later, he spent time in Montana, where he camped at the Little Bighorn and painted portraits of Plains Indians. In 1900, those portraits traveled east, in a successful exhibition that went to Paris and Washington, D.C. The Smithsonian Institution purchased eleven paintings, and President Theodore Roosevelt took a personal interest in Sharp's work. The collector Phoebe Apperson Hearst (mother of the newspaper publisher William Randolph Hearst) bought eighty.

In 1910, Sharp moved to Taos, New Mexico, where he was a cofounder of the Taos Society of Artists. Although he traveled widely, he called Taos his "first love and stomping ground."[75] Sharp maintained his studio there for more than four decades, painting hundreds of images of local scenery and people.

37

38

STREET IN CHINATOWN, 1885
Edwin Deakin
(American, born England, 1838–1923)
Oil on panel
35½ x 25½ in. (90.2 x 64.8 cm)

STREETS OF PROVINCETOWN, 1900
Childe Hassam (American, 1859–1935)
Oil on canvas
21½ x 15½ in. (54.6 x 39.4 cm)

LIVING AND WORKING in San Francisco from 1870, Edwin Deakin captured the city's Chinatown at a time of tremendous growth and change. After the last spike for the transcontinental railroad was driven home in 1869, thousands of Chinese laborers flocked to the city; an estimated twelve thousand lived there in 1870. Men packed into boardinghouses while street-level stores opened to provide goods and services to them.

Largely self-taught, Deakin is probably best known today for his paintings of the Spanish missions in California. But he also created still lifes, architectural views, and paintings of European cities.

In 1883, a parade in Chinatown inspired him to create a series showcasing the neighborhood; the paintings proved very popular. Here the artist has placed his signature directly on one of the buildings, like a street sign or graffiti. His name appears front and center, vertically, in an imitation of Chinese characters.

CHILDE HASSAM, THE MOST prominent of the group of American painters known as the Ten, was the leading American impressionist of his time. Today, his streetscapes of Boston, Paris, and New York are his best-known images, but he also appreciated old-fashioned New England towns. In 1900, he visited Provincetown, Massachusetts, just as the fishing town was beginning to become popular with tourists. While he was there, he painted landscapes and seascapes, as well as street scenes.

The church in this painting still stands on Commercial Street in Provincetown today, and it is still a beloved local landmark. The building was constructed in 1847, with the steeple added ten years later. But Provincetown's sandy soil could not support such a tall tower, and the steeple almost immediately started to lean. Although it has been stabilized with steel support beams, it still has a picturesque tilt.

With the handsome church, the passing pedestrians, the little dog, and the furled American flag, *Streets of Provincetown* captures a precise moment in small-town America and reflects Hassam's belief that "the man who will go down to posterity is the man who paints his own time and the scenes of every-day life around him."[76]

THE PRAIRIE, 1915

Maynard Dixon (American, 1875–1946)

Oil on canvas

74 x 90 in. (188 x 228.6 cm)

BORN IN FRESNO, California, Maynard Dixon studied briefly at the California School of Design, then set out on his own. His first job was creating illustrations of western life for the *Morning Call* in San Francisco. Advised to "travel east to see the real West,"[77] he began years of exploration, crisscrossing the western states again and again over the next decades. He visited Montana, Utah, Nevada, Arizona, and New Mexico on trips that lasted weeks and months.

In 1902, Dixon made his first visit to Hubbell's Trading Post, in the Navajo Nation reservation in northeastern Arizona. At the trading post, first opened in 1878 and today a National Historic Site, Dixon was inspired. The Hubbell family hosted exciting dinner parties for visitors from every walk of life; conversation ranged from art to agriculture to how many rounds of .30-06 ammunition Teddy Roosevelt needed to put down a full-grown rhino (nine). Dixon returned to the trading post, and to Arizona, many times over the years; he made his final home in Tucson.

The Prairie showcases his mastery of light and shadow. Although the exact location is unknown, the painting captures the spirit of the wide-open American prairies.

APPEAL TO THE GREAT SPIRIT,
ca. 1916–20
Cyrus Edwin Dallin
(American, 1861–1944),
Gorham Manufacturing Company
(American, founded 1831)
Bronze
H. 21⅜ in. (54.3 cm)

CYRUS EDWIN DALLIN was born in Springville, Utah Territory; his parents were among the founders of the town. As a child, he played with Native American children from nearby encampments. Later, as a young art student, he attended the Académie Julian—but he threw his classical studies aside when Buffalo Bill's Wild West show came to Paris in 1889.

The Wild West show combined exciting dramatizations of historic moments in westward expansion with opportunities to learn about Native American culture. More than one hundred American Indians, mostly Lakota Sioux, lived on the show grounds in tepees, demonstrating their skills for the public.

After seeing the show, Dallin began creating bronzes depicting American Indians. *Appeal to the Great Spirit* was cast in bronze in Paris and, in 1912, was erected in front of the Museum of Fine Arts, Boston. Thousands of small plaster reproductions were made of the statue and sold widely. In 1916, some 400 bronze replicas were made in three different sizes; this example is one of 109 in the middle size, about twenty-one inches tall.

Partly because of the popularity of these reproductions, the image is still widely known—and widely debated. Dallin intended his works to honor American Indians; in the twenty-first century, his art and his motivations are seen in a different light. Late in life, Dallin became a Native American rights activist. He told the *Boston Globe*, "The attitude of white people toward Indians in general is one of supreme arrogance."[78] Today, many Americans see *Appeal to the Great Spirit* and similar works as troubling reminders of our history of cultural appropriation and Native American erasure.

CERAMICS

FOREIGN WARES
TO AMERICAN SHORES

Alice Cooney Frelinghuysen

THE COLLECTION OF THE Diplomatic Reception Rooms at the U.S. Department of State contains, on the one hand, superb examples of American artistry, design, and craftsmanship and, on the other, imported wares, such as ceramics, that are a testament to the nation's early engagement and emergence in global trade, as relevant today as it was in the late eighteenth and early nineteenth centuries. The holdings encompass a dazzling array of porcelains made in China for members of the expanding merchant class, many of whom distinguished themselves as Patriots during the Revolutionary War. There are also outstanding examples from the Atlantic trade between the new nation and Great Britain and France. This essay looks at the interconnectedness of these works of art, spanning oceans and cultures, and will touch upon some of the more complicated and difficult histories that these objects may represent.

Following the Revolution, Americans enjoyed unprecedented commercial success. In the wake of routes established first by Portugal and then by other foreign nations, American ships sailed the waters across the globe to India, Indochina, the Malay Archipelago, and China, bringing back coveted products, notably tea, spices, silks, lacquerwares, ivory, and of course, porcelain. Chinese porcelain, long prized as the finest ceramic material, was a mark of wealth and good taste. In this country, it took on added meaning as a symbol of independence from Britain's restrictive trade policies, as the new nation entered into the lucrative China Trade.

While Americans had been able to acquire such goods through Britain, it was not until 1784, a year after Britain formally acknowledged American independence, that the first American ship to trade with China sailed from New York Harbor for Guangzhou, known to Europeans as Canton. Trade with China was highly regulated, and foreign merchants were confined to a small section of the city's waterfront, where Western trading establishments, or *hongs*, were located, each country with its individual outpost (see cat. 41). The porcelain, or "china ware" as it was called, was often the bulky and heavier ballast upon which the more

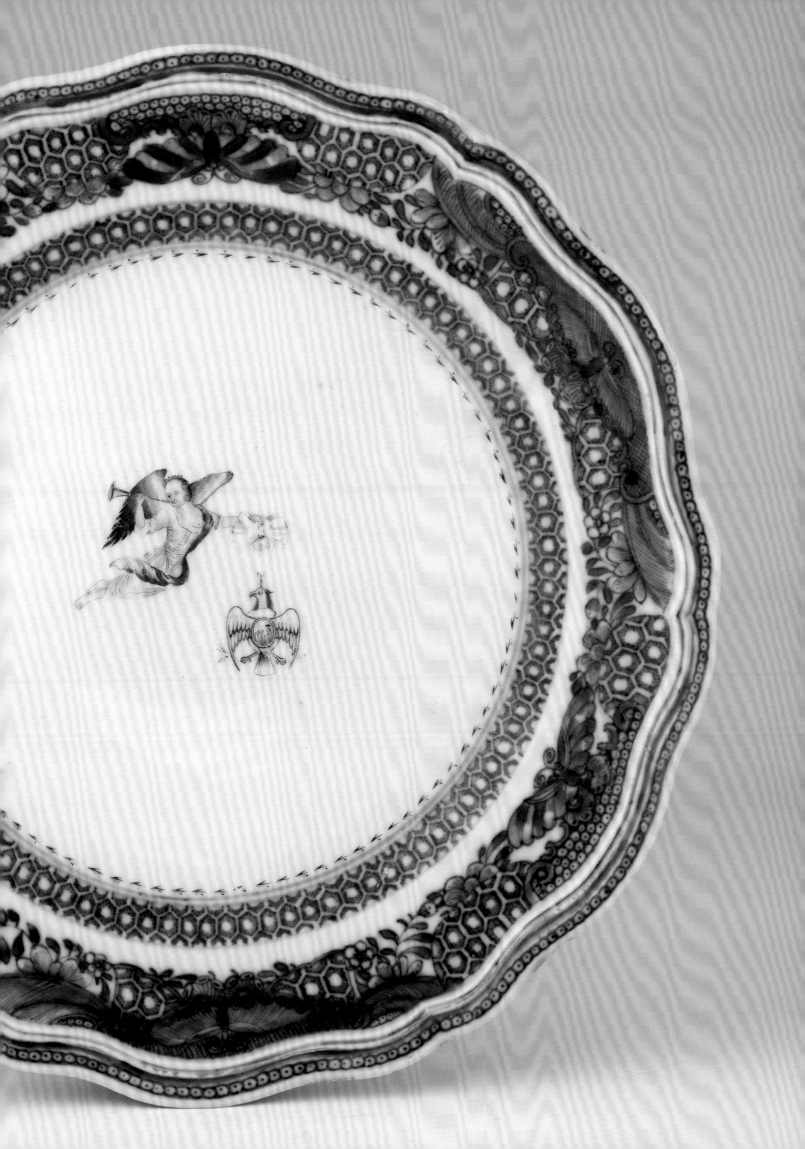

costly, delicate, and even more highly valued items like tea and silk were placed in one of the many merchant ships that plied the seas.

The porcelain was made in large kilns located inland in Jingdezhen, situated some five hundred miles away, and then sent to Guangzhou, where anonymous skilled Chinese decorators, responding to the tastes of Western patrons, provided the enamel painted decoration, a system that had been practiced by European merchants for more than a century before Americans began direct trade with China (see cat. 42). These wares would then grace the tables of the handsome homes of their owners at one of the country's thriving port cities from Salem, Massachusetts, to Charleston, South Carolina. Today, in the Diplomatic Reception Rooms, these very objects have become emblems of a nation seeking its own identity in the larger world.

Many of the porcelains were special orders, individualized for a specific client, whereby the American supercargo, or agent, would provide detailed instructions—drawings or prints—for the Chinese decorators to copy. While a number of the personalized porcelains decorated for Americans were ornamented with pseudo-armorials, perhaps a simple shield and garland enclosing the client's initials (cats. 43, 51), others display highly precise renderings, such as the coats of arms painted on the service made for the Gloucester, Massachusetts, merchant Ignatius Sargent (1765–1821), likely replicated by the Chinese painters from an engraved bookplate (cat. 46). Different services bore the coats of arms of the states most active in the China Trade, notably those of New York (cat. 50) and Rhode Island (cat. 49), often with additional embellishment of initials and borders, sometimes blue emblazoned with tiny gold stars, suggesting an American context. Others catered even more generically to the American market, like services adorned with a spread eagle (cat. 64), to which the client's initials might or might not be added.

A number of the services were made for individuals who had distinguished themselves in the fight for America's independence, such as Elias Hasket Derby (1739–1799) (cat. 47),

Jar, 1858
Dave (later recorded as David Drake)
(American, ca. 1801–1870s)
Stony Bluff Manufactory
Old Edgefield District, South Carolina
Alkaline-glazed stoneware
H. 22⅝ in. (57.5 cm); Diam. 27 in. (68.6 cm)
The Metropolitan Museum of Art,
Purchase, Ronald S. Kane Bequest, in
memory of Berry B. Tracy, 2020 2020.7

Teapot, ca. 1765–69
John Bartlam
(Staffordshire, England, and
Camden, South Carolina, 1735–1781)
Cain Hoy, South Carolina
Soft-paste porcelain with
underglaze blue decoration
H. 3⁹⁄₁₆ in. (9 cm); W. 6⅞ in. (17.5 cm)
The Metropolitan Museum of Art,
Purchase, Ronald S. Kane Bequest,
in memory of Berry B. Tracy;
Louis V. Bell, Harris Brisbane Dick,
Fletcher, and Rogers Funds and Joseph
Pulitzer Bequest; and Richard L. Chilton
and Anthony W. and Lulu C. Wang Gifts,
2018 2018.156

Richard Gridley (1710–1796) (cat. 53), and Thomas Mifflin (1744–1800) (cat. 43). George Washington (1732–1799) acquired a large service with enamel decoration of an Angel of Fame holding aloft a ribbon from which was suspended the medal for the Society of the Cincinnati (cat. 44), the fraternal organization for officers in the Continental Army who had served in the Revolutionary War. Other services associated with Washington feature a miniaturist depiction of Mount Vernon (cat. 61).

While the services owned by distinguished American citizens speak to the emerging prosperity of the new nation, at the same time, they also represent more difficult, untold histories. Notably, the fortunes of many of the owners of elegant Chinese porcelains derived either directly or indirectly from an economy fueled by enslaved labor. The China Trade made many Americans very wealthy, and porcelains were among the luxury goods that conferred status and power. One of the most affluent was Elias Hasket Derby, Salem's preeminent merchant in the late eighteenth century and probably America's first millionaire. First his father, Richard Derby (1712–1783), and then Elias were involved in the codfish and sugar trade with the West Indies that was the foundation of Salem's eighteenth-century prosperity.

Similarly, John Brown (1736–1803), a prosperous merchant in Providence, whose service is decorated in patriotic blue (cat. 56), was not only a slaveholder but also an active trader of enslaved people, owning numerous slave vessels himself and investing in those owned by others. He was part of the so-called triangular trade (involving Europe, Africa, and the Americas, including the West Indies), which included not just shipping but the production of rum from sugar and molasses plantations with their crews of forced labor. An active defender of slavery throughout his life, Brown continued to engage in the international slave trade even after American participation in it was outlawed under the Slave Trade Act of 1794.

Others whose material wealth was represented by their impressive large, commissioned Chinese export services were plantation owners, such as the Chew family of Philadelphia (cat. 62), who had multiple plantations and homes in Maryland, Delaware, and Pennsylvania. Similarly, two large Chinese export services are associated with the Manigault family (cat. 65), who owned extensive rice plantations in and around Charleston and on the Savannah River in Georgia, the prosperity of which was the direct result of owning large numbers of enslaved workers.

Ceramics not only represented the trappings of wealth but also communicated other stories, such as the small jasper-ware medallion depicting in relief an enslaved Black man, kneeling, with his raised hands in chains, and the words "AM I NOT A MAN AND A BROTHER?" made by Wedgwood pottery in Staffordshire, England (cat. 66). While the medallion was not specifically made for the American market, the

Vase, ca. 1828–36
Tucker Factory (1826–1838)
Philadelphia, Pennsylvania
Soft-paste porcelain with overglaze
enamel decoration and gilding; gilt-bronze handles
H. 21⅛ in. (53.7 cm)
The Metropolitan Museum of Art, Purchase,
Friends of the American Wing Fund;
Mr. and Mrs. Richard L. Chilton Jr., Annette de la Renta
and Anthony W. and Lulu C. Wang Gifts;
Richard Hampton Jenrette American,
Sansbury-Mills and The Beatrice G. Warren
and Leila W. Redstone Funds,
2012 2012.243

sentiment resonated with many Americans, who only a few years before had shed the shackles of British rule. Medallions were first produced in 1787 by Josiah Wedgwood (1730–1795), the firm's founder, who was an ardent opponent of slavery, for the Society for Effecting the Abolition of the Slave Trade, founded in that year, and from whose seal the relief derived. The following year, Wedgwood sent a shipment of the medallions to Benjamin Franklin (1706–1790) in Philadelphia, as he was then president of the Pennsylvania Abolition Society in America. Franklin acknowledged the gesture, writing, "I am persuaded [the medallion] may have an Effect equal to that of the best written pamphlet in procuring favour to those oppressed people."[79] It became an important emblem for social justice on both sides of the Atlantic. (For a related, American-made anti-slavery medal, see cat 19.)

Indeed, slavery may be directly linked to ceramics made in this country. In the Old Edgefield District in South Carolina, where significant clay deposits were located, there developed a large-scale production of alkaline-glazed stoneware utilitarian vessels that became essential to the operation of the large plantations in the region for food preparation and storage. Recent research has determined that stoneware was produced on a mammoth scale, in operations founded by Euro-American potters, and enslaved workers were integral to every aspect of manufacture.[80] Skilled potters threw the often massive vessels, while others were involved in building kilns, preparing the clay, and felling the trees necessary to fuel the kilns, as well as loading and unloading the kilns—widespread industrial slavery. One of the few enslaved potters to be identified is Dave (later recorded as David Drake), who often signed and dated his vessels. Many, like a jar dated 1858 in the collection of the Metropolitan Museum of Art (p. 188), are monumental in size and also bear verses or couplets, indicating that Dave was literate at a time when the enslaved were not permitted to read or write.[81]

The rich natural resources in Georgia and the Carolinas, not just stoneware clay but also large deposits of kaolin, gave rise to the first development of fine wares in America, demonstrating the ingenuity and entrepreneurship of the new nation. The kaolin that was available to the stoneware potters of Edgefield had been first discovered a little farther north in the 1760s, and British potters even sent a delegation to southwestern North Carolina to mine and export the precious clay. At the same time, between 1765 and 1769, the Staffordshire-trained John Bartlam (1735–1781) began making the earliest porcelain produced in America, in Cain Hoy, just outside Charleston. Few examples survive from that nascent operation, but as seen in a small teapot

(p. 189), Bartlam was striving to compete with the popular luxury ceramics that were made in England at that time and exported to the colonies. Such was his success that it prompted Wedgwood to write in 1767 of his concern that Bartlam's "Pott work in Charles Town" would threaten the American markets that had been his stronghold.[82] The use of local porcelain clays speaks to the nation's rich natural resources, and Bartlam's success is testament to the intrepid ambition and entrepreneurial spirit of colonial America. While there were other attempts to produce porcelain on American shores in the eighteenth century, it would not be until over half a century later that significant success was achieved for a duration of more than a few years.

Notwithstanding Bartlam's and others' efforts to manufacture porcelain and refined earthenwares, Americans in both the pre- and post-Revolutionary eras continued to rely on imported goods for their fine dinnerware and teaware. Following independence and a strong nationalistic fervor, and despite political embargoes and anti-British sentiment, British potters seized on a commercial opportunity to produce refined, cream-colored earthenware decorated with transfer-printed motifs specifically targeted to an American clientele. Often in highly standardized shapes—pitchers and mugs predominate—the decorations vary from eagles to portraits of American political leaders, armorials, and maritime scenes. Testament to America's continuing prowess on the seas, ships' portraits were common subjects (cat. 68), often personalized with the name of the ship, such as the *Two Pollys* (cat. 69). Patriotic motifs that catered to America's pride as a nation were often dominantly featured, as seen on the reverse of the *Two Pollys* pitcher with its elaborate engraving that memorializes the death of George Washington (cat. 69, left).

During the late eighteenth century, French porcelain became increasingly popular among America's elite, strengthened by the close cultural and political ties between America and France during the Revolution. Signaling this alliance is the bisque porcelain figure group of King Louis XVI in all his royal finery with Benjamin Franklin, signing the 1778 Treaty of Amity and Commerce, which recognized the United States' independence as a nation and encouraged trade between the two countries, and the Treaty of Alliance in case anything should threaten that trade (cat. 70). Franklin was a favorite presence while he was in Paris, and the French emblazoned his image on every manner of decorative element, including porcelain vases (cats. 74, 75). Beginning with Washington, the nation's presidents set the tone by ordering extensive Paris porcelain services (cats. 71, 72,

73). Many American diplomats and other political figures stationed in France in the late eighteenth and early nineteenth centuries—Benjamin Franklin and Thomas Jefferson (1743–1826) among them—purchased porcelains and sent them back to family and friends in America. A preference for things French became an indication of culture and prestige.

French and English taste set the stage for the growth of a successful ceramic industry on American shores. During the early nineteenth century, American entrepreneurs sought to enter the porcelain market by producing wares that resembled the popular French imports and rivaled them in quality. The first enterprise to witness any degree of lasting success was that established in Philadelphia by William Ellis Tucker (1800–1832) in 1826, which lasted an unprecedented twelve years. Tucker porcelains mimic both French and English forms with decorations ranging from simple gilded borders to colorful painted floral bouquets and delicate landscapes (cat. 77). The most elaborate are a small group of ornamental vases that vied with the best being produced abroad, with meticulously painted landscape scenes and applied gilt-bronze mounts (p. 190).

Thus, the ceramics in the collection of the Diplomatic Reception Rooms, U.S. Department of State—the Chinese export and French porcelains and British earthenwares—provide material evidence of America moving outward, trading as an independent nation and setting the platform for a global trade. Many of the goods imported not only reflected America's very independence but also showed their owners' adherence to the values of acquiring traditional trappings of prosperity and exhibiting such evidence of their newfound wealth. At the same time, America's emerging entrepreneurial spirit generated a powerful groundswell of support to become a self-sufficient nation and laid the foundation for an industrial age that fostered its own successful manufactories.

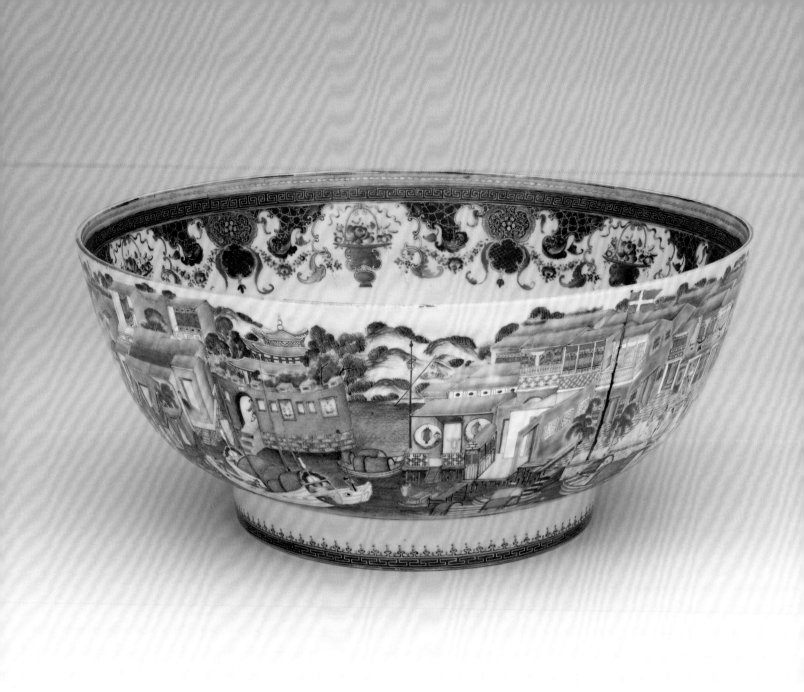

41

PUNCH BOWL,
ca. 1779–81
Made in Jingdezhen,
decorated in Guangzhou
China
Hard-paste porcelain
H. 6⅛ in. (15.6 cm.),
Diam. 14½ in. (36.8 cm)

BOWLS LIKE THIS are called hong bowls: they depict the hongs, or warehouses, lining the waterfront in Guangzhou, China (known at the time to Europeans and Americans as Canton). In the eighteenth century, thirteen hongs stood side by side, packed into a stretch about a thousand feet long. The two- and three-story warehouses extended back as much as five hundred feet from their narrow facades. The warehouses were rented by companies from different countries, and the little flags shown on these bowls mark the nationality of each tenant. They also help date the bowls today.

On this example, the flags reveal that the warehouses were rented by Denmark, Sweden, France, the Netherlands, and Britain. An unusual flag that was used only between 1779 and 1781 by a Hungarian-licensed French ship dates this bowl to a narrow sliver of time.

These bowls would be packed into crates and loaded onto the little boats depicted. Then they would make the journey to larger ocean-going ships docked at Whampoa Island (now Pazhou), a deepwater anchorage farther down the Pearl River. When the bowls reached America or Europe, their large size made them the perfect vessels for serving punch—a fashionable beverage at East Coast gatherings at the end of the century.

<div style="text-align:center">

42

CHARGER MADE FOR ELDRED LANCELOT LEE OR HIS SON, LANCELOT, ca. 1735

Made in Jingdezhen,
decorated in Guangzhou
China
Hard-paste porcelain
Diam. 12⅜ in. (31.4 cm)

</div>

IN THE 1700s, trade relations between Westerners and merchants in China were well established. By the time Americans arrived in China, everyone knew that Western traders were allowed to live in just one port city—Guangzhou—and only for four months of the year. Even there, they were restricted to a tiny area, less than a quarter of a mile square. The zone was along the waterfront, but it was packed with warehouses including living quarters.

For the bustling port cities of London and Guangzhou, life along the river took on familiar patterns. Yet traders of the British East India Company viewed the busy scene in Guangzhou Harbor with wonderment and awe. A visitor wrote, "The scene upon the water is as busy as the Thames below London Bridge, with this difference, that instead of our square-rigged vessels of different dimensions you have junks. . . . Nothing appears more extraordinary to the eyes of a stranger at Canton."[83]

This plate reveals what that visitor saw, in beautifully detailed scenes painted along the border. One panel shows London, looking from Southwark with London Bridge in the foreground; the other shows the Pearl River just below Guangzhou.

<div style="text-align:center">

43

SAUCER FROM THOMAS AND SARAH MORRIS MIFFLIN'S SERVICE, ca. 1775

Made in Jingdezhen,
decorated in Guangzhou
China
Hard-paste porcelain
Diam. 5⁹⁄₁₆ in. (14.1 cm)

</div>

BORN TO A QUAKER family of merchants in Philadelphia, Thomas Mifflin (1744–1800) held many offices during his life. But he is probably best remembered for his involvement in the Conway Cabal, a plot to oust George Washington as commander-in-chief, while Mifflin was serving as quartermaster general of the Continental Army. When the scheme was revealed and an inquiry was launched into Mifflin's activities, he resigned his commission in early 1779.

Thomas Mifflin had married Sarah Morris (1747–1790) in 1767; there is a double portrait of the couple by John Singleton Copley (now in the Philadelphia Museum of Art). After returning to Philadelphia following his resignation from the army—he had been ousted from the Philadelphia Friends Meeting earlier, for participating in the war—Mifflin served as a delegate to the Continental Congress and became its president in 1783.

In 1790, he was elected the first governor of the Commonwealth of Pennsylvania. Unfortunately, Mifflin overspent in his private life; this plate from his elegant Chinese import tea set reflects his taste for the finer things. With its blue-and-gilt border, its initial "M" in a central cartouche, and its dove with an olive branch, the plate reflects his commitment to peace even during Revolutionary times.

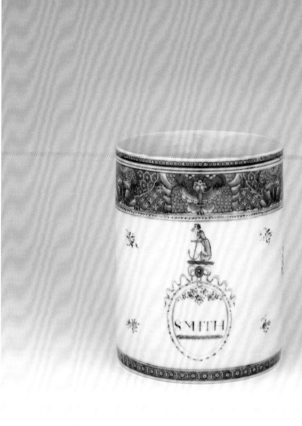

PLATE FROM GEORGE WASHINGTON'S SOCIETY OF THE CINCINNATI SERVICE, ca. 1784–85

Made in Jingdezhen, decorated in Guangzhou
China
Hard-paste porcelain
Diam. 9⅝ in. (24.5 cm)

MUG MADE FOR HENRY SMITH, ca. 1784

Made in Jingdezhen, decorated in Guangzhou
China
Hard-paste porcelain
6 x 4¾ in. (15.2 x 12.1 cm)

WHEN GENERAL Henry J. Knox and other veterans of the Continental Army formed the Society of the Cincinnati, the fraternal society honoring the Roman gentleman farmer and soldier Lucius Quinctius Cincinnatus, George Washington was honored to become the first president general of the group. A visitor to Mount Vernon in 1785 wrote that Washington's "greatest pride now is, to be thought the first farmer in America. He is quite a Cincinnatus, and often works with his men himself."[84]

The newly formed society had specially commissioned membership diplomas and badges (see cats. 107, 140). Then Samuel Shaw (1754–1794), an aide-de-camp to General Knox and a member of the Society of the Cincinnati, traveled to China on the *Empress of China*, the first ship to travel the trade route between America and China.

In China, Shaw ordered this special service—custom-designed to reflect the symbols of the Society of the Cincinnati. It was the first such set that Shaw commissioned; in the years to come, he commissioned at least six other Cincinnati-related sets for friends in the society. When it reached America, Washington acquired it for his personal use; his set features the Angel of Fame bearing the eagle-shaped Society of the Cincinnati badge on a blue ribbon and blowing a trumpet to declare its importance.

BORN IN 1766 in Providence, Rhode Island, Henry Smith (1766–1818) became a successful merchant who rose in the militia to be a colonel. In the early 1800s, he built a mansion on Smith Street in Providence. The house, known as the Colonel Henry Smith House, was a local landmark until the early 1920s, when it was razed to make way for an annex to the Rhode Island State House.

Smith was, very briefly, the governor of Rhode Island. Elected to the state senate in 1803, he was the senate leader when Governor Arthur Fenner died two years later, and because the lieutenant governor had died before Fenner, Smith was next in line. He remained in the office for less than a year.

When still a young man, Smith probably ordered this customized mug from China through an American agent. Unlike other American customers who ordered personalized porcelain, he was not satisfied with using just his initials on his mug—he chose to spotlight his full surname. The cylindrical mug is beautifully painted with an underglaze blue Fitzhugh border, with the personification of Hope leaning on an anchor above an oval enclosing the word "SMITH."

<table>
<tr><td>46</td><td>47</td></tr>
</table>

PLATE FROM IGNATIUS
SARGENT'S SERVICE, ca. 1785–90
Made in Jingdezhen, decorated in Guangzhou
China
Hard-paste porcelain
Diam. 6⅛ in. (15.6 cm)

SOUP PLATE FROM ELIAS HASKET
DERBY'S SERVICE, ca. 1786
Made in Jingdezhen, decorated in Guangzhou
China
Hard-paste porcelain
Diam. 9¹/₁₆ in. (23 cm)

IN THE EARLY years of Chinese porcelain made for the American market, most customers personalized their imported Chinese porcelain by paying extra for Chinese porcelain painters to decorate their wares with the customer's monogram. A few buyers, though, wanted something more striking; they often chose armorial decorations—sometimes modifying existing coats of arms for their family, or sometimes creating entirely new ones.

Ignatius Sargent (1765–1821), a Boston merchant, ordered his service from China to feature the arms from the Sargent family of Gloucester, England: "argent, three dolphins naiant embowed sable," which, in the language of heraldry, means "against a field of silver, three arched black dolphins swimming horizontally."[85]

Sargent used paper bookplates engraved by the silversmith Joseph Callender showing this herald with one modification—he added an American eagle at the top. The family motto, *Nec quaerere honorem nec spernere*, which can be translated as "Neither to seek honors, nor to spurn them," appears on a banner at the bottom. The Chinese decorators of Sargent's service probably followed his bookplates for the design.

FOR HIS PORCELAIN, Elias Hasket Derby (1739–1799), for a time the wealthiest man in America, chose a relatively simple pattern customized with his monogram. Despite his modest taste in tableware, he was a colorful character—a merchant in colonial America, a bit of a dandy, and the owner of a large fleet of privateers. His ships, licensed by the Continental Congress, took hundreds of prizes during the Revolutionary War—and made huge profits for Derby. He also grew wealthier from the exploitation of enslaved people.

When the war ended, Derby's *Grand Turk* became the first ship from New England to be engaged in trade directly with China. For the ship's return journey, the hong merchant Pinqua presented a punch bowl to the captain. The ship's cargo on that voyage included seventy-five boxes of porcelain, probably including this soup plate and the rest of Derby's personal service. The *Grand Turk* sailed into Salem Harbor in May 1787, to much excitement and fanfare.

Derby was so well known in Salem, and his wealth so famous, that Nathaniel Hawthorne gave him a new nickname in *The Scarlet Letter*: "Here, no doubt, statistics of the former commerce of Salem might be discovered, and memorials of her princely merchants, —old King Derby, —old Billy Gray, —old Simon Forrester, —and many another magnate in his day; whose powdered head, however, was scarcely in the tomb, before his mountain pile of wealth began to dwindle."[86]

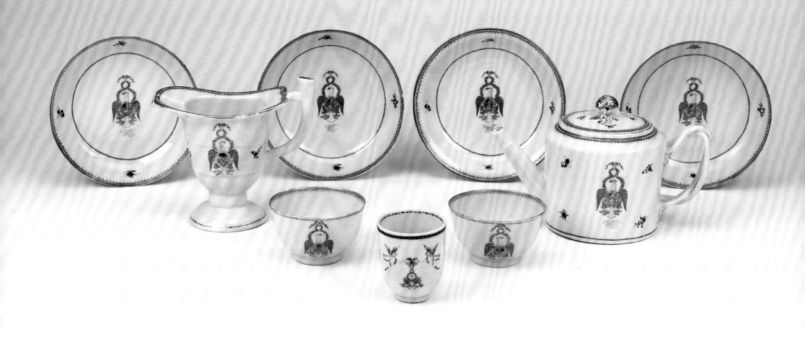

<div style="text-align:center">

48

NINE PIECES FROM
WILLIAM EUSTIS'S SOCIETY
OF THE CINCINNATI TEA
SERVICE, ca. 1789–90

Made in Jingdezhen,
decorated in Guangzhou
China

Hard-paste porcelain

Various sizes

</div>

THE SOCIETY OF the Cincinnati, the fraternal group of American and French officers who had served in the Revolutionary War, boasted lavish badges in the shape of an eagle, designed by Pierre Charles L'Enfant (see cat. 140). In February 1784, Samuel Shaw, a member of the group, made his first trip to China—so when the Society of the Cincinnati handed out badges to members at the first meeting, in May, Shaw was not there. He would have received his badge when he returned home in 1785.

On later trips to China, with the impressive look of the eagle firmly etched in his mind, Shaw ordered Society of the Cincinnati porcelain that reflected the badge. The first set, featuring the Angel of Fame, the badge, and a blue border, went to George Washington

(cat. 44). Then Shaw ordered at least six other Society of the Cincinnati-related sets, as gifts for friends in the group and one for himself. These sets were decorated with the eagle-shaped badge, plus the initials of the recipient and the mottoes of the society.

One tea set was intended for David Townsend, and in 1790 Shaw wrote to him, "Accept, my dear friend, as a mark of my esteem and affection, a tea set of porcelain, ornamented with the Cincinnati and your cipher."[87] The other recipients of tea sets who have been identified were Benjamin Lincoln, William Lithgow, Henry Knox, and Constant Freeman—plus William Eustis (1753–1825), the original owner of the collection's set. From 1809 to 1813, Eustis served as secretary of war through nearly all of James Madison's first term.

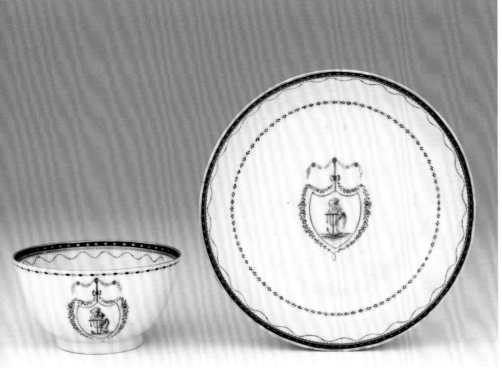

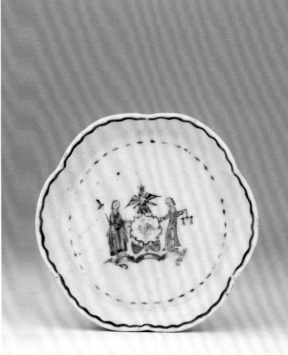

49 *ABOVE LEFT*

TEABOWL AND SAUCER WITH
ARMS OF RHODE ISLAND, ca. 1790

Made in Jingdezhen,
decorated in Guangzhou
China
Hard-paste porcelain
Various sizes

NEW YORK AND RHODE ISLAND were active in trade with China in the early days of our country, and export porcelain depicted the states' coats of arms for patriotic buyers. Rhode Island's coat of arms features a gold anchor against a blue field, with the word "HOPE"; the reason for the combination is uncertain, but it may come from the Bible: "Which hope we have as an anchor of the soul, both sure and steadfast" (Hebrews 6:19). The interpretation of the Rhode Island coat of arms here has kept the anchor and added, perhaps, a personification of Hope, all surrounded by a floral decoration.

50 *ABOVE RIGHT*

TEAPOT STAND WITH ARMS OF
NEW YORK STATE, ca. 1790

Made in Jingdezhen,
decorated in Guangzhou
China
Hard-paste porcelain
Diam. 5^{13}/$_{16}$ in. (14.8 cm)

The New York State coat of arms, adopted in 1778, features personifications of Justice (on the right, with the blindfold and scales; Justice often holds a sword in one hand, but it is missing here) and Liberty (on the left, holding a staff topped with a Phrygian cap—the headgear given to a Roman enslaved person upon emancipation). At the top, an eagle stands over a hemisphere.

The New York coat of arms also features a central medallion with a view of a landscape featuring a body of water, two ships, a mountain, and the sun, but here that has been removed completely in favor of a gilt flower. Special orders might have included the buyer's monogram in place of the flower.

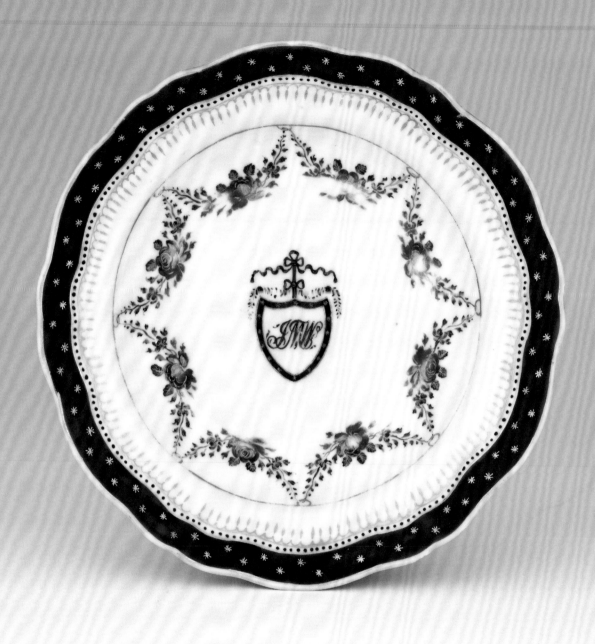

51

TEA PLATE FROM JAMES M. WATSON'S SERVICE, ca. 1800

Made in Jingdezhen, decorated in Guangzhou China

Hard-paste porcelain

Diam. 6¼ in. (15.9 cm)

THIS PLATE, designed for serving tea, is part of a large set that was handed down for more than two hundred years in the family of James M. Watson (1750–1806) and his wife, Mary Talcott Watson (1752–1806). Watson, a merchant, was also a member of the Society of the Cincinnati; after holding a number of political offices, he served as senator from New York. In 1800, he resigned when John Adams appointed him naval officer of the Port of New York.

The Watsons' service features a border with gilt stars against a blue background, plus floral swags and a center shield with the owner's monogram. Fifty-four pieces from this set survive at the New-York Historical Society, including eight dinner plates, eight soup plates, six tea plates, five serving dishes, four platters, three bowls, and a soup tureen and cover.

These dishes would have been used at Watson's house at 7 State Street in lower Manhattan. Built in 1793, shortly before Watson served a one-year term as Speaker of the New York State Assembly, the house still stands today.

PLATES FROM ELIAS BOUDINOT'S SERVICE, ca. 1790
Made in Jingdezhen,
decorated in Guangzhou
China
Hard-paste porcelain
Each: Diam. 9¼ in. (23.5 cm)

IN APRIL 1777, George Washington asked Elias Boudinot (1740–1821), a New Jersey lawyer, to become commissary general of prisoners, responsible for trying to help more than two thousand American prisoners of war held by the British in jails, warehouses, and prison ships in New York City but given meager rations and no clothing, bedding, or firewood by their captors. Boudinot also attempted—with little success—to oversee American treatment of enemy prisoners at widely scattered locations.

But there was more behind Washington's job offer. He wrote, "I intend to annex another duty to this Office; and that is, the procuring of Intelligence. . . . [You] will have as much leizure, and better oppertunities, than most other Officers in the Army, to obtain knowledge of the Enemys Situation—Motions—and (as far as may be) designs."[88]

Despite misgivings, Boudinot took the job—and over the next year, he advanced about thirty thousand dollars of his own money to aid American prisoners of war. He also aided in spying on the British to the end of the war. One night in early December 1777, he wrote in his private journal, a woman named Lydia Darragh "put into my hands a dirty old needle book. . . . [Inside I] found a piece of paper rolled up into the form of a pipe shank. On unrolling it I found information that General Howe was coming out the next morning with 5,000 men, 13 pieces of cannon, baggage wagons, and 11 boats on wheels."[89] Boudinot immediately raced to warn Washington, who was able to block repeated British attempts to penetrate the American lines in scattered skirmishes over four days, before Howe withdrew to Philadelphia for the winter.

After the Revolutionary War, Boudinot served in the House of Representatives from 1789 to 1795, and then as director of the United States Mint until 1805. His service bears his motto *Soli Deo gloria et honor*: "All glory and honor for God alone."

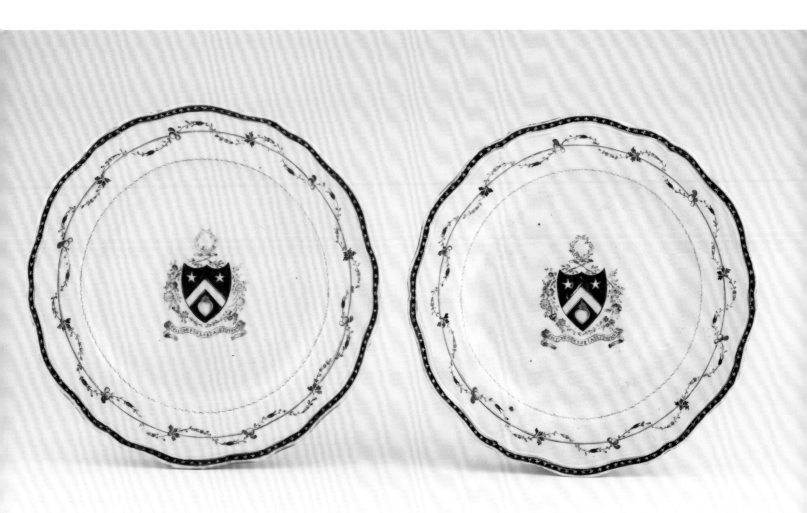

PUNCH BOWL MADE FOR RICHARD GRIDLEY, ca. 1790

Made in Jingdezhen,
decorated in Guangzhou
China
Hard-paste porcelain
H. 6½ in. (16.5 cm),
Diam. 15¾ in. (40 cm)

RICHARD GRIDLEY (1710–1796), born in Boston, served in the British army as a young man. But as the American Revolution drew closer, Gridley's sympathies went to the colonists. Asked which side he intended to fight on, Gridley replied, "I never drew my sword but in the cause of justice and such I consider my country's to be."[90] He became the first chief engineer of the Continental Army.

Like other prominent colonists, Gridley was a Freemason. Freemasonry attracted many young men for its tenets of faith, brotherly love, and service. However, the group's reputation for secrecy left some in doubt about their practices—including Benjamin Franklin's mother. Franklin soothed her, writing, "They are in general a very harmless sort of People and have no principles or Practices that are inconsistent with religion and good manners."[91]

Before about 1750, lodges generally convened in coffeehouses; later, Freemasons began to meet in halls and to accumulate objects decorated in Masonic motifs, especially vessels for serving beverages. Masonic symbols from the 1700s—including stonemasons' tools, beehives, and pillars representing the entrance to Solomon's temple—appear on covered pitchers, mugs, and large punch bowls for use within the lodge hall and perhaps in private homes, where the brotherhood would feel comfortable raising a glass together.

Punch was a fashionable drink at the time, served hot or cold; most recipes featured citrus, plus sugar; rum, and/or brandy; spices; and water. Punch bowls could be small, for individual portions, or large, to hold larger quantities that could be ladled out. This large bowl, imported from China, features Richard Gridley's name—misspelled—along with Masonic symbols.

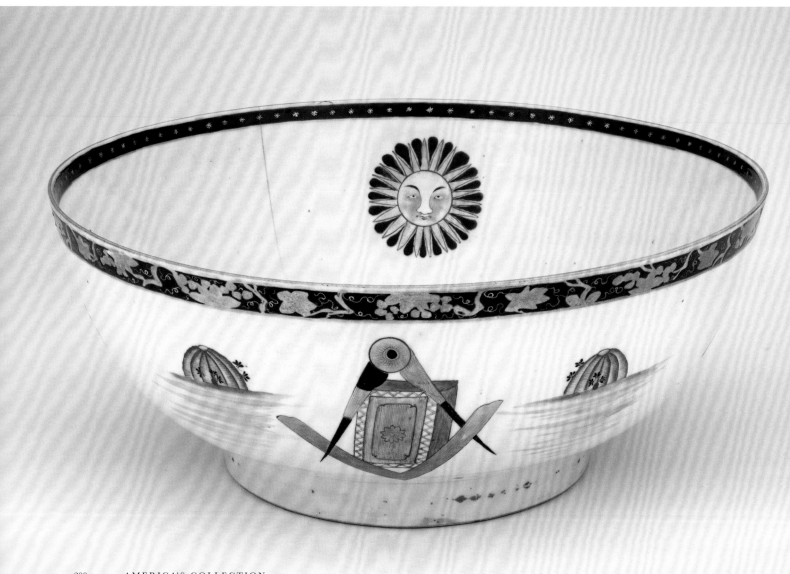

54

SAUCER FROM MARTHA WASHINGTON'S STATES SERVICE, 1795

Designed by Andreas Everardus
van Braam Houckgeest (Dutch, 1739–1801)
Made in Jingdezhen,
decorated in Guangzhou
China
Hard-paste porcelain
with polychrome enamels
H. 1⅜ (3.5 cm),
Diam. 6¼ in. (15.9 cm)

WHEN ANDREAS EVERARDUS van Braam Houckgeest stepped off the *Lady Louisa* in Philadelphia in April 1796, he brought a good deal of baggage. Van Braam (as he was known) had traveled from Guangzhou via Cape Town with 116 packages, including art, artifacts, and "a Box of China for Lady Washington."[92]

Van Braam probably designed this set himself, adapting its patriotic design from currency printed at the time, as an elegant gift for the wife of the president. Dutch by birth, he spent years in Europe, America, and China, making his fortune as a trader with the Dutch East India Company. He fell in love with America and its Revolutionary ideals and made it his new home.

The set that van Braam designed for Martha Washington features a border design of a snake biting its own tail, a symbol of eternity, plus a chain enclosing the fifteen states (including Vermont and Kentucky) united by the new republic. In the center, a golden sunburst features Martha Washington's initials and a ribbon with the motto *Decus et tutamen ab illo*. The motto derives from Virgil's *Aeneid* and essentially means, "[Our Union is our] Glory and [our] Defense against [Him]." Van Braam intended the words to signify the ideals of our country and its fight against tyranny.

<table>
<tr><td align="center">55</td><td align="center">56</td></tr>
</table>

PLATE FROM THE JOHN MORGAN SERVICE, ca. 1785 Made in Jingdezhen, decorated in Guangzhou China Hard-paste porcelain Diam. 7½ in. (19.1 cm)	SOUP PLATE FROM JOHN BROWN'S SERVICE, 1795 Made in Jingdezhen, decorated in Guangzhou China Hard-paste porcelain Diam. 9½ in. (24.1 cm)

JOHN MORGAN (1753–1842), a successful hardware merchant in Hartford, Connecticut, chose an armorial design for his porcelain service, with a gilt-ground coat of arms and crossed laurel branches tied with a gilt bow. Family tradition recalls that, in 1785, he "imported from Canton [Guangzhou], China, in the first American vessel that ever entered Chinese waters, the ship 'Empress of China,' a large quantity of China ware, among it a rich and extensive dining set, made to his order, each piece bearing his own name and arms."[93] John's half brother Elias, who was also a merchant, ordered another set several years later, with the same armorial decoration plus his full name.

John Morgan, a nephew of John and Elias, served as carpenter on that first voyage of the *Empress of China*; he died on the trip home. The ship's records show that he asked his friend Thomas Blake, the ship's gunner and steward, to deliver his personal effects to his father in Groton, Connecticut. The effects, when delivered, included two large punch bowls—and perhaps this porcelain service as well, although it may have arrived aboard another ship.

JOHN BROWN (1736–1803), born into a large and prosperous family in Providence, Rhode Island, sent his ship named for George Washington to Guangzhou, China, for the first time in 1787. When it returned in 1789, it carried a set of dishes described as "best blue china for Dining Table,"[94] along with other household supplies for his beautiful new home at 52 Power's Lane. With profits made as a China trade merchant, shipbuilder, and privateer—who also engaged in the transatlantic slave trade—Brown could afford the best. In 1788, a visitor wrote of his home, "It is situated on a very high hill and commands a prospect of the town and country for many miles with a delightful view of the river. The house is very large and furnished in a most extravagant manner."[95]

This soup plate came home six years later, part of a second "sett of the better sort"[96] that arrived in Providence on the first voyage of another ship that Brown named for the first president. With its blue urn full of blue flowers, surrounded by blue swags, the set imitates services being produced by English factories such as Bristol and New Hall. Like the earlier set, it would have complemented the lavish interiors of Brown's home.

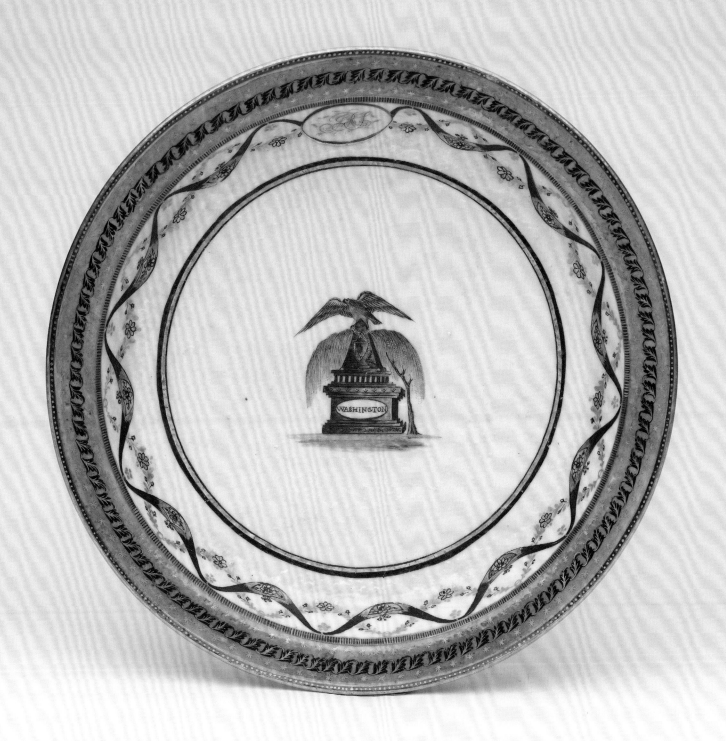

57

JARDINIERE STAND MADE FOR JOSEPH AND REBECCA HEATH SIMS,

1800–1802

Made in Jingdezhen,
decorated in Guangzhou
China
Hard-paste porcelain
Diam. 9¼ in. (23.5 cm)

GEORGE WASHINGTON was truly revered, and his death at sixty-seven on December 14, 1799, stunned Americans. This jardiniere stand, part of a larger service, displays one of the more unusual forms of public grief, a fanciful depiction of Washington's tomb, plus an eagle carrying a wreath in its talons and a weeping willow. The porcelain must have been rushed into production soon after word of Washington's death reached Guangzhou, then speedily sent off to the United States.

The jardiniere stand carries the monogram "JRS," for Joseph (1760–1851) and Rebecca

(1769–1830) Sims of Philadelphia, which would have been applied by decorators in Guangzhou. Joseph Sims was involved in trade with China.

The mourning pattern has been found on platters, a tureen cover, a sauce tureen, pots de crème, a coffee canister, and a hot-water dish. The tomb shown on the pieces, predictably, does not remotely resemble George Washington's real tomb at Mount Vernon, although the expressive grief reflected the nation's loss over its Revolutionary hero and president.

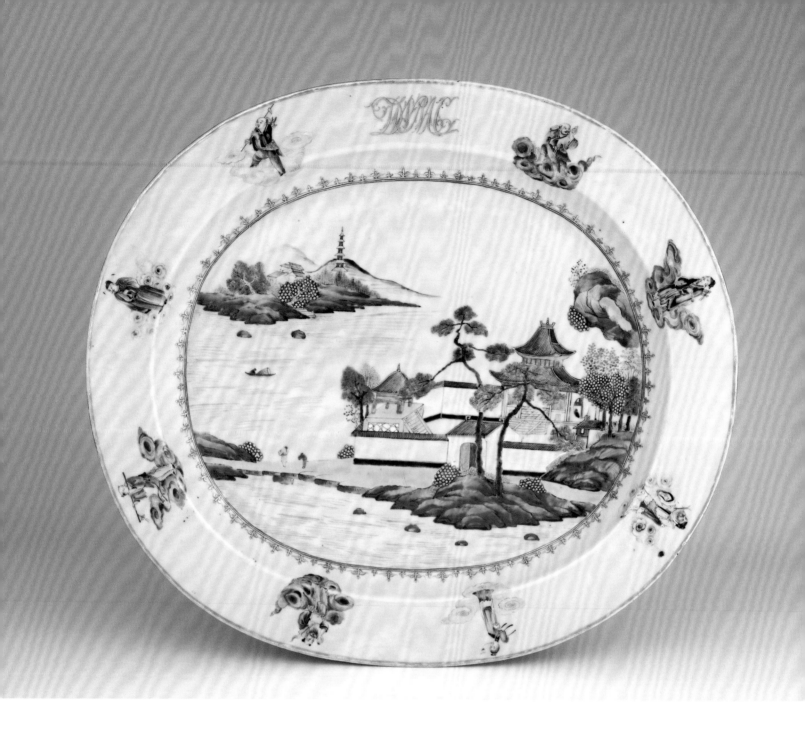

58

ONE FROM A PAIR OF
PLATTERS FROM DEWITT
AND MARIA FRANKLIN
CLINTON'S SERVICE,
ca. 1796

Made in Jingdezhen,
decorated in Guangzhou
China

Hard-paste porcelain

18½ x 20¼ in.

(52.1 x 46 cm)

PROBABLY MADE FOR the wedding of DeWitt Clinton (1769–1828) and Maria Franklin (1775–1818) in 1796, this platter carries their joined initials—DWMC. Part of a very large set of dinnerware, the platter has a striking design that features a Chinese riverscape with picturesque buildings and trees, some with red blossoms, surrounded by a gold spearhead border. The rim shows the Eight Immortals of Chinese mythology, posed dynamically. While the center decoration and border reflect traditional taste for fanciful and even imagined landscapes, the figures anticipate the bright decorations that would be popular on Chinese export porcelain in the nineteenth century.

DeWitt Clinton, a stalwart of New York politics, served as a state assemblyman and then a U.S. senator. He was the mayor of New York City, then became the governor of the state in 1817. Today he may be best remembered as the force behind the Erie Canal—which opponents of the governor called "Clinton's Big Ditch" until it opened, in 1825, to huge financial success. DeWitt Clinton led the opening ceremony with the first trip through the canal; the journey took nine days. After he arrived at the eastern end, in Albany, the boats traveled south on the Hudson River to New York City, where, amid much fanfare, he poured a keg of water from Lake Erie into the Atlantic to consummate the event, celebrated as the "Wedding of the Waters."

SAUCER FROM THE BACHE
FAMILY SERVICE, ca. 1800

Made in Jingdezhen,
decorated in Guangzhou
China
Hard-paste porcelain
Diam. 5½ in. (14 cm)

SARAH FRANKLIN (1743–1808), the only daughter of Benjamin Franklin and his wife, Deborah Read, was known as Sally all her life. She married a merchant, Richard Bache (1737–1811)—against her father's wishes—in 1767. Franklin, in the middle of his many years in England, had his doubts about Bache, but he warmed to his son-in-law when they met for the first time in 1771.

A dedicated Patriot, Sally raised money for the Continental Army; in 1781, a friend wrote to Franklin, "If there are in Europe any women who need a model of attachment to domestic duties and love for their country, Mrs. [Sally] Bache may be pointed out to them as such."[97]

Sally and Richard Bache lived with her mother until 1774, when Deborah Read died; the couple continued in the house in Philadelphia, with their growing family. Franklin returned to the United States after the Revolutionary War ended and lived with the couple until his death in 1790. In 1794, the family moved to a farm several miles from Philadelphia, where they may have used this saucer showing a bucolic country riverscape, a sailboat, fishermen, cattle, and swans floating dreamily by.

<table>
<tr><td align="center">60</td><td align="center">61</td></tr>
</table>

PLATE DEPICTING THOMAS JEFFERSON'S MONTICELLO, ca. 1800–1810	**PLATE DEPICTING GEORGE WASHINGTON'S MOUNT VERNON**, ca. 1810

<table>
<tr>
<td align="center">

PLATE DEPICTING THOMAS JEFFERSON'S MONTICELLO, ca. 1800–1810

Made in Jingdezhen, decorated in Guangzhou

China

Hard-paste porcelain

Diam. 10 in. (25.4 cm)

</td>
<td align="center">

PLATE DEPICTING GEORGE WASHINGTON'S MOUNT VERNON, ca. 1810

Made in Jingdezhen, decorated in Guangzhou

China

Hard-paste porcelain

Diam. 7½ in. (19 cm)

</td>
</tr>
</table>

VIEWS OF George Washington's home, Mount Vernon, are fairly common on porcelain imported from China in the early years of the 1800s. But depictions of Thomas Jefferson's home, Monticello, are much more unusual. This large sepia and gilt-decorated plate is part of one of two known sets; on the other set, the same view is labeled "Monticello" and "Thomas Jefferson."

Construction on Monticello began in 1769; a project to rebuild and expand the house started in 1796 and finished in 1809. The original Monticello had eight rooms; the expanded version had twenty-one. More than that, it was loaded with handy gadgets that appealed to the scientifically minded Thomas Jefferson, some invented by Jefferson himself. Monticello features, among other innovations, dumbwaiters, folding doors, a copying press, bookshelves that turn into storage boxes, a duplicate-writing machine (which made a copy as he wrote a letter), and a remarkable clock with two faces—an outside one, with only an hour hand, and an inside one, showing hour, minute, and second, powered by gravity and eighteen-pound cannonball weights.

AFTER GEORGE WASHINGTON'S death on December 14, 1799, tributes to him were everywhere—in newspapers, memorial speeches, prints, needlework, jewelry, medallions, and poems and songs. February 22, 1800, was chosen as the national day of mourning, and many Washington-related items were rushed into production to be ready for that date, including a book of songs of tribute that was printed, bound, and distributed before the February date—in fact, some of the songs were ready in time for a memorial service held in Boston on January 9.

This plate, with an image of Mount Vernon probably adapted from an 1804 print by Samuel Seymour based on a painting by William Birch, is from a tea and coffee set that was produced a few years later. This scene of Washington's home, and variations on it, was available with at least five different borders and on many different porcelain items.

Mount Vernon itself, a working farm, had been owned by Washington's family since the 1670s and remained in the family for almost two hundred years. The last Washington to own the estate was John Augustine Washington III, George Washington's great-grandnephew. By that time, Mount Vernon was in a state of disrepair, and opening it to day-trippers arriving by steamboat three days a week—with Washington's tomb promoted as one of the attractions—hastened its deterioration. The Mount Vernon Ladies' Association purchased the mansion, outbuildings, and two hundred acres of surrounding land in 1860. Today the association still owns and manages the historic site.

PLATE MADE FOR THE CHEW FAMILY
OF PHILADELPHIA, ca. 1810

Made in Jingdezhen, decorated in Guangzhou

China

Hard-paste porcelain

Diam. 8 in. (20.3 cm)

WHEN BENJAMIN CHEW (1722–1810) was born, his family had already been in America for four generations; the Chews were close with the family of William Penn. Benjamin Chew studied law in London, then returned to Philadelphia to practice. In time he represented most of the Penns on legal matters. In 1774, he became chief justice of Pennsylvania—then lost that position when he did not support the Declaration of Independence. He was arrested for treason and briefly imprisoned in New Jersey.

Born into wealth and then made wealthier by two advantageous marriages, Chew maintained a home in the city of Philadelphia and a large country home called Cliveden in Germantown. That home, a two-hour journey from Chew's town house by carriage when it was completed in 1767, was sumptuous in every way; a visitor called it an enchanted castle.

The stunning Georgian mansion was filled with expensive furnishings—including this gilt-decorated porcelain plate personalized with Chew's initial, part of a large set. The battle of Germantown, in 1777, was fought practically at the doorstep of Cliveden; cannonballs pounded the walls, and musket burns can still be seen in the entranceway.

SOUP PLATE MADE FOR STEPHEN
VAN RENSSELAER III, ca. 1810–25

Made in Jingdezhen, decorated in Guangzhou

China

Hard-paste porcelain

Diam. 9¾ in. (24.8 cm)

STEPHEN VAN RENSSELAER III (1764–1839) was a descendant of the seventeenth-century Van Rensselaers, and he inherited almost a million acres in what are now Albany and Rensselaer Counties in New York State. The manor house for the area, called Rensselaerswyck, was built overlooking the Hudson River by Van Rensselaer's parents between 1765 and 1768. The sumptuous entrance hall, one of the largest rooms constructed before the American Revolution, featured hand-painted English wallpaper and richly carved rococo woodwork. The entire room is now in the Metropolitan Museum of Art in New York.

The land that Van Rensselaer inherited was the last surviving patroonship, or private plantation, granted by the Dutch West India Company. The land grant was given in 1629, along with others, but only the Van Rensselaer patroonship survived the end of Dutch rule in 1664, until an anti-rent revolt by tenant farmers led to a change in the state constitution in 1846, effectively abolishing the patroon system; accordingly, Stephen Van Rensselaer III was known as "the last patroon." In 1783, he married Margarita Schuyler (1758–1801; famous as "And Peggy!" in the Broadway musical *Hamilton*); later he served in the New York State Assembly, as lieutenant governor of the state, and as a member of the House of Representatives.

This soup plate, with its elegant central butterfly surrounded by blossoming peonies and a gilt border, would have been a charming addition to Rensselaerswyck.

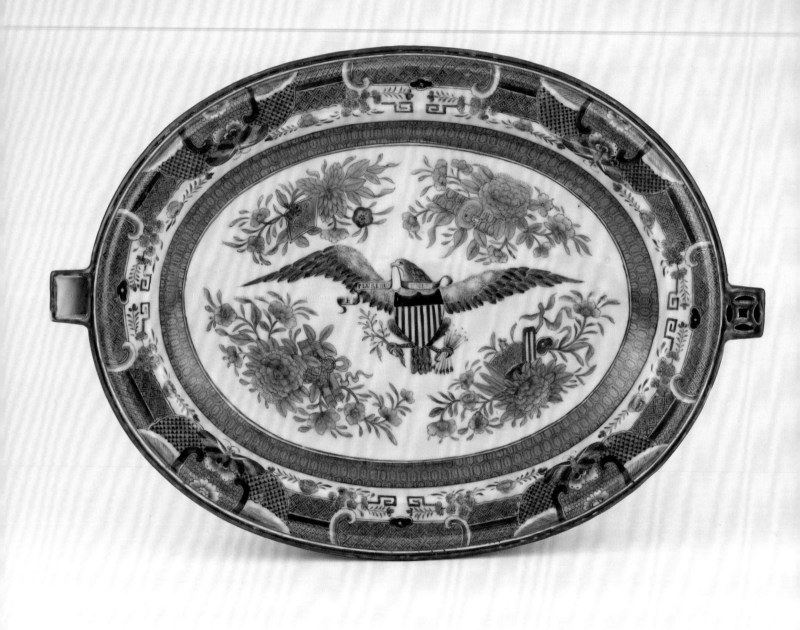

64

HOT-WATER DISH, ca. 1815
Made in Jingdezhen,
decorated in Guangzhou
China
Hard-paste porcelain
14⅛ x 9¹¹⁄₁₆ in.
(24.6 x 35.9 cm)

THIS DISH IS A TYPE of Chinese export porcelain known as "Fitzhugh," made between about 1780 and 1840. Fitzhugh porcelain features a central medallion surrounded by four clusters of flowers and emblems associated with the four main accomplishments of the ideal Chinese scholar: music, painting, analytical skills, and calligraphy. The whole design is enclosed by a Nanking border (a trellis-and-spearhead design) or a more complex design with butterflies and floral motifs. The colors may be blue, brown, green, yellow, rose

pink, lavender, black, gray—or orange, as in this striking dish.

This example, part of a larger service, was customized for the U.S. market with an American eagle bearing a banner reading *E pluribus unum*—the motto that appears on the Great Seal of the United States and translates to "Out of many, one." As its name implies, this hot-water dish would have been filled with hot water to keep food warm during meals.

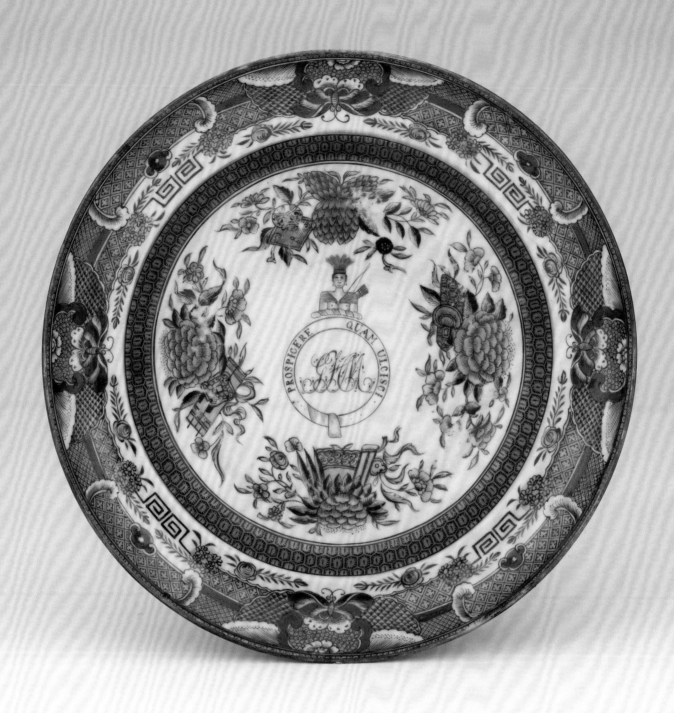

PLATE FROM GABRIEL HENRY MANIGAULT'S SERVICE,

ca. 1820–30

Made in Jingdezhen, decorated in
Guangzhou
China
Hard-paste porcelain
Diam. 7¹³/₁₆ in. (19.8 cm)

GABRIEL HENRY MANIGAULT (1788–1834), one of the eleven children of Gabriel and Margaret Izard Manigault, was born into a wealthy and prominent family from Charleston, South Carolina. His father was the architect of some of Charleston's most distinguished buildings, including its city hall. When Gabriel came of age, he married his first cousin Anne Manigault Heyward, in 1817.

This plate, part of a large set of Fitzhugh porcelain, features his initials and Native American decoration, plus the Latin motto *Prospicere quam ulcisci*, meaning "Better to anticipate than to avenge."

Gabriel Henry's brother Charles Izard Manigault (who married Elizabeth Heyward, Anne's sister) ordered two sets of the service, with slight variations, when he was in China from 1817 to 1823. In an inventory, Charles listed an impressive 381 pieces of porcelain.

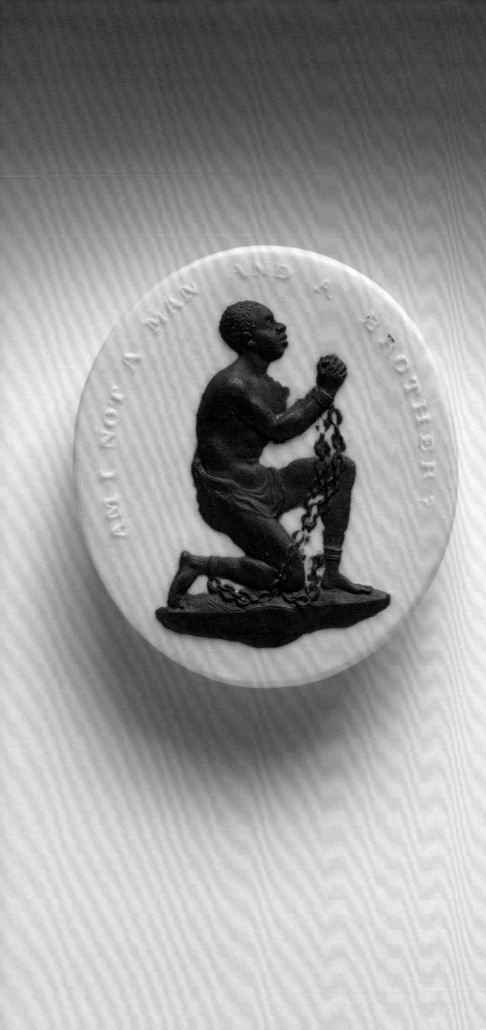

ANTI-SLAVERY MEDALLION ("AM I NOT A MAN AND A BROTHER?"), ca. 1787

Designed by Henry Webber
(British, 1754–1826) and
modeled by William Hackwood
(British, ca. 1753–1836) for Wedgwood
England
Jasperware
1³/₁₆ x 1¹¹/₁₆ in. (3.1 x 4.3 cm)

JOSIAH WEDGWOOD (1730–1795), remembered today for his blue-and-white jasperware, was an ardent abolitionist. He produced this medallion, at his own expense, for the Society for Effecting the Abolition of the Slave Trade. Some of the medallions were distributed as gifts, to like-minded individuals around the world; a number went to Benjamin Franklin in his role as president of the Pennsylvania Abolition Society. Wedgwood wrote, "It gives me great pleasure to be embarked on this occasion in the same great and good cause with you, Sir, and I ardently hope for the final completion of our wishes. This will be an epoch before unknown to the world, and while relief is given to so many of our fellow creatures immediately the object of it, the subject of freedom itself will be more canvassed and better understood in the enlightened nations."[98]

Since the committee purposely did not copyright, patent, or otherwise restrict use of the powerful image in any way, it was used on many different objects; the result was increased awareness of the transatlantic trade in enslaved people. The motto and the kneeling figure appeared on tobacco jars, pipes, pin trays, hatpins, brooches, necklaces, plates, pitchers, snuffboxes, tea canisters, and other items—though, as upper-class Europeans did not kneel to pray at that time, the supplicant pose came to be seen by some as problematic, conveying a sense of racial inferiority. Another abolitionist wrote, "Fashion, which usually confines itself to worthless things, was seen for once in the honorable office of promoting the cause of justice, humanity and freedom."[99]

FIGURE OF BENJAMIN FRANKLIN, ca. 1790

Attributed to Ralph Wood the Younger
(British, 1748–1795),
after Ralph Wood the Elder
(British, 1715–1772)
Burslem, England
Pearlware
13⅛ x 5 x 4½ in.
(33.3 x 12.7 x 11.4 cm)

FOR MOST OF HIS LIFE, Benjamin Franklin was celebrated everywhere he went—as a diplomat, a statesman, a philanthropist, an inventor, a scientist, a printer, a writer, and a wit. This figure of him, attributed to the British potter Ralph Wood the Younger, was probably made for the American market to commemorate Franklin's death in 1790.

It may be based on an earlier figure by Ralph Wood the Elder, a skilled modeler, made during Franklin's stay in London from 1757 to 1775. Franklin was sent to London as an agent of the Pennsylvania Assembly; he remained there, representing American interests and pursuing his own, for most of the next eighteen years, leaving when war with the American colonies was clearly on the horizon.

In February 1766, Franklin appeared before Britain's House of Commons, advocating for a repeal of the Stamp Act of 1765. In testimony lasting more than four hours, Franklin provided evidence by answering 174 questions from members of Parliament. His comments made him even more of a celebrity, and the Stamp Act was repealed in March 1766—a result Franklin attributed to "what the Profane would call *Luck* & the Pious *Providence*."[100]

This pearlware figure is much larger than other figures made by the Woods; the size demonstrates the high regard Americans had for the leader. Franklin's bemused expression and unbuttoned waistcoat give the viewer a sense of the personality of the great Dr. Franklin.

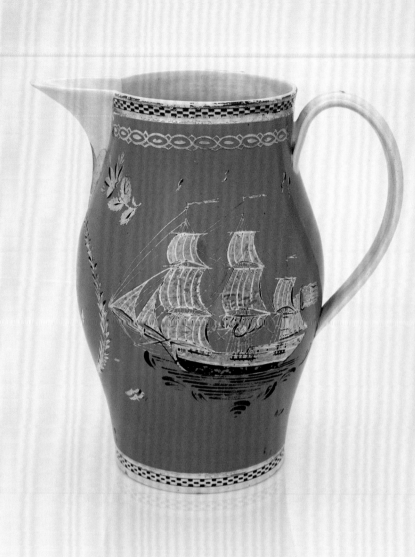

PEARLWARE PITCHER, 1795
Unidentified maker
England
Pearlware
9¼ x 8⅞ x 6 in.
(23.5 x 22.5 x 15.2 cm)

BY THE LATE 1700s, America was emerging as a distinct market for ceramics—with an appetite for distinctly American decorations, either commemorating American events or heroes, or celebrating proud American achievements.

In the early days of these wares, British manufacturers applied black transferware decorations to cream-colored earthenware pitchers (often called Liverpool pitchers today). Customers in the new country appreciated ships, heroes of the American Revolution, or the Great Seal of the United States.

In 1779, Josiah Wedgwood introduced pearl-white wares to meet customer demand for brighter products; the clay was whitened with the addition of kaolin from Cornwall. With the lighter-colored clay, pearlware could be given a bright bluish glaze that coordinated well with blue-and-white Chinese porcelain.

This pearlware pitcher features a ship with an American flag on one side, and a female figure—possibly symbolizing Hope—with an anchor on the other. With the bold inscription "WT / 1795" under the spout, the pitcher may commemorate the American shipping industry and the role of someone with those initials in that industry.

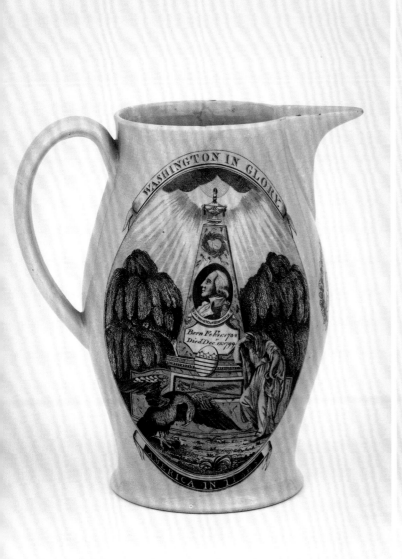

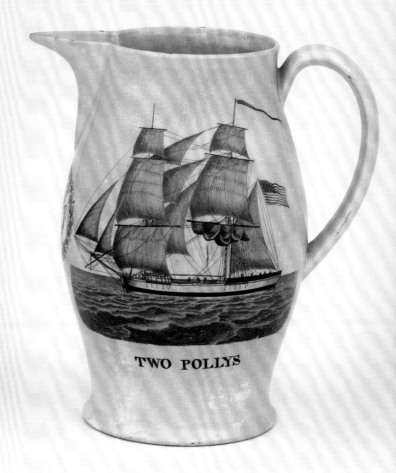

69 *TWO VIEWS*

CREAMWARE PITCHER,
ca. 1801–5

Unidentified maker

Liverpool, England

Creamware

H. 8½ in. (21.6 cm)

THIS ENGLISH PITCHER, with its cream-colored body and mostly black transfers, contrasts with whiter imported porcelain from China and France. The lighter backgrounds showed off colorful decoration to advantage, but creamware pitchers like this were sturdy and affordable. They were inexpensive enough that middle-class Americans could purchase them as everyday tableware.

The black transfers on these pitchers often commemorated a historical event on one side, with a more personalized image on the other. This pitcher, like many others, memorializes the death of George Washington with the words "Washington in Glory," the president's birth and death dates, a picture of Washington's tomb, and a weeping angel—plus the attention-grabbing words "America in Tears" at the bottom.

The pouring-spout side carries the initials "RF PJ." The side opposite the Washington memorial shows the American sailing ship the *Two Pollys*, launched in Bridgewater, Massachusetts, in 1801—a yellow ship floating eternally on a green sea, with a red, cream, and blue American flag rippling in the wind forever.

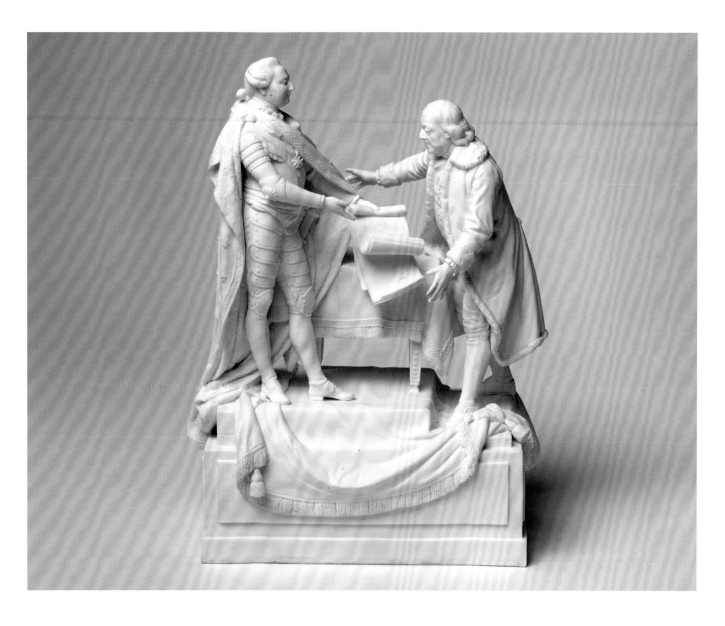

FIGURE GROUP OF LOUIS XVI AND BENJAMIN FRANKLIN,

ca. 1780–85

Attributed to Charles-Gabriel Sauvage
(called Lemire) (French, 1741–1827)
Niderviller factory
(French, active 1754–1827)
Bisque porcelain
12⁵⁄₁₆ x 9½ x 6 in.
(31.3 x 24.1 x 15.2 cm)

ON FEBRUARY 6, 1778, a treaty of alliance was signed between France, represented by King Louis XVI, and the fledgling United States, represented by a delegation that included Benjamin Franklin and two other diplomats, Silas Deane and Arthur Lee. The treaty, signed at the Palace of Versailles, established trade relations and, when knowledge of it became known, marked France's entry into the war against Britain. (A second treaty, signed the same day, allowed for protection of vessels in French and American waters.)

All three Americans—but especially Benjamin Franklin—were hugely popular with the French. Franklin made the calculated decision to dress unpretentiously, capping off his modest outfits with a fur hat rather than a wig. It worked: the French found him delightfully charming and witty (despite his just-passable French). And the king made a favorable impression on Franklin too. "The King, a young and

virtuous Prince, has, I am persuaded, a Pleasure in reflecting on the generous Benevolence of the Action in assisting an oppress'd People, and proposes it as a Part of the Glory of his Reign," wrote Franklin.[101]

To support the war effort, the French king sent about six thousand soldiers under the command of the comte de Rochambeau. These forces helped defeat the British at the battle of Yorktown in 1781, sealing the end of the war and securing independence for the United States.

This figure group is probably the work of Charles-Gabriel Sauvage, the artistic director and principal modeler at the Niderviller factory in France between 1779 and 1807. Benjamin Franklin humbly conveys the gratitude of all Americans to the king, who receives his words graciously.

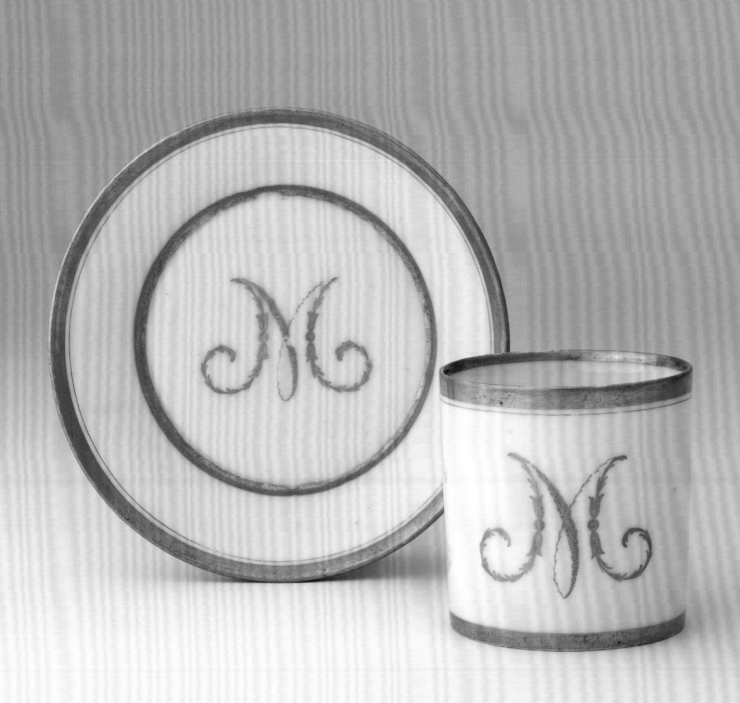

71

COFFEE CUP AND
SAUCER FROM
DOLLEY MADISON'S SERVICE,
ca. 1792–1807

Made by Blancheron's factory
(Paris, 1793–1802); decorated
by Étienne Jean Louis Blancheron
(French, active 1792–1807)
Paris
Hard-paste porcelain
Cup: H. 2½ in. (6.3 cm);
saucer: Diam. 5⅞ in. (14.9 cm)

WHEN JAMES MADISON married Dolley Payne Todd in 1794, he had an urgent need for domestic goods—his new life would mean entertaining and leading a busy household, with Dolley Madison's young son, from her first marriage, and niece as part of the family.

Madison's friend James Monroe was in France, serving as minister plenipotentiary, and he volunteered to buy goods in Paris for the Madisons; accordingly, he sent furniture, textiles, and porcelain home in 1795 and 1796. Like Thomas Jefferson, both Madison and Monroe admired the latest French styles.

When Madison was appointed secretary of state under Jefferson in 1801 and the family moved to Washington, Dolley Madison became the official hostess for the president, a widower. The Madison home on F Street was a hub of social activity. This cup, emblazoned with the initial "M" (which could have been for Madison or Monroe), was originally part of a set that included twelve coffee cups and saucers, twelve tea cups and saucers, and a tea set. It must have seen a good deal of use—and yet the set must also have been treated with great care throughout Madison's presidency and retirement. The M porcelain appears, mostly intact, in inventories as late as 1843. After Dolley Madison's death, though, the set was dispersed, and only a few cups and saucers are known today.

PLATE FROM
JAMES MADISON'S
SERVICE, 1806

Jean Népomucène Hermann Nast
(French, 1754–1817), Nast porcelain factory
(French, 1783–1835)

Paris

Hard-paste porcelain

Diam. 9⅛ in. (23.2 cm)

IN 1806, JAMES and Dolley Madison acquired a large porcelain service in this pattern. The pathway was a little unusual: their friend Fulwar Skipwith wrote to Madison that he had purchased the set from Jean Népomucène Hermann Nast, a Paris manufacturer, rather than buying it from a factory in Sèvres, as he had originally intended.

By going with the less prominent company, Skipwith had saved 40 percent on the purchase—and he was pleased to share the news of his good deal with James Madison. "This China in whiteness is not much inferior to the china of the celebrated Manufactory of Sève, & is just 40 p/c cheaper," he wrote on September 3, 1806. "I might have pleased myself better in my choice among much dearer sets of China . . . but in no one of the Manufactories could I select a Table & Desert [sic] set so good & so neat at the prices paid by me for yours."[102]

The handsome set probably went into storage when Madison's family moved into the White House in 1809. But after the British burned the White House in 1814, the family set up housekeeping at nearby Octagon House with their own items, including this service. They were not able to return to the White House during Madison's administration, and so today this service is considered the Madisons' White House china.

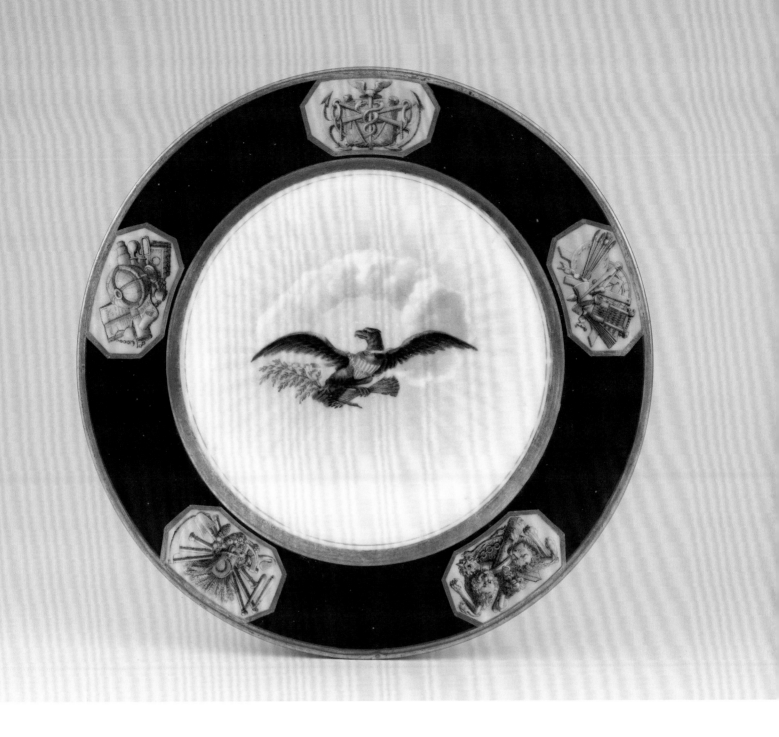

PLATE FROM
JAMES MONROE'S
DESSERT SERVICE, ca. 1817

Dagoty and Honoré
(French, 1816–20)
Paris
Hard-paste porcelain
Diam. 8^{11}/$_{16}$ in. (22.1 cm)

WHEN JAMES MONROE was elected president in 1816, he was ready to start entertaining—but the White House, newly rebuilt after being burned by the British in 1814, was not ready to receive guests. Still, Monroe, who had lived in France during two diplomatic missions, began to purchase the porcelain services and other items he would need when the residence was ready for occupancy in the fall of 1817.

On November 11, 1817, the ship *Resolution* arrived in Alexandria, Virginia, with this 166-piece dessert service for thirty. The design is striking: in the center, the American eagle clutches an olive branch and an arrow, and the motto *E pluribus unum* waves on a ribbon.

The five vignettes around the border represent commerce, the arts, strength, agriculture, and the sciences.

The presentation of dessert was a key part of formal dining in the eighteenth and nineteenth centuries, and so a set of dessert dishes could easily be far more elaborate than the service used for dinner. Accordingly, this dessert set included flat plates like this one, along with deep plates, large and small serving dishes, bowls for chestnuts and for sugar, fruit baskets, and ice cream urns—everything needed for genteel presentation of treats of every kind.

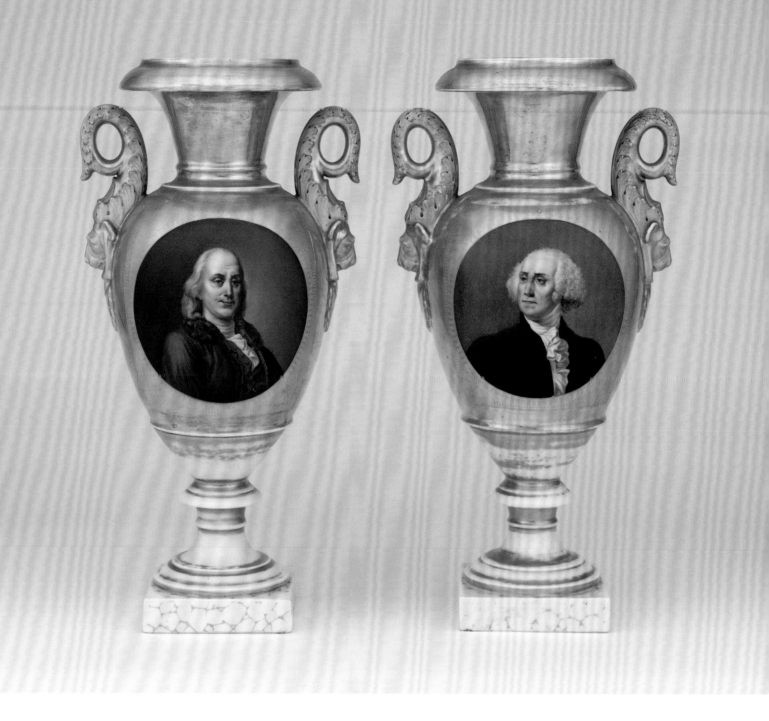

AMERICA'S COLLECTION

74

PAIR OF VASES,
ca. 1810–30

Unidentified maker

France

Hard-paste porcelain

13¹¹/₁₆ x 6⁷/₈ x 5⁷/₈ in.
(34.8 x 17.5 x 14.9 cm);
13½ x 6¾ x 5⅛ in.
(34.3 x 17.2 x 13 cm)

IN PARIS IN the early part of the 1800s, manufacturers of porcelain and fine china catered to foreigners—from continental Europe, Britain, and the United States. Americans and other foreign buyers perceived the items from Paris as more elegant and less expensive than wares from Sèvres.

All presidents from George Washington throughout the nineteenth century chose French porcelain for their tables. "We were taken to the state dining-room where was the gorgeous supper-table shaped like a horseshoe, and covered with every good and glittering thing French skill could devise," wrote Jessie Benton Frémont, recalling a childhood visit to the home of the president in the 1830s.[103]

This decorative pair of mantel vases squarely targeted the U.S. market. Portraits of Benjamin Franklin and George Washington were sure to interest Americans, and the elegant forms and sparkling gold grounds added to the appeal. Their survival to the present shows that more than several generations of Americans admired these elegant vases.

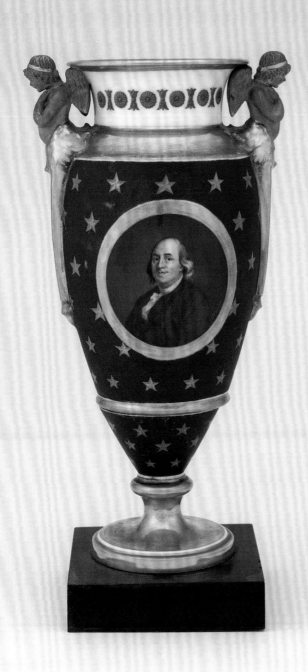

75 *TWO VIEWS*

VASE, ca. 1830–40
Unidentified maker
Paris
Hard-paste porcelain
11⅞ x 5¾ x 4¼ in.
(30.2 x 14.6 x 10.8 cm)

MADE IN FRANCE, like other portrait vases showing American heroes, this example celebrates the international favorite Benjamin Franklin, with a handsome portrait of the great man on one side, and an angel reading, presumably, his long list of accomplishments on the other. The star-spangled background and three-dimensional gilt angels add to the richness of this elegant commemoration.

Franklin's popularity made him one of the most-recognized faces on the planet during his lifetime and afterward, a fact that he himself acknowledged. In 1779, he wrote to his daughter, explaining that a medallion with his likeness "was the first of the kind made in France. A variety of others have been made since of different sizes; some to be set in lids of snuff boxes, and some so small as to be worn in rings; and the numbers sold are incredible. These, with the pictures, busts, and prints, (of which copies upon copies are spread every where) have made your father's face as well known as that of the moon."[104]

76

PLATE FROM JOHN A. AND ISABELLA PATRICK BROWN'S SERVICE, ca. 1805

Attributed to Dihl et Guérhard
(French, 18th and 19th centuries)
France
Hard-paste porcelain
Diam. 9¼ in. (23.5 cm)

IN THE 1700s and early 1800s, French porcelain manufacturers used a distinctively white base, usually with rococo gold decorations. More than thirty factories produced this type of ware in France at its peak around 1800; of these, Dihl et Guérhard was certainly one of the most distinguished. This plate, designed specifically for the American market and attributed to Dihl et Guérhard, shows the sophistication of the company's work. It was part of a service owned by John A. Brown (1788–1872), a wealthy Philadelphia merchant, and his wife, Isabella Patrick Brown (d. 1820).[105]

In France in the 1700s, all porcelain production was controlled by the crown and limited to Sèvres. Other French manufacturers were restricted from creating decorated porcelain. But in time, factories gained the patronage of nobles to help protect them, and they soon produced porcelain wares that rivaled those from Sèvres.

Dihl et Guérhard was established in 1781 under the protection of the very young Louis-Antoine d'Artois, duc d'Angoulême—the duke was a child of six at the time. The company's royal patronage (he was a nephew of Louis XVI) allowed it to manufacture colored and gilt porcelain. (One specialty was finishes that imitated hardstone and other natural materials—producing handsome wares that looked as if they were carved from marble or tortoiseshell.) By 1785, the company employed thirty painters and twelve sculptors.

Gouverneur Morris, the American diplomat, and a major figure at the Constitutional Convention in 1787, visited the factory often between 1789 and 1793; he noted, "We agree that the porcelaine here is handsomer and cheaper than that of Sèvres. I think I shall purchase for General Washington here."[106]

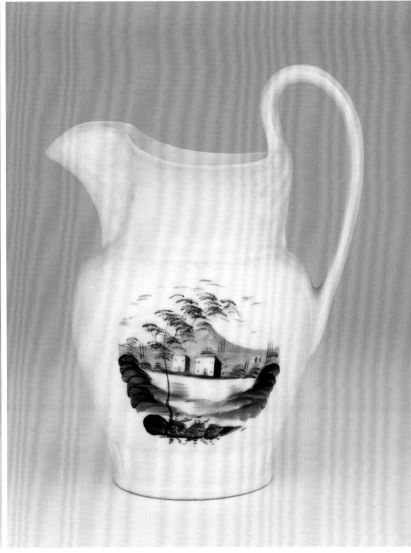

**TWO DECORATED
PITCHERS**, ca. 1826–38
William Ellis Tucker
(American, 1800–1832),
with partners and successors
(active 1826–38)
Philadelphia
Hard-paste porcelain
LEFT 9¼ x 8 x 5⁵⁄₁₆ in.
(23.5 x 20.3 x 13.6 cm);
RIGHT 9⅜ x 7⅜ x 4 in.
(23.8 x 18.7 x 10.2 cm)

FOR HUNDREDS OF years, only manufacturers in China knew the secrets of hard-paste porcelain. Not until the 1700s did European potters discover the correct mix of materials and temperatures to make true porcelain. In the United States, the development of domestic porcelain took even longer.

There were a handful of attempts at making porcelain in North America on a commercial scale, but it was William Ellis Tucker of Pennsylvania who succeeded in producing commercial quantities. Years later, his brother recalled, "My father had a china store on Market street, and in the year 1816 he built William a kiln in the yard back of the store, when William commenced painting upon the white ware in the store, and burning it in the kiln. . . . After many experiments and much labor, he was successful in making a very beautiful porcelain in a small way."[107]

By 1831, Tucker had expanded the business, acquiring land and mineral rights for raw materials from New Jersey, Delaware, and Pennsylvania. He moved and enlarged his operation, which grew to support forty workers and continued after Tucker's death in 1832. His factory is considered the first venture to be successful in making porcelain in the United States with American materials.

In 1832, when Tucker's brother recorded the shapes and decorations in production, more than 140 different forms were being made, including vases and table items. Number seven in the shape book was the "vase pitcher." The collection includes two examples of the form: one with monochrome enamels of pastoral scenes and one with bright polychrome enamels of flowers.

FURNITURE

REFLECTIONS ON THE CULTURAL TRADITIONS OF AMERICA'S ARTISANS

Alexandra Alevizatos Kirtley

FURNITURE IN THE Diplomatic Reception Rooms at the U.S. Department of State stands as a testament to generations of highly skilled and mostly anonymous artisans who transformed carefully chosen materials into functional pieces of sculpture. The tables, sideboards, chairs, desks, bookcases, chests, and clock cases are among the arts made in colonial North America and the early years of the United States that reflect the various cultures of people inhabiting the Indigenous lands. Beginning in the early 1600s, merchant ships brought furniture into America's ports from Britain, Ireland, continental Europe, India, and China that inspired artisans and patrons alike, but the people living in early America hailed from various cultural backgrounds and created wholly singular designs in their shops. American furniture at the State Department is a composite, demonstrating a distinctively American artistic dialect displaying the confluence of backgrounds, aspirations, designs, and impulses.

As arranged in the Diplomatic Reception Rooms, furniture was part of an architectural setting. Furniture makers—known early on as joiners and later as cabinetmakers—outfitted architectural interiors as well as ship cabins. Joiner-made seating and case furniture was composed mainly of mortise-and-tenon joined panels, or frames, and molding planes formed decorative profiles on the edges. Carvers used awls and gouges to ornament the flat surfaces, which were then often painted in shockingly vibrant colors. Turners used lathes to provide round supports for architectural elements such as balusters, and they turned spindles for rush- and cane-seated chairs, Windsor seating, and the pillars and round tops of tables and stands like the outstanding examples in the Rooms' collection (cats. 78, 79). The inextricable link between the design and execution of furniture and architecture persisted: in July 1788, when Philadelphia's artisans paraded through the city on elaborate floats to celebrate Pennsylvania's ratification of the U.S. Constitution, the cabinetmakers Jonathan Gostelowe (1745–1795) and Jedidiah Snowden (1724–1797) led the chairmakers and cabinetmakers, carrying furniture makers' tools (scales and dividers) and the foundational text, Andrea Palladio's *Four Books of Architecture* (Venice, 1570).[108]

OPPOSITE

Armchair (detail), ca. 1755–75 (see p. 224)

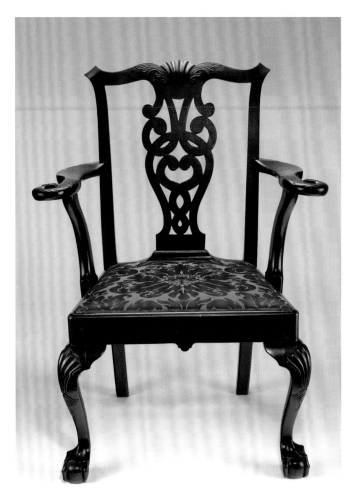

its tight grain suitable for carving. Walnut's swirling and sometimes dappled figure was sliced into veneers and added showy pattern, such as on the voluptuously shaped splat (or banister) of a Boston or New York chair (cat. 80). Even before Kalm's observations in Pennsylvania, colonists of Virginia had enslaved laborers felling American black walnut for export to ports in both North America and Britain, where the designation "Virginia Walnut" or "Virginia walnut-tree" indicated a desirable quality.[110] The potential for commercial success in the trade of cabinet woods may have inspired the proprietor William Penn when he named his colony, quite literally, "Penn's Woods."

More desirable than walnut was the tropical hardwood mahogany (*Swietenia macrophylla*); American artisans and patrons preferred its redder brown, even tighter grain, livelier figure, and suppler texture for carving (cat. 81). The Taíno of the Caribbean islands introduced mahogany first to Spanish and then to British colonizers for fortifications and canoe and boat building.[111] The extraordinary height and girth of the grand mahogany trees overwhelmed the tropical and mostly island landscapes, stupefying the eighteenth-century British naturalist Mark Catesby.[112] By the early 1700s, mahogany was prized in the Atlantic world for furniture making, and it began to be systematically felled by enslaved Africans who worked on large Caribbean plantations owned by prosperous white colonists from many cultures and religions, including Quakers.[113] Mahogany was shipped northward along the East Coast, where American merchants and artisans had first dibs on choosing the largest logs and most figured planks and flitches.

Architectural and furniture design books, imported furniture, and artisans and patrons from the trendsetting capitals of Britain, Ireland, continental Europe, and Asia, as well as enslaved Africans, came together in British North America to create the dynamic qualities that characterize American furniture. Being liberated from the restrictive guild system encouraged ingenuity, and traits emerged that distinguished furniture made in each American urban center; in larger communities, networks of shops and artisans developed identifiable styles.

The cabinetmaker and ardent Patriot Benjamin Frothingham (1734–1809) made the collection's monumental bombé desk

ARMCHAIR, ca. 1755–75
Unidentified maker
New York City
Mahogany, sweetgum, eastern white pine
39⅛ x 29 x 24 in. (99.4 x 73.7 x 61 cm)

The bounty of North America's forests encouraged the work of colonial and early federal furniture makers. The Swedish-born naturalist Pehr (or Peter) Kalm described the Lenape people's colonized lands (the Lenapehoking) in Pennsylvania in 1748, noting,

> The maple with red flowers grows in swampy, wet places over all of North America, but also does well on other soil if it is not too dry and sandy. . . . The wood is used for all kinds of cabinet work such as bureaus, desks, cupboards, chests, boxes, tables, chairs, and gunstocks. . . . The black walnut tree. It grows in the forests of Pennsylvania and New Jersey in good, loose soil. . . . The wood is exceptionally beautiful and is preferable to that of the European walnut for cabinet work. For this reason it is one of the most expensive woods found in North America. The roots are used in making bureaus, desks, cupboards, tables, chairs, boxes, and . . . all kinds of fine cabinet work.[109]

Like their European counterparts, elite American patrons were drawn to walnut's rich brown color, and artisans found

and bookcase early in his career in Charlestown, Massachusetts, the peninsular enclave (then) outside Boston (cat. 83). The scrolled pediment centers on a double oculus punctuated by flame finials. In a direct reference to classical architecture, the fluted pilasters with precisely carved Corinthian capitals separate fielded panel doors with arched tops. Below, the slant front conceals the desk that would have been illuminated by candles on the slides above. The trapezoidal-shaped feet are formed by stacks of molded profiles, and, along with the pilasters, they underscore the relationship between furniture and architecture and provide a glimpse of the moldings in the room for which it was made.

While Frothingham constructed his bombé desk and bookcase with four drawers of equal width and straight across the front, with the bulging sides sawn, a Boston artisan (possibly the Portsmouth-born Thomas Sherburne [1713–1784]) combined multiple variations to form a masterpiece of sculptural casework on a compact chest of drawers (cat. 84). Raised on rather small ogee bracket feet, the bombé sides and drawers span the width of the case. Most remarkably, the front of the case undulates in what is known as a reverse serpentine, where the center of it projects forward.

Distinguished by a tripartite facade of alternating projections, block-front designs derive from the profiles on the rails of Continental and British chairs and are reminiscent of the crescendo effect of facades on baroque buildings. A walnut high chest (cat. 82) and dressing table (not shown), made in Portsmouth, New Hampshire, by a cabinetmaker who likely trained in Boston, represent an early example of architectonic block-fronted case furniture. On the pair, intended for an elegant bedchamber, the front rail incorporates a scallop shell, which was also a crucial element of block-fronted furniture in Newport, Rhode Island. There, the shops of the Quakers John Townsend (1733–1809), who trained with his father, Christopher (1707–1787; a master ship and house joiner), and his cousin's husband, John Goddard (1724–1785), churned out elegant variations of the block and shell. Like an architectural capital, these formulaically carved scallop shells cap the undulating convex and concave blocks, producing a rhythmic effect (cats. 85, 86). Their masterpieces, almost always in imported mahogany rather than local maple or cherry, established the Townsend and Goddard families as Newport's cabinetmaking dynasty.[114]

While British cabinetmakers abandoned the high chest design in favor of a pair of drawers (also known as a double chest or a chest-on-chest), American cabinetmakers made both (cats. 87, 88). Such cases of drawers were intended for the bedchamber and were made with a "table to suit" or dressing table, such as one from Newport (cat. 89).[115] Philadelphia high chests and dressing tables in the collection demonstrate the range of rail shapes and carved ornament that the city's great number of cabinetmakers and carvers made.[116] While its upper case is missing, a base to a high chest is nonetheless extraordinary because it is part of a small number of Philadelphia-made high chests and dressing tables with narrative carvings rather than the more predictable carved scallop shell (cat. 90). Several have scenes from Aesop's Fables, and here, the Chinese-inspired phoenix, or ho-ho bird, is perched among attenuated arabesques flanked by columns and garlands and above C-scrolls and a basket of florals.[117]

Sophisticated but sturdy table frames were designed to support precious marble slabs, either imported or from American quarries (cat. 91). The deep rails of the frame made in Boston or Salem provide substantial support for the thick but brittle marble top. Most marble or other stone tops rely solely on the figure of the stone for ornament, but this remarkable slab is engraved with an image of Ceres, the goddess of summer, framed in a rocaille cartouche and surrounded by floral sprigs.[118]

While slab tables remained in a fixed position along a wall, card tables and tea tables were moved about the house and became centerpieces of a parlor when in use. Cabinetmakers designed these tables' proportions and shapely presence to command those spaces and be seen from all sides. New York's cabinetmakers made card tables with dramatically incurved rails, and the tops were supported by five legs instead of the typical four (cat. 92), and in Philadelphia artisans mastered the design of round tables with tops that tilted up (cats. 78, 79).

Chairs were made to complement tables. Rounded shoulders and seats (called "compass" because they required a compass to make[119]) gave way by the late 1740s to yoke crests and trapezoidal seats, and solid chair splats (or banisters) gave way to cut-through designs with carved decoration that created patterns when placed along the wall of a room—along the chair rail. The London cabinetmaker Thomas Chippendale's exhaustive publication of fashionable furniture, *The Gentleman and Cabinet-Maker's Director* (London, 1754, 1755, and 1762), influenced designs in Britain as well as North America. Artisans and patrons took cues from imported furniture as well as from publications like those by Chippendale and his contemporaries Robert Manwaring (see cat. 93) and the partners William Ince and John Mayhew, combining them to create vernacular designs that they passed on to apprentices and journeymen through shop templates.[120]

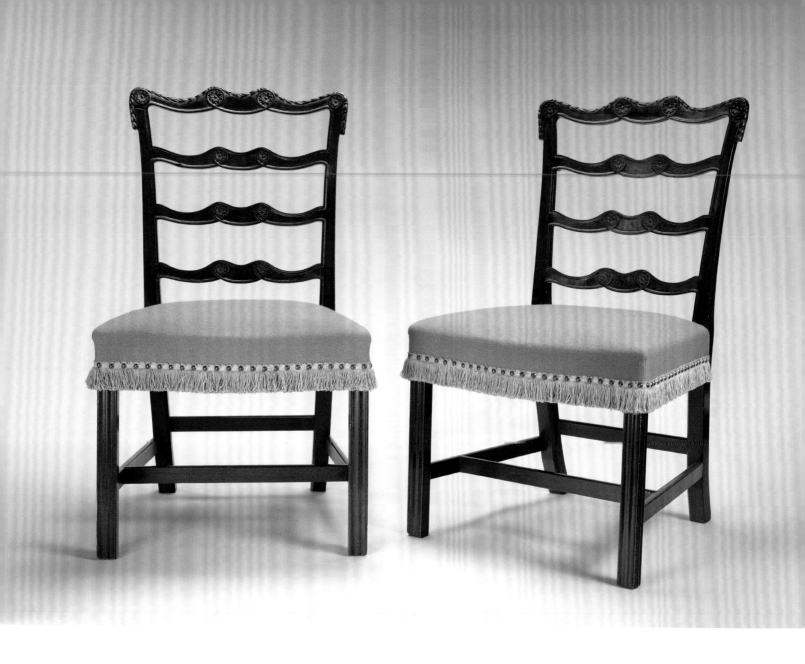

China tables held a place of honor in parlors. They feature stationary tops surrounded by a gallery, and elaborate ornament communicated their elevated status as a stage for a complete set of porcelain or china for tea, coffee, and chocolate.[121] Most likely the work of the London émigré artisan Robert Harrold (active 1765–92), a Portsmouth example is inspired by an ambitious design published in Chippendale's *Director* (3rd edition, 1762, pl. LI) (cat. 94).

A china table made in Williamsburg, Virginia, has legs, rails, and a gallery composed entirely of fret-sawn mahogany (cat. 95). It closely follows London examples and was likely made in the Nicholson Street shop of the cabinetmaker Anthony Hay (d. 1770). Like cabinetmakers from Portsmouth to

CHAIRS, ca. 1780

Unidentified maker

Possibly Annapolis, Maryland

Mahogany

37¼ x 21¼ x 20 in. (94.6 x 54 x 50.8 cm)

Savannah, Georgia, Hay worked alongside skilled journeymen and apprentices, including at least one enslaved African, named Wiltshire. A china table made in Beverly or Salem, Massachusetts, has plain rails and pierced corner brackets and was specifically made to support the imported tin-glazed earthenware tray with its transfer-printed classical landscape decoration (cat. 96).

Acting as interior designers do today, upholsterers of the 1700s and 1800s designed and fabricated elaborate furnishings for beds, windows, and seating that coordinated with one another. They required large workshops, which often included women; the expense of the stuffing, woven covers, and trims was limiting, and only the most prosperous Americans could afford upholstery. Two so-called French chairs—a British interpretation of French armchairs—were made as part of a set of chairs most likely in the shop of the Scottish-born Philadelphia cabinetmaker Thomas Affleck (1740–1795), a Quaker who used the skilled labor of enslaved Africans (cat. 97).[122] Such extravagant seating was not common in the

Americas, and these were likely commissioned by Richard Penn II (1731–1781) and his brother John Penn (1729–1795) while they oversaw Pennsylvania's proprietary government in the contentious years of the early 1770s.[123] As with most upholstered furniture, the original upholstery does not survive, but remarkably it does on the Diplomatic Reception Rooms' Philadelphia sofa (cat. 98). Sofas evolved from the Turkish tradition of laying upholstered textiles around the floors and walls of the perimeter of the room, giving the sitter a soft seat and backrest. The sofa's back screws into slots on the rear legs so that it can be removed for reupholstery and so the sofa can fit through narrow doorways. Like slab tables, the frame was not where the emphasis was; rather the sculptural qualities of the sofa came from curves and rolls of the upholstered form, the elegance of the original yellow moreen, and the gilded brass nails that both held the fabric in place and added visual excitement.[124]

Impressively monumental, a clock case in the collection displays the interplay of gusto and elegance that typifies Revolutionary-era Philadelphia furniture, especially that influenced by the throngs of German émigrés—heft and volume overlaid by fine floral and scroll carving, here with lattice and a delicate basket of flowers flanked by two flame finials (cat. 99). Tall cases for eight-day clocks allowed the movements (or clockworks) to keep time for as many as eight days, which was the time it took for the weights to fall to the bottom of the case. Little is known about the clockmaker, Joseph Bourghelle.

As Baltimore's significance as a port emerged in the late 1760s, entrepreneurial cabinetmakers from Philadelphia ventured south to Baltimore. The best known of them is Gerrard Hopkins (1742–1800), a Quaker who likely made a set of chairs for the parents of Francis Scott Key (1779–1843) of Maryland, the poet who wrote what would eventually become the national anthem (cat. 100). They share similarities with Philadelphia chairs, but nuances such as the inset shell on the front rail and unconventionally low, broad back are found on Hopkins's Maryland seating. John Bankson (1754–1814) of Philadelphia arrived in Baltimore in 1784 and partnered almost immediately with the London émigré Richard Lawson (1749–1803), who advertised that he had worked at "Mr. Seddon's cabinet warehouse, in London," referring to the great firm Seddon and Sons.[125] Together, Bankson and Lawson created innovative designs of neoclassical-style furniture, best demonstrated on the Rooms' sideboard (cat. 102).

Even in colonial Philadelphia and certainly in neoclassical Baltimore, French design exerted a strong but often unsung impact on American furniture, upholstery, and ornament. As the federal city of Washington, D.C., was built and populated in the 1790s and early 1800s, cabinetmakers in the port towns of Alexandria and Georgetown served an international and cosmopolitan clientele. The French-born and -trained ébéniste, or cabinetmaker, Andre Joseph Villard (ca. 1749–1819) brought his taste and talents with him to the district and made cabinet wares like the secretary and bookcase (cat. 101). Its rectilinear form, low tapered feet, and straightforward ornament epitomize the sophistication of French neoclassicism. By comparison, a secretary with wardrobe made in the important port and cultural center of Charleston, South Carolina, speaks to the predominant British taste entrenched in that city's artistic tradition (cat. 103).

If the pinnacle of Baltimore furniture is found in neoclassical masterpieces, New York's finest hour was the classical furniture of the first quarter of the nineteenth century. Trained as an ébéniste in Paris with his brother and his uncle, Charles-Honoré Lannuier (1779–1819) arrived in New York in 1803. He escaped the consequences of the French Revolution, but his work caused a different sort of revolution in New York. As seen on the collection's dressing chest (cat. 104) that fortunately bears one of his exquisitely detailed labels, Lannuier introduced the highest quality of wrought work that combined gilded ormolu mounts and a precision of execution not matched or seen elsewhere.

Since the early days of European colonization, America's furniture artisans have drawn on various backgrounds, tastes, and traditions to create individualized works of art. Their thoughtfully designed and well-executed furniture served as the sculpture of an interior where the architectural elements also complemented the furniture.

American furniture in the Diplomatic Reception Rooms represents the work of artisans up and down the East Coast and over the span of more than a hundred years, and it speaks to the creativity and ingenuity of all those who came together in North America to form a nation rich in the arts that reflected all its people.

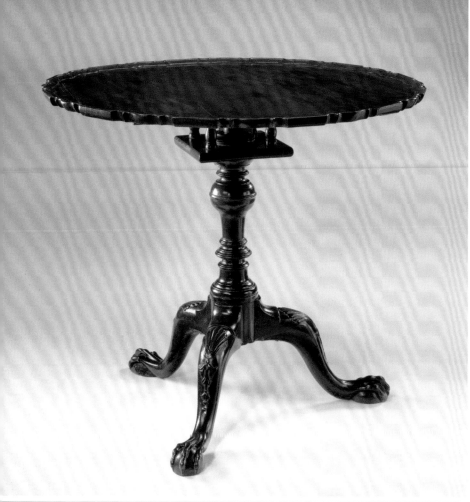

TEA TABLE, ca. 1750–58
Carving attributed to
Samuel Harding (American, d. 1758)
Philadelphia
Mahogany
27 x 31 in. (68.6 x 78.7 cm)

TEA TABLE, 1760–75
Carving attributed to the
shop of the so-called Garvan Carver
(probably Richard Wolley, American,
born England, 1728–1774)
Philadelphia
Mahogany
28 x 32½ in. (71.1 x 82.6 cm)

ROUND TEA TABLES, popular throughout the 1700s, feature tilting tops that allow the table to be placed against the wall or in a corner when not in use. More sophisticated examples, like these, feature a mechanism that allows the top to rotate while it is in the serving position. Philadelphians preferred these round tables with turned pillars and on three legs. Patrons could commission inexpensive mahogany versions with "plain top & feet,"[126] which cost two pounds fifteen shillings in 1772, or elaborate tables like these, with carved pillars and scalloped edges, which fetched as much as five pounds.

Cabinetmakers often bought uncarved pillars and tops from specialized artisans who turned those elements. Then the master cabinet-maker commissioned carvers to embellish the pillar, legs, and top. The table with carving attributed to Samuel Harding features an unusual base—the baluster (or vase) is inverted, with the broadest part at the top, rather than the bottom, as was more common.

The carver who ornamented the base of the table at the bottom is known as the Garvan Carver—the name comes from a chest in the Mabel Brady Garvan Collection at the Yale University Art Gallery. Even without a confirmed identity, the work of the Garvan Carver and his shop is revered. The distinctive carving features detail cuts to add volume and shading, with turned-over ends on the long leaves and clusters of parallel straight cuts to shade the leaf tips.

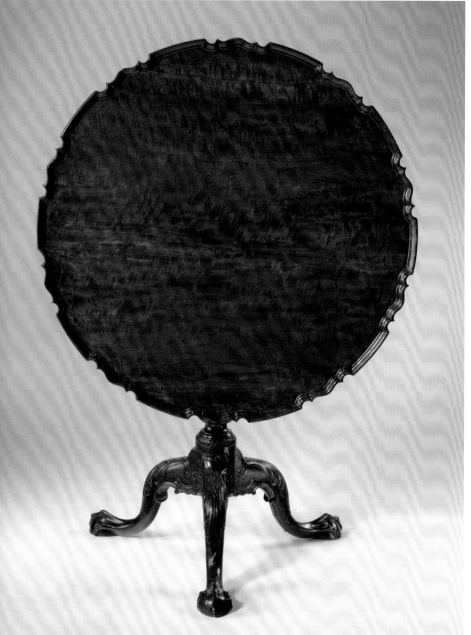

CHAIR, ca. 1750–60
Unidentified makers
Boston or New York City
Black walnut, eastern white pine, maple
38⅝ x 21½ x 21¼ in. (98.1 x 54.6 x 54 cm)

ONE OF A SET owned by John Aspinwall (1705–1774) and his wife, Mary Sands Aspinwall (1708–1766), this chair is identified as number four in a set by the "IIII" chiseled on the inside of the front rail. Aspinwall, a self-made man, went to sea and worked his way up to the command of a ship trading with the West Indies.

He went into partnership with his son-in-law Lawrence Kortright, and together the two made a tidy sum privateering during the French and Indian War. Later, one of Aspinwall's granddaughters married James Monroe, later the fifth president of the United States; another granddaughter married a Roosevelt, and their grandson was another president, Franklin Delano Roosevelt.

The Aspinwalls' set of finely sculpted chairs likely furnished their large house in Flushing, New York, built in 1762. The British used the house as a headquarters during the American Revolution, and later it reportedly served as a stop on the Underground Railroad—a tunnel belowground provided a route to a house nearby. The Aspinwalls' house survived until the 1950s.

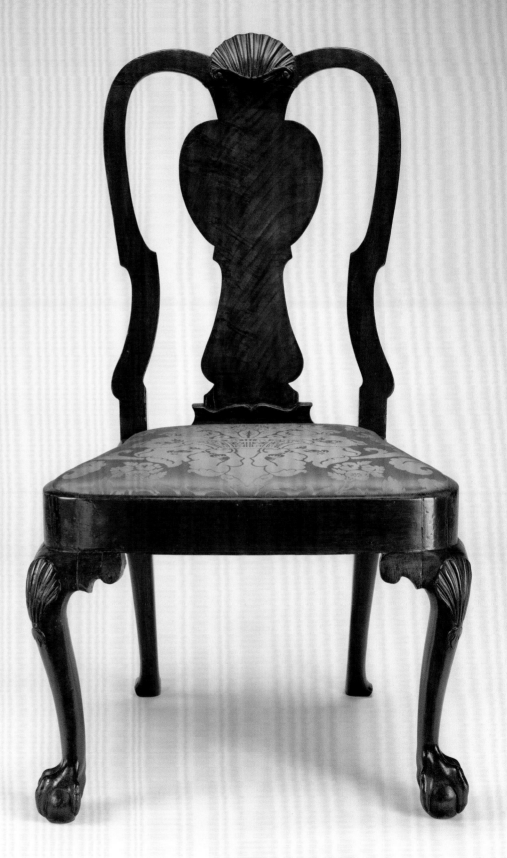

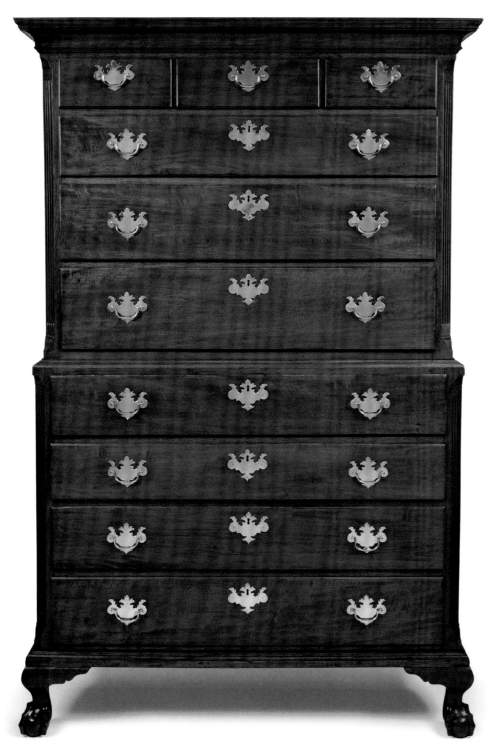

CHEST-ON-CHEST, ca. 1755–75
Unidentified maker
New York City
Mahogany, sweetgum, tulip poplar,
eastern white pine
79¼ x 50¼ x 22⅛ in.
(201.3 x 127.6 x 56.2 cm)

IN NEW YORK, colonists stored their linens and clothing in British-style linen presses and chest-on-chests (usually called double chests or pairs of drawers)—this one standing proudly on cabriole legs with ball-and-claw feet. But farther from the city, New York colonists of Dutch extraction used kasts, substantial two-door cabinets in the Continental style.

The government of New York was British; New York City, the seat of the colonial government and a hub for trade and immigration, had a sizable British presence. But farmers and other workers—on Long Island, in the Hudson River Valley, in the Adirondacks—were largely Dutch. Today, more kasts survive than monumental chests like this one.

This example, believed to have descended in the Van Rensselaer family, reflects New York's predominant British style, although the family was Dutch, a common hybridization. The Van Rensselaers owned significant land around Albany, but they assimilated with the British traditions in the area.

This chest-on-chest displays New York City design traditions, with mahogany as the primary wood, a flat cornice, three small drawers in the upper case, chamfered corners with a flattened "lamb's-tongue" terminal, and ball-and-claw feet. The patron who commissioned this chest had a desk set in the top drawer of the lower case; the drawer front drops forward to reveal pigeon holes and a writing surface. The chest also has a clever and practical twist: the rail above the bottom drawer is actually part of the drawer front—so the drawer is an inch taller than it appears.

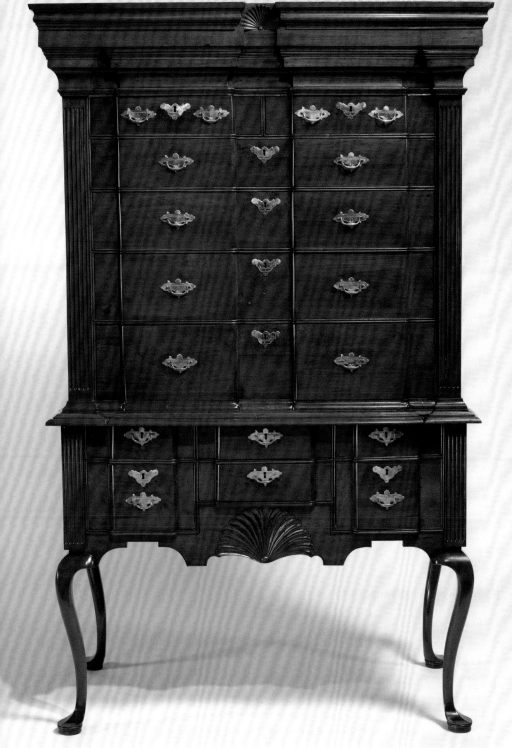

HIGH CHEST OF DRAWERS,
ca. 1740–50
Unidentified maker
Portsmouth, New Hampshire
Black walnut, eastern white pine, red oak
74⅛ x 47⁵⁄₁₆ x 25½ in.
(188.3 x 120.2 x 64.8 cm)

ELEGANT COLONIAL bedchambers featured two pieces of furniture that were made as an ensemble: a high chest and a dressing table. The British preferred pairs of drawers (or chest-on-chests) and abandoned the high chest design around the time this chest was made, so the development of the high chest design in the 1750s through the 1780s is a completely American confection. In this case, the high chest and dressing table (RR-1990.0007; not pictured) were separated for some time, took different journeys, and were then reunited at the State Department. The original legs of the chest did not survive, and they were restored by conservators in the 1990s who used the design of legs on the dressing table as the model.

The high chest and dressing table were created by an artisan from Portsmouth, New Hampshire, who is unidentified except by the body of his work that survives. The name Joseph Davis is chalked on the bottom of a drawer in the dressing table. While at least three men named Joseph Davis lived in Portsmouth at the time, none of them has been identified as a cabinetmaker or joiner, which suggests that Davis was the owner, not the maker. With only about two thousand residents, Portsmouth was a fairly small town when this chest was made, but furniture made there was remarkably dynamic.

DESK AND BOOKCASE, 1753

Benjamin Frothingham
(American, 1734–1809)
Charlestown, Massachusetts
Mahogany, white pine,
eastern red cedar, Spanish cedar
98¼ x 44½ x 24¾ in.
(249.6 x 113 x 62.9 cm)

THIS STATELY MAHOGANY desk and bookcase, an icon of Boston furniture, may be the first documented piece of bombé cabinetwork made in America. The bombé shape—from the French word for "bulging"— was developed in the sixteenth century by Italian artisans. Soon Dutch, French, and British furniture makers adapted the stylish look. In Boston, where artisans were trained in and patrons preferred British designs, displaying a bombé chest was practically de rigueur among the wealthy and prominent.

This is the earliest furniture documented to Benjamin Frothingham of Charlestown, Massachusetts, who was one of dozens of cabinetmakers in the Boston area. He was only about twenty when he created it in 1753; with its monumental presence and modish carved details—and even secret document drawers—it may have been the culmination of an apprenticeship. Frothingham, who ensured his place in furniture history through his assiduous use of engraved paper labels later in his career, served in the Continental Army, rising to the rank of major. George Washington visited him in 1789 during a tour of New England.

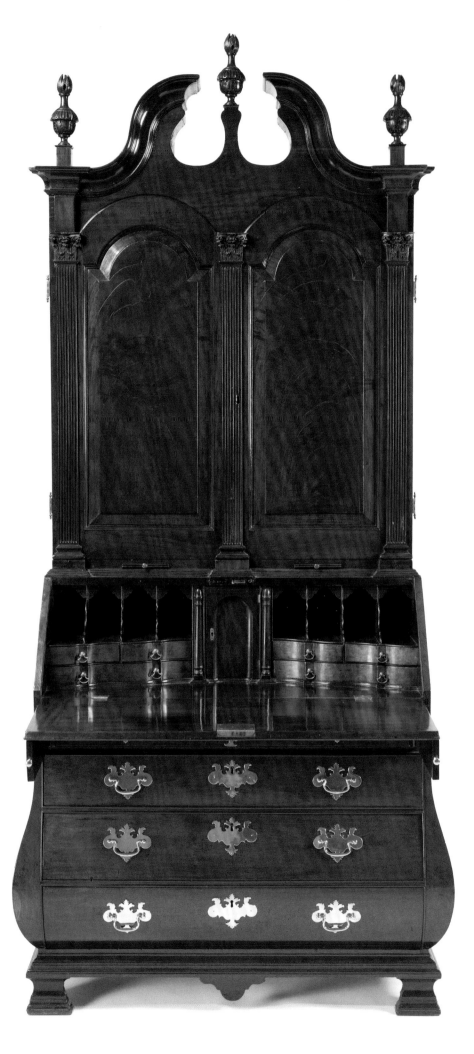

CHEST OF DRAWERS, ca. 1770–85

Attributed to the shop of Thomas Sherburne

(American, 1713–1784)

Boston

Mahogany, eastern white pine

30½ x 35⅞ x 20 in.

(77.5 x 91.1 x 50.8 cm)

IN 1765, THOMAS SHERBURNE advertised that he made and sold all sorts of cabinet-ware at his shop in Boston. This chest would surely have been one of the most elegant and costly products of the shop. Not only does it have the stylish bombé form, figured mahogany, and gilded hardware imported from England, but it is one of only thirteen known bombé chests that are also serpentine—meaning it is shaped and curved both along its sides and across the front.

In the colonial era, the owners of bombé furniture included Boston's most prominent families, such as John and Dorothy Hancock, Gardiner Greene, Joseph and Anna Barrell,

Thomas and Hannah Dawes, Edward and Sarah Brinley, Samuel and Catherine Dexter, and Ebenezer and Elizabeth Storer, who all attended services at the Brattle Square Church, home to a spectacular bombé pulpit.

Storer (1729–1807), a prosperous merchant, who with his wife, Elizabeth Green Storer (1734–1774), commissioned this chest from Thomas Sherburne, served as the treasurer of Harvard College from 1777 until his death in 1807. The Storers' mansion on Sudbury Street was filled with the latest and most extravagant furniture, paintings, carpets, and ornaments. Their portraits were painted by John Singleton Copley.

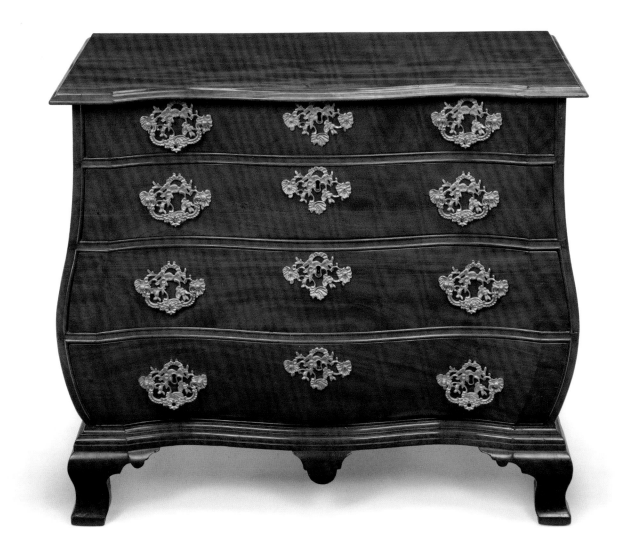

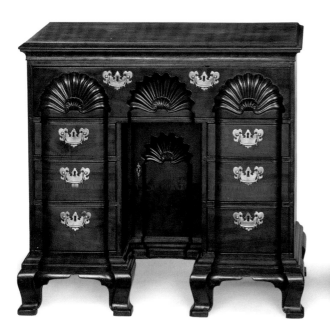

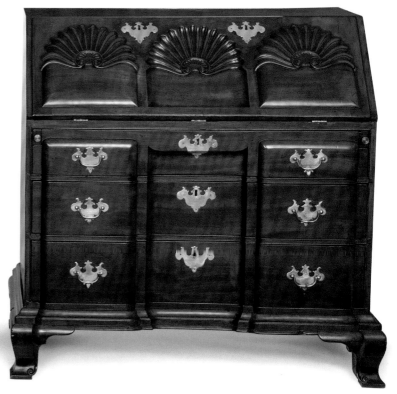

85 *ABOVE LEFT*

BUREAU TABLE, ca. 1765

Thomas Townsend (American, 1742–1827)
Newport, Rhode Island
Mahogany, eastern red cedar, eastern
white pine, tulip poplar, and chestnut
32⅞ x 36¼ x 20¾ in.
(83.5 x 92.1 x 52.7 cm)

86 *ABOVE RIGHT*

DESK, 1765

John Townsend (American, 1733–1809)
Newport, Rhode Island
Mahogany, tulip poplar
42 x 45¼ x 24⅞ in.
(106.7 x 114.9 x 63.2 cm)

THE TOWNSEND and Goddard dynasties of cabinetmakers began with two wood-working brothers, Job Townsend and Christopher Townsend, both Quakers who were working in Newport by 1725. In 1743, Job Townsend took on a young apprentice, John Goddard, who married Job's daughter Hannah. John Goddard's brother, James Goddard, married Job's daughter Suzanna. At least twenty Townsends and Goddards in several generations made fine furniture over a 120-year period.

John Townsend, Christopher's son, signed several of his cabinet wares. The hand-written label on this slant-front desk includes the date, 1765, and Rhode Island. Desks similar to this one, with block fronts and shell decorations, distinguish Rhode Island and eastern Connecticut furniture. On this desk, Townsend demonstrates his meticulous

eye for construction details and employs his signature shell carving, all in the finest mahogany. The writing board drops down to reveal small drawers and pigeonholes inside with a well that provides direct access to the drawer below.

More than fifty bureau tables from Rhode Island survive, a sizable number for a form with such a particular use in an office, bed chamber, or dressing chamber. This example's combined utility for writing, storing, and dressing symbolized the elite status of its owner. The three shells across the top and smaller shell on the recessed door at the center relate it to other furniture (and possibly the architectural carving) that may have been in the house for which it was made.

CHEST-ON-CHEST,

ca. 1760–75

Unidentified maker

New York City

Mahogany, eastern white pine, tulip poplar

81¼ x 51 x 26 in.

(206.4 x 129.5 x 66 cm)

JOHN STEVENS (1716–1792) and Elizabeth Alexander Stevens (1726–1800) were the first owners of this remarkable chest-on-chest. He was a ship captain and merchant who served in many offices in New Jersey over his lifetime, including president of the state convention that ratified the U.S. Constitution in 1787.

John and Elizabeth Stevens were known for their refined tastes and extensive real estate holdings. His shipping business was based in Perth Amboy, New Jersey, and he bought a town house at 7 Broadway in New York City in 1761. In 1771, he and Elizabeth built a large house in central New Jersey. Any of their residences could have housed the chest-on-chest and three chairs that also descended in their family; all the surviving furniture shows Stevens's famously opulent taste.

The chest-on-chest is built in three sections: a framed cornice, an upper case of drawers, and a lower case of drawers. Other New York works have similar construction, all following British furniture from the mid-eighteenth century. New York cabinetmakers particularly favored the dentil-block ornament on the cornice; such elements may have been inspired by Thomas Chippendale, who illustrated them again and again in *The Gentleman and Cabinet-Maker's Director*. These dentils also likely related to the architectural details in the interior for which the chest was made. The extraordinary hairy paw carving on the feet represents an upgrade from the more typical talons on a ball-and-claw foot.

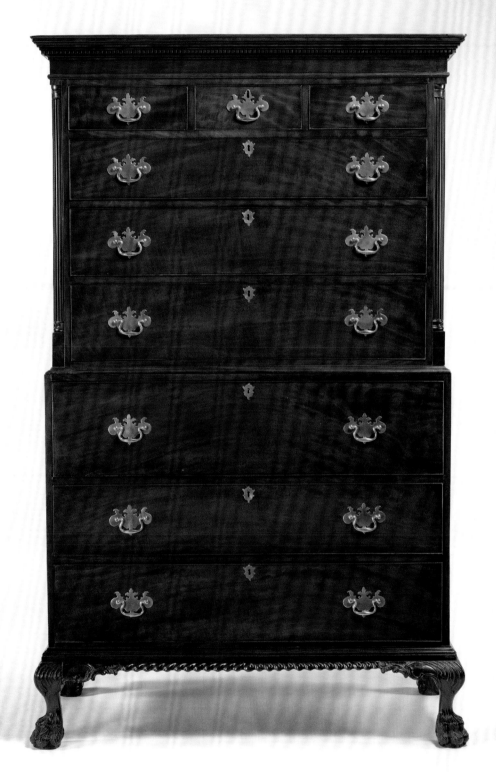

HIGH CHEST OF DRAWERS,

ca. 1755–85

Possibly by Daniel Goddard

(American, b. 1747)

Newport, Rhode Island

Mahogany, tulip poplar, chestnut,

yellow pine, maple, white pine

81⅞ x 41 x 20⅞ in.

(208 x 104.1 x 53 cm)

HIGH CHESTS LIKE this were popular in America in the second half of the eighteenth century, and this one exemplifies Newport's furniture-making tradition. In Newport, local tastes among both cabinetmakers and clients favored strong lines, little ornamentation beyond restrained carving, and the use of dark mahogany. This chest features striking plaques between the scrolls of the pediment, a local preference.

The height of the lower case relative to the upper case gives the high chest verticality. The molding in the middle is attached to the upper case. The scrolled pediment is a slightly unusual feature that would have been the choice of the cabinetmaker and the patrons for whom he was making it.

The carving and case construction are distinctive of Newport furniture. The concave shell has eleven lobes and is carved from the solid mahogany of the front rail, with incised scrolls at the ends. The cabriole legs retain the squared shape of the block, giving them a a sturdy look, and the ball-and-claw feet are notably tall with attenuated talons.

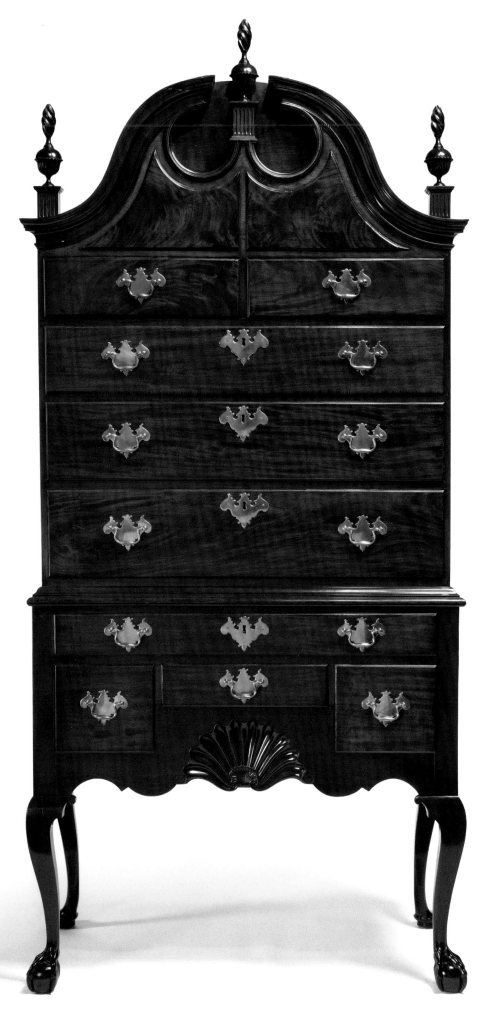

DRESSING TABLE,
ca. 1750–70
Possibly by John Goddard
(American, 1723–1785)
Newport, Rhode Island
Mahogany, eastern white pine, chestnut
31⅞ x 34¼ x 21¾ in.
(81 x 87 x 55.2 cm)

ACCORDING TO TRADITION, this dressing table was owned by Stephen Hopkins (1707–1785) of Providence, Rhode Island, who possibly acquired it in 1755 when he married his second wife, Anne Arnold Hopkins (1717–1782). Hopkins served as the first chancellor of Brown University and as governor and then chief justice of Rhode Island before participating in the First and Second Continental Congresses. He was passionate about the freedoms from Britain that the colonists needed, and his Quaker beliefs made him a strong opponent of the institution of slavery. Hopkins was the second oldest signer of the Declaration of Independence (after Benjamin Franklin), proudly stating, "My hand trembles, but my heart does not."[127]

Made in Newport and shipped to Providence, the Hopkinses' dressing table has cabriole legs carved with low-relief acanthus leaf and palmette decoration. The wide stance of the legs is designed to accommodate the chair of its users (both men and women), who could store their accouterments in the drawers. The gently curved front rail centers on a plain, smoothly carved, stylized scallop shell with ten lobes. The front legs end in well-articulated claws grasping large balls that represent the pearl of wisdom, a popular motif that originated in China. The claws are undercut so that light passes underneath the pointy talons, giving the legs a lofty appearance. Nuances in its construction suggest that the table was made by the Newport cabinetmaker John Goddard.

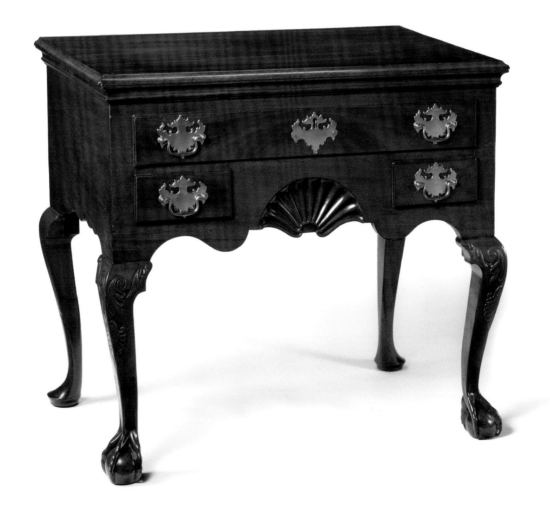

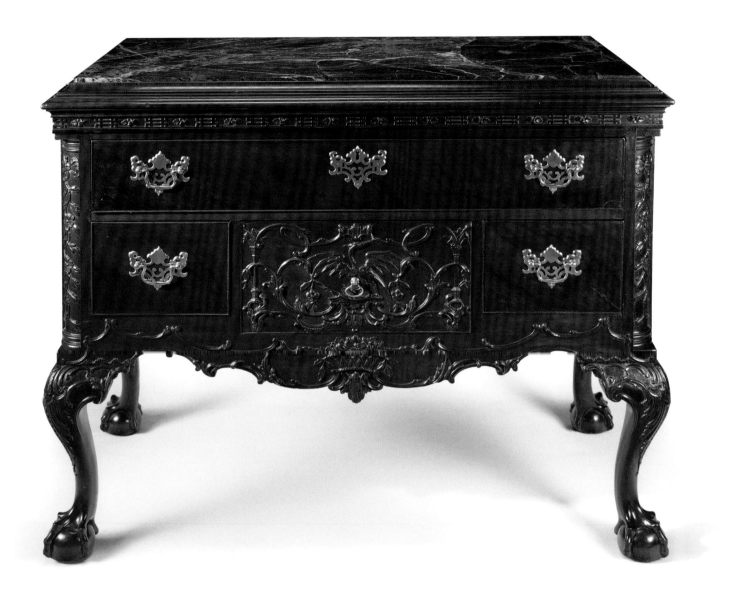

90

BASE OF A HIGH CHEST OF DRAWERS, ca. 1765–90

Unidentified maker

Philadelphia

Mahogany, southern yellow pine, Atlantic white cedar

38 x 45⅝ x 22⅞ in.

(96.5 x 115.9 x 58.1 cm)

IN THE MID-EIGHTEENTH century, fashionable designs and ornaments coexisted, such as the gothic, rococo (or rocaille), baroque, classical, and Chinese. Related Philadelphia high chests are carved only with bold shells and verdant foliage, but on this example, many styles converge: delicate arabesques, C-scrolls, Chinese fretwork, slender carved columns, and a basket of flowers. Together they frame a narrative that centers on a mythical ho-ho bird.

As an American form with carved elements of the playful rococo, the Chinese bird and fretwork, and the naturalistic flowers and foliage, this high chest base is one of only three known with narrative carving on the central drawers. (A closely related dressing table is in the Museum of Fine Arts, Boston.) The delicate carving is by a specialist, such as John Pollard (1740–1787), who trained in London at the height of the rococo style there. He arrived in 1765 in Philadelphia, where he advertised as a "house carver" and worked for the cabinetmaker Benjamin Randolph (1737–1791), who advertised furniture "in the Chinese and Modern Tastes."[128]

Pollard remained with Randolph for several years before partnering with Richard Butts; they established their own business on Chestnut Street. So ingrained was Chinese ornament in their work that Pollard and Butts advertised in the *Philadelphia Gazette* on February 22, 1773, that they could provide "all manner of carving" at the Sign of the Chinese Shield.[129]

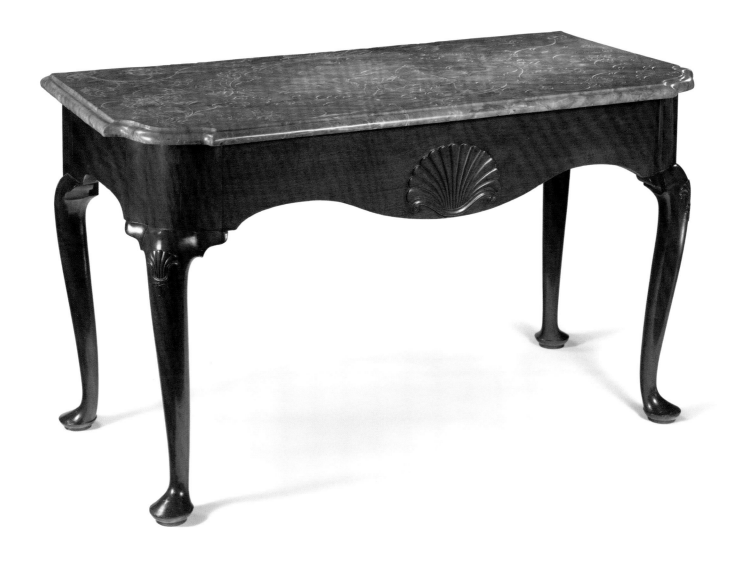

91

SLAB TABLE, ca. 1740–60
Unidentified maker
Boston or Salem, Massachusetts
Mahogany, eastern white pine, marble
26¾ x 46 x 23 in.
(67.9 x 116.8 x 58.4 cm)

IN THE 1700s, the elegant houses of Boston's prosperous elite often boasted a marble slab table, which might be described in household inventories as "1 marble slab and table" or "1 marble table with mahogany frame."[130] The entries make it clear that the slab and the wooden frames were separate items, procured from separate artisans, and that the marble took precedence.

Extraordinarily, this table's marble slab is engraved with a scene depicting Ceres, the goddess of agriculture and a symbol of summer. The mansion of Jeremiah and Martha Lee in Marblehead, Massachusetts,

has its pendant table, engraved with a robed man facing a fire with rising flames, the personification of winter. The two tables are considered mates, and it is possible that two more tables existed, one depicting spring and the other autumn.

Because the marble was resistant to water, heat, and dampness, tables like these were useful for serving hot food and drinks. The marble was luxurious, and the supporting frames were handsome and elegantly carved—like this one, with its crisp shell and shapely legs, which made an imposing visual statement (and was rarely moved) in a front hall.

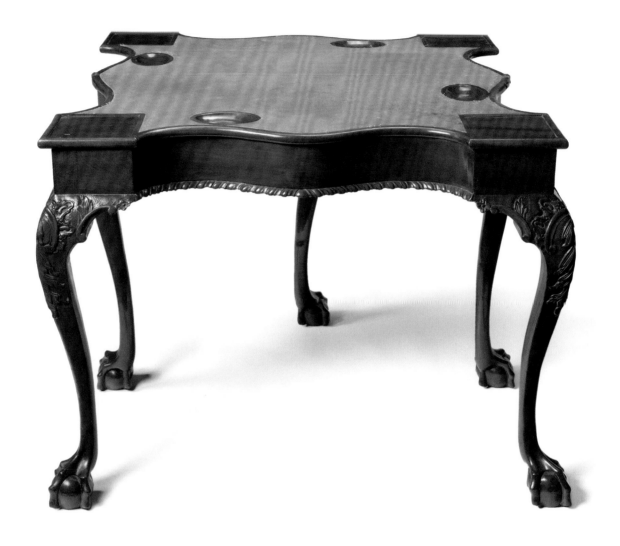

92

CARD TABLE, ca. 1760–90
Unidentified maker
New York City
Mahogany, red oak, tulip poplar, hickory
27⅜ x 34 x 16½ in.
(70.2 x 86.4 x 41.9 cm)

BY TRADITION, this card table descended in the family of the New Yorkers Richard Varick (1753–1831) and Maria Roosevelt Varick (1763–1841). Richard Varick served in the Continental Army as military secretary to Benedict Arnold—whose collusion with the enemy was discovered at a pivotal moment in September 1780. That November, a court of inquiry concluded "That Lieutenant Colonel Varick's conduct with respect to the base Peculations and Treasonable Practices of the late General Arnold is not only unimpeachable but [we] think him entitled (throughout every part of his conduct) to a degree of Merit that does him great honor as an Officer and particularly distinguishes him as a sincere Friend to his Country."[131] Later, George Washington selected Varick to organize his

official papers, a job that took more than two years and produced forty-four volumes. Varick also served as mayor of New York City from 1789 to 1801.

With its long, elegant lines and carved front legs, this card table would be placed against the wall when not being used. When it was pulled out for games, the fifth leg extended to support the top . . . and to reveal a hidden drawer. The interior surface is lined with green baize and fitted with holders for counters, and the corners are shaped to support candlesticks. The setup was perfect for games of whist, loo, quadrille, cribbage, or piquet—all beloved by American colonists, who would often start a game after supper and play until dawn.

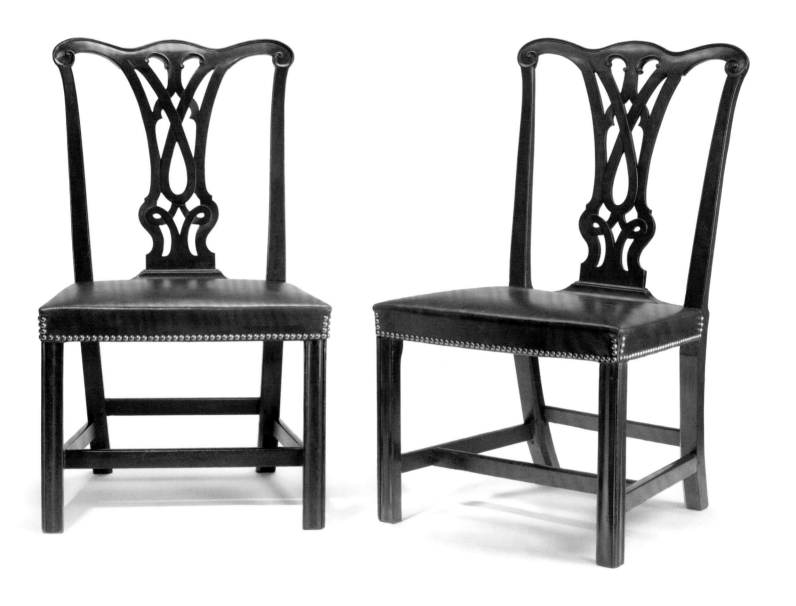

CHAIRS, ca. 1765–85
Attributed to Robert Harrold
(American, born England, active 1765–92)
Portsmouth, New Hampshire
Mahogany, soft maple, eastern white pine
37⅜ x 22¼ x 18⅛ in.
(94.9 x 56.5 x 46 cm)

ORIGINALLY PART OF a set of ten, these two chairs have intricately cut-through and carved splats (or banisters) and were probably commissioned before the American Revolution from Robert Harrold, a cabinetmaker in Portsmouth, New Hampshire. Matthew S. Marsh (1773–1814) and Sarah Massey Marsh (d. 1810) commissioned the chairs and used them in their house. When Matthew Marsh died in 1814, they were valued at two pounds each—a substantial sum for at least thirty-year-old chairs.

Marsh's name is branded on the chairs, an identifying technique that was unusual elsewhere but common in Portsmouth. The city had three major fires between 1802 and 1813,

and local residents worried about both the destruction of their worldly goods in a fire and pilfering during or after a fire. At least three dozen other people branded their furniture to make their ownership clear.

As clearly as the brand, the design marks these chairs as products of Portsmouth. Where the diamond and scrollwork are found on the Marshes' chairs, others usually have a circular opening. This configuration of the splat matches two chairs that descended in the Doe family of Rollinsford, New Hampshire, ten miles from Portsmouth. The carving on the ears is similar to that on an armchair that was owned in 1832 by a Portsmouth watchmaker named George Gains Brewster.

CHINA TABLE, ca. 1760–75

Attributed to Robert Harrold
(American, born England, active 1765–92)
Portsmouth, New Hampshire
Mahogany, sabicu, soft maple,
eastern white pine
27½ x 32½ x 22½ in.
(69.9 x 82.6 x 57.2 cm)

THE ESTEEMED CABINETMAKER Robert Harrold, an English immigrant, introduced this dramatic take on the rococo to Portsmouth, New Hampshire, borrowing the double-scrolled, cross-shaped stretcher design from Thomas Chippendale's *The Gentleman and Cabinet-Maker's Director* (3rd edition, 1762, plate LI).

Seven similar china tables from Portsmouth survive today in various collections. All the tables have a railed gallery, fretwork brackets, and serpentine stretchers rising to a central plinth and pierced finial. All but one—this one—have legs and tops of solid mahogany and rails of mahogany veneer on maple. This example, however, has a top made of sabicu

(*Lysiloma sabicu*), a tropical wood sometimes known as horseflesh mahogany.

While the provenance of the collection's table is unknown, several of the similar tables can be traced back to Portsmouth's most prosperous families. One was owned by William Whipple (1731–1785) and Catherine Moffat Whipple (1734–1821); William was a general in the Continental Army who signed the Declaration of Independence. In early 1776, Whipple wrote, "This year, my Friend, is big with mighty events. Nothing less than the fate of America depends on the virtue of her sons, and if they do not have virtue enough to support the most Glorious Cause ever human beings were engaged in, they don't deserve the blessings of freedom."[132]

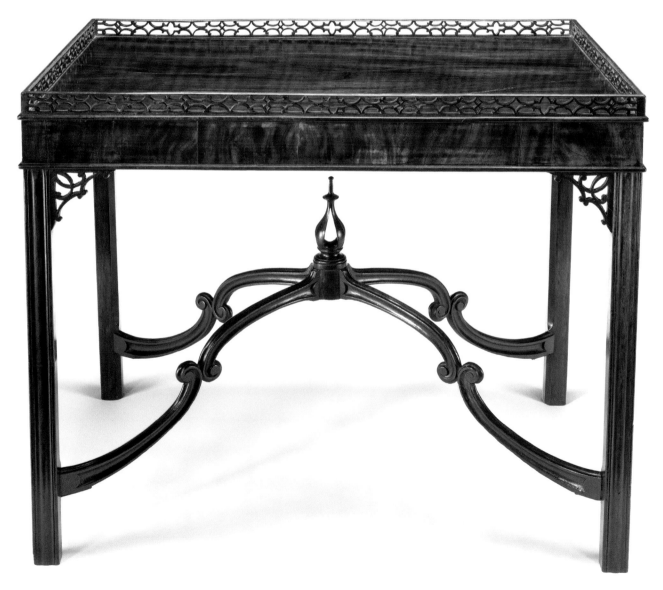

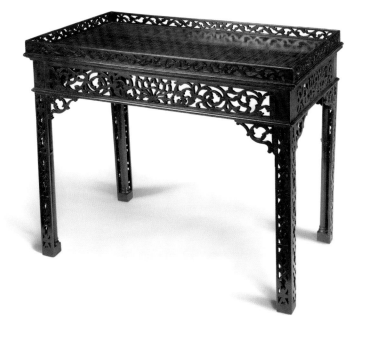

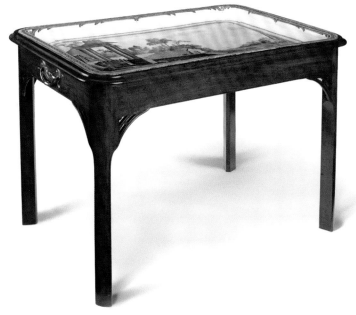

CHINA TABLE, ca. 1760–70

Shop of Anthony Hay (founded by Anthony Hay,
American, born Scotland; active 1751–66;
shop operated by Benjamin Bucktrout 1766–70)
Williamsburg, Virginia
Soft maple, cherry, mahogany, white oak, eastern white pine
30⅜ x 34½ x 21 in. (77.8 x 87.6 x 53.3 cm)

CHINA TABLE WITH EARTHENWARE TRAY,
ca. 1780–95

Unidentified maker
Beverly or Salem, Massachusetts (table); Sweden (tray)
Mahogany, eastern white pine,
tin-glazed earthenware
27¹⁵⁄₁₆ x 37¼ x 25¹³⁄₁₆ in. (71 x 94.6 x 65.6 cm)

IN THE 1750s, Anthony Hay founded a cabinetmaking shop in Williamsburg, Virginia. The baroque table on the left, with its elegant pierced fretwork, is one of a group of six that have been attributed to Hay's shop; in 1754, Thomas Chippendale described similar tables in the first edition of *The Gentleman and Cabinet-Maker's Director,* calling them china tables, "for holding each a Set of China and may be used as Tea-Tables."[133]

Elsewhere in America, John Tittle, a ship captain from Beverly, Massachusetts, owned a "mohogany fram'd Table cover'd with China," similar to the table on the right.[134] That table is now at Winterthur. The two faience trays were imported from Sweden, where ceramic trays were incorporated in furniture. Tittle kept one tray for himself and may have given the other—this one—to a friend or relative. Although made by the same cabinetmaker, the friend's version is slightly more elaborate, with extra piercings in the fretwork and brass carrying handles on the sides, as he requested.

Drinking tea was a messy business in the late eighteenth century, requiring hot water and producing soggy used leaves. Faience tray tables, like the one on the right, offered a practical way to serve tea while not putting the surfaces at risk from spills and stains.

ENSLAVED AND FREE BLACK ARTISTS & ARTISANS

WHEN WE LOOK AT THE MANY extraordinary works of art in the collection of the Diplomatic Reception Rooms, we understand and appreciate them in part by attributing them to the artists and artisans who made them. Many of these people we know well from years of scholars' research and study; some are unknown but represent regional styles or workshops. Yet many of the collection's works—both those that are anonymous and those assigned to known artists—involved the contributions of unnamed enslaved, indentured, or free Black artists.

Artists and artisans of color were prevalent in colonial-era America and long after. Some, like the Black painters Robert S. Duncanson and Joshua Johnson (see pp. 146–47 and cat. 27), achieved professional success in their lifetimes. Others were not recognized in their day, known only by a first name or a workshop record. Much research and study remain to be done to reveal exciting new perspectives on American art.

What is certain is that enslaved and free Black artists and artisans were everywhere in eighteenth- and nineteenth-century America, and in significant numbers, even if many of their names are unknown and their stories are waiting to be rediscovered.

An elegant table in the collection is from the Williamsburg, Virginia, shop of the cabinetmaker Anthony Hay (active 1751–66; cat. 95 and opposite page), who employed enslaved workers. One, referred to only as Wiltshire, was described as "a very good cabinetmaker" when he was offered for sale after Hay's death (below).[135] The words "very good" were an assessment of the quality of his work, but they also indicated that, as a trained cabinetmaker, he might be valued more highly.

In Philadelphia, the Quaker Thomas Affleck (1740–1795) was one of many who had enslaved artisans in his cabinetmaking shop (cat. 97).[136] Elsewhere, Thomas Elfe (1719–1775) had enslaved and free apprentices, journeymen, and artisans in his shop in Charleston, South Carolina, including men named Oxford, George, Liverpool, and Portsmouth.[137] Contemporary records in Charleston document hundreds of enslaved workers in artisanal shops, as such labor fueled South Carolina's bustling economy. It was common practice to train enslaved cabinetmakers and hire them out by the day, week, or month to provide income for their enslavers' businesses.

The cabinetmaker Thomas Day (1801–1861), born into a free Black family, established his own business in North Carolina in 1825 and rose to become one of the state's most successful furniture makers, although he resorted to using enslaved workers himself to gain a foothold in the competitive marketplace.[138] The complicated race politics of the time and place likely meant that by keeping them in his own enterprise, he may have been sheltering these workers from harsh treatment by others. Thomas Gross (1775–1839), a free Black cabinetmaker in Philadelphia, also had his own shop, but only one of his works, a handsome double chest, has been found to bear his signature.[139]

During the colonial era and afterward, large plantations often had their own joiner's shops on-site to outfit and repair residences, build farm equipment, and manufacture "everyday" furniture. Perhaps the most famous was at Thomas Jefferson's Monticello, in Charlottesville, Virginia, where the enslaved artisan John Hemmings (1776–1833) realized (and possibly refined) some of Jefferson's inventions and architectural additions.[140]

Pursuant to the last Will and Testament of Mr. Anthony Hay, deceased, will be SOLD, on TUESDAY the 7th of MAY, before the Raleigh Door, in Williamsburg, NINETEEN NEGROES belonging to his Estate, among them a very good Cabinet Maker, a good Coachman and Carter, some fine Waiting Boys, good Cooks, Washers, &c.——Six Months Credit will be allowed, the Purchasers giving Bond and Security to
WILLIAM TREBELL, } Executors.
ROBERT NICOLSON, }

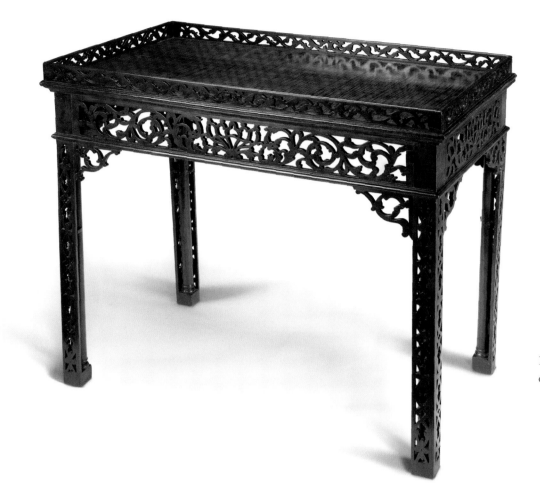

The silversmith Peter Bentzon (ca. 1783–after 1850), a free Black man born in the Danish West Indies and trained in Philadelphia, is the first American silversmith of African descent whose works can be identified by a mark with his name. Fewer than three dozen objects bear Bentzon's mark, but his work is distinctively elegant and assured (opposite, bottom right). Many other silversmiths used enslaved and free Black workers in their shops. The New York silversmith John Hastier (1691–1771) employed an enslaved man named Jasper, and in Philadelphia, the silversmith Joseph Lownes (1754–1820) had a Black apprentice named Joseph Head; Lownes would later provide a character reference for him (see p. 286 for Lownes's trade card). Henry Bray and Anthony Sowerwalt are listed as silversmiths and "Persons of Colour" in Philadelphia directories in the early 1800s. No objects with their personal marks are known, so their work remains unidentified today.[141]

Enslaved workers were important to America's ceramics industry as well. A few miles from Charleston, the British-born potter John Bartlam (1735–1781; see pp. 189–91) mortgaged two enslaved artisans, Fortune and Hector, to support his porcelain manufactory.[142] Works by the enslaved South Carolina potter David Drake (ca. 1801–1870s) are particularly remarkable in that he not only signed many of his pieces but inscribed verses on some of them as well (see pp. 188, 190).[143] He worked at a time when anti-literacy laws forbade enslaved people from reading and writing, so signed works in this period were not just uncommon; their very existence is a symbol of resistance and protest by the maker.

Moses Williams (b. 1777) was an enslaved apprentice to the painter and naturalist Charles Willson Peale (1741–1827). Peale, though later an avowed abolitionist, benefited early on from enslaved workers. Williams became adept at making silhouettes at Peale's museum, earning his freedom (a year before Pennsylvania law required) and continuing to practice his art.[144] Many other early Black painters, engravers, lithographers, and carvers produced work under their own names, including John Bush (ca. 1725–ca. 1758), Scipio Moorhead (active ca. 1773–after 1775), Robert Douglass Jr. (1809–1887), and Patrick H. Reason (1816–1898).

Artists and artisans of different races, genders, and cultural backgrounds worked independently and together in the principal shops of this time. Today, we seek through new scholarship to recognize the contributions of everyone involved in the creation of early American art, including enslaved and free Africans, indentured workers, Indigenous people from the British, French, and Spanish colonies, and those from the many cultures around the world, such as India and China, whose art influenced America's aesthetic sensibility.

Understanding their achievements enhances the rich history and character of American art.

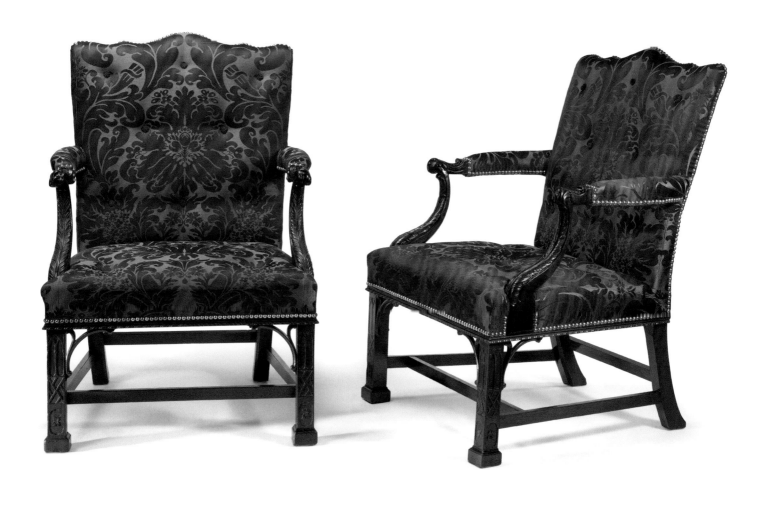

FRENCH CHAIRS
(ARMCHAIRS), ca. 1766
Attributed to Thomas Affleck
(American, born Scotland, 1740–1795)
Philadelphia
Mahogany, white oak
40⅝ x 28⅛ x 28⅝ in.
(103.2 x 71.4 x 72.7 cm)

THESE TWO ARMCHAIRS survive from a set of at least thirteen that were likely commissioned around the mid-1760s by Richard Penn (1731–1781) and John Penn (1729–1795), the grandsons of William Penn and the last two pre-Revolutionary governors of Pennsylvania.[145] Upholstered furniture was costly, and a set of armchairs would have been wildly extravagant. The furniture may have been used in governmental chambers and then, based on their provenances, distributed (in twos) to prominent residents of Philadelphia.

The Scottish-born Philadelphia cabinetmaker Thomas Affleck likely made the chairs. Affleck trained in Ellon, Scotland, a small inland town north of his native Aberdeen, and he arrived in Philadelphia in late 1763. In 1772, he married Isabella Gordon, the daughter of a prominent agent (known as a plenipotentiary)

of the Penn family, and enjoyed a prosperous career after receiving many commissions through her family's connections. When Affleck died in 1795, he owned a personal copy of Thomas Chippendale's *The Gentleman and Cabinet-Maker's Director*, and the designs clearly had inspired his work. For the Penns' set, Affleck based the chairs—which are referred to as "French chairs"—on plate 19 of the 1762 edition of the *Director*. Affleck would have constructed the chair frames himself, then hired out the finishing work, including upholstery and carving, to specialists.

Through close analysis and comparison, researchers have been able to determine that, when they were new, all the chairs had casters and the brass upholstery nails were gilded, adding extra burnish and opulence to what was originally a worsted wool damask upholstery.

98

SOFA, ca. 1770–85
Attributed to Thomas Affleck
(American, born Scotland, 1740–1795)
Philadelphia
Mahogany, southern yellow pine,
tulip poplar, soft maple, white oak
38½ x 95½ x 35 in. (97.8 x 242.6 x 88.9 cm)

UPHOLSTERED FURNITURE was an expensive luxury in the eighteenth century, and the size of sofas placed them high on the price list. Possibly made by the cabinetmaker Thomas Affleck, the frame—which required a minimal amount of imported mahogany—was described as having "plain feet & rails without Casters."[146] The under upholstery (stuffed with horsehair) and the cover (a dyed moreen) cost at least four times as much as the frame. A sofa equaled the expense of a desk and bookcase or a high chest and dressing table.

The collection's example is the first eighteenth-century American sofa to be discovered with part of its original upholstery still in place. Despite being re-covered at least five times, it retained not only parts of the original stuffing but also the show cover, both hidden beneath the layers on the back.

Its original moreen, a wool fabric, was calendered (pressed with heated rollers) in decorative patterns and was a less expensive, longer-lasting alternative to the woven damasks made in silk threads. Its eighteenth-century yellow color and bold pattern of leaves and pomegranates are still bright and vibrant today.

The sofa's back is separately constructed, and its frame fits into slots on the legs and is screwed to the arms and seat rail. The upholsterer of the sofa stuffed the back tightly and tapered the stuffing toward the edges, to emphasize the lines of the frame, then added the double row of brass nails. Three pieces of moreen (woven at only 21 inches wide) were required to span the width, and the material was so precious that the upholsterer made no attempt to match the pattern. Areas of the sofa's back that were covered by the arms were sewn together in a patchwork of scraps.

TALL CASE CLOCK, ca. 1775

Works by Joseph Bourghelle
(clockmaker, French, active Philadelphia
ca. 1773–75 and New York ca. 1786–87),
engraved by James Poupard
(Martinican, active Philadelphia 1772–1807)
Possibly Philadelphia
Mahogany, southern yellow pine, tulip poplar,
eastern white pine, Atlantic white cedar
111⅛ x 24⅛ x 10⅞ in.
(282.3 x 61.3 x 27.6 cm)

THIS CLOCK AND CASE, originally owned by Ludwig Prahl (active 1776–1809; d. 1809), is among the most unusual and mysterious works in the collection. Listed in Philadelphia directories as a gunsmith, armorer, cutler, and whitesmith, Prahl served in the Continental Army under General Anthony Wayne. He also supplied, on generous credit, hundreds of muskets, pikes, swords, and bayonets to Wayne's forces.

Prahl's clock features dials for sidereal, solar, and zodiacal time, and it was also apparently intended to regulate eight more dials with the dates of Pennsylvania state and local court sessions. (Why a gunsmith would have needed to keep up with these dates is unknown.) But the subsidiary dials were never fitted with the levers needed to run them.

Certainly this clock was a highly ambitious creation, though little is known about the artisans who created it or its case. Joseph Bourghelle's name appears only once in all of Philadelphia's records, when he arrived from London on the *Pennsylvania Packet* in 1773. He appears once more, in New York City directories in 1786, but then disappears altogether.

The maker of the mahogany case is also unknown. Although the case is reminiscent of one engraved on the label of the cabinetmaker and carver Benjamin Randolph, aspects of this case suggest that it was made by a cabinetmaker of less acumen. The laminated latticework in the pediment, the half thickness of the fretwork under the dentil molding, and the applied carving in the hood demonstrate an artisan working outside his regular sphere.

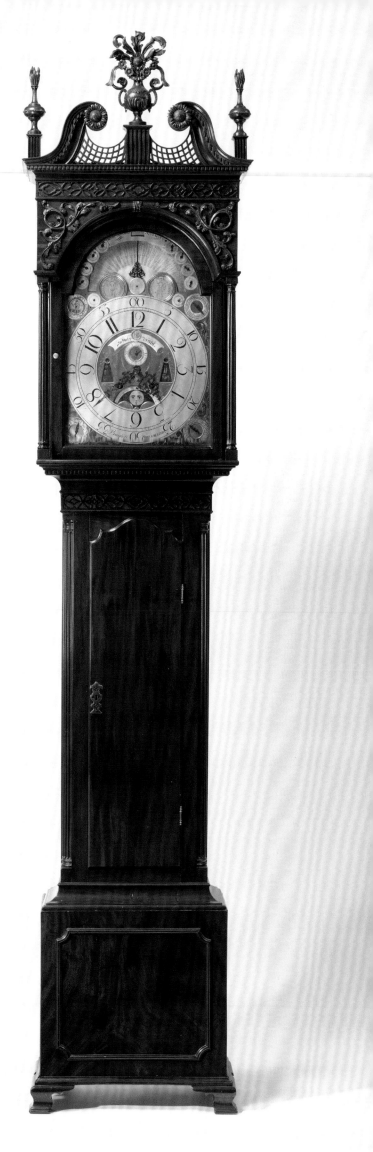

CHAIRS, ca. 1770
Attributed to the shop of Gerrard Hopkins
(American, 1742–1800)
Baltimore
Mahogany, southern yellow pine, spruce
39 x 23¼ x 20¼ in.
(99.1 x 59.1 x 51.4 cm)

TRAINED IN PHILADELPHIA, the cabinet-maker Gerrard Hopkins opened his shop on Gay Street in Baltimore in 1767. He advertised his business in the newspaper, noting that he "makes and sells the following goods in the best manner, and in the newest Fashions in Mahogany, Walnut, Cherry-tree, and maple viz. Chest of drawers of various sorts, Desk, Bookcases, . . . Cloth-presses, Tables of Various sorts such as bureau, card, chamber, parlor, and Tea Tables, Chairs of Various sorts such as easy, arm, Parlor, Chamber or corner chairs. . . ."[147] Hopkins was a leader of the city's cabinet-making community, both before and after the Revolution, and his shop was the genesis for the flowering of at least two generations of cabinetmaking in Baltimore.

Furniture made in Baltimore before the American Revolution is relatively rare and difficult to distinguish from furniture made in nearby Philadelphia. These chairs, however, are identifiable not only as coming from Baltimore—but also have features of work from Gerrard Hopkins's shop.

These chairs and the other four in the set—all part of the collection now—are believed to have been owned by John Ross Key (1734–1821) and Ann Phoebe Charlton Key (1756–1830) and descended to their son, Francis Scott Key (1779–1843), a lawyer and amateur poet. In 1814, inspired by American endurance under the British bombardment of Fort McHenry during the War of 1812, Key wrote the words to "The Star-Spangled Banner," which became the national anthem in 1931.

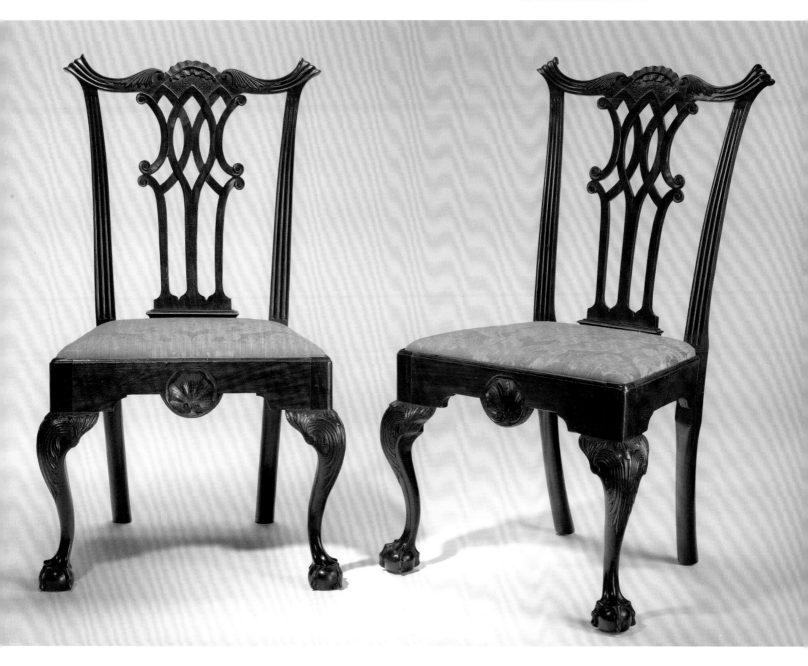

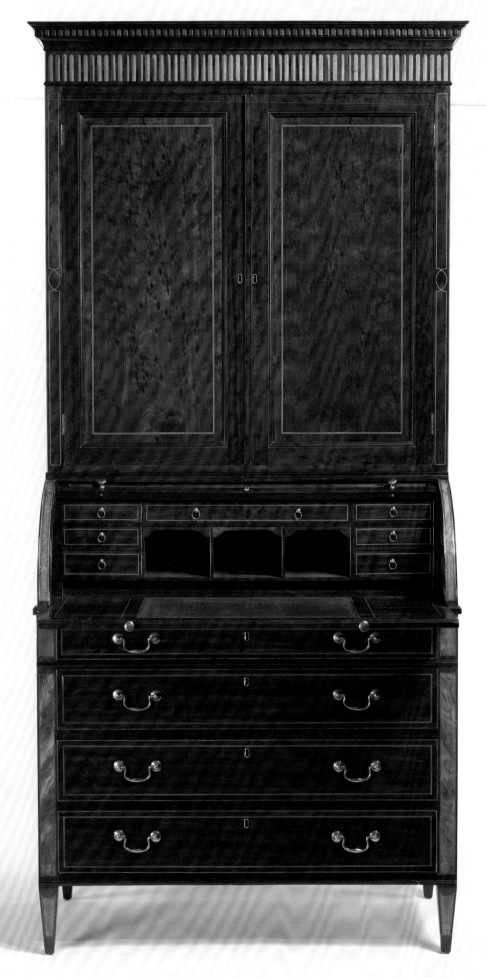

SECRETARY AND BOOKCASE,
ca. 1800
Andre Joseph Villard
(American, born France, ca. 1749–1819)
Alexandria, Virginia, and Washington, D.C.
Mahogany, satinwood, cedar,
maple, pine, tulip poplar, walnut
89¼ x 42 x 21¾ in.
(226.7 x 106.7 x 55.2 cm)

BORN IN FRANCE and trained there as an *ébéniste*, or cabinetmaker, Andre Joseph Villard brought his sophisticated style to Alexandria, Virginia, and Washington, D.C., in the 1790s. He constructed this secretary in three parts: an upper case with the bookcase, a middle case with the cylinder-covered desk, and a lower case with the stack of wide drawers.

The cornice above has a broad frieze of inlaid bands; below, the doors open to reveal three shelves for books. The middle case has a cylinder top that conceals pigeonholes and drawers for writing implements, as well as a sliding writing frame. The bottom case is made up of a shallow drawer above three deeper drawers. The entire case, restrained yet elegant, rests on four well-proportioned tapered legs with light wood inlays.

For many years, Villard was associated with Stratford Hall, the Virginia home of the Founder Richard Henry Lee (1732–1794), who served as the president of the Continental Congress in 1784–85, and his second wife, Anne Pinckard Lee (ca. 1738–1796). It is believed that Villard contributed to architectural work and cabinetmaking at the property. In 1792, a son, Richard Henry Lee Villard, was born to Villard and his wife, Sophia; just two years later, Villard made the coffin for his patron, Richard Henry Lee.[148]

SIDEBOARD, ca. 1785
Attributed to John Bankson
(American, 1754–1814) and Richard Lawson
(American, born Britain, 1749–1803);
partnership active 1785–92
Baltimore
Mahogany, mahogany veneers,
satinwood, tulip poplar, white oak
$40^{1}/_{2}$ x $72^{3}/_{8}$ x $27^{7}/_{8}$ in.
(102.9 x 183.8 x 70.8 cm)

AFTER THE AMERICAN Revolution, the British, Irish, and continental Europeans immigrated to the new country in large numbers—and the flourishing port town of Baltimore was a popular destination for entrepreneurial artisans. In 1776, the town was home to about six thousand people. By 1800, more than twenty-six thousand people lived there. Baltimore became the leading port in the country for the export of grain, and an increasingly affluent population grew around the bustling harbor.

By the 1780s, at least thirty cabinetmakers ran their own shops in the prosperous downtown. Most had been trained elsewhere in America (primarily Philadelphia), but six were British immigrants. Reflecting the taste and preferences of the patrons, these cabinetmakers had a disproportionately large impact on the furniture

trade, and this handsome sideboard showcases the wealth and exuberence of Baltimoreans at the time. The form is borrowed from published British styles of the 1770s: the profusion of marquetry inlays distinguishes the sideboard as a product of the dynamic sensibilities of Baltimore artisans and patrons.

The cabinetmaker Richard Lawson was a key player in bringing this British style to Baltimore. A native of Yorkshire, Lawson worked at Seddon and Sons in London for thirteen years; the company was the largest furniture maker in the city at the time. Lawson immigrated to Baltimore and partnered with John Bankson, of Philadelphia, a retired major in the Continental Army. Together, they made furniture for local leaders and dignitaries, and the firm inspired other makers to create dynamic neoclassical furniture.

SECRETARY WITH LINEN PRESS, ca. 1790

Attributed to William Jones
(cabinetmaker, American, active 1787–92)
Charleston, South Carolina
Mahogany, mahogany veneer, eastern white
pine, eastern red cedar, tulip poplar
99¼ x 49⅜ x 24⅝ in.
(252.1 x 125.4 x 62.5 cm)

EIGHTEENTH-CENTURY Charleston was an exceedingly wealthy port with a large cosmopolitan population. The value of South Carolina's exports to Britain in the decade before the American Revolution amounted to more per year than all the exports from New England, New York, and Pennsylvania combined, and local planters, merchants, and shippers made vast fortunes on these exports. The town saw an economic downturn during the war, but by the 1790s, it was flourishing again—with many cabinetmakers meeting the demand for sophisticated furniture in the latest styles. In the ensuing decades, though, much Charleston furniture disappeared through natural disaster, economic decline, climate, wars, and sales to northern dealers. This handsome secretary is a significant survivor.

While German émigré cabinetmakers also thrived in Charleston, the predominant taste was for British forms like this secretary with press, whose design is particularly associated with Charleston. The shape of the broken scroll pediment and its fan terminals, the pictorial inlays on the frieze, the wide crossbanding on the doors, the bracket feet with chevron stringing, and the multicolored inlay on the interior drawers are distinctive to Charleston.

This work appears to have five drawers, but the secret drawer (or secretary drawer) is disguised. The top two "drawers" fall forward to reveal an elegant writing compartment, complete with pigeonholes and drawers for writing instruments—making it just the thing for a busy exporter trying to keep up with correspondence.

DRESSING CHEST WITH GLASS, ca. 1810–19

Charles-Honoré Lannuier
(American, born France, 1779–1819)
New York City
Mahogany, mahogany veneer, eastern
white pine, tulip poplar, silvered glass
66⅜ x 35¾ x 20½ in.
(168.6 x 90.8 x 52.1 cm)

CHARLES-HONORÉ LANNUIER emigrated from France to New York City after training as an *ébéniste*, or cabinetmaker, with his brother and his uncle. Throughout his career, he created dazzling furniture in the classical style popular at the time in America, and he proudly promoted his background with dual-language paper labels like the one on this piece: "Hre Lannuier / Cabinet Maker from Paris / Kips is Whare House of / new fashion fourniture / Broad Street, No 60. / New-York. / Hre Lannuier / Ebeniste de Paris, / Tient Fabrique & / Magasin de Meubles / les plus a la Mode, / New-York."

The leaf-carved legs and mirror supports on this dressing table are typical of Lannuier's work. Like his other works, this striking table combines a variety of decorative styles, ranging from early neoclassical suggestions to later classical designs that imitated ancient furniture. The panels of flame-grained mahogany, highlighted by contrasting borders of cross-cut veneers, place this work clearly in the 1810s, when richly figured veneers were widespread in the United States, Britain, and Europe.

Lannuier's work was in great demand, and his productivity during an abbreviated career was impressive: while he was listed in New York City directories for only fifteen years, more than fifty documented works survive. Lannuier's inimitable aesthetics, rooted in French art from after the 1789 Revolution, influenced not only furniture in New York but also the landscape of furniture design in Philadelphia, Baltimore, and Richmond, where elite and discerning patrons commissioned and acquired his sophisticated furniture for their houses.

WORKS ON PAPER

THE DIPLOMATIC
WORD & IMAGE

Elliot Bostwick Davis

MERRIAM-WEBSTER REPORTED that the first known use of the word "diplomacy" to mean "the art and practice of conducting negotiations between nations" was in 1766.[149] Then, as now, words of diplomacy and negotiations between nations stood at the core of defining the present and future of the United States of America. When John Adams wrote to his wife, Abigail, from Paris in May 1780, while working toward a diplomatic alliance with France, he eloquently described the relationship between the art and practice of negotiation and the broader arts:

> I could fill Volumes with Descriptions of Temples and Palaces, Paintings, Sculptures, Tapestry, Porcelaine, &c. &c. &c.—if I could have time. But I could not do so without neglecting my duty. The Science of Government it is my Duty to study, more than all other Sciences: the Art of Legislation and Administration and Negotiation, ought to take Place, indeed to exclude in a manner all other Arts. I must study Politicks and War that my sons may have liberty to study Mathematicks and Philosophy. My sons ought to study Mathematicks and Philosophy, Geography, natural History, Naval Architecture, navigation, Commerce and Agriculture, in order to give their Children a right to study Painting, Poetry, Musick, Architecture, Statuary, Tapestry and Porcelaine. Adieu.[150]

Within the grand architectural interiors and splendid furnishings of the Diplomatic Reception Rooms, more than 250 works on paper ranging from maps and documents to prints and drawings reflect the power of word and image in the service of diplomacy over the course of nearly two and a half centuries.

John and Abigail's son John Quincy Adams served his nation in multiple roles over the course of his long career, as diplomat to five nations (1794–1817), senator from Massachusetts (1803–8), secretary of state (1817–25), president (1825–29), and member of the House of Representatives (1831–48). Shaped by the words of his father expressed above, John Quincy Adams may have been acutely aware

OPPOSITE
Americae Nova Tabula (detail), between 1630 and 1662;
Willem Janszoon Blaeu (see cat. 108)

St DOMINGO. CARTAGENA. MEXICO. CUSCO. POTOSI.

Septentrionalißimas Americæ partes, Groenlandiam puta, Islandiā et adjacentes, quod Americæ tabulæ commodè comprehendi non potuerint, peculiari hac tabella Spectatoribus exhibendas duximus.

Groenlan

Islandia

Frislandia

Hiberniæ pars

NOVA Canadenses

TERRA CORTEREALIS

Terra Nova

AMERICA

SEP TENTRIONALIS

FRAN CIA

Honguedo

Virginia

LA FLORI DA

La Bermuda

Tropicus Cancri

HISPANIA NOVA MEXICO

SINUS MEXICA

Spanniola

Circulus Æquinoctialis

OCEANUS

ZUR

MAR DEL

GUIANA

AMA ZONUM

PERU

Tropicus Capricorni

PERUVIANUS

CHILI

MARE PACIFICUM

Patagones

MARE PACIFI CUM

AMERICÆ nova Tabula.

Auct. Guilielmo Blaeuw.

Fretum Magellanicum

Terra del Fuego

TERRA AUSTRALIS INCOGNITA.

of the freedoms afforded him to enjoy the arts as part of a full life in politics. In 1820, then Secretary of State Adams commissioned William J. Stone to create a facsimile of the Declaration of Independence, originally lettered by hand with quill and ink on vellum, as a copperplate engraving. Stone produced 201 prints on vellum, dated July 4, 1823—three years to the day before both Adams's father and Thomas Jefferson, the leading author of the Declaration of Independence, died (cat. 105). By distributing the resulting engravings of the *Declaration of Independence* to key leaders and institutions, Adams effectively rekindled the aspirations of the nation's Founders for a new republic committed to equality and to life, liberty, and the pursuit of happiness.

Beginning in 1922, the *New York Times* published a copy of Stone's Declaration each year on the Fourth of July for a century.[151] Thanks to the foresight of John Quincy Adams and Stone's artistry, I was among those millions of readers in the United States and around the world who initially experienced the Declaration of Independence reproduced on newsprint. Then as now, the elaborate handwriting shapes the words proclaiming our nation's independence and articulating those freedoms worthy of our aspirations.

Given that the majority of works on paper in the collection of the Diplomatic Reception Rooms predate modern means of communication, their central role in daily life is hard for us to imagine today. Yet some forms of ornamental printmaking, both modest and grand, are familiar. One is engraved currency in the form of a twenty-dollar note bearing a scene of the wind god blowing a gale across tilled furrows curving across the landscape (cat. 106). The Society of the Cincinnati's elaborate membership document bears features similar to those of modern diplomas (cat. 107). The society was named after the Roman statesman and military leader Lucius Quinctius Cincinnatus (ca. 519–ca. 430 BCE), a model of civic virtue who gave up power, retiring from public life to his farm, and in honor of George Washington's decision to return to his Mount Vernon farm after serving as commander of the Continental Army. Membership was awarded to all Continental Army officers who served for three years or more, as well as to officers of the French army and navy. Yet the composition reflects cross-continental collaboration between the foremost French designers, draftsmen, and engravers who created the imagery and the unidentified American printmakers who produced the wording to accompany original signatures of the society's secretary, Henry Knox, and president, George Washington.[152]

For all those who did not belong to Indigenous communities, the Americas were first known as an imaginary place.

The seventeenth-century Dutchman Willem Janszoon Blaeu (1571–1638) envisioned the Americas in his map *Americae Nova Tabula*, Latin for "new map of America," printed sometime between 1630 and 1662 and finished with brilliant colors applied by hand (cat. 108). The Caribbean and Central America hold the center of Blaeu's world. Along the edges are ten vignettes of people and places of import in the Americas, including portrayals of Native Americans as the "noble savages" later described by the eighteenth-century French philosopher Jean-Jacques Rousseau.

Joining the power of the word expressed in founding documents like the Declaration of Independence and the role of maps in diplomatic efforts, images of leaders and noteworthy figures in public life populate the collection of works on paper. Many neoclassical portraits appear in profile, a tradition dating back to Greek and Roman coinage and later revived during the Renaissance.

One of the most striking is by Samuel Folwell (1765–1813), a profile portrait of George Washington, produced about 1794–95 in pen and india ink (cat. 109). The toll of years spent fighting the American Revolution and serving as the nation's first president is evident in his jowls, falling beneath his white collar. Folwell lavishes attention on the ruffles of his shirtfront, the bow on his queue, and delicate wisps of his hair resembling a paintbrush at its end, evoking an air of intimacy and refinement unusual in Washington portraits.[153]

The prolific French immigrant artist Charles Balthazar Julien Févret de Saint-Mémin (1770–1852) produced about a thousand profile portraits of prominent residents of the United States during his travels between 1793 and 1814. Two in the collection portray the U.S. diplomat Hugh Nelson and his wife, Eliza Kinloch Nelson (cat. 110). Facing left, as does her husband, Eliza wears French-inspired, neoclassical dress, appropriately cosmopolitan and fashionable attire for an elegant hostess serving alongside her husband in an unofficial diplomatic role. In the context of the Rooms, her portrait stands in for many individuals, often women, who have served and continue to serve their country alongside their partners and spouses in the interest of diplomacy.

One of the grandest drawings in the collection is the pastel portrait of Benjamin Franklin, produced when he was serving in France (cat. 111). The French master Jean-Baptiste Greuze (1725–1805) portrayed Franklin, the plainspoken polymath, swathed in an elegant, sable-trimmed cloak and satin waistcoat and absent his wig, as was his fashion. Captured by Greuze, Franklin was a study in contrasts. It's hard to imagine today his personal preference for *Meleagris gallopavo*, better

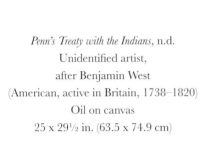

Penn's Treaty with the Indians, n.d.
Unidentified artist,
after Benjamin West
(American, active in Britain, 1738–1820)
Oil on canvas
25 x 29½ in. (63.5 x 74.9 cm)

known as the wild turkey, as the national bird of the United States emblazoned across the Diplomatic Reception Rooms in lieu of eagles.[154] Yet the Haiti-born American artist John James Audubon (1785–1851) later honored Franklin's choice by selecting *Great American Cock Male—Vulgo* as the first plate of his monumental set of double elephant folio prints for *The Birds of America* (cat. 112).

The power of prints to disseminate news of important military engagements is vividly expressed by the 1770 handbill circulated in Boston and beyond following the brutal event it calls *The Bloody Massacre* (cat. 113). In the *New Map*, hand coloring highlighted costumes and geographic details of famous cities and regions (cat. 108). Here, red paint freely applied onto the Boston handbill symbolizes the blood of innocent bystanders spilled, including that of African American activist Crispus Attucks, along with the names of four others cited in the inscription who were killed, and two dying later of their wounds.[155]

Military and naval engagements with Britain in the War of 1812 appear in a series of four prints documenting the humiliating loss of the American frigate *Chesapeake*, led into Halifax Harbor by the conquering British frigate HMS *Shannon* (cat. 114). It was during this battle that the mortally wounded Captain James Lawrence reportedly cried out to his valiant comrades, "Don't give up the ship!"[156]

As the tumultuous events of the late eighteenth and early nineteenth centuries unfolded, the diplomatic word ran the course of personal correspondence. The collection includes everyday communications such as a letter from Thomas Jefferson to George Washington, asking the president to

"exercise [his] judgment" about the most advanced machines for sawing stone.[157] The Marquis de Lafayette (1757–1834), the celebrated French general serving in the Continental Army, himself a popular subject in works of art of the period (see cat. 9), wrote to Miss Clara Baldwin and her sister, Ruth Baldwin Barlow, describing his pleasure in seeing her again "after so much Woe," as she prepared to leave France for her voyage to the United States (cat. 115). Lafayette closed with heartfelt sentiments and sympathetic respects offered to the sister, the widow of Joel Barlow, an American diplomat who died of pneumonia after negotiating a treaty with Napoleon in Lithuania during the bitter winter of 1812.[158] Barlow stands at the head of a long line of diplomats who died abroad while serving their country.

Official documents in the collection representing land grants further complicate the nature of the word in the role of diplomacy during negotiations with Native Americans. One of the numerous grants issued by William Penn (1644–1718), an example dated 1705 (cat. 116), effectively sold ownership of about ten thousand acres of land occupied by the Lenape Nation. Penn had met with members of the Lenape (Delaware) Nation starting in 1682; however, the nature of their encounters as popularized by late eighteenth- and early nineteenth-century images by Philadelphia-based painters, such as Benjamin West and Edward Hicks, was imagined (above).[159] The proliferation of those and similar scenes sustained the narrative that inspired the eminent French philosopher Voltaire to declare in 1733 that Penn's treaty with the Indians was the only agreement never broken between Christians and Native Americans. Despite the popularity of the legend, the validity of Penn's transfer of lands

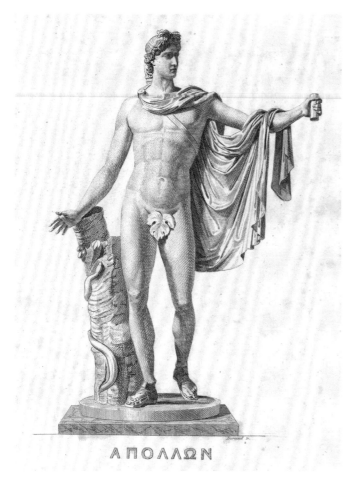

ΑΠΟΛΛΩΝ

was contested in the U.S. Court of Appeals, Third Circuit, as recently as 2006.[160]

Penn's reputation for fostering religious freedom was celebrated in a hand-colored engraving produced by the German printmaker Balthazar Frederic Leizelt (ca. 1727–1796) of the "old Capital of Pa., North America" (cat. 117). An inscription at the bottom in both German and French highlights William Penn's 1682 charter from King Charles II, "between two navigable rivers called Philadelphia because its citizens lived in brotherly love." The lettering in reverse at the top of the print indicates that it was intended to be viewed as parlor entertainment through specially designed viewing boxes fitted with a lens that would make the image appear three-dimensional.[161]

In the aftermath of the Revolution, for some, peace and prosperity afforded time for leisure pursuits, including the creation of an elaborate collage by Sarah (Sally) DeHart (1759–1832) around 1785 (cat. 118). At the center, an image of George Washington presides above a small city in a nutshell, perhaps a reference to the highly personal, miniature world DeHart re-creates on a single sheet of paper.

A design for a printed handkerchief shown in the partially colored engraving by the British printing firm Talwin & Foster (active 1783–90) may have been created for American women like Sally DeHart (cat. 119). The inscription identifies "Gen. Washington directing to restore to Justice the Sword which gained Independence to America." Produced in Britain for an American market, the work is a global collaboration, as the reproduction of a design by the Swiss-born and later American artist Pierre Eugène Du Simitière (1737–1784).

Earlier images of Indigenous Americans such as those flanking the *New Map* perpetuated representations of Native Americans as partially clothed, distinguishing them as "other," and different from their European audience. By the early nineteenth century, European artists such as the Swiss-born Karl Bodmer (1809–1893) had the opportunity to create portraits of Native Americans from life. Between 1832 and 1834, Bodmer participated in an expedition along the Missouri River funded by the German prince Maximilian zu Wied-Neuwied, who later published an elaborate volume illustrated with Bodmer's hand-colored aquatint prints. *A Blackfoot Indian on Horseback (Vignette 19)* represents a dynamic scene of a poised rider (cat. 120). Robert Ackermann, a German-born publisher well established in London, later issued affordable versions of the original volumes, effectively spreading Bodmer's portrayals of Native Americans far and wide. Indeed, the horseman in *Vignette 19* bears a striking resemblance to the lead rider in the later watercolor of *Blackfeet [Across the Plains]* by the American artist Charles Marion Russell (1864–1926) (cat. 121).

The popularity of Bodmer's Native American prints in the United States may have encouraged Thomas McKenney (1785–1859) and James Hall (1793–1868) from Philadelphia to publish their own series of hand-colored lithographs of Native Americans. Following earlier conventions of eighteenth-century portraiture, such as those by Folwell and Saint-Mémin (cats. 109, 110), McKenney and Hall often portray only the head and shoulders of these sitters, some wearing contemporary clothing, while others appear with naked torsos, which perpetuate the earlier tradition of portraits rendered by and for the dominant white culture of the time.[162] One noteworthy exception is the McKenney and Hall portrait *Aseola, a Seminole Leader* (cat. 122), fully clothed, standing with his rifle. The figure's posture resembles that of the Apollo Belvedere (above), the revered statue of ancient Rome, also used by Gilbert Stuart for his full-length Lansdowne portrait of the first leader of the United States, George Washington.

Another full-length portrait of a person of color appears prominently in the print *The Power of Music*, after William Sydney Mount's painting of 1847, in the first lithograph of his work published with the foremost French firm, Goupil, Vibert and Company (cat. 123). Mount (1807–1868) worked

in Stony Brook, Long Island, where enslaved and free African Americans had lived and worked alongside white neighbors for generations. The composition is ambiguous. Leaning against the inside of the barn door is an English-born laborer named Reuben Merrill. Employed by the artist's brother-in-law, Merrill lacked standing within the Stony Brook community. Outside the barn door is Robin Mills, a landowner and elder of the local African Methodist Episcopal Zion Church. Despite Mills's significant stature in the Stony Brook community, he is excluded from the group inside.[163] Mount's own passion for music suggests his belief in the power of art to heal the human spirit. That said, Mount was undoubtedly aware that his paintings and popular prints of African American musicians playing the bones or the banjo tapped into the early popularity of black minstrel performers.[164]

New printing technologies imported from Europe from French lithographic firms like Goupil, Vibert and Company fueled popular presses in the United States, giving rise to the proliferation of prints that could serve as affordable decorations.[165] To keep up with the demand, Currier and Ives, the foremost producer, employed artists such as Fanny Palmer (1812–1876), one of the few women whose drawings are credited, and many others who worked anonymously, hand coloring the prints. Just as fires sold newspapers, dramatic conflagrations fueled print sales.[166] Palmer emphasized the dramatic flames spewing from steamboats in *A Midnight Race on the Mississippi* (cat. 124), while also producing popular, imaginary scenes of lush tracts of land along the transcontinental railroad in *Across the Continent. "Westward the Course of Empire Takes Its Way,"* 1868 (above).

In contrast to thousands of reproductions of a single image through popular wood engravings and lithographs, the fleeting, unique image is often arresting. Albert Bierstadt (1830–1902), best known for his grand images of the American West, found the spontaneous expression of natural beauty in his diminutive painted images of butterflies, including a beautiful blue example in the collection (cat. 125).

With Childe Hassam (1859–1935) and his pastel drawing of *The Holley Farm* (cat. 126), we come full circle to John Adams's observation that it was his duty to study negotiation in order to give future generations the freedom to study the arts. The Holley house, built during the colonial period and expanded into a late nineteenth-century boardinghouse, welcomed artists and writers to the art colony in Cos Cob, Connecticut. Unlike Greuze's carefully blended pastels in his refined portrait of Franklin (cat. 111), discrete marks left by Hassam's hand are visible. The motto of the new republic of the United States of America, *E pluribus unum*, declared in Latin, "Out of many, one"; Hassam's individual strokes together create his twentieth-century image of the colonial saltbox at the heart of the house, ensconced, over time, by flourishing trees. The modest colonial interiors of the Holley house enabled Hassam to re-create the style of the French impressionists according to his own vision; the many artistic expressions embodied by works on paper in the collection of the Diplomatic Reception Rooms invite us to consider how the art of the past kindles our imagination, enabling us to envision our own future.

THE ORIGINAL DECLARATION OF INDEPENDENCE, signed by the Founders, was probably written out in pen and ink on vellum by Timothy Matlack, the clerk of Charles Thomson, the secretary of Congress. The document is believed to have traveled with the Continental Congress up and down the East Coast throughout the American Revolution. In 1789, the newly founded Department of Foreign Affairs—almost immediately renamed the Department of State—was given custody of all such important papers, so when Thomas Jefferson became the first secretary of state the following year, he took charge of the document he had drafted. It continued to be itinerant, moving with the federal capital from New York to Philadelphia to Washington, D.C., and it was even rushed out of Washington when the British approached during the War of 1812.

In 1820, Secretary of State John Quincy Adams, concerned that the original document was fading and wanting to preserve and disseminate its words and ideals, commissioned William J. Stone to create a facsimile engraving. Stone worked on his copper printing plate for three years. When it was completed, the Department of State requested 200 copies. Stone printed 201 copies on vellum (of which this is one)—adding one copy for himself. All the reproductions that have been printed since—appearing in books and textbooks, in magazines and newspapers—are based on Stone's replica. The faded original, along with the original U.S. Constitution and Bill of Rights, is now in the National Archives Museum in Washington, D.C.

IN THE REVOLUTIONARY ERA, paper money was almost the downfall of the new nation. From 1775 to 1779, Congress ordered Continental Currency in the total amount of 226 million Spanish milled dollars, a standard unit of silver currency at the time. The government contracted Hall and Sellers, a Philadelphia printing company established by Benjamin Franklin, to print bills like this one.

With almost no real backing, the government's paper money devalued rapidly—so rapidly that, by the end of 1779, a paper dollar was worth only a penny or two in silver. Washington wrote, "A wagonload of currency will hardly purchase a wagonload of provisions," and the phrase "Not worth a Continental" sprang up.[167]

America's financial distress was no secret. In May 1780, King George III was confident that monetary problems would force the revolutionaries to settle. Aid from France became ever more critical to keeping the United States fighting for freedom.

The new treasurer of the Continental Congress, Robert Morris, developed a plan to withdraw the paper money from circulation: paper currency could be used for payment of taxes to the states, exchanged at the rate of $40 in paper money to $1 in silver. Some $120 million in paper money was retired in this way, and the country's financial health was eventually restored.

SOCIETY OF THE CINCINNATI MEMBERSHIP DIPLOMA, 1788

Design by Pierre Charles L'Enfant
(French, 1754–1825),
drawn by Augustin Louis Belle
(French, 1757–1841),
engraved by Jean Jacques André
Le Veau (French, 1729–1786)
Paris
Line engraving on laid paper
21 x 27 in. (53.3 x 68.6 cm)

THE SOCIETY OF THE CINCINNATI was founded in 1783 to honor officers of the Continental Army and certain officers of the French military who had served together in the American Revolution, as well as some French ministers. Pierre Charles L'Enfant, the engineer and architect who planned Washington, D.C., as the new capital of the United States, designed a gold-and-enamel badge in the shape of an eagle (see cat. 140) and a diploma for the members.

To ensure the highest-quality engraving and printing for the diplomas, L'Enfant traveled to France. A nineteenth-century historian described the final product: "The design represents American Liberty as a strong man armed, bearing in one hand the Union Flag, and in the other, a naked sword. Beneath his feet are British flags, and a broken spear, shield and chain. . . . Britannia, with the crown falling from her head, is hastening toward a boat to escape."[168]

The first group of diplomas was sent to George Washington on January 24, 1785. Washington,

as president of the society, was to sign them for the Pennsylvania branch, and his diary for a snowy day in February notes, "Employed myself (there could be no stirring without) in signing 83 Diplomas for the members of the Society of the Cincinnati."[169] He sent them on to General Otho Holland Williams in Baltimore—but they never arrived. In April, Williams learned from authorities that signed diplomas had been found in the possession of an inmate of the city jail. Williams pursued the matter, but found only a few crumpled remnants. New diplomas were requested, and from then on the valuable documents were always carried by a society representative.

This example, signed by Washington and Henry Knox, who was a founder of the society and its secretary general, was sent to France for Claude Gabriel, Marquis de Choisy (1723–1799), who had commanded a detachment in the decisive battle of Yorktown.

108

AMERICAE NOVA TABULA,
between 1630 and 1662
Willem Janszoon Blaeu
(Dutch, 1571–1638)
Amsterdam
Engraving with hand coloring
25½ x 30½ in. (64.8 x 77.5 cm)

WILLEM JANSZOON BLAEU studied with Tycho Brahe (1546–1601), the pioneering Danish astronomer, before starting his career as a cartographer. In time, Blaeu developed his own printing presses and began designing, engraving, and printing maps that were decorative as well as practical. His maps were status symbols among aristocrats and wealthy businessmen. (One of his maps, of Holland and West Friesland, appears prominently—and accurately—in Jan Vermeer's *Officer and Laughing Girl* [ca. 1657; Frick Collection].)

With its high-quality engraving and tinting, this map of the Americas combined up-to-date geographic knowledge with rich illustrations of the New World. Hudson's Bay is labeled, along with an inset showing Iceland, part of Greenland, and the Davis Strait. California is shown to be a coast, not an island as other maps insisted. Cities and harbors, including Havana and Cartagena, are shown in vignettes; the depictions of Indigenous peoples are less accurate.

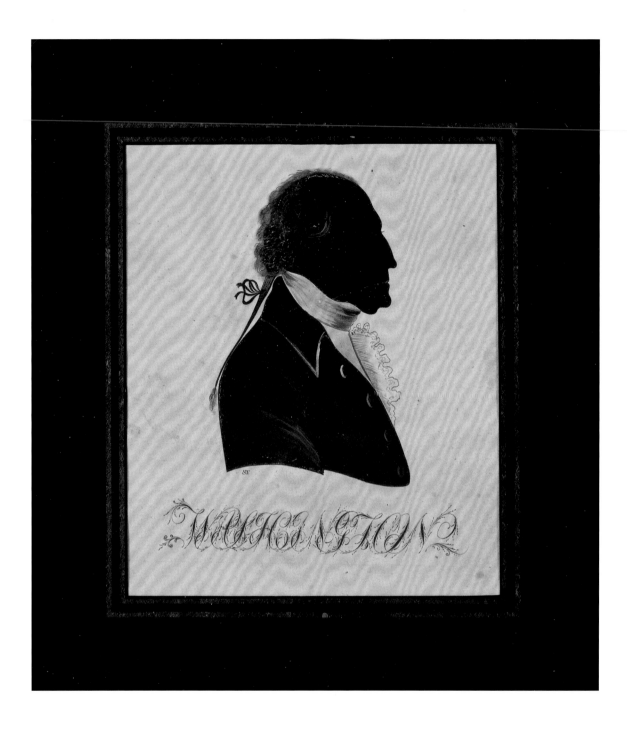

109

SILHOUETTE OF GEORGE WASHINGTON, ca. 1794–95
Samuel Folwell (American, 1765–1813)
India ink on paper
5¾ x 5 in. (14.6 x 12.7 cm)

IN THE 1790s, Samuel Folwell of Philadelphia advertised himself as a miniature painter, a cutter of profiles, and a maker of pictures made from human hair. An artistic jack-of-all-trades, he opened a school for girls and ran it with his wife, Ann Elizabeth; the curriculum was centered on drawing and needlework.

Folwell produced several different silhouette portraits of George Washington, most, like this one, painted rather than cut from paper. The artist deftly painted in india ink, adding highlights in white. Although Washington never sat for the artist—Folwell saw Washington only at a public appearance—the artist's depiction is nevertheless accurate.

Silhouettes, less expensive than full painted portraits, were popular with Americans. For politicians and military leaders, the portraits linked them to the heroes of ancient Greece and Rome shown on coins, also in profile. For students of physiognomy, who believed that facial features revealed a person's character, the silhouettes could be studied for clues about the personalities of famous people. Affordable and intriguing, silhouettes remained popular from the 1790s to the mid-1800s, when photography became available to capture comparatively inexpensive portraits.

PORTRAITS OF
HUGH NELSON AND ELIZA
KINLOCH NELSON, 1808

Charles Balthazar Julien Févret
de Saint-Mémin (French, 1770–1852)
Black crayon and black and
white chalk on paper
20 x 14 in. (50.8 x 35.6 cm) each

AFTER EMIGRATING from France to flee the French Revolution, Charles de Saint-Mémin used his talent for art to develop a system for creating affordable engraved portraits of America's famous and not so famous. To capture his sitters' likenesses, Saint-Mémin used a physiognotrace, an apparatus that allowed him to trace an outline of the person's profile on paper. He would then fill in the life-size portrait with chalk, coat the drawing with a pink wash, and use it to create his engravings.

In 1801, Saint-Mémin advertised in the *Philadelphia Aurora and General Advertiser*, offering a convenient package: "The original portrait, plate and twelve impressions, shall be delivered for the moderate price of twenty five dollars for gentlemen, and thirty five dollars for ladies."[170] (Pictures of women usually required more work to render their clothing and hair, although in this pair of portraits, husband and wife seem about equally matched.)

The images of Hugh Nelson and Eliza Kinloch Nelson in the collection are the original life-size portraits made by Saint-Mémin. Just as photo packages in recent decades might include extra "wallet-size" prints, Saint-Mémin's packages included twelve small, circular engraved copies of the original large-size portrait. Measuring less than three inches in diameter, they were perfect for framing or as gifts for loved ones. (Saint-Mémin sold frames too.)

Painted portraits were expensive, and even when a customer had purchased one, there were no copies to share—so Saint-Mémin found a ready audience of eager customers.

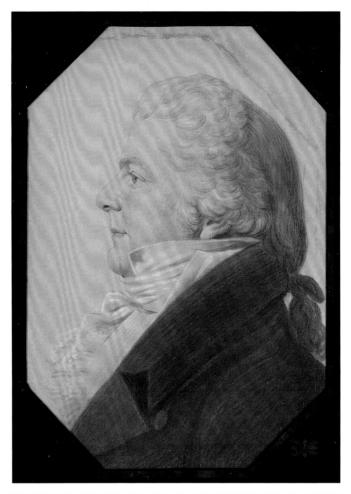

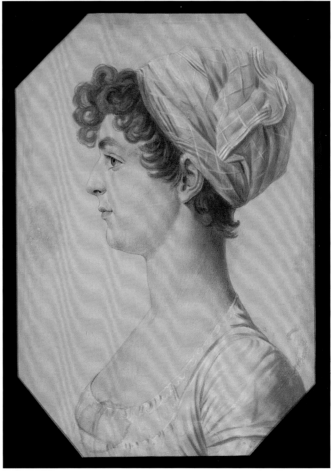

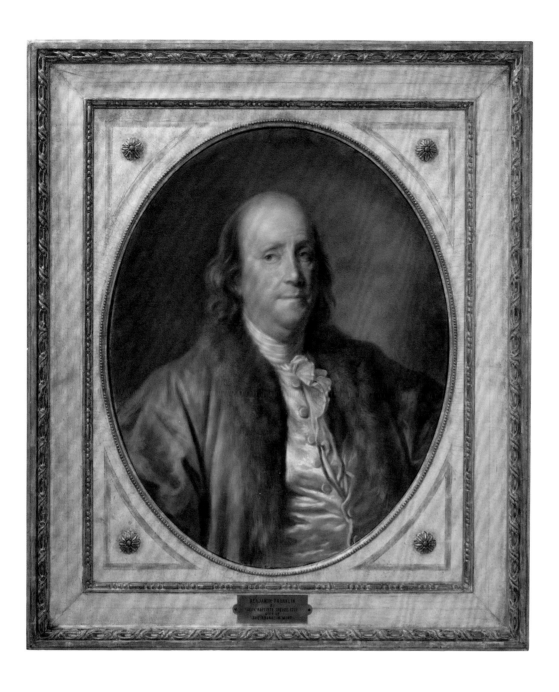

BENJAMIN FRANKLIN, 1777
Jean-Baptiste Greuze
(French, 1725–1805)
Paris
Pastel on paper
31½ x 25⅛ in. (80 x 63.8 cm)

JEAN-BAPTISTE GREUZE, a portrait painter also known for his genre and history paintings, prepared this pastel of Benjamin Franklin as the basis for a portrait in oils commissioned by Franklin's friend Elie de Beaumont. Franklin had arrived in France in December 1776, settling into a large house in the village of Passy. Appointed commissioner plenipotentiary to the court of France, Franklin secretly represented the Continental Congress until 1779, when he formally presented his diplomatic credentials to France. But there was little doubt as to what he was really doing there—persuading France to recognize and support the United States in its revolution against Britain.

Franklin, an inventor, scientist, and writer, immediately made a sensation among the people of France, and his face appeared in paintings, engravings, medallions, jewelry, snuffboxes, and even ladies' hats. Greuze shows the seventy-one-year-old diplomat as urbane and benevolent—although he does not capture Franklin's much-discussed "simplicity of dress," or the fur hat he often sported. Instead, Franklin wears a sable-trimmed blue cloak over a white satin waistcoat and ruffled jabot. The blue accentuates his auburn-flecked gray hair; Franklin had stopped wearing powdered wigs, to create a more humble and democratic look.

GREAT AMERICAN COCK
MALE—VULGO [WILD
TURKEY] MELEAGRIS
GALLOPAVO, 1826
William Home Lizars
(British, 1788–1859),
after John James Audubon
(American, born Saint Domingue
[now Haiti], 1785–1851)
Hand-colored copperplate engraving
44½ x 32 in. (113 x 81.3 cm)

THE AMERICAN bald eagle is the symbol of the United States, although Benjamin Franklin famously disdained it, finding it "a Bird of bad moral Character." The wild turkey, thought Franklin, was "a true original Native of America . . . and would not hesitate to attack a Grenadier of the British Guards who should presume to invade his Farm Yard with a red Coat on."[171]

Turkeys remained important to the American character. In his work *The Birds of America*, John James Audubon introduced Europe to never-before-seen birds from the United States, and he chose the turkey as its first plate. The print is life-size—it was used to illustrate "the neces-sity of the size of the work,"[172] Audubon wrote in his journal.

Large and extravagant, *The Birds of America* was originally sold by subscription, and Audubon traveled to Europe to persuade potential subscribers to commit to the project. He met Hannah Mary Rathbone there in 1826, and they became good friends. In the fall, she asked him for a picture of the wild turkey. Obligingly, he sketched the bird on a small piece of paper and gave her the drawing; she remarked that it would make a good seal. Nothing more was said of the matter. Then, about a month later, Audubon received a present from his friend: a seal with an engraving of his wild turkey and the words "America My Country." Audubon cherished the gift and used it on his correspon-dence for many years.

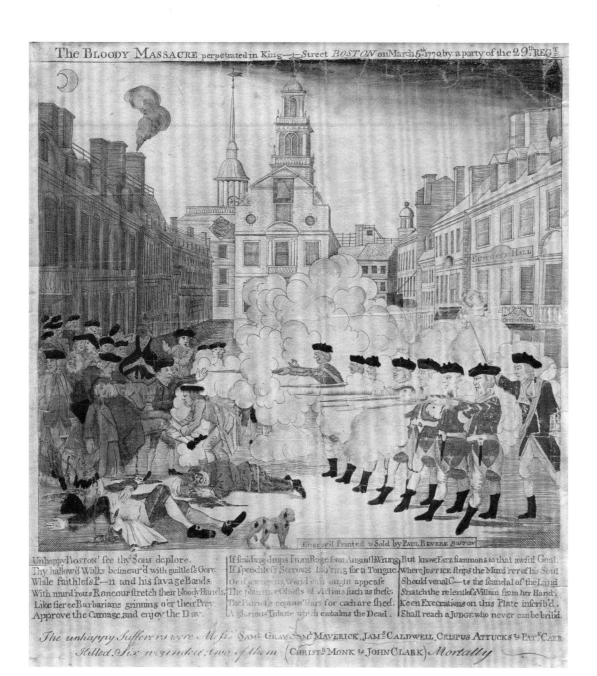

The unhappy Sufferers were Messrs SAML GRAY SAML MAVERICK, JAMS CALDWELL, CRISPUS ATTUCKS & PATK CARR
Killed. Six wounded; two of them (CHRISTR MONK & JOHN CLARK) Mortally

113

THE BLOODY MASSACRE, 1770

Paul Revere Jr.
(American, 1735–1818),
after Henry Pelham
(American, 1749–1806)
Boston
Hand-colored copperplate
engraving on paper
11½ x 9½ in. (29.2 x 24.1 cm)

AFTER THE TOWNSHEND ACTS of 1767 were passed, levying duties on British imports ranging from paper to tea, American colonists were angry—and they let the British troops in Boston know it. On March 5, 1770, in a confrontation that became known as the Boston Massacre, British troops fired on an unruly crowd of colonists. The event, and this famous image of it, proved a catalyst to anti-British sentiment in the years leading up to the American Revolution.

Paul Revere, better known as the Patriot silversmith, carefully engraved the copperplate and ordered the first two hundred copies of the image that, in coming days and weeks, was seen throughout the colonies and in London.

But Revere did not create this image on his own. Henry Pelham, a half brother of John Singleton Copley and an artist himself, designed it. The original title was *The Fruits of Arbitrary Power, or The Bloody Massacre*. Before Pelham sent his artwork to the printer, he made the mistake of showing it to Paul Revere—and then quickly regretted it when Revere's plagiarized image appeared before his own.

This print is perhaps the only impression to have descended in the family of one of the victims of the Boston Massacre: James Caldwell, a seventeen-year-old sailor. Caldwell's name has been underlined in pencil—by his granddaughter, according to family tradition.

[173]

HMS SHANNON *LEADING
HER PRIZE THE AMERICAN
FRIGATE* CHESAPEAKE
INTO HALIFAX HARBOUR, 1830
Louis Haghe (engraver; British,
born Belgium, 1806–1885),
after John Christian Schetky
(British, 1778–1874),
and designed by Captain Richard
Henry King (British, 1790–1862)
London
Hand-colored engraving on paper
25 x 28 in. (63.5 x 71.1 cm)

AS THE WAR OF 1812 BEGAN, the Royal Navy was confident that it could defeat the United States at sea. After all, the British navy was bigger and stronger; the American navy was small and inexperienced.

But in the first year of the war, American ships won battle after battle. The Americans were well trained, and their ships were lighter, faster, and heavily armed. The British became desperate for a victory. "We must catch one of those great American ships and send her home for a show," wrote Philip Broke, the captain of the frigate HMS *Shannon*.[173]

Just three months later, on June 1, 1813, the *Shannon* would be challenged by the USS *Chesapeake* in Boston Harbor. Under the command—for just two weeks—of James Lawrence, the frigate *Chesapeake* was about

evenly matched with the *Shannon*, and spectators in Boston anticipated a speedy, showy victory; they were already planning celebrations as the two ships engaged.

Instead, the *Shannon* fired, damaging the American frigate severely. In just eleven minutes, the *Shannon* defeated the *Chesapeake* in one of the bloodiest sea battles of the war. Forty men on the *Chesapeake* were killed and ninety-six wounded; the *Shannon* had thirty-four killed and fifty-six wounded. The *Shannon* towed the *Chesapeake*, its prize, to Halifax; Captain Lawrence died of his injuries on the way. The battle proved a turning point in the War of 1812, and Britain, with its stronger, better-trained navy, eventually triumphed at sea, in a war that effectively ended in a draw.

Painted by J. C. Schetky Esq.ʳ & On Stone by L. Haghe.

Designed by Capt. R. H. King R. N.

To Captain Sir Philip Bowes Vere Broke, Bar.ᵗ and K. C. B.
This representation of H.M.S. SHANNON, leading her PRIZE the AMERICAN FRIGATE CHESAPEAKE, into HALIFAX HARBOUR, on the 6ᵗʰ June 1813
is Dedicated by his obliged and most grateful Servant. R. H. King.

London Published by Smith Elder & Cᵒ 65 Cornhill.



LETTER FROM MARQUIS DE LAFAYETTE TO MISS BALDWIN, April 13, 1813

Marquis de Lafayette (French, 1757–1834)

France

Ink on paper

8⅛ x 6½ in. (20.6 x 16.5 cm)

WHEN THE MARQUIS DE LAFAYETTE, a nineteen-year-old aristocrat with no combat experience, sailed to America to join George Washington's Continental Army, he explained his decision to his wife: "The welfare of America is intimately connected with the happiness of all mankind; she will become the respectable and safe asylum of virtue, integrity, tolerance, equality, and a peaceful liberty."[174] Having helped American colonists win the Revolutionary War, he returned to France, where he continued to espouse his commitment to those principles.

Joel Barlow (1754–1812), an American Patriot, businessman, politician, poet, and diplomat, had many successes in his several careers. In 1797, he negotiated the release of American hostages held for years by the Turkish regent of Algiers. In 1807, he supported the publication of a lavish edition of his long national epic *The Columbiad*; with it and other works, Barlow was the first American poet to be held in high regard in Europe. Barlow also cofounded the newspaper *American Mercury* and backed the development of Robert Fulton's steamboat (his nickname for Fulton was "Toot").

In 1813, after Barlow's death while serving as the American minister to France under President James Madison, the Marquis de Lafayette penned this letter to Miss Clara Baldwin (1782–1856) and her sister, Ruth Baldwin Barlow (1756–1818), the widow of Joel Barlow. Along with extending his sympathies, Lafayette added, "I rejoice with you both, my dear friends, and American fellow citizens, in the glory of the flag, and in the Achievements of those officers whom I am happy to have known personally."

116

LAND GRANT, July 24, 1705

William Penn

(British, 1644–1718)

Philadelphia

Vellum

12 x 15¾ in. (30.5 x 40 cm)

IN 1680, KING CHARLES II of England owed thousands of pounds to William Penn Sr., the late father of William Penn Jr. The younger Penn asked the king for land in America in payment, and Charles II signed a large area over to him. The king called the area Pennsylvania, naming it after the elder Penn.

The younger Penn, who had converted to become a Quaker, immediately began organizing matters in Pennsylvania according to his religious values of goodwill and friendship. About three thousand Europeans lived in the area at the time, and Penn sent instructions regarding Native Americans: "Be tender . . . let them know that you are come to sit down lovingly among them."[175]

Starting in 1682, Penn traveled to Pennsylvania, and he insisted on buying the land granted to him by the king from its inhabitants, in many cases the Lenape, who had first settled the lands and still occupied them. (This land grant is one of those purchase agreements, but it is between Penn and a later settler.) At the treaty meetings, Penn would say, "When the purchase was agreed, great promises passed between us, of kindness and good neighborhood, and that the Indians and English must live in love as long as the sun gave light."[176] Alas, when Penn died in 1718, fair relations between Europeans and the Lenape dissolved.

Philadelphia.

Die Haupt Stadt in der Nord-Americanischen Provinz Pensylvanien,
sie ist vom William Penn (dem Caroll II. König in Engelland.
die ganze Provinz geschencket hatte) im Iahr 1682. zwischen
2. Schiffreichen Flüssen angelegt und dessvegen Philadelphia genen-
net wordë, weil die Einvohner in Brüderlicher Einigket dasëlbst lebë sollen.

Philadelphie.

La Ville Capitale de Pensylvanie, Province Nord-Americaine,
William Penn, à qui Charles II Roi d'Angleterre donna cette
Province entiere la planta en 1682 entré deux fleuves navi-
gables et l'apella Philadelphie, parceque les habitans y vi-
voient dans une Harmonie fraternelle.

Se vend a Augsbourg au Négoce commun de l'Academie Imperiale d'Empire des Arts liberaux avec Privilege de Sa Majesté Imperiale et avec Defense ni d'enfaire ni de vendre les Copies.

117

VUE DE PHILADELPHIE, ca. 1770

Balthazar Frederic Leizelt

(German, ca. 1727–1796)

Augsburg, Germany

Hand-colored engraving on paper

13½ x 18¾ in. (34.3 x 47.6 cm)

(Detail, pp. 274–75)

THE MIRROR-IMAGE TITLE at the top of this engraving tells the viewer that the image is intended to be seen through a zograscope. These optical devices involved a large convex lens in a vertical frame, with an angled mirror on one side. A specially designed image—usually of a cityscape—would be placed on a table under the mirror, and the viewer's eyes would be "tricked" into seeing the picture in three dimensions.

Zograscopes were usually large and ornate, with the lens set into a mahogany frame and the whole mechanism perched at the top of a carved pedestal. According to a 1784 catalogue, the viewing devices were intended for discerning (and wealthy) buyers

who wished to look at "remarkable Views of Shipping, eminent Cities, Towns, Royal Palaces, Noblemen and Gentlemans Seats and Gardens in Great Britain, France and Holland, Views of Venice, Florence, Ancient and Modern Rome, and the most striking Buildings in and about London."[177]

Both machines and engravings were expensive, so the buyer of this hand-colored print would have needed significant wherewithal and a strong desire to see Philadelphia—a desire that in this case would have been thwarted, since, in the rush to meet demand, publishers were not conscientious about the images they used. This one is, in fact, a view of the hospital in Greenwich, England.[178]

118

SILHOUETTE COLLAGE, 1802
Sarah (Sally) DeHart
(American, 1759–1832)
Elizabethtown, New Jersey
Paper
16 x 11½ in. (40.6 x 29.2 cm)

SARAH DEHART, born into a wealthy family of Huguenot descent in northern New Jersey in 1759, rubbed shoulders with many prominent colonists during her life and began recording them with hand-cut silhouettes from the age of twelve. Creating her silhouettes using the hollow-cut method, she cut the images from white paper and then mounted them against dark paper or colored silk. Her father was active in Revolutionary politics, and many prominent figures visited the family home—including the Marquis de Lafayette, whose silhouette she cut. She and her sister even visited George Washington at Mount Vernon.

This collage is packed with remembrances of friends and heroes—a printed portrait of Washington, two revenue stamps, a fragment of a song, a calling card, drawings of a French battleship and a regimental flag, riddles, rebuses, lines from the poem "Days of My Youth" by St. George Tucker, and more. The silhouettes, all made by DeHart, include portraits of Pierre Charles L'Enfant; François Étienne Kellermann, an aide to the French ambassador; Elias Dayton, a local merchant and Revolutionary War Patriot; William Griffith, a New Jersey lawyer; and, presumably, three other admired friends whose exact identities are unclear.

The words of the song in the upper right translate as "Love only lasts one day in marriage and it is a fable that when they love they will always love more." Combined with other clues scattered across the collage, it suggests that DeHart held a dim view of marriage.[179]

DESIGN FOR A
HANDKERCHIEF, ca. 1785
Talwin & Foster (British, active 1783–90)
Middlesex, England
Engraving on paper
28 x 28 in. (71.1 x 71.1 cm)

HANDKERCHIEFS WERE popular during the American Revolution and beyond. The handkerchiefs, printed on cotton, linen, or even silk, were fairly inexpensive; in colonial times, they were made in Europe and shipped over. In time, handkerchiefs were printed from delicate copperplates. Their intricate designs celebrated significant events; when worn, they revealed the wearer's political sympathies.

This handkerchief was printed by Talwin & Foster, Bromley Hall, in London, shortly after the Revolution. The design, with an indication of the color to be used for the background,

illustrates George Washington plus twelve profile portraits of noted Americans. The small portraits are based on well-known images by Pierre Eugène Du Simitière (1737–1784); the artist, originally from Switzerland, immigrated to America after a decade in the West Indies. Among many other accomplishments, Du Simitière was a principal designer of the Great Seal of the United States—he contributed the shield, the date 1776 in Roman numerals, and the "Eye of Providence in a radiant Triangle."

BLACKFOOT INDIANER ZU PFERD. | INDIEN PIEDS NOIR A CHEVAL.

A BLACKFOOT INDIAN ON HORSE-BACK.

120

A BLACKFOOT INDIAN ON HORSEBACK (VIGNETTE 19), 1840
Karl Bodmer (Swiss, 1809–1893),
published by R. Ackermann & Co.
(British, active 1829–55)
London
Aquatint with hand coloring
12 x 15 in. (30.5 x 38.1 cm)

IN MAY 1832, Prince Maximilian zu Wied-Neuwied, a German explorer and naturalist, began a Missouri River expedition to explore the United States. He had hired the Swiss painter Karl Bodmer to travel with him and record his discoveries. Together, the two men documented the people, plants, animals, and landscapes they saw on their journey from New England to what is now Montana.

The pair arrived in St. Louis in 1833 and traveled up the Missouri River; they went as far as Fort McKenzie, then returned to Fort Clark (in present-day North Dakota) to stay for the winter of 1833–34. At every step of the journey, Bodmer captured images of the Native Americans they encountered, while Maximilian recorded their appearance, customs, languages, and cultures. Maximilian related that the Blackfeet obtained "at a high price" panthers' skins from the Rocky

Mountains to place under their saddles: "The panther's skin is so laid across the horse that the long tail hangs down on one side, and has scarlet cloth laid under it, which forms all round a broad border."[180]

After returning to Europe, Maximilian published the two-volume work *Travels in the Interior of North America*. The oversized book included eighty-one hand-colored aquatints based on Bodmer's watercolors, with portraits of Omaha, Dakota, Assiniboine, Atsina, Mandan, Hidatsa, and Blackfeet chiefs and warriors, as well as women and children, plus depictions of ceremonies and landscapes. More than a century after the men returned to Europe, Maximilian's handwritten journals and nearly four hundred of Bodmer's original watercolors and sketches were discovered in the Wied family archives; today the collection is at the Joslyn Art Museum in Omaha, Nebraska.

121

BLACKFEET [ACROSS THE PLAINS], 1905

Charles Marion Russell

(American, 1864–1926)

Watercolor and gouache on paper

11 x 14 in. (27.9 x 35.6 cm)

ONE OF THE GREAT Caucasian artists portraying the American West, Charles Marion Russell captured every aspect of frontier life in his work. Born in St. Louis, Russell went west at sixteen, determined to become a cowpuncher. He became a night herder in the Judith Basin of Montana, watching cattle at night and sketching during the day. In the summer of 1888, he lived in Alberta, Canada, near camps of Blackfeet, Piegan, and Blood tribes; he spent the following winter with the Blood. His time spent in the West gave him firsthand knowledge of the area and the way of life there, apparent in his realistic depictions of people, animals, and their activities, contributing to the air of immediacy in his portrayals.

Here, a group of riders advances purposefully through an unforgiving landscape—the sky is the same color as the dry grass. For all its perceived veracity, though, the image is romanticized. By the time Russell painted it, this way of life had all but disappeared, displaced by westward expansion. Russell recognized these changes, but he remained committed to depicting a bygone time, to respect and honor the Plains Indian, the cowboy, and the majestic landscape of the old West.

ASEOLA,
A SEMINOLE LEADER.

PUBLISHED BY DANIEL RICE&JAMES G.CLARK, PHILAD.

122

ASEOLA, A SEMINOLE LEADER,
1837–43
Thomas McKenney
(American, 1785–1859) and
James Hall (American, 1793–1868)
Philadelphia
Hand-colored lithograph
20 x 14 in. (50.8 x 35.6 cm) overall

IN THE 1820S, Thomas McKenney, the first superintendent of Indian affairs, commissioned portraits of Native American leaders from the portrait artist Charles Bird King. King painted the leaders in his Washington, D.C., studio when they visited the capital to negotiate treaties with the federal government. The portraits were reproduced as lithographs in the three-volume work *History of the Indian Tribes of North America.* King's original paintings, along with many by John Mix Stanley, were destroyed in the Smithsonian fire of 1865, leaving these lithographs as the only surviving record of the paintings.

In the Second Seminole War, Osceola (Aseola), a Seminole leader of mixed Creek, European, and African descent, led the resistance to the Indian Removal Act of 1830—which demanded that the Seminoles relocate from their traditional lands in Florida to Indian Territory in what is now Oklahoma. After being captured under a false flag of truce, Osceola died in prison.

His capture and death led to a national uproar, including a poem of tribute written by Walt Whitman and included in *Leaves of Grass.* Whitman wrote, "When I was nearly grown to manhood in Brooklyn, New York, (middle of 1838,) I met one of the return'd U.S. Marines from Fort Moultrie, S.C., and had long talks with him—learn'd the occurrence below described—death of Osceola. The latter was a young, brave, leading Seminole in the Florida war of that time—was surrender'd to our troops, imprison'd and literally died of 'a broken heart,' at Fort Moultrie."[181]

123

THE POWER OF MUSIC, 1848
(after the painting of 1847)
Alphonse Léon Noël
(lithographer; French, 1807–1884),
after William Sidney Mount
(American, 1807–1868),
published by Goupil, Vibert and Company,
Paris (French, active 1827–1919)
New York City, Paris
Hand-colored lithograph on paper
14½ x 18⅜ in. (36.8 x 47.3 cm)

BASED ON *The Power of Music*, an oil painting by William Sidney Mount, this powerful image shows a dignified Black man listening to music. When the painting was first displayed, one critic wrote, "We never saw the faculty of listening so exquisitely portrayed as here. . . . He leans his right shoulder against the barn door, . . . and inclines his ear toward the musician; while his eye, looking at nothing, . . . melts with delight at the effect of the ravishing sounds."[182]

Convinced of music's transcendent power to elevate its listeners, Mount, also a musician, used music to unite people of all races, even though divisions are very real—the barn door creates two spaces, one inside and the other outside.

The New York agent of the French lithographer Goupil, Vibert and Company quickly secured rights to reproduce *The Power of Music*. The lithograph may have been the first of an American painting published by Goupil, and the firm took special care with the reproduction. The finished lithograph appeared in November 1848 in both black-and-white and hand-colored examples. The availability of inexpensive copies of his work probably pleased Mount, who wrote, "Paint not for the few but the many."[183]

A MIDNIGHT RACE ON THE MISSISSIPPI.

124

A MIDNIGHT RACE ON THE
MISSISSIPPI, 1860
Frances F. "Fanny" Palmer
(American, born England, 1812–1876),
after H. D. Manning
(American, active 19th century),
published by Currier and Ives, New York
(American, active 1834–1907)
Hand-colored lithograph
29½ x 38½ in. (74.9 x 97.8 cm) framed

AMERICANS OF the nineteenth century loved images of steamboats on the Mississippi River. The publishers Currier and Ives sold more than two hundred different images of boats plying the country's big rivers—and this was surely one of the most dramatic. In its catalogue, the company described this lithograph as a "spirited representation of one of those exciting scenes that sometimes occur when rival steamers are running opposition on the river."[184]

In the print, the *Natchez* and the *Eclipse* race on the Mississippi, in a scene made even more dramatic by the moonlit clouds. There was a string of nineteenth-century riverboats called *Natchez*; seven belonged to Captain Thomas P. Leathers, a legendary figure on the river. All

of them featured a cotton bale hung between the stacks as the ship's flag.

Like other Americans, Mark Twain, a steamboat pilot in one of his many careers, loved a good steamboat race. In *Life on the Mississippi* (1883), he wrote, "Much the most enjoyable of all races is a steamboat race. . . . Two red-hot steamboats raging along, neck-and-neck, straining every nerve—that is to say, every rivet in the boilers—quaking and shaking and groaning from stem to stern, spouting white steam from the pipes, pouring black smoke from the chimneys, raining down sparks, parting the river into long breaks of hissing foam—this is sport that makes a body's very liver curl with enjoyment."[185]

BUTTERFLY (BLUE GREEN)
OIL ON PAPER, APRIL 16, 1896
ALBERT BIERSTADT (1830-1902)
GIFT OF MRS. DEEN DAY SANDERS

125

BUTTERFLY, 1896
Albert Bierstadt
(American, born Germany, 1830–1902)
Oil and gouache on paper
13 x 15½ in. (33 x 39.4 cm)

ALBERT BIERSTADT, BEST KNOWN for his landscapes showcasing dramatic Western scenery, was known to charm visitors with little gifts. Sometimes, at the beach, he painted the insides of seashells; at many other times, he presented guests with delicate butterflies.

A reporter from the *Detroit Free Press* described how she acquired a Bierstadt butterfly on a day in 1892, writing: "We women were so glad we *were* women that afternoon, for Mr. Bierstadt presented each lady with a souvenir. This is how he made them. We all clustered about the table and he took out a palette, a knife and some large slips of cartridge paper. Two or three daubs of pigment on the

paper, a quick fold, and holding it still folded against a pane of glass, he made two or three strokes of that wizard-like palette knife on the outside, and hey, presto! a wonderful Brazilian butterfly or moth, even the veining on the wings complete! A pencil touch added the antennae, that artist's autograph was added to the corner, and now we each of us own a painting by Bierstadt."[186]

Bierstadt's first butterfly was made in 1872, at a children's party in San Francisco, and he continued making them for many years thereafter. Although they were treasured keepsakes, few of Bierstadt's butterflies have survived to the present day.

THE HOLLEY FARM, 1902
Childe Hassam (American, 1859–1935)
Pastel on paper
18 x 22 in. (45.7 x 55.9 cm)

MANY ARTISTS spent pleasant hours at Holley Farm, a boardinghouse in the art colony of Cos Cob, Connecticut. Affordable rooms, fresh air, and pretty, paintable surroundings—all less than an hour from New York City by train—attracted a stream of artists and writers, including John Henry Twachtman, Ernest Lawson, Theodore Robinson, Genjiro Yeto, Lincoln Steffens, and Willa Cather. The house had begun as a modest colonial saltbox; expansion over the years allowed it to accommodate its guests.

In 1896, Childe Hassam began making annual visits to the Holley Farm, often accompanied by his wife, Kathleen Maud Hassam

(1862–1946), and the house itself became a focus of his paintings. Inspired by the mix of Japanese-influenced floral arrangements and old New England furniture, he created many paintings set inside the house.

This pastel, showing the exterior of the house on a sun-dappled day, was a gift to the artist J. Alden Weir, another frequent visitor to Holley Farm. Hassam, like other visitors to Cos Cob, often painted the scenic old houses, barns, mills, and other buildings in the area—in fact, such paintings were so common that Hassam suggested the output be called "the Cos Cob clapboard school of art."[187]

SILVER & OTHER METALS

WROUGHT WITH SKILL

Deborah Dependahl Waters

IN THE SEVENTEENTH- AND eighteenth-century settlements in what is now the United States, ownership of "plate" (silver objects) for food and beverage service, civic or religious rituals, or personal adornment was a way of displaying one's perceived social and economic status within the community and securing one's wealth. Residents and institutions commissioned plate from local artisans skilled in the "art and mystery" of precious metal smithing or purchased imported wares. Smiths working primarily in silver but traditionally identifying as "gold-smiths" reflected the ethnic, religious, and political diversity of the founding communities—English, French, Dutch, Puritan, Huguenot, Dutch Reformed, Jewish, Quaker, Anglican, Patriot, Loyalist.

Clients likely considered both utility and style ("of the latest fashion") as well as the metal's monetary value when ordering precious metal goods. Their purchases of small personal items such as buttons, buckles, and rings and necessities like spoons far exceeded hollowware purchases recorded in surviving shop accounting records through the end of the eighteenth century.[188] Stamped by makers or retailers and often engraved with the arms or initials of owners, like the Philadelphia Bayard family's rococo teapot with asymmetrical cartouche (cat. 127) marked by Philip Syng Jr. (1703–1789), flatware and hollowware were more readily identified than a hoard of coins if stolen.[189] Over time, objects became heirlooms passed from one generation to the next, as was the flat-topped tankard in Anglo-Netherlandish mannerist style stamped by Samuel Vernon (1683–1737), the first silversmith in Newport, Rhode Island (cat. 128), or relics, given or bequeathed to commemorate an esteemed relationship, such as the English fused-plate, two-bottle wine cooler given to Secretary of State Timothy Pickering (1745–1829) by George Washington in 1797 (cat. 129).

A master silversmith's workforce often included apprentices related to him by blood or heritage, white or free Black journeymen paid by the piece or day, skilled indentured servants, and enslaved people of color. Peter Bentzon (ca. 1783–after 1850; see p. 244) is the first early American silversmith of color to be identified by his stamp.[190] Specialist artisans—engravers, chasers, and jewelers—often shared bench space within a silversmith's shop. The chaser John Anthony Beau from Geneva

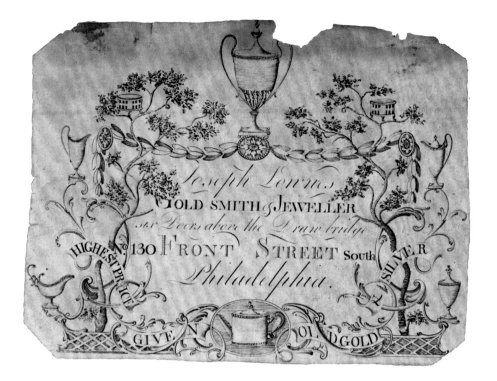

Trade card of Joseph Lownes
(1754–1820), 1785–1817?
Unidentified artist
Philadelphia
Engraving (ink on paper);
$3^{15}/_{16}$ x $5^{1}/_{4}$ in. (10 x 13 cm)
Courtesy American Antiquarian Society

worked from the New York City shop operated initially by the Swiss émigré Daniel Christian Fueter and subsequently by Fueter's son Lewis before moving to Philadelphia by 1772. Others freelanced from their own premises, like the London-trained engraver Henry Dawkins, who worked in New York between 1754 and 1757 and again between 1774 and 1780, and in Philadelphia in the interval.[191] Woodworkers such as the Huguenot Quaker Joshua Delaplaine, who supplied the Jewish New Yorker Myer Myers with pot and chafing dish handles in 1754, and hardwood and ivory turners like James Ruthven, who provided finishing services for New York silversmiths from 1792 to 1804, likely worked in their own shops equipped with appropriate tools.[192]

Before tea became politicized in the decade preceding the American Revolution, acquisition of tea equipage and observation of proper etiquette governing its use marked emerging social refinement among residents. As coffee became the patriotic beverage of choice, silversmiths produced fewer teapots.[193] Coffeepots typically assumed a vertical stance, like one with a "double-bellied" body and an asymmetrical cartouche enclosing script initials supplied by the shop of the Wilmington Quaker Bancroft Woodcock (1732–1817); this object has a history of descent in the extended family of the Washington, D.C., social diarist Margaret Bayard Smith (1778–1844), who married the *National Intelligencer* founder Samuel Harrison Smith (1772–1845) in 1800 (cat. 130).[194]

Once opposition to British oppression flared into armed conflict, silversmiths chose sides. Paul Revere Jr.

(1735–1818) actively supported the Patriot cause. Loyalists like Charles Oliver Bruff (1735–1817) and Lewis Fueter remained in British-occupied New York City until war's end and then evacuated to Nova Scotia. Myer Myers and the Southampton, Long Island, resident Elias Pelletreau (1726–1810) sought refuge in Patriot-controlled Connecticut.[195]

As the emerging nation strove to establish a viable economic and diplomatic presence, artisans found a new aesthetic had taken hold, one that exploited available technology and a fresh neoclassical ornamental vocabulary. From volumes such as the folios illustrating antique vases assembled by Sir William Hamilton, published from 1767 to 1776 and available at the Library Company of Philadelphia, and from imported objects and catalogues issued by English manufacturers of plate and plated wares, silversmiths chose vessel forms that the Philadelphia silversmith Abraham Dubois (in partnership with his son Abraham Jr. in 1803–7) called "the urn fashion," such as the unmarked coffee urn associated with the future president James Monroe (1758–1831) (cat. 131). Bright-cut ornament (engraving consisting of shallow, noncontinuous gouges that catch light) complemented the sleek, smooth surfaces of pots like the coffeepot engraved with the initials of John and Abigail Adams, possibly made by the Revere shop and retailed by the Bostonian Nathaniel Austin (1734–1818) (cat. 132).[196]

Classical imagery and patriotic symbols also ornamented base-metal elements of household furnishings and fireplace equipage. For a cherry tall case clock, the Norwich,

Connecticut, shop of the clock- and watchmaker and silversmith Thomas Harland (1735–1807), a pre-Revolution English émigré, engraved classically garbed figures representing the seasons in the corners and centered the date, "1776," on a silvered brass sheet metal dial fronting an eight-day brass weight-powered musical movement (cat. 133).[197] The new decorative vocabulary worked for the sand-cast brass elements of andirons (cat. 134) attributed to the New York City shop of the Birmingham, England, native Richard Whittingham Sr. (1747–1821) or his son Richard Whittingham Jr. (b. 1776). Urn-shaped finials engraved with bellflower swags tied with bowknots complement trophies of French and American ensigns flanking a liberty cap above a broken sword and toppled crown on the plinth faces.[198] A trade card for the Philadelphia Quaker silversmith Joseph Lownes (1754–1820) records forms and ornament common during the period when "the urn fashion" dominated (opposite).[199]

"Flatting" mills for the production of sheet silver, available from the 1730s on, reduced the amount of hammer labor and time required to transform an ingot of metal into an imperfection-free sheet[200] suitable for raising cups like those engraved with the initials of Major Winthrop Sargent (1753–1820), who was a Revolutionary War officer, Ohio Company agent, secretary of the Northwest Territory, and governor of the Mississippi Territory from 1798 to 1801 (cat. 135). The Revere shop used sheet silver to seam the fluted and swag-and-tassel engraved teapot with matching stand monogrammed for Judith Hays (1767–1844), the daughter of Moses Michael Hays, a Revere client and fellow Mason, and his wife, Rachel Myers Hays, the sister of the silversmith Myer Myers. It was one of fifty-five teapots produced between 1779 and 1797 and one of three purchased by Hays (cat. 136).[201] The Philadelphia and Wilmington, Delaware, shop of John LeTellier (or LeTelier) Sr. and Jr. produced variations on fluted oval-bodied forms in a large matched beverage service owned by the Philadelphia and Baltimore merchant Cornelius Comegys (1758–1844) and his second wife, Catherine Baker Comegys (1777–1861), who married in 1794. Unusual elements include the locked tea caddy, the use of a rococo cast spout and double C-scroll wooden handle on the coffeepot, and the lack (or loss) of stands for the two teapots (cat. 137).[202]

New foods and new silver forms in which to serve them came to American dining tables, paralleling changes in the silver manufacturing industry. Innovation began at the President's House. Dining with Thomas Jefferson in February 1802 was Samuel Latham Mitchill (1764–1831) of New York,

who wrote home that Jefferson's cook was a Frenchman who "understands the art of preparing and serving up food, to a nicety. All the Meats are well-done, and no half-rare Viands are put upon the Table." And the dessert was ice cream balls "inclosed in Covers of warm Pastry: exhibiting a curious Contrast, as if the Ice had been just taken from the Oven." Four years later, Mitchill's wife, Catharine (1778–1864), attended her first White House dinner and reported that although there "was not a profusion of Dishes on the table," the president provided "plenty of food, well cook'd, and served up in elegant style." The vegetables were served in "silver Basins or Dishes with covers. The rest was on China Dishes." Jefferson's French covered dishes may have inspired American artisans such as the New York silversmith William Thomson to fabricate similar vessels.[203]

To conduct business domestically and internationally, the new nation required devices and emblems that found their way into silver objects. The Great Seal, designed by Charles Thomson (1729–1824), the long-serving secretary of the Continental, and then Confederation, Congress, and adopted in 1782, provided imagery for medals, armbands, and wristbands supplied by the shop of Joseph Richardson Jr. (1752–1831) for presentation as tokens of peace and friendship to Native American visitors of distinction or negotiators of treaties (cat. 138). A consular seal with ivory handle is marked by the London silversmiths Peter Bateman (1740–1825) and his nephew William Bateman (1774–1850), in partnership from 1805 to 1815 (cat. 139); and the gold-and-enamel eagle insignia of the Society of the Cincinnati was designed by Pierre Charles L'Enfant (1754–1825) for members of that hereditary fraternal organization of Revolutionary War officers, founded in May 1783. The one shown on p. 302 was one of the first 225 examples made by the French artisans Francastel and Duval in Paris and was owned originally by Timothy Pickering (cat. 140). Silver skippets, or seal boxes, protected the authorized wax seal attached by a cord to official documents such as treaties and commissions negotiated by the U.S. Department of State from the 1814 Treaty of Ghent until 1871 (cat. 141). Although this example is unmarked, it may have been constructed in the period between 1824 and 1852, when the Washington, D.C., artisan Seraphim Masi (1797–1884) was among a select group of local jewelers commissioned to make skippets for the State Department.[204]

Change in the quality of the basic alloy worked by American silversmiths accompanied stylistic and technological innovation. While some shops advertised retention of the British sterling standard of 925/1000 parts silver, others utilized

Mace of the U.S. House of Representatives, 1841
William Adams
(American, active 1829–61, manufacturing silversmith)
New York, New York
Silver, ebony; 51³/₁₆ x 14¹⁵/₁₆ x 4³/₄ in.
(130 x 38 x 12.1 cm)
Collection of the U.S. House of Representatives, 2006.162.000

the standards of their raw material—French crowns or five-franc pieces or Spanish milled dollars, the last of which were 900/1000 parts silver, or American dollars and half-dollars, at 892.4/1000 parts silver between 1792 and 1837, and 900/1000 afterward—and marked their wares voluntarily. Only in Baltimore between 1814 and 1830 were compulsory assay and hallmarking required, with firms including that of Samuel Child Kirk (1793–1872) continuing to test and mark wares into the 1840s. A water pitcher embellished with the eclectic and often whimsical ornament known as Baltimore repoussé is stamped "11/12," indicating it met the Baltimore standard of eleven ounces of fine silver per troy pound, or 916.7/1000 parts silver (cat. 142).[205]

Mechanization of silver manufactories moved beyond hand mills for flatting silver and die-rolling borders in the period from 1815 to 1850, with gravity-operated downfall presses added for stamping appliqué ornaments, jewelry, and vessel lids. In Boston, Philadelphia, and New York City, firms installed steam engines to power their machinery, including lathes for spinning hollowware bodies, a technique likely used by the New York firm Wood and Hughes to fabricate two 18-karat gold goblets (cat. 143) engraved with images of an inside-cylinder locomotive.[206]

Championed by the former secretary of state and senator Henry Clay (1777–1852), the Tariff of 1842 increased the ad valorem tax on imported silverware from 20 percent to 30 percent, thereby promoting domestic manufacture by firms such as Wood and Hughes. Established in 1845, Wood and Hughes employed fifty-five men and ten women by 1850, and they used 70,000 ounces of silver to produce wares valued at $120,000.[207] In response to Clay's actions, "the Gold and Silver Artizans [sic] of the City of New York" presented him with a lavish urn manufactured by William Adams surmounted with an American eagle in 1845, not unlike the Great Seal–inspired eagle atop the 1841 Mace of the U.S. House of Representatives (left).[208]

Major retail silversmiths like New York's Ball, Black & Co. (active 1851–74) thrived by fulfilling customer needs, including assembling in 1857 a tea service in a mahogany chest combining late 1820s pieces with those marked by the midsized manufacturer Eoff & Shepard (active ca. 1852–61) (cat. 145). The spirit, if not the detail, of the earlier bright-cut engraving shines through in the Eoff & Shepard pieces.[209]

127

TEAPOT, ca. 1755
Philip Syng Jr.
(American, born Ireland, 1703–1789)
Philadelphia
Silver
5½ x 2¾ in. (14 x 7 cm)

THIS TEAPOT, ENGRAVED WITH the Bayard family arms and handed down through the years, is a prime example of the Philadelphia rococo style. The shallow, domed cover and flush hinge let the voluptuous curves flow without interruption. The finial is an early example of the bell-shaped type used by Philadelphia silversmiths of the 1760s and 1770s. The maker, Philip Syng Jr., marked this teapot with his initials. It also carries a notation that reads "oz 2 wt 18-11." This "scratch weight" records the amount of silver used. Eighteenth-century silversmiths listed two costs on their bills: the cost of the silver, in troy ounces and pennyweights, and the "making," or labor, charge. Added together, the total was the price to the customer.

A lifelong friend of Benjamin Franklin, Philip Syng Jr. was one of Philadelphia's most successful silversmiths. Like Franklin, he was also a scientist, artist, public servant, and Patriot, as well as a founder and officer of many of the city's cultural institutions. Syng was interested in science and medicine, successfully inoculating a child against smallpox in 1734 and carrying out experiments with electricity. Franklin called Syng his "worthy and ingenious friend."[210]

As a silversmith, Philip Syng's most famous work is the Syng Inkstand, used during both the signing of the Declaration of Independence in 1776 and the signing of the U.S. Constitution in 1787. The inkstand, which survives today, was used by Thomas Jefferson, Alexander Hamilton, John Adams, James Madison, and—of course—John Hancock.

TANKARD, ca. 1710
Samuel Vernon (American, 1683–1737)
Newport, Rhode Island
Silver
7⅝ x 5¼ in. (19.4 x 13.3 cm)

TANKARDS WERE AMONG the first of the English silver forms to be re-created in America, appearing in the seventeenth century. Available in sizes ranging from large to very large, tankards usually held a full quart or more of liquid—generally beer—and were intended to be passed around as a communal cup. The lid kept insects and other debris out, and the contents of the vessel in, as the tankard moved from hand to hand.

Practical and stylish, tankards were extremely popular in New England and New York, and they remained popular even after they went out of fashion in England. American silversmiths changed tankard styles to suit local tastes, combining English and Dutch elements and adding regional flourishes.

This tankard blends characteristics from New York and Boston. Its maker, Samuel Vernon, fused elements of both styles at his workshop in Rhode Island. The tankard's stepped, domed cover, with its button finial, shows a Boston influence. The proportions of the tankard, the wide cover flange, and the wire wriggle work at the base reveal a New York style. The tankard's Boston-style dolphin-and-mask thumbpiece is especially notable, with its cavorting dolphins and startling gremlin-like mask.

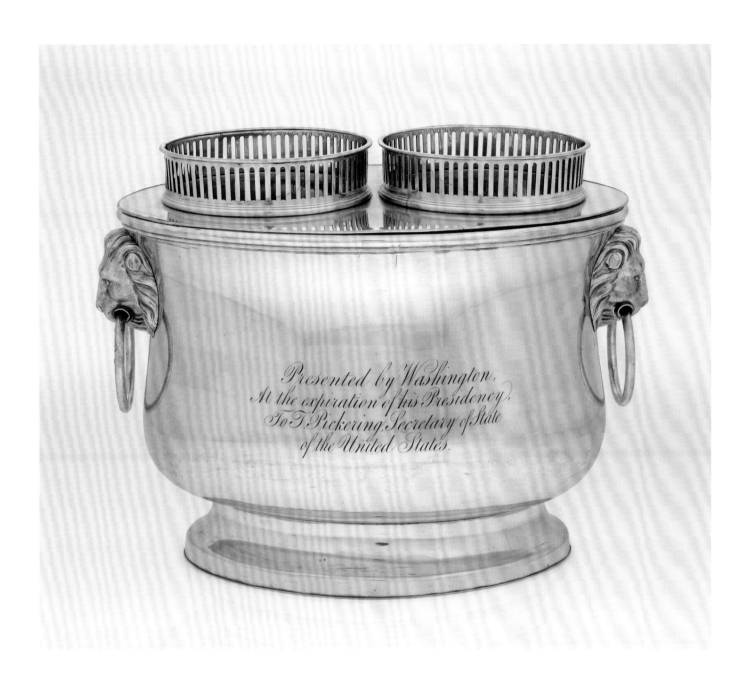

GEORGE WASHINGTON'S
WINE COOLER, ca. 1789

Maker unknown

England (possible)

Fused plate

8¹/₁₆ x 11 x 6⅞ in. (20. 5 x 27.9 x 17.5 cm)

AS THE FIRST president of the United States, George Washington had many concerns— among them, obtaining the items he would need to set an attractive table. In October 1789, he asked Gouverneur Morris to get him silver coolers, mirrors, and table ornaments.

In particular, Washington was looking for several wine coolers, of very specific design: "eight double ones (for Madeira and claret the wines usually drank at dinner) each of the apertures to be sufficient to contain a pint decanter, with an allowance in the depth of it for ice at the bottom so as to raise the neck of the decanter above the cooler; between the apertures a handle is to be placed by which these double coolers may with convenience be removed from one part of the table to the other."[211] For after-dinner drinks, he asked for four quadruple coolers.

Washington, a wealthy Virginia planter, purchased these wine coolers for himself. On August 14, 1797, a few months after the president had left office, he wrote to James McHenry, the secretary of war, about the wine coolers, that, "as a token of my friendship and as a remembrancer of it, I ask you, Colonel Pickering, and Mr. Wolcott to accept, each one of the two bottle Coolers."[212] Oliver Wolcott Jr. was the second secretary of the treasury, and Timothy Pickering (1745–1829) served as third secretary of state, under Washington. These coolers became cherished gifts; this one belonged to Pickering, who had it engraved in commemoration of the honor.

COFFEEPOT, ca. 1775
Bancroft Woodcock
(American, 1732–1817)
Wilmington, Delaware
Silver
13¹⁄₁₆ x 9⅞ x 4⁵⁄₁₆ in.
(33.2 x 25.1 x 11 cm)

IN 1754, BANCROFT Woodcock advertised his new venture in the *Pennsylvania Gazette*. "Bancroft Woodcock, Goldsmith, Hereby informs the publick, that he has set up his business in Wilmington, near the upper market house, where all persons that please to favour him with their custom, may be supplied with all sorts of Gold and Silver work, after the neatest and newest fashions. N.B. Said Woodcock gives full value for old gold and silver."[213]

Woodcock's work does indeed seem to have kept up with the neatest and newest fashions. This coffeepot boasts particularly fine proportions, more elegant than earlier pear-shaped and inverted-pear-shaped examples. The engraved rococo cartouche, combined with plain edges on the foot and cover, suggests that this pot was made just before the Revolutionary War. The delicate engraving, swirled bell-shaped finial, and design of the spout are very similar to the work of the best of Woodcock's Philadelphia peers.

The stylish coffeepot descended in the family of Margaret Bayard Smith (1778–1844), who married Samuel Harrison Smith (1772–1845) in 1800. In the same year, he founded the *National Intelligencer*, the first newspaper published in Washington, D.C.

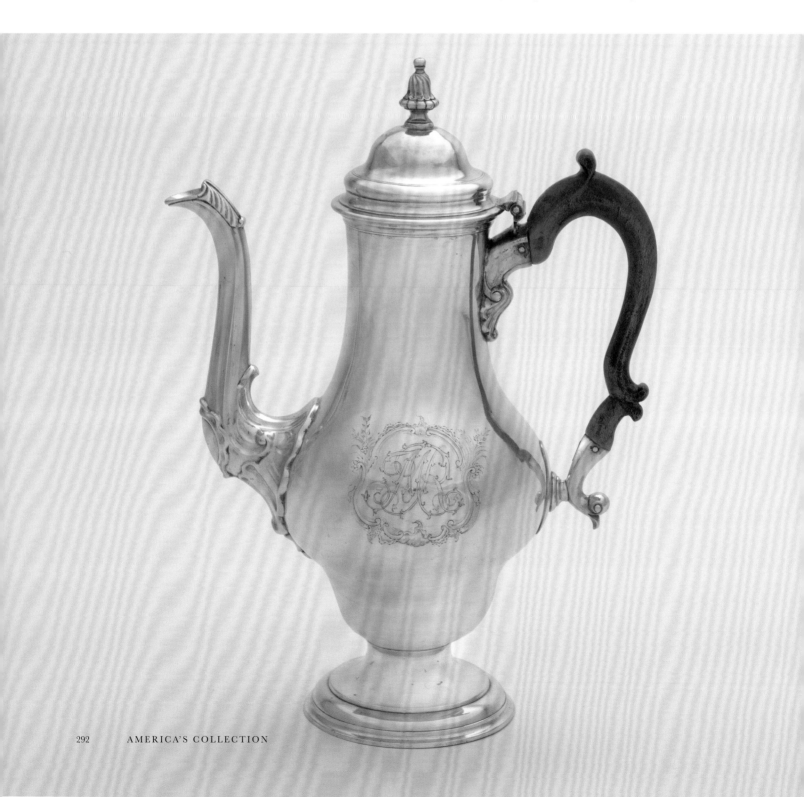

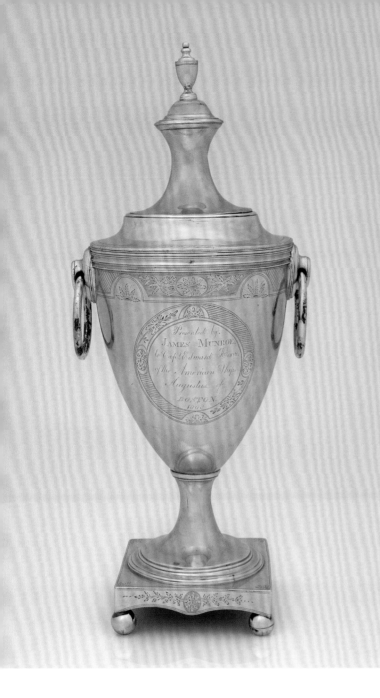
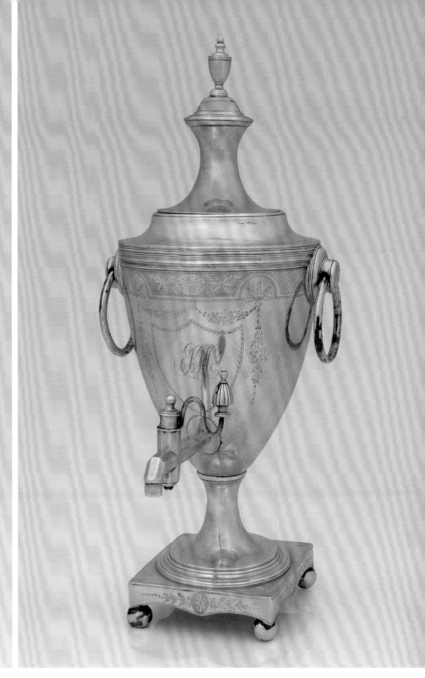

JAMES MONROE'S COFFEE URN, ca. 1808

Maker unknown
Boston (possible)
Silver
15½ x 4¼ in. (39.4 x 10.8 cm)

BY EARLY 1807, James Monroe (1758–1831), then the minister to Great Britain, had been working for years to persuade the British to stop forced impressment of sailors from American ships during the Napoleonic Wars. (The British, in desperate need of men, believed that British deserters were serving on American ships.)

But Monroe had won no concessions on the issue, and in July 1807, the American ship *Chesapeake* was boarded by the crew of the British ship *Leopard* off the coast of Norfolk, Virginia. In the struggle, three American crew members were killed and eighteen others wounded. The two countries nearly plunged into war. Monroe was summoned home.

Disheartened, feeling that his relationships with Thomas Jefferson and James Madison had been damaged by his work in Britain, Monroe was glad to come back to America. His relief at getting home safely and swiftly prompted this gift to Captain Edward Howe (1742–1821) of the ship *Augustus*, which made the Atlantic crossing in record time.

Silver urns were a traditional gift to ship captains who performed their duties with extraordinary courage. This example is unmarked, and since Monroe's passage was paid for by government funds, it is possible that Howe himself bought the urn. According to family tradition, Howe was a veteran of the Boston Tea Party; he would have been proud to carry James Monroe home to Virginia, and may well have wanted to commemorate the occasion.

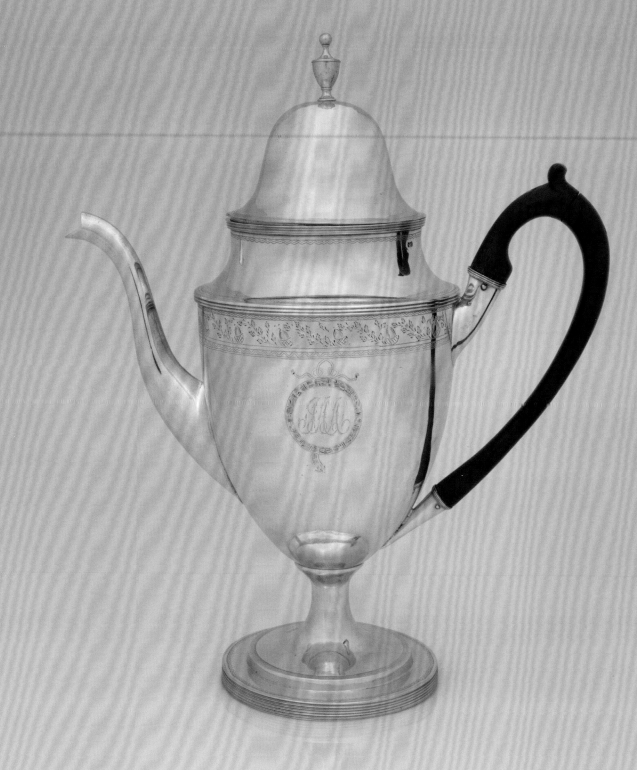

132

COFFEEPOT, ca. 1800
Paul Revere Jr.
(American, 1735–1818) (possible);
retailed by Nathaniel Austin
(silversmith, 1734–1818)
Boston
Silver
14⅛ x 12⅜ x 5 in.
(35.9 x 31.4 x 12.7 cm)

THIS CHIC COFFEEPOT is marked "JAA," for its owners, John Adams (1735–1826) and Abigail Adams (1744–1818). Though the coffeepot was retailed by Nathaniel Austin, John's first cousin by marriage, it was almost certainly made by the shop of Paul Revere.

Coffeepots became popular during the American Revolution, as taxes on tea and anti-British sentiment persuaded colonists to change their beverage of choice. Revere was the leading maker of silver coffeepots in eighteenth-century Boston, although he was still not making a huge number of these luxury

items. Between 1767, when the Townshend Acts went into effect, and the end of the war in 1783, Revere made at least seven coffeepots. After the war, he made at least seven more.

The Museum of Fine Arts, Boston, owns a very similar Revere coffeepot with acorn-and-oak-leaf decoration. Probably owned by William and Hannah Smith, that pot was purchased, along with other silver items, through Nathaniel Austin. A receipt dated October 22, 1798, shows that William Smith paid $81 for the coffeepot—the equivalent of almost $2,000 today.

133

MUSICAL TALL CASE CLOCK,
1776

Works by either Thomas Harland
(American, born England, 1735–1807)
or Benjamin Hanks
(American, 1755–1824)
Norwich, Connecticut
Case: cherry, eastern white pine, chestnut;
dial: silvered sheet-brass
91¾ x 20½ x 10¾ in. (233 x 52.1 x 27.3 cm)

TALL AND DISTINGUISHED, this remark-
able clock may have been made by Thomas
Harland of Norwich, Connecticut. In
December 1773, he advertised in the *Norwich
Packet* that he had opened a shop "where
he makes in the neatest manner . . . spring,
musical, and plain clocks."[214] This example,
with an eight-day brass movement and
musical chimes that play six different songs,
must have been one of the most ambitious
produced by the shop. It also would have been
among the most expensive, based on the costs
of labor and materials noted in Harland's
record books.

The clock's six tunes—the names are engraved
on the clockface, and selected by a pointer—
play at three, six, nine, and twelve o'clock.
The dial, which retains silvering over brass, is
also engraved with personifications of the four
seasons.

Like many clockmakers, Harland turned his
hand to a range of mechanical projects over
the years, making steam-powered roasting
jacks and even valves and pistons for the town
fire engine. Although attributed to Harland,
family tradition says that this clock was made
by one of Harland's apprentices, Benjamin
Hanks. He too was an innovator, inventing a
"pneumatick" clock that wound itself using
air currents.

PAIR OF ANDIRONS,
ca. 1795–1810

Attributed to Richard Whittingham Sr.
(American, born England, 1747–1821)
or Richard Whittingham Jr.
(American, born England, b. 1776)
New York City
Brass, iron
Each: 27 x 12 in. (68.6 x 30.5 cm)

AT FIRST GLANCE, these andirons seem like simple, practical hearth tools—and in their overall form, they are. But the decorative details tell a deeper story.

Each of the pedestals is engraved with a cloverleaf, possibly a symbol of unity, that joins the liberty pole—its famous cap held high—and crossed flags, one representing the United States, the other, the French national colors. On the ground are a broken spear and a toppled crown, lying on the turf, probably representing the toppling of the British monarchy. Taken altogether, the decorations on these andirons pay tribute to the contributions of the French to American independence.

Richard Whittingham Sr. was born in 1747 in England, where he learned brass founding. When he arrived in America, he first worked in Passaic Falls, New Jersey, as a member of the Society for Establishing Useful Manufactures, a planned industrial community endorsed by Alexander Hamilton. By 1795, Whittingham was working in New York. His son Richard Whittingham Jr. also worked in brass at different addresses in New York until 1818, when the son probably took over his father's business on Henry Street.

135

SET OF FIVE CAMP CUPS,
ca. 1785
Joseph Anthony Jr. (American, 1762–1814)
Philadelphia
Silver
1¹¹/₁₆ x 1¹³/₁₆ in. (4.3 x 4.6 cm) each

DURING THE REVOLUTIONARY WAR, American military officers provided their own equipment—their own uniforms, utensils, arms, horses, and servants. Small, simple beakers like these were useful in the field and in camp. (In the 1700s, the word *beaker* was used to describe any straight-sided cup with a flared rim.) A set like this one was suitable for sharing a drink or a toast with fellow officers.

Many of the cups were lost along the campaign trail; others were melted down over the years. These particular cups belonged to Major Winthrop Sargent (1753–1820), an aide-de-camp to George Washington. The inscription, probably added soon after Sargent left service in 1785, may have helped the cups survive the years after the war, since it says, "from Camp Chest of Major Winthrop Sargent U.S.A 1776–1785." A treasured memento, a set of at least twelve cups descended in Major Sargent's family. (George Washington had a similar set.)

The maker, Joseph Anthony Jr., created very simple, practical cups for Sargent. The only embellishment is the two inscribed lines near the lip, appropriate for the emerging neoclassical style of the 1780s. Though the cups look tiny to modern eyes, they held about the same amount as wineglasses of the era: two ounces. Wineglasses were refilled frequently; when the family and guests were dining at home, servants would remove an empty glass from the table and take it to a sideboard to be refilled, then bring it back.

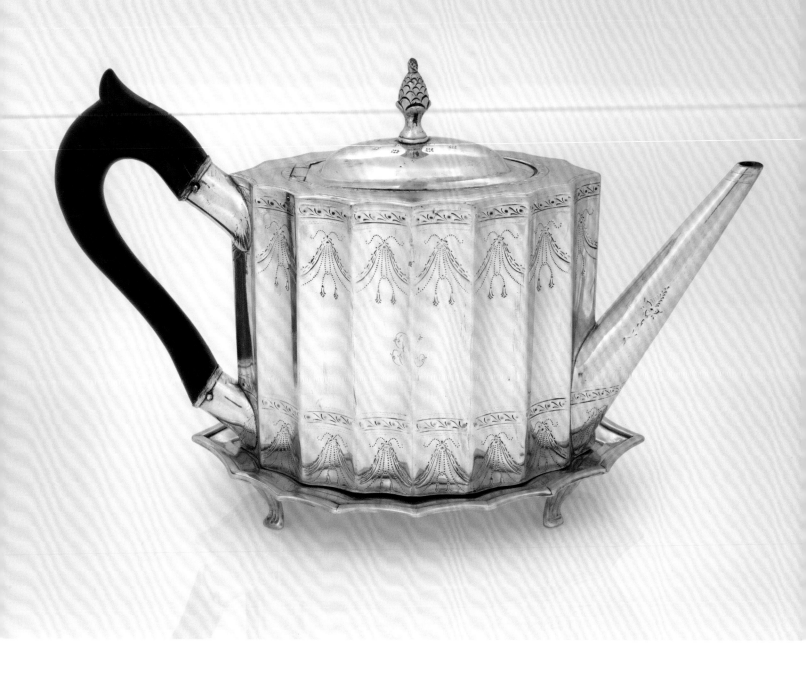

TEAPOT AND STAND, ca. 1796
Paul Revere Jr.
(American, 1735–1818)
Boston
Silver
Various sizes

PAUL REVERE JR., America's most famous silversmith Patriot, made at least ninety different types of items in his bustling shop in Boston. Because Revere kept detailed daybooks, we have a good idea of the range of items he produced: teapots, flatware, cups, tankards, porringers, saltcellars, sugar casters, trays, bowls, coffeepots, creamers, and sugar tongs. He also made personal items, including gold jewelry and buttons, silver buckles, and even metal harness fittings.

He also found time to craft some unusual items, including a whistle for a child, surgical instruments, an ostrich-egg snuffbox, and most endearingly of all, a chain for a pet squirrel. Items were available to suit every budget, from a child's spoon that might cost just a few pennies, to a lavish coffeepot like the one owned by John and Abigail Adams (see cat. 132).

This teapot and stand are one of fourteen similar surviving sets from Revere's shop. This form, with its fluted sides, was certainly inspired by imported Sheffield-plate wares and pattern book illustrations. A similar teapot appeared in the catalogue of Love, Silverside, Darby & Co., of Sheffield, England, around 1785, and Revere noted, "They enclosed me in the case of plated ware a book with drawings which is a very good direction for one to write by."[215] Both the teapot and its stand are marked with the initials "JH," for Judith Hays (1767–1844). She married Samuel Myers, son of the New York silversmith Myer Myers, in 1796.

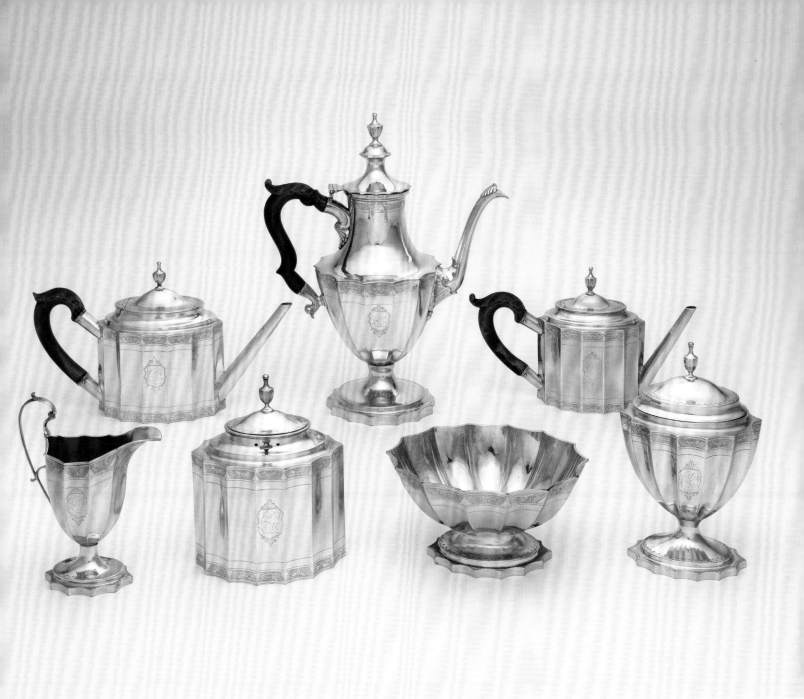

SEVEN-PIECE COFFEE
AND TEA SERVICE, ca. 1794
John LeTellier
(American, active ca. 1770–1800)
Wilmington, Delaware
Silver
Various sizes

BEFORE THE REVOLUTION and for at least two decades after, few Americans could afford to buy a silver coffee and tea set all at one time. So such services were assembled over several years, with stylistically mismatched pieces, often from different silversmiths in different cities. This set, then, is among the earliest matched examples; it even includes a tea caddy with a lock.

It was made by "John LeTellier Wilmington, Delaware," a shop headed by a father and son of the same name, and the urn-shaped coffeepot especially reflects the local taste for tall, elegant forms. The set was owned by the fashionable Cornelius Comegys (1758–1844) and his second wife, Catherine (1777–1861), of Philadelphia and Chestertown, Maryland.

Each piece is marked by a restrained "CC" in a simple shield border, rather than the large ornamental initials in script that were popular at the time.

Married in 1794, the couple may have received the elaborate set as a wedding gift. It is believed to be similar to another set made by LeTellier for President James Madison, lost on the night that the British burned the White House in 1814.

138 *FRONT AND BACK*

INDIAN TRADE PEACE MEDAL, 1793

Joseph Richardson Jr.
(American, 1752–1831)
Philadelphia
Silver
6¼ x 4¹⁵/₁₆ in.
(15.9 x 12.5 cm)

THE FIRST INDIAN peace medals were used by European powers to solidify relations with North American tribes. Early medals featured Minerva, the goddess of wisdom and a symbol of the new country, but in 1789, the newly elected president, George Washington, appeared in her place. The reverse side carries the arms of the United States as they appeared on official treaties of the time. The silversmith, Joseph Richardson Jr., had a family history of creating peace medals; his father, also a silversmith, made some of the earliest examples in America, ordered by a Quaker group that hoped to promote peaceful and friendly relations with Lenape Indians (whom the English called Delaware), in 1757.

Thomas Jefferson wrote, "The medals are considered as complimentary things, as marks of friendship to those who come to see us, or who do us good offices, conciliatory of their good will towards us."[216] They were prized by the Native American leaders who received them, and some turned in their British or French medals to symbolize that a new alliance with the United States had taken the place of an old one.

During the Revolutionary War, the Seneca chief Sagoyewatha fought with the British and frequently wore a British red coat; the troops nicknamed him Red Jacket. After the war, he negotiated for his tribe. In 1792, when Sagoyewatha traveled to Philadelphia to represent Seneca claims, Washington presented him with a medal similar to this one. Later portraits show him wearing the large medal, along with the latest in a series of red jackets.

CONSULAR SEAL, 1808–9
Peter Bateman (British, 1740–1825)
and William Bateman (British, 1774–1850);
worked together 1805–15
London
Silver; ivory handle
4⅞ in. (12.4 cm)

THE UNITED STATES Consular Service, a branch of the State Department, was established in 1792 to promote American commerce and protect American interests abroad. President George Washington, in his second annual address to the First Congress, in 1790, had said, "The patronage of our commerce, of our merchants and Seamen, has called for the appointment of Consuls in foreign Countries."[217]

Peter and William Bateman were well-known silversmiths in England when they made this handsome seal. Its solid, easy-to-grip handle, made of turned ivory, ends in a silver ferrule and a disk cut with the arms of the United States—all in mirror image, of course, so that the arms would read correctly when stamped on a document. The seal was probably used for official business of the American consulate in England.

The two men, uncle and nephew, were among seven members of the Bateman family to work in silver and gold. Today Peter's mother, Hester Bateman, is the most famous of the family, as a successful woman in a field dominated by men; and as the matriarch, after her husband's death, of a successful workshop that thrived from 1761, when she registered her mark, until the mid-nineteenth century.

SOCIETY OF THE CINCINNATI BADGE AND RIBBON, 1784

Designed by Pierre Charles L'Enfant
(French, 1754–1825),
cast by Claude Jean Autran Duval
(French, active 18th–19th century),
and embellished by Nicolas Jean Francastel
(French, active 1784–86)
Paris
Gold with polychrome enamels,
silk ribbon (reattached)
H. 1¼ in. (3.8 cm)

ESTABLISHED IN 1783, the Society of the Cincinnati is a hereditary fraternal order intended to perpetuate the "friendships which have been formed under the pressure of common danger" among officers of the Continental Army and their French allies.[218] The name honors Lucius Quinctius Cincinnatus of ancient Rome, the model of the citizen soldier (and subsequently, George Washington, who, like Cincinnatus, returned to civilian life after war was over).

In its founding document, the group described members wearing a gold medal on a deep blue ribbon, edged with white. Cincinnatus was to be shown with "three senators presenting him with a sword and other military ensigns. On a field . . . his wife standing at the door of their cottage—near it a plough and instruments of husbandry."[219]

Some officers questioned whether a hereditary society was appropriate in a country founded on republican ideals—but it is unlikely that this medal's owner, Timothy Pickering, who served in the Continental Army as adjutant general and quartermaster general, and later as the nation's third secretary of state, was among the doubters. Today the Society of the Cincinnati continues as the oldest hereditary society in the United States, with the oldest members only four generations removed from the original Revolutionary War officers, and the youngest members nine generations removed.

Pierre Charles L'Enfant, a member of the society and later the city planner of Washington, D.C., designed a simplified version of the scene on an eagle-shaped medal. This example was made in Paris. It is gold with details in white, red, green, and blue enamel.

141

SKIPPET, ca. 1840
Seraphim Masi
(American, born Italy, 1797–1884)
Washington, D.C. (possible)
Silver
Diam. 5³⁄₁₆ in. (13.2 cm)

THIS ELEGANT LITTLE box is a skippet—a container meant specifically for protecting wax seals affixed to official documents in a practice that dates back centuries. On the front cover is the Great Seal, and when the box was opened, the wax seal (now lost) was impressed with this same image that gave the document its importance. The United States used skippets only for major international treaties, and only in the nineteenth century.

The United States started to use pendant seals for the Treaty of Ghent, which was signed at the end of 1814; for that treaty, representatives used the die of a 1782 seal to make the wax seal. But the seal was small, and it looked even smaller next to large, impressive European seals. So Seraphim Masi, a silversmith who

had a shop in Washington, D.C., designed a more imposing treaty seal. Like this skippet, it featured a realistic eagle turned to the side, with thirteen arrows, a shield, and the motto *E pluribus unum* over the eagle's head. The Masi seal, about five inches in diameter, was used until 1871, when the government stopped using pendant seals and retired the die. (Today the original die is in the National Archives.)

Although this skippet is unmarked, it is believed that Masi made the box as well as the die—he had a government contract at the time that this skippet was made. A pendant seal made with the large Masi die would have fit into this skippet perfectly, with little room to shift and become damaged.

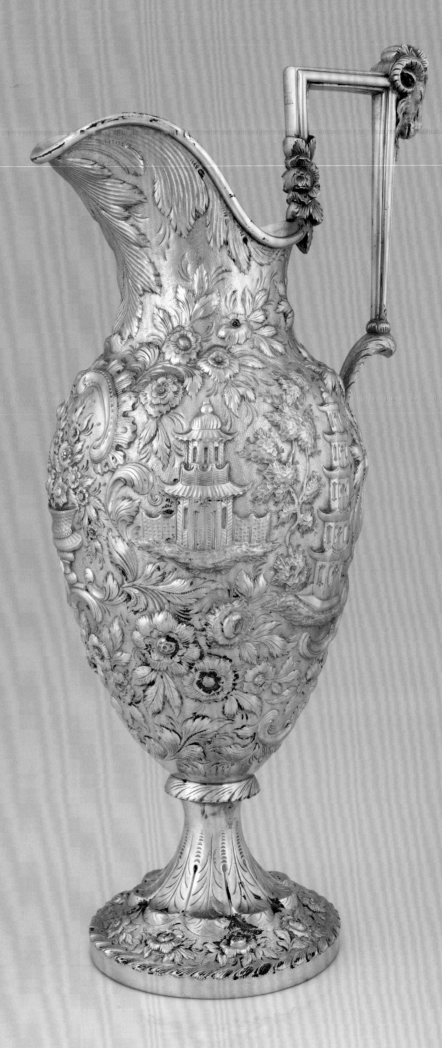

142

REPOUSSÉ WATER PITCHER, ca. 1840

Samuel Child Kirk
(American, 1793–1872)
Baltimore
Silver
16⅜ x 4¾ in. (41.6 x 12.1 cm)

AFTER APPRENTICING with James Howell of Philadelphia, Samuel Kirk opened his silver shop in Baltimore in 1825. In those years, Baltimore was one of the busiest ports in the country, and Kirk found many wealthy customers eager to buy elegant silver wares for their homes and tables. His repoussé work was popular on tea services, tureens, flatware, and many other objects—in fact, it became so well known that this type of decoration is still called Baltimore repoussé.

This elegant pitcher is one of hundreds made by Kirk and his successors between 1820 and the middle of the twentieth century. The basic shape remained the same, but the repoussé ornamentation was individualized for custom orders. Most pieces were hammered by hand from the reverse side to create the sophisticated high relief patterns on the exterior. This example, with its miniature chinoiserie buildings, uses a motif that was popular in Baltimore in the 1840s. Other patterns ranged from flowers and leaves to castles, swans, and even elephants.

The company's location in Baltimore drew customers from both the North and the South. President James Monroe ordered a flatware service from Kirk for his daughter's wedding, and in 1906, the company fulfilled a large commission for the naval cruiser *Maryland*—a dinner service with forty-eight pieces, each illustrating scenes from Maryland history.

PAIR OF GOBLETS,
ca. 1850
Wood and Hughes (1845–99)
Jacob Wood
(American, 1809–1850)
Jasper W. Hughes
(American, 1811–1864)
New York City
18-karat gold
H. 5⅜ in. (13.7 cm) each

SILVERSMITHS COULD WORK in gold as well as silver, but they rarely created domestic objects out of gold—it was expensive and far more difficult to sell than silver. In the 1850s, though, the firm of Wood and Hughes had the resources to create these golden cups; the company was the one of the largest manufacturers of silverware in the country.

Founded in 1845 by Jacob Wood and Jasper W. Hughes, the company expanded rapidly and, in time, produced a full line of silver for table, home, and business. Wood and Hughes wares were sold to clients all over the United States; in 1855, the company reported to the Industrial Census of the State of New York that it employed 105 people and had annual income of $225,000—the equivalent of almost $8 million today.

Throughout the 1800s, presentation items like these goblets, usually in silver—elaborate engraved bowls, trophies, goblets, even decorative garden spades to commemorate a groundbreaking—were used to honor a wide variety of officials and events. This pair of gold cups, with their engraved locomotives, was probably intended to serve as a presentation gift for some achievement in railroading. However, these cups have no inscriptions. Engraved writing might have been removed at some point, or perhaps no presentation was ever made.

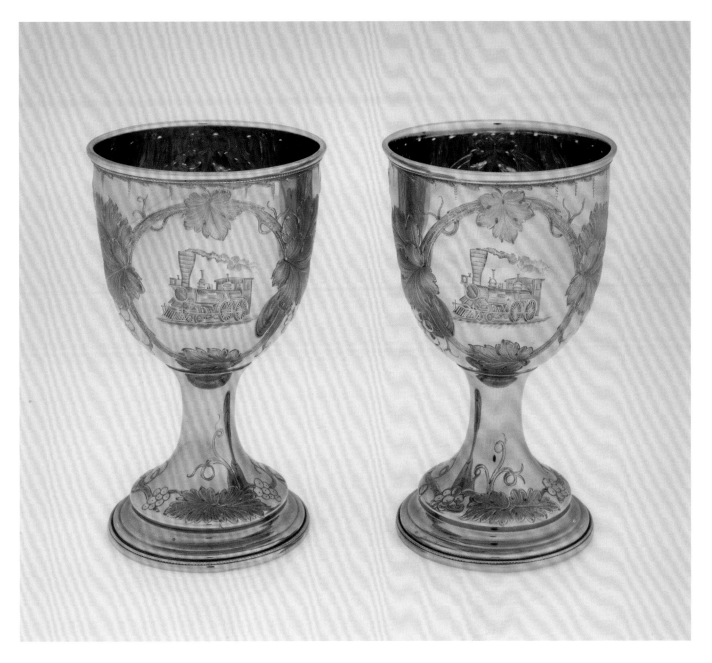

BRONZE MEDALLION OF
HENRY CLAY, 1851

Charles Cushing Wright
(engraver, American, 1796–1854),
Thomas Dow Jones
(sculptor, American, 1811–1881),
and William Walcutt
(sculptor, American, probably 1819–1882)
Bronze
3½ in. (8.9 cm)

HENRY CLAY (1777–1852) had a long and distinguished career—almost fifty years at the center of American politics. But as Abraham Lincoln wrote in his eulogy for Clay, "Mere duration of time in office constitutes the smallest part of Mr. Clay's history. Throughout that long period, he has constantly been the most loved, and most implicitly followed by friends, and the most dreaded by opponents, of all living American politicians."[220]

Near the end of Clay's life, members of his Whig Party commissioned this commemorative medal listing some of his many achievements. The original was struck in nearly thirty ounces of solid California gold and presented to Clay personally, in February 1852, at his bedside at the National Hotel in Washington, D.C. President Millard Fillmore,

members of Congress, and Clay's friends packed into the room. Daniel Ullmann, the chair of the medallion committee, told Clay that he felt no American medal had ever surpassed its beauty.

Later in 1852, a batch of 150 copper-bronzed medals were struck at the U.S. Mint. In 1861, Ullmann sent one to President-elect Lincoln, writing, "I reserved at the time, one of them with the intention, if ever such result should occur in my day, of presenting it to the citizen of the school of Henry Clay, who should first be elected to the presidency of the United States. I rejoice that that event has at last occurred, and, recognizing in you a true disciple of our illustrious friend, I take great pleasure in carrying out my purpose."[221]

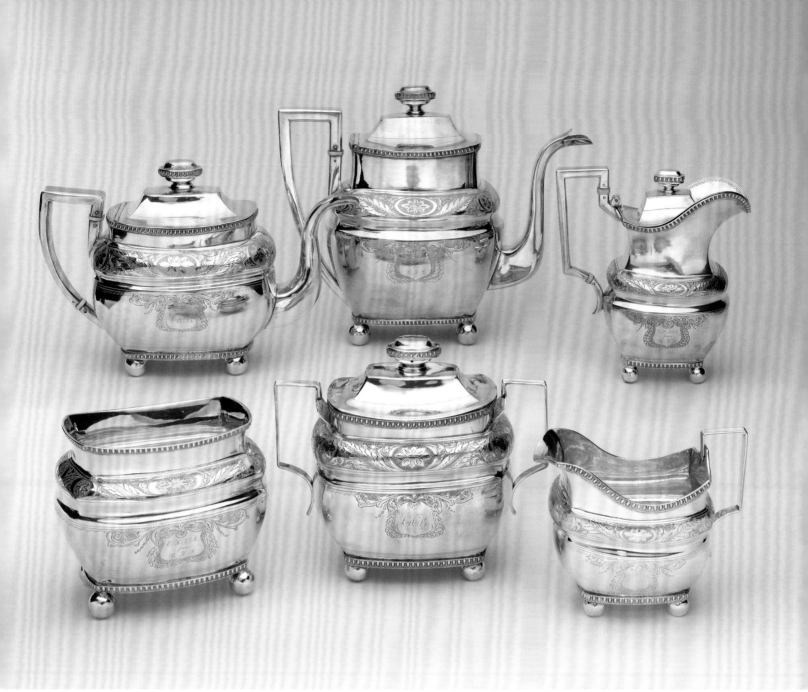

145

ASSEMBLED SIX-PIECE TEA AND COFFEE SERVICE, 1857

William I. Tenney
(American, active ca. 1828–48)
and Eoff & Shepard
(American, active ca. 1852–61);
retailed by Ball, Black & Co.
(American, active 1851–74)
New York City
Silver
Various sizes

BENJAMIN FRANKLIN BUTLER (1795–1858) was born in Kinderhook Landing, New York, where his father was a tavern owner just a few miles from the tavern owned by Martin Van Buren's family. Butler grew up to become a clerk in Van Buren's law practice, then his business partner. When Van Buren moved his office to Albany and became more involved in politics, Butler managed the firm and helped write Van Buren's speeches, bills, and other materials. He served as United States attorney general under Andrew Jackson, and then Van Buren, from 1833 to 1838.

In 1857, he purchased this elegant coffee and tea set for his youngest sister, Cornelia Hannah Butler Van Alen (1814–1892). The tall coffeepot, small hot-water pitcher, and waste bowl are engraved to show the date,

January 11, 1857, and "CHVA from BFB," indicating the recipient and the giver. The teapot, the creamer, and the sugar bowl are simply inscribed "CHB." It is possible that the CHB items, marked "E&S" for the designers Eoff & Shepard, were purchased first and the others, by William Tenney, acquired later to complete this assembled set.

Ball, Black & Co., the retailer where Butler purchased the set, was a leading retail silversmith and jeweler in the nation from 1852 to 1874; its stores, first at 247 Broadway and later at 565–567 Broadway at Prince Street in New York, sold enormous amounts of American-made silver by a wide range of designers.

AFTERWORD

David M. Rubenstein

IT IS FAIR TO PRESUME that someone who served his country as ably as Benjamin Franklin did arrived in heaven centuries ago and has since then been watching as his creation—the American Foreign Service—has endeavored and succeeded in preventing wars and ending those that could not be prevented.

Similar pride and support can be presumed from Thomas Jefferson, James Madison, James Monroe, John Quincy Adams, and Henry Clay—early secretaries of state who helped to mold that position into the leading force for peace in nearly every president's cabinet.

And it is thus not a surprise that the U.S. Department of State has chosen to honor these Americans by naming the department's most significant Diplomatic Reception Rooms in their honor. But a name can go only so far in reminding current and future visitors to the State Department of the achievements of these individuals, and others—like Dolley Madison and Martha Washington—for whom Diplomatic Reception Rooms are also named.

To help those who visit the Rooms learn a bit more about these individuals' accomplishments, and those of this country, the State Department has wisely and carefully collected, curated, and displayed some five thousand invaluable works of art and artifacts from the country's past.

But why do that? Why not just name the Rooms after extraordinary diplomats and public servants and have a few words about them in these State Rooms? Why not just have a few pictures of the desk on which the Treaty of Paris—which ended the Revolutionary War—was signed, rather than display the actual desk itself? Or why not just have a few pictures of historic artifacts on video screens in each of the rooms, for all to see and experience the past virtually?

To be sure, the virtual world has its benefits. And much can be learned over a computer. But the human brain has not evolved to the point that the enjoyment—and learning experience—of seeing an artifact on a screen or in a book is the same as seeing it in person.

When works of art more than two hundred years old can be seen in person—and a curator can explain their significance in real time—the experience is a more memorable one, and much more likely to have an impact on the visitor. Seeing

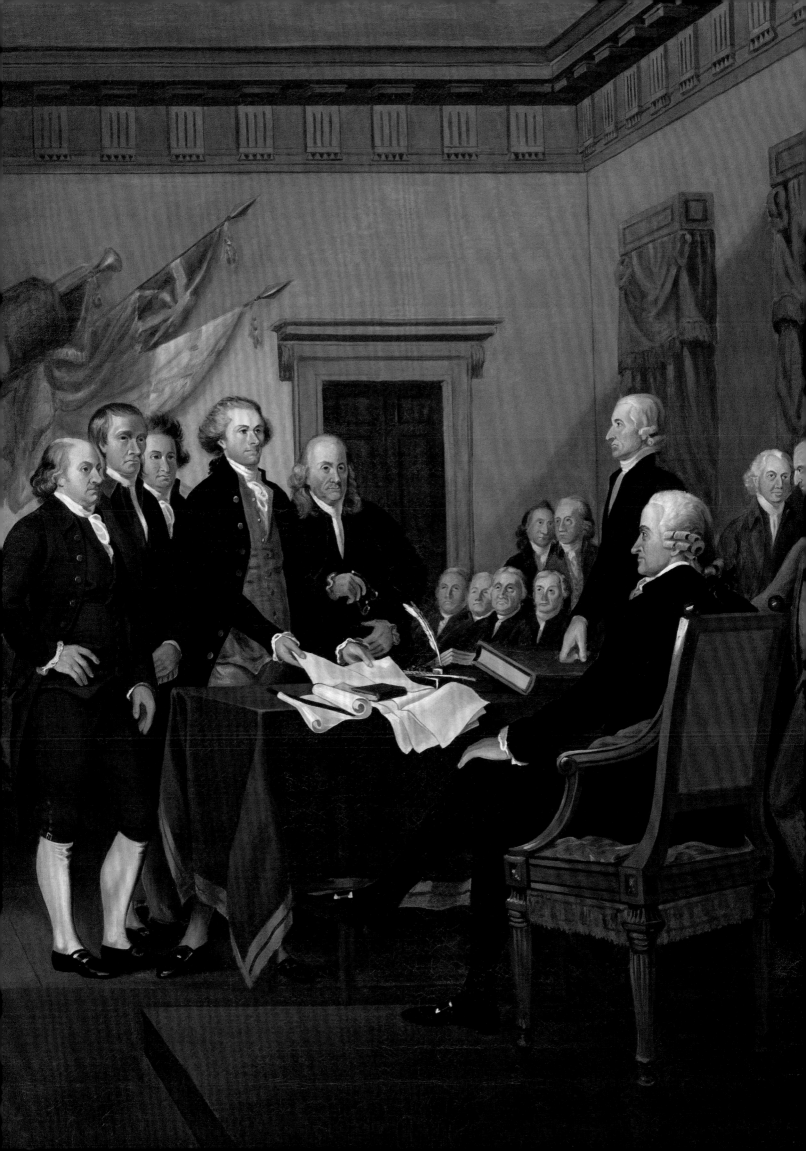

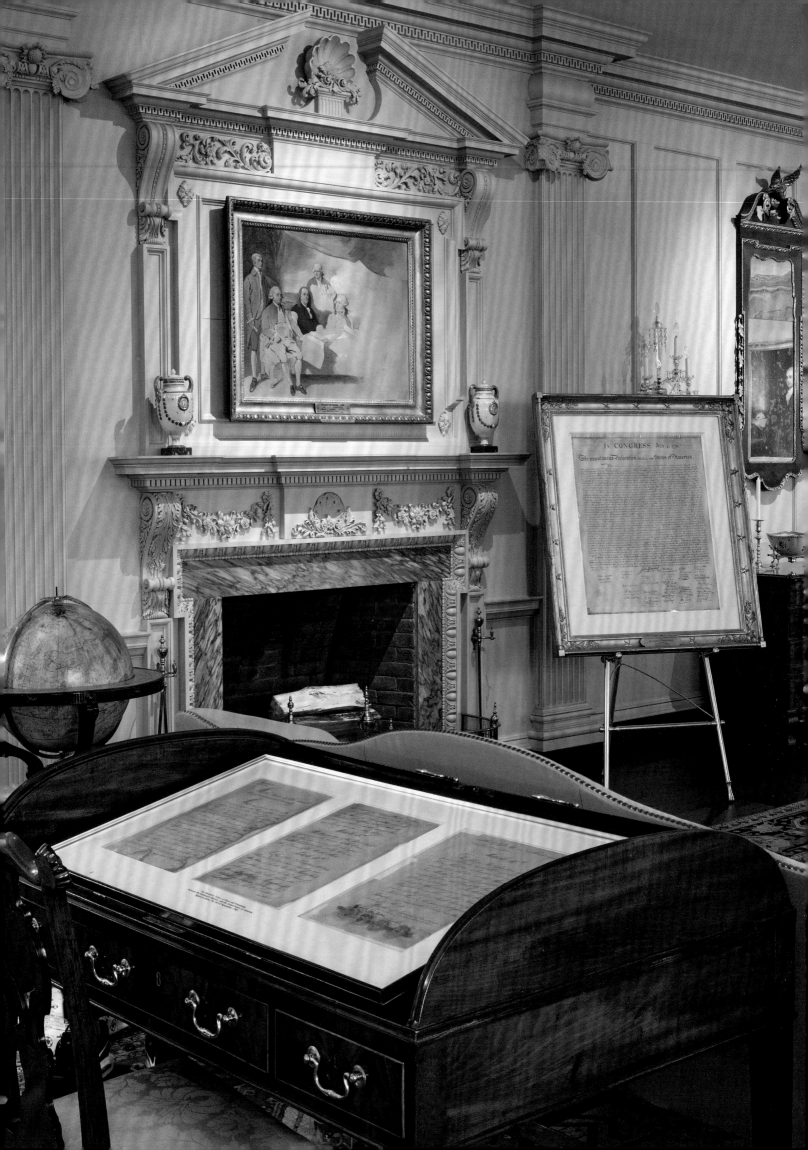

these rare objects displayed in settings that re-create interiors of the past serves to further promote an appreciation for our predecessors and their legacy.

And it is essential to know the history of our country.

The theory behind the age-old desire to study history is that people today can learn from the achievements and mistakes of previous generations and, by doing so, move civilization and human existence forward, benefiting current and future citizens. In the area of diplomacy, for instance, to the extent that today we can better educate the public about the past, we might have a society better able in the future to appreciate and value diplomatic skills and achievements—most especially those designed to achieve peace.

That is the hope. And with their magnificent display of historic works of art and irreplaceable documents, the Diplomatic Reception Rooms perform this service for the American people, and indeed for all of humanity. Surrounded by portraits of Founders and other Patriots and by objects that they owned and used—Thomas Jefferson's writing box; items with the insignia of the Society of the

Cincinnati, the organization that commemorates the successes and sacrifices of the Revolutionary War; and paintings and prints that represent the essence of the American character—we are reminded of the Founders' ideas and ideals, the principles they stood for and fought for, the values enshrined in the Constitution and embedded in our national consciousness. And we're inspired to continue to pursue their essential beliefs: liberty, democracy, equality, and freedom of speech and religion.

To the extent that I have been able to contribute toward this goal in a modest way, through support for the Diplomatic Reception Rooms and other cultural institutions and by sharing with the public foundational documents such as William Stone's facsimile engraving of the Declaration of Independence, I feel I am doing my small part toward advancing knowledge of the country's accomplishments. I encourage all Americans to visit the Diplomatic Reception Rooms and other historical collections for instruction, perspective, and inspiration. One can never learn too much about our country's history.

ADDITIONAL DOCUMENTATION

P. 13

ARCHITECT'S TABLE

PROVENANCE
Dr. William F. Gallaher; by descent in the
Parsons family; to the Fine Arts Committee
through purchase
INSCRIPTIONS
In pencil at the rear of the writing surface,
"James C. Gallaher, April 1825"
Funds donated by Mrs. Thomas Lyle
Williams, Jr., RR-1969.0070

P. 16

CONVEX MIRROR

PROVENANCE
Kentshire Galleries, Ltd., New York; to the
Fine Arts Committee through purchase
INSCRIPTIONS
None
Funds donated by Mrs. Mary N. Mathews,
RR-1984.0077

P. 17

LIBRARY BOOKCASE

PROVENANCE
Max Webber, a Middleton, Mass., dealer,
until 1958; to Israel Sack, Inc., New York; to
Lansdell Christie in 1963; to Israel Sack, Inc.,
in 1965; to the Fine Arts Committee through
purchase
INSCRIPTIONS
Modern pencil and chalk numbers on the
drawers
Funds donated by the Jefferson Patterson
Foundation, RR-1966.0021

OPPOSITE Martha Washington Ladies'
Lounge

P. 21

BENJAMIN FRANKLIN

PROVENANCE
By descent from Jean Antoine Houdon
through the Houdon family; to Mme Perrin-
Houdon, of Lorient, Brittany, France; in
1936, to Dr. B. Perlmutter, of Paris, a French
electroradiologist and collector who lived in
Brittany until at least 1959; to an anonymous
collector; through Mrs. Coggeshall (Mary
C.) Kuhn, a dealer in New York and later
Washington, D.C., by 1961; to the Fine Arts
Committee through purchase
INSCRIPTIONS
Studio stamp on the back reading, "ACADEM
/ ROYALE / DE PEINTURE / ET SCULPT /
HOUDON / SC."; incised on the edge of the
right shoulder, "J. Houdon f. 1778"
Funds donated by Mr. John J. McCloy, Mr.
Robert Lehman, Mr. Frank Altschul, Mr.
David K. E. Bruce, Mr. W. L. Clayton, Mr.
Arthur H. Dean, Mr. Roland E. Harriman,
Mr. W. Averell Harriman, Mrs. Coggeshall
Kuhn, Mr. Thomas S. Lamont, Mr.
Robert A. Lovett, Mr. Andre Meyer, Mr.
V. F. Neuhaus, and Mr. Herman Phleger,
RR-1963.0025

P. 25

WRITING TABLE

PROVENANCE
David Hartley (1731–1813), British
commissioner at the signing of the Treaty
of Paris, September 3, 1783. The desk
was acquired by John Wilmot, "Chief
Commissioner for settling claims of the
American Loyalists," from Hartley, and
remained in the Wilmot family until 1843,
when acquired by H. G. Newton, Esq. In
1926 the Newton family sold it to J. Wilson
Sons and Coombe, Exeter, England, who
shipped the desk to the United States for
auction by Grant's Art Galleries, Evanston,
Ill., in May 1927. From then until 1963 it was
in the collection of Mr. and Mrs. Benjamin
Stein of Chicago.
INSCRIPTIONS
In chalk in the center of the bottom of the
desk portion, "Shepherd"
Gift of Mrs. Raymond F. Tartiere and Mrs.
Benjamin F. Rosenthal in memory of Mr.
Benjamin F. Rosenthal and of Mrs. Benjamin
F. Stein in memory of Mr. Benjamin F. Stein,
RR-1964.0010

P. 31

FITZHUGH PLATES

PROVENANCE
Benjamin (1807–1883) and Priscila
[Ballenger] Leedom (1809–1887) (married
March 23, 1831); to their daughter, Hannah
[Leedom] Sharp (born 1859) and her
husband, Benjamin Sharp, Sr.; to their son,
Dr. Benjamin Sharp of Nantucket (b. Nov.
1, 1858); Dorothy Sharp Richmond (d. ca.
1959); her son, Benjamin Richmond; to his
son, Philip Richmond, the donor.
INSCRIPTIONS
Monogrammed R in gilt script
Gift of Mr. and Mrs. Philip J. Richmond,
RR-1966.0028

PP. 40, 41

FIREPLACE MANTEL

PROVENANCE
Undocumented
INSCRIPTIONS
None

Gift of Mr. Charles Bode with funds donated by Mrs. Lewis S. Thompson in memory of her husband, RR-1973.0059

PP. 138–39

LOUISA CATHERINE JOHNSON ADAMS

PROVENANCE

The portraits descended to Thomas Baker Johnson, brother of Louisa Catherine Adams; to Charles Francis Adams (d. 1886), the son of John Quincy Adams, in 1836; probably to his son, Charles Francis Adams (d. 1915); to his brother, Brooks Adams (d. 1927), by 1921; to his niece, Mrs. Robert Homans; to her son, Robert Homans, Jr.

INSCRIPTIONS

None

Gift of Robert Homans, Jr., Lucy Aldrich Homans, and Abigail Homans, in memory of their father, Robert Homans, RR-1975.0039

PAINTINGS & SCULPTURE

CAT. 1

FRANCES TUCKER MONTRESOR

PROVENANCE

Joan (Montresor) Read; to Howard Young Galleries, New York, in 1934; to the donors, of Greenwich, Conn., in 1935

INSCRIPTIONS

Signed at the lower right, "JS Copley"; inscribed on the reverse "Frances Montresor / nee Tucker / Born 1744–died 1826 / PINXIT Copley"

Gift of Mr. and Mrs. Richard I. Robinson, RR-1981.0050

CAT. 2

THE AMERICAN COMMISSIONERS OF THE PRELIMINARY PEACE NEGOTIATIONS WITH GREAT BRITAIN

PROVENANCE

Traditionally thought to have been presented to Lewis Cass (d. 1866; secretary of state 1856–60), while he was minister to France (1836–42); by descent to his great-grandson, Cass Canfield (1897–1986), of New York; to

Mrs. Cass (Katherine Emmet) Canfield (later Mrs. Frank Gray Griswold), by 1938; to her son, Cass Canfield Jr. of New York

INSCRIPTIONS

In graphite, diagonally at the lower right, "An original Sketch / by / Benjamin West -;" and, in the corner, "Franklin / Adams / Jay / & / Laurens / Temple Franklin;"; also, "Paris / 1783 [*sic*] Treaty of Peace."

Gift of Cass Canfield Sr. and Cass Canfield Jr. (canvas); gift of Mrs. Wunderlich of Kennedy Galleries (period frame), RR-1965.0024

CAT. 3

THOMAS JEFFERSON

PROVENANCE

Undocumented

INSCRIPTIONS

None

Gift of Mrs. Henry S. McNeil in memory of Mr. Henry S. McNeil, RR-1988.0013

CAT. 4

GEORGE WASHINGTON

PROVENANCE

Owned by Colonel Briggs of Brooklyn, N.Y. Descended in family and sold by an heir to New York artist Koeniger; purchased from Koeniger by Robert Vose, who sold it to Mrs. Galen Stone of Brookline, Mass.

INSCRIPTIONS

None

Gift of Mrs. Robert G. Stone, RR-1981.0068

CAT. 5

MARY MCINTOSH WILLIAMS SARGENT

PROVENANCE

Governor and Mrs. Winthrop Sargent, of Natchez, Miss.; to Mrs. Winthrop Sargent, until 1844; to her son by her first marriage, James Williams; to his widow, who gave it in about 1855 to Governor Sargent's grandson, George Sargent, until 1893; to his sister, Jane Percy Sargent, wife of William Butler Duncan, of New York, until 1905, when it was reunited with its pendant painting of Governor Sargent; their histories are thenceforward identical

INSCRIPTIONS

None

Funds donated by the Morris and Gwendolyn Cafritz Foundation, RR-1973.0056

CAT. 6

A FLUTIST

PROVENANCE

French & Company, N.Y.; to the Fine Arts Committee through purchase

INSCRIPTIONS

None

Funds donated by Mildred and Jack L. Bowers, RR-1970.0007

CAT. 7

JOHN QUINCY ADAMS

PROVENANCE

John Quincy Adams (1767–1848); to his mother, Abigail Adams (d. 1818); to his son, John Adams (d. 1834); to Mary Catherine Hellen Adams (d. 1870), his widow; to her granddaughter, Mary Adams Johnson (later Mrs. Charles Andrews Doolittle), 1870; to her son, Ebenezer Brown Sherman Doolittle; to his daughter, Lois Doolittle (Mrs. Carpenter Inches); to Max Webber, Inc., Middleton, Mass.; to the Fine Arts Committee through purchase

INSCRIPTIONS

On the reverse of the gold case, interlaced monogram "JQA"

Funds donated by Mrs. Charles S. Payson, RR-1967.0070

CAT. 8

LOUISA CATHERINE JOHNSON ADAMS

PROVENANCE

John Quincy Adams (1767–1848); to his mother, Abigail Adams (d. 1818); to his son, John Adams (d. 1834); to Mary Catherine Hellen Adams (d. 1870), his widow; to her granddaughter, Mary Adams Johnson (later Mrs. Charles Andrews Doolittle), 1870; to her son, Ebenezer Brown Sherman Doolittle; to his daughter, Lois Doolittle (Mrs. Carpenter Inches); to Max Webber, Inc., Middleton, Mass.; to the Fine Arts Committee through purchase

INSCRIPTIONS

Signed with initials at the sitter's left shoulder, "SS."

Funds donated by Mrs. Charles S. Payson, RR-1967.0071

MARQUIS DE LAFAYETTE

PROVENANCE

Undocumented

INSCRIPTIONS

None

Funds donated by the F. M. Kirby
Foundation, Inc., RR-1993.0006

ALEXANDER HAMILTON

PROVENANCE

Undocumented

INSCRIPTIONS

None

Gift of Mr. and Mrs. A. Varick Stout,
RR-1973.0101

THOMAS JEFFERSON

PROVENANCE

Earle's Gallery, Philadelphia, 1830; to
James Henry Hammond (1807–1864), of
Columbia, S.C., later governor of South
Carolina (1842–46); to his son, Edward
Spann Hammond (b. 1834); to his son, James
H. Hammond (b. 1885); to Daniel H. Farr
Co., N.Y., by 1930; the same year to Edward
Small Moore (1881–1948), of Sheridan,
Wyo.; to his son, Edward Small Moore, of
N.Y.; to the Brook and Snake Society, Yale
University; to Graham Gallery, New York, in
1980; to the Fine Arts Committee through
purchase

INSCRIPTIONS

On the reverse, "Painted by T. Sully / 1821 /
TS" ("TS" in monogram)

Funds donated by Mrs. Thomas Lyle
Williams Jr., in memory of her husband,
RR-1980.0084

JAMES MONROE

PROVENANCE

Mr. and Mrs. Lyttleton B. Purnell III, of
Baltimore; to Mrs. Josephine Warfield
Purnell; to the Fine Arts Committee through
purchase

INSCRIPTIONS

The canvas was relined at least twice. A piece
of canvas glued to the back reads "President
Monroe 1820 / relined 1909 New York." A
second inscription reads "This above canvas
with inscription formed / Part of of [sic] the
lining of the President Monroe / Portrait.
This was removed when the painting / Was
again relined in 1934. by A. J. Brooks."
Funds donated by Mrs. Thomas Lyle
Williams Jr., in memory of her husband,
RR-1967.0049

JAMES MADISON

PROVENANCE

James and Dolley Madison; to James C.
McGuire, Esq., creditor and executor;
Sale of Late James C. McGuire Estate,
Washington, D.C., December 12, 1886; to
Secretary of State Thomas F. Bayard, in
1886; ex-collection Department of State; to
the Fine Arts Committee

INSCRIPTIONS

None
RR-1963.0001

JAMES MADISON

PROVENANCE

The Marquis de Lafayette; by descent to a
family branch in Turin, Italy; Christie's, New
York, Cecily Sale, May 23, 1979, Lot 3; to the
Fine Arts Committee through purchase

INSCRIPTIONS

On the reverse, "President Madison / Copy
from Wood by C King / Washington 1826."
Funds donated by Mr. and Mrs. David S.
Ingalls, RR-1979.0035

LEONIDAS WETMORE

PROVENANCE

Undocumented

INSCRIPTIONS

None

Partial gift of Mr. George Baumunk,
RR-1993.0012

EARLY VIEW OF THE CAPITOL

PROVENANCE

Mr. Pearson Hardee to the Fine Arts
Committee through purchase

INSCRIPTIONS

None
Funds donated by the Monica and Herman
Greenberg Foundation, RR-1980.0034

A GLIMPSE OF THE CAPITOL
AT WASHINGTON

PROVENANCE

Possibly the painting distributed by the
American Art Union in 1848, by lottery;
Kennedy Galleries, New York, 1969; to the
Fine Arts Committee through purchase.

INSCRIPTIONS

Signed at the lower right, "W MacLEOD"
Funds donated by Mrs. Nancy S. Reynolds,
RR-1969.0034

VIEW OF BOSTON HARBOR

PROVENANCE

Graham Gallery, New York; to the Fine Arts
Committee through purchase

INSCRIPTIONS

Signed and dated on lower right of canvas,
"F.H. Lane 1852"

Funds donated by Miss Elizabeth Cheney,
RR-1974.0023

ANTI-SLAVERY TOKEN

PROVENANCE

Undocumented

INSCRIPTIONS

None

Gift of Mr. and Mrs. James Garrison
Stradling, RR-2015.0004

VIEW ON THE KISKEMINITAS

PROVENANCE

David David, Inc., Philadelphia, by 1982; to
the Fine Arts Committee through purchase

INSCRIPTIONS

Signed and dated at the lower right, "J. Shaw.
1838.X."

Funds donated by the Freed Foundation,
RR-1983.0003

VIEW OF NIAGARA FALLS AND TERRAPIN TOWER FROM THE AMERICAN SIDE

PROVENANCE

Lawrence Goldsmith of Sheffield, Mass.; to Dana E. Tillou, Ltd., Buffalo, N.Y., by 1989; to the Fine Arts Committee through purchase

INSCRIPTIONS

Signed at the lower right, "Fred. Richardt"; inscribed on protective cardboard backing "Wax Relined/ By Kim Clark/ Rockport, Ma./ 1988"

Funds donated by the F. M. Kirby Foundation, Inc., RR-1989.0014

WATERFALL

PROVENANCE

The Old Print Shop, New York; to Parke-Bernet Galleries, New York, Sale 848, March 15, 1947, Lot 517; to Arthur D'Espies, of Short Hills, N.J.; to Sotheby Parke-Bernet, New York, Sale 3978, April 16–20, 1977, Lot 16; to the Fine Arts Committee through purchase

INSCRIPTIONS

Signed in monogram and dated at the lower right, "J.F.K. 53."; with framer's label, "Tracy & Newkerk, 124 Grand Street, New York"

Funds donated by Mr. and Mrs. Joseph M. Bryan, RR-1977.0008

VIEW OF OTSEGO LAKE NEAR COOPERSTOWN, NEW YORK

PROVENANCE

Undocumented

INSCRIPTIONS

None

Gift of Mrs. James Frederick Martin Stewart, RR-1974.0042

INDIANS IN A MOUNTAIN LANDSCAPE

PROVENANCE

Ex-collection of the donor

INSCRIPTIONS

Signed "T.Cole" lower right

Gift of Mrs. Deen Day Sanders, RR-2008.0004

A TWO-TIERED STILL LIFE WITH FRUIT

PROVENANCE

Undocumented

INSCRIPTIONS

Signed, with the vine tendril, in script, at the lower left center, "S Roesen" (the letters "SR" in the form of a monogram)

Gift of Mrs. Pennington Sefton, RR-1984.0033

BARTER FOR A BRIDE

PROVENANCE

Colonel John K. Kilbreth; to General J. William Kilbreth; to Gertrude O. Barclay Kilbreth; to James Graham & Sons, Inc., N.Y.; to the Fine Arts Committee through purchase

INSCRIPTIONS

None

Funds donated by the Morris and Gwendolyn Cafritz Foundation, RR-1965.0053

VALLEY OF LAKE PEPIN, MINNESOTA

PROVENANCE

Undocumented

INSCRIPTIONS

Signed and dated "R.S. Duncanson 1864 Montreal," lower left center

Gift of Mr. and Mrs. James O. Keene, RR-1978.0078

VALLEY OF THE YOSEMITE

PROVENANCE

The Fine Arts Committee through purchase

INSCRIPTIONS

Signed and dated at the lower right, "T. Hill. / 1868"

Funds donated by the Honorable Herman Phleger and Mrs. Phleger, RR-1966.0029

THE CLIFFS OF GREEN RIVER, WYOMING

PROVENANCE

Sotheby's, New York, Sale 5644, December

3, 1987, Lot 130; to the Fine Arts Committee through purchase

INSCRIPTIONS

Signed and dated at the lower right, "TYMORAN 1900" ("TYM" in monogram)

RR-1987.0026

AMERICAN EAGLE WALL PLAQUE

PROVENANCE

Israel Sack, Inc., New York; to the Fine Arts Committee through purchase

INSCRIPTIONS

None

Funds donated by Mr. and Mrs. Ashley H. Priddy, RR-1982.0030

WINTER FARMSTEAD

PROVENANCE

William Macbeth, Inc., N.Y.; to Mabel Brady Garvan by 1947; to Sotheby Parke-Bernet, N.Y., Sale 4365, April 25, 1980, Lot 9; to Wineland Enterprises, Inc., Marlow Heights, Md.; to the Fine Arts Committee through purchase

INSCRIPTIONS

Signed and dated with monogram on the rock at the lower left, "G.HD /56" (the letters "HD" in form of monogram)

Funds donated by Patricia Anne Morton, in memory of her family, RR-1982.0075

THOMAS STRONG'S FARM, SETAUKET

PROVENANCE

Mrs. Caleb Tangier Smith, to her son, Mr. Edward H. L. Smith; to Mrs. Edward H. L. Smith, St. James, N.Y.; private collection; Christie's, May 26, 1988, Lot 42; Rudolf Wunderlich Gallery by 1993; Christie's, Sale 9368, May 24, 2000, Lot 138; to the lender through purchase

INSCRIPTIONS

Signed on face, "Wm. S. M. Oct 1864"; label from Gerald Peters Gallery

Gift of Mr. and Mrs. Henry Laufer, RR-2015.0010

FARM ON THE HUDSON

PROVENANCE

Ex-collection of the donors, Mr. and Mrs. John C. Newington, the latter a great-granddaughter of the artist

INSCRIPTIONS

Signed and dated at the lower right, "J.F. Cropsey / 1879"

Gift of Mr. and Mrs. John C. Newington, RR-1972.0061

THE SPIRIT OF '76

PROVENANCE

Archibald M. Willard, the artist; to J. F. Ryder, Cleveland; to G. C. Kramer, Lorraine and Cleveland, Ohio; to George and David Kramer, Lorraine, Ohio; to Mary Kramer Curry, Erie, Penn.; to Gerald Czulewicz, the donor

INSCRIPTIONS

Signed "A.M. Willard" on reverse stretcher bar

Gift of Gerald E. Czulewicz and Sue Huffaker-Czulewicz, RR-1990.0006

MANDAN VILLAGE ON UPPER MISSOURI

PROVENANCE

Undocumented

INSCRIPTIONS

None

Gift of Dr. Thornton Boileau, RR-1991.0034

INDIAN PUEBLO

PROVENANCE

Undocumented

INSCRIPTIONS

Signed in lower right, "JH Sharp"

Gift of Dr. Robert A. Delp, RR-1991.0018

STREET IN CHINATOWN

PROVENANCE

Undocumented

INSCRIPTIONS

Signed and dated, "Edwin / Deakin / 1885" on building at right

Funds donated by Mr. and Mrs. David L. Keeger, RR-1971.0097

STREETS OF PROVINCETOWN

PROVENANCE

Ex-collection of the artist, 1900–1935; by bequest to the American Academy of Arts and Letters, New York, 1935–1942; Milch Galleries, New York, 1942; John Levy Galleries, New York; to Mr. and Mrs. Russell W. Nowels, Rochester, Mich., by 1951; by gift to their daughter, Miss Martha E. Nowels, Tucson, Ariz., about 1951–1980; to the Fine Arts Committee by 1981, through purchase

INSCRIPTIONS

Signed "Childe Hassam" at lower left

Funds donated by an anonymous donor, RR-1980.0007

THE PRAIRIE

PROVENANCE

John Howell Bookstore, San Francisco, California; private collection, Texas, by 1972; Sale: Reno, Nevada, The Coeur d'Alene Art Auction, July 24, 2004, lot 140, illustrated in color; private collection; Sale: New York, New York, Sotheby's, May 23, 2007, lot 184; Acquired by a dealer; Ambassador John Price, Salt Lake City, Utah, the donor

INSCRIPTIONS

Signed "Maynard Dixon / 1915"

Funds donated by Patricia Anne Morton; partial gift of Price Auto Museum, RR-2017.0013

APPEAL TO THE GREAT SPIRIT

PROVENANCE

Undocumented

INSCRIPTIONS

Inscribed and dated "C.E. Dallin 1913" on the base and stamped and inscribed "Gorham Co Founders" and "GFC QPN #37" on edge of base

Gift of Mr. Philip L. Poe, RR-1965.0046

CERAMICS

PUNCH BOWL

PROVENANCE

Elinor Gordon, a Villanova, Penn., dealer; to the Dietrich American Foundation, Philadelphia, in 1965; to the Fine Arts Committee through purchase

INSCRIPTIONS

None

Funds donated by Robert E. Vogle and Barbara Shipley Vogle, RR-1965.0004.3

CHARGER MADE FOR ELDRED LANCELOT LEE OR HIS SON, LANCELOT

PROVENANCE

Ex-collection of George Skakel (1892–1955) or George Skakel Jr. (1922–1966); acquired by Thomas K. Libby, a Stamford, Conn., dealer; to the donor through purchase

INSCRIPTIONS

"Virtus vera est nobilitas" ("Virtue is the true nobility")

Gift from Robert Kogod Goldman and Caroline Goldman Cassagnol in memory of their brother, Ronald Kogod Goldman, RR-2014.0004

SAUCER FROM THOMAS AND ELIZABETH BAGNALL MIFFLIN'S SERVICE

PROVENANCE

Polly Latham, dealer, Boston, Mass.; to the donor through purchase

INSCRIPTIONS

Asymmetric cartouche reserved with "M" in gilt-heightened script

Gift of Robert Kogod Goldman in memory of his brother, Ronald Kogod Goldman, RR-2016.0004

PLATE FROM GEORGE WASHINGTON'S SOCIETY OF THE CINCINNATI SERVICE

PROVENANCE

Mrs. Ludwell L. Montague; to the Fine Arts Committee through purchase

INSCRIPTIONS
None

Funds donated by Mr. H. Richard Dietrich
Jr., RR-1972.0027

CAT. 45

MUG MADE FOR
HENRY SMITH

PROVENANCE

Made for Henry Smith (1766–1818) of
Providence, R.I.; Polly Latham, dealer,
Boston, Mass.; to the donor through purchase

INSCRIPTIONS

"SMITH" contained in a cartouche for
Henry Smith

Gift of Robert Kogod Goldman in memory
of Justice Arthur Chaskalson of South Africa,
RR-2013.0007

CAT. 46

PLATE FROM IGNATIUS
SARGENT'S SERVICE

PROVENANCE

By descent of Ignatius Sargent of Gloucester,
Mass.

INSCRIPTIONS

A banner inscribed with the motto "NEC
QUAERERE HONOREM, NEC SPERNERE"
("Neither to seek nor to despise honors")

Gift of Mr. Malcolm Donald, Mr. Peter A.
Donald, Mrs. Deborah D. LaMontagne,
Ms. Susan D. Michalski, Mr. Lloyd
Malcolm Pearson, and Ms. Sarah Vasques,
RR-1997.0008.8

CAT. 47

SOUP PLATE FROM ELIAS
HASKET DERBY'S SERVICE

PROVENANCE

Polly Latham, dealer, Boston, Mass.; to the
donor through purchase

INSCRIPTIONS

None

Gift of Robert Kogod Goldman and
Caroline Goldman Cassagnol in memory
of their parents, Marvin J. and Ruth Kogod
Goldman, RR-2016.0005

CAT. 48

NINE PIECES FROM WILLIAM
EUSTIS'S SOCIETY OF THE
CINCINNATI TEA SERVICE

PROVENANCE

Through Elinor Gordon, a Villanova, Pa.,
dealer, by 1968; ex-collection the Dietrich
American Foundation, Philadelphia; to the
Fine Arts Committee through purchase

INSCRIPTIONS

In black block letters within the seal, "OMNIA
RELINQUIT SERVARE REMPUBLICAM"
("He gave everything to serve the Republic");
in gilt script, below the badge, "WE" for
William Eustis; on the seal's obverse, shown
on the teapot and cream pot, "SOCIETAS
CINCINNATORUM INSTITUTA * 1783"

Funds donated by the Folger Fund,
RR-1968.0011.47–.51, .55–.57

CAT. 49

TEABOWL AND SAUCER WITH
ARMS OF RHODE ISLAND

PROVENANCE

Undocumented

INSCRIPTIONS

Monogrammed

Gift of Robert Kogod Goldman in
memory of his wife, Linda B. Goldman,
RR-2014.0007.1–.2

CAT. 50

TEAPOT STAND WITH ARMS
OF NEW YORK STATE

PROVENANCE

Undocumented

INSCRIPTIONS

None

Gift bequest of Robert E. and Barbara
Shipley Vogle, RR-1992.0021

CAT. 51

TEA PLATE FROM JAMES M.
WATSON'S SERVICE

PROVENANCE

Polly Latham, dealer, Boston, Mass.; to the
donor through purchase

INSCRIPTIONS

Bearing script initials "JMW" for James M.
Watson (1750–1806), in underglaze blue
enamels

Gift of Robert Kogod Goldman in memory
of Ruth Kogod Goldman, RR-2013.0003

CAT. 52

PLATES FROM ELIAS
BOUDINOT'S SERVICE

PROVENANCE

Northeast Auctions, August 20–21, 2016, lot
826; to the donor through purchase

INSCRIPTIONS

Gilt-heightened motto, "Soli Deo Gloria Et
Honor." RR-2017.0002.1 bearing paper label
reading "Northeast Auctions" and "5369-
13/2"; RR-2017.0002.2 bearing paper label
reading "5369-13/2."

Gift of Robert Kogod Goldman in memory
of his brother, Ronald Kogod Goldman,
RR-2017.0002.1–.2

CAT. 53

PUNCH BOWL MADE
FOR RICHARD GRIDLEY

PROVENANCE

Undocumented

INSCRIPTIONS

Painted near the outside of the rim,
"RICHARD GRIDILY" [*sic*], indicating
Richard Gridley (American, 1710/11–1796)

Gift of Mr. and Mrs. James O. Keene,
RR-1980.0060

CAT. 54

SAUCER FROM
MARTHA WASHINGTON'S
STATES SERVICE

PROVENANCE

The Tayloe family, who lived in Octagon
House, Washington, D.C., and who are
believed to have received the saucer as a gift
from Martha Washington; by descent to the
donor

INSCRIPTIONS

In the center the monogram "MW"; below
the monogram, "DECUS ET TUTAMEN
AB ILLO" ("A glory and a defense from it");
around the edge of the saucer, the names of
fifteen states

Gift of Miss Elizabeth Renshaw,
RR-1977.0018

CAT. 55

PLATE FROM THE JOHN
MORGAN SERVICE

PROVENANCE

Made for John Morgan, Hartford, Conn.

(1753–1842); to Polly Latham, dealer, Boston, Mass.; to the donor through purchase

INSCRIPTIONS

Inscribed "Morgan" in script. Two stickers for Polly Latham, "7055," and another dated "24 Jan 97 / Sale 8580 / Lot 221/2."

Gift of Robert Kogod Goldman in memory of his brother, Ronald Kogod Goldman, RR-2018.0002

CAT. 56

SOUP PLATE FROM JOHN BROWN'S SERVICE

PROVENANCE

Made for John Brown (1736–1803), Providence, R.I.

INSCRIPTIONS

None

Gift of Wendy Cooper, RR-2018.0004

CAT. 57

JARDINIERE STAND MADE FOR JOSEPH AND REBECCA HEATH SIMS

PROVENANCE

Walker-Poinsett Antiques, Seattle, 1987; Sotheby's New York, Sale N09305, January 23, 2015, Lot 170; to the donor through purchase

INSCRIPTIONS

Inscribed in gilt letters, "WASHINGTON" and "JRS" for Joseph (1760–1851) and Rebecca Heath (1769–1830) Sims

Gift of Robert Kogod Goldman and Caroline Goldman Cassagnol in memory of their parents, Marvin J. and Ruth Kogod Goldman, RR-2018.0006

CAT. 58

ONE FROM A PAIR OF PLATTERS FROM DEWITT AND MARIA FRANKLIN CLINTON'S SERVICE

PROVENANCE

By descent in the family of John Jay; to the donor

INSCRIPTIONS

Bears the cypher of DeWitt and Maria Clinton, "DWMC," in gilt script

Gift of Mrs. Susan Mary Alsop in memory of her mother, Mrs. Peter A. Jay, RR-1975.0040.1

CAT. 59

SAUCER FROM THE BACHE FAMILY SERVICE

PROVENANCE

Associated with Richard and Sarah Franklin Bache, Philadelphia, Pa.; James Gallery, a Rahms, Pa., dealer; by unknown descent; to Matthew and Elisabeth Sharpe Antiques, Spring Hill and Conshohocken, Pa.; to the donor

INSCRIPTIONS

A label of Matthew and Elisabeth Sharpe, dealers from Conshohocken, Pennsylvania.

Gift of Robert Kogod Goldman in memory of his wife, Linda B. Goldman, RR-2016.0003

CAT. 60

PLATE DEPICTING THOMAS JEFFERSON'S MONTICELLO

PROVENANCE

Polly Latham, dealer, Boston, Mass.; to the donor through purchase

INSCRIPTIONS

None

On loan from Mr. Robert Kogod Goldman, RR-L2013.0001

CAT. 61

PLATE DEPICTING GEORGE WASHINGTON'S MOUNT VERNON

PROVENANCE

The Dietrich American Foundation to the Fine Arts Committee through purchase

INSCRIPTIONS

None

Funds bequest of Robert E. and Barbara Shipley Vogle, RR-1968.0011.31

CAT. 62

PLATE MADE FOR THE CHEW FAMILY OF PHILADELPHIA

PROVENANCE

Polly Latham, dealer, Boston, Mass.; to the donor through purchase

INSCRIPTIONS

Inscribed with gilt C in script at center of starburst; white sticker on underside reading, "Polly / 7341 / Latham," and another with "Chew family of Cliveden" in blue ballpoint ink

Gift of Caroline Goldman Cassagnol and

Robert Kogod Goldman in memory of their parents, Marvin J. and Ruth Kogod Goldman, RR-2019.0004

CAT. 63

SOUP PLATE MADE FOR STEPHEN VAN RENSSELAER III

PROVENANCE

Private collection, Los Angeles, Ca.; Polly Latham, dealer, Boston, Mass.; to the donor through purchase

INSCRIPTIONS

A gummed circular label of Polly Latham pasted to the underside of the plate, overwritten "4406" in black ink

Gift of Robert Kogod Goldman in memory of his wife, Linda B. Goldman, RR-2014.0012

CAT. 64

HOT-WATER DISH

PROVENANCE

Elinor Gordon, a Villanova, Pa., dealer; to the Fine Arts Committee through purchase

INSCRIPTIONS

A banderole inscribed "E PLURIBUS UNUM"

Funds donated by Mr. John R. Williams, RR-1971.0071

CAT. 65

PLATE FROM GABRIEL HENRY MANIGAULT'S SERVICE

PROVENANCE

From the service of the Manigault family of Charleston, S.C.

INSCRIPTIONS

Monogrammed "GHM" within a girdle inscribed with the motto "PROSPICERE QUAM ULCISCI"

Gift of Robert Kogod Goldman in memory of Ruth Kogod Goldman, RR-1994.0015

CAT. 66

ANTI-SLAVERY MEDALLION

PROVENANCE

Undocumented

INSCRIPTIONS

Impressed mark "WEDGWOOD" on verso

Gift of Mr. and Mrs. Carlyle Eubank II, RR-2009.0003

FIGURE OF BENJAMIN FRANKLIN

PROVENANCE

Ex-collection Benjamin Ginsburg of New York, N.Y.; to Christie's, New York, Sale 5412, October 15, 1983, Lot 72; to the Fine Arts Committee through purchase

INSCRIPTIONS

On plinth, inscribed "Dr. Franklin"

Funds contributed by Mrs. Lili-Charlotte Sarnoff, RR-1983.0062

PEARLWARE PITCHER

PROVENANCE

Undocumented

INSCRIPTIONS

"WT / 1795" within a wreath below the spout

Gift of Mrs. Jerauld Wright, RR-1981.0031

CREAMWARE PITCHER

PROVENANCE

Undocumented

INSCRIPTIONS

Under the spout are the initials "RF" & "PJ," probably for Richard Francis and Polly Johnson

Gift of Mrs. Lawrence G. Bell Jr. in memory of her husband, RR-1995.0008

FIGURE GROUP OF LOUIS XVI AND BENJAMIN FRANKLIN

PROVENANCE

Undocumented

INSCRIPTIONS

The right proper rear of the base is impressed "NIDERVILLER" and incised "No 70"

Gift of Mr. and Mrs. Donald F. Carpenter, in memory of Mrs. Carpenter's parents, United States Senator from Massachusetts and Mrs. Marcus A. Coolidge, RR-1982.0090

COFFEE CUP AND SAUCER FROM DOLLEY MADISON'S SERVICE

PROVENANCE

Possibly James Madison; to James and Dolley Madison; possibly to Payne Todd (Mrs. Madison's son); to Dr. and Mrs. James H. Causten (Annie Payne was Mrs. Madison's niece); to Mary Causten Kunkel (their daughter); sold in 1899 by Mrs. Kunkel at S. V. Henkels's auction house, Philadelphia; Christie's, New York, Sale 6893, October 24, 1989, Lot 244; to J. Garrison Stradling, a New York City dealer; to the Fine Arts Committee through purchase

INSCRIPTIONS

Each piece is decorated with a gold initial "M"; "EB" is stamped in iron-red stencil on the saucer; "EB" is painted in gold on the cup

Funds donated by Mrs. Elizabeth G. Schneider, RR-1989.0028.1–.2

PLATE FROM JAMES MADISON'S SERVICE

PROVENANCE

Undocumented

INSCRIPTIONS

"NAST a Paris" mark stenciled in iron red on back

Funds donated by the Folger Fund, RR-1999.0002

PLATE FROM JAMES MONROE'S DESSERT SERVICE

PROVENANCE

Descent from James Monroe's barber; C. G. Sloans & Company, Washington, D.C., September 25, 1983, Lot 2207; to the Fine Arts Committee through purchase

INSCRIPTIONS

Printed in red on reverse: "M.ture de MADAME. / Duchesse d'Angouleme / P.L. Dagoty G. Honore / a Paris"

Funds donated by the Ethyl Corporation (Mr. and Mrs. Floyd D. Gottwald Jr.), RR-1983.0058

PAIR OF VASES

PROVENANCE

Undocumented

INSCRIPTIONS

None

Gift of Israel Sack, Inc., RR-1980.0066.1–.2

VASE

PROVENANCE

By tradition, given to the Roy family "by a lady who once lived in the White House," said to have been Mrs. Hanna Van Buren; the estate of Miss Eugene Roy; auction at Melvin S. Clarke Co., Ltd., Halifax, N.S.; to United States Consul Robert S. Back; to the Fine Arts Committee through purchase

INSCRIPTIONS

"Franklin" in the portrait vignette

Funds donated by the Honorable Clifford Folger and Mrs. Folger, RR-1965.0049

PLATE FROM JOHN A. AND ISABELLA PATRICK BROWN'S SERVICE

PROVENANCE

Undocumented

INSCRIPTIONS

Apparently unmarked

Gift of Mr. Ronald S. Kane, RR-1999.0001.1–.3

TWO DECORATED PITCHERS

PROVENANCE

Undocumented

INSCRIPTIONS

None

Gifts of Mr. and Mrs. Joseph D. Shein, RR-1973.0082, RR-1973.0083

FURNITURE

ARMCHAIR

PROVENANCE

Probably owned originally by Colonel Thomas Ellison (1701–1779) of New Windsor, N.Y., or his son, Thomas Ellison Jr. (1732–1796) of New York; to Enos S. Conkling, a merchant and jeweler of Brooklyn, N.Y., in the 1850s; to Margaret Fletcher of California in the 20th century; to Israel Sack, Inc., New York; to the Fine Arts Committee through purchase

INSCRIPTIONS

"X" chiseled on the inside of the rear rail; "E

S Conkling" in black paint under the rear rail
Funds donated by Mr. and Mrs. Joseph H.
Hennage, RR-1968.0071.1

P. 226

CHAIRS

PROVENANCE
Ex-collection of Dr. William Crim; to O. A.
Kirkland, auctioneer, Crim Sale, Baltimore,
April 22, 1903, Lot 1427; ex-collection of
Mrs. Breckinridge Long of Montpelier, Md.;
to her daughter, Mrs. Arnold A. Willcox
INSCRIPTIONS
None
Gift of Mr. and Mrs. Arnold A. Willcox,
RR-1966.0105, RR-1966.0106

CAT. 78

TEA TABLE

PROVENANCE
By descent in the Wharton family of
Philadelphia to Esther Fisher Wharton; to
her grandson, William Wharton Smith of
Philadelphia; to the Fine Arts Committee
through purchase
INSCRIPTIONS
"SAGS," the initials of Sarah Anne Greene
Smith, the sister of the last owner, in red
paint on the underside of the birdcage and
on the underside of the iron brace securing
the legs
Funds donated by Dr. and Mrs. William D.
Seybold, RR-1982.0072

CAT. 79

TEA TABLE

PROVENANCE
Dr. James Hutchinson (1752–1793) of
Philadelphia, who may have inherited it
from a relative in the Howell family. In 1935,
William Hornor referenced this piece as the
"Howell-Hutchinson-Fox-Lukens" table,
when it was owned by Dr. and Mrs. George
Lukens. From their son, John Brockie Lukens
of Lafayette Hill, Pennsylvania; to the Fine
Arts Committee through purchase
INSCRIPTIONS
None
Funds donated by David and Juli Grainger,
RR-1982.0071

CAT. 80

CHAIR

PROVENANCE
By descent from John Aspinwall (1707–1774)
of New York, N.Y., and Flushing, Long
Island; to the donors, of Philadelphia
INSCRIPTIONS
"IIII" chiseled on the inside of the front rail;
a small inventory label "94/1920" on the rear
bracket of the right rear leg. A paper label
taken from the bottom of the slip seat, now
in the curator's file, reads, "Property of / Mr.
Joseph l. Phillips / Belonged to / Mr. John
Aspinwall / of Flushing, Long Island / Born
1707 Died 1774 / great grandfather of/G.
Woolsey Hodge."
Gift of Mr. and Mrs. Walter M. Phillips,
RR-1976.0064

CAT. 81

CHEST-ON-CHEST

PROVENANCE
By tradition, descended in the Van
Rensselaer family of Albany, N.Y.; to
Ginsburg & Levy, Inc., New York; to the
donors of Williamsburg, Va.
INSCRIPTIONS
The six small drawers in the secretary drawer
marked "1" through "6" in white chalk,
from left to right on the underside of each
drawer bottom; drawer "6" also has a small
pencil inscription on the inside of the drawer
bottom: "Q V/P"
Gift of Mr. and Mrs. Joseph H. Hennage,
RR-1986.0051

CAT. 82

HIGH CHEST OF DRAWERS

PROVENANCE
Acquired by the noted Providence collector
Charles L. Pendleton (1846–1904); sold in
1905 to G. C. Ernst of Norwalk, Conn.;
offered at auction at the American Art
Galleries, New York, January 20–23, 1926,
Lot 848, but did not sell; offered by Ernst's
widow, Juliet Wyman Ernst, at Parke-Bernet
Galleries, New York, January 11–13, 1945,
Lot 610; to Maurice Rubin; to O'Reilly's
Plaza Art Galleries, New York, December
8, 1951, Lot 421; to W. Colston Leigh,
a Basking Ridge, N.J., dealer; to James
Campbell Lewis of Cornish, N.H.; at 1971
auction of the Lewis estate; to James L.

Britton of Dallas, Tex.
INSCRIPTIONS
Inside back of upper case in chalk, "Piscatqua
/ Taply / Capt Lible [or Libbe] house";
outside back of upper case, "Colston Leigh";
"#PR 18" scratched into the top of the lower
case and the outside of the upper case
Gift of Mr. and Mrs. James L. Britton,
RR-1974.0068

CAT. 83

DESK AND BOOKCASE

PROVENANCE
Undocumented
INSCRIPTIONS
All in pencil in the same hand, "Do [John]
Sprage Benj. Frothingham" on the rear
surface of the back of the upper drawer of
the lower case ("Do" is an archaic form of
"Dr."); "Benj. Frothingham" on the bottoms
of two upper left desk interior drawers; "Do
[John] Sprage 1753" on the side of the inner
left secret document drawer; "BF 1753" on
the side of the inner left secret document
drawer; "BF 1753" on the bottom of the
upper left letter drawer; "TN jr" on the back
of the upper left letter drawer; box on back
of the prospect door. All in similar black
paint, "Dr H F Spee {r} New York Harlem
RR (New York and Harlem Railroad)" on
the back panels of the upper case; "Dr. H F
Speer New York" on the back panels of the
lower case; "Car 1534, Sept 19, l863" on the
top of the lower case (Dr. Speer's identity is
unknown). "59471" stamped in ink on the
top of the lower case; "2332" in chalk on the
back panel of the upper case; "82" in black
crayon on the back panel of the upper case.
"1753" is scratched twice into the top board
of the lower case.
Gift of Mr. Dana C. Ackerly and Mr. Earle
S. Thompson, estate executors, in memory
of Mrs. Bell McKerlie Watts and Mr. Samuel
Hughes Watts of Fairfield, Connecticut,
RR-1970.0094

CAT. 84

CHEST OF DRAWERS

PROVENANCE
Ebenezer Storer Jr. of Boston; purchased
from an unknown source in the 1930s by
Mrs. John E. Livingood; by descent to Mrs.
John W. (Elsa L.) Bowman of Wyomissing,

Penn.; to Parke-Bernet Galleries, New York, Sale 2918, October 25, 1969, Lot 124; to the Fine Arts Committee through purchase

INSCRIPTIONS

In chalk on the underside of the bottom board, "Bottom"; engraved silver plaque mounted to the upper left side reading, "Ebenezer Storer 1730–1807"

Funds donated by the Honorable C. Douglas Dillon and Mrs. Dillon, RR-1969.0103

CAT. 85

BUREAU TABLE

PROVENANCE

By descent through the Watts family of Newport; to Christie's, New York, Fine Americana Sale, October 21, 1978, Lot 296; to the Fine Arts Committee through purchase

INSCRIPTIONS

In graphite, on underside of drawer divider (second up from bottom) lower right facing: "Thomas Townsend of Newport Son of Job Townsend / Deceased of Newport" in script

Funds donated by the Pew Memorial Trust, RR-1978.0067

CAT. 86

DESK

PROVENANCE

Presumably by descent to Robert Y. Townsend (1827–1878) and Emily M. Cleland (1842–1875, married 1865); to Israel Sack, Inc., New York; to Stanley Sax of Birmingham, Mich., by 1975

INSCRIPTIONS

Handwritten paper label inside the top drawer reading, "Made by / John Townsend / Rhode Island / 1765"

Gift of Mr. and Mrs. Stanley Paul Sax, RR-1976.0063

CAT. 87

CHEST-ON-CHEST

PROVENANCE

The Honorable John Stevens (1716–1792) of New York City and Perth Amboy, N.J.; by descent to the donor, of Bernardsville, N.J.

INSCRIPTIONS

"Donely," "Give my Complements to Peter. . . . ," "John L[?] . . . ," and other chalk scrawls on the outside bottom of the middle drawer in the base

Gift of Mrs. Mary Stevens Baird, RR-1983.0036

CAT. 88

HIGH CHEST OF DRAWERS

PROVENANCE

Sotheby Parke-Bernet, New York, sale 4211, January 31, February 1–3, 1979, Lot 1283; to the Fine Arts Committee through purchase

INSCRIPTIONS

In chalk across the middle board of the upper section: "John" (?); also, in pencil, script letters "A" and "B" inside the bottoms of the small drawers on either side of the lower case

Funds donated by the Rockwell International Corporation, RR-1979.0009

CAT. 89

DRESSING TABLE

PROVENANCE

Said to have been owned by Stephen Hopkins (1707–1785); to William Randolph Hearst; to Ginsburg & Levy, Inc., New York, in the 1930s; to a Mr. Rickettson of New Bedford, Mass.; to Ginsburg & Levy, Inc., New York; to the Fine Arts Committee through purchase

INSCRIPTIONS

Stephen Hopkins, Providence, Rhode Island; by descent in his family; sold to William W. Tapley, Springfield, Massachusetts; sold to Hyman Kaufman, Boston; consigned to American Art Association Anderson Galleries, Inc., New York, April 12–14, lot 445; sold to William Randolph Hearst, New York; consigned to Parke-Bernet Galleries, Inc., New York, November 17–19, 1938, lot 538; Ginsburg & Levy, New York, 1967; sold to the Diplomatic Reception Rooms, U.S. Department of State, Washington, D.C., 1967

Funds donated by Mrs. Richard Bethell Wilder, RR-1967.0027

CAT. 90

BASE OF A HIGH CHEST OF DRAWERS

PROVENANCE

This piece is credited to the estate of James Curran, a Philadelphia antiques dealer, an estate auctioned in March 1940, when the base was apparently acquired by the Philadelphia office of the advertising agency N. W. Ayer, headquartered in the

18th-century Morris House. The Ayer Collection of antique furniture was dispersed in the 1960s, when Henry A. Batten, chairman of the board, acquired this piece.

INSCRIPTIONS

A remnant of an 18th-century ink inscription on the top board of the case, containing the words "venered" and "Januy"

Gift of Mrs. Henry A. Batten, RR-1980.0054

CAT. 91

SLAB TABLE

PROVENANCE

By descent to Mrs. Paul T. Haskell of Marblehead, Mass.; to the Fine Arts Committee through purchase

INSCRIPTIONS

Chalk columns of figures on the inside of the back rail

Funds donated by Miss Louise Ines Doyle, RR-1981.0033

CAT. 92

CARD TABLE

PROVENANCE

By descent in the Varick family of New York, N.Y.; to Israel Sack, Inc., New York; to the Fine Arts Committee through purchase

INSCRIPTIONS

Some illegible chalk inscriptions on one drawer runner

Funds donated by the Dorothy Jordan Chadwick Fund, RR-1975.0025

CAT. 93

CHAIRS

PROVENANCE

Matthew S. Marsh (1773–1814); by descent in the Williams and Denison families of Stonington, Conn.; to Esther N. Breed (1905–1987) of Garden City, N.Y.; to her son, Ebenezer Breed; to Sotheby's, New York, Sale 5968, January 24–27, 1990, Lot 1106 (not sold); to the Fine Arts Committee through purchase

INSCRIPTIONS

Acc. no. RR-1973.46.1: Branded on the bottom of the rear seat rail, "M.S. MARSH."; Acc. no. RR-1973.46.2: "X" inscribed on shoe and splat

Funds donated by Mr. and Mrs. Kenneth R. Giddens, in honor of Clement E. Conger, RR-1973.0046.1–.2

CHINA TABLE

PROVENANCE

John S. Walton, Inc., New York; to the donors in 1959

INSCRIPTIONS

"This table belongs to Mary Anderson [?] Poore of . . . [?] Greenwood [or Greenland], Maine" in pencil on paper pasted to underside of top

Gift of Rear Admiral Edward P. Moore and Mrs. Moore, RR-1966.0100

CHINA TABLE

PROVENANCE

Ex-collection Louis Guerineau Myers of New York, a major early 20th-century collector of American furniture; to American Art Galleries, Myers Sale, February 24–26, 1921, Lot 669; Ginsburg & Levy, Inc., New York; to the donors, of Williamsburg, Va.

INSCRIPTIONS

None

Gift of Mr. and Mrs. Joseph H. Hennage, RR-1971.0157

CHINA TABLE WITH EARTHENWARE TRAY

PROVENANCE

Owned in the late 19th century by Augustus Flagg (1818–1903) of Boston and Worcester, Mass.; by descent in the Flagg family; to Robert W. Skinner, Inc., Bolton, Mass., Sale 1126, Jan. 2, 1987, Lot 184; to the Fine Arts Committee through purchase

INSCRIPTIONS

None

Funds donated by Eugene B. Casey Foundation in memory of Eugene B. Casey, RR-1987.0002

FRENCH CHAIRS (ARMCHAIRS)

PROVENANCE

When John and Ann Penn returned to England in 1771, this pair of chairs, and other furniture they owned, were acquired by John Morton (b. 1738) of Philadelphia, who had married Esther Deshler in 1770. The furniture

descended to Morton's daughter, Esther Morton Smith; to her son, Benjamin R. Smith, who married Esther Fisher Wharton; to their daughter, Esther Morton Smith (d. 1942); to her nephew, William Wharton Smith; to the Fine Arts Committee through purchase

INSCRIPTIONS

None

Funds donated by the Claneil Foundation (Mr. and Mrs. Henry S. McNeil), RR-1976.0020.1–.2

SOFA

PROVENANCE

Purchased by the Fine Arts Committee from Deborah Wharton Smith Lutman, a direct descendant of Charles Wharton (1743–1838) and Samuel Rowland Fisher (1745–1834), prominent Philadelphia merchants. A pair of similar sofas that belonged to her father, Edward Wanton Smith, was described by Hornor [William McPherson Hornor, Jr.] as "from the Charles Wharton House." It is unlikely that Charles Wharton owned as many as three sofas; the one in the Diplomatic Reception Rooms may have descended from the Fisher family. The Department of State also owns a pair of side chairs (acc. no. RR-1982.0073) and tea table (acc. no. RR-1982.0072) that descended to the previous owner's brother and sister, William Wharton Smith and Sarah Anne Green Smith.

INSCRIPTIONS

None

Funds donated by the Honorable John McCone and Mrs. McCone, RR-1976.0001

TALL CASE CLOCK

PROVENANCE

Originally made for Ludwig Prahl (d. 1809; active 1776–1809) of Philadelphia; purchased in Boston by the Mechanicsburg, Pa., dealer Edward LaFond about 1985; to F. J. Carey III, a Philadelphia dealer; to the Fine Arts Committee through purchase

INSCRIPTIONS

In addition to calendar, celestial, and zodiacal calibrations in the four spandrels and arched top of the dial, "Bourghelle Philadelphia" engraved at the bottom of the chapter ring;

"I Poupard Sculpt." engraved on the moon dial; and "Ludwig Prahl" engraved on a plate above the center of the dial

Funds donated by Mr. and Mrs. Floyd D. Gottwald Jr., RR-1983.0067

CHAIRS

PROVENANCE

By descent from Francis Scott Key (1779–1843). The chairs' paper labels show this set's descent. Jane Frances Hunt Pendleton (Mrs. Arthur Tilghman Brice, 1860–1950) was a daughter of Alice Key (Mrs. George Hunt Pendleton, 1824–1886), the second youngest of the eleven children of Francis Scott Key and his wife, Mary Tayloe Lloyd. At least two of the chairs passed to Jane F. Brice's daughter, Julie (Mrs. Herman B. Chubb, 1896–1953), before becoming the property of Mrs. Chubb's sister, Alice K. P. Brice (Mrs. John F. Joline, 1893–ca. 1975). Two other chairs were owned by their brother, Colonel Arthur Tilghman Brice Jr. (1892–ca. 1973). The remaining two chairs (RR-1973.0002.1–.2) belonged to Mrs. Chubb's daughters, Julia Frances and Sarah Jane (Mrs. Stephen Gummersall and Mrs. Raymond Cox, respectively). It is likely, then, that the first owners of the chairs were Francis Scott Key's parents, John Ross Key (1734–1821) and Ann Phoebe Charlton (1756–1830) of Frederick County, Md., who married in 1775. To the Fine Arts Committee through purchase

INSCRIPTIONS

Inscribed on paper, "Belonged to / Francis S. Key / my grandfather / Jane F. Brice."

Funds given by an anonymous donor, RR-1972.0062.2

SECRETARY AND BOOKCASE

PROVENANCE

Undocumented

INSCRIPTIONS

"[IZ] Segal D.C." in pencil on the top of the desk, under the bookcase; "[IZ] Segal 1969" in red on the underside of the desktop

RR-2002.0003

SIDEBOARD

PROVENANCE

Israel Sack, Inc., New York; to the donors of
Ardsley, N. Y.

INSCRIPTIONS

"L37.12.1" on modern paper label
Gift of Mr. and Mrs. Mitchell Taradash,
RR-1967.0007

SECRETARY WITH PRESS

PROVENANCE

The estate of a Maryland collector; to F. J.
Carey III, a Pennsylvania antiques dealer; to
the Fine Arts Committee through purchase

INSCRIPTIONS

None

Funds bequest of Mr. Robert E. and Mrs.
Barbara Shipley Vogle in memory of her
parents, H. Dorsey Shipley and Bessie Rhine
Shipley, RR-1988.0016

DRESSING CHEST
WITH GLASS

PROVENANCE

Ex-collection of Mr. and Mrs. Norvin H.
Green; probably sold at Parke-Bernet, New
York, Sale 1202, November 29–December
1, 1950; to Mr. and Mrs. John McCracken
of New York City; to Mr. and Mrs. Edward
Vason Jones of Albany, Georgia; to the Fine
Arts Committee through purchase

INSCRIPTIONS

In the shape of a standing cheval glass, in
the top right drawer of the bureau, a paper
printed "Hre Lannuier / Cabinet Maker
from Paris / Kips is Whare House of / new
fashion fourniture / Broad Street, No 60.
/ New-York. / Hre Lannuier, / Ebeniste
de Paris, / Tient Fabrique & / Magasin de
Meubles / les plus a la Mode, /New-York"
Funds donated by the J. S. Johnson and
Barbara P. Johnson Fund, RR-1980.0103

WORKS ON PAPER

PENN'S TREATY WITH
THE INDIANS

PROVENANCE

Louis Wine, Ltd., to the Fine Arts Committee
through purchase

INSCRIPTIONS

None

Funds donated by Mrs. Benjamin C. Russell
in memory of Benjamin Commander
Russell, RR-1975.0042

ACROSS THE CONTINENT.
"WESTWARD THE COURSE OF
EMPIRE TAKES ITS WAY."

PROVENANCE

Undocumented

INSCRIPTIONS

Train marked, "THROUGH LINE / NEW
YORK / SAN FRANCISCO"
Gift of Elizabeth Hay Bechtel,
RR-1971.0156

DECLARATION OF
INDEPENDENCE

PROVENANCE

Undocumented

INSCRIPTIONS

None

On loan from David M. Rubenstein,
RR-L2010.0018

TWENTY-DOLLAR BILL OF
CONTINENTAL CURRENCY

PROVENANCE

Undocumented

INSCRIPTIONS

With signatures "J.Gray" and "Jno. Nelson"
Gift of Dr. Robert W. McDermott,
RR-1971.0006.3

SOCIETY OF THE CINCINNATI
MEMBERSHIP DIPLOMA

PROVENANCE

Knoedler Galleries

INSCRIPTIONS

Signatures signed in iron gall ink
Gift of Mr. and Mrs. R. Y. Mottahedeh,
RR-1966.0027

AMERICAE NOVA TABULA

PROVENANCE

Undocumented

INSCRIPTIONS

None

Gift of Mr. Thomas J. O'Donnell,
RR-2006.0008

SILHOUETTE OF GEORGE
WASHINGTON

PROVENANCE

Ex-collection of Emerson Greenaway;
Jane Sampson to the Fine Arts Committee
through purchase

INSCRIPTIONS

Under Washington's arms are the letters
"SF." At the bottom of the silhouette is the
caption "Washington" in a floriated script.
Funds donated in memory of Mr. Thomas
Edward Garrard by his wife, Allece,
RR-1993.0013

PORTRAITS OF HUGH AND
ELIZA KINLOCH NELSON

PROVENANCE

Undocumented

INSCRIPTIONS

None

Gift bequest of Mrs. Thomas Gordon
Greene, RR-2003.0002, RR-2003.0003

BENJAMIN FRANKLIN

PROVENANCE

In the collection of the artist; to Nicholas
Nikitich Demidov (d. 1828), of Paris,
before 1805; to his son, Paul (d. 1840), of
San Donato, Italy; to his brother Anatole
(d. 1870), of San Donato, Italy; to F. Petit,
Demidov Sale, Pt. IV, Paris, 1870, Lot 397;
to James Lawrence, of Boston; to his widow,
Anna Lothrop Lawrence (later Mrs. Thomas
Lindall Winthrop; d. 1923); to her son, James
Lawrence; to his son, James Lawrence Jr., of

Boston; to the Franklin Mint Corporation, Franklin Center, Pennsylvania

INSCRIPTIONS

On the label attached to the reverse, "This Portrait of / Benjamin Franklin / by Greuze / Was bought in Paris / at the San Donato / Sale of Prince Demidoff [*sic*] / by Mr. James Lawrence / in 1870 / Given to his Grandson / James Lawrence / by Anna Lothrop Winthrop / May 7th, 1923-"

Funds donated by the Franklin Mint Corporation, RR-1973.0006

CAT. 112

GREAT AMERICAN COCK MALE—VULGO

PROVENANCE

Sotheby Parke-Bernet, Inc., to the Fine Arts Committee through purchase

INSCRIPTIONS

Inscribed "engraved by W.H. Lizars, Ednr.; colored by R. Havell, Senr."

Funds donated by the Williams Family Foundation of Georgia, RR-1988.0006

CAT. 113

THE BLOODY MASSACRE

PROVENANCE

By descent in the family of James Caldwell, one of the victims pictured and named in the engraving; to his great-great-granddaughter, Maria Caldwell; to her daughter; to her son, the donor, of Westpoint, Massachusetts, in 1941

INSCRIPTIONS

In the plate within the image, "Engrav'd Printed & Sold by PAUL REVERE BOSTON."

Gift of Mr. William H. Coburn, RR-1976.0075

CAT. 114

H.M.S. *SHANNON* LEADING HER PRIZE THE AMERICAN FRIGATE *CHESAPEAKE*

PROVENANCE

Undocumented

INSCRIPTIONS

Signed in plate: "Painted by J. C. Schetky, Esqre., & on stone by L. Haghe. Designed by Captn. R. H. King, R.N. London: Pubd. by Smith, Elder Co., 65 Cornhill"

Gift of Mr. Arthur G. Altschul, RR-1978.0058.4

CAT. 115

LETTER FROM MARQUIS DE LAFAYETTE TO MISS BALDWIN

PROVENANCE

Walter R. Benjamin Autographs, New York, to the Fine Arts Committee through purchase

INSCRIPTIONS

None

Funds donated by Mr. and Mrs. Joel Barlow, RR-1971.0163

CAT. 116

LAND GRANT

PROVENANCE

Undocumented

INSCRIPTIONS

Signed: Wm Penn

Gift of Mrs. Margaret D. Hicks, RR-1983.0020.1

CAT. 117

VUE DE PHILADELPHIE

PROVENANCE

Undocumented

INSCRIPTIONS

In both German and French: "The old Capital of Pa., North America. William Penn to whom Charles II, the King of England the entire charter in 1682 between two navigable rivers called Philadelphia because its citizens lived in brotherly love."

Gift of Mrs. Mildred R. Mottahedeh, RR-1981.0026

CAT. 118

SILHOUETTE COLLAGE

PROVENANCE

Undocumented

INSCRIPTIONS

None

Gift of Mr. and Mrs. James O. Keene, RR-1973.0109

CAT. 119

DESIGN FOR A HANDKERCHIEF

PROVENANCE

Undocumented

INSCRIPTIONS

Inscribed "Gen Washington directing to restore to Justice the Sword which gained

Independence to America." Marks: Talwin and Foster Bromley Hall, Midd.

Gift of Mrs. John Jay Ide, RR-1972.0025

CAT. 120

A BLACKFOOT INDIAN ON HORSEBACK (VIGNETTE 19)

PROVENANCE

Undocumented

INSCRIPTIONS

No blind stamp

Gift of Mrs. Frances R. Dittmer, RR-1984.0035

CAT. 121

BLACKFEET [ACROSS THE PLAINS]

PROVENANCE

The artist; to General John A. Johnson; to the donor by descent

INSCRIPTIONS

Signed and dated "CMRussell 1905" and inscribed with the artist's skull device at lower left; above that, inscribed in pencil by another hand, "Copyrighted by."

Gift of Mrs. Francis O. Wilcox in memory of her husband, Francis O. Wilcox, RR-1987.0022

CAT. 122

ASEOLA, A SEMINOLE LEADER

PROVENANCE

Undocumented

INSCRIPTIONS

None

Gift of Mr. and Mrs. John L. Sanders in honor of James Baxter Hunt, Jr., Governor of North Carolina, 1977–1985, and Mrs. Hunt., RR-1984.0017

CAT. 123

THE POWER OF MUSIC

PROVENANCE

Undocumented

INSCRIPTIONS

None

Gift of Mr. Stephen Neal Dennis, RR-1994.0018

A MIDNIGHT RACE ON THE MISSISSIPPI

PROVENANCE
Old Print Shop to the Fine Arts Committee through purchase
INSCRIPTIONS
None
Funds donated by an anonymous donor, RR-1978.0068

BUTTERFLY

PROVENANCE
Undocumented
INSCRIPTIONS
Signed and dated by the artist, lower right, "Albert Bierstadt 16/96"
Gift of Mrs. Deen Day Sanders, RR-2008.0006

THE HOLLEY FARM

PROVENANCE
The artist, 1902; by gift to Mr. J. Alden Weir, Branchville, Connecticut, and New York, New York; by descent in family to private collection, until 1979; to sale, C. G. Sloan & Company, Washington, D.C., February 18, 1979, no. 1849, illustrated; to the Diplomatic Reception Rooms
INSCRIPTIONS
Signed and dated "Childe Hassam 1902" at lower left
Funds donated by the Ruth and Vernon Taylor Foundation, RR-1979.0011

SILVER & OTHER METALS

TEAPOT

PROVENANCE
By descent in the Bayard-Henley-Smith-Warwick family; to the donors
INSCRIPTIONS
Engraved Bayard coat of arms in an asymmetrical cartouche on one side. Marks: In block letters within a rectangular reserve, struck twice, once on either side of the scrolled leaf mark on the bottom, "PS"; and scratched in, "oz 2 wt 18-11"
Gift of Miss Alice Harrison Warwick, Mr.

John Edward Warwick, and Mrs. Virginia Henley Ameche in memory of their mother, Mrs. Alice Harrison-Smith Warwick, RR-1966.0097.1

TANKARD

PROVENANCE
Undocumented
INSCRIPTIONS
In block letters on the handle, "FWM"; in old script on the shield terminus of the handle, "W*C"; in small, later script on the front, "BWCC / to / LHC." Marks: In block letters above a cross within a heart-shaped reserve near the rim to the left of the handle, on the cover between the thumbpiece and finial, and on the pin of the finial, "SV"
Gift of Mrs. Thomas Pierrepont Hazard and the Honorable Elliot Lee Richardson and Mrs. Richardson in memory of Mr. Thomas Pierrepont Hazard, RR-1970.0096

GEORGE WASHINGTON'S WINE COOLER

PROVENANCE
Northeast Auction, August 20–21, 1994, lot 476
INSCRIPTIONS
"Presented by Washington at the expiration of his Presidency to T. Pickering, Secretary of State of the United States"
Funds donated by Mrs. Frank L. Wright in memory of her husband, RR-1994.0014

COFFEEPOT

PROVENANCE
By descent in the Bayard-Henley-Smith-Warwick family; to the donors
INSCRIPTIONS
In large script initials with flourishes, within an asymmetrical cartouche on one side, "MR." Marks: In block capitals within a scalloped rectangular reserve, struck once on each side of the center point on the bottom, "B:WOODCOCK"
Gift of Miss Alice Harrison Warwick, Mr. John Edward Warwick, and Mrs. Virginia Henley Ameche in memory of their mother, Mrs. Alice Harrison-Smith Warwick., RR-1966.0097.2

JAMES MONROE'S COFFEE URN

PROVENANCE
Undocumented
INSCRIPTIONS
In the shield on the front in script: "EJH"; on the side in script and block letters, "Presented by. / JAMES MUNROE. [*sic*] / to Cap[t] Edward Howe, / of the American Ship, / Augustus, of BOSTON. / 1808." Apparently unmarked
Funds donated by the Wunsch Americana Foundation, RR-1971.0142

COFFEEPOT

PROVENANCE
Originally owned by President and Mrs. John Adams; ex-collection Mark Bortman
INSCRIPTIONS
In script within a circular reserve on both sides, "JAA" for John and Abigail (Smith) Adams. Marks: In block letters within a reserve on the shoulder near the rim to the left of the handle, "NA"
Gift of Mrs. Joel Larus in memory of her father, Mark Bortman, who served as a member of the Fine Arts Committee from November 1964 to May 1967, RR-1971.0124.2

MUSICAL TALL CASE CLOCK

PROVENANCE
According to tradition, made by Thomas Harland's apprentice, Benjamin Hanks, for his father, Uriah Hanks (1736–1809) of Mansfield, Conn.; to Uriah's youngest son, Rodney Hanks (1782–1846), also of Mansfield; to his first son, Frederick Freeman Hanks (b. 1805); to his son, Edward Page Hanks of Jersey City, N.J.; to his grandson, the donor
INSCRIPTIONS
None
Gift of Mr. Frederick L. Hanks, RR-1963.0010

PAIR OF ANDIRONS

PROVENANCE

Ginsburg & Levy, Inc., New York; to the Fine Arts Committee through purchase

INSCRIPTIONS

None

Funds donated by Miss Henrietta E. Bachman, RR-1974.0090.1–.2

CAT. 135

SET OF FIVE CAMP CUPS

PROVENANCE

By descent from Major Winthrop Sargent; to the donor. Probable descent through the children of Sargent's first cousin, John Turner Sargent (1769–1813): Howard Sargent (1810–1872) and his wife, Charlotte Cunningham (1818–1888); to their daughter Mary Sarah Sargent (1844–1908) and her husband, Arthur Malcolm Thomas (1844–1879); to their daughter, Elizabeth Whitwell Thomas (b. 1868) and her husband, Frederick Josiah Bradlee; to their son, the donor, Sargent Bradlee (1898–1987)

INSCRIPTIONS

In script on the front of each cup, "WS"; in script on the bottom of acc. no. RR-1978.0080.2 "from / Camp Chest of / Major Winthrop Sargent / U.S.A. / 1776–1785." Marks: In block letters within a small rectangle, struck twice on the underside of each cup, "J.A"

Gift of Mr. Sargent Bradlee, RR-1978.0080.1–.5

CAT. 136

TEAPOT AND STAND

PROVENANCE

Moses Michael Hays (1739–1805), married Rachel Myers (1738–1810), sister of Myer Myers; purchased for their daughter, Judith Hays Myers (1767–1844), who married Samuel Myers (1755–1836) and moved to Richmond, Va.; Samuel Hays Myers (1799–1849), son; Edmund Trowbridge Dana Myers (1830–1905), son; Edmund Trowbridge Dana Myers Jr. (1862–1934), son; Anne Hays Myers (b. 1895), daughter; thence by descent to the donor

INSCRIPTIONS

Both engraved "JH" (script) for Judith Hays and Samuel Myers's marriage in 1796.

Marks: Marked on base of teapot and stand with Revere mark "d"

Funds donated in honor of Gail F. Serfaty, director of the Diplomatic Reception Rooms from 1995 to 2007, and by the Friends of the Diplomatic Reception Rooms, RR-1991.0035.1–.2

CAT. 137

SEVEN-PIECE COFFEE AND TEA SERVICE

PROVENANCE

Engraved for Cornelius and Catherine (Baker) Comegys of Philadelphia and Chestertown, Md., probably on the occasion of their marriage in 1794; David Stockwell, Inc., Wilmington, Del.; to the Fine Arts Committee through purchase

INSCRIPTIONS

In script with flourishes in a bright-cut shield on the side or front of each piece, "CC." Marks: "I.LT" in block letters within a rectangular reserve; struck twice on the bottom of the coffeepot and once on the sugar bowl, "I.LETELIER"; once in the same manner on all other pieces except the cream pot, which is marked on the outside of the plinth "I.LT"

Funds donated by Mrs. Wiley T. Buchanan, Jr., in memory of the Honorable Wiley T. Buchanan Jr., RR-1982.0038.1–.7

CAT. 138

INDIAN TRADE PEACE MEDAL

PROVENANCE

Ex-collection Mark Bortman

INSCRIPTIONS

In block letters on the obverse, "GEORGE WASHINGTON / PRESIDENT 1793"; in block letters engraved in a banner on the reverse, "E. PLURIBUS / UNUM." Marks: In block letters within a square reserve struck at the lower end of the obverse, "JR"

Gift of Mrs. Mark Bortman in memory of her husband, RR-1967.0037

CAT. 139

CONSULAR SEAL

PROVENANCE

Robert Holden, Ltd., of London; to the Fine Arts Committee through purchase

INSCRIPTIONS

In deep intaglio carving, all in mirror image,

"CONSULAR·SEAL·OF·THE·UNITED· STATES·OF·AMERICA / E PLURIBUS UNUM." Marks: "PB/WB" in block letters within a small rectangle with a leopard head, a lion rampant, and the date letter N for 1808–9 on the back of the seal

Funds donated by Mr. and Mrs. Phillip Park Robertson, RR-1983.0017

CAT. 140

SOCIETY OF THE CINCINNATI BADGE AND RIBBON

PROVENANCE

Timothy Pickering (1745–1829) by unknown descent; Northeast Auction, August 20–21, 1994, lot 477; to the Fine Arts Committee through purchase

INSCRIPTIONS

"VIRT__AEM- SOCI- CIN- RUM- INST A.D. 1783"; on reverse, "OMNIA- RELINQT- SERVARE- REMPB"

Funds donated by Mr. and Mrs. Richard A. Milburn, RR-1994.0013

CAT. 141

SKIPPET

PROVENANCE

Purchased in Argentina by Col. Frederic Harrison Smith III; to the Fine Arts Committee through purchase

INSCRIPTIONS

In banner in block letters, "E PLURIBUS UNUM." Apparently unmarked

Funds donated by the Honorable Ronald S. Lauder and Mrs. Lauder, RR-1980.0013

CAT. 142

REPOUSSÉ WATER PITCHER

PROVENANCE

Undocumented

INSCRIPTIONS

Marks: "SK" in block letters within a square reserve on the outside edge of the foot; "11/12" incuse near maker's mark on the outside edge of the foot and struck incompletely a second time nearby

Gift of Mrs. Charles W. Bunker, RR-1978.0074

PAIR OF GOBLETS

PROVENANCE

Undocumented

INSCRIPTIONS

In block letters within a rectangular reserve,
inside the bottom of each, "W & H"
Gift of Mr. Philip H. Hammerslough,
RR-1970.0086.1–.2

BRONZE MEDALLION
OF HENRY CLAY

PROVENANCE

Undocumented

INSCRIPTIONS

Reverse bears inscription within a very ornate
wreath of cotton and corn: "SENATE / 1806.
/ SPEAKER 1811. / WAR OF 1812 WITH
G. BRITAIN / GHENT 1814. / SPANISH
AMERICA 1818–1822. / MISSOURI
COMPROMISE 1821. / AMERICAN SYSTEM
1824. / GREECE 1824. / SECRETARY OF
STATE 1825. / PANAMA INSTRUCTIONS
1826 / TARIFF COMPROMISE / 1833 /
PUBLIC DOMAIN 1833–1841. / PEACE
WITH FRANCE / PRESERVED 1835. /
COMPROMISE / 1850." Obverse, below
bust, at left: "T.D.JONES. DEL."; obverse,
below bust, at lower right: "C.C.WRIGHT.
FECIT."; reverse, below design, at left: "WM.
WALCUTT"
Gift of William Adair, RR-2013.0002

ASSEMBLED SIX-PIECE TEA
AND COFFEE SERVICE

PROVENANCE

Gift of Attorney General Benjamin Franklin
Butler (1795–1858) to his sister Cornelia
Hannah Van Alen (1814–1892)

INSCRIPTIONS

Waste bowl, diminutive hot-water pitcher, and
coffeepot inscribed "Jan. 11, 1857" on one
side and "C.H.V.A. / From / B.F.B." (Cornelia
Hannah Van Alen from Benjamin Franklin
Butler) on the opposite side. Sugar bowl and
teapot inscribed "CHB" (Cornelia Hannah
Butler) on one side in conjoined script
Gift of Paul Guarner in memory of his
mother, Helen Riedlinger Guarner (1905–
2000), RR-2017.0010.1–.6

AFTERWORD

DECLARATION OF
INDEPENDENCE

PROVENANCE

Thomas Swann Sr., governor of Maryland,
willed this painting to his son in 1837. It
hung at Morven Park, Leesburg, Va., until
1946, when it was acquired by Mrs. Francis
Allen Jaeger. Mrs. Jaeger to the Fine Arts
Committee through purchase

INSCRIPTIONS

None
Funds donated by Mrs. J. Clifford Folger,
RR-1965.0010

JOHN HANCOCK

PROVENANCE

Knoedler Galleries

INSCRIPTIONS

Signed by the artist
Gift of Funds by Mrs. Orme Wilson
in memory of The Honorable Orme
Wilson (1885–1966), Diplomatic Officer
1920–24, Foreign Service Officer 1924–46,
RR-1964.0033

ON THE JACKET

ONE FROM A PAIR OF VASES

PROVENANCE

According to tradition, brought to America
by Lafayette on his second tour and presented
to the Comstock family of Washington,
D.C.; by descent to Misses Eliza and Clara
Comstock; Arpad Antiques, Washington,
D.C., in 1966; to the Fine Arts Committee
through purchase

INSCRIPTIONS

Incised in gold, "12" and inscribed in gold,
"'deroche Vasginton."
Funds donated by Mr. and Mrs. Frederick M.
Lange in honor of former Ambassador and
Mrs. George C. McGhee, RR-1971.0118.2

ENDPAPERS

LES PAYSAGES DE TÉLÉMAQUE

PROVENANCE

Ex-collection of the donor

INSCRIPTIONS

None
Gift of Mrs. Eugene B. Casey,
RR-2011.0012

*For further information about works in the
Diplomatic Reception Rooms collection, please
see the website, www.diplomaticrooms.state.gov,
which is searchable by accession number.*

NOTES

THE AMERICANA PROJECT

1 "Timeline," *The Sixties: The Years That Shaped a Generation*, PBS, https://www.pbs.org/opb/thesixties/timeline/timeline_text.html.

2 From Robert Frost, "Dedication"; see http://archive.boston.com/bostonglobe/editorial_opinion/blogs/the_angle/2011/01/frost_at_kenned.html. Glare from sunlight reflecting off the snow prevented him from reading the poem, which he had written for Kennedy's inauguration; instead, he recited from memory his poem "The Gift Outright."

3 J. B. West with Mary Lynn Kotz, *Upstairs at the White House* (New York: Coward, McCann & Geoghegan, 1973), 200.

4 Christopher Anderson, *Jack and Jackie: Portrait of an American Marriage* (New York: William Morrow, 1996), 243.

5 Betty C. Monkman, *The White House: Its Historic Furnishings and First Families* (New York: Abbeville, 2000), 234.

6 Clement E. Conger, "The Diplomatic Reception Rooms, United States Department of State: Introduction," *Magazine Antiques* 132, no. 1 (July 1987): 120.

7 Robert C. Williams and James H. Lide, "Diplomatic Reception in America: Private Interiors in Public Service," in Clement E. Conger et al., *Treasures of State: Fine and Decorative Arts in the Diplomatic Reception Rooms of the U.S. Department of State* (New York: Harry N. Abrams, 1991), 50.

8 Paul Goldberger, "Allan Greenberg's Rooms in the Department of State," *Magazine Antiques* 132, no. 1 (July 1987): 133.

9 Ironically, in spite of Conger's and Kennedy's parallel pursuits of restoration, when Pat and Richard Nixon engaged Conger as curator of the White House, he proceeded to undo much of what Jackie had done, finding her aesthetic too French.

10 Clement E. Conger, "The Story of the Collection: Gifts to the Nation," in Conger et al., *Treasures of State*, 36.

11 Sarah Booth Conroy, "The Artful Conger," *Washington Post*, March 16, 1984.

12 There are some exceptions. The elevator hall, the first area seen by visitors, was renamed the Edward Vason Jones Memorial Hall, in memory of the Rooms' first architect. Benjamin Franklin, the father of American diplomacy, is the namesake of the grand State Dining Room. Two rooms are named for First Ladies, and the Walter Thurston Gentlemen's Lounge, which celebrates the country's westward expansion, honors a diplomat who served in Central and South America.

13 Email to Carolyn Vaughan, August 13, 2022.

14 "Becoming a Nation," Fund for the Endowment of the Diplomatic Reception Rooms, video, 2017, https://www.youtube.com/watch?v=HcOHFEa6Mg4.

15 "Secretary Honors Donors to Diplomatic Reception Rooms, U.S. Department of State Archive, July–August 2000, https://1997-2001.state.gov/publications/statemag/statemag_jul2000/feature6.html.

16 Gail F. Serfaty, preface to Jonathan L. Fairbanks, *Becoming a Nation: Americana from the Diplomatic Reception Rooms, U.S. Department of State*, ed. Gerald W. R. Ward (New York: Rizzoli, 2003), 18.

17 John F. Kennedy, "Remarks at Amherst College, October 26, 1963," National Endowment for the Arts, https://www.arts.gov/about/kennedy-transcript.

THE ARCHITECTURE OF THE DIPLOMATIC RECEPTION ROOMS

18 John Summerson, *The Classical Language of Architecture* (Cambridge, Mass.: MIT Press, 1963), 7.

19 See Elizabeth Sarah Kite, *L'Enfant and Washington, 1791–1792* (Baltimore: Johns Hopkins University Press, 1929).

20 William H. Pierson Jr., *American Buildings and Their Architects*, vol. 1, *The Colonial and Neo-classical Styles* (Garden City, N.Y.: Anchor Press, 1970).

21 Brooklyn Museum, *The American Renaissance 1876–1917*, exh. cat. (Brooklyn: Brooklyn Museum, 1979).

22 Richard Longstreth, ed., *The Mall in Washington, 1791–1991* (New Haven: Yale University Press, 2002).

23 Jones, quoted in Allan Greenberg, "The Diplomatic Reception Rooms of Edward Vason Jones," *Magazine Antiques* 132, no. 1 (July 1987), 125–26.

24 Section originally published as Allan Greenberg, "The Diplomatic Reception Rooms of Edward Vason Jones," *Magazine Antiques* 132 (July 1987), revised and edited by Mark Alan Hewitt, 2022.

25 Born 1948, two centuries after the more widely known Robert Adam.

26 Benjamin Forgey, "Classic Designs, Newly Minted," *Washington Post*, June 23, 1990, quoted in Diplomatic Reception Rooms website on John Blatteau, https://diplomaticrooms.state.gov/about-us/our-history/the-architects/john-blatteau/.

27 William Adair, "Painting with Light: Gilding the Benjamin Franklin State Dining Room," Diplomatic Reception Rooms website, https://diplomaticrooms.state.gov/painting-with-light-gilding-the-benjamin-franklin-state-dining-room/.

28 Allan Greenberg, interview with Mark Alan Hewitt, June 10, 2022.

29 Email to Mark Alan Hewitt, August 13, 2022.

30 James Gibbs, *Rules for Drawing the Several Parts of Architecture . . .* (London, 1736), plate, p. 91.

PAINTINGS & SCULPTURE: THE AMERICAN SCHOOL AND BEYOND

31 Dorinda Evans, *Benjamin West and His American Students* (Washington, D.C.: Smithsonian Institution Press, 1980).

32 Hannah Fayerweather Winthrop to Mercy Otis Warren, August 17, 1775, *Warren-Adams Letters: Being Chiefly a Correspondence among John Adams, Samuel Adams, and James Warren*, Massachusetts Historical Society, Collections, vol. 72, Boston, 1917–1925, 102.

33 Carrie Rebora and Paul Staiti, *John Singleton Copley in America* (New York: Metropolitan Museum of Art, 1995).

34 Kaylin H. Weber, "A Temple of History Painting: West's Newman Street Studio and Art Collection," in Emily Ballew Neff with Kaylin H. Weber, *American Adversaries: West and Copley in a Transatlantic World* (Houston: Museum of Fine Arts, Houston, 2013), 21–23.

35 Charles Coleman Sellers, *Mr. Peale's Museum: Charles Willson Peale and the First Popular Museum of Natural Science and Art* (New York: W. W. Norton, 1980).

36 Helen A. Cooper, *John Trumbull: The Hand and Spirit of a Painter* (New Haven: Yale University Art Gallery, 1982).

37 Carrie Rebora Barratt and Ellen G. Miles, *Gilbert Stuart* (New York: Metropolitan Museum of Art, 2004), 129–91.

38 Kimberlee A. Cloutier-Blazzard, "The *Portrait of Mary McIntosh Sargent* in the Sargent House Museum: Slavery and 'Natural Slavery' in Federalist Era America," in *Locating American Art: Finding Art's Meaning in Museums, Colonial Period to the Present*, ed. Cynthia Fowler (Farnham, Surrey: Ashgate, 2016), 185–200.

39 Daniel Fulco, ed., *Joshua Johnson: Portraitist of Early American Baltimore* (Hagerstown, Md.: Washington County Museum of Fine Arts, 2021).

40 Elizabeth Mankin Kornhauser would like to thank Dr. Bradley Strauchen-Scherer, curator, Department

of Musical Instruments, Metropolitan Museum of Art, who confirmed that the flute in the portrait was likely late eighteenth century, and its design materials—boxwood with ivory ferrules—are typical of European- and American-made flutes of this period.

41 Robin Jaffee Frank, *Love and Loss: American Portrait and Mourning Miniatures* (New Haven: Yale University Art Gallery; Yale University Press, 2000).

42 Elizabeth Mankin Kornhauser, "Manifesto for an American Sublime: Thomas Cole's *The Oxbow*," in Kornhauser and Tim Barringer, *Thomas Cole's Journey: Atlantic Crossings* (New York: Metropolitan Museum of Art, 2018), 63–96.

43 Joseph D. Ketner II, *Robert S. Duncanson: "The Spiritual Striving of the Freedmen's Sons"* (Catskill, N.Y.: Thomas Cole National Historic Site, 2011).

PAINTINGS & SCULPTURE: ENTRIES

44 West to Charles Willson Peale, quoted in Robert C. Alberts, *Benjamin West: A Biography* (Boston: Houghton Mifflin, 1978), 150; see also https://assets.diplomaticrooms.state.gov/objects/the-american-commissioners/.

45 West to John Quincy Adams, recorded in Adams's diary (June 1817), quoted in Helmut von Erffa and Allen Staley, *The Paintings of Benjamin West* (New Haven: Yale University Press, 1986), 219, cat. no. 105; see also https://assets.diplomaticrooms.state.gov/objects/the-american-commissioners/.

46 Peale to Thomas Jefferson, after December 3, 1791, *The Papers of Thomas Jefferson*, ed. Charles T. Cullen (Princeton: Princeton University Press, 1986), vol. 22: 372; see also https://assets.diplomaticrooms.state.gov/objects/portrait-of-thomas-jefferson-1st-secretary-of-state-under-president-george-washington-2/.

47 George Ticknor, quoted in Merrill D. Peterson, ed., *Visitors to Monticello* (Charlottesville: University of Virginia Press, 1989), 61–66; see also Elizabeth Chew, "Jefferson's Indian Hall: Expedition Souvenirs and Specimens," Discover Lewis & Clark, https://lewis-clark.org/sciences/ethnography/jeffersons-indian-hall/.

48 John Dowling Herbert, quoted in William T. Whitley, *Gilbert Stuart* (Cambridge, Mass.: Harvard University Press, 1932), 85; see also https://assets.diplomaticrooms.state.gov/objects/portrait-of-george-washington-4/.

49 Sigma [pseud.], "The Character and Personal Appearance of Washington," *National Intelligencer*, February 1847, quoted in Ellen G. Miles, *George and Martha Washington: Portraits from the Presidential Years* (Washington, D.C.: Smithsonian Institution, National Portrait Gallery, in association with the University Press of Virginia, Charlottesville, 1999), 46; see also https://assets.diplomaticrooms.state.gov/objects/portrait-of-george-washington-4/.

50 Frederick S. Allis, Jr., ed. *Guide to the Microfilm Editions of the Winthrop Sargent Papers* (Boston: Massachusetts Historical Society, 1965), reel 7, October 1, 1818, https://www.masshist.org/collection-guides/view/fa0261; see also https://assets.diplomaticrooms.state.gov/objects/mary-mcintosh-williams-sargent/.

51 John Neal, "Our Painters: I," *Atlantic*, December 1868, https://www.theatlantic.com/magazine/archive/1868/12/our-painters-i/629961/.

52 Casey Olson, "John Quincy Adams' Congressional Career," United States Capitol Historical Society, Spring 2000, https://capitolhistory.org/explore/historical-articles/john-quincy-adams-congressional-career/.

53 Nicandro Iannacci, "10 Facts about John Quincy Adams on His Birthday," *Constitution Daily Blog*, National Constitution Center, https://constitutioncenter.org/blog/10-fascinating-facts-about-john-quincy-adams-for-his-248th-birthday.

54 National Park Service, "Louisa Catherine Adams (1775–1852)," Adams National Historical Park, Quincy, Massachusetts, last updated February 13, 2017, https://www.nps.gov/adam/learn/historyculture/louisa-catherine-adams-1775-1852.htm.

55 James R. Gaines, *For Liberty and Glory: Washington, Lafayette, and Their Revolutions* (New York: W. W. Norton, 2007), 37; quoted in Mary Stockwell, "Marquis de Lafayette," *The Digital Encyclopedia of George Washington*, https://www.mountvernon.org/library/digitalhistory/digital-encyclopedia/article/marquis-de-lafayette/?gclid=Cj0KCQjwlK-WBhDjARIsAO2sErQgvg6Lx-cKk35pA63nC5x9K7r1a5krEYjtNJUPzxIq6lfqGKI-u7MmsaAjvBEALw_wcB.

56 Matthew C. Hunter, "Did Joshua Reynolds Paint His Pictures? The Transatlantic Work of Picturing in an Age of Chymical Reproduction," Terra Foundation for American Art, https://www.terraamericanart.org/wp-content/uploads/2019/12/02-Matthew-C-Hunter-Did-Joshua-Reynolds-Paint-His-Pictures_-Terra-Essays-01-Picturing-2016.pdf.

57 Paul D. Schweizer, "William J. Weaver's Secret Art of Multiplying Pictures," in *Painting and Portrait Making in the American Northeast*, Dublin Seminar for New England Folklife, Annual Proceedings (Boston: Boston University, 1995), 159; see also https://assets.diplomaticrooms.state.gov/objects/portrait-of-alexander-hamilton/.

58 "Thomas Sully (1783–1872)," Worcester Art Museum, https://www.worcesterart.org/collection/Early_American/Artists/sully/biography/index.html.

59 Quoted in Alfred L. Bush, *The Life Portraits of Thomas Jefferson* (Charlottesville, Va.: Thomas Jefferson Memorial Foundation, 1962), 92; see also https://assets.diplomaticrooms.state.gov/objects/portrait-of-thomas-jefferson-3/.

60 Thomas Jefferson Papers, inscribed Florence [Italy], March 11, 1794, United States Library of Congress, Washington, D.C.; see also https://diplomaticrooms.state.gov/objects/high-relief-profile-bust-of-james-madison/.

61 Paul C. Nagel, "The Man and His Times," in *George Caleb Bingham*, ed. Michael Shapiro (New York: Harry N. Abrams), 1993.

62 "History of the U.S. Capitol Building," Architect of the Capitol, https://www.aoc.gov/explore-capitol-campus/buildings-grounds/capitol-building/history.

63 Charles Dickens, *American Notes for General Circulation and Pictures from Italy* (Philadelphia: J. B. Lippincott 1874), 135; see also https://assets.diplomaticrooms.state.gov/objects/a-glimpse-of-the-capitol-at-washington/.

64 The advertisement is reproduced in "Prominent African Americans: Am I Not a Woman & a Sister," Numismatic Guaranty Company, https://coins.www.collectors-society.com/wcm/CoinView.aspx?sc=258620.

65 Edward J. Nygren et al., *Views and Visions: American Landscape before 1830* (Washington, D.C.: Corcoran Gallery of Art, 1986), 46; see also https://assets.diplomaticrooms.state.gov/objects/view-on-the-kiskeminitas-kiskiminetas/.

66 Samuel Jones, *Pittsburgh in the Year 1826* (1826; repr., New York: Arno, 1970), 83: see also https://assets.diplomaticrooms.state.gov/objects/view-on-the-kiskeminitas-kiskiminetas/.

67 Kensett, December 16, 1844, quoted in John Paul Driscoll and John K. Howat, *John Frederick Kensett: An American Master* (New York: W. W. Norton, 1985), 62; see https://www.bonhams.com/auctions/26629/lot/72/.

68 James Fenimore Cooper, *The Deerslayer* (Philadelphia: Lea & Blanchard, 1841), 328.

69 Thomas Cole, "Essay on American Scenery," *American Monthly* 1 (January 1836), quoted in "The Making of the Hudson River School: Part 4, Something Truly American," Albany Institute of History & Art, https://www.albanyinstitute.org/something-truly-american.html.

70 *Sun and Banner*, June 27, 1895, quoted in D. Everett Smith, "Some of Prolific Williamsport Painter's Pieces Still in City," *Williamsport Sun-Gazette*, December 2, 2019, https://www.sungazette.com/news/top-news/2019/12/some-of-prolific-williamsport-painters-pieces-still-in-city/.

71 Julie Aronson and Emily Holtrop, "Robert S. Duncanson," Cincinnati Art Museum, https://artsandculture.google.com/story/robert-s-duncanson-cincinnati-art-museum/XwVxYinFqXw_Lw?hl=e.

72 Franklin to Sarah Bache, January 26, 1784, quoted in Philip M. Isaacson, *The American Eagle* (Boston: New York Graphic Society, 1975), 43; see also https://diplomaticrooms.state.gov/objects/carved-wood-and-paint-decorated-american-eagle-wall-plaque/.

73 Kathryn Elizabeth Sackett, "Organized Nostalgia: G. H. Durrie's Winter Landscapes and Nineteenth-Century American Art Association's Promotion of a National Identity" (master's thesis, Michigan State University, 1999), https://d.lib.msu.edu/etd/27931/datastream/OBJ/View/.

74 Margaret Tsuda, "Spearing Eels, Catching Flat Fish," *Christian Science Monitor*, December 19, 1989, https://www.csmonitor.com/1989/1219/umount.html.

75 Carleen Milburn, "Perspective: Joseph H. Sharp," *Western Art & Architecture*, https://westernartandarchitecture.com/articles/perspective-joseph-h-sharp.

76 H. Barbara Weinberg, *Childe Hassam: American Impressionist* (New York: Metropolitan Museum of Art, 2004), 301.

77 J. Mark Sublette, "Maynard Dixon: Biography (1875–1946)," https://www.maynarddixon.org/biography/.

78 "Cyrus Dallin's 'Appeal to the Great Spirit,'" MFA Boston, https://www.mfa.org/collections/art-americas/appeal-to-the-great-spirit.

CERAMICS: FOREIGN WARES TO AMERICAN SHORES

79 Quoted in Tristram Hunt, *The Radical Potter: The Life and Times of Josiah Wedgwood* (New York: Metropolitan Books, Henry Holt, 2021), 230.

80 Adrienne Spinozzi, ed., *Hear Me Now: The Black Potters of Old Edgefield, South Carolina* (New York: Metropolitan Museum of Art, 2022), 33–36.

81 The vase is inscribed and signed (incised into the wet clay with a tool): "this jar is to Mr Segler who keeps the bar in orangeburg / for Mr Edwards a Gentle man — who formly kept / Mr thos bacons horses / April 21 1858" "when you fill this Jar with pork or beef / Scot will be there; to get a peace, - / Dave" [25 slashes (representing gallonage)]

82 Josiah Wedgwood to Thomas Bentley, May 22, 1767, quoted in Robert Hunter, "John Bartlam: America's First Porcelain Manufacturer," *Ceramics in America 2007* (Chipstone Foundation) 7 (2007): 193.

CERAMICS: ENTRIES

83 William Hickey, quoted in John Goldsmith Phillips, *China-Trade Porcelain* (Cambridge, Mass.: Harvard University Press, 1956), 12–13; see also https://diplomaticrooms.state.gov/objects/charger/ and https://diplomaticrooms.state.gov/objects/chinese-export-porcelain-armorial-soup-plate-made-for-eldred-lancelot-lee-or-his-son/.

84 "An Account of a Visit Made to Washington at Mount Vernon, by an English Gentleman, in 1785: From the Diary of John Hunter," *Pennsylvania Magazine of History and Biography* 17, no. 1 (1893), 76–82, quoted in Susan Gray Detweiler, *George Washington's Chinaware* (New York: Harry N. Abrams, 1982), 81; see also https://diplomaticrooms.state.gov/objects/chinese-export-porcelain-plate-from-george-washingtons-society-of-the-cincinnati-service/.

85 Sir John Maclean and William Crawshay Heane, eds., *The Visitation of the County of Gloucestershire, Taken in the Year 1623* [. . .] (London: Harleian Society, 1885), 258.

86 Nathaniel Hawthorne, *The Scarlet Letter* (1850; repr., Boston: Houghton Mifflin, 1878), 46–47, http://google.cat/books?lr=&output=html&id=oJxUAAAAYAAJ&d-q=editions%3AUOM39015076610404&jtp=46.

87 Shaw to Townsend, December 20, 1790, quoted in Lindsay E. Borst, "The Society of the Cincinnati Chinese Export Porcelain," Society of the Cincinnati, https://www.societyofthecincinnati.org/the-society-of-the-cincinnati-chinese-export-porcelain/#fnref-8.

88 Washington to Boudinot, April 1, 1777, "Founders Online," National Archives, https://founders.archives.gov/?q=Correspondent%3A%22Washington%2C%20George%22%20Correspondent%3A%22Boudinot%2C%20Elias%22&s=1111311111&r=1.

89 "Lydia Darragh," USHistory.org, https://www.ushistory.org/people/darragh.htm.

90 "Richard Gridley," Boston National Historical Park, National Park Service, https://www.nps.gov/people/richard-gridley.htm.

91 Quoted in Steven C. Bullock, *Revolutionary Brotherhood: Freemasonry and the Transformation of the American Social Order, 1730–1840* (Chapel Hill: University of North Carolina Press for the Omohundro Institute of Early American History and Culture, Williamsburg, Va., 1996), 76.

92 Hannah Boettcher and Ronald W. Fuchs II, "Martha Washington's 'United States China': A New Link Found in a Family Notebook," *Ceramics in America 2020*, Chipstone, https://chipstone.org/article.php/839/Ceramics-in-America-2020/Martha-Washington's-"United-States-China":-A-New-Link-Found-in-a-Family-Notebook.

93 Nathaniel Harris Morgan, *Morgan Genealogy: A History of James Morgan, of New London, Conn. and His Descendants; from 1607 to 1869* (Hartford: Case, Lockwood & Brainard, 1869), 92–93, https://books.google.com/books?id=itMxAQAAMAAJ&pg=PA92&lpg#v.

94 "Platter," American Decorative Arts, Yale University Art Gallery, https://artgallery.yale.edu/collections/objects/134291.

95 Quoted in C. Morgan Grefe, "The Best Laid Plans: House and Myth Building at 52 Power's Lane," in *The John Brown House Museum: A Passion for the Past*, ed. C. Morgan Grefe (Providence: Rhode Island Historical Society, 2010), 16, https://www.khammerstrom.com/uploads/1/6/2/6/16261628/jbhfin.pdf.

96 "Platter."

97 M. de Marbois to Franklin, January 4, 1781, quoted in "Sarah Bache," AmericanRevolution.org, https://www.americanrevolution.org/women/women30.php.

98 Wedgwood to Franklin, February 29, 1788, quoted in "Am I Not a Man and a Brother?," Birmingham Museum of Art, Birmingham, Alabama, https://www.artsbma.org/am-i-not-a-man-and-a-brother-medallion/.

99 Thomas Clarkson, quoted in Highlights, "Am I Not a Man and a Brother?," Wiener Museum of Decorative Arts, https://www.wmoda.com/am-i-not-a-man-and-a-brother/.

100 Franklin to Charles Thomson, September 27, 1766, "Benjamin Franklin . . . in His Own Words," Library of Congress, https://www.loc.gov/exhibits/franklin/franklin-cause.html#7.

101 Franklin to Samuel Huntington, August 9, 1780, Founders Online, National Archives, https://founders.archives.gov/documents/Franklin/01-33-02-0129.

102 Skipwith to Madison, September 3, 1806, Founders Online, National Archives, https://founders.archives.gov/documents/Madison/02-12-02-0415.

103 Jessie Benton Frémont, *Souvenirs of My Time* (Boston: D. Lothrop, 1887), 95.

104 Franklin to Sarah Bache, June 3, 1779, Founders Online, National Archives, https://founders.archives.gov/documents/Franklin/01-29-02-0496.

105 Alice Cooney Frelinghuysen, "A Paris Porcelain Dinner Service for the American Market," *Metropolitan Museum Journal* 37 (2002): 288, https://www.metmuseum.org/art/metpublications/paris_porcelain_dinner_service_for_american_market_the_metropolitan_museum_journal_v_37_2002.

106 *The Diary and Letters of Gouverneur Morris* [. . .], ed. Anne Cary Morris, vol. 1 (New York: Charles Scribner's Sons, 1888), chap. 13, entry for January 14, 1790; see https://oll.libertyfund.org/title/morris-the-diary-and-letters-of-gouverneur-morris-vol-1.

107 Thomas Tucker to Professor [John F.] Frazer, November 27, 1852, in "American Porcelain," *Journal of the Franklin Institute, of the State of Pennsylvania, for the Promotion of the Mechanic Arts* 55 (January 1853) 43, https://books.google.com/books?id=--lCAQAAMAAJ&pg=PA43.

FURNITURE: REFLECTIONS ON THE CULTURAL TRADITIONS OF AMERICA'S ARTISANS

108 *The Pennsylvania Mercury and Universal Advertiser*, Wednesday, July 9, 1788, 2: see https://www.loc.gov/item/sn84026234/.

109 Peter Kalm, *Kalm's Account of Plants in North America*, trans. Esther Louise Larson, *Agricultural History* 13, no. 1 (1939): 36, 47; JSTOR, http://www.jstor.org/stable/3739390.

110 *Jackson's Oxford Journal* (Oxford, U.K.), August 21, 1784, 3; *Ipswich Journal* (Ipswich, U.K.), September 21, 1765, 3.

111 Jennifer L. Anderson, *Mahogany: The Costs of Luxury in Early America* (Cambridge, Mass.: Harvard University Press, 2012), 20–23.

112 Anderson, *Mahogany*, 221–24.

113 The name may derive from *m'oganwo*, the word used by the enslaved Yoruba and Igbo peoples of West Africa to describe the related African genus *Khaya* (part of the Meliaceae family). Anderson, *Mahogany*, 4–5. For information on Caribbean plantations, see Harriet Frorer Durham, *Caribbean Quakers* (Hollywood, Fla.: Dukane Press, 1972).

114 See Patricia E. Kane, project director, Rhode Island Furniture Archive at the Yale University Art Gallery, https://rifa.art.yale.edu/.

115 *Prices of Cabinet and Chair Work* (Philadelphia: James Humphreys, Jr., 1772), 4, 5; reproduced in Alexandra Alevizatos Kirtley, *The 1772 Philadelphia Furniture Price Book: An Introduction and Guide*, Primary Sources in American Art 2 (Philadelphia: Philadelphia Museum of Art, 2005).

116 See Philadelphia Furniture: Design, Artisans, and Techniques, www.philafurniture.com. For other dressing tables in the collection, see https://diplomaticrooms.state.gov/objects/chippendale-carved-mahogany-dressing-table-2/; https://diplomaticrooms.state.gov/objects/chippendale-carved-mahogany-dressing-table-4/; and https://diplomaticrooms.state.gov/objects/chippendale-carved-walnut-dressing-table/.

117 See Alexandra Alevizatos Kirtley, *American Furniture, 1650–1840: Highlights from the Philadelphia Museum of Art* (Philadelphia: Philadelphia Museum of Art, in association with Yale University Press, 2021), 69–70. For Philadelphia high chest and dressing table pairings, see cat. nos. 11–12, 41, 52–53, 69–70, 84–85. Other examples of narrative carvings are at the Museum of Fine Arts, Boston (39.150) and the Metropolitan Museum of Art (18.110.4; 32.93). See also https://philafurniture.com/taxonomy-overview.

118 The pendant to this table is in the Jeremiah Lee Mansion in Marblehead, Massachusetts. It is unclear if spring and autumn were ever executed.

119 For example, "6 New Compass Bottomed Chairs" in will of Thomas Lacy (d. 1755), Philadelphia Wills and Inventories.

120 Kirtley, *American Furniture*, cat. no. 67, n1. See will of George Pickering, Philadelphia Wills and Inventories, 1784, no. 326. For other examples in the collection, see https://diplomaticrooms.state.gov/objects/queen-anne-carved-walnut-side-chairs/; https://diplomaticrooms.state.gov/objects/chippendale-carved-mahogany-chair/; https://diplomaticrooms.state.gov/objects/chippendale-carved-mahogany-side-chair-3/; https://diplomaticrooms.state.gov/objects/pair-of-chippendale-carved-mahogany-side-chairs; https://diplomaticrooms.state.gov/explore-the-collection/; and https://diplomaticrooms.state.gov/objects/chippendale-carved-mahogany-side-chair-5/.

121 China tables are described as mahogany tables with straight legs, bases and brackets, stretchers, a fret top,

and an option for commode (or serpentine) sides in *Prices of Cabinet and Chair Work*, 19–20. No price was offered for china tables in walnut.

122 See Kirtley, *American Furniture*, cat. nos. 60–61.

123 See Kirtley *American Furniture*, cat. nos. 60–61.

124 Affleck often worked with upholsterer Plunkett Fleeson (1712–1791). Fleeson was born in Philadelphia, trained in London and Dublin, and returned to Philadelphia in 1739; there he operated the most successful and enduring upholstery shop "at the sign of the easy chair." His shop included the skilled labor of enslaved Africans.

125 Maryland Journal and Baltimore Advertiser, July 29, 1785, quoted in Sumpter Priddy III, J. Michael Flanigan, and Gregory R. Weidman, "The Genesis of Neoclassical Style in Baltimore Furniture," *American Furniture*, 2000, Chipstone, https://www.chipstone.org/article.php/402/American-Furniture-2000/The-Genesis-of-Neoclassical-Style-in-Baltimore-Furniture.

FURNITURE: ENTRIES

126 Martin Eli Weil, "A Cabinetmaker's Price Book," in "American Furniture and Its Makers," ed. Ian M. G. Quimby, special issue, *Winterthur Portfolio: A Journal of American Material Culture* 13 (1979), 187; see also https://diplomaticrooms.state.gov/objects/chippendale-carved-and-figured-mahogany-piecrust-tea-table/.

127 Quoted in Thomas Williams Bicknell, *The History of the State of Rhode Island and Providence Plantations* (New York: American Historical Society, 1920), 3:1085.

128 "Benjn. Randolph cabinet maker . . . ," Library Company of Philadelphia, https://digital.librarycompany.org/islandora/object/Islandora%3A59327.

129 Andrew Brunk, "Benjamin Randolph Revisited," in *American Furniture*, 2007, Chipstone, https://www.chipstone.org/article.php/568/American-Furniture-2007/Benjamin-Randolph-Revisited.

130 Luke Vincent Lockwood, *Colonial Furniture in America*, 3rd ed., 2 vols. (1926; repr., New York: Castle Books, 1951), 1: 111.

131 Samuel K. Fore, "Richard Varick," George Washington's Mount Vernon, https://www.mountvernon.org/library/digitalhistory/digital-encyclopedia/article/richard-varick/.

132 John C. Glynn, Jr., "William Whipple (1730/31–1785)," Descendants of the Signers of the Declaration of Independence, https://www.dsdi1776.com/signer/william-whipple/.

133 Thomas Chippendale, *The Gentleman & Cabinet-Maker's Director* . . . (London, 1754), 7 and pl. 51; see also https://diplomaticrooms.state.gov/objects/chippendale-fretwork-carved-tea-table/.

134 John Tittle, Inventory, taken February 5 1801, Docket 27748, Essex County Probate Records, Essex County Courthouse, Salem, Massachusetts; see also https://diplomaticrooms.state.gov/objects/chippendale-faience-and-mahogany-china-table/.

135 Bill Pavlak, "A Very Good Cabinetmaker," *Fine Woodworking*, March 20, 2020, https://www.finewoodworking.com/2020/03/30/a-very-good-cabinetmaker.

136 In 1774, Thomas Affleck's wife, Isabella Gordon Affleck, inherited an enslaved person named Cato, who was later listed in tax records of Affleck's shop. See A. A. Kirtley, "The Ties That Bind: New Light on

Philadelphia Cabinetmaker Thomas Affleck," *Magazine Antiques* 177, no 5 (September/October, 2010): 155.

137 William A. Strollo, "'An Amazing Aptness for Learning Trades': The Role of Enslaved Craftsmen in Charleston Cabinetmaking Shops" (master's thesis, Virginia Commonwealth University, 2017), 62, https://scholarscompass.vcu.edu/cgi/viewcontent.cgi?article=6280&context=etd.

138 Patricia Dane Rogers and Laurel Crone Sneed, "The Missing Chapter in the Life of Thomas Day," *American Furniture* 2013, Chipstone, https://www.chipstone.org/article.php/648/American-Furniture-2013/The-Missing-Chapter-in-the-Life-of-Thomas-Day.

139 Kirtley, *American Furniture*, 151.

140 "John Hemmings," Thomas Jefferson Monticello, https://www.monticello.org/research-education/thomas-jefferson-encyclopedia/john-hemmings/.

141 For Bentzon, see Rachel E. C. Layton, "Peter Bentzon: A 'Mustice' Silversmith in Philadelphia and St. Croix," *International Review of African American Art* 12, no. 2 (1995): 30–35. For Hastier, see Deborah Dependahl Waters, ed., *Elegant Plate: Three Centuries of Precious Metals in New York City*, 2 vols. (New York: Museum of the City of New York, 2000), 1:139. For Head, see Deborah Dependahl Waters, "'The Workmanship of an American Artist': Philadelphia's Precious Metals Trades and Craftsmen, 1788–1832" (PhD diss., University of Delaware, 1981), 43, 59n57; for Bray and Sowerwelt, see Rachel E. C. Layton, "Race, Authenticity and Colonialism," in *Colonialism and the Object: Empire, Material Culture and the Museum*, ed. Tim Barringer and Tom Flynn (New York: Routledge, 1998), 90.

142 Bradford L. Rauschenberg, "John Bartlam, Who Established 'new Pottworks in South Carolina' and Became the First Successful Creamware Potter in America," *Journal of Early Southern Decorative Arts* 17, no. 2 (November 1991): 9, https://archive.org/stream/journalofearlyso1721991muse/journalofearlyso1721991muse_djvu.txt.

143 David Drake, Storage jar, 1858, Metropolitan Museum of Art, https://www.metmuseum.org/art/collection/search/747045?ft=David+Drake&offset=0&rpp=40&pos=1; see also Adrienne Spinozzi, ed., *Hear Me Now: The Black Potters of Old Edgefield, South Carolina* (New York: Metropolitan Museum of Art, 2022).

144 Sarah Fling, "Charles Willson Peale: Slavery and Art in the White House Collection," White House Historical Association, March 22, 2021, https://www.whitehousehistory.org/charles-willson-peale; Allison C. Meier, "The Former Slave Who Became a Master Silhouette Artist," JSTOR Daily, June 7, 2018, https://daily.jstor.org/the-former-slave-who-became-a-master-silhouette-artist/. Williams used a physiognotrace, as did Charles de Saint-Mémin (see cat. 110).

145 Kirtley, *American Furniture*, cat nos. 60–61.

146 Weil, "A Cabinetmaker's Price Book," 184; see also https://diplomaticrooms.state.gov/objects/chippendale-mahogany-camel-back-sofa-2/.

147 Christopher Storb, "Two Triple-Leaf Card Tables," Dietrich American Foundation, Incollect, https://www.incollect.com/articles/dietrich-american-foundation-two-triple-leaf-card-tables-by-christopher-storb.

148 Laaren Brown would like to acknowledge Judy Hynson, director of research and library collections

at Stratford Hall, Stratford, Virginia, for this information.

WORKS ON PAPER: THE DIPLOMATIC WORD & IMAGE

149 *Merriam-Webster Dictionary*, accessed July 26, 2022, https://www.merriam-webster.com/dictionary/diplomacy.

150 John Adams to Abigail Adams, post May 12, 1780, Adams Family Papers: An Electronic Archive. Massachusetts Historical Society, accessed July 26, 2022, https://www.masshist.org/digitaladams/archive/doc?id=L17800512jasecond#.

151 In 2022, it appeared a day late, on July 5.

152 Jonathan L. Fairbanks, *Becoming a Nation*, 113–14.

153 For further discussion of Washington portraits, see Elliot Bostwick Davis, *Thomas Sully: George Washington and "The Passage of the Delaware"* (Boston: Museum of Fine Arts, Boston, 2016); and Wendy C. Wick, *George Washington, An American Icon: The Eighteenth-Century Graphic Portraits* (Washington, D.C.: Smithsonian Institution Traveling Exhibition Service and National Portrait Gallery, 1982).

154 For the range represented in the collections of the Diplomatic Reception Rooms, see, for example, Fairbanks, *Becoming a Nation*, 35, 53, 57, 80, 98, 103, 112–14, 118–20, 139, 146–47, 151, 158–60, 177, 179, 183–85.

155 Fairbanks, *Becoming a Nation*, 104. See also Lauren B. Hewes and Nan Wolverton, *Beyond Midnight: Paul Revere* (Worcester, Mass.: American Antiquarian Society, 2019).

156 U.S. Department of State, Diplomatic Reception Rooms, database, consulted online, July 2022, https://www.diplomaticrooms.state.gov/objects/naval-action-between-american-frigate-chesapeake-and-h-m-s-shannon/.

157 Thomas Jefferson to George Washington, December 12, 1792. Diplomatic Reception Rooms, RR-2010.0010.

158 Transcript of letter, 3, PDF, in email correspondence to Elliot Bostwick Davis from Virginia B. Hart, curator, Diplomatic Reception Rooms, June 29, 2022.

159 Fairbanks, *Becoming a Nation*, 50.

160 For Voltaire reference, see Fairbanks, *Becoming a Nation*, 50. For the federal appeals court case, see, Delaware Nation v. Pennsylvania, 446.F.3d410, June 14, 2006, accessed September 12, 2022, https://casetext.com/case/delaware-nation-v-pennsylvania?q=.

161 For the inscription, see https://www.diplomaticrooms.state.gov/objects/vue-de-philadelphie-view-of-philadelphia/. For looking at these prints using popular perspective glasses and specially designed furniture and viewing boxes, see also E. McSherry Fowble, *To Please Every Taste: Eighteenth-Century Prints from the Winterthur Museum* (Alexandria, Va.: Art Services International, 1991), 54 and passim.

162 See Vivien Green Fryd, *Art and Empire: The Politics of Ethnicity in the United States Capitol, 1815–1860* (New Haven: Yale University Press, 1992), esp. chaps. 4–6, 88–124. Elliot Bostwick Davis is grateful to Professors Sarah Lewis and Joseph Koerner for their course titled Monuments, winter 2022, Department of History of Art and Architecture, Harvard University, for providing their excellent context on this publication.

163 Bruce Robertson, "Stories for the Public, 1830–1860," in *American Stories: Paintings of Everyday Life, 1765–1915*,

ed. H. Barbara Weinberg and Carrie Rebora Barratt (New York: Metropolitan Museum of Art, 2009), 69.

164 For further background on the role of French lithographic firms reproducing American paintings and Mount's lithograph *The Bone Player*, as well as the broader context of printmaking between 1825 and 1861, see Elliot Bostwick Davis, "The Currency of Culture: Prints in New York City," in *Art and the Empire City: New York, 1825–1861*, ed. Catherine Hoover Voorsanger and John K. Howat (New York: Metropolitan Museum of Art, 2000), 189–226.

165 For the specific development of American lithography between 1825 and 1861, see Davis, "The Currency of Culture."

166 Nathaniel Currier made his reputation as a printer of color lithographs with a print of the 1835 burning of the Merchants' Exchange, New York, and followed that in 1840 with *The Awful Conflagration of the Steam Boat "Lexington"* . . . ; see Davis, "The Currency of Culture," 214.

WORKS ON PAPER: ENTRIES

167 "This Day in History, June 22, 1775: Congress Issues Continental Currency," updated June 21, 2021, History.com, https://www.history.com/this-day-in-history/congress-issues-continental-currency.

168 "The Society of the Cincinnati Diploma," The Society of the Cincinnati, https://www.societyofthe-cincinnati.org/the-society-of-the-cincinnati-diploma/.

169 "The Society of the Cincinnati Diploma."

170 Ellen G. Miles, "Federal Profiles: Saint Mémin in America, 1793–1814," Smithsonian Education, http://www.smithsonianeducation.org/migrations/portrait/essay.html.

171 Aaron Killian, "Benjamin Franklin and the Turkey," Historic America, November 28, 2014, https://www.historicamerica.org/journal/2014/11/28/benjamin-franklin-and-the-turkey#:~:text=For%20the%20Truth%20the%20Turkey,with%20a%20red%20Coat%20on.

172 Audubon, journal entry, December 4, 1826, in Maria R. Audubon, *Audubon and His Journals* (New York: Charles Scribner's Sons, 1897; Project Gutenberg EBook, 2012), 1:175, https://www.gutenberg.org/files/39975/39975-h/39975-h.htm.

173 "The Battle between Shannon and Chesapeake," Nova Scotia: Communities, Culture, Tourism and Heritage, https://cch.novascotia.ca/stories/battle-between-shannon-and-chesapeake#:~:text=On%20June%201%2C%201813%2C%20HMS,the%20battle%20had%20even%20begun.

174 "The Marquis de Lafayette," Lafayette College, https://about.lafayette.edu/mission-and-history/the-marquis-de-lafayette/.

175 Peter S. Du Ponceau and J. Francis Fisher, *A Memoir on the History of the Celebrated Treaty Made by William Penn with the Indians . . .* , vol. 3, part 2 (Philadelphia: McCarty & Davis, 1836), 14–15, https://books.google.com/books?id=VCUUAAAAYAAJ&pg=PA1&source=gbs_selected_pages&cad=3#v=onepage&q=lovingly&f=false.

176 Du Ponceau and Fisher, *Celebrated Treaty Made by William Penn*, 16.

177 Kees Kaldenbach, "Optical Prints," Paulus Swaen Gallery, https://www.swaen.com/articles-about-prints/optical-prints.

178 "Balth Frederic Leizelt 'Philadelphia/Philadelphie," The Philadelphia Print Shop, https://philaprintshop.com/products/balth-frederic-leizelt-philadelphia-philadelphie.

179 Leslie Warwick and Peter Warwick. "Sarah DeHart, Early American Silhouettist." *Magazine Antiques*, September 2008, 87–90.

180 Maximilian Alexander Philipp, prinz von Wied-Neuwied, *Travels in the Interior of North America, 1832–1834*, pt. 2 (Cleveland: Arthur H. Clark, 1906), 88, copy in Library of Congress, https://tile.loc.gov/storage-services/service/gdc/lhbtn/th023/th023.pdf.

181 Walt Whitman, note above "Osceola," in *Leaves of Grass*, 417, The Walt Whitman Archive, https://whitmanarchive.org/published/LG/1891/poems/393.

182 Unsigned review of the painting as "No. 158. *The Force of Music*. W. S. Mount," in "The Fine Arts: Exhibition at the National Academy, Second Saloon," *Literary World* 1, no. 18 (June 5, 1847): 419, https://archive.org/details/sim_literary-world_1847-06-05_1_18/page/418/mode/2up.

183 Quoted in James Thomas Flexner and Henry Allen Moe, "Paintings on the Century's Walls," *New York History* 44, no. 3 (July 1963), at https://www.jstor.org/stable/23162601.

184 Currier and Ives, *Descriptive Catalogue of Prints* (1864), quoted by AbeBooks, https://www.abebooks.com/Midnight-Race-Mississippi-River-CURRIER-IVES/30247478721/bd.

185 Mark Twain, chapter 45, "Southern Sports," in *Life on the Mississippi* (1883), http://www.telelib.com/authors/T/TwainMark/prose/lifeonmississippi/lifeonmississippi45.html.

186 Gordon Hendricks, *Albert Bierstadt: Painter of the American West* (New York: Harry N. Abrams, 1974), 302–3.

187 Alberta Eiseman, "'Cos Cob Clapboard' Artists Honored at House They Loved," *New York Times*, September 23, 1990, https://www.nytimes.com/1990/09/23/nyregion/cos-cob-clapboard-artists-honored-at-house-they-loved.html.

SILVER & OTHER METALS: WROUGHT WITH SKILL

188 Deborah Dependahl Waters would like to acknowledge Nilda Lopez, reference librarian, Smithsonian Institution Libraries, Cooper Hewitt National Design Library, New York, for her generous assistance. For analysis of the production of Paul Revere Jr.'s shop, see Jeannine Falino, "'The Pride Which Pervades thro Every Class': The Customers of Paul Revere," in *New England Silver & Silversmithing 1620–1815*, Jeannine Falino and Gerald W. R. Ward (Boston: Colonial Society of Massachusetts, 2001), 152–59, 177n13. Elias Pelletreau's surviving shop ledgers record a similar pattern; see Dean F. Failey, *Elias Pelletreau: Long Island Silversmith and Entrepreneur, 1726–1810* (Cold Spring Harbor, N.Y.: Preservation Long Island, 2018), 71, and chap. 4, 110–11, tables 4–2a, 4–2b.

189 For thefts, see Rita Susswein Gottesman, *The Arts and Crafts in New York, 1726–1776: Advertisement and News Items from New York City Newspapers* (New York: New-York Historical Society, 1938; repr., New York: Da Capo Press, 1970), 29–32, 36, 39, 44, 48, 50–52, 54–55, 57–58.

190 Elias Pelletreau served his apprenticeship with fellow French Huguenot Simeon Soumaine beginning in 1742; see Failey, *Ellias Pelletreau*, 44–45. Lewis Meares, an English indentured servant working as a jeweler and engraver, ran away from his master Myer Myers in 1753; see David L. Barquist, *Myer Myers: Jewish Silversmith in Colonial New York* (New Haven: Yale University Art Gallery in association with Yale University Press, 2001), 31, 57. New York silversmith John Hastier's "lusty well-set Negro Man named Jasper," who was trained as a silversmith, ran away in May 1758 ; see Waters, *Elegant Plate*, 1:139. By 1787, Joseph Lownes had two apprentices working with him—fifteen-year-old Quaker Samuel Williamson and "Negro" Joseph Head, for whom he provided a character reference preserved in the Pennsylvania Abolition Society Papers; see Waters, "The Workmanship of an American Artist": 43, 59n57. For Peter Bentzon, see Layton, "Peter Bentzon": 30–35. For the last three references, see n141.

191 Gottesman, *Arts and Crafts*, 8–9, 42–43; John Anthony Beau advertisement, "A celebrated Chaser, in Fourth street, opposite the new Lutheran Church," *Pennsylvania Packet*, July 13, 1772, in Alfred Coxe Prime, *The Arts & Crafts in Philadelphia, Maryland, and South Carolina*, vol. 1, *1721–1785* (Topsfield, Mass.: Walpole Society,1929), 47; For Dawkins, see *Philadelphia: Three Centuries of American Art* (Philadelphia: Philadelphia Museum of Art, 1976), 77.

192 Waters, *Elegant Plate*, 1:46, 161, 170n3

193 Barbara G. Carson, "Determining the Growth and Distribution of Tea Drinking in Eighteenth-Century America," in *Steeped in History: The Art of Tea*, ed. Beatrice Hohenegger (Los Angeles: Fowler Museum at UCLA, 2009), 158; Richard Bushman, *The Refinement of America: Persons, Houses, Cities* (New York: Vintage, 1993), 183–85; Jane T. Merritt, "Beyond Boston: Prerevolutionary Activism and the Other American Tea Parties," in Hohenegger, *Steeped in History*, 172–83, 219.

194 See Margaret K. Hofer and Debra Schmidt Bach, *Stories in Sterling: Four Centuries of Silver in New York* (New York: New-York Historical Society in association with D. Giles, Ltd., London, 2011), 261, 262n3, no. 6.15; object provenance recorded in object files, Diplomatic Reception Rooms.

195 Deborah A. Federhen, "Paul Revere, Jr.," in Patricia E. Kane, *Colonial Massachusetts Silversmiths and Jewelers* (New Haven: Yale University Art Gallery, 1998), 795–806; Jayne E. Triber, *A True Republican: The Life of Paul Revere* (Amherst: University of Massachusetts Press, 1998), 89–139; Barquist, *Myer Myers*, 62–64; Failey, *Elias Pelletreau*, 54–56; Waters, *Elegant Plate*, 1: 126–27, 132–34.

196 See Deborah Dependahl Waters, "'Rich and Fashionable Goods': The Precious Metals Trades in Philadelphia, 1810–1840," in Donald L. Fennimore and Ann K. Wagner, *Silversmiths to the Nation: Thomas Fletcher and Sidney Gardiner, 1808–1842* (Woodbridge, Suffolk: Antique Collectors' Club for the Henry Francis du Pont Winterthur Museum, 2007), 21–22, 249n4; "Abraham Dubois and Abraham Dubois Jr.," in Catherine B. Hollan, *Philadelphia Silversmiths and Related Artisans to 1861* (McLean, Va.: Hollan Press, 2013), 57–58; "Nathaniel Austin, 1734–1818," in Kane, *Colonial Massachusetts Silversmiths*, mark "A," 158–62.

197 Kevin J. Tulimieri, "Thomas Harland's Tea Party," *Magazine Antiques* 175, no. 5 (May 2009): 112–17; Frank L. Hohmann III, *Timeless: Masterpiece American Brass Dial Clocks* (New York: Hohmann Holdings, 2009), 108–11, nos. 5–6; Martha J. Willoughby, "Thomas Harland," in Hohmann, *Timeless*, 341–43, updates Harland's biography.

198 Donald L. Fennimore, *Metalwork in Early America: Copper and Its Alloys from the Winterthur Collection* (Winterthur, Del.: Henry Francis du Pont Winterthur Museum, 1996), 141–42, nos. 61–62.

199 Text: *Joseph Lownes*/Goldsmith & Jeweller/*six Doors above the Draw bridge*/No. 130 Front Street South/*Philadelphia*/Highest Price Given/Old Gold & Silver

200 For a diagram of a plating (or flatting) mill and additional references to mills, see Deborah Dependahl Waters, *A Handsome Cupboard of Plate: Early American Silver in the Cahn Collection* (Cambridge: John Adamson in association with the Minneapolis Institute of Arts, 2012), 22–23, 29nn53–59, fig. 6.

201 Federhen, "Paul Revere, Jr.," 805, 837–40; Falino, "Customers of Paul Revere," 169–70. In 1796, Judith Hays Myers married her first cousin Samuel Myers; see Malcolm Stern, *First American Jewish Families*, American Jewish Archives, accessed August 16, 2022, https://sites.americanjewisharchives.org/aja-publications/first-american-families/, 104.

202 Ruthanna Hindes, "Delaware Silversmiths 1700–1850," *Delaware History* 12, no. 4 (October 1967): 275–76, uses the LeTelier spelling and notes that three marks, two of which are stamped on pieces in this service, "have been ascribed without differentiation to the work of both father and son." Hollan, *Philadelphia Silversmiths*, 118–19, notes that LeTelier Jr. worked with his father in Philadelphia, Wilmington, and Chester County, Pennsylvania, and used his father's stamps, "plus a few of his own." The finding aid for the Cornelius Comegys Papers, Collection 0493-MDHC, Hornbake Library, University of Maryland, College Park, includes a brief biography, at https://archives.lib.umd.edu/repositories/2/resources/1688.

203 Samuel L. Mitchill to Catharine Mitchill, February 10, 1802, Samuel Latham Mitchill Papers, William L. Clements Library, University of Michigan, accessed August 2022, http://quod.lib.umich.edu/m/mitchill/mitchill.0108.001/1?rgn=full+text;view=image;q1=Viands#page-text. Catharine Mitchill to Margaret (Akerly) Miller, April 8, 1806, cited in Carolyn Hoover Sung, "Catharine Mitchill's Letters from Washington, 1806–1812," *Quarterly Journal of the Library of Congress* 34, no. 3 (July 1977): 175, accessed July 12, 2022, https://www.jstor.org/stable/29781736. The "silver Basins or Dishes with covers" used for vegetables may have been casseroles believed to be by the Parisian Pierre-Jacques Lamine, about 1787, illustrated in James A. Bear Jr., "Thomas Jefferson's Silver," *Magazine Antiques* 74, no. 3 (September 1958): 234, fig. 2. For the Thomson vegetable dishes in the Diplomatic Reception Rooms, see RR-1982.0050.1-.2, https://diplomaticrooms.state.gov/objects/vegetable-dishes-and-covers/.

204 The State Department is the custodian of the Great Seal. For its development, see Frank H. Sommer, "Emblem and Device: The Origin of the Great Seal of the United States," *Art Quarterly* 24, no. 1 (Spring 1961): 57–76; Richard S. Patterson and Richardson Dougall, *The Eagle and The Shield: A History of the Great Seal of the United States* (Washington, D.C.: U.S. Department

of State, 1976), 111–27, illus. 20–21. For skippets, see Joan Sayers Brown, "Skippets," *Magazine Antiques* 114, no. 1 (July 1978): 140–41; Ian M. G. Quimby with Dianne Johnson, *American Silver at Winterthur* (Winterthur, Del.: Henry Francis du Pont Winterthur Museum, 1995), 197–98, nos. 401a, b, 402.

205 Deborah Dependahl Waters, "From Pure Coin: The Manufacture of American Silver Flatware, 1800–1860," *Winterthur Portfolio*, vol. 12 (1977): 19–33; Hollan, *Philadelphia Silversmiths*, 232–40, illustrates Philadelphia purity marks and symbols. For Baltimore, see Patrick M. Duggan, "Marks on Baltimore Silver, 1814–1860: An Exploration," in Jennifer Faulds Goldsborough, *Silver in Maryland* (Baltimore: Museum and Library of Maryland History, Maryland Historical Society, 1983), 26–37i, and figs. 13, 15a for the marks struck on the pitcher.

206 Among the firms introducing steam power were those of Newell Harding in Boston, Fletcher and Gardiner in Philadelphia, and Baldwin Gardiner in New York City; see Jeannine Falino and Gerald W. R. Ward, eds., *Silver of the Americas, 1600–2000: American Silver in the Museum of Fine Arts, Boston* (Boston: Museum of Fine Arts, Boston, 2008), 261–69, 311–12, nos. 203–209; Fennimore and Wagner, *Silversmiths to the Nation*, 46–50. Spinning forms on a lathe over a chuck was a technique borrowed from Britannia manufacture; see Nancy A. Goyne, "Britannia in America: The Introduction of a New Alloy and a New Industry," *Winterthur Portfolio*, vol. 2 (1965): 179–81.

207 See Charles L. Venable, *Silver in America, 1840–1940: A Century of Splendor* (Dallas: Dallas Museum of Art, 1995), 19–20; Waters, *Elegant Plate*, 2:593–95, 595n1.

208 Venable, *Silver in America*, 18–19, fig. 1.1; Deborah Dependahl Waters, "'Silver Ware in Great Perfection': The Precious-Metals Trades in New York City," in *Art and the Empire City*, ed. Voorsanger and Howat, 366–68, 566–67, 596, no. 296. In 1845, the shop of silversmith William Adams fabricated a krater-form vase for Clay (collection of the Henry Clay Memorial Fuondation) surmounted by an eagle akin to that perched atop the 1841 Mace of the House of Representatives, also made by Adams. The mace is inscribed, engraved on bottom repoussé band: "Wm. Adams/Manufacturer/New York/1841."

209 Ball, Black & Co. at the Sign of the Golden Eagle, succeeded the firm of Ball, Tompkins & Black at 247 Broadway, opposite City Hall, after the death of Erastus O. Tompkins in 1851. William I. Tenney (active ca. 1828–48) established a jewelry store at 251 Broadway by 1828. His stamps appear on three pieces of the service. George L. Shepard joined Edgar Mortimer Eoff (1817–1897), son of silversmith Gerritt Eoff (1779–1845), at 83 Duane Street, Manhattan, in 1852–53. In 1855, the firm employed twenty men and five boys, used steam-powered machinery, and produced wares valued at $36,832. Edgar and his parents are buried in Green-Wood Cemetery, Brooklyn, New York. See Waters, *Elegant Plate*, 2:407, 450, 477–82. Cornelia Hannah Butler (1814–1892) married Abraham Van Alen of Stuyvesant Falls, New York, on May 20, 1847, according to *Christian Intelligencer of the Reformed Dutch Church* 17, no. 880 (June 10, 1847).

SILVER & OTHER METALS: ENTRIES

210 "Philip Syng, 1703–1789," *Penn People A–Z*, University Archives & Records Center, University of Pennsylvania, https://archives.upenn.edu/exhibits/penn-people/biography/philip-syng/.

211 Kathryn C. Buhler, *Mount Vernon Silver* (Mount Vernon, Va.: Mount Vernon Ladies' Association of the Union, 1957), 50.

212 Buhler, *Mount Vernon Silver*, 71–72.

213 "Bancroft Woodcock, 1732–1817," American Silversmiths, https://www.americansilversmiths.org/makers/silversmiths/119446.htm.

214 Sotheby's, *Important Americana*, 2018, lot 1136, https://www.sothebys.com/en/auctions/ecatalogue/2018/important-americana-n09805/lot.1136.html.

215 Revere to Frederick William Geyer, January 19, 1784, in Deborah A. Federhen, "From Artisan to Entrepreneur: Paul Revere's Silver Shop Operation," in Paul M. Leehey et al., *Paul Revere: Artisan, Businessman, and Patriot: The Man Behind the Myth* (Boston: Paul Revere Memorial Association, 1988), 85.

216 "1793 Washington President Oval Peace Medal," Heritage Auctions, 2021, lot 3056, https://coins.ha.com/itm/washingtonia/1793-george-washington-president-oval-engraved-indian-peace-medal-silver-by-joseph-richardson-baker-174-unlisted-belden-8/a/1329-3056.s.

217 George Washington, "December 8: 1790: Second Annual Message to Congress," transcript, Miller Center, University of Virginia, https://millercenter.org/the-presidency/presidential-speeches/december-8-1790-second-annual-message-congress.

218 "The Institution of the Society of the Cincinnati," Society of the Cincinnati, https://www.societyofthecincinnati.org/institution-the-society-of-the-cincinnati/.

219 "Institution of the Society of the Cincinnati."

220 Abraham Lincoln, "Eulogy on Henry Clay," July 6, 1852, Abraham Lincoln Online, https://www.abrahamlincolnonline.org/lincoln/speeches/clay.htm.

221 Ullmann to Lincoln, January 25, 1861, "Massive U.S. Mint Medal . . . Struck for Presentation to Henry Clay . . . ," Heritage Auctions, https://historical.ha.com/itm/political/massive-us-mint-medal-of-pure-california-gold-struck-for-presentation-to-henry-clay-lincoln-s-own-ideal-of-a-great-man/a/6163-43082.s?ic4=ListView-ShortDescription-071515.

SELECTED
BIBLIOGRAPHY

For further information about the Diplomatic Reception Rooms and the collection, please see the website: www.diplomaticrooms.state.gov.

ADAMSON, Jeremy Elwell. *Niagara: Two Centuries of Changing Attitudes, 1697–1701*. Washington, D.C.: Corcoran Gallery of Art, 1985.

ANDERSON, Jennifer L. *Mahogany: The Costs of Luxury in Early America*. Cambridge, Mass.: Harvard University Press, 2012.

ANDREWS, William Loring. *Paul Revere and His Engraving*. New York: Charles Scribner's Sons, 1901.

BARQUIST, David L. *American Tables and Looking Glasses in the Mabel Brady Garvan and Other Collections at Yale University*. New Haven: Yale University Art Gallery, 1992.

———. *Myer Myers: Jewish Silversmith in Colonial New York*. With essays by Jon Butler and Jonathan D. Sarna. New Haven: Yale University Art Gallery in association with Yale University Press, 2001.

BARRATT, Carrie Rebora, and Ellen G. Miles. *Gilbert Stuart*. New York: Metropolitan Museum of Art; New Haven, Yale University Press, 2004.

BECKERDITE, Luke. "A Problem of Identification: Philadelphia and Baltimore Furniture Styles in the Eighteenth Century." *Journal of Early Southern Decorative Arts* 12, no. 1 (May 1986): 20–65.

BELDEN, Louise Conway. *The Festive Tradition: Table Decoration and Desserts in America, 1650–1900*. New York: W. W. Norton, 1983.

———. *Marks of American Silversmiths in the Ineson-Bissell Collection*. Charlottesville: University Press of Virginia for the Henry Francis du Pont Winterthur Museum, 1980.

BENES, Peter. *Old-Town and the Waterside: Two Hundred Years of Tradition and Change in Newbury, Newburyport, and West Newbury, 1635–1835*. With assistance from Gregory H. Laing and Wilhelmina V. Lunt. Newburyport, Mass.: Historical Society of Old Newbury, 1986.

BIAŁOSTOCKI, Jan. "The *Firing Squad* from Paul Revere to Goya: The Formation of a New Pictorial Theme in America, Russia, and Spain." In *The Message of Images: Studies in the History of Art*, 211–18. Vienna: IRSA Verlag, 1988.

BIDDLE, Edward, and Mantle Fielding. *The Life and Works of Thomas Sully (1783–1872)*. Philadelphia: privately printed, 1921.

BIDDLE, James. *American Art from American Collections: Decorative Arts, Paintings, and Prints of the Colonial and Federal Periods [. . .]*. New York: Metropolitan Museum of Art, 1963.

BLACKHAWK, Ned. *Violence over the Land: Indians and Empires in the Early American West*. Cambridge, Mass.: Harvard University Press, 2006.

BLACKIE and Son. *The Victorian Cabinet-Maker's Assistant*. With a new introduction by John Gloag. 1853. Reprint, New York: Dover, 1970.

BRIGHAM, Clarence S. *Paul Revere's Engravings*. Rev. ed. New York: Atheneum, 1969.

BROWN, Joan Sayers. "Skippets." *Magazine Antiques* 114, no. 1 (July 1978): 140–41.

BUHLER, Kathryn C. *American Silver, 1655–1825, in the Museum of Fine Arts, Boston*. 2 vols. Boston: Museum of Fine Arts, Boston, 1972.

[———]. *Silver Supplement to the Guidebook to the Diplomatic Reception Rooms*. Washington, D.C.: U.S. Department of State, 1973.

BUHLER, Kathryn C., and Graham Hood. *American Silver: Garvan and Other Collections in the Yale University Art Gallery*. 2 vols. New Haven: Yale University Press for the Yale University Art Gallery, 1970.

BUSHMAN, Richard L. *The Refinement of America: Persons, Houses, Cities*. New York: Vintage Books, 1993.

CARPENTER JR., Ralph E. *The Arts and Crafts of Newport, Rhode Island, 1640–1820*. Newport, R.I.: Preservation Society of Newport County, 1954.

CHIPPENDALE, Thomas. *The Gentleman & Cabinet-Maker's Director [. . .]*. 1754. Reprint, New York: Dover, 1966.

CLEMENT, Arthur W. *Our Pioneer Potters*. New York: privately printed, 1947.

CLUNIE, Margaret. "Joseph True and the Piecework System in Salem." *Magazine Antiques* 111, no. 5 (May 1977): 1006–13.

COMSTOCK, Helen. *The Looking Glass in America, 1700–1825*. New York: Viking, 1968.

CONGER, Clement E. "Chippendale Furniture in the Department of State Collection." *American Art Journal* 8, no. 1 (May 1976): 84–98.

———. "The Genesis and Development of the State Department Collection." In "Treasures from the White House and Department of State." Special issue, *Connoisseur* 192, no. 771 (May 1976): 64–72.

CONGER, Clement E., Allan Greenberg, Paul Goldberger, Frederick D. Nichols, John Wilmerding, Harold Sack, Jennifer Faulds Goldsborough, and Elinor Gordon. "The Diplomatic Reception Rooms United States Department of State." Special issue, *Magazine Antiques* 132, no. 1 (July 1987).

CONGER, Clement E., et al. *Treasures of State: Fine and Decorative Arts in the Diplomatic Reception Rooms of the U.S. Department of State*. Edited by Alexandra W. Rollins. New York: Harry N. Abrams, 1991.

COOKE JR., Edward S. *Inventing Boston: Design, Production, and Consumption, 1680–1720*. New Haven: Yale University Press for the Paul Mellon Centre for Studies in British Art, 2019.

———, ed. *Upholstery in America and Europe from the Seventeenth Century to World War I*. New York: W. W. Norton, 1987.

COOPER, Wendy A. *In Praise of America: American Decorative Arts, 1650–1830; Fifty Years of Discovery since the 1939 Girl Scouts Loan Exhibition*. New York: Alfred A. Knopf, 1980.

CORNELIUS, Charles Over. *Furniture Masterpieces of Duncan Phyfe*. 1922. Reprint, New York: Dover, 1970.

COWDREY, Mary Bartlett. *American Academy of Fine Arts and American Art-Union: Exhibition Record, 1816–1852*. 2 vols. New York: New-York Historical Society, 1953.

CRAMER, Diana. "Wood and Hughes." *Silver* 22, no. 6 (November–December 1989): 28–32.

CUMMING, William P. *North Carolina in Maps*. Raleigh, NC: State Department of Archives and History, 1966.

———. *The Southeast in Early Maps*. Princeton: Princeton University Press, 1958.

CUMMINGS, Abbott Lowell, ed. *Rural Household Inventories: Establishing the Names, Uses and Furnishings of Rooms in the Colonial New England Home, 1675–1775*. Boston: Society for the Preservation of New England Antiquities, 1964.

CURTIS, Phillip H. "The Production of Tucker Porcelain, 1826–1838: A Reevaluation." In *Ceramics in America*, edited by Ian M. G. Quimby, 339–74. Winterthur Conference Report, 1972. Charlottesville: University Press of Virginia for the Henry Francis du Pont Winterthur Museum, 1973.

DAVIS, Elliot Bostwick. "The Currency of Culture: Prints in New York City." In *Art and the Empire City: New York, 1825–1861*, edited by Catherine Hoover Voorsanger and John K. Howat, 189–226. New York: Metropolitan Museum of Art, 2000.

DEÁK, Gloria Gilda. *Picturing America, 1497–1899: Prints, Maps, and Drawings Bearing on the New World Discoveries and on the Development of the Territory That Is Now the United States*. 2 vols. Princeton: Princeton University Press, 1988.

DE GUILLEBON, Régine de Plinval. *Porcelain of Paris, 1770–1850*. Translated by Robin R. Charleston. New York: Walker, 1972.

DENKER, Ellen. *After the Chinese Taste: China's Influence in America, 1730–1930*. Salem, Mass.: Peabody Museum of Salem, 1985.

DETWEILER, Susan Gray. *George Washington's Chinaware*. New York: Harry N. Abrams, 1982.

DOWNS, Joseph. *American Furniture: Queen Anne and Chippendale Periods in the Henry Francis du Pont Winterthur Museum*. New York: Macmillan, 1952.

DURHAM, Harriet Frorer. *Caribbean Quakers*. Hollywood, Fla.: Dukane Press, 1972.

EFIRD, Callie Huger. *Chinese Export Porcelain from the Reeves Collection at Washington and Lee University*. With a contribution by Katharine Gross Farnham. Lexington, Va.: Washington and Lee University, 1973.

EHRENFRIED, Albert. *A Chronicle of Boston Jewry from the Colonial Settlement to 1900*. Boston: privately printed, 1963.

ELAM, Charles H., ed. *The Peale Family: Three Generations of American Artists*. Detroit: Detroit Institute of Arts, 1967.

ELDER III, William Voss, and Lu Bartlett. *John Shaw: Cabinetmaker of Annapolis*. Baltimore: Baltimore Museum of Art, 1983.

ELDER III, William Voss, and Jayne E. Stokes. *American Furniture, 1680–1880, from the Collection of the Baltimore Museum of Art*. Baltimore: Baltimore Museum of Art, 1987.

EVANS, Dorinda. *Benjamin West and His American Students*. Washington, D.C.: Smithsonian Institution Press for the National Portrait Gallery, 1980.

FAILEY, Dean F. *Elias Pelletreau: Long Island Silversmith and Entrepreneur, 1726–1810*. With contributions by Deborah Dependahl Waters and David L. Barquist. Edited by Jennifer L. Anderson. Cold Spring Harbor, N.Y.: Preservation Long Island, 2018.

FAIRBANKS, Jonathan L. *Becoming a Nation: Americana from the Diplomatic Reception Rooms. U.S. Department of State*. Edited by Gerald W. R. Ward. New York: Rizzoli, 2003.

———. "Queen Anne and Chippendale Furniture: Department of State Diplomatic Reception Rooms, Washington, D.C." In "Treasures from the White House and Department of State." Special issue, *Connoisseur* 192, no. 771 (May 1976): 48–55.

FAIRBANKS, Jonathan L., and Elizabeth Bidwell Bates. *American Furniture: 1620 to the Present*. New York: Richard Marek, 1981.

FAIRBANKS, Jonathan L., Wendy A. Cooper, Anne Farnam, Brock W. Jobe, and Martha B. Katz-Hyman. *Paul Revere's Boston, 1735–1818*. With an introduction by Walter Muir Whitehill. Boston: Museum of Fine Arts, Boston, 1975.

FAIRMAN, Charles E. *Art and Artists of the Capitol of the United States of America*. Washington, D.C.: U.S. Government Printing Office, 1927.

FALES JR., Dean A. *Essex County Furniture: Documented Treasures from Local Collections, 1660–1860*. Salem, Mass.: Essex Institute, 1965.

FALES, Martha Gandy. *Early American Silver*. Rev. ed. New York: E. P. Dutton, 1973.

———. *Joseph Richardson and Family: Philadelphia Silversmiths*. Middletown, Conn.: Wesleyan University Press for the Historical Society of Pennsylvania, 1974.

FALINO, Jeannine, and Gerald W. R. Ward, eds. *New England Silver & Silversmithing, 1620–1815*. Boston: Colonial Society of Massachusetts, 2001.

FENNIMORE, Donald L. *Metalwork in Early America: Copper and Its Alloys from the Winterthur Collection*. Winterthur, Del.: Henry Francis du Pont Winterthur Museum, 1996.

FENNIMORE, Donald L., and Ann K. Wagner. *Silversmiths to the Nation: Thomas Fletcher and Sidney Gardiner, 1808–1842*. With contributions by Cathy Matson, Deborah Dependahl Waters, and Beth Carver Wees. Woodbridge, Suffolk: Antique Collectors' Club for the Henry Francis du Pont Winterthur Museum, 2007.

FITZGERALD, Oscar P. *Three Centuries of American Furniture*. Englewood Cliffs, N.J.: Prentice-Hall, 1982.

FLANIGAN, J. Michael. *American Furniture from the Kaufman Collection*. Washington, D.C.: National Gallery of Art, 1986.

FLYNT, Henry N., and Martha Gandy Fales. *The Heritage Foundation Collection of Silver, with Biographical Sketches of New England Silversmiths, 1625–1825*. Old Deerfield, Mass.: Heritage Foundation, 1968.

FORBES, H. A. Crosby. *Yang ts'ai: The Foreign Colors; Rose Porcelains of the Ch'ing Dynasty*. Milton, Mass.: China Trade Museum, 1982.

FORMAN, Benno M. *American Seating Furniture, 1630–1730: An Interpretive Catalogue*. New York: W. W. Norton, 1987.

———. "German Influences in Pennsylvania Furniture." In *Arts of the Pennsylvania Germans*. Edited by Catherine E. Hutchins, 102–70. New York: W. W. Norton for the Henry Francis du Pont Winterthur Museum, 1983.

FOWBLE, E. McSherry. *Two Centuries of Prints in America, 1680–1880: A Selective Catalogue of the Winterthur Museum Collection*. Charlottesville: University Press of Virginia for the Henry Francis du Pont Winterthur Museum, 1987.

FOWLER, John, and John Cornforth. *English Decoration in the 18th Century*. Princeton: Pyne Press, 1974.

FRANCIS, Rell G. *Cyrus E. Dallin: Let Justice Be Done*. Springville, Utah: Springville Museum of Art, 1976.

FRANK, Robin Jaffee. *Love and Loss: American Portrait and Mourning Miniatures*. New Haven: Yale University Art Gallery; Yale University Press, 2000.

FREDERICKSON, N. Jaye, and Sandra Gibb. *The Covenant Chain: Indian Ceremonial and Trade Silver*. Ottawa: National Museums of Canada, 1980.

FRÉGNAC, Charles, ed. *Les porcelainiers du XVIIIe siècle français*. Paris: Hachette, 1964.

FRELINGHUYSEN, Alice Cooney. "Paris Porcelain in America." *Magazine Antiques* 153, no. 4 (April 1998): 554–63.

———. "Tucker Porcelain, Philadelphia, 1826–1838." *Magazine Antiques* 135, no. 4 (April 1989): 918–29.

FRENCH, Hollis. *Jacob Hurd and His Sons Nathaniel & Benjamin, Silversmiths, 1702–1781*. 1939. Reprint, New York: Da Capo Press, 1972.

FRYD, Vivien Green. *Art and Empire: The Politics of Ethnicity in the United States Capitol, 1815–1860*. New Haven: Yale University Press, 1992.

GARRETT, Elisabeth Donaghy. *The Arts of Independence: The DAR Museum Collection*. Washington, D.C.: National Society of the Daughters of the American Revolution, 1985.

GERDTS, William H., and Russell Burkc. *American Still-Life Painting*. New York: Praeger, 1971.

GORDON, Elinor. *Collecting Chinese Export Porcelain*. New York: Universe, 1977.

GOTTESMAN, Rita Susswein. *The Arts and Crafts in New York, 1726–1776: Advertisements and News Items from New York City Newspapers*. New York: New-York Historical Society, 1938. Reprint, New York: Da Capo Press, 1970.

GREENBERG, Allan. *Allan Greenberg: Classical Architect*. New York: Rizzoli, 2013.

———. *Architecture of Democracy*. New York: Rizzoli, 2006.

———. "Diplomatic Reception Rooms, U.S. Department of State, 1984." *Architectural Design: Contemporary Architecture* 58, nos. 7/8 (1988).

GREENTHAL, Kathryn, Paula M. Kozol, and Jan Seidler Ramirez. *American Figurative Sculpture in the Museum of Fine Arts, Boston*. With an introductory essay by Jonathan L. Fairbanks. Boston: Museum of Fine Arts, Boston, 1986.

HALL JR., Virginius Cornick, comp. *Portraits in the Collection of the Virginia Historical Society: A Catalogue*. Charlottesville: University Press of Virginia for the Virginia Historical Society, 1981.

HAYWARD, Helena, and Pat Kirkham. *William and John Linnell: Eighteenth Century London Furniture Makers*. 2 vols. New York: Rizzoli, 1980.

HECKSCHER, Morrison H. *American Furniture in the Metropolitan Museum of Art*. Vol. 2, *Late Colonial Period: The Queen Anne and Chippendale Styles*. New York: Metropolitan Museum of Art; Random House, 1985.

———. "The New York Serpentine Card Table." *Magazine Antiques* 103, no. 5 (May 1973): 974–83.

HECKSCHER, Morrison H., and Leslie Greene Bowman. *American Rococo, 1750–1775: Elegance in Ornament*. New York: Metropolitan Museum of Art; Los Angeles: Los Angeles County Museum of Art, 1992.

HERVOUËT, François, Nicole Hervouët, and Yves Bruneau. *La Porcelaine des compagnies des Indes: À décor occidental*. Paris: Flammarion, 1986.

HEWITT, Benjamin A., Patricia E. Kane, and Gerald W. R. Ward. *The Work of Many Hands: Card Tables in Federal America, 1790–1820*. New Haven: Yale University Art Gallery, 1982.

HINCKLEY, F. Lewis. *A Directory of Queen Anne, Early Georgian, and Chippendale Furniture: Establishing the Preeminence of the Dublin Craftsmen*. 1953. Reprint, New York: Crown, 1971.

HIPKISS, Edwin J. *Eighteenth-Century American Arts: The M. and M. Karolik Collection of Paintings, Drawings, Engravings, Furniture, Silver, Needlework, and Incidental Objects Gathered to Illustrate the Achievements of American Artists and Craftsmen of the Period from 1720 to 1820*. 1941. Reprint, Cambridge, Mass.: Harvard University Press for the Museum of Fine Arts, Boston, 1950.

HOHMANN III, Frank L. *Timeless: Masterpiece American Brass Dial Clocks*. With essays by Donald L. Fennimore, David F. Wood, and Kirtland H. Crump, biographies by Martha Willoughby, and a foreword by Morrison H. Heckscher. New York: Hohmann Holdings, 2009.

HORNOR JR., William Macpherson. *Blue Book, Philadelphia Furniture: William Penn to George Washington*. 1935. Reprint, Washington, D.C.: Highland House, 1977.

HOWARD, David Sanctuary. *Chinese Armorial Porcelain*. London: Faber & Faber, 1974.

———. *New York and the China Trade*. With an essay by Conrad Edick Wright. New York: New-York Historical Society, 1984.

HOWARD, David Sanctuary, and John Ayers. *China for the West: Chinese Porcelain and Other Decorative Arts for Export Illustrated from the Mottahedeh Collection*. 2 vols. London: Sotheby Parke-Bernet, 1978.

HUMMEL, Charles F. *A Winterthur Guide to American Chippendale Furniture: Middle Atlantic and Southern Colonies*. New York: Crown, 1976.

HUNNEWELL, James Frothingham. *A Century of Town Life: A History of Charlestown, Massachusetts, 1775–1887*. Boston: Little, Brown, 1888.

HUNTER, Robert. "John Bartlam: America's First Porcelain Manufacturer." *Ceramics in America 2007* (Chipstone Foundation) 7 (2007): 193–96.

HURST, Ronald L., and Jonathan Prown. *Southern Furniture, 1680–1830: The Colonial Williamsburg Collection*. Williamsburg, Va.: Colonial Williamsburg Foundation, 1997.

INCE, William, and John Mayhew. *The Universal System of Household Furniture*. 1762. Reprint, London: Alec Tiranti, 1960.

JOBE, Brock W., ed. *Portsmouth Furniture: Masterworks from the New Hampshire Seacoast*. Boston: Society for the Preservation of New England Antiquities, 1993.

JOBE, Brock, and Myrna Kaye. *New England Furniture: The Colonial Era; Selections from the Society for the Preservation of New England Antiquities*. With the assistance of Philip Zea. Boston: Houghton Mifflin, 1984.

JONES, Samuel. *Pittsburgh in the Year 1826*. 1826. Reprint, New York: Arno, 1970.

JÖRG, C. F. A. *Porcelain and the Dutch China Trade*. The Hague: Martinus Nijhoff, 1982.

JOY, Edward T. *English Furniture, 1800–1851*. London: Sotheby Parke-Bernet; Ward Lock, 1977.

KANE, Patricia E., ed.. *Colonial Massachusetts Silversmiths and Jewelers: A Biographical Dictionary Based on the Notes of Francis Hill Bigelow and John Marshall Phillips*. New Haven: Yale University Art Gallery, 1998.

———. *300 Years of American Seating Furniture: Chairs and Beds from the Mabel Brady Garvan and Other Collections at Yale University*. Boston: New York Graphic Society, 1976.

KANE, Patricia E., with Dennis Carr, Nancy Goyne Evans, Jennifer N. Johnson, and Gary R. Sullivan. *Art and Industry in Early America: Rhode Island Furniture, 1650–1830*. New Haven: Yale University Art Gallery, 2016.

KENNY, Peter M., with Frances F. Bretter and Ulrich Leben. *Honoré Lannuier, Cabinetmaker from Paris: The Life and Work of a French Ébéniste in Federal New York*. New York: Metropolitan Museum of Art, 1998.

KIRK, John T. *American Furniture and the British Tradition to 1830*. New York: Alfred A. Knopf, 1982.

KIRTLEY, Alexandra Alevizatos. *American Furniture, 1650–1840: Highlights from the Philadelphia Museum of Art*. Philadelphia: Philadelphia Museum of Art in association with Yale University Press, 2021.

KLAPTHOR, Margaret Brown. *Official White House China: 1789 to the Present*. 2nd ed. New York: Barra Foundation in association with Harry N. Abrams, 1999.

KLOSS, William. *Treasures from the National Museum of American Art*. Washington, D.C.: National Museum of American Art; Baltimore: Smithsonian Institution Press, 1985.

KOHN, Richard H. *Eagle and Sword: The Federalists and the Creation of the Military Establishment in America, 1783–1802*. New York: Free Press, 1975.

KORNHAUSER, Elizabeth Mankin, and Tim Barringer. *Thomas Cole's Journey: Atlantic Crossings*. New York: Metropolitan Museum of Art, 2018.

KUSSEROW, Karl, and Alan C. Braddock, eds. *Nature's Nation: American Art and Environment*. Princeton: Princeton University Art Museum, 2018.

LANGE, Amanda E. *Chinese Export Art at Historic Deerfield*. Deerfield, Mass.: Historic Deerfield, 2005.

LE CORBEILLER, Claire. "China Trade Armorial Porcelain in America." *Magazine Antiques* 112, no. 6 (December 1977): 1124–29.

———. *China Trade Porcelain: Patterns of Exchange*. New York: Metropolitan Museum of Art, 1974.

LEEHEY, Paul M., Janine E. Skerry, Deborah A. Federhen, Edgard Moreno, and Edith J. Steblecki. *Paul Revere: Artisan, Businessman, and Patriot: The Man Behind the Myth*. Boston: Paul Revere Memorial Association, 1988.

LEWIS, Sarah Elizabeth. "The Arena of Suspension: Carrie Mae Weems, Bryan Stevenson, and the 'Ground' in the Stand Your Ground Law Era." In "Law and Contemporary Art." Special issue, *Law & Literature* 33, no. 3 (July 12, 2021): 487–518.

LOCKWOOD, Luke Vincent. *Colonial Furniture in America*. 3rd ed. 2 vols. 1926. Reprint, New York: Castle Books, 1951.

MACQUOID, Percy, and Ralph Edwards. *The Dictionary of English Furniture from the Middle Ages to the Late Georgian Period*. 3 vols. London: Country Life, 1924–27.

MARGOLIN, Sam. "'And Freedom to the Slave': Antislavery Ceramics, 1787–1865." *Ceramics in America 2002* (Chipstone Foundation) 2 (2002): 80–109.

MCCAULEY, Robert H. *Liverpool Transfer Designs on Anglo-American Pottery*. Portland, Maine: Southworth-Anthoensen Press, 1942.

MCELROY, Cathryn J. "Furniture of the Philadelphia Area: Forms and Craftsmen before 1730." Master's thesis, University of Delaware, 1970.

MILLER, V. Isabelle. *Furniture by New York Cabinetmakers, 1650 to 1860*. New York: Museum of the City of New York, 1956.

MONKHOUSE, Christopher P., and Thomas S. Michie. *American Furniture in Pendleton House*. With the assistance of John M. Carpenter. Providence: Museum of Art, Rhode Island School of Design, 1986.

MONKMAN, Betty C. *The White House: Its Historic Furnishings and First Families*. New York: Abbeville, 2000.

MONTGOMERY, Charles F. *American Furniture: The Federal Period in the Henry Francis du Pont Winterthur Museum*. New York: Viking, 1966.

MONTGOMERY, Charles F., and Patricia E. Kane, eds. *American Art: 1750–1800, Towards Independence*. Boston: New York Graphic Society for the Yale University Art Gallery and the Victoria and Albert Museum, 1976.

MORRISON, Russell, Edward C. Papenfuse, Nancy M. Bramucci, and Robert J. H. Janson-La Palme. *On the Map: An Exhibit and Catalogue of Maps Relating to Maryland and the Chesapeake Bay* [. . .]. Chestertown, Md.: Washington College, 1983.

MOSES, Michael. *Master Craftsmen of Newport: The Townsends and Goddards*. Tenafly, N.J.: MMI Americana Press, 1984.

MUDGE, Jean McClure. *Chinese Export Porcelain for the American Trade, 1785–1835*. 2nd ed. Newark: University of Delaware Press, 1981.

———. *Chinese Export Porcelain in North America*. New York: Clarkson N. Potter, 1986.

NAYLOR, Maria. "American Paintings in the Diplomatic Reception Rooms of the Department of State." *Connoisseur* 192, no. 773 (July 1976): 198–207.

NEFF, Emily Ballew, with Kaylin H. Weber. *American Adversaries: West and Copley in a Transatlantic World*. Houston: Museum of Fine Arts, Houston, 2013.

NEW-YORK HISTORICAL SOCIETY. *Catalogue of American Portraits in the New-York Historical Society*. 2 vols. New Haven: Yale University Press for the New-York Historical Society, 1974.

NOËL HUME, Ivor. "Creamware to Pearlware: A Williamsburg Perspective." In *Ceramics in America*, edited by Ian M. G. Quimby, 217–54. Winterthur Conference Report, 1972. Charlottesville: University Press of Virginia for the Henry Francis du Pont Winterthur Museum, 1973.

NYGREN, Edward J., Bruce Robertson, Amy R. W. Meyers, Therese O'Malley, Ellwood C. Parry III, and John R. Stilgoe. *Views and Visions: American Landscape before 1830*. Washington, D.C.: Corcoran Gallery of Art, 1986.

OLIVER, Andrew. *Portraits of John Quincy Adams and His Wife*. Cambridge, Mass.: Belknap Press of Harvard University Press, 1970.

OTT, Joseph K, Clarkson A. Collins III, and Antoinette F. Downing. *The John Brown House Loan Exhibition of Rhode Island Furniture*. Providence: Rhode Island Historical Society, 1965.

PALMER, Arlene M. *A Winterthur Guide to Chinese Export Porcelain*. New York: Crown, 1976.

PARK, Lawrence, comp. *Gilbert Stuart: An Illustrated Descriptive List of His Works*. With contributions by John Hill Morgan, Royal Cortissoz, William Sawitzky, Mrs. E. Hadley Galbreath, and Theodore Bolton. 4 vols. New York: W. E. Rudge, 1926.

PATTERSON, Jerry E. *The City of New York: A History Illustrated from the Collections of the Museum of the City of New York*. New York: Harry N. Abrams, 1978.

PHILADELPHIA MUSEUM OF ART. *Philadelphia: Three Centuries of American Art*. Philadelphia: Philadelphia Museum of Art, 1976.

———. *Tucker China, 1825–1838* [. . .]. Philadelphia Museum of Art, 1957.

PIERCE, Sally, with Catharina Slautterback and Georgia Brady Barnhill. *Early American Lithography: Images to 1830*. Boston: Boston Athenaeum, 1997.

PRIME, Alfred Coxe. *The Arts & Crafts in Philadelphia, Maryland, and South Carolina*. Vol. 1, *1721–1785*. Topsfield, Mass.: Walpole Society, 1929.

———. *The Arts & Crafts in Philadelphia, Maryland, and South Carolina*. Vol. 2, *1786–1800*. Topsfield, Mass.: Walpole Society, 1932.

PROWN, Jules David. *John Singleton Copley, 1738–1815*. 2 vols. Cambridge, Mass.: Harvard University Press for the National Gallery of Art, 1966.

PRUCHA, Francis Paul. *Indian Peace Medals in American History*. Lincoln: University of Nebraska Press, 1971.

PUIG, Francis J., and Michael Conforti, eds. *The American Craftsman and the European Tradition, 1620–1820*. Minneapolis: Minneapolis Institute of Art, 1989.

RAINWATER, Dorothy T. *Encyclopedia of American Silver Manufacturers*. New York: Crown, 1966.

RALSTON, Ruth. "Franklin and Louis XVI: A Niderviller Group." *Bulletin of the Metropolitan Museum of Art* 20, no. 11 (November 1925): 271–73.

RANDALL JR., Richard H. *American Furniture in the Museum of Fine Arts, Boston*. Boston: Museum of Fine Arts, Boston, 1965.

RATHER, Susan. *The American School: Artists and Status in the Late Colonial and Early National Era*. New Haven: Yale University Press for the Paul Mellon Centre for Studies in British Art, 2016.

REBORA, Carrie, Paul Staiti, Erica E. Hirshler, Theodore E. Stebbins Jr., and Carol Troyen. *John Singleton Copley in America*. With contributions by Morrison H. Heckscher, Aileen Ribeiro, and Marjorie Shelley. New York: Metropolitan Museum of Art, 1995.

REED, Robert. *Old Washington, D.C., in Early Photographs, 1846–1932*. New York: Dover, 1980.

RICE, Norman S. *New York Furniture before 1840 in the Collection of the Albany Institute of History and Art*. Albany, N.Y.: Albany Institute of History and Art, 1962.

RODRIGUEZ ROQUE, Oswaldo. *American Furniture at Chipstone.* With a foreword by Stanley Stone. Madison: University of Wisconsin Press, 1984.

ROLLINS, Alexandra West. "Furniture in the Collection of the Dietrich American Foundation." In "American Furniture Issue." Special issue, *Magazine Antiques* 125, no. 5 (May 1984): 1100–1119.

ROSENBAUM, Jeanette W. *Myer Myers, Goldsmith, 1723–1795.* Philadelphia: Jewish Publication Society of America, 1954.

RUTLEDGE, Anna Wells, comp. and ed. *Cumulative Record of Exhibition Catalogues: The Pennsylvania Academy of the Fine Arts, 1807–1870; the Society of Artists, 1800–1814; the Artists' Fund Society, 1835–1845.* Philadelphia: American Philosophical Society, 1955.

SCHIFF, Stacy. *A Great Improvisation: Franklin, France, and the Birth of America.* New York: Henry Holt, 2005.

SCHWARTZ, Seymour I., and Ralph E. Ehrenberg. *The Mapping of America.* New York: Harry N. Abrams, 1980.

SELLERS, Charles Coleman. *Charles Willson Peale with Patron and Populace: A Supplement to Portraits and Miniatures by Charles Willson Peale.* Philadelphia: American Philosophical Society, 1969.

———. *Mr. Peale's Museum: Charles Willson Peale and the First Popular Museum of Natural Science and Art.* New York: W. W. Norton, 1980.

SHARPE, Elisabeth K. "Chinese Export Porcelain with Arms of Rhode Island." *Magazine Antiques* 139, no. 1 (January 1991): 246–55.

SHAW, Gwendolyn DuBois. *Portraits of a People: Picturing African Americans in the Nineteenth Century.* With contributions by Emily K. Shubert. Andover, Mass.: Addison Gallery of American Art, Phillips Academy, in association with University of Washington Press, 2006.

SHEPHERD JR., Raymond V. "Cliveden and Its Philadelphia-Chippendale Furniture: A Documented History." *American Art Journal* 8, no. 2 (November 1976): 2–16.

SHERATON, Thomas. *The Cabinet Dictionary* [. . .]. 2 vols. London, 1803. Reprint, New York: Praeger, 1970.

SMITH, Robert C. "Masterpieces of Early American Furniture at the United States Department of State." *Magazine Antiques* 98, no. 5 (November 1970): 766–73.

SMITH, Thomas E. V. *The City of New York in the Year of Washington's Inauguration, 1789.* 1889. Reprint, Riverside, Conn.: Chatham Press, 1972.

SPINOZZI, Adrienne, ed. *Hear Me Now: The Black Potters of Old Edgefield, South Carolina.* New York: Metropolitan Museum of Art, 2022.

SWAN, Mabel M. *Samuel McIntire, Carver, and the Sandersons: Early Salem Cabinet Makers.* Salem, Mass.: Essex Institute, 1934.

TEITELMAN, S. Robert, Patricia A. Halfpenny, and Ronald W. Fuchs II. *Success to America: Creamware for the American Market, featuring the S. Robert Teitelman Collection at Winterthur.* With essays by Wendell D. Garrett and Robin Emmerson. Woodbridge, Suffolk: Antique Collectors' Club, 2010.

TEMPLEMAN, Eleanor Lee. "The Lee Service of Cincinnati Porcelain." *Magazine Antiques* 118, no. 4 (October 1980): 758–59.

TILMANS, Emile. *Porcelaines de France.* Paris: Éditions Hypérion, 1953.

TOWNER, Donald. *The Leeds Pottery.* New York: Taplinger, 1965.

TRACY, Berry B. *Federal Furniture and Decorative Arts at Boscobel.* With painting documentation by Mary Black. New York: Boscobel Restoration and Harry N. Abrams, 1981.

TRACY, Berry B., Marilyn Johnson, Marvin D. Schwartz, and Suzanne Boorsch. *19th-Century America: Furniture and Other Decorative Arts.* New York: Metropolitan Museum of Art, 1970.

TRUETT, Randall Bond, ed. *Washington, D.C.: A Guide to the Nation's Capital.* Rev. ed. New York: Hastings House, 1968.

TRUETTNER, William H. *The Natural Man Observed: A Study of Catlin's Indian Gallery.* Washington, D.C.: Smithsonian Institution Press, 1979.

TYLER, Ron. *Visions of America: Pioneer Artists in a New Land.* New York: Thames and Hudson, 1983.

TYLER, Ron, with contributions by Linda Ayres, Walter H. Cadbury, Carol Clark, and Herman J. Viola and an introduction by Peter Hassrick. *American Frontier Life: Early Western Painting and Prints.* New York: Abbeville, 1987.

VERNER, Coolie. *Smith's Virginia and Its Derivatives: A Carto-Bibliographical Study of the Diffusion of Geographical Knowledge.* London: Map Collectors' Circle, 1968.

VON ERFFA, Helmut, and Allen Staley. *The Paintings of Benjamin West.* New Haven: Yale University Press, 1986.

VOORSANGER, Catherine Hoover, and John K. Howat, eds. *Art and the Empire City: New York, 1825–1861.* New York: Metropolitan Museum of Art, 2000.

WAINWRIGHT, Nicholas B. *Colonial Grandeur in Philadelphia: The House and Furniture of General John Cadwalader.* Philadelphia: Historical Society of Pennsylvania, 1964.

WARD, Barbara McLean. "'In a Feasting Posture': Communion Vessels and Community Values in Seventeenth- and Eighteenth-Century New England." *Winterthur Portfolio: A Journal of American Material Culture* 28, no. 1 (Spring 1988): 1–24.

WARD, Gerald W. R. *American Case Furniture in the Mabel Brady Garvan and Other Collections at Yale University.* New Haven: Yale University Art Gallery, 1988.

WARREN, David B. "Bancroft Woodcock: Silversmith, Friend, and Landholder." In Roland H. Woodward and David B. Warren, *Bancroft Woodcock, Silversmith.* Wilmington: Historical Society of Delaware, 1976.

———. *Bayou Bend: American Furniture, Paintings and Silver from the Bayou Bend Collection.* Houston: Museum of Fine Arts, Houston, 1975.

WATERHOUSE, Ellis. *Painting in Britain, 1530 to 1790.* 4th ed. New York: Penguin Books, 1978.

WEES, Beth Carver, with Medill Higgins Harvey. *Early American Silver in the Metropolitan Museum of Art.* New York: Metropolitan Museum of Art, 2013.

WEIDMAN, Gregory R. *Furniture in Maryland, 1740–1940: The Collection of the Maryland Historical Society.* Baltimore: Maryland Historical Society, 1984.

WEIL, Martin Eli. "A Cabinetmaker's Price Book." In "American Furniture and Its Makers," edited by Ian M. G. Quimby, 175–92. Special issue, *Winterthur Portfolio: A Journal of American Material Culture* 13 (1979).

WEINBERG, H. Barbara, and Carrie Rebora Barratt, eds. *American Stories: Paintings of Everyday Life, 1765–1915* (New York: Metropolitan Museum of Art, 2009).

WHITEHILL, Walter Muir, ed. *Boston Furniture of the Eighteenth Century: A Conference Held by the Colonial Society of Massachusetts, 11 and 12 May 1972, Boston.* With contributions by Brock Jobe and Jonathan Fairbanks. Boston: Colonial Society of Massachusetts, 1974.

WILMERDING, John, et al. *Paintings by Fitz Hugh Lane.* With contributions by Elizabeth Garrity Ellis, Franklin Kelly, Earl A. Powell III, and Erik A. R. Ronnberg Jr. Washington, D.C.: National Gallery of Art; New York: Harry N. Abrams, 1988.

WOODHOUSE JR., Samuel W. "Thomas Tufft." *Magazine Antiques* 12, no. 4 (October 1927): 292–93.

CONTRIBUTORS

BRI BROPHY (BB) is the deputy chief curator of the Diplomatic Reception Rooms, as well as a studio artist, designer, and writer. Her portfolio includes creative direction, content creation, outreach, and institutional strategy for the Rooms and their museum collection. She joined the Diplomatic Reception Rooms in 2010 from an academic background in the history of decorative arts with an emphasis on historical textiles and costume.

LAAREN BROWN has been a writer and editor for more than thirty years. While most of her writing covers art and natural history topics, she has worked on books and other publications covering a wide range of subjects, including business and economics, history, health care, crafts, Jewish ideas, and more. Her clients include the Metropolitan Museum of Art, HarperCollins, Time, Wolters Kluwer, and Harry N. Abrams.

ELLIOT BOSTWICK DAVIS, a 2022 Fellow in Harvard's Advanced Leadership Initiative, was formerly a curator at the Metropolitan Museum of Art, John Moors Cabot Chair at the Museum of Fine Arts, Boston, and director of the Norton Museum of Art. She has published extensively on American art by Fitz Henry Lane, Winslow Homer, Edward Hopper, Mary Cassatt, and Jamie Wyeth, as well as on African American artists and American works on paper. A cum laude graduate of Princeton University, Dr. Davis received her doctorate in art and archaeology from Columbia University.

ALICE COONEY FRELINGHUYSEN, the Anthony W. and Lulu C. Wang Curator of American Decorative Arts at the Metropolitan Museum of Art, graduated from Princeton University and received her M.A. from the Winterthur/University of Delaware Program in Early American Culture. At the Met, she has curated and published widely on American ceramics, glass, stained glass, late nineteenth-century furniture, and the work of Louis C. Tiffany. In 2016 she presented the Clarice Smith Distinguished Scholar lecture for the Smithsonian American Art Museum, and in 2014, she received the Frederic E. Church Award for contributions to American culture.

ALLAN GREENBERG (AG) is an American architect, born and trained in South Africa. In the 1970s, he initiated the current resurgence of classical architecture with a series of residential homes; the exhibition *The Architecture of Sir Edwin Landseer Lutyens* at the Museum of Modern Art, New York; and the Treaty Room suite and Offices of the Secretary of State in the Diplomatic Reception Rooms. He was the first American to win the Richard H. Driehaus Prize for Classical Architecture. Among his many books are *George Washington, Architect* and *The Architecture of Democracy*. Among his many buildings are the Humanities Building and the new Brockman Opera House, both at Rice University.

VIRGINIA B. HART is the Diplomatic Reception Rooms' fifth director and curator, having previously served as assistant curator. Since joining in 2008, she has established the Rooms as a robust and publicly accessible museum collection, spearheading major renovation projects, leading collection conservation and research, improving the visitor experience, and upgrading the online catalogue and educational programming.

MARK ALAN HEWITT (MAH) is an architect, preservationist, and architectural historian, especially known for his work on architectural history and the history of architectural drawing. He has taught at leading schools of architecture, and his numerous publications include the award-winning *The Architect and the American Country House* and *Gustav Stickley's Craftsman Farms*. He received his master of architecture degree from the University of Pennsylvania, where he studied with Allan Greenberg.

JOHN F. KERRY currently serves as our nation's first special presidential envoy for climate. Previously, as the sixty-eighth U.S. secretary of state, he guided the department's strategy on nuclear nonproliferation and on actions to combat radical extremism and the threat of climate change. His tenure was marked by the successful negotiation of the Iran nuclear deal and the Paris Climate Agreement. From 1985 to 2013, he served as a U.S. senator representing Massachusetts, and he was chairman of the Senate Foreign Relations Committee from 2009 to 2013.

ALEXANDRA ALEVIZATOS KIRTLEY is the Montgomery-Garvan Curator of American Decorative Arts at the Philadelphia Museum of Art, where she began her curatorial career in 2001. Known for her innovative art historical approach to American furniture, she curated the groundbreaking exhibition *Classical Splendor: Painted Furniture for a Grand Philadelphia House*, the 2016 collaboration with conservator Peggy Olley, and the museum's new early American galleries that opened in 2021. Kirtley is the author of *American Furniture, 1650–1840: Highlights from the Philadelphia Museum of Art* (2020).

ELIZABETH MANKIN KORNHAUSER, an expert in the field of American painting, is the Alice Pratt Brown Curator of American Paintings and Sculpture at the Metropolitan Museum of Art. Previously Dr. Kornhauser held curatorial and leadership positions at the Wadsworth Atheneum Museum of Art. At the Wadsworth and the Met, she has broadened collecting and programming to be more inclusive of underrepresented artists. Her major exhibitions range from *Thomas Cole's Journey: Atlantic Crossings* to *Marsden Hartley*.

DAVID M. RUBENSTEIN, a financier and philanthropist, is cochair of Carlyle and chair of the boards of the John F. Kennedy Center for the Performing Arts, the Council on Foreign Relations, and the University of Chicago. He is host of *The David Rubenstein Show: Peer-to-Peer Conversations* on Bloomberg TV and author of four books, including *How to Invest: Masters on the Craft*. Mr. Rubenstein graduated from Duke University and the University of Chicago Law School.

DURSTON SAYLOR's photography has defined the imaging of contemporary interior design and architecture for the last thirty years. Recognized for his twenty-five-year association with *Architectural Digest*, he has also contributed to numerous books, such as *American Houses: The Architecture of Fairfax and Sammons* and *Blair House: The President's Guest House*. Assignments have included the residence of the vice president at the U.S. Naval Observatory and the Villa Aurelia at the American Academy in Rome, and he maintains an ongoing relationship with the Diplomatic Reception Rooms.

STACY SCHIFF is the author of *Véra (Mrs. Vladimir Nabokov)*, winner of the Pulitzer Prize; *Saint-Exupéry*, a Pulitzer finalist; and *A Great Improvisation: Franklin, France, and the Birth of America*, winner of the George Washington Book Prize. Her latest book is *The Revolutionary: Samuel Adams*, and two other recent books, *Cleopatra: A Life* and *The Witches: Salem, 1692*, have been no. 1 bestsellers. She has received fellowships from the Guggenheim Foundation, the National Endowment for the Humanities, and the Cullman Center for Scholars and Writers at the New York Public Library. Inducted into the American Academy of Arts and Letters in 2019, she has been named a Chevalier of the French Ordre des Arts et des Lettres.

CAROLYN VAUGHAN is a writer and editor of art books, exhibition catalogues, and children's books; she was formerly on staff at the Metropolitan Museum of Art and at the Museum of Fine Arts, Houston. She compiled *Michelangelo's Notebooks: The Poetry, Letters, and Art of the Great Master*, and she is the author of *First Ladies* in the FANDEX Family Field Guides series.

DEBORAH DEPENDAHL WATERS, Ph.D., is an independent decorative arts historian and part-time assistant professor at Parsons School of Design, the New School. She guest-curated the 2018 exhibition *Elias Pelletreau: Long Island Silversmith and Entrepreneur* and contributed to the publication. Other recent publications include *A Handsome Cupboard of Plate: Early American Silver in the Cahn Collection* (2012) and *The Jewelry and Metalwork of Marie Zimmermann* (2011). Dr. Waters received her M.A. and Ph.D. from the University of Delaware.

BRUCE M. WHITE photographs works of art and historic architecture for leading museums, noted artists, and government institutions. His images illustrate more than three hundred art books; prestigious awards include several George Wittenborn ARLIS Prizes. After working at Sotheby's New York and the Metropolitan Museum of Art, he established an independent studio in 1992. He is a member of the Editorial Advisory Board of the White House Historical Association and a member of the Royal Oak Foundation and the Victorian Society in America.

INDEX

IMAGE CREDITS

First published in the United States of America in 2023 by

Rizzoli Electa
A Division of Rizzoli International Publications, Inc.
300 Park Avenue South
New York, NY 10010
www.rizzoliusa.com

In association with

The Diplomatic Reception Rooms
U.S. Department of State
2201 C Street, NW #8213
Washington, D.C. 20520
www.diplomaticrooms.state.gov

Photography of views of the Diplomatic Reception Rooms © 2023 Durston Saylor
Photography of the Diplomatic Reception Rooms' collection © 2023 Bruce M. White

For Rizzoli Electa:
Publisher: Charles Miers
Associate Publisher: Margaret Rennolds Chace
Senior Editor: Ellen R. Cohen
Production Manager: Alyn Evans
Copyeditor: Richard Slovak
Proofreader: Marian Appellof

For the Diplomatic Reception Rooms:
Director and Curator: Virginia B. Hart
Deputy Chief Curator: Bri Brophy
General Editor: Janice Yablonski-Hickey
Project Managing Editor: Carolyn Vaughan
Editorial Associates: Nicholas H. Allison, Carrie Wicks

Design: Sarah Gifford

2024 2025 2026 2027 / 10 9 8 7 6 5 4 3 2

ISBN: 978-0-8478-7327-2 (Rizzoli Electa hardcover edition)
ISBN: 978-0-8478-7388-3 (Diplomatic Reception Rooms deluxe edition)
Library of Congress Control Number: 2023934216

PRINTED IN ITALY

MIX
Paper | Supporting
responsible forestry
FSC
www.fsc.org FSC® C013123

Unless otherwise noted, all works
of art are from the collection of the
Diplomatic Reception Rooms,
U.S. Department of State.

ON THE JACKET
One from a pair of vases (detail),
ca. 1824–30; Paris, France;
hard-paste porcelain; 13¾ x 7⅝ x 5½ in.
(34.9 x 19.4 x 14 cm). The Diplomatic
Reception Rooms, U.S. Department of State

ENDPAPERS
Les Paysages de Télémaque dans l'Île de Calypso
(details), ca. 1818; Joseph Dufour
(French, 1752–1827; firm founded 1797);
paper, W. 22 in. (55.9 cm) each section
(see pp. 88 and 92)

HALF-TITLE
Consular seal, 1808–9; Peter Bateman
(British, 1749–1825) and William Bateman
(British, 1744–1850) (see cat. 139)

TITLE PAGE
Early View of the Capitol (detail);
attributed to Victor de Grailly (see cat. 16)

PP. 4–5
Treaty Room Suite

P. 6
Carved architectural detail
from the Treaty Room